A Mieke Bal Reader

Mieke Bal is an Academy Professor in the Royal Netherlands Academy of Arts and Sciences, and cofounder of the Amsterdam School for Cultural Analysis at the University of Amsterdam. Her previous books include *Double Exposures: The Subject of Cultural Analysis*; *Quoting Caravaggio: Contemporary Art, Preposterous History*; and *Louise Bourgeois' Spider: The Architecture of Art-Writing*, the last two published by the University of Chicago Press.

The University of Chicago Press, Chicago 60637
The University of Chicago Press, Ltd., London
© 2006 by The University of Chicago
All rights reserved. Published 2006
Printed in the United States of America

15 14 13 12 11 10 09 08 07 06 1 2 3 4 5

ISBN: 0-226-03584-0 (cloth)
ISBN: 0-226-03585-9 (paper)

Library of Congress Cataloging-in-Publication Data

Bal, Mieke, 1946–
 A Mieke Bal reader.
 p. cm.
 Includes index.
 ISBN 0-226-03584-0 (cloth: alk. paper)—ISBN 0-226-03585-9 (pbk.: alk. paper)
 1. Arts. 2. Feminism and art. 3. Art and religion. I. Title.
 NX65.B35 2006
 700′.9—dc22

 2005019829

⊚ The paper used in this publication meets the minimum requirements
of the American National Standard for Information Sciences—
Permanence of Paper for Printed Library Materials, ANSI Z39.48-1992.

For Lena, my lovely
For Damar, for her desire to understand it all

Contents

Illustrations

Preface

Consistent with tradition, this *Reader* begins with my earliest theoretical article and ends with what was, at the moment of composing the *Reader,* the latest. But don't expect a neatly ordered, temporal sequence from which to glean my intellectual development. For the rest of the book breaks with this chronological principle. Its contents reflect my octopus-shaped, rather than linear, mind and my civil disobedience as an academic who has never felt at ease in any single discipline. This was not because I cannot discipline myself to do what it takes to be an "expert" in any one field—on the contrary, I have often taken a somewhat perverse pleasure in doing just that—but because the excitement of intellectual creativity and analytical discovery always took place on the edge between disciplines. Like the child I once was, I had to climb the wall to see what's on the other side and always found that new thing more exciting than my own garden, if only briefly.

In spite of this restlessness, the volume has been divided, if not according to disciplines, at least to areas, fields, or centers of interest, so as to orient the reader through the meanderings of that messy ensemble of writings called "my work." I will first take the reader through these sections, then explain what binds them together.

The first concerns literature, an art that for me is the art that gives access to the possibility of thinking the unthinkable and imaging the invisible or unimaginable. In other words, from childhood on, literature has been a world where words and images could not be distinguished from one another. Language is less its tool than its outcome, its support as well as its surface, but below which no depth lingers. Only words are there, but no single word, only sounds, music, images, thrills, and affective states pop up from the pages.

In the opening essay, "Narration and Focalization"—my first international publication and the groundwork of my ideas on narrative—I explore how a wo-

ven surface of words, rather than conveying the products of the imagination, pro-
duces imaginings for readers to play with, and then to be caught in their philo-
sophically and psychologically tenacious complexity. For someone who grew up
reading stories at all times, even while walking to school, the enigma of the will-
ing suspension of disbelief never lost its pull. Yet the tight bond between fiction
and what it purportedly distorts, that social reality in which all readers function,
not for a moment disappeared from sight. How could fictional narratives be so
effective in creating visions of reality and beat the narratives of truth-speak in their
authenticity? If I chose to study literature, then it was because during the dreary
process of growing from girl to woman, I had lived by its grave importance.

The essays in this first section all turn on ways of world-making in this sense,
not hiding the world through distraction. From Shakespeare on rape to Proust on
intimacy, Flaubert on boredom and Barnes on estrangement, the texts that cap-
tured my interest to the point of surrender created a reality affiliated to my own,
offering alternatives to what confined me and an understanding of what held me
in thrall. Yet in the process, they opened up my world, importing into it creatures
emerging from a tangible, sensuous language that told me a thing or two about
what mattered outside my own subjectivity. From these figures made of words, I
learned the value of that imaginative, everyday democracy called *intersubjectivity*.

But it is not the characters that populate narratives that I found most fascinat-
ing. It is their emergence, the way they pop up, are just there, being and doing
things according to a rhythm liable to affect me physically. The study of narrative
that has marked most of my work and propelled me to dig ever deeper into the
ways narrative works in and outside of the literature we recognize as novels can-
not be reduced to its traditional chapters: events, voice, focalization, character,
time, space. The essays of this first section reflect a desire to understand how
those categories, rather than being discrete, articulate each other while riding the
waves of narrative discourse. As the author of a textbook on narrative theory,
I have never been entirely at ease with the divisions that academic practice im-
posed. The selection presented here reflects that hesitation.

Indeed, having a *Reader* of one's work published—it's a blush-inducing
honor. When Susan Bielstein of the University of Chicago Press proposed to
publish such a *Reader,* I felt deeply grateful for the opportunity to present a syn-
thesis of my work, and for the respect for that work her proposal implied. To then
proceed to put it together required some moments of uneasy self-reflection. His-
torical distance entails self-distancing, including the temptation to disavow ear-
lier moments, earlier thoughts. To include the first essay took some tough reflec-
tion, as much as some arm-twisting from those friends who saved me from an
embarrassing act of self-disavowal. And when I now realize how much the clos-
ing essay owes to that earliest one, I am so very grateful they insisted.

But, clearly, literature could not be isolated from all the cultural artifacts that incorporate narrative devices, effects, and ploys to do their work, and soon I began to explore what I call narrativity outside the domain of recognized storytelling. This entailed excursions from which I never quite returned. Every time I found myself confronted with a boundary, the other side of the boundary beckoned. As a result, my work is so insistently interdisciplinary that many of my readers in particular fields I entered don't even know that I have worked in other fields as well. But working across disciplinary boundaries, shedding the certainties so painstakingly learned, is no license for "anything goes." On the contrary, rather than making me lose methodological ground, every excursion required methodological reflection. This is how interdisciplinary methodology became, paradoxically, the unifying element. My fondest hope for this volume is that my readers experience some of the excitement I felt when making these steps and accounting for them. Hence, the second section of this collection, "Interdisciplinary Methodology."

The four chapters here each represent an issue that has been important for me as an entrance into a field other than the one of my primary training. Language and metaphor, and theory in general, appear to be issues congenial with literary analysis. But once they become problematic, as when theory is met with suspicion and language asked to be straightforward, the problem surpasses literary theory alone because that field itself is at stake. In "Scared to Death"—also chosen because this essay is less known than some others—I attempt to treat the odd combination of issues on the same level, in terms of a cultural defensiveness detrimental to the advance of insight.

"Telling, Showing, Showing Off" is, again, included on the insistence of a friend. In the first selection I didn't include it, this time not out of a sense of temporal distance but because I feared it had been overpublished. But, as this friend insisted, it does provide a clear discussion of how to analyze the combinations of images and texts, artifacts and wall labels, in a museum that itself stands at the edge between art and culture. The tension between storytelling and description, even that between presenting and boasting that characterizes museums, cannot be understood, I argue in this essay, without a sense of how the categories and objects displayed function socially. This essay thus frames the objects in the American Museum of Natural History much in the way I consider all cultural artifacts must be framed. I was searching for a mode of analysis that would do justice both to the larger picture, as in social history, and to the detail of the objects—here, the displays—considered as works of art. This commitment to such an integrative approach has remained strong up until today.

A strand that runs through my work with some continuity, and that cannot be confined to any one discipline, is feminist thought and issues of gender. In "En-

folding Feminism," I betray a slight weariness with some forms of feminist thought, not because I do not think feminism to be one of the most important intellectual movements of the late twentieth century, but because of the reluctance of many of its practitioners to do what I find most important in intellectual life: refuse boundaries and, instead, climb up those walls and look over the edge, to the other side. Nevertheless, I used the opportunity of the invitation to look back to feminism from the year 2000—a year of an annoying overload of retrospective gazes, but that aside—to get a clearer grip on what of feminist thought had an ongoing importance for me: whether or not the work analyzed is particularly gender-specific.

The last essay of this section, "Intention," is central to my work. In the course of my many discussions with colleagues, including grumpy ones, I have invariably been confronted with the need to defend what I came to consider a rather fierce anti-intentionalism. I hold this position for a great variety of reasons, from a skepticism concerning rampant and recurrent deterministic tendencies to a skepticism concerning the knowability of intentions, and from a rejection of the authoritarianism inherent in the search for intention to an adversity of the futility of that search in relation to the object or situation to be explained. Indeed, deferring to the author's intention is, I have often argued, a form of intellectual laziness as well as an abject surrender of one's own responsiveness, even one's responsibility to one's cultural hic et nunc. I came to realize that this conviction—that intention is best bracketed if not altogether eliminated—is difficult to defend, since intention as the starting and checkpoint is, frankly, so dogmatically entrenched in the humanities as to be almost impossible to even discuss. The essay reprinted here is the best argumentation I have been able to come up with by way of defense.

In addition to the methodological reflections at the heart of these essays, there are two fields that I have entered without the politeness of an access code in the form of a degree, namely, visual studies/art history and biblical studies—not in that order. I wrote the bulk of my work on the Hebrew Bible in the second half of the 1980s and began to work on visual art and culture after, and in relation to, that work. It was when I needed, literally, a vision to overcome the dogmatic, repetitive interpretations of some biblical passages that I realized visuality was a force to be reckoned with, even, and especially, within textual artifacts. This was a heart-stopping moment for me, and a decisive one for the course of my work. If I present the work in these two fields here in their anti-chronological order, there are two reasons for this. The first is that the particular essays selected are not so easy to capture in a chronology. (For obvious reasons I have avoided including many book chapters and have rather selected autonomous articles.) The more important reason is that for the readers of this volume, the issues broached in the second section are followed up, so to speak, quite logically in the third. For the

questions I raise in "Visual Analysis" are all related to interdisciplinarity and the methodological problems such an approach entails. Meanwhile, the essays on what I have somewhat halfheartedly called "Postmodern Theology," in an attempt to mark the distance from theological traditions that characterize these pieces, all possess a crucial moment where visuality turns the tables on narrative.

In the section on visual analysis, "Telling Objects" is an attempt to "read" collecting as a narrative. I wrote this paper for a conference on collecting, an event where I felt thoroughly out of my depth in the company of specialists of the history of collections. But as has happened every once in a while, the absence of the required specialized knowledge had the effect of mobilizing ideas I did know, and which were usually not brought to bear on collections, so that I was able to imaginatively "see through"—to use one etymological synonym of "theory"—the collecting impulse, motivation, and strategy. In this sense, the essay is more an extension of the reflection on method, albeit an implicit one, than it is a specific case of visual analysis.

The question of how to analyze visual art, and specifically what the point can be of deploying the notion of "reading" to do so, is also primarily a question of method. In "Reading Art?" I make this question my guideline in discussing a number of issues that can be derived from the conceptual metaphor of reading, trying to avoid the facile use to which that metaphor is often put, and, instead, derive from its most literal sense a number of principles that can be productive for a visual analysis that shares with reading an engagement to the work and a detailed attention to it, a listening to potential meaning production and dialogue, and a skepticism toward the work's finitude—but not, of course, the predominance of language. Visuality can be considered a discourse, but not a linguistic one. No confrontation with an image is "pure" of language, but acknowledging the measure in which images "speak" to their viewers does not entail a reduction of the visual to language. Like the discussion in "Intention," I had been led to write this essay in answer to questions that, for all the productive power of polemics, became a little repetitive.

The last essay of this section offers primarily a detailed visual analysis of a single work. I like to say that detailed analysis is a theoretical stance for me. But as is hopefully clear by now, my essays are never entirely at ease with a detailed analysis that suppresses the theoretical questions that inevitably guide it. "Reading Bathsheba," a spin-off from my book *Reading "Rembrandt,"* centers around a Rembrandt "masterpiece," but it becomes obvious from the beginning that even the greatest masterpiece must let go of its boundaries and endorse the presence in its frame of other discourses, from biblical to social doxa, on gender and genre, murder and deceit, whether these concepts were around at the time of making or not.

Anachronism—as I have argued in response to critics of *Reading "Rembrandt"* who were disturbed by my positioning of the images in contemporary culture—is not only a very productive approach, but an inevitable and necessary one. In *Quoting Caravaggio,* I introduce the term "preposterous history" to name an anachronistic approach that is nevertheless self-consciously historical.

My earliest work, as the first essay in the volume demonstrates, was already deeply committed to understanding the ways subjectivity is present in such public things as cultural artifacts, without that subjectivity being attributable to the author. The place of subjectivity in public culture is for me the tension we need to heed in order to overcome the tricky and disingenuous resurfacing of individualism every time social criticism begins to prevail in progressive academic circles. The stumbling blocks of identity politics—its condescendence, its recidivism into a tokenist individualism, and its lost battle against legal finesse in a culture of contradiction—are a good example, but only one among many. The field of religion—where I am personally ill at ease but realize that too many people feel a sense of home and community there to be able to ignore its importance—is an area where subjective experience and collective behavior are intimately bound up together. But lest we consider this an archaic form of being, let me remind my fellow-atheist readers that friendship, love, and sex belong to the same category of intimate collectivity. Not coincidentally, the essays devoted to religion in the section "Postmodern Theology" share a preoccupation with extreme situations where subjectivity and collectivity are entangled in a deadly embrace.

One of the topics that has preoccupied me consistently through the years has been the culture of that extreme violation of subjectivity that is rape. When I say "culture of," I mean both a culture where rape frequently occurs and a culture that condones such crimes. Earlier in the volume, the analysis of Shakespeare's *Rape of Lucrece* also addresses the issue of rape. There, as in "The Rape of Narrative and the Narrative of Rape," the effort to articulate the specific *cultural* intricacies of the semi-condoned practice of rape guides the analysis. In both essays, the visual imagination rules the narrative process through which the rape has been made speakable. In addition, both essays reread a classical text that is emblematic for Western culture's attitudes toward rape. But whereas Shakespeare's text is notoriously sharp in its critique of the cultural tendency to condone rape, the biblical text central in "The Rape of Narrative and the Narrative of Rape" has been doubly overlooked. First of all, perhaps due to the sheer horror of the story, Judges 19 is among the rarely read, practically never analyzed texts of the Hebrew Bible. Second, when it is spoken of at all, the story is turned into a psychological, sentimental novel, a reading that manages, against all odds, to blame the victim, thus raping this emblematic figure of victimhood once more.

There is little theology in this essay, only a revisiting of a text that, to all intents and purposes, remains part of a religious canon for two of the world's major monotheistic traditions, and therefore must, by necessity, be misread.

The second essay of this section, "Lots of Writing," also revisits a classical text, this time a much more popular one, the book of Esther. The figure of Esther is generally considered a heroine, although of what exactly opinions differ. In my analysis, the relationship between the way she is used to offset another woman demonstrates that the absolute power of men over women is at stake. Moreover, the threat of personal danger as well as of genocide that looms over the story is another case of a story used by religious tradition for unpacking extreme situations in order to understand how these situations remain threatening, even if an exceptional mind manages to dissolve the immediate danger. Meanwhile, an anthropology of writing permeates the book of Esther. My analysis focuses on the tension between forms of blindness—a blindness that also inspired Rembrandt's depictions of the story's key episodes—and the skillful exploitation of the properties of writing as delayed, visual communication.

The last two essays of this section offer musings on the possibility to practice cultural analysis as a form of disabused and unorthodox theology in and for the present. "Postmodern Theology as Cultural Analysis" proposes a cultural analysis of theology based on a critique of the cultural imperialism of Christianity, as well as on a "preposterous" conception of history. In this perspective, theology is the name for a specialization within the domain of cultural analysis that, from the point of view of the integrative premises outlined above, focuses on those areas of present-day culture where the religious elements from the past survive and, hence, "live." Two short studies in visual culture, one on two paintings by Caravaggio (not discussed in my book on the subject) and one on an exhibition on the figure of Judith, demonstrate how such a cultural-analytical approach to theology can work.

The chapter that closes this section, "Religious Canon and Literary Identity," is largely a rethinking of my own earlier work in the domain where cultural analysis and theology meet. Here, I re-envision an analysis in *Reading "Rembrandt"* where I had attempted to establish a dialogue among the Bible, modern literature, Rembrandt, and the Quran. The occasion for this self-reflection was a request to write about the canon and the differences between its theological and literary incarnations. The issue of canon, I discovered, is so entangled with temporality and change that I could not ignore its enticing suggestion of self-reflection.

Divided as it is into sections that show areas of interest I have been pursuing in the work from which this *Reader* offers a selection, this volume nevertheless

proposes to forgo such divisions. Instead, the unity underlying the diversity of the topics discussed in these essays is an interest in *concepts* and the help they can offer in our attempts to understand a cultural artifact or object in the fullest possible way. If I may reiterate what I wrote on the use of concepts in the humanities in a book devoted to that topic, concepts are the tools of intersubjectivity: they facilitate discussion on the basis of a common language. This is their political-pedagogical function.

Mostly, concepts are considered abstract representations of an object. But, like all representations, they are neither simple nor adequate in themselves. They distort, unfix, and inflect the object. To say something *is* an image, metaphor, story, or what have you—that is, to use concepts to label something—is not a very useful act. Nor can the language of equation—"is"—hide the interpretive choices made. In fact, concepts are, or rather *do,* much more. If well thought through, concepts offer miniature theories and, in that guise, help in the analysis of objects, situations, states, and other theories.

But because they are keys to intersubjective understanding, they need more than anything to be explicit, clear, and defined. In this way, everyone can take them up and use them. This is not as easy as it sounds, because concepts are flexible: each is part of a framework, a systematic set of distinctions—*not* oppositions—that can sometimes be bracketed or even ignored but that can never be transgressed or contradicted without serious damage to the analysis at hand. Concepts, often precisely those words outsiders consider jargon, can be tremendously productive. If explicit, clear, and defined, they can help to articulate an understanding, convey an interpretation, check an imagination run wild, and enable a discussion, on the basis of common terms and in the awareness of absences and exclusions. Seen in this light, concepts are not simply labels easily replaced by more common words.

But concepts are neither fixed nor unambiguous. To say that, while maintaining that concepts can work as shorthand theories, has several consequences. Concepts are not ordinary words, even if words are used to speak (of) them. Nor are they labels. Concepts (mis)used in this way lose their working force; they are subject to fashion and quickly become meaningless. But when deployed as I think they should be, concepts can become a third partner in the otherwise totally unverifiable and symbiotic interaction between critic and object. This is most useful, especially when the critic has no disciplinary traditions to fall back on and the object no canonical or historical status.

But concepts can only do this work, the methodological work that disciplinary traditions used to do, on one condition: that they are kept under scrutiny through a confrontation with, not application to, the cultural objects being examined, for these objects themselves are amenable to change and apt to illuminate

historical and cultural differences. The shift in methodology I am arguing for here is founded on a particular relationship between subject and object, one that is not predicated on a vertical and binary opposition between the two. Instead, the model for this relationship is interaction, as in "interactivity." It is because of this potential interactivity—not because of an obsession with "proper" usage—that every academic field, but especially one like the humanities that has so little in the way of binding traditions, can gain from taking concepts seriously.

I said that concepts are not fixed. They travel—between disciplines, between individual scholars, between historical periods, and between geographically dispersed academic communities. Between disciplines, their meaning, reach, and operational value differ. Between individual scholars, each user of a concept constantly wavers between unreflected assumptions and threatening misunderstandings in communication with others. The two forms of travel—group and individual—come together in past practices of scholarship. Disciplinary traditions didn't really help resolve that ambiguity, although they certainly did help scholars to *feel* secure in their use of concepts, a security that can, of course, just as easily turn deceptive. As I see it, disciplinary traditionalism and rigid attitudes toward concepts tend to go hand in hand, together with the hostility to jargon, which, more often than not, is an anti-intellectual hostility to methodological rigor and a defense of a humanistic critical style.

Nor are concepts ever simple. Their various aspects can be unpacked; the ramifications, traditions, and histories conflated in their current usages can be separated out and evaluated piece by piece. Concepts are hardly ever used in exactly the same sense. Hence their usages can be debated and referred back to the different traditions and schools from which they emerged, thus allowing an assessment of the validity of their implications. This would greatly help the discussion between participating disciplines. Concepts are not just tools. They raise the underlying issues of instrumentalism, realism, and nominalism, and the possibility of interaction between the analyst and the object. Precisely because they travel between ordinary words and condensed theories, concepts can trigger and facilitate reflection and debate on all levels of methodology in the humanities.

To end this preface with an instance of the mobility of words transforming into concepts, let me suggest the temporal adverb "meanwhile," a word that I had chosen as the main title of the last piece in this volume. Especially in a book with a bit of a retrospective flavor to it such as a *Reader*, last pieces are situated at the provisional ending of an itinerary, hence, in the present. The delay between putting together a volume and seeing it in print inevitably makes that temporal situatedness in the present somewhat fake. The article that closes this volume, written in 2002, bears that insistently temporalizing title not to position it as a

provisional endpoint but, in its proclaimed ignorance as starting point, as a contrastive resonance with the first article, so full of confidence in my own ability to produce reliable knowledge. "Meanwhile" as a potential concept holds the cotemporal presence of heterogeneous temporalities in a world where, as Arjun Appadurai put it, the "research imagination" can, indeed must, resituate methods and paradigms. Loosened from their certainties and unquestionable status as directive, methods must be discussed in a dialogue with different traditions, so that our groping for "knowledge of globalization" can be fed by a process of true, that is, grassroots, globalization of knowledge. In this last essay, the possibility of knowledge itself is on the line.

Since this *Reader* was put into production, I have increasingly felt challenged by the need to develop alternative forms of knowledge. In some instances, this has led me to making films. Two primary motivations governed this step. First, filmmaking is a collective process. In teams of a radically international signature, I saw possibilities to achieve at least provisionally a kind of dialogical, performative knowledge production of the kind that Appadurai and, earlier, Johannes Fabian had advocated. Second, the contribution of the visual image, along with the multi-voiced presentation of a narrative without a single-voiced narrator, made me realize how much of our knowledge remains estranged from its own object. And although I will without any doubt continue to use the written word and academic discourse to reflect on issues of cultural encounter, the experience with film has decisively marked my sense of what it is, today, to be an academic and, meanwhile, not quite fitting the slots that, for having been dug so long ago, no longer fit us.

I am deeply grateful to Bregje van Eekelen for her expert, patient, and cheerful work on what has become a set of very elaborate indexes. And for everything else she does to make my life easier and more pleasant.

Part 1 **Analyzing Literature in Culture**

1. Narration and Focalization

Introduction

In *Narrative Discourse: An Essay in Method,*[1] Gérard Genette has worked out a typology of narrative figures[2] based on the three categories of tense, mood, and voice. The study of tense (chapters 1–3), in which Genette makes very precise distinctions among order, duration, and frequency, forms a coherent system. Both systematic and relevant, it has already received the wide attention it deserves, so there is no need to dwell here on the merits of that important contribution to narratology.

In chapters 4 and 5 of *Narrative Discourse,* Genette has clarified a theory in the most elusive and most "narratological" area of narratology: the narrating. The chief originality of his theory lies in separating two categories that are ordinarily combined—the categories of perspective and narrating agent.[3] Genette classifies them under mood and voice, respectively.

Besides separating, he also joins. Under mood he includes not only perspective or point of view (that is, what constitutes the answer to the question "who sees?"), but also distance, which has to do with the old distinction between showing and telling or the even older one between mimesis and diegesis. Under voice he includes not only the status of the narrator (that is, what constitutes the answer to the question "who speaks?"), but also the two problems of the time of the narrating and the different narrative levels (the narrative within the narrative).

The importance of the subject, the quality of the theory, and the great need finally to understand these areas of mood and voice are my reasons for undertaking the present analysis of Genette's theory. I will be careful to limit myself to the purely narratological aspects of the two chapters in question. There is no point

in reconsidering the value of the often brilliant analyses and interpretations of *À la recherche du temps perdu,* which served some readers as illustrations and others as touchstones and to the author were guidelines making it possible to sustain steady and fruitful interaction between deductive theory and the indispensable induction.

Nor will I go into the details of some fairly speedy distinctions that are not part of the theory itself, such as the functions of the narrator[4] or some hard-to-verify variants like "alterations" and "polymodality." What matters here is to analyze and evaluate the basic principles of the theory and, wherever the theory reveals imperfections, to see the extent to which we can modify it on its own level: that of a typology of narrative figures.

Analysis

Mood

Wishing to pattern his theory on a linguistic model—that of the categories of verbs[5]—Genette demarcated the area of mood by taking as his basis the *Littré* dictionary's definition of mood as aspect of verbs: the "name given to the different forms of the verb that are used to affirm *more or less* the thing in question, and to express . . . the different *points of view* from which the life or the action is looked at."[6] The first part of this definition becomes his point of departure for a theory of the difference between mimesis and diegesis. The second part gives rise to a theory of "focalization."

Noting along with Booth[7] that narration, by definition diegetic, cannot be mimetic, that it can only create a stronger or weaker illusion of mimesis, Genette, in discussing the difference between the two, distinguishes between the "narrative of events" and the "narrative of words." In the narrative of events, the contrast between mimesis and diegesis is relative: "Mimesis [is] defined by a maximum of information and a minimum of the informer, and diegesis by the opposite relationship" (166). This formulation does indeed account for the relative nature of the opposition; narrative can never be absolutely mimetic. In the narrative of words, in contrast, the situation is completely different because there the narrated content consists of words and can thus be presented directly, without the mediation of an informer *within* this content. Yet there, too, degrees of mimesis are possible. Genette differentiates "reported speech," identifiable as direct discourse, from "narratized" or "recounted speech," in which the content of the discourse is reduced to the bare minimum and speech has become simply an event like any other. Between these two extremes—the mimesis and diegesis of speech—is an

intermediary state: "transposed speech" (for example, free indirect style). In transposed speech, the narrator adheres as closely as possible to the words of the character without yielding him the floor; the narrator speaks, yet does not replace the character's words with his own narration of them.

"Who sees?" is a totally different kind of question. After a very convincing analysis of the theories of Stanzel, Brooks and Warren, Friedman, and Booth, in which he unerringly exposes in all these authors the same confusion between sight and speech, Genette proposes for the problems of point of view a three-term typology based on focalization.[8]

The narrative in which the narrator "*says* more than any of the characters knows" (189) is the "nonfocalized" narrative. If the narrator "says only what a given character knows" (189), the narrative has "internal focalization," whether that focalization be fixed, variable, or multiple. By focalized narrative Genette means what Georges Blin would call a narrative with "restricted field" and what Pouillon would call a narrative having "vision with."[9] The third type is the narrative with "external focalization," in which the narrator "says less than the character knows" (189), with the latter thus being presented from the outside.

Voice

Chapter 5 of *Narrative Discourse* concentrates on the narrating agent: "Who speaks?" Under the heading of voice, Genette discusses all the relations between the narrating agent and the narrated object: temporal relations, relations of subordination, and the "person" by whom the narrative is told. The chapter ends by defining the status of the narrator; the definition makes use of the last two aspects of the narrating agent, but not the first.

The *temporal relation* between story and narrating is defined in the same terms as relations between main clauses and adverbial clauses of time: by antecedence, posteriority, or simultaneity. Moreover, a combination of the last two relations is conceivable and would occasion an interpolated narrating. Examining the temporal aspect of the narrating requires one already to take into account the "person" of the narrator, to the extent that (especially in a "first-person" narrative) the narrator is distinguishable from the character by the temporal aspect as well. With a "first-person" narrative, the hero cannot be identified with the narrator, because the moment of writing down one's adventures is never the moment of experiencing them.

A *relationship of subordination* exists between two narratives located at different narrative levels. We are dealing here with "metanarrative," the *narrative within the narrative*—not only narratives that are framed or embedded[10] (as in *Manon Lescaut* or the *Thousand and One Nights*) but also less obvious insertions

within a narrative. In general, the narrator of a second narrative is connected, by his function as a character, to the first narrative; he thus belongs to the diegetic universe of that first narrative. Hence Genette's statement that "any event a narrative recounts is at a diegetic level immediately higher than the level at which the narrating act producing this narrative is placed" (228). Here the passage to the second degree is presented as a passage to a *higher* level, whereas normally subordination would be denoted by the word *lower*.[11] This problem of terminology is all the more serious since a regular profusion of meta-terms with the prefix "meta-" has sprouted since the publication of "Discours du récit." This abuse must positively end, for it produces an unfortunate looseness in terms that were created or introduced for their exactness. But at the moment, what counts is distinguishing narrative levels and diegetic levels, their reciprocal relationships, and the place of the narrator within such relationships.

Between a metadiegetic narrative and its first narrative, three possible kinds of relationships can exist. The relationship may be causal (functioning as an explanation), as when the metanarrative explains what is happening in the first narrative. Or the relationship may be thematic, involving no spatio-temporal continuity between the two narratives. This second relationship may be one of contrast and analogy, as in the *mise en abyme* so esteemed by the New Novelists. In this case the second narrative may influence the events of the first narrative "by example," on condition, of course, that the second narrative be *told* to the characters in the first narrative. The third relationship between metadiegetic narrative and first narrative is strictly narrative: not the content of the "metanarrative" but the very act of narrating influences the events of the first narrative. It goes without saying that the canonical example of this type is the *Thousand and One Nights*. From the first type to the third, the relationship is less and less direct: the importance of the content of the "metanarrative" for the content of the first narrative decreases, while the importance of the narrating act itself increases. The crossing from one narrative level to another must be by way of the narrating. Transgressions of this rule are instances of "narrative metalepsis," a figure that consists of "taking hold of (telling) by changing level" (235n).

Apropos of the (grammatical) "*person*" of the narrator, Genette is quite right in saying that so long as that question concerns grammar, it is irrelevant. By definition, a "third-person" narrator does not exist: any time there is narrating, there is a narrating subject, one that to all intents and purposes is always in the "first person." The "person" of the narrator (this time in the "human" sense—the narrator as agent—since the question has been eliminated on the grammatical plane) can be distinguished only in terms of his presence or absence in the narrative at the level in question. The narrator who is present in the story he tells is "homodiegetic"; the narrator who is absent (invisible) or who tells at a higher level a narrative from which he himself is absent is "heterodiegetic." Among homodiegetic

narrators, we can distinguish in terms of the degree of presence: some homo-diegetic narrators tell a story in which they are the main character (in which case they are "autodiegetic"), while other homodiegetic narrators are merely wit-nesses.

So with any narrative we can define the status of the narrator both by his nar-rative level and by his relationship to the story he tells: he is always extra-, intra-, or metadiegetic; at the same time he is always hetero- or homodiegetic.

Commentary

There, summed up very quickly, is Genette's theory. The distinction between "who sees" and "who speaks" is essential, and it very decidedly advances the theory of narratology as well as the practice of textual analysis. Never before has the confusion between the two agents been explicitly exposed, and never has the remedy for it been presented so lucidly.

It is appropriate, however, to examine the two categories of mood and voice more closely, bringing to bear the criteria of internal coherence and relevance.

Mood

Right away, we note a dissymmetry: while the chapter on voice focuses entirely on the subject and the object of the narrating—on the relations between "he who speaks" or tells and what is told—the chapter on mood is divided into two fairly heterogeneous parts. The part on "focalizations" in fact elaborates a theory about "he who sees," while the part on "distance" seeks to contribute to the millennial discussion of mimesis and diegesis, and in that part we are not dealing at all with the status of one of the agents of narrative. The *Littré* dictionary's definition of mood—Genette's pretext for the division into distance and focalization—in-cludes the idea of "affirm[ing] more or less" (161) the content of a statement. That formulation implies a *degree* of affirmation. In contrasting mimesis and diegesis, Genette uses a quantitative criterion ("more or less") to distinguish *ways* (mimetic or diegetic) of affirming.[12] So his reasoning slides from degree by quan-tity, to manner. What we have to examine is whether and to what extent distance actually belongs with the figures of mood. We also have to examine whether, in discussing focalization—which clearly does belong with the figures of mood— Genette's typology has a sound basis.

A. THE SUPERFLUITY: DISTANCE. Genette classifies narratives into two groups: the narrative of events and the narrative of words. Both types will be more mimetic or less, more diegetic or less. Now, the criterion on which this typology

is based is the quantity of information and, in inverse ratio, the quantity of the informer (or, to put it differently, the quantity of traces of the informer). For this criterion to be operational, we need to know exactly what is *information* and what is *informer*. By information, Genette means what is constituted by the narrated object—and from this perspective, the maximum amount of information is the object narrated with as many details as possible. Any "useless" detail, whether it be picturesque, circumstantial, symbolic, or indicative—in short, any descriptive element—constitutes the superfluity, whose function is to "show" what Genette points to as "reality." These details are "connotators of mimesis." The more diegetic the narrative, the fewer the details, for diegesis is limited to the series of *events* that form the story. Every description is mimetic, every event is diegetic— that is what this theory comes down to. We are simply, despite what Genette has said elsewhere, again in the presence of the old prejudice that denies to description any properly narrative function.[13] So long as the idea of event is not more clearly defined, it is impossible to perform the analyses necessary to classify narratives within the proposed typology.

While the narrative of events is defined only proportionally within the opposition mimesis/diegesis, the narrative of words, Genette says, "can, by contrast, seem condemned a priori to . . . absolute imitation" (169). Basically, that "absolute imitation" occurs in only one of the three types of the narrative of words. Indeed, reported speech, which is no different from direct discourse—the literal quotation of the words or thoughts of a character—constitutes a pure instance of mimesis. As to narratized speech, it represents "the most distant and generally . . . the most reduced" (171) type. Of the three types, then, this discourse is the most diegetic, the most narrative. Now, the reason this discourse is called narratized is precisely that it is no longer discourse; it is taken in hand by the narrator and *integrated* into his narrative. Discourse has become an event like any other. It is inserted into the narrative discourse and, theoretically, is indistinguishable from the narrative of events. It is, therefore, radically different from reported speech: narratized speech is not speech. Reported speech is inserted into the narrative text by the use of a mark of transition, most often a declarative verb. With that transition the narrator yields the floor to someone else—to the character who speaks. That speech is thereby a virtual "metanarrative," a narrative within the narrative, for the same reason that the framed or embedded narrative is.[14]

Transposed speech, which according to Genette is a state midway between the two others, testifies to the narrator's effort to "give as much information as possible" about a speech, to recount it as mimetically as possible, but without yielding the floor, without changing narrative level. We ought then to separate reported speech—"metanarrative" speech—from the two other types and to consider it "metanarrative." The two other types would then constitute the two extreme states of the mimetic and the diegetic, paralleling the types of the narrative

of events. Ultimately, then, the distinction between narrative of events and narrative of words—however interesting some of the critical results it generates—has only a provisional meaning: actually the two types of narrative are only one.

For the moment, let us accept Genette's theory with that modification. Let us also accept the possibility of defining with some certainty the idea of event. In that case the theory would be coherent, and for every narrative we would in fact be able to investigate the type—the relative type—of *distance* that predominates and the changes it undergoes in the course of the narrative.[15] But one difficulty remains, one that the author himself pointed out. The proportional opposition between mimesis and diegesis refers us to two other categories.

On the one hand, the "quantity of information" can be comprehended with respect to duration: that quantity determines the speed of the narrative, which is defined by the relationship between the duration of the story and the duration—length—of the narrative. The mimetic narrative will always be slow, while the diegetic narrative, in which narrative efficiency is greatest, will be fast. In chapter 2 of his book, Genette clarified a theory of duration that is perfectly coherent and allows us to account for that aspect of narrative. Bringing the problem of duration into the chapter on mood blurs the clarity of that latter chapter as a whole—which is all the more unfortunate, since in the area of mood, confusion reigns. It is true that traditionally the problem of mood has been incorporated into the study of point of view because point of view has been assimilated to "presentation," and this assimilation is precisely what Genette seeks to refute. For in this tradition, "presentation" covers practically all aspects of the text—indeed, the text itself, which is considered synonymous with the narrative: the narrative is the presentation of the story.[16]

On the other hand, the second part of the formulation, the "quantity of the informer," obviously refers us to the category of *voice,* since what we are dealing with is the traces in the narrative of the presence of the narrator.[17] We can, therefore, conclude that the section on distance, even when modified, has no place in the category of mood, whose systematic character it weakens. It is superfluous.

B. THE DEFICIENCY: FOCALIZATION. Although nowhere does Genette explicitly define "focalization," he says he uses it as a slightly more abstract synonym of terms that are "too specifically visual" (189), like "vision," "field," or "point of view." Unfortunately, these three terms are not synonymous, and Genette's typology suffers accordingly. In his first distinction, the one between nonfocalized narrative and narrative with internal focalization, focalization has a restrictive meaning. Referring here to Blin's restrictions of field, Genette distinguished the narrative whose narrator is traditionally called omniscient (the narrator who knows, if not "everything," at least more than the character knows) from the narrative whose narrator knows only what a given character knows. This character,

"from whom" the narrative is recounted, is the "focalized character." The third type of narrative, however, the narrative with external focalization, is distinguished from the second by a wholly different principle of classification. Now we are no longer dealing with a restriction, but with an inversion of functions. In the narrative with external focalization, characters also are focalized, but they are focalized from without. That means that the narrative's center of interest is a character (as it is with internal focalization), but his development is seen only from the outside.

It is true that, in moving from the first type to the third, the narrator's "knowledge" diminishes, and in this sense the series is homogeneous. But that difference does not have to do with point of view or focalization. The difference between the nonfocalized narrative and the internally focalized narrative lies in the agent "who sees": is the agent the narrator who—omniscient—sees more than the character, or (in the second type) is the agent the narrator who sees "with" the character, sees as much as he does? Between the second and third types, the distinction is not of the same order. In the second type, the "focalized" character *sees*; in the third type, he does not see, he *is seen*. The difference this time is not between the "seeing" agents, but between the objects of that seeing. This confusion will prove fatal to the theory of focalizations. The following passage perfectly illustrates this difficulty:

> External focalization with respect to one character could sometimes just as well be defined as internal focalization on another: external focalization on Phileas Fogg is just as well internal focalization on Passepartout dumbfounded by his new master, and the only reason for being satisfied with the first term is Phileas's status as hero, which restricts Passepartout to the role of witness.[18]

We see that the nonchalant use of a preposition is enough to overturn a theory. If Genette had thought to distinguish "focalization on" from "focalization through," he would never have ended up treating Phileas and his valet as almost interchangeable agents—treating the subject (Passepartout) or the object (Phileas) alike as "focalized." That mistake highlights the confusion among the various meanings Genette attributed to the term "focalization." If, in the final analysis, the decisive criterion were to remain the distinction between main character and secondary character, it could obviously be said that we have not made very much progress since E. M. Forster. (Analysis would be doing no more than paraphrasing the ideological taxonomy of the literary text and would hence not be *critical*.)

I would not go that far. Although Genette confuses certain ideas, his typology is not without value. That typology, it is true, cannot be defined by focalization— whose definition needs more precision—but solely and entirely by the narrator's knowledge, and this is betrayed by the very formulation Genette uses in defining

his types: the narrator *says* more than, as much as, or less than the character *knows*. In that formulation, knowledge and speech go hand in glove with each other. Could it be that the distinction between mood and voice, between sight and speech, is less radical than it seems? Or, on the contrary, should we push it further? However valuable the distinction provided by this chapter on mood, one other distinction is needed: that between subject and object.

Voice

THE REFRACTORY ABSENTEE: THE NARRATOR. Genette's typology of narratives according to the temporal relationship between story and narrating is flawless. In the great majority of cases, the narrating *follows* the events narrated. Predictive narratives remain in the minority and are most often "metanarratives," rarely first narratives. Simultaneous narrating, a sort of running commentary, is entirely exceptional and belongs to the experimental novel. The epistolary novel, though, constitutes the prototype of the interpolated narrative, so that that type is on the whole fairly widespread; by greatly simplifying, we can say in fact that the correspondents write their letters each time after the event prompting them to write but before the event leading them to write the next letter.

One small problem remains. Determining the narrating time in relations to the narrated time is possible only in cases in which the narrator appears. In other words, this problem of the temporal relationship cannot be separated from the problem of the status of the narrator. If the narrator, in one way or another, is present in the narrating—whether he be homodiegetic or heterodiegetic—we can determine the relationship between story and narrating. The narrator must tell his own story or someone else's "in the first person"; otherwise, the time of the narrating remains vague, indefinite, and above all uninteresting. The most widespread type of narrative, the one in which the narrator is absent or invisible (the narrative told "in the third person"), has no place in the typology. Who knows, for example, whether the narrator of Colette's *La Chatte*, when he describes a quiet evening at home at the beginning of the novel, is already fully informed about the novel's unhappy ending? The question seems to me totally irrelevant, for this narrator, being absent, is removed from the novel's center of interest. Restricting the typology's applicability in this way does not in itself mean discrediting the typology, for with narratives whose narrators are visible, the typology has great analytical value.

The idea of "narrative level" offers an important advantage. Its range of application is such that with it we can consider two different kinds of narrative from a single point of view: narratives within the narrative (of the *Thousand and One Nights* type), which have always been classified as a particular kind of narrative, as well as other, subtler changes of level, the "micronarratives" (like the *mise en*

abyme) that characterize the New Novel without thereby being absent from the classical novel. In analyzing some examples, Genette is entirely convincing. As with time, however, changes of level will be hard to identify in narratives whose narrators are absent or invisible. In one way or another, the narrator has to *mark* the passage from one level to another, and this the absent or invisible narrator cannot do. To take *La Chatte* again as an example: Alain's dream in the first chapter is clearly felt by the reader to be an interpolated narrative, a "metadiegetic" narrative. It does not enter into the series of events constituting the story of the novel, and it contains in itself an independent series of events. Where is the transition that lets us characterize the dream as "metadiegetic"? Denying it that designation is absurd, since the consensus of readers proves, albeit intuitively, that the dream is "metanarrative."[19]

Classifying narrators as homo- or heterodiegetic is in reality the only possible way to classify them, if we rigorously restrict ourselves to voice. The group of heterodiegetic narrators contains two types that we traditionally differentiate: the "third-person" narrator—absent, invisible as narrator—and the narrator who is visible ("first person") but who tells a story from which he is absent. No difference of level exists between the narrator who narrates in the third person (the absent narrator) and the narrator who tells in the first person a story from which he is absent: but neither does any difference of level exist between the latter and the narrator who tells his own story—for in that story the narrator is present not as the narrator but only as a character. The narrator as narrator is always at the higher diegetic level; at the very most, he can as a person be identified with a character.

But the narrator is not a person; he is an agent—an "it"—and therein lies the problem. We can appreciate Genette's systematic rigor, which kept him, in the chapter on voice, from going outside the realm of pure voice. But in the final analysis, perhaps this rigor is untenable. If it ends in a theory altogether too opposed to the reality of its object, one must no doubt look elsewhere for the solution to the problem—to systematicness of another kind.

II. THE NARRATING AND THE FOCALIZING

Agents

In every narrative, the functions that give effect to the kernels of the action are fulfilled by what we traditionally call "characters"; we also call them "actants" or "actors."[20] The character is defined by everything that has to do with his function in the action, his identity, his personality, his history, his relationships with other

characters. In other words, he is defined by everything involved in the answer to the question "who is he?" But as we cannot yet even define the content of this personal pronoun "he," we can use the more abstract formulation "who is?"[21] Since the earliest attempts at narrative theory, critics have been preoccupied with finding the answer to that obviously pertinent question. From round characters/flat characters to Greimas's roles, critics have been speculating on the status of the character inside the story within which he develops and which he causes to develop. If the question of the character's status is harder to answer than it would first seem to be, that is because the reader becomes acquainted with this "who is" *through the medium* of several agents, which had best be carefully differentiated.

The reader can interpret—indeed, can pass judgment on[22]—a character. That is because, in one way or another, the character is readable, or shall we say "visible": the reader "sees" him. The reader sees him through the medium of an agent other than the character, an agent that sees and, seeing, causes to be seen. I will examine this agent, provisionally called the "focalizer" (a term I define below), in seeking to answer the question "who sees?" For we must answer that question of mood (that metaquestion, if we may play this game with Genette's terminology) before we can say anything at all about the character seen, because the focalizer influences how the reader perceives the character seen. But our game does not stop there: we cannot determine "who sees" without taking into account the medium through which we perceive that sight: the narrating. So we must know "who speaks." "Who speaks" is the narrating agent, set in motion by and representing the author (the answer to the question "who writes?").

In interpreting narratives, too often—it seems needless to say—critics pass directly from the author to the character, with any possible resemblance between the two being conclusive so far as the critic's idea of the character is concerned. The critic passes directly from the agent "who writes" to the agent "who is." At a crucial moment in the history of the theory of narrative, the vital importance of that representative was discovered, the autonomy of him whom the author deliberately entrusted with the narrative function within the narrative: the narrator. At another moment, just as crucial although more recent, another discovery was made—that of the presence of the one to whom this narrator in turn delegates a function midway between himself and the character: the focalizer. The significance of this discovery cannot be overestimated; credit for it belongs entirely to Genette.[23]

The agents that function, *hierarchically,* in every narrative form the following series, which characterizes narrative as writing.

narrator → focalizer → actor → each of whom has an activity:
narrating → focalizing → acting → the objects of which are:
the narrated → the focalized → the object of the acting

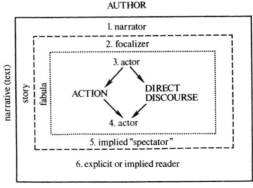

FIGURE 1.1

Each agent affects the transition from one plane to another: the actor, using the acting as his material, creates the story; the focalizer, who selects the actions and chooses the angle from which to present them, with those actions creates the narrative; while the narrator puts the narrative into words: with the narrative he creates the narrative text. Theoretically, each agent addresses a receiver located on the same plane: the actor addresses another actor, the focalizer addresses a "spectator"—the indirect object of the focalizing—and the narrator addresses a hypothetical reader. In some texts these receivers are referred to explicitly, like the reader in *Jacques le fataliste*; in others, they remain implied. In either case, the only way to comprehend how narrative communication functions is to distinguish among these receivers.

The model these reflections lead to is indicated in figure 1.

Reader

Now, every activity has its own object, just as it has its particular subject. If we confine ourselves, as I do here, to the agents that are peculiar to narrative and define it as a written genre, we must differentiate between the object of the speaking and the object of the focalizing, just as we must differentiate between the respective subjects of those two activities.

The agents that concern us here, therefore, are

- the subject of the narrating: the narrator;
- the object of the narrating: the narrated;[24]

- the subject of the focalizing: the focalizer;
- the object of the focalizing: the focalized.

By defining these four concepts, I hope to resolve the problems that Genette's theory neglects.

The Narrator

We have seen that only a single narrative "person" exists: the first person. The narrator, in his narrating, can be "visible," present in the narrative, or absent. His presence is defined with respect to the very narrative being studied: to be present, the narrator must be *inside* the narrative. This is Genette's homodiegetic narrator, telling a story in whose fabula he himself appears. He can also be a heterodiegetic narrator, telling "in the first person" a story from whose fabula he is absent. The "third-person" narrator does not exist. If—in some of Maupassant's tales, for example—an I-narrator yields the floor to someone else who up until then has been referred to as "he," this second-degree narrator immediately stops being a "third person" at the very moment he begins to recount: he takes first-person responsibility for the narrative he is about to tell the others, among whom the first narrator, too, is present. This latter, who has been "first person," thereby becomes "second person," the extradiegetic recipient of the "metanarrative."[25] Both narrators can be homodiegetic in their respective narratives.

All this is understood, and my reason for dwelling on it once again is to emphasize the importance of the *change in level,* which is essential for the status of the narrator. In his typology of the possibilities for the status of the narrator, Genette's implicit starting point is the hypothesis that the "third-person" narrator, the absent one, is automatically extradiegetic.[26] Since the extradiegetic narrator is defined by a difference of level, this implicit hypothesis of Genette's means that the absent narrator is located at the same narrative level with respect to the narrative he tells as is the extradiegetic "first-person" narrator of the type I have just described. Now, no indication attests the presence of this hypothetical level higher than the narrative itself. As Genette himself says, there is no narrator except as *subject*—thus, an "I," whether we see him or not. The most frequent type of narrator, the "invisible" narrator, achieves nothing by leaving no traces of his act of enunciating: regardless, he is well and truly the subject of the narrating. In this sense, he is as present as the other one—even though invisible.

If, regardless, the "invisible" narrator is located inside his narrative for the same reason that the homodiegetic narrator is, like the homodiegetic narrator (although in a different way), he must be present in his narrative. For like him, he has an object: the narrated.

The Narrated

The narrated is composed of the words of the narrating. It is the statement. To define the status of the narrator, we sought an answer to the question "who speaks?" and once we have the answer, we will ask, "What does he say?" Just as the object of an action *submits* to that action which the subject has performed, in the same way the object of the narrating is dependent on the subject, is *subordinate* to it. We can indeed say with Genette that every narrator maintains a hierarchical relationship with his object.

I continue to be unhappy with Genette's hierarchical inversion. I think that to indicate *dependence,* we have to replace *higher* by its opposite. To save the prefix "meta-" for a more appropriate use, I want to propose, provisionally and for lack of anything better, that we speak of "hypo-": "hypo-narrative," "hypo-diegetic."[27]

We have already seen that the narrator—present or absent, it makes little difference which—can yield the floor to a character. The character then speaks in direct discourse: this is reported speech—eminently mimetic, according to Genette. At that moment the *level changes,* the intradiegetic narrator becomes extradiegetic with respect to the new, hypodiegetic narrative formed by the direct discourse that the character-subject becomes narrator of. Clearly, not all direct discourse is necessarily narrative. It has to be brought about, if only virtually, by the agents that define the narrative. Otherwise it is still a hypo-discourse, but is in that case a "dramatic" intrusion in the narrative.

What the character talks about is located at a level even lower than the level at which the character-narrator is located, and the character-subject who talks ceases to be equal to the character he is talking about: in terms of narrative structure, the character-subject is higher than the character-object. We can sum it all up this way: the narrator tells that the character tells that a certain character does or is this or that, and if the character-object of the direct discourse is in turn supposed to speak, the series can be continued endlessly. We recognize Todorov's way of summarizing what happens in the *Thousand and One Nights*: "Scheherazade tells that Jaafer tells that the tailor tells that the barber tells that his brother (and he has six brothers) tells that. . . ."[28] When such a change in level occurs, the reader becomes aware, if not of the presence, at least of the activity (and thus of the existence) of the narrator within the narrative. The declarative verb, or whatever other form the yielding of the floor by the narrator to the character can take, functions to *connote the transfer,* the handing over, like a sign indicating that the object of speech will in turn become its subject.

We can redefine the narrated object with respect to the narrator: the narrated is everything located at the level immediately below the level at which the act of enunciating is located.[29] From this formulation (which parallels Genette's defi-

nition of the status of the narrator), we can logically deduce that reported speech is fundamentally different from recounted speech: they are not located at the same narrative level. The narrated defined in this way is still an abstraction. It will be rendered concrete by its indispensable complement: the focalized, object of the focalizing.

The Focalizing

Now is the time to define the term "focalizing." We have seen that Genette's use of the term "focalization" is based on two concepts: point of view and restriction of field.[30] These two are neither completely different from each other nor completely identical. Furthermore, "point of view" is used with two opposite meanings.

Among the definitions in the *Robert* dictionary of point of view, these two should be kept in mind:

- totality of objects or scene on which one fastens one's gaze
- particular opinion

In the first definition, which is more literal than the second, we are dealing with the object of the gaze; in the second, with the subject who sees or considers. We recognize the difference between "internal focalization," which corresponds to the second definition, and "external focalization," which corresponds to the first. Ordinarily we say that "the story is told from the point of view of thus-and-such a character," where Genette speaks of internal focalization. In this case we are defining the *subject* of the "gaze"—the focalizer.

The term "focalization" is preferable to the traditional terms because it is more technical and thereby can be used in a way that is both more restricted and more extensive. The term excludes the psychological meanings of point of view, which is the reason Genette prefers it. At the same time, it can extend to any object of the "gaze," whether that object be a character, a place, or an event. Each of these elements is thus granted comparable status in the structures of narrative.

Genette's typology can be explained thus: "The story is told in *internal focalization*" means that the characters, places, and events are presented *from* thus-and-such a character. That character is the *subject* of the *presentation*. If the story is "told in *external focalization*," it is told from the narrator, and he has a point of view (in the radical, pictorial sense) on the characters, the places, the events. He is then not in the least privileged and sees only what a hypothetical spectator would see.

"Restriction of field" is a term that takes features from each of the two mean-

ings of point of view. The object of the gaze is *limited* to what a spectator can see, but this spectator is not hypothetical: he is a character. This idea thus corresponds to internal focalization with respect to the subject of the gaze and to external focalization with respect to its object—which is why the term "focalization" as Genette uses it is not univocal enough to account for the whole range of narrative possibilities.

Actually, we can keep all the meanings of the term "focalization" on condition that we carefully define and differentiate them. Immediately, extending the term beyond the purely visual lets us take "focalization" in the broad sense that, provisionally and for lack of anything better, I refer to as "center of interest." By that I mean, first, the result of the *selection,* from among all possible materials, of the content of the narrative. Next, the concept includes the "gaze," the *vision,* also in the abstract sense of "considering something from a certain angle"; and finally, the concept includes the *presentation.* The subject and object of these three activities, which can be summarized as *orientation,* are the narrative agents we are dealing with here.

Focalizer and Focalized

Thus there is a focalizer, who is not the narrator (as Genette has sufficiently said), but neither is he the focalized. Phileas Fogg, hero though he may be, is, for the focalizing, subordinate to his valet. In a narrative with an "invisible" narrator, the focalizer, too, is often anonymous. But no more than the narrator is the focalizer expected to retain this power for himself throughout the narrative. As the narrator can yield the floor, the focalizer can yield the focalizing. That is when the narrative is "told from the point of view of a character," in internal focalization. Therefore, two possibilities exist: if a narrative begins in external focalization and changes to internal focalization, it is not necessarily the focalizer who changes; the change may equally well be in the focalized, with the character "seen from within" being not the subject but the object of the focalizing. The "knowledge" of narrator and character, a concept that is inoperative because purely figurative, can thus be left out of account. This use of the term "focalization" differs from Genette's in several respects:

1. The use of the term is no longer limited to a typology of narratives that, with some rare exceptions, helps us characterize the great majority of narratives. It has also become an analytical tool, capable of accounting for the specific functioning of each individual narrative and discerning the figures within each.

2. The term does not have the restrictive meaning it does in the distinction between nonfocalized narrative and narrative with internal focalization, where focalization means that the narrator is the focalizer because he knows less than the omniscient narrator does.

3. The functional difference—subject or object—that differentiates the narrative with internal focalization from the narrative with external focalization is made explicit.

4. Parallel to the narrating, the focalizing, too, has levels. A change of level in the focalizing often goes hand in hand with a change in narrative level, but not always—far from it. Everything that has traditionally been looked on as author's intrusions, the traces of the implied author, can be analyzed as traces of the narrator and of the focalizer.[31]

5. The focalized, when understood in this way, is not limited to characters. Things, places, events also form part of it. Thus, for a description, for example, we can determine whether the object being described is focalized (that is, chosen, considered, and presented) by an anonymous focalizer or by a character. Needless to say, this distinction is very important for the interpretation of particular descriptions, but also for the theoretical definition of the descriptive in general.

6. The focalized can be perceptible or imperceptible. This distinction differentiates between what a hypothetical spectator can perceive—by sight, hearing, smell, touch, and taste—and what he cannot (the Genettian distinction between internal focalization and external focalization, but now kept strictly for the focalized). For lack of a better word, I will use "perceptible" to indicate the presentation of an external focalized; "imperceptible" is for a focalized that is solely internal, like psychological material. The important thing here is that the distinction has nothing directly to do with the focalizer, but characterizes only the nature of what is focalized.

In this theory the concepts of the focalizing and the narrating are symmetrical, and in this sense my theory, although based on Genette's fundamental distinction, utterly parts company with his. Yet if I seem to draw together what he disconnected, I am not invalidating his distinction but, on the contrary, radicalizing it. For to treat the agents of focalization and voice in isolation conceals the parallelism of their organization in narrative. And this parallelism is what must have caused the confusion that for so long dominated the theory and criticism of narrative. Ultimately, the way to keep that confusion from recurring is to elucidate and not merely denounce it. That is what I attempt to do in the few illustrations that follow.

Illustrations

The examples I analyze are taken from *La Chatte* by Colette.[32] This novel is of the type that occurs most frequently, whether we define it as "told in the third person from the point of view of a character" or as "told by a hetero-extradiegetic narrator and with internal focalization." At the outset, let us say that the consensus readers have reached concerning the novel's technique does not extend to the novel's psychological, psychoanalytic, or moral stance. Of the three characters — Alain, Camille, and the cat — each has its fervent partisans, each its unremitting adversaries. That is why we can use this novel to illustrate two things: the coherence and relevance of the theory of agents I have just put forward, and the reasons that unsophisticated readers and experienced critics alike are necessarily misled by the technical aspects of the novel. For what Genette's theory does not sufficiently allow us to see is that true responsibility for both the moral and the narratological misunderstanding on the part of readers of this book lies with the narrative.

The Narrator-Focalizer

Take the first sentence of the novel: "Towards ten o'clock, the family poker-players began to show signs of weariness" (71). The situation is presented, but by whom? The information conveyed in the sentence is fairly plentiful. The reader is given information about the time (ten o'clock), the characters present (players), the relations among them (familial), their occupation (poker), and their reaction (weariness). No sign of the narrator, no sign of the focalizer. And the word "signs"? It indicates that the behavior of the characters is such that a spectator can see and interpret it. This spectator we know is not the reader: the nature of narrative makes it impossible for the reader to perceive the content of the information directly. Nor is the spectator the narrator: the narrator is entitled to speech and not to anything else. The spectator must be the focalizer, anonymous and neutral, who sees "in place of" the reader. Since this focalizer is invisible, he has to be at the first level of focalization. The words "signs" functions as a *connotator of level*: it indicates not only that the "family poker-players" are starting to let their minds wander, to yawn, to fidget, but also that the narrative — told, certainly, by an extradiegetic narrator — is focalized, too, by an extradiegetic focalizer. The "signs" *given* are like winks from the diegesis at the extradiegetic agents: the focalizer and the narrator — and also the "spectators" (the recipients of the focalizing), the narratees, the readers. We see that at the beginning of this narrative, as at the beginning of many narratives, narrator and focalizer go hand in hand. As long as both those agents are on the same level in relation to their objects, con-

ceivably they can be referred to by a term that recognizes their interdependence while respecting their autonomy. The term "narrator-focalizer," a formulation in which they are simultaneously together and apart, fulfills these conditions. Despite the unquestionable drawbacks inherent in such terminological exuberance—which will irritate, and rightly so, many a reader—prudence warns us against the too-facile use of a single term. We will have to keep sight of every change in level.

Limits and Transgressions

It is self-evident that a change in the level of narrating, since it is denoted most often by a declarative verb and punctuation marks, is easier to see than a change in the level of focalizing. For that reason it may be worthwhile to dwell on some borderline cases with which we can more firmly ground the concepts put forth.

Shortly after the beginning of the novel, we find the following sentence: "Her eyes appealed to her fiancé, who lay back, overcome, in the depths of an armchair" (71). In this sentence it is no longer "signs" that are being recounted, but an appeal to fellowship issued by one character to another and the situation of the other character at that moment. Despite the greater complexity of the object of the focalizing, the technique is the same: the appeal to fellowship is recounted in its external manifestation. Camille appeals to her fiancé with "her eyes," thus letting the "spectator" see what she sees. This spectator sees it at the same time that the character, Alain, the recipient of the appeal, sees it. As far as the agents are concerned, then, the functioning of the phrase in the first sentence: the sign—"signs" there, "eyes" here—functions simultaneously at the diegetic and at the extradiegetic levels. In each case the sign is the point of contact between the two levels.

Similarly, Alain, "overcome, in the depths of an armchair," is "seen" both by his fiancée, who addresses herself to him, and by the extradiegetic agents (readers and the narrator-focalizer). In a case like this, in which the focalizer looks along "with" the character, the focalizing has a strange resemblance to a "transposed view," through analogy with "transposed speech," like free indirect discourse. In transposed speech the narrator takes on the speech of the character, adhering to it as closely as possible without effecting a change in level; in transposed focalizing, the focalizer assumes the character's view but without thereby yielding the focalizing to him (or, in this case, to her). We have already seen that such speech is nothing other than narrating at its most mimetic. So we may say that here the focalizing is at the limit of the first level, and for the same reason: through the sign "eyes," the extradiegetic focalizer is able to retain his power.

A more complex problem arises in the following passage:

She watched him drink and felt a sudden pang of desire at the sight of his mouth pressing against the rim of the glass. But he felt so weary that he refused to share that pang and merely touched the white fingers with the red nails as they removed his empty tumbler. (72)

The verb "watched" in the first sentence denotes a change in the level of focalization. Alain, then his mouth, is the object of the focalizer Camille. Alain is focalized in the second degree, by the focalizer who is focalized. Camille, who "felt a sudden pang," is still focalized in the first degree. Thus she is located at the first level as the focalized, and she functions at the second level as the focalizer. In the second sentence, the first level is reinstated. Alain is once again focalized directly by the focalizer-narrator of the first level. In the narrating, no change takes place.

The two sentences differ in another way, one that affects only the focalized. Twice in the passage a "feeling" is recounted. In the first—Camille's—her pang of desire is perceptible to the "spectator," all the more so as its expression is preceded by the verb "watch," a verb that is unlike "see" in allowing perception from without. Here, then, the focalized is perceptible. But the other feeling—Alain's—is of a different kind. True, as a rule fatigue can be read on a face and a refusal is perceptible in its consequences. But the *feeling* ("he felt . . .") of fatigue and the *decision* to refuse ("refused") could not be manifest at the very moment they were realized. Thus this passage is characterized by the following features:

- both sentences are recounted at the first level;
- in the first sentence there is one focalizer at the first level (the one who sees Camille watch) and a second one at the second level (the one—Camille—who sees Alain);
- in the second sentence there is only a focalizer at the first level (the focalizer-narrator);
- in the first sentence each focalized is perceptible; and
- in the second sentence the focalized is imperceptible.

We see a correlation between the level of focalizing and the nature of the focalized. From that analysis, I think it possible to construct the following hypothesis:[33]

An imperceptible focalized can be focalized only by a focalizer at the first level, whereas a perceptible focalized can be focalized at any level.

In the passage I have just analyzed, the change in level affects only the focalizing. Focalizer and narrator are thus dissociated from each other. In the following example, the situation is even more complex:

"She's pretty," Alain reasoned, "because not one of her features is ugly, because she's an out-and-out brunette. Those lustrous eyes perfectly match that sleek, glossy, frequently-washed hair that's the colour of a new piano." He was also perfectly aware that she could be as violent and capricious as a mountain stream. (73)

This passage begins in direct discourse. With the verb "reasoned," the narrator yields the floor to the character. He takes it back in the next sentence: "He was also perfectly aware . . ." The verb "reasoned" functions *to connote* a transfer, to signal the change in narrative level.

The focalizing, in turn, determines the choice of this verb among all possible declarative verbs. The verb denotes a logic that should normally lead to the discovery of the truth. What we are dealing with here is a young man's opinion of his fiancée, a week before their wedding. In that context—and, of course, in the context of the bourgeoisie in the 1920s—the denoted logic is connoted as misplaced, as proof of a lack of feelings—or, at the very least, as ambivalent. The focalizer chose this way of presenting the content of the discourse, influencing with this choice the degree of "truth" the reader will attribute to the content: the reader will tend to react to the content with mistrust. He will, moreover, be interested in the point of view, in the focalizer rather than in the focalized. The first focalizer is very powerful here: by choosing an inappropriately logical verb, he reveals and exposes the inappropriately neutral character of Alain's discourse. While the narrator simply sets his power aside, the focalizer—before setting his aside—momentarily tightens the bond between him and his object.

Within the hypo-story, Alain is the narrator and his opinion of Camille is the narrated. Alain is also the focalizer: he *chooses* the attributes of Camille that he wants to highlight; he *sees* Camille in his own way and *presents* her as he wishes. The change in the level of focalizing is thus parallel to the change in narrative level. The opinion about Camille is recounted in the second degree, and Camille herself is focalized in the second degree.

In the second part of the passage, after the direct discourse, the first narrative level is reinstated. The narrator again takes the floor, and Alain's thoughts again become the first level of the narrated. The same with the focalizing. The words "He was also perfectly aware that" are focalized in the first degree, just like the verb "reasoned" at the beginning of the passage, and the object of this focalizing—Camille and her attributes—is taken on by the first narrator-focalizer. He accepts responsibility for the focalized, the rather negative view of Camille, thus making this view more "true," since it is the object of a "neutral" focalizer. Selection of the neutral verb confirms that "truth."

But there is more. The word "also" reinforces the bond between the hypo-

story and the first story, inasmuch as the influence it connotes works against the influence of the verb "reasoned" at the beginning of the passage: the word "also" links Alain's opinion to that of the first focalizer, for it joins the opinion that has just been expressed in the second degree to the opinion now to be expressed in the first degree (the phrase "was perfectly aware" is synonymous with "knew," and likewise presupposes the unquestionable truth of the content of this knowledge). The word "also" confirms after the event the truth of the very opinion that the verb "reasoned" called into question. Thus, on the "moral" plane, the position of the focalizer contrasts radically with what it was at the beginning of the passage.

We can summarize the analysis this way:

- the narrative level changes in the first sentence and changes back in the second sentence;
- the level of focalizing changes in the first sentence and changes back in the second sentence;
- along with the first change in the level of focalizing, the first focalizer influences the focalized at the second level; and
- along with the second change in the level of focalizing, the second focalizer influences the focalized at the first level.

We can easily imagine how such complex structures lead to the kind of confusion Genette denounces. Actually, that second influence—which is, to say the least, paradoxical, given the hierarchical relationship between the two focalizers—is responsible for some of the reactions readers have had, tending as they do to support Alain vehemently against Camille on the grounds that he resembles the author of the novel.[34] Probably these readers, without being aware of it, are sensitive to the privileges that the presentation bestows on Alain.

The Case of the Dream: Hypo-Narrative or Hypo-Focalized?

Finally, what about Alain's dream? This dream comes at the beginning of the novel, at the end of the first chapter, and takes up several pages (84–86). The passage begins in the following way:

> He loved his dreams and cultivated them. Not for anything in the world would he have revealed the successive stages which awaited him. At the first stopping-place, while he could still hear the motor-horns in the avenue, he met an eddy of faces, familiar yet distorted. . . . (84)

The dream is recounted in the first degree and, furthermore, that fact is explicitly noted—for several lines earlier, we read that "he did not talk about his ad-

ventures of the night." So the narrative of this dream cannot be a hypo-narrative. Nonetheless, it constitutes an "independent" and fantastic story that, as a story, is apparently not at all distinguishable from the framed or embedded type of story. In such a case, the status of the dream can be accounted for only with the concept of focalization.

A dream, in terms of being the focalized, is by definition imperceptible. According to my hypothesis, therefore, it can be focalized only at the first degree. But how could it be focalized at the first degree here, since Alain himself is the only one able to "see" this dream and he is not the first focalizer? The problem this case raises is obviously a general one.

Let us suppose that the dream were recounted in the second degree. We would then have something like this: "Alain recounts, 'Last night, in a dream I met an eddy of faces, familiar yet distorted.'" Such a narrative, which is clearly a hypo-narrative, is perfectly possible. It will be more likely to occur in a narrative with a homodiegetic and "present" narrator (for example, in a diary or an autobiography) than in a narrative like *La Chatte*. The reason is that a homodiegetic narrator can more easily dispense with a narratee than a character-narrator can. If Alain had told his dream, he would probably have told it to someone, which is exactly what he does not want to do. But at the moment, that does not much matter. The dream as a hypo-narrative, told in the second degree, will always in any case be an imperceptible focalized. The passage analyzed earlier, on the basis of which I constructed the hypothesis that an imperceptible focalized must be focalized in the first degree, will thus differ fundamentally from this one. In fact, it differs in two ways.

- In the sentence that had a focalization in the second degree, the second focalizer was not the same character as the second focalized: Camille was watching Alain. In a dream, the second focalizer, the one who "sees" and presents the dream, is also part of the focalized: he *has* the dream and he *presents* his own dream.
- The change in level of focalizing was not accompanied by a change in narrative level. But in a dream-hypo-narrative, the change in narrative level, which goes hand in hand with the change in level of focalizing, implies that the narrator in the second degree can become a narrator-focalizer who recounts an event at which he was present. In that case he is a homo- (and intra-) diegetic narrator-focalizer.

We must therefore revise the hypothesis as follows:

- An imperceptible focalized can be focalized only by *(1) a focalizer in the first degree; (2) a focalizer-narrator in the second degree if he is homodiegetic; or (3)*

*a focalizer in the second degree within a first-degree narrating if that focalizer is
homodiegetic—thus, if he forms part of the second focalized.*

- A perceptible focalized can be focalized at any level.[35]

The hypothetical dream would go into the second category, and the dream as it
appears in the novel must go into the third category: it is told at the first level, but
focalized at the second level by a focalizer who is focalized. Actually, the focalizer
is not constant. There is an alternation between the two levels. The following pas-
sage illustrates the difficulty:

> Each was furnished with one great eye and they circled round in an effortless
> gyration. But a submerged electric current shot them far away as soon as they
> touched an invisible barrier. In the humid gaze of a circular monster, in the eye
> of a plump moon or that of a wild archangel with rays of light for hair, Alain
> could recognise the same expression. . . . (84)

The content of the first two sentences of this passage is focalized at the second
degree. The focalizer, Alain, is not named. The nature of the focalized makes it
clear that the dreamer must be the focalizer. In the third sentence, Alain is named
and thus focalized, and the first focalizer thereby reappears. The first focalizer
sees Alain who sees the monsters who . . . see Alain, as the text of the dream will
say a little later.[36] Such indications of the presence of the first focalizer appear
throughout the passage, as if it were necessary to confirm regularly the fact that
Alain is focalizing his own dream. It is like a clarification of the rule that holds that
an imperceptible focalized is focalized by a homodiegetic focalizer.[37] If the dream
is not a hypo-narrative, it must at least be hypo-focalized. Thus it is partly like and
partly unlike other dreams, hypo-narrative dreams. The formulation explains the
reader's intuition while allowing a precise analysis of the technique brought into
play in the narrative.

Interpretations

Figures and Levels

Every change in level constitutes a figure. In any given narrative, a certain type of
figure will be found to predominate. For example, changes in level will be many
or few. The changes in narrative level will be numerous or relatively sparse. The
changes in the level of focalizing will benefit one or another character (one focal-

ized character will often be imperceptible; another will always be perceptible).
Or, on the contrary, the changes in the level of focalizing will be randomly dis-
tributed among the characters. The focalized characters may be exclusively per-
ceptible.

From these patterns, we can set up a typology of narratives and then charac-
terize a narrative in relation to other narratives. We can also give a detailed ac-
count of a narrative and describe its major cruxes, in order to lay bare its narra-
tive originality. By carrying the analysis further, a critic who wants to interpret a
particular narrative in depth will be able to study its narrative functioning and
take note of any figure that is exceptional in terms of the type of narrative he orig-
inally classified his narrative as. After describing the characteristics of a narrative
we can formulate its inner rules, the rules that it generally observes and that are
peculiar to it. Again, some examples from *La Chatte* can illustrate various possi-
bilities of interpretation.

Immanent Rules

Every narrative can choose its stance with regard to the general rules of narrative.
It can strictly observe them or, on the contrary, it can violate them, either as an ex-
ception or regularly. In theory the narrative will observe its own immanent rules,
but there, too, infractions are possible, and the critic will have to call attention to
those infractions in particular.

The narrative of *La Chatte* observes the following eight rules:

1. The changes in narrative level are limited to two levels.
2. Camille is a narrator at the second level when the narrated consists of spoken
 words.
3. Alain is a narrator at the second level when the narrated is perceptible or
 imperceptible and when it consists of spoken words (introduced by "he
 said") or thoughts (introduced by "he said to himself").
4. The changes in the level of focalizing go beyond the second level.
5. At the second level, Camille can be a focalizer when the focalized is percep-
 tible.
6. At the second level, Alain can be a focalizer when the focalized is perceptible
 or imperceptible.
7. At the second level, Alain can be a focalizer when the focalized is in turn,
 focalizer.
8. At the second level, any other focalizer is a focalizer-narrator, and in such
 cases the focalized and the narrated must be perceptible.

This overall description, worked out inductively, can be verified. It lets us see at once that the privileged character is Alain. He can not only focalize another focalizer, but he can also narrate an imperceptible narrated and focalize an imperceptible focalized. Moreover, he is entrusted with the narrating and the focalizing much more often than his antagonist is.

To give an exhaustive description of the narrative in any case, we will have to examine in particular:

- the figures created when the rules are pushed to extremes, and
- the figures created when the rules are violated.

It must be said immediately that this narrative is characterized by strict observance of its own rules. The only rule it breaks is the last one. I will present some examples of the rigor of this narrative, the faithfulness with which it abides by its own nature, to demonstrate that analyzing figures and formulating the rules inferable from the analysis do lead to interpretations. At stake here is the *relevance* of my theory to the criticism of narrative texts.

FIRST RULE. This rule implies that the characters can recount, but that they cannot recount that someone else recounts.

Example. He got up from the green bench and assumed the important smile of the heir of Amparat Silks who is condescendingly marrying the daughter of Malmaert Mangles, "a girl who's not quite our type," as Mme Amparat said. (95)

In this passage, the narrating passes from the first level to the second, and the narrator gives the floor to Mme. Amparat directly, without going through Alain. The focalizing, however, does go through him first, before he yields it in turn to his mother. This disconnection between narrating and focalizing, between speech and sight, can be looked on as the sign of a psychological disconnection. Alain sees Camille as his mother does, but does not yet dare to take that opinion as his own: he shares it without *saying* so. The narrative's strict observance of the first rule is a sign, a definite type of sign: a diagrammatic icon.[38]

SECOND RULE. This rule implies that neither the reader nor Alain has access to Camille's thoughts and feelings unless she ventures to express them. (Making her thoughts perceptible to the reader means making them perceptible also to the intradiegetic narratees, including Alain, whom she is almost always with.) In the occasionally stormy discussions between Camille and Alain, the reader can become acquainted only with what Camille says, whereas what the reader perceives

of Alain is both words and *thoughts* (and the difference between words and thoughts).

> *Example.* "Oh! the alterations! Don't tell me you're interested in those alterations! Admit"—she folded her arms like a tragic actress—"admit that you're going to see my rival!" "Saha's not your rival," said Alain simply. "How could she be your rival?" he went on to himself. "You can only have rivals in what's impure." (105)

In this passage, Camille confesses her jealousy aloud. Alain reacts, but his *perceptible* reaction is not all there is. Mentally he reacts further. Quite obviously Camille's words have an effect on Alain's thoughts—they harm her case—but Camille is unaware of the influence her words have. Not only does she lack the (technical) means to know her partner's thoughts and therefore to understand him, but she also expresses her own thoughts, thus making them available to an interpretation she will never have access to. If she is disadvantaged on the narrative level, she is also—and as a consequence—disadvantaged as a character, in the novel's thematic and psychological structure. This disconnection, too, is a sign.

The rule is equally strictly observed when Camille is alone, a wholly exceptional situation. The only time she is alone is the "assassination" scene. At that time no narratee is present at the diegetic level. After the assassination attempt—after Camille has hurled the cat nine floors down—the reader is vitally interested in her reaction. But the same solitude that made the assassination attempt possible means there is no character present for her to tell her reaction to—and the rule prevents her from "telling" her feelings inside herself.

> *Example.* "It's as if I'd got thinner," she said out loud. (157)

It might surprise us that even at this crucial point in the novel, the rule that forbids direct access to Camille's thoughts remains unbroken. We see, however, that strict observance of the rule is not simply a technical means of guaranteeing the novel's formal coherence. Not only is this a way to reveal the moving intensity of Camille's feeling, but we can go even further and claim that, having taken her fate into her own hands and altered her life, she now feels disconnected from herself. Docile in her love until that moment, after the attempt on Saha she is profoundly other than what she was before. Her speaking aloud reflects the momentary estrangement she experiences: she is her own narratee. This interpretation is confirmed by the very content of the narrated, with the estrangement manifesting itself on the physical plane. The loss of flesh experienced is, to some extent, a change in the individual. We can add that she is not only alone—physically—at

that moment, but that she well knows that her solitude, through her own action, is now beyond remedy. The absence of a narratee, then, is equally a sign. The figure of the change in level with the denial of an imperceptible narrated (the observance of the rule) is a complex sign that draws together a constellation of meaning on all levels—narrative, structural, thematic, and psychological.

THIRD RULE. As for Alain, he can transmit his most intimate and secret thoughts. Vis-à-vis Camille, he has the advantage: readers know him better than they know Camille and better than she knows him. Psychologically, that advantage is relative and provisional. True, he can pick and choose among his feelings and transmit only what he wants to transmit. But since he does not express his thoughts at the diegetic level at which he "lives," he fails to put his thoughts into words and is thus denied the therapeutic function of speech. The example given apropos of the second rule can illustrate this one, too. In that passage, we see in particular that had Alain's reaction ("You can only have rivals in what's impure") been spoken aloud, it would have provoked a discussion that could have raised to consciousness an ambivalence in the area of sexuality that the observance of the narrative rule relegates to the unconscious.

In general, Alain recounts an imperceptible narrated more often than a perceptible one, which contributes to his ultimate isolation.

FOURTH RULE. This rule produces a disconnection between the narrating and the focalizing. Besides the example cited apropos of the first rule, we find some interesting instances that involve the domestic help. Here is one, from the final chapter of the novel. The day after the catastrophe in whose wake Alain leaves his wife, she comes to see him for the last time. She rings the doorbell, and with this simple gesture produces a miraculous effect.

> *Example.* Behind the clipped hedge Alain could see the Basque woman retreating in disorder, her black silk apron flying in the wind, while a slither of slippers on the gravel announced the flight of old Emile. (185)

The first narrator-focalizer focalizes Alain, who focalizes the servants reacting to Camille's arrival. The verb "see," in its ambiguity, does indeed show what is happening: it refers to the physical action in its literal sense. Alain really sees the servants going by. But at the same time the verb has the figurative sense related to the *Robert* dictionary's definition of "point of view," with "to see" meaning "to consider." In other words, the substantives "disorder" and "flight" form part of an interpretation by Alain. In the literal sense his view is incomplete: "Behind the clipped hedge" where he is hiding, he does not see everything; so, too, in the broad sense, his view is incomplete: he interprets his incomplete (physical) view

in accordance with his own reaction of panic. This hierarchical subordination of the focalized at the third level is a sign of Alain's great power over the servants. They are presented as being scarcely alive, they vegetate, and they exist only to the extent that they unreservedly adore the only son, king in his domain. The text of the novel is very clear on this point. The focalization has to pass through Alain because the servants do not exist except through him.

This rule produces the same ambiguity as the third rule. Alain's focalizing power is as great as his narrative impotence. He sees more and says less than he would have to, to maintain real communication and emerge from his solitude.

FIFTH RULE. Camille as focalizer depends totally on what she can see. Focalizing for her is limited to direct perception, bound to the original meaning of the phrase "point of view." Thus, her sudden awareness of the impossibility of her relations with Alain comes via her perception of signs.[39] As an example of such a thematic sign that, by standing in for an imperceptible focalized which Camille is unable to focalize, transmits in a perceptible sign the signified of that imperceptible focalized, I quote three passages:

Example. "I can see your hair running," she called out. "It's crazy to be as fair as all that!" (75)

Example. With his fair hair spread out and his eyes closed, he seemed to be sleeping on Saha's flank and to wake with a [sigh] only to see Camille standing there silent and apart, watching the close-knit group they made. (158)

Example. She was struggling to make herself understood and, at the same time, pointing to certain accidental [signs] about Alain which did indeed suggest [a somewhat delirious meaning]: the torn-off sleeve; the trembling, insulting mouth; the cheek from which all the blood had retreated; the wild crest of dishevelled fair hair. (190–91)

The first passage comes at the beginning of the novel, the second after the assassination attempt and before the discovery of Camille's guilt, and the third at the end of the novel when Alain and Camille meet for the last time.

At the beginning, before their marriage, Camille, who is in love with her fiancé, already suspects that he "is not like other people." At that point she sees his fair hair as a sign of superiority. The word "crazy," still metaphorical, is used here in a positive sense, but essentially it already contains the literal sense it will have at the end. In the second passage, immediately after the assassination attempt, the dissension between Alain and Saha on one side and Camille on the other is more clearly manifest. The same sign—we can take the words "fair hair spread out" as

synonymous with the words "hair running"—associates superiority with the exclusion that is its reverse. At the end of the novel, the sign is explicitly perceived as such. The word "signs" appears in the text, as well as the word "meaning." The hair is deviant with respect to "normal" hair—for example, brown hair neatly arranged—in color and in outline. It is always in motion. Its motion is less and less under control. At the beginning it runs, later it spreads out, and finally it gathers into a wild crest. The evolution of the outline of Alain's hair brings gradually to light the real meaning of the color of the hair and is a sign of the evolution of the person on whose head the hair grows, the person who is at first exceptionally superior and then becomes crazy.

But this development is not absolute. It depends on and is brought about by Camille's perception. Alain does not really change, for we have seen that at the beginning he is "crazy" on the strength of the color of his hair. His peculiar character becomes manifest only at the end. The sign, which consists of a thematic structure, can take effect only within the perception of Camille as focalizer. The observance of the rule is a sign of that sign: the focalizing brings about the sign.

SIXTH RULE. The scope of this rule is limited by the general rule enunciated apropos of Alain's dream. Alain can focalize an imperceptible focalized, but only if he himself forms part of the focalized—for example, when he focalizes his own thoughts. The example used for the third rule (presented, however, in the discussion of the second rule), which illustrates the narrative power of this character, can illustrate this rule, too. I add an example in which Alain focalizes a perceptible focalized.

> *Example.* But before he went out, he could see more clearly, at a distance, the dark circles round her eyes and the moisture which covered her temples and her smooth, unlined neck. (173)

The sentence comes at the point in the story when Alain is leaving his wife. He covertly observes her reaction. Rather than violate the second rule and let Camille as narrator tell her feelings, the narrative produces this second-degree focalization. The reaction that in itself is imperceptible is transmitted to Alain—and to the reader—by means of signs:[40] "the dark circles round her eyes," the moisture on her face. Camille gives off signs without intending to: by remaining silent she wanted precisely to "build . . . up [Alain's] exit" (172), as he himself puts it. She has chosen not to tell her reaction. Nevertheless, her reaction is "put into a sign" and this sign is focalized by Alain. A convincing illustration, it seems to me, of the principle that Alain, as a character and as an agent, is given the advantage.

SEVENTH RULE. This rule implies that Alain often sees things indirectly. His opinion of his wife in particular seems to a large extent determined, or at least confirmed, by those around him. The long conversation (135–36) among the servants, who are criticizing Camille, is focalized by Alain. The procedure, then, is the following: the first focalizer-narrator focalizes Alain, who focalizes (i.e., listens to) the servants, who focalize Camille. She is focalized at the third degree. In that way Alain receives the evidence of "prejudiced witnesses" (137). This indirect focalization is obviously an iconic sign of the character's tendency to spy, to get information without speaking up. The passage, which is fairly long, is worth a detailed analysis that would be too much here.

EIGHTH RULE. This rule brings about the exclusiveness of the novel's center of interest and is undoubtedly what has prompted some critics to look on Colette's narratives as novellas rather than novels.[41] In fact, the focalizing at the second degree is reserved strictly for the two main characters (whereas the focalizing at the third degree can belong to a secondary character, as we have seen apropos of the seventh rule). I have found only one exception.

> *Exception.* At the foot of the nine-storeyed building, a gardener lifted his head and saw this white young man leap through the transparent wall like a burglar. (153)

The passage comes immediately before the scene of Camille's assassination attempt. Alain, a perceptible focalized, is focalized by a focalizer at the second degree who is a stranger to the story. So this focalizer is intraheterodiegetic. This gardener is an unknown; this unknown person, whose view is limited to what is perceptible and is further limited by distance, sees Alain "the way a neutral spectator would see him." We recognize the formulation: it is how I defined the first narrator-focalizer. Why then does the focalizing pass to the second level?

The gardener sees signs of Alain's oddness: the "white young man" reminds one of a pantomimist, a fairylike creature, and the word "burglar" hints even at guilt, while "leap through the transparent wall" partakes of the miraculous. This gradation, going from astonishment to mistrust and from play to unreality, strangely evokes the thematic structure of the hair. But since Alain is alone here, he cannot be focalized by Camille. He could be by the first narrator-focalizer, but the latter, in delegating his power, lends his view more credibility: he reinforces it with a witness. Furthermore, the physical distance is a sign of the moral distance. Thus Alain's oddness, now "objectified," prepares the reader for Camille's desperate act. It is as though the reader, without having access to her feelings, were in this way being called on to absolve her.

Conclusion

The rules underlying the system of narrative as a genre, some of which I have tried to formulate, produce rules immanent in each individual narrative. If a given narrative is different from those similar to it, the difference will necessarily lie in its compliance with the rules of the genre. Otherwise, it is not a narrative.

The rules of narrative produce the rules of a narrative, and these produce *the* particular narrative, its system of signs. In our analysis of *La Chatte,* we have seen some of these signs operating. In reality their number is limitless.

The signs that form part of the rules of the particular narrative produce in turn other signs, as we have seen apropos of Alain's hair. In turn again, these other signs, hypo-signs produced by the signs of the narrative, form a network of signi-fications, a structured constellation signifying the totality of the meaning of the narrative.

The creative activity of narrative is immense. The signs it creates are innu-merable—like the hairs on Alain's head.

Notes

Originally published as "Narration et focalisation," Chapter 1 of *Narratologie: Essais sur la sig-nification narrative dans quatre romans modernes* (Paris: Klinksieck, 1977), 21–55. Translated by Jane E. Lewin as "The Narrating and the Focalizing: A Theory of the Agents in Narrative," *Style* 17, no. 2 (1983): 234–69.

1. In this article, page numbers for most of the quotations from Genette's *Narrative Dis-course* will be given in parentheses in the text.

2. The French title *Figures* represents both the limits and the originality of Genette's study and should therefore be taken completely literally.

3. [Translator's note.] "Narrating agent" is the translation used in this article for the French phrase *instance narrative.* In *Narrative Discourse,* however, the same French phrase was translated as "narrating instance"—but there it meant "something like the narrating situation, the narrative matrix . . . out of which a narrative statement is produced" (Genette 1980, 31n10), whereas here *instance narrative* ("narrative agent") refers to a channel or medium within the narrative—a channel or medium that is both active and impersonal: a subject.

4. Genette (1980, 255–59).

5. *Narrative Discourse* is divided according to the three aspects of verbs: tense, mood, and voice.

6. Genette (1980, 161). The words I italicize are those guiding Genette in the development of his theory.

7. Booth (1961). It is unfortunate that in analyzing the "narrative of words," Genette was un-able to take into account the theories of Doležel and Schmid. See Doležel (1973) and Schmid (1973).

8. Genette (1980) prefers this term because it is more abstract than the "too specifically

visual" (189) terms "point of view," "vision," and "field." He does not define the exact meaning of his chosen term or the meanings of the other terms he refers to. I will come back to this problem.

9. Pouillon (1964); Blin (1954).

10. Maatje (1968) systematically analyzes the possible relationships between the framing narrative and the framed narrative. The idea of *Doppelroman,* however, does not overlap that of a "narrative with a frame." The latter has stricter laws about dependence, whereas the former requires, precisely, a certain minimum of independence. This difference is irrelevant here. Maatje's typology does not take account of different levels; it is based on the spatio-temporal relations between the two narratives. Genette uses only the term "embedding," which I will come back to. Apropos of *mise en abyme,* see Dällenbach's excellent study, *Le récit spéculaire* (1977).

11. It is obvious that Genette chooses "higher" so that he can use the prefix meta-, by analogy with "metalanguage." As he himself notes, the way the term functions here is the opposite of the way it functions in the model of logic and linguistics.

12. It is not the actual quantity but the *proportion* that, in the final analysis, determines the *way* of recounting, according to Genette.

13. In his essay "Frontières du récit" (1969), Genette's position is more moderate but does not invalidate the principle of what he says here. Genette's article has been translated as "Frontiers of Narrative" (1982). For a comprehensive study of description, see Bal (1983).

14. "Reported speech" is not always a complete narrative. To be that, it must be produced as such by the indispensable agents of narrative. Fragmentary "reported speeches" could perhaps be units of the "dramatic" genre intruding into a narrative. If the nature of fragmentary "reported speeches" is still to be defined, their narrative level is nonetheless lower than that of the narratives into which they are inserted. If reported speech is not always narrative, it is at least always "meta-." The particular problems raised by the distinction between reported speech and narratized speech are shrewdly discussed by Schmid (1973).

15. Let me say parenthetically: in this part of the "Genettian metadiscourse," we are not dealing with *figures.* If in a pinch we could say that the theory allows a typology of narratives, it does not allow us to discern very easily any "distance" figure within particular narratives. The place where this section belongs is therefore not only outside of this chapter but even—if we take the title of the book literally—outside of the book.

16. [Translator's note.] In her introduction to *Narratologie,* the volume of which this essay is the first chapter, Bal explains her disagreement with Genette on narrative hierarchy. His use of the word "narrative" (*récit*) is, she claims, imprecise, since it is equated with "narrative text," which sometimes means what results from the arrangement of the story and other times what results from the narrating; so basically Genette distinguishes only two levels, story and plot. Bal, on the other hand, postulates a third level, neither *histoire* nor *récit,* called "narrative text" (*texte narratif*). Her explanation of that third level is as follows:

> Once the story has been ordered and structured, it must be put into words to become a narrative text. Being put into words is the condition of its semiotic functioning. Without that, we would be unable to study the story. However, as indispensable as the operation of being put into signs is, this operation is not necessarily a linguistic one. Instead of putting a story into words, we can stage it or present it in pictures, for example. The hypothetical phase of elaborating the story that has been ordered can therefore not be identified with elaborating the

narrative text. Which is why we must distinguish the phase of elaborating the story from the first phase (arranging the story) and from the last (putting it into words). The story ordered and structured (but not yet put into words) is the *narrative.* . . . From a semiotic point of view, the narrative text is considered a sign. The sender of this sign is the author, the receiver is the reader. Within this sign, another sender—the subject of the enunciating, or the narrator—produces a sign for another receiver (the narratee). The sign transmitted by the narrator is not the story, for we have seen that the story is not told as such by the narrator. To be sure, the story is a signified. So there must be another level of communication midway between text and story, a level at which both the signified of the text and the signifier of the story are located. The narrator produces the sign-narrative within which the sign-story is transmitted. The nature of this communication is hard to grasp: the narrative [*récit*] is the signified of a linguistic signification but is itself a signifier by a nonlinguistic means. (1977, 8–9)

17. Here one wonders whether Genette is not somewhat the victim of his own method. Analyzing the discourse of *La recherche,* the inductive occasion of his work, must have prompted him to speak, at whatever costs of these problems of the discourse of the characters in order to have an occasion for dealing with the "ideolectical speaking" of Proust's characters.

18. [Translator's note.] The translation given here varies from the translation given in *Narrative Discourse* (Genette 1980, 191–92). In the original French, the crucial phrase, the one Bal's argument centers on, is *focalisation interne sur*—literally, "internal focalization on," as it is rendered here. In *Narrative Discourse,* the phrase was rendered as "internal focalization through"—thus anticipating the point Bal makes here.

19. The relations that can exist between a "metadiegetic" narrative and its first narrative are defined only in terms of relations between the "metanarrative" and the narrating, which is logical since the narrating is what is being discussed. One could, however, also consider these relations in terms of the action and the actants. In my essay on hypo-narratives, I proposed to distinguish between "framing" and "embedding" on the basis of the actantial function. This distinction can be added to the one Genette makes. See also Bal (1981).

20. Obviously, these terms are not synonyms. The differences among their respective meanings are not relevant here, but it may nonetheless be useful to redefine them. The term "actor" has the abstract meaning of "the agent that acts." "Actant" has a functional meaning: "Who makes the action move forward." The term "character" refers to the actant in his own individuality, with the broad meaning conferred by tradition. For my part, I use the term "character" when I am dealing with narrative level, that is, when the meaning I want to refer to transcends the precise framework of the two other terms.

21. His identity is in large part determined by what he *does.* Since we are dealing here only with the result of that determination, it seems to me justifiable to use the shortened formulation "who is."

22. Even if the verb "judge" will upset—and rightly so—the modern literary critic and theorist, let us not forget that the reader does judge. If we want to modify that reactive behavior on the part of the reader, we must start from that behavior as it is, or else be in danger of widening still further the gulf that exists—unfortunately and wrongly, but more and more—between reading as a cultural activity and reading as a science.

23. Genette separated the two agents, yet without seeing that they are positioned in a narrative hierarchy. While he is not the first to have *differentiated* the two agents (Henry James did that), he is the first to have *separated* them in theory.

24. [Translator's note.] In idiomatic English, this might be translated "the thing narrated" or "what is narrated" and, two bullets below, "the thing focalized" or "what is focalized"; but since semiotics speaks of "the signified," it is appropriate to parallel that usage with "the narrated" and "the focalized"—less idiomatic but more direct.

25. Extradiegetic in relation to the narrative of which he is the narratee.

26. Actually, here the terminology slides dangerously. The homodiegetic narrator is just as extradiegetic as the heterodiegetic narrator is, for every narrator "is at a diegetic level immediately higher than the level at which the story he is telling is situated." The "I" actant is not the narrator of his own story; the narrator in that instance is telling a story in which he is present as a character but is telling it by means of an agent who is hierarchically higher than that character. Genette implies that if the narrator is absent from the narrative, there is a still higher level, comparable to the one at which an extradiegetic narrator is located in relation to a "metanarrative." Basically, then, if we followed Genette's reasoning, the absent narrator would be doubly extradiegetic.

27. Scholes (1971) uses the term "metanarrative" with the logical meaning of "a narrative *on* a narrative." Using the term in this sense—even putting it in the title of the article—requires the introduction of another term to indicate its opposite.

28. Todorov (1977); cited by Genette (1980, 214n).

29. The narrated is thus a statement, the object of the enunciation produced by an enunciator.

30. I consider "vision" synonymous with "point of view."

31. The "implied author" also supposedly injects his "opinion" into the narrative. Needless to say, in my scheme of things, the author's opinion ("The ideological function of the narrator," according to Genette [1980, 256]) comes under the focalizer and not the narrator. That is also true of the "ideological perspective" analyzed by Uspensky (1973). The so-called identification of the narrator with the character is properly defined as an impersonal narrating (by an "invisible" narrator) with a character as focalizer.

32. [Translator's note.] References to this novel are to *The Cat,* Colette (1955, 71–193). Page numbers of passages quoted will be given in the text. Where the translation is too free for purposes of Bal's analysis, I have supplied my own translation in brackets.

Bal's introduction to *Narratologie* explains the problem posed by Colette's novel:

> *La Chatte* . . . deals with the failure of a marriage, and the failure is tied to the presence of a cat. The question of the responsibility borne by the different prótagonists seems an obvious one to ask. Whose fault is it? In several ways the text invites the reader to side with the young man. The young woman, however, seems the more reasonable of the two. And, in the dispute dividing them, what is the cat's function? At the crucial moment, the cat defies her enemy and precipitates the catastrophe.
>
> The problem of fixing moral or psychological responsibility can be resolved only with a narratological investigation, which will explain how the problem is even relevant. The reason it is relevant—the reason the reader feels called on to judge—is that vision and voice are disconnected from each other. The events are presented in a certain way, in keeping with a certain vision, which may be that of the main character—but the main character is not the one who does the narrating. So the problem the novel poses is that of the relationship between the agent who *speaks* and the agent who *sees*. Moral responsibility therefore takes a back seat to narrative "responsibility." (1977, 2)

Interpretation of this novel also has to do with the language in which one reads it. *Chatte* is the feminine form of the English word "cat," and while the title "character" is sometimes called by its name (Saha), it is most often referred to simply as "la chatte." That recurrent reminder of the cat's gender—of her sexuality—is unavailable in English, but in French it strongly affects the reader's sense of the underlying dynamic among the three characters.

33. The hypothesis is still incomplete. This rule can be broken under two conditions, which I will specify in analyzing the dream.

34. See, among others, Davies (1961).

35. It goes without saying that this rule is inferred for the moment from the particular narrative I am analyzing. Nothing proves that we are dealing with a general rule. A more extensive analysis of a large number of narratives is indispensable if we want to formulate the rule of the genre, or even of one type of narrative. However, it is quite likely that this rule will be valid for a considerable number of narratives.

36. I have analyzed this dream, whose sexual significance is apparent as soon as one superimposes the passage on other passages in the novel, in the second chapter of my book *Complexité d'un roman populaire* (1974).

37. This rule can be broken, as it is in some experimental novels. One can affirm the importance of rules just as much by deliberately setting out to break them as by strictly observing them. The experienced reader has no doubt seen another ambiguity in this dream, an ambiguity having to do with frequency: the narrative of the particular dream alternates with comments on the dreams Alain habitually has. Since this ambiguity does not involve the agents of the narrative, I will not linger over it here, although an analysis of that figure is indispensable to a complete interpretation of the dream.

38. For a definition of this term, see Browne (1971) and Van Zoest (1977).

39. These signs are different in kind from the signs we saw functioning on the level of agents. These are thematic, and they function within the content of the narrated by means of a series of rearrangements involving the (unwitting) sender (the focalized) and the receiver (the focalizer). Strict observance of the rule is an absolutely narratological sign, unlike these thematic signs, which can figure in non-narrative texts as well.

40. These signs are different still: signs in the ordinary sense, such as they occur in daily life too. Here they function at the level of the story, and not in the transmission of the fabula to the story.

41. Magny (1950).

References

Bal, Mieke. 1974. *Complexité d'un roman populaire: Ambiguité dans "La Chatte."* Paris: La Pensée Universelle.

——. 1977. *Narratologie: Essais sur la signification narrative dans quatre romans modernes.* Paris: Klinksieck.

——. 1981. "Notes on Narrative Embedding." *Poetics Today* 2 (2): 41–59.

——. 1983. "On Meanings and Descriptions." Translated by Robert Corum. *Studies in Twentieth Century Literature* 6 (Fall 1981–Spring 1982): 100–48.

Blin, Georges. 1954. *Stendhal et les problèmes du roman.* Paris: Corti.

Booth, Wayne. 1961. *The Rhetoric of Fiction.* Chicago: University of Chicago Press.

Browne, R. M. 1971. "Typologie des signe littéraires." *Poétique* 7:334–53.

Colette. 1955. *The Cat.* Translated by Antonia White. In 7 *by Colette,* 71–193. New York: Farrar, Straus and Cudahy.

Dällenbach, Lucien. 1977. *Le récit spéculaire: Essai sur la mise en abyme.* Paris: Editions du Seuil.

Davies, Margaret. 1961. *Colette.* London: Oliver and Boyd.

Doležel, Lubomír. 1973. *Narrative Modes in Czech Literature.* Toronto: University of Toronto Press.

Genette, Gérard. 1969. "Frontières du récit." In *Figures II.* Paris: Editions du Seuil. Translated as "Frontiers of Narrative." In *Figures of Literary Discourse.* Edited by Marie-Rose Logan. Translated by Alan Sheridan, 127–46. New York: Columbia University Press, 1982.

———. 1980. *Narrative Discourse: An Essay in Method.* Translated by Jane E. Lewin. Ithaca, NY: Cornell University Press. Published in French as "Discours du récit." In *Figures III,* 67–273. Paris: Editions du Seuil, 1972.

Maatje, Frank Christiaan. 1968. *Doppelroman.* 2nd ed. Utrecht: Wolters-Noordhoff.

Magny, Claude-Edmonde. 1950. *Histoire du roman français depuis 1918.* Paris: Armand Colin.

Pouillon, Jean. 1964. *Temps et roman.* Paris: Gallimard.

Schmid, Wolf. 1973. *Der Textaufbau in den Erzählungen Dostoevskijs.* München: Wilhelm Fink Verlag.

Scholes, Robert. 1971. "Métarécits." *Poétique* 7:402–12.

Todorov, Tzvetan. 1977. "Narrative-Men." In *Poetics of Prose.* Ithaca, NY: Cornell University Press.

Uspensky, Boris. 1973. *A Poetics of Composition.* Berkeley: University of California Press.

Zoest, Aart J. A. van. 1977. "Le Signe iconique dans les texts." *Zagadnienia Rodzajów Literáckich* 20 (2): 5–22.

2. The Story of W

At a moment when moralizing contextualizations of literature
illiterately reinscribe the characters of master texts, it is all the more
urgent to recognize, by reading, the specifically literary formation
of the subjective "appetite" occasioned by "happ'ly that 'name' of
chaste unhapp'ly set." For this is the only way to break the legacy
of Shakespeare's "*Will*," the only way to open up a time outside the
temporality of rape. —*Joel Fineman*[1]

The Practice of Theory

In this chapter, following up on the analysis of expository discourse, I turn the
tables between subject and object of display and give "art" as discourse a chance
to expose itself. To that effect I will turn to William Shakespeare, most canonical
of writers, or, rather, to my favorite among his heroines. Shakespeare's poem *The
Rape of Lucrece* of 1594, with its outmoded rhetoric and overextended plot, often
dismissed, has recently received more critical attention.[2] This reclaiming of the
poem today might happen because it speaks to contemporary culture in the in-
tricate relations it represents between visuality, competition, and sexual violence.
These three themes are all central to cultural analysis. Visuality, competition, and
sexual violence have, of course, received due attention from Shakespeare schol-
arship within its own discipline.[3] Yet there has not been much awareness that the
intertwinement of the three in the poem is apt to revitalize it for a contemporary
readership embedded in a cultural frame where, overwhelmed with visual
images, specifically of (sexual and other) violence, competition is the basis of so-
cial structure. But what has remained unnoticed is the extent to which this text
represents the very issue the present study is engaged in arguing: the insepara-
bility of exposition, exposure, and exposé. Indeed, Lucrece's tragedy is triggered
by the exposé, the description of her by her boasting husband, a rhetorical exer-

cise that exposes her in an ekphrastic nude, an "indecent exposure." What is more, prefiguring the exposure of the hidden voice of the first-person expository agent, it is the figure of Lucrece herself who points out to her rapist that by exposing her he exposes himself. By exposing her, she claims, he puts himself under the glass of the cultural showcase:

> Wilt thou be *glass* wherein it shall discern
> Authority for sin, warrant for blame,
> To privilege dishonour in thy name?
> (619–621; my emphasis)

Thus Shakespeare makes his tragic heroine the spokesperson of a theory of exposition. It is that theory that I am interested in extricating from the rhetoric that both displays and obscures it. In doing that I will be practicing theory by showing how the literary text itself practices theory.

This engages the relationship between literary text and social, lived, cultural reality. Hence it is apt to subvert the relationship between literary text and scholarship and criticism, and to raise relevant questions that have a bearing on today's culture. I need to first reconsider the most typical responses to this poem and its thematic antecedents, the "pre-texts" that both precede it and sustain the effort to take the critical sting out of it. There is a tendency to dismiss the subject of the rape story on the grounds that it is an allegory.

Allegory is a historical reading attitude. It is a mode of reading that isolates the event from its own history in order to place it within a different one; it is an act of displacement and reframing. But the gist of my argument is that allegory can never replace the "literally" real.[4] Rather, allegory is an extended metaphor; it is a reading based on the continuous *similarity*, involving both difference and *contiguity*, between its vehicle—say, here, the myth of Lucretia—and its tenor—according to the oldest pre-texts, political tyranny. I consider allegory in light of Benjamin's statement:

> If the object becomes allegorical under the gaze of melancholy, if melancholy causes life to flow out of it and it remains dead, but eternally secure, then it is exposed to the allegorist, it is unconditionally in his power. That is to say it is now quite incapable of emanating any meaning or significance of its own; such significance as it has, it acquires from the allegorist. He places it within it, and stands behind it; not in a psychological but in an ontological sense.[5]

The deadly quality of allegorical reading seems to have a particular and disturbing affinity for allegorizing stories of violent death. As Teresa de Lauretis writes:

> The very notion of a "rhetoric of violence" . . . presupposes that some order
> of language, some kind of discursive representation is at work not only in the
> concept "violence" but in the social practices of violence as well.[6]

Similarity and contiguity can only produce meaning if metaphor is fully ex-
ploited and kept alive, even in the case of deadly allegory, if both vehicle and tenor
are activated. Hence, alleging allegorical meaning in no way dismisses the mean-
ing of the vehicle. On the contrary: if tyranny is alleged to be a kind of rape, it bor-
rows its meaning from the characteristics of rape and not the other way around.
The murderous denouement of the allegorized story, then, is alleged to be a fea-
ture of rape that *also* holds for tyranny.

The subject of the chaste Roman Lucretia who stabbed herself in the presence
of her husband and father after she had been raped by her husband's fellow sol-
dier was familiar in the Renaissance; it was, so to speak, part of the culture.[7] In
that capacity of myth, it received political and religious allegorical interpreta-
tions. But such cultural currency is never sufficient to explain a work's interest
when the subject both offers a persistently powerful image, a cultural emblem,
even a cliché, and addresses a real and serious problem such as rape.

I want to discuss the relevance of Shakespeare's *Lucrece* as an appropriate
subject for cultural analysis today as well as the place of the subject of cultural
analysis in relation to *Lucrece.* I will do so by addressing the two key questions.
The first is the question at the core of exposition, its motivations and its modes:
What are the relations between cultural fascination, verbal representation, and vi-
sual representation? And second, how does rhetoric, a mode of analysis tradi-
tionally applied to verbal art, serve to connect these?

Rhetoric has traditionally been divided untenably between argumentation
and ornamentation.[8] My claim in this chapter will be based on the intricate con-
nection between "beautiful"—that is, ornamental—speech and persuasion. As
such, this connection is at the heart of exposition. I will try to show the limits to,
if not the lack of, any distinction between modes of expression and rhetorical—
that is, real—effect. But I must emphasize that claiming that rhetoric touches, has
an effect on, reality is not the same as claiming that reality is only rhetorical.

Lucretia is undoubtedly the "heroine of rape" celebrated throughout Western
culture. She killed herself, calling for revenge, because she was raped; her death
initiated the revolution that led to the Roman Republic. As a mythical story, we
may assume that the Lucretia legend speaks to the culture that brought it forth,
as well as to the cultures that maintain and repeatedly reproduce it. Its popular-
ity in the Renaissance and in northern Renaissance painting in particular is im-
mense.[9] Yet, whereas in literature the entire story remains narratable, in visual art

there is a shift from one representation to another. Sometimes the act of rape is portrayed, often with a handsome Tarquin and a colluding Lucretia. Other pictures depict the moment of suicide, where the token dagger seems a pretext for a good look at Lucretia's body, virtually nude.

As A. Robin Bowers notes, by the end of the sixteenth century the iconographic tradition represents Lucretia mostly in individualized portraits where no traces of the violence of her rape and death can be seen. Bowers's interpretation of these depictions as those of a "serene, partly nude figure to show the external beauty which reflected her inner virtue" only emphasizes one aspect of these images, their theological meaning. That limitation might be due to a lack of serious consideration of the semiotics, not only of the portraits, but also of rape.[10] In other words, the violence is also omitted, one can presume, to erase the troubling conflation of rape and suicide, which confuses the two subjectivities of the rapist and his victim. This is an example of a censoring, obscuring metaphor.[11]

Joel Fineman's polemic quoted in the epigraph triggers a further polemic which has to do with allegorizing and rape, and allegorizing rape. What I want to respond to is the way he opposes, and thereby locks into a dichotomy, three interpretations of the poem that would undoubtedly fall under his indictment of moralism, of what he calls "naturalistic or naturalizing accounts."

In his warning against naïvely realistic readings that obscure the literariness of the text, Fineman is referring to three "schools" of interpretation. He rejects a psychoanalytically oriented suggestion that Tarquin's impulse to rape Lucrece[12] is a latent homosexual desire to reach Collatine. He objects to an anthropological suggestion of triangular desire where Tarquin desires Lucrece because she belongs to another man.[13] And he argues against a Lévi-Straussian mythology of the conciliation of opposites. The second of these interpretations seems to me the most compelling. Fineman takes this interpretation to task for over-ruling the text's literariness by realistic projection, in his terms, of an "illiterate naturalism."

Aware of how easily feminist responses to rape stories turn moralistic (and realistic, hence "illiterate") I think I follow the spirit of Fineman's worry when I propose to resist the dichotomy that opposes "letters" to "nature." That dichotomy informs allegory and, to a certain extent, Fineman's position. First, countering an overly linguistic bias, I will take a hyper-rhetorical view of "real rape," weaving through the use of metaphor in antique and Renaissance material a pernicious insistence of rhetoric's conjunction with rape as event. Then I will take some distance from this excessive "naturalism" and consider the function of speech so as to be better able to expose rape.

Rape, Suicide, Signs, and Show

Fineman traces the metaphoric figurations of rape which precede the act in the shape of obstacles to it: the closed doors, the wind which, threatening to extinguish Tarquin's torch, hinders his vision, and Lucretia's glove in which the pin—instrument of her handiwork, token of her chastity—is hidden, and pricks him. Fineman notes these obstacles are suitable figurations of the rape, proleptic metaphors for it, because they embody the resistance that heightens erotic desire. This reading suggests that if the desire is erotic, and resistance stimulates it, then Lucrece is, after all, responsible for her rape. This interpretation gives us a glimpse of the internal divisiveness that makes rape such a complex concept, and such an apt metaphor for cultural analysis.

Although I am not convinced that the erotic nature of Tarquin's compulsion is beyond doubt the primary one, the metaphorization of the rape is inescapable. But what is equally inescapable is another important way in which the rape is metaphorized, not through Tarquin's intensified desire but through Lucrece's intensified pain. What strikes me in the shift, noted by Bowers, from representations of the rape itself to portraits of its victim at the moment she kills herself, is not so much the question of virtue inscribed in them, but rather the allegedly elliptic inscription of rape in the gesture. If the representation is not a plain nude, using the pre-text of the mythical story to clothe the nude with the painter's prestige, the representation of the suicide may be a clever exposition, in the three senses in which I am using that term here. By *showing* the woman in her self-immolation, the painter *opines* on her tragedy in the very image that *exposes* her. For when rape is implied in suicide, suicide is predicted, entailed, by rape. Suicide stands to rape as its metaphor, powerfully motivated by contiguity. Let me commit a bit of "naturalism" with this metaphoricity.[14]

In Titian's *Rape of Lucretia,* as in other cases where the act itself is represented, the ambiguity lies in either one of two visual aspects. Here, I see it in the theatricality of the representation of resistance. Titian's Lucretia raises her arm elegantly, almost as if welcoming Tarquin. There, the rape tends to be represented as the victim's own doing. One may, and indeed must, reject attempts to project this sexist bias on Shakespeare's Lucrece.[15] But rather than presenting a more sympathetic view, I will argue that the metaphoric representation of rape as suicide, which the later images show, is even more pernicious than that.[16]

Suicide replaces the rape in visual representations because rape itself cannot be visualized, because rape makes the victim invisible. It does that literally—the perpetrator first covers her—and then figuratively—the rape destroys her self-image, her subjectivity, which is temporarily narcotized, definitively changed, and often destroyed. Finally, rape cannot be visualized because the experience is,

physically as well as psychologically, *inner*. Rape takes place inside. In this sense, rape is by definition "imagined"; it can only exist as experience and as memory, as *image* translated into signs, never adequately objectifiable.[17] This might seem to be an "illiterate" response to the poem. But I contend that, in contrast, it invigorates the text's literariness. For it amounts to taking the text's tropology "to the letter" so that it can be taken as an exposition of what rape is (also).

Because of this difficulty in representing rape, its depiction is often displaced; it is then depicted as self-murder, as in Lucretia's case where self-murder stands for rape, the suicide becoming its metaphor. Killing herself: as far as the subject of action is concerned, attention is shifted from the rapist to the victim. But Lucretia's agency here is radically divorced from her intention. As a consequence of the non-representability of rape, however, spectators/readers reinterpret the self-murder rhetorically as metaphor.

This consequence shows that the notion of rhetoric can be extended, like the notion of semiotic, to signify the real.[18] By this I do not mean that rhetoric is exactly identical with "literal" language, but that rhetoric is important because of the very difficulty it presents in deciding which reading is literal and which is figurative. Such an extension of rhetorical concepts is particularly useful in analyzing Shakespeare's poem because it is such an emphatically visualizing text, in addition to being excessively rhetorical. It seems apt, therefore, to expose exposing.

Rhetoric turns images from likenesses into signs and from single objects into complex "sentences," thus producing figurations that help to construct the views of rape dominant in the culture in which the rhetorical discourse or image functions, and that condition the responses to real rape. It posits the inextricable intertwining of verbal and visual representation. The importance of seriously attending to rhetoric, advocated by Maus, Vickers, and others,[19] becomes obvious as soon as we look again at the metaphor of suicide.

The use of metaphor raises the question of motivation: why compare this tenor—the content of the metaphor—with this vehicle—the metaphoric image? This motivation is more often than not metonymical: a sign represents the rape not by similitude but by temporal contiguity, and as a consequence can represent its cause or a later event as its predecessor. Read metonymically, then, we would interpret the scene depicted in the late Renaissance portraits of Lucretia as well as in Shakespeare's text as follows: rape is *like* self-murder (metaphor) because rape *leads* to self-murder (metonymy). In other words, the choice of a rhetorical term is itself already a decision pertaining to cultural politics. By limiting ourselves to metaphor, we displace responsibility onto the victim, emphasizing "self" (sui-) rather than "murder" (-cide). In contrast, if we use metonymy as well, responsibility is returned to where it belongs: to the rapist and the rape as destruction—to murder, rather than "self."

But if rhetorical terms are so important, then we need not stop at a metonymic reading. Synecdoche, taking the detail to stand for the whole—*pars pro toto*—the very trope that earlier [in my *Double Exposures*] led to the construction of the problematic concept of artifact, can also become an important tool in reading these representations. In other words, from the perspective of cultural analysis, no *a priori* value can be assigned to the tropes, and neither can they be taken to be value free.

By using synecdoche within such a rhetorical strategy, self-murder becomes the "detail" representing the entire process. Lucretia's raped body part comes to stand for her whole person, just as her suicide, *her* act which stands for herself, comes to stand for the entire story, the rape and its consequence. Not only is the rape itself thus brought back into sight, but also the narrative aspect of the poem: the rape also recovers its place as the act that brings about the *murder* of the *self*.[20]

Reading synecdochically, then, includes the rapist in the representation. This is of crucial importance in light of the Augustinian argument. As is well known, this argument, which was very much in the air in Shakespeare's time, disapproves of Lucretia's suicide on the basis of a separation of mind from body.[21] The argument ignores the rhetoric of the suicide scene which reinscribes the rapist. Given Augustine's general misogyny and anti-body attitude, I would rather read it not to excuse the body but to further censor the mind, in Lucretia's case, to limit or retrospectively denounce, her "semblance" of self-determination. This argument is explicitly rejected by Lucrece.

Reading the suicide rhetorically as synecdoche, the rapist becomes again a part of the represented whole, despite, or even because of, his absence from the final scene, and his invisibility in the late Renaissance paintings. And as he is synecdochically reinstated in the scene, his vacant place needs to be filled. The urge to fill that place involves the viewer, the reader, or, in the case of *Lucrece,* the reader who is so vigorously visually addressed. How can a rhetorically and visually engaged reader make metaphoric sense of the weapon, a dagger? In the late Renaissance painting, it points to the rape victim, who is so much destroyed as a subject that her subjectivity disappears behind that of the rapist. The rapist dictates her self-image to her. *His* murder of her subjectivity becomes *her* self-murder. Only by *becoming* the rapist is the woman able to perform an act which, however negative and destructive it may be, is the only illusion of self-determination she has left.

The replication of the one—the rapist—by the other—the woman—is signified in the dagger. Shakespeare's text emphasizes the narrativity of this reduplication as it is prefigured in the needle. The needle hidden in Lucrece's glove which pricks Tarquin on his way through the enticing obstacles is, I think, too attractively accounted for, or from another perspective, abused, when Fineman calls it "clitoral."[22] At the very least, the needle forewarns Tarquin of what he is about to inflict on Lucrece: pain by means of penetration; and it signals that he,

too, may be vulnerable to pain and violence. The triple repetition of forms uses iconicity but not similarity; congruence of form, not of size, nor of gravity of consequences. As the needle iconically, albeit feebly, prefigures the penis, so the penis prefigures the dagger it calls forth. Dagger and penis, the weapon of the victim and the weapon of the rapist, become each other's metaphor, metonymically motivated by causality, and visualized by iconicity. The violent penetration of her body by the alien and hard destructive object occurs *twice*. The dagger thus represents the feeling of guilt.

In Livy's story Lucretia kills herself for two reasons: she fears for her reputation and she wants to set an example for other women. In Livy's text the rape equals the destruction, not because it denies the woman's subjectivity, but because it is an assault on her chastity, her exclusive possession by some other man. Livy makes her say that her suicide must prove her innocence. Lucrece's motivation is more complex, more semiotic. Lucrece must die to avoid misreading. Her death, I will argue, is an act of writing up, in expository discourse, its own mode of reading.

This is not superfluous. In spite of Lucrece's lesson in visual interpretation before the painting of Troy, which considerably complicates mimeticism, her father persists in reading her as a mirror when, after her death, he blames her for having broken his mirror. Yet she decides to die because the abuses of mimeticism and the arbitrariness of the sign equally lend her case/face to misreading. Only the index will do, but an index that contains within it the iconicity of rape/suicide.

To the extent that no re-production of a story can completely duplicate its "sources," the cultural life of the legend is always active, always transforming the cultural view of the fictitious "source" to which each work contributes. Thus a text or a painting can contribute to the transformation of a view held by the culture in which it functions; this poem does so by representing its own interpretation of rape. This could be one reading of what has been called the elliptic representation of the rape.[23] To be sure, the representation of the event is short as well as metaphorical, but it should not be dismissed as elliptical. Doing so is a form of literalism, ignoring metaphoric meaning-making. It begins with the metaphoric representation of violence in verse 673—"This said, he sets his foot upon the light." The verse "The wolf hath seiz'd his prey, the poor lamb cries" can hardly be misunderstood. In all, the representation of the rape itself can be taken to continue until, in verse 729, Tarquin leaves Lucrece ("Even in this thought through dark night he stealeth").

Such a representation—of 54 verses—cannot be considered elliptic.[24] But the particular rhythm which sandwiches the rape itself between the long preparation and the long aftermath has its own rhetorical effect. By conveying a suggestion of

a succession of two moments, the moment before the rape and the moment after, the Shakespeare *Lucrece* emphasizes rape's deadliness. The symmetrical composition suggests as a formal metaphor a "resemblance" between rape and suicide which the paintings convey visually, and rape itself, experientially.

The actual representation of the rape matters *narratively*. It divides the poem in three sequences, not two, each betokened by an act of penetration which brings forth an identification between Tarquin and Lucrece. This tripartite narrative structure stands in tension with the twofold rhetorical development of speech, the two long parts in which each protagonist holds a *disputatio* with him- or herself. Whereas the bipartite rhetorical structure establishes an iconic relation of formal "semblance" between boasting and painting, the tripartite narrative structure keeps vivid the contiguity, the causality, between the first and the second. Painting is like, but also caused by, *boasting*.

Boasting is a form of display. Telling the wonders of what you possess, are, or can do is a way of descriptively showing it. It is, so to speak, the counterpart of ostentatious self-definition by negation. It is a way of filling that void, even if with emptiness—with things that are untrue, or that you don't really own.

Enough naturalism for now. In keeping with Renaissance debates about the respective value of images as sites of clear vision and words as sites of the fall into deceptive language, let me briefly look at the disease which allegedly produced the Roman Republic: sick speech—cause, companion, and rival of violent vision.

Contagious Logorrhea: Between Men

Shakespeare's poem has been blamed for its rhetorical wordiness. But was it the poem, or was it the characters? Wordiness was the cause of the misery to begin with: "Or why is Collatine the publisher / of that rich jewel he should keep unknown / From thievish ears, because it is his own?" (32–35). What is the place of words in this exceedingly wordy and visual story about competition between words *and* images?

In Livy's *Annales* there is already too much talk and too little of it is attributed to Lucretia.[25] The rape scene is narrated as follows:

> With this terror his lust gained the victory, victorious [victrix] as if by violence over her obstinate chastity, and [when] Tarquinius [had] left after the conquest of the woman's honour . . .[26]

The rape itself, both as an act (his rape) and as an experience (the rape of her), is skipped over. And the vocabulary is military. The latter aspect will be exploited

to the point of parody in Shakespeare's version. Although this military rhetoric is commonplace, it shows that rape is a fight, a war between the sexes to which the man comes fully armed. The drawn sword with which Tarquin approaches the defenseless, sleeping Lucretia is not only a metaphor for his real weapon. As metonymy it foreshadows the suicide and shows that *his* sword causes it. But, also, it expresses his own insecurity, by suggesting that the victim is dangerous.

Violence is represented as a comparison: "victorious as if by violence." The rhetorical comparison, the "as if" structure is used as an ideological code. In the common notion of "literal" and "figurative" language, violence would be only a figure of speech here, superfluous and ornamental. Ovid exploits this possible interpretation by representing his Tarquin as a passionate lover. The military language, however, deconstructs this hierarchy between "literal" and "figurative" language by showing what is primary and what is secondary. But as this is a discourse of display, based on the gesture that says "Look!" I prefer to take seriously the "color" or "shade" of the language. Rather than seeing in Livy's sentence the suggestion that Lucretia's resistance called forth Tarquin's violence, thus making the scene military, it seems clear to me that his violence needs the rhetorical device—the "as if"—as an apology.

The comparison "as if by violence" must then be read literally in its figurality. It thus becomes a direction for reading this passage, a comment on the relation between "literal" and "figurative," between "reality" and the "decoration" of reality. The comparison proves that rhetoric surpasses reality, in that the rhetorical phrase says more, rather than less, about it. But if rhetoric can surpass reality, then my rhetorical reading may also override the "real" rhetoric of Livy's language. Then the interpretation "it is no real violence, it only seems as if it were real violence" would be superseded by a second interpretation: "the rhetoric, the language is more important than the reality," which, once appropriated, comes to mean, "the important thing [about rape] is not the 'objective' fact but the language used [by the victim] to express her experience." This reversal, in turn, allows us to activate the other meaning of the ambiguous Latin word for violence, which also means "force" or "strength." The phrase "victorious as if by violence" then also means: "My strength is just a manner of speaking." The insecurity about his own strength that made Tarquin draw his superfluous weapon thus turns the rape into a test of power, a test of the rapist's insecure masculinity. That insecurity is the violent enemy faced by the woman experiencing rape.

The alienating use of the victim's voice for the verbalization of a male view can thus be countered by the operation of the reversals and displacements of this "hyper-rhetoric." The two kinds of reversing figurative and literal—decorative and "essential"—and verbal and visual are crucial for this endeavor. These two operations of reversal go together and reinforce each other.

It is no accident that the rape of Lucretia is represented as caused by a visual image exposed for view. The voyeurism that leads to Lucretia's rape is not simply the gaze directed at the (arousing) sight of female beauty, but the sight of her as a possession of another man. The emphasis on the visual hardly conceals the crucial discursive factor, as the attraction of the woman hardly conceals the real target—the other man. This becomes clearer in Ovid's fragment of the story. Collatine's statement in Livy's version has been replaced by Ovid by an equally ambiguous one: "non opus esse verbis, credite rebus," translated by Frazer as "no words are needed; trust deeds." This translation shifts from sight—trust things: "Look! that's how it is"—to action, thus anticipating Tarquin's follow-up.

Shakespeare fully develops this paradox, thus exploding the underlying sickness. For here, the words alone produce the visual image, and the rape is planned *before* the rival has so much as seen the woman. He "sees" her through her husband's verbal description, and it is through his words that he sees her even when he "really" sees her. The discourse of exposure turns aesthetics and realism into seduction, but the subject of seduction is the expository agent, not the object on display:

> Therefore that praise which Collatine doth owe
> Enchanted Tarquin answers with surmise
> in silent wonder of *still-gazing eyes*.
> (82–84; my emphasis)

The "you" of exposition demonstrates that exposing is a speech act and hence has a perlocutionary effect. "Logorrhea": stream of logos, both in the broader sense of words and in the narrower sense of pre-established, fixed meanings, the doxa of male possession of the female body. The word "logorrhea" is here used to mean the sickness inherent in this exercise of power through words. This is a power both in terms of representation—the capacity to produce a powerful enough image to entice the listener—and in terms of social power—Collatine's right to speak and be listened to versus Lucrece's reduction to being an object of evocation and desire. The sickness is contagious, thus passing from Collatine to Tarquin. It is also fatal, killing not the sick, but those submitted to the sick men's power.

The description of Lucrece rivals in semiotic power the ekphrastic description of the Trojan War. There seems to be a *disputatio* going on in the poem about the power of words, and the many symmetries partake of it. Not only is the painting of Troy a more complex and more adequate semiotic object than Collatine's description. The responsibility of Lucrece's death is also shifted from the one to the other, and back again. But Collatine's sick talk is also symmetrically opposed

to his dumbness, then his babble, and finally his recovery from the disease of log-
orrhea when, at the end, he manages to pronounce the name of Tarquin:

> Weak words so thick, come in his poor heart's aid,
> That no man could distinguish what he said.
> Yet sometime "Tarquin" was pronounced plain,
> But through his teeth, as if the name he tore. (1784–1788)

Learning to speak happens anew, in the symbolic order where men compete over
a woman's dead body. And again symmetrically, Tarquin is unable to speak. In
the face of Collatine's logorrhea at the beginning of the story, during the boasting
contest, Tarquin is dumbfounded. His eyes stare at the image produced by Col-
latine's words, but the rhetoric, entirely military, produces a (visual) image of
war—a war, in turn, represented through sexual imagery of the queens for whom
the knights fight. This mixture of sexual and military imagery is cemented by an
additional isotopy: that of color, of painting. Here is a passage in which these
three semantic fields are equally represented:

> This heraldry in Lucrece's face was seen,
> Argu'd by beauty's red and virtue's white;
> Of either colour was the other queen,
> Providing the world's minority their right.
> Yet their ambition makes them still to fight;
> The sov'reignty of either being so great,
> That oft they interchange each other's seat. (65–71)[27]

Does the dumbfounded Tarquin with the still-gazing eyes see an attractive
woman or a Medusa? Is he overcome by desire or by fear?[28] This is the point of
the interpretation according to Girard/Sedgwick, mentioned above, an interpre-
tation which is needed to make sense of the intermale rivalry. The point is "natu-
ralistic" in Fineman's terms, but the text raises and complicates it explicitly
enough. The semiotic point is, he is contaminated by the expository discourse,
the logorrhea that paradoxically strikes him dumb, makes him dangerously and
deadly sick as if to prove that display is a discourse. However, the danger and the
death are displaced onto the object of the discourse: Lucrece.

Here is a "literate" objection to Fineman's objection: it is hard, indeed, artifi-
cial, not to bring Sedgwick's theory of homosocial desire to bear on this instance.
But in order to heed Fineman's anti-moralism and anti-naturalism, it is necessary
to take into account the way the text discursively bears out what it thematizes. Not
only does the rivalry between words and images remain unresolved, at least for

now, but also the explicit insistence on the rivalry between the men, narratively supported by the disease of logorrhea and its aftermath, is rhetorically insisted upon in an almost explicit criticism. As much as Collatine's "publication" of Lucrece's chastity is castigated by the narrator, and for the good reason that it is contagious ("For by our ears our hearts oft tainted be"; 38) just so, right after this theory of linguistic performativity the narrator diagnoses the grounding of that power of words in male competition:

> Perchance that envy of so rich a thing,
> Braving compare, disdainfully did sting
> His high-pitch'd thoughts, that meaner men should vaunt
> That golden hap which their superiors want. (39–42)

Whereas Livy and Ovid mention the boasting contest as an event, an anecdote needed to set the story in motion, Shakespeare belabors the connection it establishes between (ab)use of language, competition between men, and social stratification. And he examines, and then questions, the possibility of countering logorrhea with vision.

Vision Vying Violence: Between Women

The competition between men, played out in the competition between the verbal and visual media as means of exposition, receives a poignant counterpart after the rape in what is called, but only half adequately, an ekphrastic digression. For the evocation of the painting of Troy is more dramatic than descriptive. This is not so because the painting comes to life through it, for that is part of the discursive genre. But thematically it is not only a *disputatio* about the rivalry between the media, but also a trigger of semiotic agency and reflection: through it, Lucrece herself comes to life, for the telling of her experience becomes possible. Shakespeare's Lucrece's despair is caused by her frustration about her inability to represent what was done to her as she became an object of ekphrasis—in other words, as she was exposed.

In contrast with the verbally evoked visuality that condemned her to victimization, she feels sharply the inadequacy of her mastery over the language that the men have, if not mastered well, at least put to mastering use. And she seeks comfort in a visual image, but not as a simple alternative. There is neither ekphrastic hope nor fear here; and yet the painting is alive.

Significantly, it is a painting of the paradigmatic destructive woman-related war, the Trojan War. And it is a painting full of eyes. The following fragment from

the lengthy description of the painting displays the insistent inscription of the visual, not as a semiotic alternative—the very description of a painting would suffice—but as a semiotic problematic:

> And from the towers of Troy there would appear
> The very *eyes* of men through loop-holes thrust
> *Gazing* upon the Greeks with little lust:
> Such sweet *observance* in this work was had
> That one might see those far-off *eyes look* sad.
> (1382–1386; my emphasis)

Vision, here, is both ubiquitous and problematic; "sweet" and "little lust" go together, "observance" and "look sad" match. The very number of notations of vision makes the issue of vision confused. This painting of vision is a mirror to Lucrece, a mirror to those readers, also, who are able and willing to be addressed by what she shows. She who was not given a voice—a tongue—in the ancient legend is assigned a double "literate" task here: to explore the constructive powers of language, and to show the paradoxes of representation. For Lucrece these are three: the paradox of mirroring, the mutual production of vision and experience, and the narratability of history.

That visual images cannot be used as mirrors in any simple sense is the wisdom Lucrece acquires when confronting maid and groom the morning after, and fearing that they read her shame in her face.[29] The face can be read as text, perhaps as image, but not as mirror. Two complications prevent it: gender difference, and semiotic variation. In a passage that prefigures Freud's "mystic writing pad" and Derrida's response to it, Lucrece spells out the limitations of women's mental autonomy through the image of semiotic modes:

> For men have marble, women waxen minds,
> And therefore are they form'd as marble *will*;
> The weak *oppress'd*, the *impression* of strange kinds
> Is form'd by force, by fraud, or skill:
> Then call them not the authors of their ill,
> No more than wax shall be accounted evil
> Wherein is stamp'd the *semblance* of a devil.
> (1240–1246; my emphasis)

We will soon revert to the double charge of "will," and see the intimate connection of wish, direction, future, and writing. That oppression becomes a synonym of impression is a fact of recent experience for Lucrece.

"Semblance" is a central term—in age-old discussions of art and literature, as well as in Lucrece's dilemma. Does it just mean mirroring, or something else as well? Taken at face value this argument is the Augustinian one: when the spirit has not colluded in the crime, the suicide is uncalled for. Lucrece, aware of the *disputatio* whose outcome, after all, determines her life or death, here points out how this lack of spiritual autonomy is gender-specific and, conversely, gender difference is semiotic in kind, not ontological but representational ("semblance").

The semblance/mirror issue comes up at two more key points in the text: at the end, when Lucrece's father and husband compete over her dead body, and when, during Lucrece's scrutiny of the painting of Troy, she contemplates the representation of Sinon the traitor, the "semblance" of Tarquin. In both these scenes and in contrast with the passage just quoted, the mirroring capacity of visual images is bound up with masculinity. Old Lucretius explores and deplores the tenuous base of fatherhood when he cries out:[30]

> If in the child the father's image lies,
> Where shall I live now Lucrece is unliv'd?
> Thou wast not to this end from me deriv'd.
> If children predecease progenitors,
> We are their offspring, and they none of ours.
> (1753–1757)[31]

The perversion of nature that occurs when children die is here tied to "semblance" as the questionable guarantee of paternity. The language is strong and literal: Lucretius asks *where* he must live now that the *place* of his image in his child is gone; a place which is then reformulated as the *goal* ("end") of the child's coming to life. What is exposed as fragile, through paternity and its lack of solidity in likeness, is history as a teleological chronology.[32]

The father's problem is not so much that "semblance" is not identity, but that his chronology is reversed. Since the support of his identity as a father is gone, he travels the path of life backward and becomes a child again. This reversal perverts time and cancels the possibility of the future that defines history.

The next lines, however, complicate this conception by questioning mirroring itself in terms of generational sequence:

> Poor broken glass, I often did behold
> In thy sweet *semblance* my old age new born;
> But now that fair fresh mirror, dim and old,
> Shows me a bare-bon'd death by time outworn.
> O! from thy cheeks my image thou hast torn,

And shiver'd all the beauty of my glass,
That I no more can see what once I was.
(1758–1764; my emphasis)

In fact, as a "literate" reading of these lines suggests, it was when the mirror func-
tioned that the father became a child ("new born"); the child provided him with
the means to stop time that paternity seems primarily to be about. Hence, the
father ends up as a child no matter what, for mirrors are deceptive to begin with.

Lucrece knows this all along, but needs to analyze the phenomenon and its
consequences in order to draw her conclusions and salvage whatever she can of
her subjectivity. For this poem is a *disputatio* about subjectivity, and about the
possibility to expose it, and to destroy it. Her visual encounter with Sinon poses
the problem with acuity, as has been pointed out.[33] Until she spots Sinon in the
painting, the work of art has been perfect. But the very perfection of visual pro-
duction of "semblance" consists in its excess—its overflow, so to speak.

Both the medium and the sign system are exceeded. The medium, which will
later on be explicitly criticized, is already spilling over when the "semblance"
produces not only visual likeness, but also a trace of language ("Nestor's golden
words"; 1420), history (Nestor's words are already lost), and action ("Lo! here
weeps Hecuba, here Priam dies, / Here manly Hector faints, here Troilus
swounds"; 1485–1488). Lucrece does not see a single image; she surveys an exhi-
bition, making sense of the combination of different images. The sign system so
privileged in painting, iconicity and its ground in "semblance," is exceeded when
Lucrece needs to act according to the index: "That with my nails her beauty I
may tear" (1472). Active agency requires signification by means of the touch.

The encounter with Sinon poses for Lucrece the problem of semblance on
two levels. Sinon the traitor is depicted as beautiful and attractive, and that is the
deceptive quality of semblance. Lucrece critiques an aesthetic that says "Look!
that's how it is." At first, she faults the painting, but then checks herself:

Such signs of truth in his plain face she spied,
That she concludes the picture was belied.
"It cannot be," quoth she, "that so much guile,"—
She would have said,—"can lurk in such a look;"
But Tarquin's shape came in her mind the while,
And from her tongue "can lurk" from "cannot" took:
"It cannot be," she in that sense forsook,
And turn'd it thus, "It cannot be, I find,
But such a face should bear a wicked mind."
(1534–1540)

The passage plays out all the complications of rhetoric, vision, and semiosis that Shakespeare's text musters, through three different insights Lucrece acquires. It is the fullest exploration this text has to offer of the possibilities and limits of vision and discourse as the media that expose, and lie in what they show.

Likeness defined in terms of truth immediately entails its opposite: untruth, "belied." But it is previous knowledge—of the words of history, about the words of Sinon—that makes Lucrece's first insight possible. But then, the conclusion in turn is belied by a visual image—the memory of Tarquin's "semblance" of honesty. Lucrece's second insight, her attempt to turn the golden rule of semblance into its opposite, doesn't quite work either, however. For letting go of semblance as a code to interpret the world rhetorically yields a sentence, or *sententia*, too complicated to serve, as, precisely, a *sententia*: each element of the threefold denial that precedes the insight denies all three stages of the hard-won insight.

The first "It cannot be" opposes the plain semblance as a sign of truth. The second opposes, in the guise of meta-linguistic commentary, Lucrece's own capacity to plain speech, giving her, so to speak, a double tongue ("from her tongue 'can lurk' from 'cannot' took"). The third is the object of forsaking. It is only after "semblance" has been thus qualified beyond recognition, that Lucrece is able to formulate her insight in the mirroring problem. She begins the formulation with yet another "It cannot be" and yet another meta-textual qualification ("I find"). The insight bears out, not any unambiguous conclusion about the respective merits and powers of either medium, visual or verbal, nor of either code, iconicity or symbolicity, but rather the aporia which results from any attempt to distinguish the two, hence, the aporia of semiotic competition. She discovers the importance of an integrative semiotic of words and images, ideas and things as one ensemble in which "semblance" plays its deceptive, indispensable part. If the mirror cracks, here, it is a generic one, not a specific object but the very notion of "semblance." It cracks but it does not quite break; for semblance will remain an indispensable tool for Lucrece to withstand her reduction to wax.

The second paradox of visual representation that Lucrece, in this moment of her semiotic theorizing, examines, is the relation of visuality to experience. This relation needs addressing because we cannot forget that the rape came about because of a language-produced visual image. Lucrece was *exposed* by it; she is doomed by her exposure to aesthetic, erotic, and realistic abuse. Before dying she will in turn expose what happened to her. The objectified images of Lucrece, both the spoken and the seen one, remain essentially *outer* images. The encounter with Sinon has taught her the dangers of belief in exteriority. But more importantly, Lucrece's need to understand her own failure to read Tarquin is part of a much larger, and more urgent, enterprise, which is to read, hence, make readable, her own experience.

Readability is more urgent than representation itself. But to that effect she needs to represent it, not in either words or images, for Collatine's linguistic skill has demonstrated how untenable that distinction is. Instead, she needs to represent it in some utterly new way that will cure the sickness of words and the deceptiveness of images: this is the meaning of "Pausing for means to mourn some newer way" (1365). Again, Lucrece analyzes in the painting the various signs she might put to this use. She craves to tear Helen's beauty (1472), which was as costly as her own, but she does not act this desire out. Instead, she aims, not at the bearer of an image imposed on her from the outside, but at the image produced from the inside: she tears at Sinon who, like Tarquin, exposes others while hiding himself, thus instructing the gaze willfully to be deceived: "She tears the senseless Sinon with her nails" (1564).

But the outcome of her scrutiny is not that images deceive, nor that language can deceive as aptly; it is something more complex than that. Lucrece neither idealizes vision, nor does she discount images as mere semblance. In a semiotic style that integrates icon and index, she uses semblance in order to participate. Images do help her, not to represent and expose as exterior but to *shape* her experience. Through the visual image, Lucrece identifies with old Hecuba's mourning. The motivation for that identification is relevant: "Of what she was no *semblance* did remain."

Semblance, so deceptive in Tarquin and Sinon, so misused because exterior and produced by others, by Tarquin and Collatine, semblance appropriated but futile for Lucretius, is still an indispensable means to counter the utter powerlessness culturally assigned to Lucrece through the simile of wax and marble. Visual images because they are exterior and therefore suitable as signs, and because they signify through the semblance between outside and inside, can help Lucrece shape her experience, on the condition that she, as a subject, is enabled to do the shaping: to interact with, rather than simply contemplate images.

Her choice of Hecuba is telling because it leads up to the third paradox of representation; semblance is checked, made specific, and relativized. The factor of this relativization is time: history, and the issue is narratability. Hecuba, the historical semblance to Lucrece's predicament, is also a historical text on whose face both the passage of time and the experience of grief are written. That "text" is the only semblance appropriate for Lucrece. For she is in charge of theorizing the difficulty of representing experience and time, and the effect of experience on time. There is also the difficulty of representing exterior happenings as internally lived: history and/as autobiography.

Lucrece identifies with the destroyed subject whose destruction she *sees* negatively, by not seeing a "semblance" of her former self. The image has lost its stability; the subject's self has been irretrievably destroyed by the narrative of vio-

lence—and by the violence of narrative. The *change* of the *image* is the "telling" element that enables the identification of the young woman with the old. The visual cannot replace language, for which Lucrece blames the artist: "to give her so much grief and not a *tongue*" (1463; my emphasis). Given how dangerous the possession of a tongue has proven to be, this is not necessarily bad, although at this stage Lucrece deplores it. The painted Hecuba is deprived of speech, reduced to spectacle. But this spectacle is also productive—it allows Lucrece to express her inexpressible experience, which she could not voice by establishing "semblance," metaphoric communality, with the old woman who, like herself, had lost her old self. "Semblance," the key notion of rhetoric as well as of visual representation, thus bridges the gap between self and other, making expression possible, but on the condition that it stand out against difference on the time scale of history.

Heather Dubrow, is, I think, right in suggesting that all the poem's characters exemplify a particular attitude toward history, but I am not sure she gives the whole story in her interpretation of Lucrece's complaint in light of Brutus's later rebuff. Dubrow writes:

> Rather than observing the events that hint that the suffering of Troy will be redeemed, she devotes most of her attention to Hecuba's grief. In doing so, she demonstrates a concern with the horrors of the past rather than the hopes of the future and with the needs of the individual rather than with the broader historical and social issues of his or her culture.

Lucrece's identification with Hecuba accomplishes the integration of private and public that the revolution following her suicide embodies. Moreover, she shows herself to be keenly invested in the future when she uses the rhetoric of metaphor by establishing a "semblance" between her young person and the old woman whose "semblance" with herself had been lost. What Lucrece does, in those few hours of waiting and watching, is accelerate her whole life story and, precipitated by the violence done to her, run to her future.

Expository Writing

Lucrece before the painting of Troy, studying the pros and cons of various semiotic systems, is devising an alternative, neither to words, nor to images, but to the very opposition between both; an alternative in which she, as the exposed object, can be the agent of exposition. What can the alternative semiotic system be, that counters the problems of speech—represented by Collatine's abusive exposi-

tion—and of vision—represented by deceptive semblance? Vision, so far, has been exposed as a system that enables us through semblance to "get at" experience but that necessitates autobiographical and historical agency to check semblance.

Of course, Fineman's insistence on the letter receives full weight at this point. He insists on the way in which Shakespeare's text inscribes the centrality of subjectivity to writing. This is why writing is, as Derrida has pointed out, not a representation of speech but a fundamental semiotic system in its own right, always already inscribed, leaving traces, in speech and in images. Fineman's will to literacy leads him far into the field of letters. He makes an emblem of his enterprise, the release of Shakespeare's will, of the combination, or intertwinement, of the letters M and W, which, he argues, together shape the literate "erotic *theater* of the poem's textuality" (191), its visualizing porno-graphy. This is built up throughout the text and exasperated at the very moment of the rape when Tarquin already "kills" his victim: "Entombs her outcry in her lips sweet fold" (679; Fineman, 186). Fineman gives many associations, ultimately leading up to the authorial name, *WilliaM* whose shortened version *Will* puns on the status of his subjectivity inscribed as "will." This noun summarizes Lucrece's project: name, desire, direction, legacy, future.

But lest we turn *Lucrece* into a *Story of O,* that is, a paradigmatic pornography, this business of Shakespeare's play on W and M must be seen to bear out yet another aspect of the inscription of subjectivity in the act of exposing. For the letters, obviously, also initiate the bearers of subjectivity as the myth of Lucretia has so effectively separated them: Men and Women. And if Lucrece considers the Augustinian argument against her suicide by toying with the notion that she is just a waxen tablet, written by men, it is Shakespeare's will that she reject that vision. She is definitely on the side of W. Woman, she writes. And what she writes is her will.

Her study of painting does not provide her with "clear vision" as an alternative for "fallen language," as the *disputationes* of the time would have it. She writes: she produces traces for the future. She writes her will, insisting on its written quality and its directionality as legacy: "This brief abridgment of my will I make" (1198); "Thou, Collatine, shalt oversee this will" (1205). She still cannot write but by means of a dagger directed against herself; the story of O, so predominant, cannot be canceled, but it can be qualified, by the story of W.

Vision, embedded in Collatine's wordiness, had undone Lucrece; now, it empowers her to restore at least some form of agency, albeit, within the fabula, negative and destructive. But the point is, she can expose that agency, exposing what her exposure entailed. What counts in the final scene is less the naming of the rapist than his denunciation by "semblance," visually, in front of witnesses,

among them the visualizing reader. She who rejected her status as mere wax now writes, in the tradition of Philomela whom she evokes more than once,[34] through her dagger, but pointedly noting that she can only write by means of "semblance": "'tis he, / that guides this hand to give this wound to me" (1722). The need to spell out the stakes is great, for even this battle of images is not an easy one to win. The tension between language and vision is nowhere played out more impressively than in the episodes *following* Lucrece's rape and suicide.

In the Roman legend her rape and murder are recuperated for a male cause by the semiotic use of her blood. Brutus, the former fool or semblance of it who becomes wise in the course of the drama, recuperates the rape for his political purpose. What does it mean, for my reading of the work, that Shakespeare's story transforms the endings of the Latin texts by insisting on, and belaboring, the theme of competition? In this story a battle takes place over signs and meaning, not over facts. The meaning of Brutus's intervention, not merely the gesture itself, thus over-rules the simple political meaning.

Insisting on the negativity of complaining, Brutus may be implicitly criticizing Lucrece's foregoing complaints. Thus he might demonstrably oppose masculine toughness.[35] But Brutus, for all his closing statement and agency, is by no means a convincing orator, for Lucrece has already countered his argument beforehand, by writing, through Hecuba, the future.

Brutus, remaining locked in the dualism between private and public, represents an ahistorical attitude toward the event, even if he promotes the historical event par excellence, the revolution. For by using the rape for political purposes, Brutus became Lucretia's primal allegorist. He, not the feminist argument, "illiterately naturalized" Lucrece's rape, by forgetting her will to write, her written will.

Was he the first? Nothing is more opposed to writing than assigning origin. This is partly what Lucrece's argument exposes. But writing projects traces, and traces point, like the indexical moment of exposing. Backward exposing, then, is countering the exposure that killed Lucrece and threatened her with unreadability. Reading letter-evading allegory in Brutus's gesture points back at Tarquin, who allegorized Lucretia before. He disembodied her, turning her into an emblem of male possession, an appropriable object of male rivalry and battle. But then, would it not have been Collatine who allegorized her first, by making her into a story about who had the most desirable and secure possession? Collatine put her on the pedestal of display, in the glass case of deadly objectification.

With each new gesture of allegorization, Lucretia was robbed more and more of her self, and of her story. Until, in infinite regression, the search for origin that brought forth this text itself as a pre-text for the foundation of the Roman Re-

public allegorizes the allegory. This is what Shakespeare's final belaboring of competition can be taken to mean. It is his will, which he made Lucrece write.

As I suggested earlier, allegory is a mode of reading which takes the represented event out of its own history to put it into a different one. In this sense, an expository gesture is always also allegorical. This may be useful, indeed necessary, and it is certainly compatible with the semiotic status of texts. Dehistoricizing Lucretia's experience, an allegorical reading appropriates it, gives it a new history, divorces it from the experiencing subject. As Craig Owens put it in his defense of allegory:

> throughout its history it has functioned in the gap between a present and a past which, without allegorical reinterpretation, might have remained foreclosed. (203)

Seen in this light, allegorical interpretation is an indispensable gesture of appropriation.

The allegorical impulse allows the work to situate itself in relation to it: a particular work can encourage a reader to or discourage a reader from that gesture. But the decision remains with the reader. An allegory (or, as I would specify, an "allegorogene" detail of a work) can also have a meta-textual function that, according to Northrop Frye, prescribes the direction of its own commentary (89). If the representation of Brutus's appropriation constitutes the Latin story's allegorical direction, then the poem's insistence on that gesture is an equally meta-textual critique of allegorical appropriation. At Lucrece's own handling of the dagger as a tool to write, the allegorist should be pulled up short.

In the various Lucretia traditions, the public exposition of the woman's body is a "natural" next phase in an act of public appropriation which the rape itself constitutes. The bloody dagger is used because metonymy and synecdoche are stronger—more "penetrating"—signs than mere metaphor. As you will recall, allegory and metaphor operate through similarity, metonymy and synecdoche through contiguity. By connecting this with Peircean semiotics, we can see that the difference is fundamental. The problematic modes of reading, the modes based on similarity, are predicated upon iconicity—the mode of meaning-making that relates the sign to its meaning on the ground of *semblance*. The modes based on contiguity, in contrast, work through indexicality—the sign, there, is *in touch* with its meaning. The index is the sign of the touch. When the fight over signs has to be, somehow, a *real* fight with *real* issues, the male rivals need literally to *touch* the woman's body—to partake in its rape. In this instance we see how indexicality is implicated in interpretation. The touch here has become a blow.

This semiotic aspect of rape moves beyond the paradox of the competition between words and images, between rhetoric and "real facts" that Livy and Ovid brought to the fore and that it was Shakespeare's will—writing and legacy: written direction for the future—to write. The meaning of the speech act of rape is hatred of the male competitor for his possession of the woman—and Sedgwick's concept of homosocial desire cannot be wished away. Indirectly only is it hatred of the woman who may not be possessible. It is a hatred spoken through metonymy. The hatred comes from fear and is acted out, spoken, through the actual body of the object of fear. Rape is a speech act that reduces its sign to silence. Is rape a metaphor of imprints on wax, or is it the other way around? Reducing the woman to sign status is only an extreme variant of the common cultural attitude toward rape. As the "speaking" of rape is exclusively done by men, consisting, as it does, of reducing the victim to silence, speaking *about* rape is also generally a male privilege. The women have become merely spectacles and images.[36]

Shakespeare's poem takes this abuse to its extreme, then unwrites it. For this effect the writer hands the pen/pin/pain to Lucrece. For, opposing Augustine's argument, he knows that he cannot write his subjectivity effect only in the pornography of Lucrece-as-image; the story of O is a story of zero, and writes the subject off. Instead, Shakespeare wrote the story of W, making Lucrece write, for hers is, to borrow de Lauretis's phrase: "the body in whom and for whom semiosis takes effect."[37] Thus he offered, in the guise of a rhetorical poem, a lesson in expository writing where the pen is wielded by the "third person"; where subject matter is no longer divorced from subject. Hers is a double exposure, showing the danger of exposure as well as the means to unwrite it by pointing at the subjectivity at stake, and exposed.

Notes

Originally published in Mieke Bal, *Double Exposures: The Subject of Cultural Analysis* (New York: Routledge, 1996), 225–54.

1. Fineman (1991, 115). The first subheading of this chapter is borrowed from Moxey (1994).

2. For a critical account of this dismissal, see Maus's illuminating article "Taking Tropes Seriously" (1986).

3. Most keenly, the connection between male competition and violence has been connected to humanistic culture by Jed (1989).

4. For an understanding of the allegorical impulse in terms of structuralism and psychoanalysis, see Fineman's "The Structure of Allegorical Desire" (1991, 3–31). The basic text is Benjamin's *The Origin of German Tragic Drama* (1977). For an understanding of allegory as rhythmically analogous to obsessional neurosis, see Fletcher (1964, 279–303). De Man's open-

ing essay in *Allegories of Reading* (1979) gives a much more positive view of allegory. Spivak (1971) offers a good example.

5. Benjamin (1977, 183–84).

6. De Lauretis (1987, 32).

7. In a very broad sense, we can speak of English Renaissance culture as a *textual community* in Stock's terms (1983). The *visual* culture of that community can be conceived of in the terms analyzed by Alpers (1985) for Dutch seventeenth-century visual culture. It can be seen as partly overlapping with the textual culture. Hence, the visual culture of that community forms that part of the *textual* community that is concerned with visuality. This chapter makes no historical claims, but should not be in contradiction with evidence concerning the historical textual community. Historical evidence can neither be invoked nor dismissed by simply quoting possible allusions to this particular poem or its main character, as Levin (1981) does. Levin refutes ironic readings of the poem which present Lucrece as an ambiguous character. Whereas I have no sympathy for attempts to suggest complicity, I would argue that Levin's refusal to consider ambivalence denies the most poignant feature of rape as well as the character's complexity. Moreover, the alleged "evidence" only confirms Lucrece's innocence as a *rape victim,* not the appropriateness of her suicide (the Augustinian argument). In addition, the "evidence" is so slight that it only essentializes the text by conflating it with the myth of Lucretia. See also Jed's important book *Chaste Thinking* (1989).

8. No further argument is needed for this untenability since the appearance of White's *Metahistory* (1973) and *Tropics of Discourse* (1978). The classic on argumentative rhetoric is Perelman's *The New Rhetoric and the Humanities* (1979); on rhetoric as "l'art de bien dire," as ornamental language and the tropes and other figures of style, see Dubois et al. (1981).

9. For an overview of Lucretia texts, see Donaldson (1982). For the iconography, see Bowers (1981). For an analysis of Rembrandt's two paintings of Lucretia in connection with the Latin texts and Shakespeare's poem, see my *Reading "Rembrandt"* (1991, 60–93). The connections between rape and the ideology of chastity are analyzed by Jed (1989).

10. Bowers (1981, 9). I consider rape and its aftermath in suicide as an event that has meaning, and is therefore susceptible to semiotic analysis. The advantage of an interdisciplinary semiotic perspective is that it takes signs seriously whether they be verbal, visual, or bodily. The semiotics of rape, then, pays keen attention to the interrelations between these three domains.

11. See my paper "Scared to Death" (1994).

12. I use the name Lucretia to refer either to the mythical figure or to the representations of her in other texts than Shakespeare's; "Lucrece" only refers to the figure in the Shakespeare poem.

13. Fineman (1991, 175–76). For the triangulation of desire, the best reference is to Girard's *Deceit, Desire, and the Novel* (1965), and the gendered version of this theory by Sedgwick, *Between Men* (1985). Girard's theory of desire is compellingly—though problematically—used in his *Theater of Envy* (1991). This use is compelling because it emphasizes the derivative nature, not only of Tarquin's desire but also of Collatine's. It is problematic in that it is totally blind to the way in which the poem inscribes Lucrece's agency against the appropriation of her by the rivaling men. The mythical interpretation is allegedly based on Lévi-Strauss's *The Elementary Structures of Kinship* (1969), and the feminist reference is to Vickers's article "'The Blazon of Sweet Beauty's Best'" (1985).

14. Parker's essay "Preposterous Events" (1992) is relevant in this context.

15. Unsympathetic readings of Lucrece are numerous, and while they are responses to the literary text, the terms in which the criticism is phrased hardly disguise an aggression directed against the figure. See, for example, Battenhouse (1969), who accuses the character, and by implication the poet of figuring her that way, of "moral double-talk" (19) and "masturbatory self-rape" (28).

16. On the idea that the suicide removes the "taint" of rape, see Jed (1989).

17. "Under conditions of sex inequality, with perspective bound up with situation, whether a contested interaction is rape comes down to whose meaning wins" (MacKinnon 1983, 652). There are reasons enough to prefigure whose meaning has a chance of winning, by inserting focalization as the figuration of the woman's experience within the evidence. Modleski (1988) analyzes how little self-evident this is apropos Hitchcock's *Blackmail* and its critics: "Patriarchal law can hardly consider her innocent, nor can it possibly offer her real justice, since its categories precisely exclude her experience—an exclusion to which the critics we have quoted amply bear witness as they strain the limits of patriarchal discourse in order to subdue the truth of this experience" (28).

18. This possibility is implied in Peirce's distinction between dynamic object and immediate object. See Eco (1979) for a discussion of Peirce's view of the object, and for a discussion of Eco's paper, see de Lauretis (1987, 38–42). See also de Lauretis's seminal "Semiotics and Experience" (1983).

19. Maus (1986); Vickers (1985, 1986). See also the chapter on "Metaphor" in Parker (1987).

20. The narrative aspect of the poem is rarely considered seriously. See, however, Rawdon Wilson (1988).

21. According to Bowers (1981), the argument in Augustine is rhetorical rather than judgmental, serving to substantiate his case that for Christians chastity resides in the mind. But inevitably, such citations from mythical material do turn judgmental anyway.

22. Fineman (1991, 183). Albeit unwittingly, the very allusion to the female organ of pleasure already partakes of a suggestion of complicity which is totally unwarranted.

23. Rawdon Wilson (1988, 54).

24. Rather, I would categorize the representation with what Parker (1992) calls "preposterous events."

25. On wordy men, see Parker (1989).

26. Foster (1959, 200; my translation).

27. Vickers (1986) borrows her title from this passage.

28. In Mitchell's (1994) terms, is he the subject of ekphrastic hope or the victim of ekphrastic fear?

29. *Contra* Rawdon Wilson (1988, 43), who writes that Lucrece's narratees—the addressees of her complaints—are means of "investing it [the narrative] with an inside, an expressible experience." Rawdon Wilson thus ignores the problematization of the narrative versus the visual as *modes* and the *disputatio* over their respective powers.

30. I have extensively argued for the relevance of tropes, specifically, the competition between metaphor and metonymy, for the definition of paternity in *Death and Dissymmetry* (1988). I had taken the clue from Culler's reading of Irigaray in his seminal chapter "Reading as a Woman" (1983). Irigaray (1974), had made the argument that philosophical categories have been developed, not just by means of, but in order to "relegate the feminine to a position of sub-

ordination and to reduce the radical Otherness of woman to a specular relation" (Culler 1983, 58). Specularity, as we have seen, is already a problem of gendered semiotics in *Lucrece*.

31. This is a typical "preposterous event"; it is the example Parker (1992) uses in her article on that subject.

32. Dubrow (1986b) examines the characters in the poem as each representing a conception of history, a style of history writing. I will return to some of her comments below. On Brutus's role, see Jed (1989).

33. Dundas (1983) examines the various issues and paradoxes in the ekphrasis and relates them to Lucrece's own role as visual sign. She writes: "So conscious is Lucrece of herself as mirror or model that it is as though Shakespeare were trying to reconstruct a Lucrece who foresees her subsequent reputation in literature and art" (21). This future-oriented mirroring provided by role models constitutes a social, perhaps feminine, counterpart to Lucretius's lost mirror. Sinon serves to give the lie, not only to Lucrece's father but also to Fineman's insistence on the opposition between clear vision and fallen language. For vision is the privileged locus of the undoing of "semblance." As Dundas points out, "the cardinal sin is deception more than lack of chastity, and this is something that art, using its own means of deception, now reveals to Lucrece" (17).

34. Philomela was raped by her brother-in-law, who cut out her tongue to prevent her from telling her story. She wove a "semblance" of it instead.

35. On the subgenre of complaints, see Dubrow (1986a),

36. The phrase "women as spectacle" reminds one of Tickner's (1988) seminal study of imagery as used by the suffrage movement in Britain. Tickner demonstrates that women have been able to reverse the situation described in this paper and to use spectacle instead of being one.

37. De Lauretis (1987, 179).

References

Alpers, Svetlana. 1985. *The Art of Describing: Dutch Art in the Seventeenth Century*. Chicago: University of Chicago Press.

Bal, Mieke. 1988. *Death and Dissymmetry: The Politics of Coherence in the Book of Judges*. Chicago: University of Chicago Press.

———. 1991. *Reading "Rembrandt": Beyond the Word-Image Opposition*. Cambridge: Cambridge University Press.

———. 1994. "Scared to Death." In *The Point of Theory: Practices of Cultural Analysis,* edited by Mieke Bal and Inge E. Boer, 32–47. New York: Continuum.

Battenhouse, Roy. 1969. *Shakespearean Tragedy: Its Art and Its Christian Premises*. Bloomington: Indiana University Press.

Benjamin, Walter. 1977. *The Origin of German Tragic Drama*. Translated by John Osborne. London: New Left Books.

Bowers, A. Robin. 1981. "Iconography and Rhetoric in Shakespeare's *Lucrece*." *Shakespeare Studies* 14:1–21.

Culler, Jonathan. 1983. "Reading as a Woman." In *On Deconstruction: Theory and Criticism After Structuralism,* 43–63. Ithaca, NY: Cornell University Press.

De Lauretis, Teresa. 1983. "Semiotics and Experience." In *Alice Doesn't: Feminism, Semiotics, Cinema*, 158–86. London: Macmillan.

———. 1987. *Technologies of Gender: Essays on Theory, Film, and Fiction*. Bloomington: Indiana University Press.

De Man, Paul. 1979. *Allegories of Reading: Figural Language in Rousseau, Nietszche, Rilke, and Proust*. New Haven, CT: Yale University Press.

Donaldson, Ian. 1982. *The Rapes of Lucretia: A Myth and Its Transformations*. Oxford: Oxford University Press.

Dubois, Jacques, et al. 1981. *A General Rhetoric*. Translated by Paul B. Burrel and Edgar M. Slotkin. Baltimore: Johns Hopkins University Press.

Dubrow, Heather. 1986a. "A Mirror for Complaints: Shakespeare's *Lucrece* and Generic Tradition." In *Renaissance Genres: Essays on Theory, History, and Interpretation*, edited by Barbara Kiefer Lewalski, 399–417. Cambridge, MA: Harvard University Press.

———. 1986b. "The Rape of Clio: Attitudes to History in Shakespeare's *Lucrece*." *English Literary Renaissance* 16 (3): 425–41.

Dundas, Judith. 1983. "Mocking the Mind: The Role of Art in Shakespeare's *Rape of Lucrece*." *Sixteenth Century Journal* 14 (1): 13–22.

Eco, Umberto. 1979. "Peirce and the Semiotic Foundation of Openness: Signs as Texts and Texts as Signs." In *The Role of the Reader: Explorations in the Semiotics of Texts*, 175–99. Bloomington: Indiana University Press.

Fineman, Joel. 1991. *The Subjectivity Effect in Western Literary Tradition: Essays toward the Release of Shakespeare's Will*. Cambridge, MA: MIT Press.

Fletcher, Angus. 1964. *Allegory: The Theory of a Symbolic Mode*. Ithaca, NY: Cornell University Press.

Foster, B. O. 1959. *Livy*, with an English translation. London: Heinemann.

Girard, René. 1965. *Deceit, Desire, and the Novel: Self and Other in Literary Structure*. Baltimore: Johns Hopkins University Press.

———. 1991. *A Theater of Envy: William Shakespeare*. New York: Oxford University Press.

Irigaray, Luce. 1974. *Spéculum de l'autre femme*. Paris: Editions de Minuit.

Jed, Stephanie H. 1989. *Chaste Thinking: The Rape of Lucretia and the Birth of Humanism*. Bloomington: Indiana University Press.

Levin, Richard. 1981. "The Ironic Reading of 'The Rape of Lucrece' and the Problem of External Evidence." *Shakespeare Survey: An Annual Survey of Shakespearian Study and Production* 34:85–92. Cambridge: Cambridge University Press.

Lévi-Strauss, Claude. 1969. *The Elementary Structures of Kinship*. Translated by James Harle Bell, John Richard von Sturmer, and Rodney Needham. Boston: Beacon Press.

MacKinnon, Catharine. 1983. "Feminism, Marxism, Method and the State: Toward Feminist Jurisprudence." *Signs* 8 (4): 635–58.

Maus, Katherine Eisaman. 1986. "Taking Tropes Seriously: Language and Violence in Shakespeare's *Rape of Lucrece*." *Shakespeare Quarterly* 37:67–82.

Mitchell, W. J. T. 1994. "Ekphrasis and the Other." In *Picture Theory: Essays on Verbal and Visual Representation*, 151–82. Chicago: University of Chicago Press.

Modleski, Tania. 1988. *The Women Who Knew Too Much: Hitchcock and Feminist Theory*. New York: Methuen.

Moxey, Keith. 1994. *The Practice of Theory: Poststructuralism, Cultural Politics, and Art History*. Ithaca, NY: Cornell University Press.

Parker, Patricia. 1987. *Literary Fat Ladies: Rhetoric, Gender, Property*. London: Methuen.

———. 1989. "On the Tongue: Cross-Gendering, Effiminacy, and the Art of Words." *Style* 23 (3) (Fall): 445–67.

———. 1992. "Preposterous Events." *Shakespeare Quarterly* 43 (2): 186–213.

Perelman, Chaïm. 1979. *The New Rhetoric and the Humanities: Essays on Rhetoric and Its Applications*. Translated by William Kluback. Boston: Northeastern University Press.

Rawdon Wilson, R. 1988. "Shakespearean Narrative: *The Rape of Lucrece* Reconsidered." *Studies in English Literature* 28:39–55.

Sedgwick, Eve Kosofsky. 1985. *Between Men: English Literature and Male Homosocial Desire*. New York: Columbia University Press.

Spivak, Gayatri Chakravorty. 1971. "Allégorie et histoire de la poésie: Hypothèse de travail." *Poétique* 8:427–41.

Stock, Brian. 1983. *The Implications of Literacy: Written Language and Models of Interpretation in the Eleventh and Twelfth Centuries*. Princeton, NJ: Princeton University Press.

Tickner, Lisa. 1988. *The Spectacle of Women: Imagery of the Suffrage Campaign, 1907–14*. Chicago: University of Chicago Press.

Vickers, Nancy. 1985. "'The Blazon of Sweet Beauty's Best': Shakespeare's *Lucrece*." In *Shakespeare and the Question of Theory*, edited by Patricia Parker and Geoffrey Hartman, 95–115. New York: Methuen.

———. 1986. "'This Heraldry in Lucrece's Face.'" In *The Female Body in Western Culture: Contemporary Perspectives*, edited by Susan Suleiman. Cambridge, MA: Harvard University Press.

White, Hayden. 1973. *Metahistory: The Historical Imagination in Nineteenth-Century Europe*. Baltimore: Johns Hopkins University Press.

———. 1978. *Tropics of Discourse: Essays in Cultural Criticism*. Baltimore: Johns Hopkins University Press.

3. All in the Family: Familiarity and Estrangement According to Marcel Proust

Introduction

Marcel Proust's modernist masterpiece, *Remembrance of Things Past,* is a show-case of the male gay literary canon. I think feminist and lesbian theory should es-pouse this book, too. *Remembrance* is much less about the past, or temporal otherness and the desperate attempts to grasp it, as it is about elusiveness in the present, about contemporary otherness and the desperate attempts to grasp *it.* Through the exploration of alterity, the novel elaborates a semiotics of desire that can be characterized as gay but, more specifically, lesbian. In this essay I will demonstrate that this long novel's subject, the narrator, Marcel, is engaged in a search that is simultaneously philosophical, poetic, and libidinal, and whose ob-ject is "love," understood as the perfect match or total matching of two bodies rubbing against one another, an experience that is not based on penetration, but instead takes a fantasy about lesbian love as an ideal. The philosophical model for this experience is an epistemology of photography; the poetic model is an aes-thetic of glimmering surfaces and the limitations of exteriority; the libidinal model is lesbian love.

The subject of both search and fulfillment, however, remains a (homosexual) man. Hence, the claim that the fantasy model I will describe is lesbian would be both absurd and wrongheaded. What makes it relevant for lesbian cultural poli-tics, however, is not the model as such but the elevation of lesbianism to a primal model, compared to which other sexual, epistemic, and poetic models are deriv-atives. With Djuna Barnes's *Nightwood* and the work of Gertrude Stein, *Remem-brance* constitutes a canon of modernist fiction whose radical sexual politics point to, and start up, a postmodern future.[1] For this proto-postmodern slant in the work, photography is the poetics: it is a visual poetics that operates by means

of a photographic "eye" that probes the balance between familiarity and es-
trangement in the snapshot. Many of these snapshots balance on the edge of the
familial: grandmother, father, lover, closeted object of desire, figures who are either
within the family but must be cast out, or who are not, but must be drawn in.

Suffering from mainstream canonization, *Remembrance* has been over-
written by admirative accounts that aim at "rendering," that is, paraphrasing, the
philosophy of the text. As a consequence, the novel is usually read in terms of its
"depth." Moreover, many critics have discussed Albertine, the narrator's long-
standing love object, in terms of the author's homosexual relationship with his as-
sistant, thus seeming to do justice to a gay impulse.[2] But not to a gay poetics.
Where the biography points to homosexuality and the novel disguises it, the po-
etics might be said to be (falsely) straight. Needless to say that the epistemic
model of "depth" inherently colludes with this straightening out of the text.
Instead, I will claim that Albertine, far from being a gay man in disguise, stands as
a model for the disguise of the gay man as a lesbian, and for the importance for the
gay man to represent his homosexuality in this form.

Hence, we are better off without "deep" philosophy and thematics. Instead,
I will focus on a structure that links the three areas—epistemology, poetics,
desire—whose totally inextricable integration defines *Remembrance*'s unique-
ness. This structure is the relation between subject and object of the act of look-
ing, often referred to as "the gaze." Here, the gaze is neither the look alone—held
by the subject—nor the Lacanian gaze *stricto sensu* of the ideologically deter-
mined visual order which "looks back" at the subject, thus framing what the lat-
ter is able to see; the gaze is inflected and thickened by the familial. The Proust-
ian gaze here described probes and questions the limits of what the gaze in the
latter sense permits the look to see. The work thus offers a discussion with, not a
wholesale endorsement of, something like a Lacanian theory of the gaze.[3] The
look embedded in familiarity and affective routine is confronted with a look of es-
trangement which opens up, instead of closing off, a potentially different look,
which is offered as an alternative visual domain. Henceforward I will call this look
the (Proustian) *gaze,* to emphasize its double status.

In accordance with—but by no means reducible to—the historical time in
which the book was written, the Proustian gaze operates as a privileged device for
the closeted representation of homosexual desire.[4] The discussion must be lim-
ited to two forms in which the gaze functions to that effect. First, I will focus on
the production of textual-visual imagery, most notably snapshots, as tokens of a
sensibility that announces postmodern theories of gender as "masquerade," the-
ories that originate in feminist thought.[5] Next, I will examine the status of the sub-
ject holder of the "discussing" gaze as an explorer, or ethnographer, whose trade
is otherness. In this respect, Proust can be seen as a precursor of postcolonial

thought, also of the feminist slant.[6] Together, these two forms provide a glimpse
on the nature of lesbian desire as the most crucial meeting place of the three major
areas of *Remembrance*'s search, in summary: a sensualist poetics as an episte-
mology.

To shape the mediation between visuality and language that any visual read-
ing of a literary text requires, two terms are basic for my approach in this paper:
flatness, or *platitude,* and figuration. The former indicates the level on which the
world seen is articulated in the many passages where vision is at stake; it is the
area of textual visuality. The text's insistence on the flat quality of the image be-
comes ambiguous when photography is at stake and the meaning "banality" ac-
crues to the physical two-dimensionality. The latter indicates the way flatness is
written, the way it is made generative of the novel as narrative, as literary text. The
result of these figurations can be formulated as a series of visualizing effects,
which abound in *Remembrance.* To give a few examples: The *still-life effect* oc-
curs when the unbridgeable abyss between the remote view, which fixates and de-
colors the object and the close-up, which numbs the senses and sickens—two
epistemological and aesthetic obsessions in Proust—is overcome through the
mediation of Chardin's miraculous roving attentiveness. The *museum effect* oc-
curs when the visible world that cannot be encompassed is represented as a jux-
taposition of flat images, figured according to seventeenth-century Dutch genre
painting. The juxtaposition enables the focalizer[7] to see different views without
unifying them, and to integrate realistic description with a refusal of its major
tool, linear perspective. The *magnifying-glass effect* results from attempts to ne-
gotiate discrepancies in attention. The *photographic effect* combines flattening,
blowing up, isolating parts of the image, as when Marcel looks from a distance
at the band of girls on the beach, and decides, as he phrases it in a proto-
postmodern way, to "live his novel" with Albertine because she cycles out of the
glossy image. The *snapshot effect* constitutes a subset of the photographic effect,
and comes about when the representation takes the form of an album of multiple
"takes," and moves in the direction of photographic seriality. This effect is cen-
tral to my argument about lesbian desire in *Remembrance.*[8] And as I will later ar-
gue, these visual effects, in turn, defamiliarize the familiar and familial look we
cast on the photographs that abound in our daily lives.

Desire and the Ontology of the Snapshot

Of course, Proust's work is literary, not visual in the material sense. As I have
hinted, my analysis of vision in it is predicated upon a distinction between (ma-
terial) medium and (semiotic) mode. The language of narrative can produce vi-

sion. Where there is visuality, there is a viewer. The viewer within narrative may or may not be identifiable as the narrator. This subject of vision, the focalizer, is often used to stage the position of the outsider as photographer. That position is a condition for the production of the snapshot.

The focalizer's position is a position of the outsider, at the threshold of the diegetic world—which is, in *Remembrance,* essentially the familial. These passages refer to, or take their model from, particular kinds of photographs: snapshots, instantaneous arrests, random stills. They are narrative paradoxes: turning narrative into pictures, they subsequently turn a photo album back into a record of "life" while simultaneously emphasizing the immobility caused by the medium rather than by the object. This paradoxical character is necessary, I contend, to produce the specific epistemological mode of vision that I call, on the basis of the examples analyzed here, the closeted gaze.

There are great differences amongst Proust's visual effects. For our purpose it is important to notice the difference between, on the one hand, the museum effect, the juxtaposition of pictorially pretty images which entertain an obvious interdiscursive relation to a specific genre in painting—one based on voyeurism of domestic intimacy[9]—and, on the other, the snapshot effect of the emphatically random and vulgar kind.

Since for Proust, poetical, libidinal, and epistemological considerations are one and the same, the problems of representation he raises tend to be problems pertaining to the integration of these three domains. For example, the reflection on the changing nature of beings, *êtres de fuite,* articulates the issue of ontology—what is the other?—as one of epistemology—how can I know that? According to Brian McHale, this shift from epistemological to ontological uncertainty is crucially bound up with the shift from modernism to postmodernism.[10] Of course, Proust's work is a monument of modernism, and a postmodernist reading of it offends the delicate sensibilities of literary historians. In my reading of the novel, however, I draw it into the postmodern direction because it is there that its gay meanings escape from the closet while putting the closet to meaningful use. And it is precisely in the shift from epistemology to ontology that radical otherness becomes the ultimate object of desire, and that Marcel as the narrative subject of the novel, remaining a queer man, turns his desire into a lesbian one.[11]

The character who makes epistemology tumble into ontology is Albertine. The entire *roman d'Albertine* is a quest for knowledge about her, but this epistemological anxiety is constantly fed by glimpses of her ontological difference: she is unknowable because, as a woman and as a lesbian, she *is* doubly other. And the representation of this ontological otherness is carried out by way of snapshot effects: this object of obsessive jealousy is a fugitive being because all she leaves behind are snapshots.

The ontology of the snapshot consists of the denial of depth, of existence be-
hind or beneath the glossy, random surface of the accessible visual present. Al-
bertine is the figuration of this ontology. She was selected as a love object the mo-
ment she visually detached herself from the photograph of the girls on the beach,
taking off on her bicycle and thus riding off the picture, necessitating the change
of photographic aesthetic from group portrait to snapshot.

Indeed, in *The Prisoner,* Albertine, who has lost her former, fixed quality of
beach photo, consists only of a series of snapshots: ". . . a person, scattered in
space and time, is no longer a woman but a series of events on which we can
throw *no light,* a series of insoluble problems" (III, 99–100; emphasis added).[12]
The shift from epistemology ("no light") to ontology ("is no longer a woman")
announces postmodernism, and the phrase "scattered in space and time" (*dis-
séminé*) with its Derridean overtones articulates that shift.[13] That "woman" as
"other" falls prey to this lunacy of the snapshot is, of course, no coincidence.
This dissolution in visual, flat seriality only aggravates as Marcel tries to counter
it and "fix" Albertine by means of "light" thrown on her, and on paper. Thus she
ends up *becoming* (ontology) the sheet on which the images (epistemology) of
jealousy are going to be fixed (fig. 3.1): "For I possessed in my memory only a
series of Albertines, separate from one another, incomplete, a collection of
profiles or snapshots, and so my jealousy was restricted to a discontinuous ex-
pression, at once fugitive and fixed" (III, 145–46). With the word "mémoire"
keeping the issue also on the level of epistemology, ontological "fugitivity" is
presented here as a perversion of the former. The final words here, "à la fois fugi-
tive et fixée," define quite precisely the nature of the series of snapshots, and ex-
plain the specific use of this poetic in the novel. The importance of eroticism is
crucial: the object of this fugitive fixing is the love object of whom the focalizing
narrator is unable to fix the essence, which for him is represented by her sexual
orientation.

This is a philosophy of looking as fixing that is quite different from the stan-
dard theory of the gaze as control, which sometimes comes close to a paranoid
iconophobia.[14] Most readings of Lacan's theory of the gaze emphasize the con-
fining aspect of it, although it seems obvious that the symbolic underpinnings of
the visual imaginary also enable social intercourse through semiotic exchange. It
is this more cheerful, even, saving aspect of the gaze that Proust explores in other
passages than this.

There are three first cousins of approximately the same age in my family; one is
my own daughter, the other two the daughters of two of my sisters. They are quite
close, meet frequently but most often in pairs, and the triangle is not without its
occasional fits of jealousy when one seems fonder of the other than of the third.

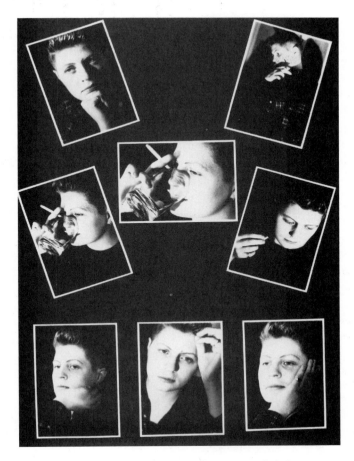

FIGURE 3.1 Series of posed portraits, 1994. Photos: Carla de Groot.

The youngest one, Lies, is becoming an excellent photographer, already getting commissions here and there. The strip of contacts reproduced as figure 3.2 is, I surmise, her attempt to "fix"—to know and thereby to be able to participate in—her cousin Eva's identity (fig. 3.2).

For me, as the doting aunt of both photographer and sitter, I see Albertine floating in and out of the subject's grasp. Close up, more distant, looking at the camera or closing her eyes, Eva cannot be fixed. The series, more than the individual snaps, inscribes the failure-to-know, which liberates Eva to be within herself. The last image of the series makes her utterly unavailable, but the others are more ambiguous. Tantalizingly almost giving herself over to scrutiny in the first

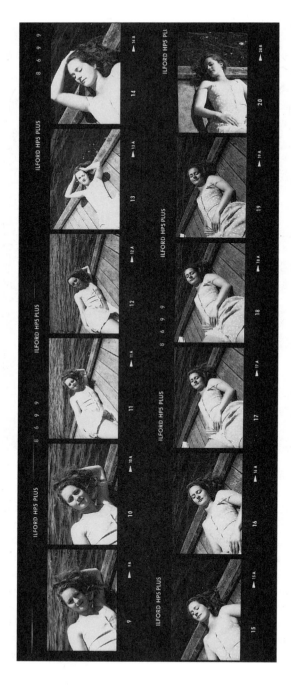

FIGURE 3.2 Contact sheet of snapshots, 1997. Photos: Lies ter Beek.

and second frames, she recedes afterward one way or the other—by distance or by closing her eyes.

The pose in the last few frames adds to the symbolic ambiguity of her spatial framing between land and water, and the ambiguity of her age between adolescent and adult, increasingly unclear as the series progresses, a hint of sexual ambiguity which remains with her when, in the last frame, she turns away from her cousin's searching camera, a fugitive from all attempts to fix her. A hint of a smile is more visible when the distance increases, disappears when she comes closer. The smile is utterly unreadable: is it pleasurable, mocking, communicative, erotic, or solitary? As if to express her refusal to disclose her secret, she does not open her mouth in any of the frames.

In conjunction with Proust's desperate attempt to grasp Albertine, Lies's attempt to enclose Eva in a familiarity that would fix her recalled to my mind a series of photographs of my own daughter, Nanna, made a few years prior to Eva's contact sheet (see fig. 3.1). Here, the photographer is not part of the family but of the social group, a closely knit lesbian community in Nanna's hometown. Suddenly I saw why I had cherished these photos, put them in my Nanna album, but never really grown fond of them. They were not "of Nanna," not of the Nanna my own familial, motherly gaze surrounds with the fixing routine of affection. In none of the photos does the sitter look at the camera. I wondered if Carla, the photographer, in addition to her ambition to be a professional photographer, also had the ambition to probe Nanna's identity—and failed. Like Albertine, Nanna refused to be fixed.

All this is either arbitrary, an unforeseeable effect of light and time, or artificial, a pose willed by the sitter. In the case of figure 3.2, none of it corresponds to the "facts" of Eva's sense of self, nor of Lies's declared intention. Anticipating the second part of my analysis of figure 3.3 below, the third party of the triangle is the familial gaze with which I scrutinize these photographs, surrounding them with both the routine of affection and the album of Albertine that Proust inscribed in my visual memory.

But Albertine, ironed out ontologically, does not benefit from this at all. If looking is a form of killing, as horror films about voyeurism suggest,[15] looking away is what kills Albertine. The minute she turns from an *être de fuite* into a real fugitive, running away from the obsessive attempts to flatten and fix her, to make her "part of the family," and escaping the desperately seeking gaze, she is killed off by redundancy, a state the author with his genius for cultural anticipation, represents, in a superbly proto-postmodern play, by her literal death.[16]

But proto-postmodernism is "proto-" precisely because it feeds off modernism. The ontology of the snapshot needs, and is predicated upon, the epistemology that founds it. During Albertine's presence at his side, the narrator com-

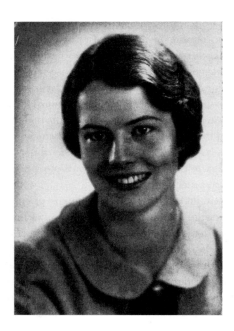

FIGURE 3.3 Studio portrait of a young woman
(my mother), 1936. Photographer unknown.

poses an album, in the vain hope of fixing the inaccessible other. But the photograph's flatness has yet another feature, and that one hinders the very attempt that makes the narrator cultivate it: it encourages deceit, role-playing, masks; what is fixed is, precisely, the exterior, the appearance, which only hides more effectively the being which, in the case of Albertine, does not exist outside of the (family) album. If the serial picture taking helps the subject to an epistemological trick, the fixing of image on paper bears on the object as well, and, hence, the endeavor cannot but fail:

> And before she pulled herself together and spoke to me, there was an instant during which Albertine did not move, smiled into the empty air, with the same air of feigned spontaneity and secret pleasure as if she were posing for somebody to take her photograph, or even seeking to assume before the camera a more dashing pose . . . (III, 146)

Dashing: definitely, this is how Nanna holding a glass or cigarette escaped Carla's probing camera in figure 3.1. The ontology is grafted upon the epistemology be-

cause what is at stake is not, or not primarily, the fugitive being herself. The series of snapshots functions to reveal not the other's essence but the relationship between subject and other. That is why it matters that this is a narrative text, and thus, needs to be considered in that way. The relationship between the subject of perception, interpretation, desire, and knowledge, on the one hand, and, on the other hand, the object whose sole function is to elude grasp, is transient, tenuous, changing, and ultimately elusive.

Thus taken seriously as a specific photographic poetics, the series of snapshots poses, and proposes to acknowledge, the limit of epistemic modesty when the object is another human being. In other words, it partakes of a methodological exploration of ethnography in which the other's being cannot be assessed without knowledge, yet knowledge infringes upon being. This, I contend, is the essence of the family as both affective haven and prison, of the familial as a denial of otherness. Albertine is the embodiment of this problem, and, therefore, it is crucial that she be gay, a woman, and literally fugitive. Neither the subject of this novel nor, of course, its author is lesbian, but the search, the desire, and the epistemology are modeled upon a fantasy—not the reality—of lesbianism as the counterpart of the familial.[17]

"Glamour"—the studio portrait—is inherently in tension with the familial snapshot; not because it grasps the essence of the subject better—it does not—but because it peels away any pretension to know. Figure 3.3 shows a young girl in the 1930s. She is twenty-one years old. Her beauty is glamorous, but, although "real," it is rhetorically emphasized and conveyed by the aesthetics of the studio portrait. The soft sheen is in the right spots: forehead, nose, cheeks, delicate neck, wave of the hair. The twinkle in the eyes rhymes with the tiny spot of light in their corners. "Beauty" is enlivened to solicit desire by the features which define the young woman as eligible, such as the smile, which gives and holds back to underline the shyness of youth within the maturity of the woman who can pose. Clearly, this girl is marriageable: ready to be taken out of her own family, of which there is no trace, into a foreign one, based on this glimmering rhetoric of the portrait.

Proust's narrator refuses to fall for such rhetoric. Whenever the "studio portrait" informs his descriptive poetics, the subject is familial: the grandmother. The familial, which encompasses the incest taboo, does not allow unmitigated desire. Albertine, then, represents one side of the novel's ambitious exploration of love, which gives the biblical euphemism of "knowing" other people a decidedly new turn. The symmetrical counterpart of Albertine-as-other is the selfsame object of desire, turned subject by narrative structure.[18] At the other side of the novel's experiments with photography, in particular, the exploration of the epistemology of the snapshot, stands the narrator's best friend and friend of the

family, his ego model, closeted homosexual, and closeted love object, Robert de Saint-Loup. Through this figure, the familial *becomes* the closet.

Robert's ontological status is like hers: surface over depth, albeit a surface characterized not by photographic fixation but by fugitive mobility. The difference shifts the poetics of the snapshot just enough to turn into a poetics of seriality: of the contact sheet à la Muybridge. Visions of him yield not a picture album but a contact sheet of rapidly taken photos of movement.

Photography in its specific guise of the serial snapshot provides the narrator with a uniquely suitable and efficient mode of representing this important character; of revealing the secrets he is invested with while keeping them. Saint-Loup is the most "photographic" character of *Remembrance*. He is the most photogenic one, of a luminous beauty, hence, he is the ideal object of "studio portrait" photography with artistic ambitions. He is also the "official" family photographer: he is the one who takes the famous photograph of the dying grandmother, who wished to leave her grandson a visual memory of her. Among a great number of narrative and poetic functions, that "photo session" narratively enables the revelation of Robert's homosexuality, as gossip has it that developing the photo in the darkroom was a pretext for him to make love to the lift-boy in the Balbec hotel. But, most importantly, he is constantly being "photographed" in his movement. One such photo session constitutes the *mise en abyme* of the poetics and politics of the snapshot in *Remembrance*.

Robert is a Muybridge character (fig. 3.4). Like the nineteenth-century photographer Eadweard Muybridge, Proust explores through this figure the possibility of fixing movement. If his movement could only be fixed, allowing the desiring gaze to pin him down, the final frame of Muybridge's series could become visible. The attempt to fix movement qua movement is, of course, as old as visual representation. But in *Remembrance* this complex narrative-pictorial trick is endowed with heavy philosophical, poetic, and libidinal investment, so as to come to signify the unbearable lightness of being.

Clearly, the issue at stake in this Muybridge work points in a different direction than does the contact sheet of Eva. Speed characterizes this Proustian character; speed is the sign of him, as it is the sign that signals the difference between writing as snapshot and cinematic writing. This character of speed is a fugitive being, but, as I said, not in the same way as Albertine. The difference between them is, of course, gendered. But in a complex way, in this gendered homosexual universe, the classical opposition between (male) subject and (female) object, which is such a defining feature of the history of Western art, doesn't turn out the way one would expect.

Albertine is more radically other; Robert more radically in movement. She is characterized by a certain passivity, an adaptation to the narrator's wishes so

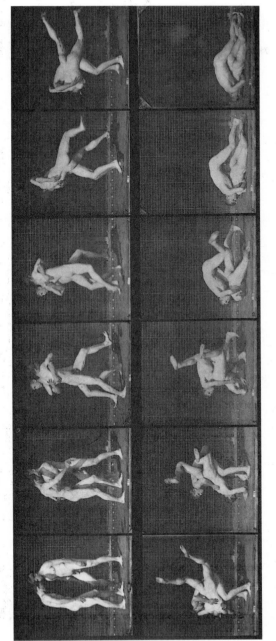

FIGURE 3.4 Eadweard Muybridge, *Wrestlers*, 1887. Coll. Ernst van Alphen. Amsterdam.

systematic that she entirely loses her consistency. Lacking autonomy as a charac-
ter, paper doll at the service of the narrative, she does exactly as she is told. The
resulting snapshots reveal only the more painfully the impossibility, in principle,
to "fix" her. This inaccessibility of Albertine is *represented as,* not a representa-
tion of, lesbianism. In Proust there is no lesbian gaze, no "lesbian as visionary,"
yet lesbianism is the most important, essential site of desire.

Robert, in contrast, escapes fixing in a different way, more actively, and even
more thoroughly visually. As of the beginning of their acquaintance, the narrator
has characterized Robert by quickness of movement, as a trait that will pursue a
character all through the novel, as his or her determining, identifying sign.[19] This
trait, however, develops into much more than the initial label or arrow, index of
identity. It is filled with narrative meaning, psychological characterization, phys-
ical feature, and, for the narrator, support onto which he can build his plot. These
fillings are slowly stored inside the black areas between Muybridge's frames.

Primal Scenes: Against the Familial Gaze

Two scenes stand as exemplary of the way Proust probes the nature of the gaze
between affective routine—the familial gaze—and estrangement—the gaze in and
out of the closet. Both scenes represent a power struggle with familial authorities:
Marcel's grandmother, and Mlle Vinteuil's father. Authority, as often in *Remem-
brance,* is defined by an excess of affection; it is fundamentally based on a femi-
nized fantasy of the familial that rubs against the Oedipal model.

As if to emphasize the distance from the Oedipal model, Marcel's paradig-
matic love object is not *maman* but his grandmother. In order that her grandson
may have a beautiful image of her to keep after her death, which she knows to be
imminent, the grandmother asks Robert de Saint-Loup to take a photograph of
her. Marcel, who does not know that his grandmother is dying, is extremely irri-
tated by what he perceives as her coquetry. This irritation provokes him meanly
to extinguish the expression of joy from the old woman's face that she would have
liked to have preserved for him (I, 844). They engage in a blind struggle for the
power over the image. They are struggling in the present both for the power to
determine what the image will be, its future, and the power to control the brief
click that immortalizes that which will nonetheless slip away, the past. Marcel's
cruelty wins out, and whereas she will soon pass away, he lives to regret his
victory.

The photograph in question reappears often in the novel, whether it be as the
object itself or as a memory of the event that produced it. In each instance it
changes meaning. It is also the object of choice around which the intrigue that op-

poses Marcel to his doubles will be developed; these doubles, whose misleading identities Marcel discovers during his "ethnographic" enterprise, that voyage of discovery that he makes without leaving home. This discovery has the effect of advancing his self-discovery. In the episode of the grandmother's photograph, de Saint-Loup, the photographer, will in retrospect be described as being "a stranger to himself" once the narrator discovers that he used this opportunity to touch up the hotel lift-boy in the darkroom, which becomes by means of this revelation a "camera lucida" (III, 699). The focalizer is semantically fleshed out by what it sees as object or other; the grandmother's photograph is also indirectly a photograph of Robert.

True to his understanding of the ambivalence of the familial, the narrator reflects often on his impulse to spoil all pleasure and happiness, which he reveals on this occasion. His reflection begins during the involuntary recollection that overcomes him on the first evening of his second stay in Balbec. He considers the photographic session as part of a more general tendency that gives him cause to believe that he killed his grandmother:

> I . . . had striven with such insensate frenzy to expunge from it even the smallest pleasures, as on the day when Saint-Loup had taken my grandmother's photograph and I, unable to conceal from her what I thought of the ridiculous childishness of the coquetry with which she posed for him, with her widebrimmed hat, in a flattering half-light, had allowed myself to mutter a few impatient, wounding words, which, I had sensed from a contraction of her features, had struck home; it was I whose heart they were rending, now that the consolation of countless kisses was forever impossible. (III, 786)

Words that struck home. Since Barthes, one might say that words have taken precedence over the photograph, but I contend that this precedence is itself "photographic." The very mission of the photograph is to strike home: "A photograph's *punctum* is that accident which pricks me (but also bruises me, is poignant to me)"—thus Barthes elaborates his concept of the punctum before the discovery of the photograph from the Winter Garden.[20]

The reflection continues by cruelly opposing the failure of the photograph to capture a nonexistent truth. Despite Françoise's remark, "Poor Madame, it's the very image of her, down to the beauty spot on her cheek," this visual detail is not capable of bridging the gap between the part and the whole (II, 803). This incapacity has significant consequences: the photographic "it's the very image of her" fails to establish the link between the subject and the object of the vision that is the only means of saving the subject in its "envelop" of familiality. The stakes are high, for as Barthes writes: "if he cannot . . . supply the transparent soul its

bright shadow, the subject dies forever" (169). Proust's narrator is well aware of this: "We had not been created solely for one another; she was a stranger to me. This stranger was before my eyes as I looked at the photograph taken of her by Saint-Loup" (II, 803).

The defamilializing effect of photography is based on an awareness that is only today becoming fully understood: that there is an irreducible divorce between the subject who looks, the object that is "fixed," and the operator who clicks the shutter. Between the three positions of this visual or love triangle, there is the movement of the merry-go-round that hides an emptiness in the center. This is the problem that the photograph poses. Unable to immobilize, it is just as slippery as the object it is supposed to fix. And in its slipperiness, it acts, it strikes home, without the subject's being able to control it.

The pain he caused—it will remain the flat, present, superficial remembrance, which is all he has; there is no depth. Pain is the only sign that offers access to a past familiality. I cannot look at the photograph of the young woman in figure 3.3, studio portrait as it may be, without seeing the pain in the eyes. The eyes do not twinkle, I now see; the spots of light are superposed from the unfamilial outside onto the eyes that cannot smile along with the mouth as soon as the sadness pierces through the glimmering surface. The woman is not holding back; on the contrary, she would like to give more so as to be able to escape the family of which she is still a prisoner. I remember her sadness, although this photograph precedes my knowledge of it. What I remember also is how I fell for the glamour because this was the mother I could admire, love, and desire (to be); but never quite. She had a beautiful smile, but I have no memory of ever seeing the glamour without the sadness. Or was it my own sadness? Within the familial, there is no gaze that does not stick onto its object in an inevitable merging. This is what Proust's narrator knew, and it was the motor of his search.

The grandmother's photograph will continue to obsess Marcel. But during all this time, the photograph has had a rival in the form of another photograph, taken when Marcel returns to Paris and unexpectedly visits his grandmother, who, for a brief instant, is not aware of his presence in the room. This other photograph will set in motion the photographic figuration in the narrative discourse of *Remembrance*, the one that probes the familial gaze as nurturing and stifling, the defamiliarizing gaze as frightening and liberating. It operates as the shifter from the visual represented to a visuality that represents. This is an important passage: it reviews in detail the significant aspects of the family photograph in Proust, defining it as the place where affectivity and cognition, epistemology and aesthetics, the subject and the object, are inextricably commingled. It is also the passage that "theorizes" how narrative can espouse visuality, how words can show. Thus we

see that the raw material of this novel consists of an interweaving of the external, "true," and objectifiable image with the mental image.

It is in this passage that we discover the phantom that will haunt the narrator throughout the work, constituting the metaphorical counterpart to the first photograph, the essence of which it describes better: the nonreciprocal gaze. Entering the room without announcing his presence, the narrator writes, "I was there, or rather I was not yet there since she was not aware of my presence, and . . . she was absorbed in thoughts which she never allowed to be seen by me" (II, 141). Here we have an example of heteropathic identification—identification based on going outside of the self, as opposed to idiopathic or "cannibalistic" identification, which absorbs and "naturalizes" the other. Heteropathic identification is associated with a risk of alienation, but enables the subject to identify beyond the normative models prescribed by the cultural screen, and is thereby socially productive.[21] This identification never stops appealing to the narrator, even while it exposes him to obvious risks. This appeal makes *Remembrance* relevant for feminist and postcolonial thought.

This passage is made all the "thicker" by the fact that it presents another aspect of the narrator's tendency toward voyeurism. The voyeur is constantly in danger, since alienation robs him of his self when he is not interacting with the other. This danger determines the extent to which the voyeur must "flatten" himself in visual identification onto his object, finding himself unable to avoid participation in the spectacle. The contemplation of the spectacle afforded by the other is a photographic act, both existential and formative. The phantom of the grandmother, which reveals her illness, is, thus, also the phantom of Marcel, who is devoid of all substance when he sees without being seen or known to be there. For a brief instant, he wavers between the disembodied retinal gaze of linear perspective that affords colonizing mastery and the heteropathic identification that takes him out of himself with body and soul to "become" other. The *specter*— both spectacle and phantom—that leads Barthes to define photography in terms of lost time, in other words, in terms of death, is exactly what the subject inevitably is himself:

> Of myself—thanks to that privilege which does not last but which gives one, during the brief moment of return, the faculty of being suddenly the spectator of one's own absence—there was present only the witness, the observer, in travelling coat and hat, the stranger who does not belong to the house, the photographer who has called to take a photograph of places which one will never see again. The process that automatically occurred in my eyes when I caught sight of my grandmother was indeed a photograph. (II, 141)

The passage continues in the longest and most sustained reflection on photography in the entire work. Here photography is defined as the threshold between familiarity and estrangement. It is seen as an art, or an "automatic process," that cuts and slices, transforming life and the past. Describing oneself in the third person amounts to describing the uncanniness, but also the excitement of discovery that results from the heteropathic identification.

The photograph that makes the photographer a stranger to himself differs from the one that is described implicitly as its negative. The word "automatic" reappears and it is said to be "some cruel trick." The passage gradually develops a more hostile, if not violent, language, leading at the end of this worrying amplification to the description of the mental photograph that will always be with the narrator: "I saw, sitting on the sofa, beneath the lamp, red-faced, heavy and vulgar, sick, vacant, letting her slightly crazed eyes wander over a book, a dejected old woman whom I did not know" (II, 143). The "truth" of photography is this stranger, this unknowable person, cut off from the familial, affective gaze by photography.

The material photograph of the grandmother is combined with the mental photograph, both of which are dispersed throughout the work. An eye for an eye: the eye that is veiled by habit, tenderness, the continual affective adjustments that we make to our field of vision, is opposed to that other eye, which is mercilessly "to one side," that is to say, the lens of the camera. It is the art, not of mimesis, nor of direct indexical contact, but of deviation.[22]

Ethnography as Voyeurism

If the photographic scenes around the grandmother generate the visual "philosophy" of the gaze between the familial and the need to escape it, and of the gaze between voyeurism and heteropathic identification, the lesbian scene generates the model toward which the alternative optic aspires. As is well known, the long novel is punctuated by a series of scenes of voyeurism, emphasizing by means of that rhythmic return of that "primal scene," the crucial importance of this particular visual libidinal epistemology. It is less well known that the series consists of four, not three, cases, and that two of these are lesbian, the other two queer scenes. The lesbian scenes precede the queer ones, and set the epistemological conditions for the other two; I contend that they also determine the libidinal and poetic conditions for the queer scenes, which in turn define the narrator's identity and sense of self. In this sense, they are just as "primal" as the one discussed in the previous section.

The series begins with the spying on an infantile "sadistic" scene between Mlle Vinteuil and her female lover, typically centered on a photograph; passes through the vision, in an oblique mirror, of Albertine and Andrée dancing with their breasts clinging against one another; then, there is the literalization of the closet at the Hôtel de Guermantes when Marcel accidentally spies on the homosexual encounter between Charlus and Jupien; and the series ends on the "adult" sadomasochistic scene during the war.

These four scenes together form a series of "ethnographic" experiences whose primary project is epistemological; they reveal "the other" to the watching subject, who presents his act of looking as a voyage of discovery. But in a profoundly biblical association, the attempt to *know* the *other*, the very core of ethnography, is libidinal as much as it is poetic, and defines the subject as someone, to recycle the biblical phrase, "who has known another man." Like the light that is fixed on paper in photography, knowledge as "seeing the light" enables writing but only if the "fixing," the identification of subject and object in a perfect matching, also happens.

The first scene occurs early on, when Marcel is still a child dreaming of unexpected encounters with girls, and when the writing skirts an overt description of masturbation linked to ethnography as well as to framing.[23] This scene generates all later figurations of the photographic gaze in its most important variety as the poetics of the snapshot, as distinct from those derived from the grandmother's "familial studio portrait." Here, the initial device for defamiliarization is an insistent fictionality. The scene begins with a fairy-tale setup, with the young hero falling asleep, the magic mirror in the shape of the pond. Like Alice, Marcel changes when he traverses the mirror. The vision or object of voyeurism, Mlle Vinteuil appears as if magically; but the magic is of a libidinal nature defined by the masturbatory fantasy that precedes. The "technical" framing, however, is modeled upon voyeurism:

> The window was partly open; the lamp was lighted; I could watch her every movement without her being able to see me; but if I had moved away I would have made a rustling sound among the bushes, she would have heard me, and she might have thought that I had been hiding there in order to spy upon her. (I, 174)

Of course, spying upon her is exactly what he is about to do. The focalizer's gaze zooms in: if Mlle Vinteuil is represented as if on a photograph, within this picture another picture becomes the figure of this libidinal epistemology: "At the far end of Mlle Vinteuil's sitting-room, on the mantelpiece, stood a small photograph of

her father . . ." (I, 175). It is the profanation of that photo by Mlle Vinteuil and her lesbian lover that constitutes the object of voyeurism. But the father does not figure here as the Oedipal authority to be killed. He is already dead, like the grandmother, and like her he needs to be kept at bay, cut off from an excess of familial love, the affective routine that precludes vision yet is its precondition.

This primal scene will later become the point of reference for the narrator's idea of sadism as well as the motor of his obsessive jealousy. According to this logic, jealousy will be a painful visual pleasure. Mlle Vinteuil's lover formulates this unwittingly when she says, not knowing they are being watched: "And what if they are [watching]? All the better that they should see us" (I, 161).[24]

Inasmuch as the narrator affirms himself the profound influence of this vision on the rest of his life, this scene sets the stage for Marcel's self-discovery through the other—in other words, for the integration of ethnography and identification, his heteropathic identification, which, in turn, enables him to become (like) a lesbian.

The second scene of voyeuristic ethnography is often referred to as the "danse contre seins," the "dance against breasts," at the casino at Incarville. Again, the effect of the scene is postponed, as it takes Marcel several weeks to fully digest the implications of the sight. Again, the scene is set up in an emphatically implausible way, an antirealism that emphasizes its "philosophical" importance. He had declined the invitation of the "gang of girls" to join them at the casino, but due to an accident, he later wanders into the casino with Doctor Cottard: the young apprentice and the older scientist. It is of crucial importance that he be accompanied by another man, and that this man be an expert. The girls comment that there are no men available to dance with, and begin to dance together; Marcel watches them in a mirror, and obliquely.

As I mentioned earlier, Marcel selects Albertine to "live his novel" with, because of the way she is situated in the flat image of the band of girls. The fact that she is part of that band, hence, that she has a girl's life to which he has no access, is just as important as the opposite fact, namely, that she cycles out of the image, detaching herself from that collectivity. Just as in the scenes on the beach, where Marcel the outsider "photographs" the band of girls whose bonding within a world of their own both arouses and distresses him, here the girls are presented as living rigorously outside the world of men. On the other hand, the talk between the two men, typical men's talk about women, produces a strong sense of homosocial bonding between the older and the younger man. This bonding shapes the event; it establishes the social distance that, superposed upon the visual distance, enables the classical evaluating discourse of power that betokens male dominance. But it is precisely through that discourse that things turn sour.

Cottard, the medical expert, is visually handicapped; he has forgotten his glasses. "Are they pretty at least? I can't make out their features," he says, establishing the blindness necessary for his expertise. "'There now, look,' he went on, pointing to Albertine and Andrée who were waltzing slowly, tightly clasped together, 'I've left my glasses behind and I can't see very well, but they are certainly having an orgasm.[25] It's not sufficiently known that women have it through their breasts. And theirs, *as you see, are touching completely*'" (II, 823–24; emphasis added).

The doctor's epistemological competence is opposed to his visual incompetence: he cannot see the women's exterior features, but he nevertheless claims that he can know the interior of their bodies. But that knowledge of their interior is even more exterior-based than a superficial judgment on their looks would be; hence the insistence on the doctor's visual incapacity. "Certainly" functions as an epistemic shifter. "It's not sufficiently known" introduces the medical cliché for whose utterance the doctor's presence was required in the first place. But, on a different level, the one where the visual prothesis is lacking, "it's not sufficiently known" implies the verdict that generates jealousy. In jealousy one never knows enough.

Whether the medical knowledge is actually true or false doesn't matter; what matters is its definition as *general* and as *exterior*. The master ethnographer, the one who "knows," doesn't *see* properly, hence, he can judge only from the outside. But without the doctor, Marcel would not have seen anything at all. On the one hand, medical discourse as the "discourse of the Other"; on the other, the failure of vision, which necessitates indirect language as the basis of a knowledge that can only be insufficient. The scene installs the failure-to-know, which establishes the challenge that Marcel's voyeurism of discovery attempts to overcome.

Ethnography's project is a doubly impossible knowledge: the interior knowledge of the other, and specific, interpretive understanding through general theoretical knowledge. In *Remembrance* this aporia takes the shape of the conflict between distant and close-up views.

The consequences of this incident are extreme. Established in a voyeuristic position, the two men are able to construct *together* a knowledge sufficient to lock the ethnographic object up. The scene generates *The Prisoner*, the long novel in which Albertine is effectively held captive by Marcel's obsessive jealousy, generated by the failure-to-know. It matters that the failure is the product of the homosocial collaboration between the two men who constitute the women as others. And whereas the two later scenes of voyeurism have male homosexuality as their object, the two earlier ones continue their effect, like a "slow poison," as Marcel says it, to determine the failure-to-know, the *manque-à-savoir*, which results from visual aporia.

The Narration of Relation

What can we learn from Proust about the familial gaze? Flipping through my family albums after reading Proust with photography, I yearned to understand my mother. Among the photos that constructed the narrative of her life, figures 3.5 and 3.6 became paradigmatic for the sadness that so often pours out from under the poses of merry play or familial togetherness—rarely in the same picture. In figure 3.5, my mother as a child poses with her mother. The latter, beautiful as she is, repulses me. There is no relation between the adult and the child. However hard I try, I do not see anything of the ambivalences of the familial in the picture. All I can see is the one side of it: the authority that looms over the child like a shadow of a power that can break. The grandmother I never knew refuses to allow familial affection to be inscribed in the photo. Her little daughter is irremediably alone. No sustenance is offered. Here begins the sadness that marks the glamorous studio portrait, as in figure 3.3.

FIGURE 3.5 Photo of my mother in colonial "India"
with her mother, 1919.

FIGURE 3.6 Photo of my mother in colonial "India"
with her *babu*, 1917.

In figure 3.6 the little girl smiles. The face of the nanny, called *babu* by the Malay-speaking child, is traversed by an incipient smile. She is beautiful, too, and beautifully dressed in ornate indigenous dress. Thanks to the smaller child, the picture comes closer to a snapshot than the other one. The child's face is lively, caught in play, her foot blurred by movement, her busy body turned in profile whereas her face seems drawn to the camera behind which the photographer hides under a black cloth. The woman holds her, safely protected from falling off the chair.

But although the child seems better off with the hired substitute mother, her nanny, the woman is no mother. As the space between the child's and the woman's body indicates, the embrace is a gesture of expertise, not of love; not of "family" but of subordination, a woman doing her job, and doing it well. Her smile does not burst open as, one imagines, it would within her own family, after work; it is one of resignation, not pleasure. Her body is stiff, as her knees and feet suggest. Most poignant is the other arm, free of the child but not of servitude and

estrangement. The curve of the arm describes tension. The hand, a fist clutching the chair's arm, demonstrates more than the unfamiliarity with the photo session. It denotes unfamiliality, unbelonging, unrelatedness to the mother-child dynamic. Counterpoint to the merry child interrupted in play, the ornately dressed "Indian"[26] woman is estranged from the gaze browsing through the family album, searching the past for a mother in the present. Although the scene is set in her country and culture, she sits there as irredeemably other, in a chair that, carved by her tradition, belongs to the masters, with a child she is kind to, but whom she can treat only as one who will be taken away at the masters' volition. For me, these two pictures embody the familial as Proust has represented it: not as a domain but as an edge, a threshold, and a stormy sky of ambivalence.

The photographic passages of *Remembrance* have taught me about photography. They uniquely represent neither the subject nor the object of the gaze, but the process that produces the relation between the two, a process that is dynamic and changing—hence, narrative is needed—as well as conducive to a resulting knowledge/pleasure best described as *matching* (although the French word *collage* suits even better). The paradigm set up by the first two scenes links visuality and lesbianism together as a model for the homosexual scenes.

It is now possible to understand the connection between visual narration and lesbian desire that I have been hinting at throughout this analysis. Much more elaborate in its preparatory stages than the previous scenes of voyeurism, this last one definitely questions the subject of the gaze: his attempt to "cover" the object will be virtually successful here, so that the act of looking, taking the inhabitants of the closet out in the open, will lock the looker himself in. The rubbing flesh of the lesbian scene at the casino, where Albertine and Andrée dance together in a closeness that feeds Marcel's jealousy while sharpening his desire, remains the model that cannot be emulated, for as much as he regrets it, Marcel is not "really" a lesbian. But the final scene of voyeurism comes as close as he will ever manage to come.

The nature of the gaze involved, and the function of the serial snapshot to represent that gaze, deserves closer attention in this respect. I contend that the novel's most basic exploration is this erotico-epistemological experiment: the serial snapshot, producing a contact sheet that allows the inside of the closet to become a knowable spectacle conveyed by a closeted gaze, accessible only to whoever is able and willing to handle such knowledge. In the tradition of the metaphor of the camera obscura—instrument, after all, of inverted vision, of ideological distortion, and of exteriorization[27]—the closet occupies the same paradoxical position of allowing vision without having anything "inside" to show. This image of the closet as darkroom suits the text perfectly: behind the surface

of photographic light-writing there is neither depth, as Albertine's case demonstrates, nor inside, as Robert's does.

But with Albertine and Robert at the center of desire in *Remembrance,* how can I claim that the desire this novel puts forward is lesbian rather than queer? This question needs to be addressed by connecting the motions of desire to the "platitude" of the imagery. The flattened breasts of the two dancing lesbians echo the numerous passages where Marcel evokes the ultimate pleasure of lovemaking with Albertine in terms of lying against her, skin on skin. Nowhere in this long and love-obsessed text is penetration mentioned.

No passage provides a clearer insight in the fundamental literary, epistemological, and libidinal lesbianism of this novel, as that where, much earlier on in the novel, Marcel is about to kiss Albertine for the first time. He reflects on the drawbacks of the human organs for sensual pleasure. The description of that kiss constitutes a showpiece of modernist writing, as the subject's itinerary to the object, Albertine's cheek, is the occasion for a multiplied series of sense perceptions. But the reflection that precedes it is a showpiece for the work's ideals in the domains it addresses. In it, the narrator discusses the impossible ideal of "knowledge through the lips" ("une connaissance par les lèvres"). Let me therefore wind up by quoting that strange passage:

> I believed that there was such a thing as knowledge acquired by the lips; . . . man, a creature obviously less rudimentary than the sea-urchin or even the whale, nevertheless lacks a certain number of essential organs, and notably possesses none that will serve for kissing. For this absent organ he substitutes his lips, and thereby arrives perhaps at a slightly more satisfying result than if he were reduced to caressing the beloved with a horny tusk. But a pair of lips, designed to convey to the palate the taste of whatever whets their appetite, must be content, without understanding their mistake or admitting their disappointment, with roaming over the surface and with coming to a halt at the barrier of the impenetrable but irresistible cheek. (II, 377–78)

It is not surprising that the ultimate pleasure is epistemological in nature. The self-irony in the absurd, farcical comparison with a sea-urchin and the whale hardly conceals the serious investment: the two animal species he discards here each stand for one of the two realms of vision, the small and the big, the close-up and the distant views, which obstruct the narrator's visual epistemology all along because of the irreducible gap between them. The "horny tusk" combines the hardness of the urchin's thorns with the greatness of the whale. But the tusk resembles most of all that instrument of penetration that men use for their incom-

plete and disappointing pleasure that pushes them to seek fulfillment in other forms—in flat, rubbing flesh. The tusk represents those aspects of that instrument that are totally negative in terms of the narrator's quest: hard, insensitive, blind, big, and hurting. If only the skin would not be a barrier, the "roaming" kiss could do.

There are not eyes that can see in close-up beyond the skin. But the interior pleasure that Doctor Cottard "sees" within the bodies of the two dancing girls, brought about by their flattened breasts, constitutes the perfect image of the ideal the narrator pursues all along. When, in the final scene of voyeurism, Charlus tries to overcome the drawbacks of the "tusk" by being flattened by beatings, the skin is no longer a barrier. But the only way to understand this bizarre masochism beyond the vulgarity of the event in the plot, and to link it to the larger and more radical pursuit of this long novel, is to see it as the closest emulation to those two pairs of breasts. The superficiality of the snapshot, then, is the unexpected representation beyond the confines of the familial, of a homosexual practice seen by an anxious outsider whose keenest desire is in-sight.

Notes

I thank the members of my family for their collaboration in providing the photographs included in this essay and allowing me to expose (on) them.

Some of the ideas in this essay were published under the title "Bird Watching: Visuality and Lesbian Desire in Marcel Proust's *À la recherche du temps perdu,*" *Thamyris* 2, no. 1 (1995): 45–66. Some (other) of the ideas are developed in my book on the subject, Mieke Bal, *The Mottled Screen: Reading Proust Visually,* translated by Anna-Louise Milne (Stanford, CA: Stanford University Press, 1997). This version was originally published in *The Familial Gaze,* edited by Marianne Hirsch (Hanover, NH: University Press of New England, 1999), 223–47.

1. My approach is best understood as comparable—although not identical—to Van Alphen's analysis of *Nightwood* as a "poetics" for the paintings of Francis Bacon (1992, 119–42).

2. See Rivers (1980) for a typical account.

3. My main interlocutor, here, is Silverman, especially her *Threshold of the Visible World* (1996). I consider her the most Lacanian *and* the most feminist of the Lacanian feminists I know. See my review of her most recent book (Bal 1997a).

4. Bryson (2001) usefully examines the historical implications of the view I am putting forward here.

5. Butler develops this idea in depth in *Gender Trouble* (1990) and effectively responds to misunderstandings later in *Bodies That Matter* (1993), especially in the introduction.

6. For this aspect I consider myself in line with Spivak (1987, 1993).

7. The term "focalizer" refers to the subject of vision, also called "point of view," within the narrative. For all narratological concepts, see my *Narratology* (1997c).

8. These effects are analyzed in detail in my book *The Mottled Screen* (1997b).

9. See Bryson (1989) specifically the picture on the book's cover. For the gender aspects of this domesticity and its relation to class and age, see Salomon's fine analysis of seventeenth-century prints (1996).

10. McHale (1987).

11. A similar approach to lesbian desire as a principle of figuration, albeit a different one, is developed by Van Alphen (1990) for Djuna Barnes's *Nightwood*. For a shortened version of this analysis in English, see Van Alphen (1992, 119–42).

12. Proust (1981).

13. Derrida, "Différance," most accessible in *Margins of Philosophy* (1982). For a feminist critique of the concept of dissemination, see Bal (1991, 19–23; 1994).

14. See Jay's seminal account of iconophobia in contemporary thought (1993). Also see Bryson (1988).

15. Adams (1995).

16. Thus, the earlier decision to "live" his novel with her is here coming to a symmetrical closure when she is killed off "in reality" but resurrected in a posthumously received letter, and later in a misread telegram. This is one argument why it is necessary to interpret Proust's way as, at least, proto-postmodern. Either that, or he qualifies as a misogynistic, sadistic monster, a view that few of his readers will want to endorse, although some of his fanatically realist readers do. See, for example, Georgin (1991).

17. A different but still compatible view of lesbianism as a model for looking is Fuss (1992).

18. Bal (1997b, 214–37).

19. See the chapter on characterization in Bal (1997c, 79–92); also see Rimmon-Kenan (1981).

20. Barthes (1981, 27, 49).

21. These two forms of identification have been extensively theorized by Silverman (1992, 1996).

22. This is an allusion to Krauss's seminal study on the subject, *Le photographique* (1990).

23. The passage begins with an allusion to the masturbation scene in the "cabinet sentant l'iris":

> appealing to it as to the sole confidant of my earliest desires when, at the top of our house in Combray, in the little room that smelt of orris-root, I could see nothing but its tower framed in the half-open window as, with the heroic misgivings of a traveller setting out on a voyage of exploration or of a desperate wretch hesitating on the verge of self-destruction, faint with emotion, I explored, across the bounds of my own experience, an untrodden path which for all I knew was deadly—until the moment when a natural trail like that of a snail smeared the leaves of the flowering currant that drooped around me. (I, 172)

The French is more precise in its allusions to the masturbation fantasy and its connection to writing ("trace de colimaçon"; I, 158).

24. The translation is here, as in many other places, censoring away the explicit sexuality. The French has "Quand même on nous verrait, ce n'en est que meilleur," meaning "it [the lovemaking] would only get better because of it."

25. I have modified the translation here, which is decisively censoring: "Elles sont au comble de la jouissance" can only refer to an actual orgasm, whereas the translation "they are . . . keenly aroused" is clearly minimalizing the sexuality while making the narrative more realistic than the text warrants.

26. Before the liberation of Indonesia from Holland in an extremely bloody war, the Dutch called the country "Indië" and the people "Indiërs," a terminology indistinguishable from the one referring to India and its inhabitants. Future Indonesia was to the Dutch what India was to the British. And the Orient, in the Dutch imagination, was just the Orient, remote and mysterious, as well as ready for the taking.

27. See Mitchell (1985), especially the last chapter; and, for the aspect of exteriorization, see Alpers (1985).

References

Adams, Parveen. 1995. *The Emptiness of the Image.* London: Routledge.

Alpers, Svetlana. 1985. *The Art of Describing: Dutch Art in the Seventeenth Century.* Chicago: University of Chicago Press.

Alphen, Ernst van. 1990. *Over de verwoording van verwording. Zellfverlies in "Nightwood" van Djuna Barnes.* Amsterdam: Perdu.

———. 1992. *Francis Bacon and the Loss of Self.* Cambridge, MA: Harvard University Press.

Bal, Mieke. 1991. *Reading "Rembrandt": Beyond the Word-Image Opposition.* Cambridge: Cambridge University Press.

———. 1994. "Light in Painting: Dis-seminating Art History." In *Deconstruction and the Visual Arts: Art, Media, Architecture,* edited by Peter Brunette and David Wills, 49–64. New York: Cambridge University Press.

———. 1995. "Bird Watching: Visuality and Lesbian Desire in Marcel Proust's *À la recherche du temps perdu.*" *Thamyris* 2 (1): 45–66.

———. 1997a. "Looking at Love: An Ethics of Vision." *Diacritics* 27 (1): 59–72.

———. 1997b. *The Mottled Screen: Reading Proust Visually.* Translated by Anna-Louise Milne. Stanford, CA: Stanford University Press.

———. 1997c. *Narratology: Introduction to the Theory of Narrative.* 2nd rev. ed. Toronto: University of Toronto Press.

Barthes, Roland. 1981. *Camera Lucida: Reflections on Photography.* Translated by Richard Howard. New York: Hill and Wang.

Bryson, Norman. 1988. "The Gaze in the Expanded Field." In *Vision and Visuality,* edited by Hal Foster, 87–114. Seattle: Bay Press.

———. 1989. *Looking at the Overlooked: Four Essays on Still-Life.* Cambridge, MA: Harvard University Press.

———. 2001. "Introduction: Looking and Intersubjectivity." In *Looking In: The Art of Viewing,* edited by Norman Bryson and Mieke Bal, 1–39. New York: Amsterdam Art International.

Butler, Judith. 1990. *Gender Trouble: Feminism and the Subversion of Identity.* New York: Routledge.

——— 1993. *Bodies That Matter: On the Discursive Limits of "Sex."* New York: Routledge.

Derrida, Jacques. 1982. "Différance." In *Margins of Philosophy,* 1–28. Chicago: University of Chicago Press.

Fuss, Diana. 1992. "Fashion and the Homospectatorial Look." *Critical Inquiry* 18 (Summer): 713–37.

Georgin, Rosine. 1991. *Contre Proust.* Paris: Cistre/Essais.

Hirsch, Marianne, ed. 1999. *The Familial Gaze.* Hanover, NH: University Press of New England.

Jay, Martin. 1993. *Downcast Eyes: The Denigration of Vision in Twentieth-Century French Thought.* Cambridge, MA: Harvard University Press.

Krauss, Rosalind. 1990. *Le photographique: Pour une théorie des écarts.* Paris: Macula.

McHale, Brian. 1987. *Postmodernist Fiction.* London: Methuen.

Mitchell, W. J. T. 1985. *Iconology: Image, Text, Ideology.* Chicago: University of Chicago Press.

Proust, Marcel. 1981 (1913–27). *Remembrance of Things Past.* Translated by C. K. Scott-Moncrieff and Terence Kilmartin. London: Penguin Books.

Rimmon-Kenan, Shlomith. 1981. *Narrative Fiction: Contemporary Poetics.* London: Methuen.

Rivers, Julius Edwin. 1980. *Proust and the Art of Love: The Aesthetics of Sexuality in the Life, Times, and Art of Marcel Proust.* New York: Columbia University Press.

Salomon, Nanette. 1996. "Domesticating the Peasant Father: The Confluent Ideologies of Gender, Class, and Age in the Prints of Adriaen van Ostade." In *Images of Women in Seventeenth-Century Dutch Art: Domesticity and the Representation of the Peasant,* edited by Patricia Phagan, 41–70. Athens: Georgia Museum of Art.

Silverman, Kaja. 1992. *Male Subjectivity at the Margin.* New York: Routledge.

———. 1996. *The Threshold of the Visible World.* New York: Routledge.

Spivak, Gayatri Chakravorty. 1987. *In Other Worlds: Essays in Cultural Politics.* New York: Methuen.

———. 1993. *Outside in the Teaching Machine.* New York: Routledge.

4. Over-Writing as Un-Writing: Descriptions, World-Making, and Novelistic Time

Introduction

Thoughts about particular states, objects, and individuals expressed in the subject-predicate form: such a definition makes it immediately obvious that description is a major activity of all writers, among them those storytellers who produce the bulk of Western literature, in the form that we call—more on the basis of intuition than of clear definitions—"the novel."[1] The novel is a form that represents actions and events ("doings") caused and undergone by characters ("beings"), yet both theory and criticism of Western literature have traditionally treated description as, at best, a stepchild, albeit a fascinating one. Rhetorical and critical treatises have tended to be judgmental, as have the older discussions of literature. Even modern theoretical texts show traces of the old positions, however. Whereas individual authors and their novels are often praised for their concrete, visionary, or visual imagination, narrative theory has traditionally cast description in the role of "boundary of narrative," a Derridean supplement both indispensable to, yet lying outside of, narrative "proper."[2]

As it tends to go in such cases, discourse about description is either critical or defensive. Description is accused of interrupting the flow of narrative, of stopping time in its tracks. In the first section of this article, "Robin," I will begin with a short framing of these debates, by presenting description as generative of narrativity. In the remainder of my contribution, I will avoid altogether these attempts to evaluate description as a unit, discourse, or style in and of itself. Instead, I will take description as a "natural" discursive form in narrative and, hence, in the novel, because that form is as much a part of novels as are the representations of actions, which appear to be more "properly" narrative. Rather than endorsing these reasons or explaining them away, I will use the traditional grounds for rejection to reverse the perspective and to derive from them a description-bound narratology of the novel.

In fact, the reason alleged for narrative's negatively judged arresting of time is based not on discourse but on its referents. This judgment, therefore, can be called a referential fallacy. Moreover, since nothing exists outside of time, the allegation is wrong, even if we accept the referential argument not as a fallacy but as valid. The three times—of discourse, of reading, of the novel's represented world—are all unstoppable. By decelerating the first two, however, one foregrounds the artificiality of the latter. This is description's "metadeictic" function. The resulting temporal discrepancy is characteristic of the novel in general. Hence, I will advance the argument that, far from being an alien element, description is at the core of this genre.

To make such a view of description plausible, in the second section of this article, "Albertine," I will reverse some of the oft-alleged reasons for casting suspicion on description. Here, the heterogeneity of descriptive discourse in relation to smooth narrative will serve to characterize novelistic narrative. This second section is named after the character whose overwhelming importance to the novel in which she figures goes hand in hand with the refusal to make her a "real," that is, "dense," character: Proust's narrator's object of love, that is, of jealousy. Instead of a flesh-and-blood individual, I will argue, Albertine embodies metanarrative reflection on the status of characters in novels, as "descriptively generated pictures." This double-edged descriptive discourse suggests that Proust's novel is as close to postmodernism's metanarrative probings as it is to modernism's subjectivist explorations. As such, as "proto-postmodernist," it reframes historical precedents. Proust's descriptions demonstrate what novels are and do and, as such, have an "apodeictic" function.

In the third section, "Lucretia," I will go back in the history of descriptive discourse to the alleged roots of description—to attempts to isolate description and probe its autonomy—in order to look at the time-honored tradition of considering "ekphrasis" the quintessential descriptive extension within the novel; rather like separate text pieces or *pièces montées* (French for tiered wedding cakes, such as Flaubert described and Proust recycled). The tension between the description of objects or individuals, the continuous elements of a fabula, and the narration of actions or events—the fabula's dynamic elements—will also be seen as characterizing relatively autonomous descriptive pieces. Moreover, ekphrasis itself is as narrative as it is descriptive. Thus, I will argue that, far from stopping the flow of time, description slows it down, but only to better explore its fundamental heterogeneity. The "epideictic" quality of description complements its ekphrastic inner structure.

From that point on, I will develop a view of narrative as generated by a descriptive motor, rather than the other way around. I will start doing this in the fourth section, "Nana," named after Zola's most famous female character, whose beauty is as much a motor of the narrative as is her horribly destroyed face when

she is lying on her deathbed, which cannot but close the novel. I propose that by reading from description to description, the reader complies with, falls for, and, perhaps incidentally, resists the novel's appeal to construct the imaginary but coherent-enough world in which the recounted events can happen. In most cases—in the fiction we tend to call "realist" simply because we get carried along by it—this kind of reading naturalizes descriptions. In rare but significant cases, the descriptions' mismatch with the world they help to shape teases readers into an awareness of their inability to read. This may happen in postmodern literature, but it also happens in novels that are, for completely different reasons, a more or less "smooth read."

In the final section, "Emma," the argument for a descriptive narratology or, perhaps, a "descriptology," will be completed on the basis of the "deictic" function of descriptive discourse. This function encompasses the four functions already presented. Through an intra-novelistic form of deixis, description's intricate network of references, which only work within the claustrophobic universe of the novel, ties other narrative units into the descriptive units, so that the latter come to stand out as the "cores," foci, or centralizing sites of fictional worlds, rather than as the "sores" of the narrative pestilence that both traditional narrative theory and rhetoric have made of them. The final part of this essay, then, performs what it states, binding the five functions of description into a descriptology that defines the novel as everything that grows and pullulates out of the paradoxical meaning of the "de-" of description: thus, "writing about," unwrites.

Cervantes is, in many ways, both the initiator of the novel and one of its fiercest detractors, or perhaps deconstructors. He staged both its prosecution and its defense in a single act of refusal to describe, when, for example, in chapter 18 of the second part of *Don Quixote,* he represents not the object of description but description itself, thus doubling up the discursivity of that fictionalizing mode. It matters that it is this novel rather than nineteenth-century ones that displays an alertness to the generative power of description, while at the same time making any division between "real" narrative and descriptive stand still; decoration or distraction, both impossible and senseless.

Robin (the frame)

On the second landing of the hotel . . . a door was standing open, exposing a red carpeted floor, and at the further end two narrow windows overlooked the square.

On a bed, surrounded by a confusion of potted plants, exotic palms and cut

flowers, faintly oversung by the notes of unseen birds, which seemed to have been forgotten—left without the usual silencing cover, which, like cloaks on funeral urns, are cast over their cages at night by good housewives—half flung off the support of the cushions from which, in a moment of threatened consciousness she had turned her head, lay the young woman, heavy and disheveled. Her legs, in white flannel trousers, were spread as in a dance, the thick lacquered pumps looking too lively for the arrested step. Her hands, long and beautiful, lay on either side of her face.

The perfume that her body exhaled was of the quality of that earth-flesh, fungi, which smells of captured dampness and yet is so dry, overcast with the odor of oil and amber, which is an inner malady of the sea, making her seem as if she had invaded a sleep incautious and entire. Her flesh was the texture of plant life, and beneath it one sensed a frame, broad, porous and sleepworn, as if sleep were a decay fishing her beneath the visible surface. About her head there was an effulgence as of phosphorus glowing about the circumference of a body of water—as if her life lay through her in ungainly luminous deteriorations—the troubling structure of the born somnambule, who lives in two worlds—meet of child and desperado.

Like a painting by the *douanier* Rousseau, she seemed to lie in a jungle trapped in a drawing room (in the apprehension of which the walls have made their escape), thrown in among the carnivorous flowers as their ration; the set, the property of an unseen *dompteur,* half lord, half promoter, over which one expects to hear the strains of an orchestra of wood-wind render a serenade which will popularize the wilderness. (Barnes 1936, 56)

Felix Volkbein meets Robin Vote. An aristocrat in search of a wife meets the most fugitive human being, and the story of *Nightwood* can begin. Form-wise, this piece presents itself as a classical novelistic description. It comprises an introductory frame, a clear subject-object split, and a detailing of both the perception of the object and the elements that constitute it. It also turns away from description, however, through its deployment of metaphor, its decentering evocation of endless other things—sea, forest, mushrooms, painting, circus ("unseen *dompteur*," a key ambience for the man Felix, framer of this description), music—and through its narrativity. The reader is warned: "the thick lacquered pumps looking too lively for the arrested step" counter rational knowledge.

This passage ruptures linearity through its anticipatory foresight, turning from the metaphor-announcing "as if" to the referent, which escapes the focalizer and will continue to escape him forever: "the born somnambule," who cannot be a wife to him nor a lover to anyone, "meet of child and desperado." Through a rhetoric ranging from expansion to ekphrasis, disorder to distraction,

and deceleration to intensification of the moment, this description contains, in a nutshell, the history, the theory, and the criticism of description.

"On the second landing," "On a bed": these phrases literalize the realistic framing that is so characteristic of the modernist novel's predecessors. The former narrativizes the focalizer, Felix, whose vision of Robin is the narrative referent of the description. He goes up, then looks down. The focalization establishes the link of perception between the subject and the object. Ascending in body, the focalizer descends in vision. Presenting the future object of obsessive pursuit—and the subject of obsessive withdrawal—as lying on a bed, the passage presents itself not only as a view from above but also as a traditional painting. The frame comprises the paraphernalia of the late nineteenth-century artist's studio—"potted plants, exotic palms and cut flowers"—and the subliminal orientalism inherent in it. The fake fairy atmosphere of that site of representation is further expanded by the clause "faintly oversung by the notes of unseen birds," which thickens the subjectivism with senses other than vision—with sound, for example (and smell will soon be added)—while at the same time enhancing the limited focalization. Recalling, also, Huysmans's bizarrely perverse novel *À rebours*, the description's polyphony inscribes episodes of cultural and literary history within a single frame.

The intensification of the focalizer's perception together with the narrative expansion of the moment prepares the reader for a heightened sense of suspense, giving anticipatory importance to what will come. And here she is, the image of an obelisk, a Matisse painting: "half flung off the support of the cushions from which, in a moment of threatened consciousness she had turned her head, *lay the young woman,* heavy and disheveled." Half flung: as a spectacle of arrested intimate movement, unsuitable for the public gaze, so that the man looking down on her is caught up in an inevitably voyeuristic position. Passive, with the door open, the young woman "asks for it." And although the two people involved in this description are soon to marry and procreate, it seems predictable that in terms of *relationship,* their case is hopeless.

This description of Robin Vote, the central character of Djuna Barnes's *Nightwood,* foregrounds quite precisely what it is that has made description such a bone of contention, so subject to paradox, such an object of contempt. It also demonstrates subjectivity and chance as the two critical responses to realism, whose traps these two states of mind constitute. Moreover, anticipating later sections of the present essay, it recalls the dual status of ekphrasis as both interruptive and constitutive of narrativity. I allege this passage as a *mise en abyme* of the argument I wish to put forward. This convoluted and self-undermining love story begins when one of Robin's prospective lovers, Felix, chances upon her in a hotel room, where he went because someone told him to. This description,

therefore, is a beginning, but it is also a prediction of an end. Thus it comprises the time of the novel, including the body of its fabula, which is none other than the repetition of the failure to relate, as is staged here.

Is the comparison "like a painting by the *douanier* Rousseau" a decorative, expansive, or specifying metaphor that clarifies the vision so it can become visible for the reading viewers? Earlier, the woman was already described as "earth-flesh, fungi, which smells of captured dampness," so that the painted jungles follow, logically and aesthetically, rather than flesh out, what is onstage there. If this description is ekphrastic, does the ekphrasis produce the woman, or the woman the ekphrasis? While the reader goes along with Felix, adopting his perceptual apparatus, including sight, sound, and smell, our narrative goodwill is put to the test at the moment when the focalizer loses his power in favor of the awakening text, departing from the sleeping beauty to turn this focalizer into a generalized "one." The description neither presents nor explains the character for the narrative. Instead, it produces the former *as the latter,* seducing the realistic reader into getting lost in the modernist jungle. This is why modernist novels appear "difficult."

Much easier is the well-known strategy used, for example, by Thomas Hardy in his 1891 novel, *Tess of the d'Urbervilles.* There the heroine's moods and states correspond, almost point by point, with the brightness or darkness of the environment in which the character evolves. Colors appear to "stand for" states of mind that easily translate into metaphorical colors and shades. Almost inevitably, the convergence of the visible features of the character and her environment produces a prose in which description mingles with the narration of events. Hardy's novel seems to get away with a kind of descriptive exuberance that rhetoricians and, later, theorists would somehow find problematic—in other words, worth attacking or defending. I think it is because of the habit of scholars to reiterate the same examples from a limited corpus that the gap between critical writings on the novel and narrative theory is wider than is reasonable.[3]

To the contemporary literary sensibility, the gap between a critique that lauds description and a narrative theory that marginalizes it appears to come from the "experience" of reading versus the logic of structure.[4] I contend it is more plausible to understand it as historiographical. The history of the novel has privileged a certain kind of literature—say, to use an overextended term, "realist"—whereas narratology took its initial lead from folktales. To break through this divide, I draw extensively on modernist novels. Like Cervantes, these novels both deploy and denaturalize description. Whereas Cervantes' antihero is declared "mad" for seeing what is not there—for seeing an army in a cloud of dust produced by a herd of sheep—and Zola et al. boasted the referential existence of their described objects, modernism, with its dual philosophy of subjectivity and chance, is well placed to demonstrate an altogether different status for description.[5]

To start with the obvious: among the many reasons that have generated negative views of description, the one least mentioned in the rhetorical handbooks, which are so preoccupied with the issue, and most often alleged by readers is the one that says long, descriptive passages are "boring."[6] What does "boring" mean? To cite only one example of many: Shadi Bartsch begins her study of ancient Greek novels with the remark that they are considered unattractive because "the advance of the plot is frequently interrupted by discursions and descriptive passages that seem manifestly irrelevant to the 'real' business of the story" (1989, 3). In all its simplicity, this is a representative view. The boredom or, for Bartsch, the "strangeness" is due to both the lengthiness and the irrelevance to the fabula. The fabula—supposedly distinguishable from the descriptions that interrupt it—is the real stuff of narrative literature. The implied assumption is that readers read "for the plot," as Peter Brooks puts it, accepting a certain amount of delay as long as the relevance to the course of events flowing toward the ending remains convincing (1984). This is a reception-oriented readerly judgment that is overwhelmingly frequent and the target of much literary experimentation.

Theoretical studies, of which rhetorical handbooks are early versions, have attempted to explain this lack of enthusiasm for description. Even if this effort to explain has often been disguised as critical judgment—or, perhaps, the other way around—it is clear that more recent theoretical literature is at pains to counter this effort by attacking the prescriptive discourse of old. The result is theoretical literature that is defensive of description. The arguments for the prosecution are of an aesthetic, logical, representational, and ideological order. They hang together closely, roughly along the following lines. Aesthetically, the arbitrariness of the sequence of details mentioned in a description brings with it the danger of an unclassical profusion of wordiness. This issue is bound up with logic, because where randomness threatens, some logic will have to be invented to keep arbitrariness at bay. More often than not, that invented logic is derived from considerations of perceptibility. Descriptions consequently become "naturalized" as visions produced by a diegetic gaze. Thus, laws of representation come into play. The perceptions are ascribed to anthropomorphic characters, however, with faults and limitations, and this leads easily to ideological prejudice, simplification, and reduction.

The defense argues that these arguments are normative and, moreover, that they need not be so devastating. Proust's descriptions of Albertine provide an answer to all these judgments from both the negative and the positive perspectives. To anticipate that answer: the length of the failed attempt to describe Albertine is argumentative in itself. It demonstrates that boredom and length are unrelated. In *Nightwood,* as in Proust, the lengthy descriptions embody an expansion that drifts through the pages, flaunting the fact that the novel *is* such drift.[7] While reading

this novel, it is difficult to realize that descriptive discourse does, indeed, not have a "natural" *order*. This problem is couched mostly in aesthetic terms. In fact, as we shall see in Proust, it is partly aesthetic and partly (phenomeno)logical.

Theoretically, unbound by narrative sequentiality, the enumeration of the elements of the object in a description is fundamentally arbitrary. In contrast, the narration of events follows the chronology in which the events take place. If it does not, deviations are indicated by a narrative rhetoric of flashback or flashforward or, to use Genette's consistent if somewhat off-putting terminology, of analepsis, prolepsis, paralepsis (sidesteps), and the like. To remedy this problem, description tends to follow the order of the object as it is commonly perceived. One can often argue that the gaze describes or follows description, however, rather than being followed by it. This order is a complex rather than a simple one, in which the elements enumerated refer not to the described object but to description. The previously cited passage from *Nightwood* makes this complexity abundantly clear. The introductory frame represents the difficulty of keeping that frame within its own bounds. In this way, framing is put on the table. The passage posits itself as ostentatiously far from naturalizing the description through diegetic focalization. It is its "metadeictic" function to do so and thus "comment" on descriptive discourse. By binding, through internal deictic functions, each element to a larger whole—which is *not a woman* but a domain of sense perception, a painter's studio, a painting, an object that refuses to stay still, respectively—descriptive discourse comments on the "deicticity" within narrative as an altogether different kind of order.

This is quite unsettling for those accustomed to realistic narrative, in which, in the case of a person, for example, the description would move from head to foot and from the eyes to the rest of the face. This is the order from top to bottom, combined with the move from center to periphery. For landscapes, the order might be from foreground to background, vague to clear, left to right. Alternatively, the description could run through the different senses involved in the perception of the object. The famous opening of Balzac's *Le père Goriot* follows the long shot that zooms into a close-up, a move that, as it turns out, follows the character's steps. And as Eugène enters the rooming house, the sense of sight is complemented with the sense of smell. This ordered and neatly hierarchicized expansion is parodied in Barnes's novel, where smell intervenes too early and practically takes over.

The device of such (pseudo-)diegetic focalization is so naturalizing that its rhetorical efficacy is hard to undermine. For example, the first description of Yonville, with which the second part of *Madame Bovary* opens, follows the imagined itinerary of the stagecoach in which the Bovarys almost, but not quite, travel to their new home. Toward the end of the description, the discourse is "stitched"

to an anonymous "tourist," who follows the itinerary into town even when the couple has already stopped at a resting place. Yet no one notices this. Felix, ascending the stairs to reach the view of Robin that the reader gets to see as well, gets lost similarly but more radically in the jungle of perceptions and associations. The result is that the woman is being de-scribed, un-written.

If description means to write ("-scription") about ("de-")—whereby emphasis on the object is suspended—then it makes sense that the artificial ordering that stitches the description into the narration through the perceiving (focalizing) character could easily go unnoticed. Hence, according to the modernists, it is in need of denaturalizing commentary. By following the order of perception of the hypothetical object, description has a soothing, illusionistic effect that is possibly, but not inherently, realistic. After all, the object does not exist; it is written into existence by the description that purportedly "renders" it. However, if the object is thought to exist, in principle independently of a perceiving agent, then there is no inherent reason why the order of the description should follow any pattern at all. Yet to sustain that belief, a "natural" order is called for more strongly than ever, precisely because the arbitrariness must not start to irritate the reader. Robin's description turns the convention inside out: it begins with the proper frame, but only in order to produce waves of associations that take away that order and, with it, the object-status of the object.

The only reason descriptions tend to have a relatively "reasonable" order is because of their implied task of constructing coherence for the reader, the "stand-in" for the diegetic focalizer. This work necessitates an objectification of the described object with which even a lifeless object cannot comply, however. Robin did not wake up, but "her" text did. Her description, written in the objectifying "third person," disempowered the hidden "first person" of the focalizer, then ran off with its own associative chains: jungle, smell, and sound; painting, orientalist model, child, desperado.[8] As we shall see, like Barnes, Proust, writing "in the first person" and invested in examining every corner of subjectivity, did not endorse the traditional solution either. His descriptions stand in total opposition to Barnes's, however. While he does motivate description by stitching it to the perceiving "I," even almost obsessively, he still manages to keep coherence at bay, allowing it only to hover, experimentally, over the tension between time-bound, incidental, collective, and singular appearances. Thus, he, too, in a different way and with a different vision than Barnes's, replies both to the traditional critique of descriptive disorderliness and to the realistically motivated defenses of it. As his novelistic practice "argues," this is where modernist hypersubjectivism *necessarily,* rather than accidentally, tips over into the ontological querying that characterizes postmodernism.[9]

The neat stitching together of the main character in Hardy's *Tess*—of what she

feels, thinks, or does, on the one hand, of the time of day, its light, and the colors it produces as well as the visual "takes" these allow, on the other hand—seems a watershed away from Barnes's constant questioning of such seamless continuities between perception and object, which the rhetoric that we call "description" produces. One can look forward and backward at this point. In both Hardy and Barnes there is only partial continuity. In his novels *La jalousie* and *Le voyeur,* Alain Robbe-Grillet (an "objectivist" representative of that early postmodern movement that the French called *nouveau roman*) followed the modernist precept of the juxtaposition of sense perceptions—or snapshots—as generative of narrative, pushing the device to the extreme. In *Le voyeur,* for example, he clearly followed Proust's lead, where the murder around which the implied plot evolves, and the only event to constitute its fabula, is never narrated. Instead, the white page in the middle of the book signifies it iconically. The novel revolves around the circularity, the maelstrom of self-undermining logic that results from the abdication of illusionistic naturalizations.

Something similar and much easier to quote occurs in the frequently cited passage from Robbe-Grillet's book of short "stories" significantly (and Proustlike) entitled *Instantanées.* Here, the author demonstrates the arbitrariness of description. Robbe-Grillet's target is only a small fragment of Barnes's and Proust's complex questioning. His experiment probes the false melding of descriptive discourse to a hypothetical object. In the following short extract, called "Le mannequin," he describes a coffeepot whose handle is the occasion for an exercise in circularity:

> L'anse a, si l'on veut, la forme d'une oreille, ou plutôt de l'ourlet extérieur d'une oreille; mais ce serait une oreille mal faite, trop arrondie et sans lobe, qui aurait ainsi la forme d'une "anse de pot."[10]
>
> [The handle has, if you like, the shape of an ear or rather the outer edge of an ear; but that would be an ill-shaped ear, too round and without an earlobe, an ear that would thus have the shape of the "handle of a pot."]

Jean-Michel Adam advances this passage to sustain Robbe-Grillet's defense against accusations of antihumanist objectivism (1993, 60). He alleges that the phrase "si l'on veut" (if you wish) is a trace of the describing subject as "human" and, one might add, rhetorical. The human agent of which it is a trace is the projected reader (which turns the trace into a Derridean one) rather than the descriptor. The reader, I contend, is addressed by the interjection in the second person, even if this is disguised by the impersonal form ("si l'on veut" means "si vous voulez"). This address inscribes the reader as the focalizer's beneficiary, the

"focalizee." In the description of Robin, this deictic of address can be seen in the impersonal "one" that binds the focalizer and the reader into ambiguity. Making the reader's perception converge with the (diegetic) focalizer (to preserve the humanistic flavor of Robbe-Grillet's prose—a defense the author apparently supported) seems to be a return to a pre-Proustian descriptive facility, closer to Hardy than to the modernist fiction on which the *nouveau roman* experiment rests.

This figure, the addressee of the descriptive display, is delineated even more clearly in the adjustment of the reality claim of the description, being further fleshed out by "plutôt," the conditional verb form, the evaluative "trop," and the insistence on outward appearance in "forme." These textual markers of visual address make the reader complicitous with the make-believe that underlies any description in fiction. In other words, instead of writing *about* (de-) an object, description *un*-writes (de-) the handle of the pot into a handle that looks like a bad ear but is rather *like*—not *being* but only *appearing* to be like—the handle of a coffeepot. From "about" to "un," the preposition *de* is turned against itself as the rhetoric bites itself in the tail. Similarly, Barnes's figure, presented as a painting with shoes too mobile for it, ends up looking "like a painting."

In a far more ambitious experiment also based on the arbitrariness of the order of description when the object can no longer sustain it, Georges Perec's *La vie mode d'emploi* describes a building in seven hundred pages. The energy of the text is invested in experimenting with alternative orderings (mathematical, according to a checkerboard, all kinds of configurations being generated by some logic or other) invented after the demise of all "natural" order. This book may be important as a literary experiment, but it is not a particularly gripping read; not in the way Proust's much longer novel is to this day. Yet it usefully goes to show that order, or a lack of it, is not the aesthetic issue, for Perec's book, along with Robbe-Grillet's, is meticulously ordered. More relevantly, such experimental texts sharpen our sense of the aesthetic by *eliminating* such facile criteria.

What such experiments afford, then, is a triple realization: they demonstrate that description is a form of *un*-writing the reality claim of fiction; they show the price that has to be paid as a result of the transgression of the limit defended by the ancient rhetorical treatises, the limit where fiction loses its narrativity; and they lay bare the way that descriptive discourse inevitably turns into a discourse *on* description—a sample of poetics. This poetics of description through description is not a privilege of the period whose ambition was to overcome modernism. Instead, the triple realization folds back onto the past, on which it sheds a postmodern light. Thus, as Adam (1993, 5) points out, the description of the door to the Temple of Apollo in Virgil's *Aeneid* (VI, 13–39) turns out to similarly collapse the description of an ideal place into an exercise of ideal description.[11]

This last remark raises issues of historiography that this essay cannot undertake to address but that are at the heart of the history of the novel. I contend two incompatible things simultaneously: Robbe-Grillet and Perec *continue* that strand of Proust's more complex questioning of description that led the way out of modernism's remnant belief in the representability of reality, if only in terms of subjectivity, and they continue Barnes's questioning of the tenability of the diegetical framing of description. This continuity represents a historical limitation to the validity of the theoretical skepticism proposed by the two postmodernist authors. At the same time, I claim that Virgil already did this. This invocation of an antecedent from antiquity would appear to make the claim ahistorical and thus confirm theory's alleged—and criticized—ahistoricism. The reason this allegation is wrong is the one I have theorized elsewhere as a preposterous historical position (1999). To claim that a phenomenon that becomes apparent in modern or contemporary literature can retrospectively be noticed in older literature is not to claim universal validity for that phenomenon. On the contrary, the modern case makes visible something that could not have been known before.

From the vantage point of the present—a historical moment that cannot be ignored in any truly historical analysis—it becomes possible, thanks to the continuity between Barnes, Proust, and later writers, to perceive something that is essential to the nature of description in narrative. What we perceive is the standard, forward-moving line of "historical development." We also perceive the impoverishment that accompanies the "specialization" of Robbe-Grillet and Perec with regard to the two modernists' more tentative, and therefore richer and more complex, search. This specialization, then, facilitates a retrospective look at the past, in which the outcome of this so-called development already took place. What makes this double-edged historical perspective preposterous is the need for later texts to understand earlier ones, which consequently emerge as different from what they could ever have been before this later reflection took place.

This all-too-brief justification hopefully allows me to suggest, even more briefly, that the other complaints about description's lack of narrative power can be modified in a similar way. One concerns description's failing definitional precision, the other its tendency to ideological platitude. In the seventeenth century, description's logical shortcomings when it was viewed as "bad" definition were signaled, for example, by the grammarians of Port-Royal. Descriptions can only approximate definitions because they consist of particular, not general, enumerating elements and have accidental, not essential features. The logical argument is only valid, however, on the presumption that the object *exists*—and that it presents itself as a token of a type. This point anticipates Proust's difficulty in distinguishing, of which it is a more abstract version. For Proust, the difficulty is shown to be bound up with the spatial continuum within which Albertine comes for-

ward. Preposterously translated back into Arnauld and Nicole's indictment, the scene I will dwell on both generalizes the grammarians' point—casting the particularity in the coordinates of the fictional universe instead of in its objects only—and specifies it, through the denaturalization of that universe as not pre-existing its description.

As I have suggested, if both the aesthetics of order and the logic of definition lead right into the problem of fictional representation, then a third complaint about description that Barnes's presentation of Robin tackles appears to derive its meaning from Hardyan description. This complaint is based on reverse perspective. Owing to the arbitrariness of its order, and to its vagueness compared to definition, description tends to reductionism. Thus, it allegedly limits the presentation of the object to the commonplace view of its traits. This is parodied and reversed in the orientalist cliché within which Robin cannot be captured. Clichés, this description stipulates, are only lures.

Description's alleged ideological reductionism can be seen as leading back from the order of representation to the more general semiotic issue of the Peircean "interpretant." This notion (to be seen in this context as an early American-behaviorist equivalent to the Lacanian notion of "chain of signifiers") points to several aspects of meaning production. Here is, yet again, Peirce's definition:

> A sign, or *representamen*, is something which stands to somebody for something in some respect or capacity. It addresses somebody, that is, creates in the mind of that person an equivalent sign, or perhaps a more developed sign. That sign which it creates I call the *interpretant* of the first sign. The sign stands for something, its *object*. It stands for that object, not in all respects, but in reference to a sort of idea, which I have sometimes called the *ground* of the representamen. (Peirce 1984; emphasis added)[12]

First, the notion of the interpretant (the new sign that emerges "in the mind of" the receiver when he or she is presented with a sign) foregrounds the input of the receiving subject of a sign, who turns it into a more specialized sign that he or she can deal with in the new context of reception. Second, it points to the temporal shift that is necessarily involved. Between the initial proposal of the sign and the reworking of it by the recipient in charge of attributing meaning to it, a temporal logic of sequentiality must be inferred. Both these aspects make the notion of the interpretant eminently suitable as a generalization of description. I would formulate it as follows: a description is to the object produced in its wake what the sign is to the interpretant that is its follow-up. This places, on the shoulders of the subject, the responsibility for the ideological reduction not of the description or the

sign but of the production of the object—the new, more specialized meaning. In both cases, the subject of reduction is the receiver.

This responsibility is inherent not in the novel but in representation and takes specific shape in narrative. The following example is taken from a genre that was almost the novel's counterpart in nineteenth-century America—the literary sketch. An under-illuminated genre much practiced by women, the sketch is relevant here for its primarily descriptive nature and for the incipient narrativity that its descriptive discourse produces. It is ideologically fraught with the reduction of social "others" to the spectacle of sentimentalized poverty called "picturesque." This ideological reductionism is accompanied by its distancing take on modern city life. This second reduction may be attributed to the visualization of description but, obviously, it also holds a nostalgic overtone in its dystopic representation of the present.

> Hurry, drive and bustle; coaches, wheelbarrows, carts and omnibuses, dogs and children, ladies and shop-girls, apprentices and masters, each one at tip-top speed. . . . Everybody looking out for number one, and caring little who jostled past, if their rights were not infringed. . . . The overtasked sempstress, in her shabby little bonnet, looked on hopelessly at the moving panorama.[13]

The first sentence here appears to give a picture of busy city life that any writer under the shock of modernity (for example, Benjamin) might have produced: its primary feature is the dynamic mixture of people and material phenomena evolving through time with *speed*. The second sentence inserts an explicit value judgment that qualifies that picture as dystopic. The third zooms in on a single individual. The woman, however, as this description prefigures (soon to be swept away by the crowd, thus leaving her aging father to be hit and left dying in the more straightforwardly narrative discourse) is presented as "poor" not only by qualifiers such as "shabby" but, more insidiously, by the feminizing word "little," and by the suggested inability to cope, signified by "overtasked" and "hopelessly." The latter word, derived from a verb that also implies temporal anticipation, generates the narrativity that produces the subsequent anecdote about the accident.

As this example confirms, any representation is shaped by the ideological vision that informs it. This is why it is important to be suspicious of the belief in the possibility of non- or zero-focalized description that is defended by narratologists such as Genette (1980; reiterated with passion in 1983). Description appears to stand out in this regard only because of its elastic extensibility, owing to the arbitrariness discussed above. Whether plots evolve around weak or wicked

women or whether descriptions present these characters as such makes no difference to the ideological reductionism involved, however. If anything, the descriptive passages are more overtly focalized, hence, subjectively limited, than the more easily naturalized stock plots to which Roland Barthes, among others, alerted us (1976). In any case, it is fitting that the reader, in the guise of "focalizee," produces a specific object or meaning that incorporates the assessment of the ideological makeup of the object. This is why the critical attention of the frame, as solicited by its unboundedness in Barnes, is so important.

Hence, the charge of ideological reductionism is obviously both true and wrongly attributed to this particular discourse. In the passage quoted above, for example, the ideological reductions to dystopic fear, picturesque poverty, and feminized incapacity, respectively, are presented to the reader, who thus "sees" the scene, in his or her function as the focalizee, in a particular sequence. Through each step of this sequence—each visual sign—the latter is activated to construe the spectacle that, without that work, simply does not exist. Both the visuality and provisionality implied in the genre's name advances these features as a way of putting the burden of the production of an ideologically more complex and specific interpretant in the reader's lap.

One particular variation of the reductionism charge deserves attention since it accompanies experiments conducted—in the wake of Proust—by Robbe-Grillet and Perec. Robbe-Grillet's critics have led him, in particular, to a certain defensiveness regarding the alleged dehumanizing effect in his work of the rigorous limiting of narrativity to the juxtaposition of descriptions. I have already mentioned that he answered this charge by defending the human subject "behind" the objectifying descriptions. For him, the *nouveau roman* is exclusively interested in man and his place in the world.[14] It seems disingenuous to try to produce novels with no interest in human subjects, for that would be to leave behind all standard conceptions of the genre itself. As J. Hillis Miller points out, personification is an indispensable element in narrative, and the novel has developed out of a fascination with this element in particular.[15] Rather than defending Robbe-Grillet's extreme experiments by claiming their humanistic bias, however, I would favor a defense of this experimental practice with reference to another feature of the novel as a genre. This, once again, leads us to Proust's Albertine.

Thus, in the next section, I will argue that, as in Barnes, Proust's descriptions result from a deep anxiety about the motor of the relationship between self and other. Whereas Barnes's description literally posits the focalizer as lost in the jungle, even in the act of framing, Proust's anxiety concerns the (im)possibility of *distinguishing* a love object, not from the surrounding physical world but from others. By questioning the distinctiveness of a visible other person or knowable

object, he also critically examines the humanistic presuppositions underlying naturalized description. Fiction, as a discourse, on subjects without prior existence, is eminently suitable, the passage from Proust suggests, to explore what happens if, instead of rushing to the defense of fiction's humanism, we experiment with what happens if we do not. If salvaging humanistic values is a mission of the novel—which I do not think it is—then Robbe-Grillet's flabbergasted description of a coffeepot is a response to Proust's confusion when faced with the irreducible otherness of his selected object and her subsequent unknowability. This response is reductive, however.

Confusion, in both Proust and Barnes, is foregrounded as evidence of canniness in modernism. Modernist writers, Banfield (2000) argues, know where the problem of epistemology lies. Description is its discursive formation. Proust's refusal to privilege the "first person" does more than Robbe-Grillet's defensive claim for the novel as the fictional production of nonexistent objects and for the "humanistic" implications of the experiments it is thereby able to conduct. In other words, I submit, the later author fell into the trap prepared by his critic and donned the blinkers, after all, that Proust had so effectively cast off. The feature of the novel as a laboratory of social, epistemological, libidinal, and poetic experiments that do not endanger live subjects—a critical force that any culture badly needs—is put forward when Proust's impossible description of Albertine lays bare the ideology of the novel as humanistic manifesto.

Albertine (the object)

> But I could not arrive at any certainty, for the face of these girls did not fill a constant space, did not present a constant form upon the beach, contracted, dilated, transformed as it was by my own expectancy, by the anxiousness of my desire, or by a sense of self-sufficient well-being, the different clothes they wore, the rapidity of their walk or their stillness. (Proust 1987–89, II, 867)

Is this a description? According to the Russellian definition with which I began this essay—thoughts about particular states, objects, and individuals expressed in the subject-predicate form—it is. Furthermore, if, rather than a passive, reified object, literature is an interlocutor for the critic and theorist—as I submit it is—then it is in those novels in which generations of readers have been engrossed that we are most likely to find a theory of the novel that is neither simplistic nor beside the point. I see these late modern novels as exemplary in this respect because they are both modern and a bit tired of modernity, disenchanted, and in search of ways out of it. Thus, they stand at a key moment of change that works its way into the

novels in the form of a fundamental undecidability about narrative and reflection on it. At the center of this period's literature, we find texts like Marcel Proust's *À la recherche du temps perdu.*[16]

Among the many things he did to militate against assumptions on what literature was, and with the realist novel as the primary target of his biting sarcasm, Proust, more overtly than Barnes, *denaturalized* description. To drive the point home that description cannot be detached from narration, he displayed the difficulty of describing all his major characters. In realist fiction—the most common and most commonly read kind—characters bind text to fabula since they are both "being" and "doing." They *are* (continuous beings) and *do* (perform) the actions that propel the fabula and make the novel suspenseful, pushing it to a satisfying denouement. It is because characters are the (humanistic) hubs of so many novels that love and sexuality are such central themes. For this essay, then, characters are the best place to inquire into the place, function, and nature of description.[17]

For a theory of description in the novel, it seems relevant that both love and the jealousy that it generates are overwhelmingly and deceptively important in Proust's novel. Yet for Proust, characters are not *beings* at all. This has two consequences: his attempts to describe them necessarily fail and the traditional division of narrative into narration and description shipwrecks. The descriptions of the many characters populating the world of *La recherche* are not renderings in words of their static, or at least continuous, being; nor are they the creations of fictive entities contributing to the world in which the fabula takes place. Instead, the major players of *La recherche* are described along, and sometimes as representatives of, the two axes of the novelistic world: space and time. The descriptions of the main characters—or, rather, the difficulties of describing them—are the "essence" of the novel. Fugitive and ungraspable, the novel they generate is essentially without essence. The frame that failed to capture Robin in *Nightwood* is, in Proust, the only remaining object of description. His novel is a demonstration of thoughts on the novel. In this sense, Proustian description is "apodeictic."[18]

This is clearest where the two primary love objects are concerned. Albertine, the overt one, and Robert, the closeted one, are systematically presented in terms of the opposition of their outward appearance. It is already obvious in their coloring—Albertine is dark, Robert blond. And, of course, in their gender positions: one is female, the other male; both have straight relationships, while the fundamental unknowability of both turns around their uncertifiable homosexuality. However, more important than these two traits—the one utterly superficial, the other too "deep" to be knowable, and both predicated upon binary opposition—is the *ground* of their *distinction,* to be understood in the semiotic, Peircean sense. What, the descriptions of them appear to ask, *makes* them? What,

if anything, *are* they, as individuals? Proust, we could say, zooms in preposterously on Barnes's questioning of the frame.[19]

The question has literary, philosophical, erotic, and epistemological relevance. Albertine and Robert stand out in the crowd of indistinctness so that they can *become* love objects, that is, the subject matter of a novel. "Love" here is a philosophical inquiry into the relationship between two distinct beings based on impossible knowledge and the ontological uncertainty that entails—a relationship Barnes's description predicted to be impossible.

Both Albertine and Robert are first seen on the beach. Albertine is selected primarily for the way she detaches herself from the group of young girls on the esplanade, while Robert is chosen for his temporal distinction, the rapidity of his movements. The former is, literally, *seen*—perceived in her distinction—when she pushes her bicycle out of the group of young girls. Her distinctiveness is primarily spatial but, like Robin's, designed as—necessarily—movement. Both the difficulty of making the distinction and the precariousness of that distinction are of great concern to the narrator; of greater concern, in fact, than the reasons for which he finally selects her as a love object. Robert—as blond as the sand, his clothes as white as the light surrounding him—is distinct as a character eligible to be an object of fascination because the rapidity of his movements, combined with his lightness that is so similar to the surrounding sunny beach, makes him, at the same time, hard to see.[20]

The description of Albertine is not simply an account of the narrator's perception of her. Others evoke her first—as the famous "Albertine" (I, 552), then as "You've no idea how insolent she is, that child" (I, 643). Both pre-descriptions, if I may call them that, occur while the narrator is still pining away for Gilberte, his first love (*qua* color, a redhead; qua sexuality, overtly straight but covertly gay). The real "sighting" of Albertine—there has not yet been a meeting—occurs in an extended descriptive-reflective passage that takes no less than ten pages, in "Place-names: The Place" in *Within a Budding Grove*.

It begins with "In the midst of all these people . . ." (I, 847) and ends when Marcel enters the hotel ("I went indoors"; I, 856) at the end of his stroll, hence, in terms of the fabula, quite arbitrarily. This piece is an astonishing allegory of the difficulty of describing due to the impossibility of knowing other people. The problems of *distinction* and its eventual arbitrariness are at the heart of the event, and they highlight the fundamental artificiality of description. Let me just select—arbitrarily and artificially!—a few moments from this extended passage. In anticipation of my conclusion, the length of the passage is not an indication of the slowness of the description; on the contrary, it is motivated by a struggle to keep abreast of an accelerated temporality that rules the novel's combined temporalities of fabula, discourse, and reading.[21]

The phrase "*In the midst* of all these people . . . the girls *whom I had no-ticed* . . ." introduces a description of the girls' collective movement through space as they walk toward the narrator. The latter is diegetically walking toward, discursively "speaking" about, and allegorically reading the *spectacle* of the girls. When he sees them from closer proximity, the rationale for the collective de-scription is rendered in a combined terminology of taxonomy and aesthetics: "Although each was *of a type* absolutely different from the others, they all had *beauty*; . . . I had yet not individualized any of them." The struggle for distinction is rendered in a synecdochic nightmare that resembles a parody of descriptive de-tailing and is explained through the effect of time: "I saw a pallid oval, black eyes, green eyes, *emerge*, I did not know if these were the same that had already charmed me *a moment ago*, I could not relate them to any one girl whom I had set apart from the rest and identified" (I, 847).

The narrator experiences the incapacity to distinguish as a lack ("want") but also as a source of beauty and is thus placed outside himself and his subjectivity as perceiving agent: "And this *want*, in my vision, of the demarcations which I *should presently* establish between them *permeated* the group with a sort of *shim-mering* harmony, the *continuous transmutation* of a fluid, collective and *mobile* beauty" (I, 747–48). The source of beauty is the negation of distinction, yet time lifts a prescriptive finger ("should presently"). Clashing with this routine tempo-rality is the temporality that inheres in the group: "continuous transmutation," the mobility that is the site of beauty. Clearly, a stable character endowed with permanent beauty is not going to result from this descriptive dystopia.

The rhetorical makeup of this initial stage is reconfirmed throughout the pas-sage (for example, "to the delight of the other girls, especially of a pair of green eyes in a doll-like face . . ."; I, 849).[22] Even when distinction is achieved, however, the result is emphatically not closer to an individualizing and stabilizing charac-ter description. "By this time their charming features had ceased to be indistinct and jumbled" (I, 850) confirms the narrator in an uncharacteristically short, summing-up sentence, but "I had dealt them *like cards* into so many heaps to compose . . . : the tall one who had just jumped over the old banker; the little one silhouetted against the horizon of sea with her plump and rosy cheeks and green eyes; the one with the straight nose and dark complexion who *stood out among the rest*. . . ."

Curiously, the first act of distinction is hidden in a subclause ("who stood out"), whereas the actual description of the chosen one is couched in an em-phatically parallel series ("the one with the straight nose"). The next step is based on the usual (deceptive) appearances and negativity: "a girl with brilliant, laugh-ing eyes and plump, matte cheeks, a black polo-cap crammed on her head, who

was pushing a bicycle . . ." is cast as belonging to the popular classes, as being of light virtue and rather vulgar.[23] Ideological reduction appears, in effect, to result from description.

Distinction on the level of the fabula—the represented object—is not enough to facilitate successful description, however. Even after this crucial moment of election, the narrator continues his musings on the impossibility of individualizing descriptively. Again synecdoche is the figure that emblematizes that difficulty:

> Though they were now separately identifiable, still the *interplay of their eyes,* animated with self-assurance . . . an invisible but harmonious bond, like a *single* warm shadow . . . making of them a whole as homogeneous in its parts as it was different from the crowd through which their procession gradually wound. (I, 851)

The taxonomic principle, compared to the card game earlier on, does not, however, deny the object of description her subjectivity. On the contrary, it is because, ultimately, she cannot be objectified that Albertine cannot assume novelistic autonomy. Ultimately, the critical process Proust is engaged in here leads up to a fierce critique of realism precisely on the grounds of its seductively objectifying power. Gradually, the narrator merges his awareness of her unknowability with his decision to elect her.[24]

If Albertine appears to be just a playing card (here) or a snapshot (later), it is because she remains resistant to narrative integration. Descriptive discourse is the representation of that resistance. The resistance is mutual: not only can she never be known; the "I" cannot "place" himself within her world either.

> For an instant, as I passed the one with the plump cheeks who was wheeling her bicycle, I caught her smiling, sidelong glance, aimed from the center of that inhuman world which enclosed the life of this little tribe, an *inaccessible, unknown world* wherein the idea of what I was could certainly never penetrate or find a place.

As this passage demonstrates, the stakes are high: description presupposes the existence of the object. Since the other is not an object but a subject, however, her existence can never be posited, that is, fixed, assumed to *be* (as in *being*). Instead, the other holds power over his own being. As a result, the question not—or, at least, not only—of her but of *his* visibility creates an existential and therefore descriptive despair:

. . . had she seen me . . . At the moment in which the dark ray emanating from her eyes had fallen on me? If she had seen me, what could I have represented to her? From the depth of what universe did she discern me? (I, 851)

Sure enough, the metaphor of the telescope, never far away when Proust's narrator questions representability, shows up in the next sentence.

This is followed by a reflection on eyes and the ideas that cannot be read in them: on the lives of the girls and the narrator's happiness derived from them, a happiness curiously phrased as "that prolongation, that possible multiplication of oneself" and on the fundamental *heterogeneity* between him and the girls as the surest motor of desire; in other words, as a motor of narrative. The passage does not lead to a resolution of the process of perceiving, noticing, or selecting the love object. On the contrary, it ends with a flourished metaphor of the commonplace kind in which the girls, still collectively, are compared to fresh roses and butterflies and the subject of selection is compared to a botanist. It will take a long time before anything happens as a follow-up to this descriptive moment.

These initial presentations are not isolated cases. Both Albertine and Robert are consistently described in their existential fragility. Until the end of both the Albertine episode and the novel itself, the narrator, who sometimes appears cruel toward both, is keenly aware of the impossibility of pinning them down, of describing them. This is clear, for example, with Albertine's first appearance—the word is appropriate—as the one who leaves the group and later returns in the middle of the romance, when the narrator is again realizing that his stare, *by definition,* is vaguely amorous. By analogy, Proust pronounces on the function of description in the novel. Love, like the novel (the genre of which it is the primary subject matter), is not so much an encounter with another subject existing in continuity as the search to see—and, hence, distinguish or highlight—one being in the drab anonymity of "the world." It is the search, not the result, that matters; it is the spatial, world-making equivalent of his search for lost time. Thus Proust theorizes representation—its (im)possibility, its ethics, and its necessity.

Later, when the narrator is already firmly ensconced in his paranoid relationship with Albertine—paranoid, of course, because the descriptive exploration has demonstrated the impossibility of knowledge, hence, of assurance—he describes in minute detail, for example, how, at the beginning of the summer season, his searching eye seeks out the young girls who had so enraptured him before. Now he does not need to distinguish the girl with whom he had so significantly but poignantly said to have decided to "have his novel." Yet distinction remains the object of the search. In the following fragment, the gaze, distant at the beginning of the sentence, moves closer toward the end:

But I could not arrive at any certainty, for the face of these girls did not fill a constant space, did not present a constant form upon the beach, contracted, dilated, transformed as it was by my own expectancy, by the anxiousness of my desire, or by a sense of self-sufficient well-being, the different clothes they wore, the rapidity of their walk or their stillness. (II, 867)

The focalizing subject transforms the incorrect grammatical form of a singular noun (face) accompanied by a plural predicate (these girls) into a zoom effect.[25] The combination is maintained right to the end of the sentence. It is partially neutralized by the increasingly rapid succession of nouns (clothes—in the plural— rapidity, stillness). As I have argued elsewhere, the search here is primarily *photographic.* I would now add that photography is selected as the mode of this search because it is ambiguously situated between producing and recording a vision. Hence, it poses the problem of, precisely, distinction. Specifically, distinction is not only a spatial issue. It is also a temporal one. If only the model would pose for him, he would be able to fix the lens at the right distance, that is, at the distance necessary to hold the image still.

Through photography, Proust challenges the humanistic assumptions inherent in realist literature. Indeed, photography challenges any simple idea of description as distinct from narration. With its glossy, shiny, flat surface, it is neither "profound"—it has no *depth*—nor stable; it resists any attempt to subordinate description to the service of the humanistic ideal of "dense" characters, as advocated by Proust's younger contemporary, E. M. Forster. More strikingly, perhaps, in a revisionist appreciation of description, Proust challenges the notion that a connection between appearance and person is possible at all, both in terms of visual bonding and of the flatness and fragmentation that vision also entails. In *La prisonnière,* in a passage marked by negativity, Albertine, who has now lost the aspect she had in the photograph on the beach, which set her apart, consists of nothing but a series of snapshots:

> A person, scattered in space and time, is no longer a woman but a series of events on which we can throw no light, a series of insoluble problems. . . . (3.99/III, 612)

This shattering of the object inflects spatial coherence, a requisite for description, into temporal fragmentation, thus further melding description and narration.

This dissolution into a flat, visual series only gets worse, eventually becoming the base on which the images of jealousy fix themselves:

> For I possessed in my memory only a series of Albertines, separate from one
> another, incomplete, a collection of profiles or snapshots, and so my jealousy
> was restricted to a discontinuous expression, at once fleeting and fixed.
> (3.145/III, 655)

The last words, "at once fleeting and fixed," define very precisely the nature of
photography and, in particular, the nature of the series of snapshots, as well as of
the jealous passion that uses such images as its *support*. They also define description
in the novel. It is clear, then, why the snapshot's vocation is to become the *mise
en abyme* of description and its limitations according to Proust, in the same way
that Sleeping Robin is a *mise en abyme* for Barnes's questioning of description's
frameability. These words explain the specific use Proust makes of the photo-
graphic mechanism. They also underwrite his efforts to denaturalize description,
however, in a novel that makes such abundant use of that discursive form.

The quarrel implied, it seems to me, is with the assumptions that hold litera-
ture to standards of "nature," whereas literature's primary function is to be arti-
fice. Against the humanistic ideology of naturalness, Proust promotes an aware-
ness of artificiality. In a culture where "naturalism," "realism," and "illusionism"
(not identical yet still affiliated notions) are near impossible to discard, even to-
day, this plea for an endorsement of the fundamental artificiality of art remains an
embattled position. Uniquely, Proust realized this and worked through the nu-
merous difficulties underlying that dispute.

For example, the narrator composes "an album of Albertines" not in the vain
hope of fixing that inaccessible being but precisely to demonstrate that he can-
not. The "flatness" of the photograph, however, has an additional quality that
frustrates such attempts: it invites pretense, masks, and playacting. It is thus the
production and recording of artifice. It fixes only the external aspect, thereby hid-
ing all the more effectively the "inner being." Who is to say, in the case of Al-
bertine, that such a being actually exists? While the series of snapshots gives the
subject an epistemological way out, the photograph also affects the object.
Consequently, the latter's existence, its "being," is denied:

> And before she pulled herself together and spoke to me, there was an instant
> during which Albertine did not move, smiled into the empty air, with the same
> feigned spontaneity and secret pleasure as if she were posing for somebody to
> take her photograph, or even seeking to assume before the camera a more dash-
> ing pose. . . . (3.146/III, 656)

In a realistic reading, the young woman would seem insufferably vain and artifi-
cial. Inside the experimental writing here, this description reveals something

else: faced with the "collage" that the narrator is desperately trying to create, Albertine takes her place in the "picture" as best she can. But the snapshots reveal all the more clearly, and thus all the more painfully, the essential impossibility of "fixing" her down.

"Albertine," then, stands for the figuration of novelistic character as not-human, not-real, artifice. There is neither existential certainty nor continuity or contiguity between such flat, glossy paper products and the other elements of the world in which they circulate. This represents one of the problems of description insofar as it undermines the notion that description presupposes a stable object. Such a view seems astonishingly contemporary; it embodies the "proto-postmodern" side of Proust's work. There is a good reason why Proust was so invested in undermining the traditional use and view of description and why he, specifically, used *character* as his ground for experimentation, however. The reason lies in the rhetorical tradition.[26]

The complaint of description's inability to offer an adequate "copy" of the world, the central complaint to which all the others I have discussed in the previous section can be tied, is evidence of the most profoundly realistic bias in all of these debates. Representation is possible precisely because it *cannot* copy; it is culturally relevant because it will not try. Proust's *petit pan de mur jaune* can do the work it is called upon to do, including killing the writer Bergotte because of his unfulfillable ambitions, not in spite of but *thanks to* the pictorial inadequacy of the description. The latter is ambiguous in the strong, logical sense, and consequently does not "exist" and cannot be pinpointed in Vermeer's painting. Moreover, the ambiguity concerns, precisely, the existence of the patch.[27]

Like eyes, words can kill. The yellow patch does not exist, but it does kill a character. Killing a character: What better place is there than fiction—where no live subjects are endangered—to explore the dangers that cultural habits such as language, voyeurism, and ethnographic othering allow us to incur? Proust's apodeictic demonstration puts these habits relentlessly on trial: he uses the vagaries of description to make his case. Long ago, Barbara Johnson offered her profoundly moving analyses of the performative power of fiction in such consequential acts as judgment (in Melville's "Billy Budd," 1980) and address (in poetry, 1987). In contrast to these forms of language use, description is, by definition, constative not performative. Yet it can kill, even murder.

Lucretia (the killing)

And from the towers of Troy there would appear
The very eyes of men through loop-holes thrust,

Gazing upon the Greeks with little lust:
Such sweet observance in this work was had,
That one might see those far-off eyes look sad.
In great commanders grace and majesty
You might behold, triumphing in their faces;
In youth quick bearing and dexterity;
And here and there the painter interlaces
Pale cowards, marching on with trembling paces;
Which heartless peasants did so well resemble,
That one would swear he saw them quake and tremble.[28]

Performativity, pace Austin, is at the very heart of the constative utterance: illusion-istic, narrative painting is constation's model. This is why description, of necessity, generates narrative. After two descriptions generative of love stories, it is now only fair to turn to murder. Together with love, murder is perhaps the most frequently deployed novelistic theme. Of the two, murder is the more clearly narrative. The themes are each other's systematic opposite and, hence, engaged with the same problem—the relation of self to other in the order of representation. Either the per-ceived other is easily objectified, which turns her or him into a dead thing and thus makes description epistemic murder, or the other is accepted, respected—indeed, welcomed—as irreducible, which turns her or him into an inaccessible subject and makes description, then, impossible—and love kills *it*. The description of charac-ter is, therefore, the emblematic case of the paradox of description.

 This is another reason why the rhetoricians' worry about the lack of "natural" order in description seems utterly beside the point. In the same way as word order is regulated by syntax and narrative order is ordered by chronology, so de-scriptive order is guided by the double agency of the focalizer and the narrative that this agent's gaze generates. For, I will argue in this section, as in any act of showing, description is subject to the properties of *epi-deiknumai*: the one who shows, shows himself, and also argues for praise or blame, moral or aesthetic. In such acts, the moral values of describing and of "seeing" subjects merge or clash. The order is thus rhetorical but not only in the narrow, tropological sense.

 Despite being interested in precisely that narrower rhetorical issue, figura-tion, Hayden White makes a comparable point when he states, apropos of Proust's description—a properly ekphrastic one—of the Hubert Robert foun-tain already mentioned, that the tropological structure of the description gener-ates narrativity:

 The relation between the scene of the encounter with the prince and that in which the fountain is described is only tropical, which is to say that it is un-predictable, unnecessary, undeducible, arbitrary, and so on, but at the same

time functionally effective and *retro*dictable as a narrative unit once its tropical relationship to what comes before (and what comes after) it is discerned. (White 1999, 138; emphasis in text)

In a move comparable to what I have proposed as preposterous history, White here posits a preposterous narrativity for description. In this sense, too, description, especially in its perfected state of ekphrasis, is a master discourse of the novel.

The story of Lucretia has a description as its primary agent, as its murderer. From time immemorial, the name "Lucretia" has signified a narrative of triple victimization: the Roman heroine was raped; then she killed herself, unable to judge in favor of life once her subjectivity had been effectively destroyed; and, finally, the tradition of rhetorical reading erased her story by interpreting it, ironically, as "just" an allegory of the victory of democracy over tyranny. The Lucretia story, which came to us through the Latin classical canon, from Livy and Ovid, has been recycled many times throughout the history of Western literature. Church fathers, medieval allegories, Renaissance poetry and painting were all fond of it, for the opportunity it offered of fine-tuning juridical and theological questions like the right-to-life versus the right-to-choice. The story made it into opera and theater. Numerous paintings exploited the opportunity the Lucretia story presented to whitewash the nude with moral righteousness. Strangely, dramatic as it is, and as rich in potential for psychological scrutiny, Lucretia's story has never, as far as I know, made it into a novel.

Of course, it is pointless to speculate on why this is so. I can imagine, however, that its plot—perfectly narrative, suspenseful, eventful—would make novelists of the realistic persuasion stumble. For, on a level quite different from that of Albertine's entrance into the perceptual orbit of the Proustian narrator, the plot revolves around the primacy of description as the motor of narrativity. The ancient sources already suggest it was the boasting description of her by her husband, Collatine, to his friends in the army that set the rapist Tarquin in motion. With his *Rape of Lucrece*, Shakespeare, who never wrote novels but who did write two long narrative poems, came as close as he ever would to writing a novel. He did so by composing a story that revolves around description. And since the plot consists of two decisive events—rape and suicide—he doubled the descriptive causations of these events. The initial description by Collatine is matched by the description of a (nonexistent) painting of the Trojan War. The second description triggers the suicide. If it can then be said that rape is soul-murder, the second description, a typical ekphrasis and parallel to the first one, triggers the second murder, which inherently follows the first.

An extensive story with an intricate plot, characters, settings, sex, murder, and a gripping denouement: we may as well treat it as a novel. I propose to do so,

provisionally, also for theoretical reasons. Responding, preposterously, to Proust, Shakespeare underwrites the former's theory of description as both impossible and crucially generative of narrativity. By assigning a double murderous effectivity to description—the first generating murder and the second generating murderous description—the early baroque writer elaborates on the ethical consequences of Proust's radical epistemic doubt that tipped the latter's work over into the ontological skepticism that heralds postmodernism. Between proto-postmodernism and proto-baroque, a dialogic link is thus established about the narrative striking force of description. And as if to resume the age-old rhetorical discussion within which Shakespeare was immersed (but Proust was not), the final battle is then fought over the description of a nonexistent painting of the war that inaugurates narrative literature in the Western tradition, the Trojan War.

The Rape of Lucrece is, indeed, a war of images, and as such, an early novel. This claim is not only based on the relationship to Proust's elaboration of descriptive dystopia; it also has a more common historical framing. The poem is an incipient novel to the extent that, negatively speaking, it is not a play and that, positively speaking, it generates narrative out of description. Shakespeare, so skilled at writing the kind of tragedy suitable for mise-en-scène, avoided doing so in the case of Lucretia. This was not owing to lack of material. His narrative poem of 1594 is at least the right length (1,855 verses), much longer than the play by the little-known baroque/classicist French author Pierre du Ryer that was devoted to the same subject some forty years later, in 1638 (1,538 lines). Nor can it be because of lack of drama; Shakespeare's poem uses as many characters as du Ryer's play, and its action is so condensed that in this respect it could almost be called classical. Du Ryer's play goes to show that it is not impossible, or "indecent," to show suicide onstage but—and this is relevant—representing rape is. Why, then, did Shakespeare turn the subject into a narrative, when he normally wrote plays with many murders and few narratives? The speculative answer to this question further confirms the generative role that description has played in the development of the novel as a "descriptologically" defined genre.[29]

Is it through the question of visualizing or not visualizing catastrophe that tragedy is defined? I believe it is, but not in any direct way. Consider the rules of classical tragedy in France and the idea that Racine, tragedy's primary master, solved so many of its problems in such "baroque" ways—by deploying description. Obeying the rules by disobeying the genre that framed his work seemed a very clever way of enabling himself to do what, on all accounts, he could not. In line with classical tradition, from antiquity onward the famous evocation of Hippolyte's ghastly death is represented in a narrative rather than a dramatic mode. As a technical consequence of this decision, it is set in the past tense and offstage,

so as to create enough aesthetic distance for it to be bearable. However, it is common knowledge that, whereas the modality of its telling respects the rules, the representation itself, with its highly baroque imagery, labors to convey the extent of the horror. On the level of narrative representation, the "récit de Théramène," made famous by Leo Spitzer, links this classical drama to the baroque dramas discussed by Walter Benjamin to the extent that it raises the paradox of spectacle. Like these dramas, the narrative of catastrophe modifies the aesthetic, thus rupturing the totalizing harmony of classicism. The modality of representation involved in this process is, not coincidentally, visualization. This visualization is of a narrative rather than a dramatic kind, however.[30]

On the one hand, the *récit* fragments classical harmony; on the other, that fragmentation reintegrates the visualization on which theatrical spectacle had cast a taboo. The double mission of the *récit*—to respect the modesty dictated by classical aesthetics and to bridge the gap between experience and witnessing that catastrophe itself necessitates—inevitably visualizes Hippolyte's violent and horrible death. This is not just baroque exuberance—theater over life, so to speak. For it is in order to force the so-far-indifferent womanizer, Thésée, rival of his son, to *see,* to *bear witness to,* the consequence of his reversed Oedipal, murderous impulse, that the *récit*'s spectacle, hence, its descriptive thrust, is necessary.[31] This is just one—rightly famous—instance of the internal conflict in Racine's aesthetic, which led him to practice description in a way that exceeded the mode of classical drama and entered the domain that came to generate the novel. There are many more instances, however. Suicide is the prime example. The imperative of tightening the action into a single passion or obsession made it difficult to represent suicide onstage. It was impossible or offensive of *bienséance,* as du Ryer's rather successful *Lucrèce* demonstrates, but such a spectacle would inevitably arouse strong feelings and thus distract from the passions that caused the suicide. The importance of the emotional logic of causality thus overrules that of the mise-en-scène of catastrophe. And, in the case of Lucretia, that causality is located in description itself.

Reasoning preposterously from Proust's point of view, we can appreciate Shakespeare's effort, rhetorical as it may also be, to, literally, make a painting out of Lucrece. Indeed, he made a painting out of her when he made her husband, Collatine, describe her so appealingly that the rapist Tarquin set out to rape her on the basis of that description. The visuality of the power of words to *show* is underlined in the following reflection:

> Therefore that praise which Collatine doth owe
> Enchanted Tarquin answers with surmise
> In silent wonder of *still-gazing eyes* (82–84)

Then he made a painting out of her rape by deploying a metaphoric network of images in which a pin causes pain and vice versa. And, most emphatically, he made a painting out of her plight, when he made her work out her dilemma in front of a painting of Hecuba's mourning over Hector's death, in one of the most superb ekphrastic passages of Western literature.[32]

"Ekphrasis": text "full of vivid description."[33] First occurring in Dionysius of Halicarnassus in the first century B.C., this term came to be limited to descriptions of works of art. In modern literary theory, it is used in this limited sense. But, as many have argued, this limitation points to a more general problem inherent in description as such: How to represent something that exists, or might exist, in an order different from that of the medium of representation?[34] Descriptions of visual artworks only make that problem more acute. The de facto, specialized use of this term, however, is responsible for its being treated in conjunction with other terms referring to phenomena bearing a "family resemblance" to this limited use.[35]

Ekphrasis is a deployment of visibility within a linguistic discourse. The radical, ontological difference between visual and linguistic utterances is suspended in favor of an examination of the semiotic power of each and their relation to truthful representation. The age-old trust in the reliability of vision yields to the delicate balance of word and images in the production of evidence. The discursive genre of ekphrasis traditionally stands for this "intermedial" ambition, investing ekphrastic description with the mission to make present an object of visual art that does not even exist. This is only one way toward fictionalizing the desire to perfect epistemological grounding. A more general interpretation of the term implicates the act of showing, in the sense of showing *in detail*. The novelistic aftermath of the belief in the act of showing in detail is well known. And, without suggesting a continuity between Shakespeare and, say, Zola, I read in *Lucrece*, as a proto-novel, a fictionalized theorization of what makes description crucial to the fabrication of the novelistic world.[36]

After her rape, pondering in a classical Renaissance *disputatio* whether she should kill herself—whether, in other words, she must endorse the destruction of her subjectivity—Lucrece contemplates this painting. The war in it emblematizes the war of which the painting is one party: the war between media. This is the moment where narrative almost yields to argumentative discourse. It is only because description—of the painting—animates both the representation on the wall and the monologue that thus turns into dialogue that narrativity continues its course. Resonating with Proust's Albertine and Barnes's Robin and their perpetually unstable identities, Shakespeare's Lucrece continuously produces a narrativity that spills over the boundaries of ekphrastic description because she is unable to "read" the true nature of the character she can only perceive from the

false outside: Sinon, the traitor of Troy. This figure, the object of description after being the object of visual depiction, a depiction that follows his verbal description in Homer's narrative, serves as an emblem of Proustian ontological doubt. The following passage spells out what Lucrece, who already has heavy considerations on her mind, is nevertheless pondering as a theorist of description:

> Such signs of truth in his plain face she spied,
> That she concludes the picture was belied.
> "It cannot be," quoth she, "that so much guile,"—
> She would have said,—"can lurk in such a look";
> But Tarquin's shape came in her mind the while,
> And from her tongue "can lurk" from "cannot" took:
> "It cannot be," she in that sense forsook,
> And turn'd it thus, "It cannot be, I find,
> But such a face should bear a wicked mind." (1534–40)[37]

In this narrative, where the stakes are so high that the heroine's life is under threat, the battle between visual depiction and verbal description is ultimately won by the latter: Lucrece, that is, "knows better" than the figures in the painting, because her act of looking produces description. This victory is granted on the condition that description is put in charge of narrativity, however. The allegorical Sinon comes to stand for Tarquin, an allegorization that seals the latter's fate; indeed, in an ever-multiplying generation of narrative, the depiction of Sinon produces the democratic revolution.

Ekphrasis, as many have argued, is the discursive genre in which words and images vie for greater performative power. Its prototype is that moment in the founding epic text where description and narrative become inextricably mixed: the description of Achilles' shield-in-the-making, in Homer's *Iliad* (18:462–613). In terms of framing, the motivation that inserts the descriptive piece within the surrounding narrative turns it into a simple procedural description, generated by the narrative of the shield's making. Description is irresistibly representative, however, because it is simultaneously everything description can be: it de-scribes an object, writing about it and un-writing it, as the description disintegrates into a number of different scenes (this is the literal sense of epideixis); it narrativizes that object (the images of it are narrative and come to life under the describing gaze) and it frames the object with a motivating narrative (the making of the shield). In this sense, it is both an extreme case—of a description that generates narrative because it animates its environment—and a standard case—of a description that *is* narrative because it animates its object.[38]

The description of Achilles' shield offers a mix of dialogue, description, and

narrative; in other words, of the three heterogeneous orders of discourse that constitute the novel in their very heterogeneity. Even at first sight it is doubly animated: in addition to the motivation through its fabrication, the scene depicted takes on a life of its own. This turns the procedural description into a metanarrative commentary as well, for it radicalizes the representation of diegetic focalization within the description. As a result, subject and object change places. Hence, so the piece "argues," focalization, always present, is both visible and necessary in description. In Shakespeare's *Lucrece,* the two key moments of description elaborate on the position of the diegetic focalizer (who "sees" the image) as mediator between image *as* object (the woman, the painting) and image *of* object, when the fabricatedness, the artificiality of the object, is acknowledged and endorsed. Whereas Tarquin falls completely into the trap of the image's seduction, as one does in cases of idolatry, Lucrece, the victim in this war of images, is nevertheless the literary victrix. She dies but she does not believe in zero-focalization. Consequently, she counters the realistic illusion, the objectification of the described subject/object, and the detailing that breaks that object into pieces.

Description not only produces the exhilarating pieces (such as Flaubert's wedding cake) that suggest autonomy for description, albeit deceptively. It also inherently generates the world in which events take place and subsequently the events themselves. On the basis of the descriptions examined so far, I would even venture to say that description is the novel's masterpiece. For, as a narrativity machine, description succeeds where narrative "proper" fails—because narrative is inadequate, inappropriate, or both. It succeeds in creating a world for the narrative (the events) and in questioning that world—simultaneously. It points epideictically to the elements it holds together, while at the same time demonstrating apodeictically how artificial that coherence is. Metadeictically, it argues for the need and dangers of such an internal coherence that cannot be contained. By failing to fix Robin, by shattering Albertine, and by murdering Lucrece, description, in the case of Zola's most beautiful character, kills not only the person but also the very beauty that sustains her existence. Writing (the novel) is un-writing; making is un-making, says description, in the type of novel most famously built up by way of descriptions.

Nana (the decomposition)

Un frisson remua la salle. Nana était nue. Elle était nue avec une tranquille audace, certaine de la toute-puissance de sa chair. Une simple gaze l'enveloppait; ses épaules rondes, sa gorge d'amazone dont les pointes roses se tenaient levées et rigides comme des lances, ses larges hanches qui roulaient dans un balance-

ment voluptueux, ses cuisses de blonde grasse, tout son corps se devinait, se voy-
ait sous le tissu léger, d'une blancheur d'écume. C'était Vénus naissant des flots,
n'ayant pour voile que ses cheveux. Et, lorsque Nana levait les bras, on aperce-
vait, aux feux de la rampe, les poils d'or de ses aisselles. (Zola 1897, 31–32)

Nana restait seule, la face en l'air, dans la clarté de la bougie. C'était un charnier,
un tas d'humeur et de sang, une pelletée de chair corrompue, jetée là, sur un
coussin. Les pustules avaient envahi la figure entière, un bouton touchant
l'autre; et, flétries, afaissées, d'un aspect grisâtre de boue, elles semblaient déjà
une moississure de la terre, sur cette bouillie informe, où l'on ne trouvait plus
les trait. Un œil, celui de gauche . . . (523–24)

I find it problematic to commit the act of collusion that completing this quotation
would entail. For the description that ends the novel, Nana's beauty, and her life,
all three in one sweep, is aggressively voyeuristic. Reading is affected by ethical
judgment just as with any other act. Dealing with description can thus be a mat-
ter of right or wrong: The text proposes; the reader disposes. Each has a job to
do and a decision to make. In the case of *Nana,* the two descriptions—of physi-
cal glory and of decomposition—propose their effects in different ways. The
identification of the reader with the voyeuristic gaze that motivates the initial
description of the main character—the first of many scattered throughout the
novel—can be either endorsed or denied. Identification, it is useful to remember,
may be rhetorically encouraged but it is never enforced. Moreover, the reader has
a choice between reveling in the sexual arousal of the presumably male focalizer
and rejoicing in the glory of the successful actress so skilled at making a living off
her beauty.[39] Confronted with the choice, any choice, the reader is liberated from
the confinement of the trappings realism entails and is instead asked to face what
reading amounts to, and where that leaves the character. This is one thing de-
scriptions can do. The closing description does not allow such freedom.

Do voyeurism and description hang together "naturally"? This question is
raised collectively by the different descriptions of Zola's Nana. No answer is pro-
vided, but the question remains one that no theory of description can ignore. The
relation between the bringing into view and the obsessive myopism that the peep-
hole or obscurity of the theater encourages is so easily overtaken by erotic one-
sidedness that pornography barely needs a story. There are, of course, various
ways to undermine this tendency, but only if it really is a tendency. Zola under-
mines it in the description quoted above by foregrounding Nana's self-
determination in her role as sex object, even though her life story does not sus-
tain it. The fantastic provides additional ways of undermining it. From roughly
the mid-eighteenth century to the mid-nineteenth, the genre of the fantastic—the

genre of the "catless grins"—in its most characteristic form, the life of detached body parts puts these issues on the table without catering to the voyeuristic illusion. Instead, as Deborah Harter claims, "fantastic narrative brings to life the 'coming-into-view' as much as the view itself, resurrects the parts just as much as it resurrects the whole." She continues:

> This literary form allows to remain unanchored those pieces that underlie every effort at totalization in narrative art. Its texts reveal the illusory wholeness of mimesis and its ironic dependence on a binding together of shattered parts.[40]

The double discourse of irony is eminently suited for this resurrection; and, hence, also for the novel.

It is precisely these very characteristics of choice, the foregrounding of illusion itself, and fragmentation that are absent from the final description of Nana. Cruel and sadistic in its detailed (epideictic) representation of death in a woman who is still alive, this description is more profoundly voyeuristic. In its position at the text's closure, it barely lends itself to nuanced and differentiated response. Informed by descriptive reveling, it seems less designed to represent the agonizing woman than to represent her agony; less designed to represent Nana than to represent the vengeful hatred of the men who caused her horrendous death. Whereas the theater is full of life-sustaining admirers when Nana's glorious entry onstage is described, the final description also pushes the devastation of its detailed object into utter isolation. The framing gaze moves away so that the reader alone remains, unable to offer comfort to the dying woman if he or she should wish to do so. Neither sustained by choice nor trapped in identification, the cathartic moment purges the reader of the fearful identification offered for contemplation, which would have been offered for contemplation, that is, if a diegetic focalizer had preceded his or her gaze. The dangerously contagious pus in the boils that are gradually taking over Nana's entire face remains enclosed within her body.

Zola deploys the same strategy at the end of *Le ventre de Paris* (1971 [1874]). Here, the main character, male this time, is expelled simultaneously from the community and from diegetic focalization. This time, though, the reasons are political, not sexual. Clearly, description can be more than just an accompaniment to the closing scene or event. In both *Nana* and *Le ventre,* by withdrawing companionship, description constitutes that ending. For a novelist who specialized in description by both practicing and preaching it, this rhetoric, which conflates description with narration, has a programmatic thrust. It would therefore seem useful to take a closer look at the kind of description found in the work of this utterly naturalistic and naturalizing novelist, to see what it was, precisely, against which

Barnes and Proust militated and for which Shakespeare offered a preposterous user's guide. Descriptive routine follows a fixed structure: If abstract, it seems innocent enough; if fleshed out, it tends to absorb a lot of narrative power.

Philippe Hamon, one of description's most sophisticated theorists, also demonstrates, highly persuasively, that a certain degree of structuralism is indispensable for adequate narrative analysis. Not coincidentally, Hamon is a Zola specialist. His view of description is contingent upon a distinction between narration and description, and although he, more than anyone, is committed to validating the importance of descriptive discourse, that distinction remains too firmly in place for what I feel comfortable with at the present moment. It is my hope that, against the background of the later (and earlier) challenges to this view, the categories and tools or grids offered there will become both more meaningful and more relative than they might otherwise appear to be.[41]

At the end of the chapter on what he calls "a typology of description," Hamon spells out the factors that would sustain such a typology (1981, 174–75). These constitute the elements that can be found, hence analyzed to varying degrees, in those classically realist descriptions that are so overwhelmingly "natural" yet deeply contradictory. Hamon's concept of description elaborates the Russellian one. The mode in which the predicates are attributed to the subject or theme is determined by a narrative regime of readability. The relation between the series of descriptive elements and this regime, or motivation, can vary from diegetic focalizer to anonymous external focalizer (in my view, *not* the same as zero-focalization). For Hamon, descriptions vary formally according to the kind of relationships that exist between the elements of the object mentioned and the predicates attributed to those elements. Such series can in turn be connected with each other in different ways.[42]

In the two descriptions from *Nana,* these formal possibilities are in place. Both are readerly: they contribute to the naturalizing representation of the novelistic world. In this world, objects (Hamon's "themes") are not simply represented as they purportedly *are,* as a supplement and clarification of what they *do*; nor are all the elements presented equally. In the early description of Zola's famous *courtisane,* men, rarely objects of description, are sitting in closed ranks in front of her: there in the dark theater, she is illuminated onstage. They are bodily enjoying the spectacle that the description presents to the reader. In other words, the primary sense perception involved is the visual one, erotically colored. In the closing description, the object has the same identity or "rigid designation" (the proper name "Nana") but has no feature at all in common with the earlier object. And, as if to drive the point home through a form of narrative that feeds so parasitically on description as to be virtually nonexistent without it, the descriptive types, or modes, differ profoundly.

The first description is motivated, clearly, by means of diegetic focalization. Not only is the description focalized by the spectators, but, as if anticipating Barnes's and Proust's questioning of the frame as natural, the entire setting also enhances the theatricality, right up to the final spotlights that make the body hairs visible. This emphasis on setting constitutes the permeable boundary between the diegetic world, in which this event supposedly happens, and the extradiegetic world, within which the reader *makes* the spectacle. Under the realistic regime, diegetic motivation naturalizes description. Hence, here the theatricality is paradoxical, potentially ironic, because it foregrounds artificiality. The parallel series—from the compared object, Nana and her hair, to a *comparant* from the pictorial tradition, Venus and the waves—contributes to the production of enthusiasm in viewers and character alike. This enthusiasm is emphatically constructed, however, both within the diegetic world and qua construction. The motivating frame, in other words, is not designed to fool anyone.

The vision itself is equally artificial. It is represented in its effect, and although this effect follows the appearance, its specification—the collective thrill of the personified theater—precedes the description of the appearance that caused it. Similarly, the character is not presented in a homogenous series constituting the nomenclature. She is first qualified—naked, self-confident, bold—then detailed, from top to bottom: shoulders, breasts, hips, thighs. Each element of this catalog of body parts is either further specified—after the breasts, the nipples—or qualified in some way. The breasts are Amazon-like, the nipples rigid, predicates that are then metaphorically elaborated on, as if in celebration, to enhance the collective euphoria: rigid like lances, rolling hips. In other words, the structure of the description is neither logically nor rhetorically systematic. As a mise-en-scène of a mode of reading (of seeing before the mind's eye), it appears to be particularly apt for anticipating the role of spectacle in the fabula about to unfold. Description, it would now seem, is going to dominate the events.

"Nana restait seule": the closing description is the systematic opposite. First and most important, as mentioned above, it is not motivated by diegetic focalization. On the contrary, the withdrawal of the focalizing agent is the narrative-descriptive enactment of abandonment: descriptive more than narrative, since the verb's tense, the durative imperfect, insists that the description is definitive and, thus, that this is the final image. Yet, strangely, the flame of the candle that makes the character visible accompanies the first descriptive mention of the theme. This would appear to be an unnecessary detail. If there is no witness, there is no spectacle. Yet the flame casts a particular—and particularly spooky—light on the object of description. The contrast with the floodlights, the oblique nature of the light, the relative obscurity of the room—all contribute to alerting the reader to the kind of contrastive description that overrides the narration.

Instead of the reversed relationship between cause and effect, we are left with cause only. The spectacle is dystopic—to say the least—and the cause of that effect is posited first. There is nothing human in the description of the face; there are no enhancing comparisons and metaphors here. It is even hard to tell whether the elements of the nomenclature are metaphorical or not. The words "un tas d'humeur et de sang, une pelletée de chair corrompue" are not details but super-posed descriptions of the same non-face of the "face en l'air." With the "shovel of corrupted flesh," the description anticipates the death to come, and the partici-ple "jetée là" further thickens both the rejection and the anticipated funeral. The strange contradiction between the stated absence of a diegetic focalizer and the invitation to enter the room suggested by the detail of the candlelight is here given as evidence of the possibility that extradiegetic motivation is also a form of focal-ization. The verb form is passive; the corrupted flesh has been discarded by no one in particular, yet the action of throwing it/her out is mentioned.

There is no festive theatricality here, no foregrounding of artifice. Instead, the detail mentioned—the *pustules,* the festering sores—is, again, subject to super-posed qualifications. This time they are more clearly metaphorical qualifications that undermine its stability, however. The sores are described for the way they expand till they lose their individual visibility. This is an image of anti-detailing: the small sores expand to become one. Again, with the word *déjà,* the funeral, beyond death and beyond the novel's ending, is announced. Thus the descrip-tion merges, dispensing with yet another boundary, the one between text and after-text. From here on, the monstrosity of the sight is overtly hateful. The face has lost all coherence: "to dust thou shalt return," punishment, for the sins of the men, is visited upon the woman. There can be no zero-focalization.

The settings of the two descriptions are also opposed. From the upright body, with its upright nipples, detailed from top to bottom and standing on a stage and, hence, in public, we move to the deathbed attended by no one. In much narrative literature, characters are placed in specific settings. In medieval novels, the rela-tionships between characters and settings are fixed topoi in which particular events can take place. Descriptions of settings precede descriptions of characters. In upbeat stories, the places are filled with euphoric beauty, to fill the characters with the enthusiasm that will set their adventures in motion. At that point, narra-tive recuperates description. But it cannot forget its starting point. The descrip-tion, explicit or not, elaborated or not, establishes the world within which the events unfold. "At nine o'clock, the theater of the Variétés was still empty," begins *Nana.* Time and place are marked. The spectacle can begin. No particular mo-ment is mentioned at the end; only still description remains.

Narrative is a form of place-making. The link between beauty and pleasure, horror and displeasure, necessitates description. The topos of the *locus amoenus*

turns a sweet landscape into a solicitation of eroticism: the love story can begin. Writers averse to this sweetness come up with an alternative. However, all they can do is reverse it and, thus, the romantic *locus terribilis* is born. For Rousseau and the Romantic novelists, this awesome landscape sets the scene for the adventure of loneliness, which tends to produce the breathtaking experience of the sublime. Here, the character, not the reader, is supposedly threatened with being overwhelmed. And so another boundary between fiction and reading—between diegesis and the extradiegetical world—collapses. As does a third one, when Flaubert, in *Madame Bovary,* offers sublimity with an ironic wink, at the moment that Emma's mediocre lover, Léon, enthuses about playing the piano on a mountaintop. The *locus horridus,* another anti-place inspired by Dante's Hell, informs the Gothic novel. Only within a specific setting can a character exist. And character is indispensable—indeed, central—to the ego experimentation that the novel as a genre can be said to constitute.

The closing description of Zola's *Nana* demonstrates that place and character are interdependent, inseparable. This is, ultimately, the meaning of the candle. Firmly entrenched within the world of the fabula, the reader, the only remaining witness after the cowardly withdrawal of the diegetic focalizers, can *see* the shadows on the walls of the sickroom that the wavering flame turns into a *locus horridus.* This is no Gothic castle; there are no rattling chains. Instead, reminiscent of the Gothic yet distinct from it, the character herself has dissolved into horror. Thus the description that stages the withdrawal of the focalizer at the same time affirms the impossibility of zero-focalization. Where descriptions appear orphaned of diegetic focalization, it is best to look more keenly for traces of the repressed focalizer. In *Nana,* this trace is the horror of the sight itself; its motivation, the misogyny that permeates the novel.[43]

I began this section with a remark on the ethics of reading that is involved in assessing the function of description, and the motivation of which is the trace of the misogyny. The relevance of such ethics is especially great when we realize that description is the producer of the world in which events and the experiences they trigger—horrific, pleasurable, sublime—can take place. Hence, even if the reader is focused on the events, the "narrative proper," the descriptions inflect the nuances of that readerly focus. Moreover, as W. J. T. Mitchell contends in what is to my mind his most profound reflection on visuality, description is, precisely, the site where this hierarchy between narrative and description breaks down. He makes this suggestion in an analysis of the American genre of slave narrative. He elaborates the bold and, in some ways, shocking parallel between description's place in slave narrative, where it is overwhelmingly predominant due to the slave-author's position as a narrative agent deprived of time and memory, and description's traditional position as the slave of narrative.[44]

This parallel is more than just empty play, however. In Mitchell's argument, slave narrative as a genre becomes as essential to, and as generative of, the novel as description, which I propose here as a discursive form. For slave narrative—the narrative produced by a narrator confined to space and deprived of time—is predominantly descriptive. Mitchell writes: "Description might be thought of as the moment in narration when the technology of memory threatens to collapse into the materiality of its means" (1994, 194). He continues his analysis with the contention that the emergence of description from the spatial and visual order poses the conditions under which narrative is possible. Yet the same conditions explain why description and memory are considered the slaves of narrative.

> Memory is a technology for gaining freedom of movement in and mastery over the subjective temporality of consciousness and the objective temporality of discursive performance. To lack memory is to be a slave of time, confined to space; to have memory is to use space as an instrument in the control of time and language. (1994, 194)

Whereas real slaves and their conditions cannot, of course, be compared to the discursive slavery in which description is thus imprisoned, the shared features of commodification and contempt, exploitation and dispossession, do suggest that the contempt for description and the attempts to minimalize its importance are not innocent aesthetic issues.

Frederick Douglass—whose retrospective slave narrative has become the paradigm of that genre as Zola's novels have for naturalism and Proust's *Recherche* has for the modernist novel—elaborates on the ethical and political impact of reading throughout his tale, *Narrative of the Life of Frederick Douglass, an American Slave, Written by Himself*. Learning to read was his weapon to gain freedom. His self-mastery is most significantly performed when he discusses this importance of reading—and the slaveholder's interest in preventing it—in a description, however. As a double conquest of freedom, the description is of his mistress, and it is ironic:

> In entering upon the duties of a slaveholder, she did not seem to perceive that I sustained to her the relation of a mere chattel, and that for her to treat me as a human being was not only wrong, but dangerously so. Slavery proved as injurious to her as it did to me. When I went there, she was a pious, warm, and tenderhearted woman. . . . Slavery soon proved its ability to divest her of these heavenly qualities. Under its influence, the tender heart became stone, and the lamb-like disposition gave way to one of tiger-like fierceness. The first step in her downward course was in her ceasing to instruct me.[45]

In terms of discursive typology, this passage merges narrative, description, and argumentation, with the latter representing the primary goal of the text's production. The characterization of the woman borrows the discourse of sentimentality so widespread in mid-nineteenth-century America.[46] The argument aims to persuade the readers of the close bond between freedom and reading: hence, of the interests of maintaining slavery and ignorance in mutual support of each other. The narrative called upon to make the argument contains the events of incipient instruction and its untimely ending. The means through which this narrative is made possible, however, are primarily descriptive. The initially good woman becomes a fierce enemy and, as Nana, the initial beauty becomes a monster in death. Initial qualities are never stable; under social, political, and economic pressures, they decompose. The slave owner's wife simply *cannot* remain kind in a world of economic exploitation; the beautiful young woman *cannot* remain beautiful in a world of sexual exploitation. The narrative of the slave cannot be told by the slave, but only retrospectively by the former slave, writes Mitchell (1985). Likewise, the narrative cannot be told qua narrative: only by *its* slave—description. The relationship between these two intertwined discursive forms becomes even more entangled when we realize that Douglass's retrospective narrative becomes a true novel thanks to the play with the simultaneous and retrospective narration that allows the descriptions to be polyphonous. Irony, as the final section proposes, demonstrates most clearly the novel's world-making capacity when it affects the representational power of description. Douglass's mistress has power over her slave in the fabula, but it is the slave who holds her in his descriptive spell. He can make her or break her. She, and her world of power, crumbles under his descriptive hold.

If place-plus-character constitute the world in which narrativity can unfold and on which the latter is entirely contingent, then "types" of description come forward as based on that relationship. Some have proposed—and, significantly, passionately insist upon—the possibility of zero-focalization, hence, of zero description. As I have argued here, the relationship between description and its necessary focalization can, at most, be repressed. That repression, then, becomes the primary feature of the description. Related to this is the description generated by the traveling gaze of an external focalizer, who fails to receive recognizable embodiment but who, in fact, anticipates or otherwise represents particular characters' visions. The description of Yonville in *Madame Bovary* that follows the devastating ending of the first part of the novel—"Quand on partit de Tostes, au mois de mars, Mme Bovary était enceinte"—is a case in point. This description deserves close analysis because it is constituted by the traveling gaze that generates it, or rather, the gaze of the travel guide, of which the universally knowledgeable Monsieur Homais is a prime example.

This procedural description—remember Achilles' shield-in-the-making—is a typical case of naturalizing mimesis. While the character manipulates an object, the latter emerges for the viewer to see. The beginning of Zola's *L'Assommoir* (1965 [1877]) displays an entirely theatricalized fight between two women competing for the man who will bring the downfall of the winner. This is the occasion of the descriptive thrust that conjures up the women, the place, the onlooking crowd, and the bone of contention; after that the story can unfold. Of course, this rudimentary typology of descriptions, being increasingly activated by the focalization that connects discourse to fabula, can be as artificial as it can be naturalizing. The emerging world appears, or is made to appear, so fleeting, however, as to accommodate Roland Barthes's formulation of seduction as "the staging of an appearance-disappearance." In other words, between the naturalization of the diegetic world and its theatrical, artificial mise-en-scène, there is a fine line that is constantly transgressed by fiction, leaving it up to the reader to go along in one direction or another.[47] The artificiality at stake is well known to the reader of novels. It, in fact, conforms with Emma's ways of world-making.

Emma (the end)

. . . mais, tout en cousant, elle se piquait les doigts, qu'elle portait ensuite à sa bouche pour le sucer.

Charles fut surpris de la blancheur de ses ongles. Ils étaient brillants, fins du bout, plus nettoyés que les ivoires de Dieppe, et taillés en amande. Sa main pourtant n'était pas belle, point assez pâle, peut-être, et un peu sèche aux phalanges; elle était trop longue aussi et sans molles inflection de lignes sur les contours. Ce qu'elle avait de beau, c'étaient les yeux: quoiqu'ils fussent bruns, ils semblaient noirs à cause des cils, et son regard arrivait franchement à vous avec une hardiesse candide.

Une fois le pansement fait, le médecin fut invité . . . (49)

One remembers the scene where Emma and her would-be lover Rodolphe are sitting on a balcony to watch the annual parade-cum–agricultural fair, *les commices agricoles*. The moment is well chosen so that Rodolphe can implement his Don Juan method in order to break Emma's straight way of life, for heterogeneity reigns. While his lover's platitude-ridden discourse runs through the noisy and smelly air, other voices praise a maid for lifelong servitude rewarded by a paltry medal, cows suitable to be slaughtered, and the weather. Moreover, the totally incongruous combination of discourses imitates and parodies that of Zola's *Le ventre de Paris*, where cheeses are cataloged as the voices of the market cry out in

all directions. Romantic discourse, Flaubert's prime target, is properly framed—by vulgarity, hypocrisy, and banality.

On a more modest scale, the description in which Emma, still Mlle Rouault and still watched by the mesmerized country doctor Charles, is literally detailed and judged. Here, the heterogeneity is double: narrative and description mingle and motivate each other, and the charmed lover's focalization is undercut by the ruthless "objectivity" of the faceless focalizer. Charles's surprise is an event; the whiteness of the nails is a state. White is offset against the red blood; the black hair, which completes the portrait of Snow White and inserts the perversion of fairy tales, is understood by implication. Emma's sucking her finger and later inserting her tongue into the small glass to finish the last drop of liqueur point to the extent of Charles's erotic fantasy. Brilliant, cut in an almond shape, ivory: we see idealization a mile away. But whose focalization is put forward in the "however" of "Sa main pourtant n'était pas belle"? Are we supposed to think that this man, in love and endowed with mediocre intelligence and little subtlety, is detailing and weighing what is and is not pretty about Emma? In retrospect, then, would he be sophisticated enough to envisage the kind of ivory of the metaphoric network put in place around the nail? Suddenly, it all falls apart. Not only is Emma epideictically detailed to death by incoherence; so is the discourse that describes her.

Whoever says heterogeneity, thinks Bakhtin. Indeed, the scene of the *comices agricoles* is a perfect emblem of this philosopher's view of language use in general and of novelistic discourse in particular. For Bakhtin (1968, 1970, 1981), the point is that the novel mixes discourses that originate from all kinds of social strata. For Flaubert, once discourses show their messiness, there is no stopping the heterogeneity machine, against which characters do not stand a chance. Emma can only die in the end, and even then there is the blind beggar's song that destroys the moment of sublime suffering. For the present inquiry into description in the novel, it matters that this heterogeneity comprises both history—in the ever-present parody that denaturalizes the fabula—and discursive modes. Description is not only a narrative motor, as in Zola, but also a narrativity machine run wild. Only narrative motivation can offer a semblance of containment, and it does so through the deployment of a multilayered form of deixis.

Look again at this relatively simple quotation. "Charles fut surpris," hence, the poor man is bound hand and foot to the spectacle that follows even if he cannot control it. The primary framing suggests at first sight that the narrative embeds the description: Charles watches; Emma sucks; the description of her nails follows. The detail of the nail asks for the larger detail of the hand, presented in the generic singular, which freeze-frames it. But once both Charles and the external "focalizee," the seeing reader, have been sucked into the fabula by this

stitching together of the two discourses, the mastermind of the perverse negativ-ity—*pourtant*—shows his hand and points out that the spectacle is staged for the deception of the male victim of fate. The hand is not pale enough. But by what standard? It is too dry and too large. The devastating judgment "sans molles in-flection de lignes sur les contours" weaves into the lover's gaze the discourse from beauty parlors, *variété,* and ladies' magazines and sets Emma's mediocrity against this. Once this devastation is achieved, however, we are confused yet again when the idealization reclaims the power to look. The beauty she did have—the de-scription contradicts the critique—was in the eyes. There is no comfort even in heterogeneity.

The enumeration of elements to form, shape, and contrive a whole object shipwrecks halfway and leaves the object in pieces. Instead of *its* wholeness, we have the fragile totality of Charles's paltry infatuation and a novelistic situation that is no more whole than poor Emma's body. Instead of the mechanism through which anchoring is possible, so that the object described "exists" within the nar-rative world and the description becomes a recapitulation or reformulation of an element assumed to have prior existence, we have elements tied to other elements that "exist" on different ontological levels. Flaubert's postmodernism *avant la lettre* will inspire Proust's.[48]

Through the triple contributions of aspectualization, modalization, and sub-jectivization, three levels of binding description and narrative make the former fundamentally deictic. Even if we weep for Emma when she completes her grad-ual self-destruction, we are left with no figure except the one whose universe fails to sustain her. What we end up with, in Marc Eli Blanchard's view, is a mixture of style, world/self, and desire. Deixis versus reference: the fragment on Emma's hands displays, like a user's guide, the functions of description in relation to the act of reading the novel. It is no coincidence, then, that the master novelist is also a master ironist. Flaubert offers irony as a semantic theory of the novel.[49] As a re-sult, the emblem of readability that description appears to be solicits a decoding of hidden meaning. It also leads to an awareness of an inability to read, however. One of description's functions in reading as a cultural activity is temporalization. Deceleration, not stopping, makes acceleration possible. Without description, there is no narrative and, more importantly, no way to read narrative.

We can now contemplate what a "descriptology" for a history of the novel might comprise. Intuitively, description's critics have known it all along: de-scription is dangerous and must therefore be resisted. Like education for slaves, it opens doors that no violence or rules can ever close again. Descriptions are endless, and they betoken the endlessness of the novel. The compulsion to natu-ralize them through framing is symptomatic of descriptive fear; descriptions must be contained because they are, by definition, boundless. The metadeictic

function flaunts this paradox self-critically. The object cannot be pinned down either, as I have argued through Proust's elusive object of obsession. This apodeictic aporia made the need to bind clearer at the same time that the impossibility to do so became obvious.

Description has always been a problem because its anarchy seemed violent. Ekphrasis, as constative killing through epideictic detailing, emblematizes the force of descriptive discourse. Epideixis works when the object is detailed. But that murderous decomposition also affects the novel itself qua discourse for the novel falls apart into descriptive detail. This raises the question of mastery over time (slave narrative) as the paradigmatic stake of the novel. All five strands of my quest end in the same predicament: the impossibility to delimit that is inherent in the impossibility to disentangle; by binding, description unbinds. Look again at *Madame Bovary*.

Significantly and, in view of *Nana*'s disturbing end, unsettlingly, Emma's death is not the end of the novel. Both the beginning and the end are emphatically outside the frame of diegesis. The beginning, which still contains the trace of the narrator—the unforgettable description-narration duet of "nous étions à l'étude quand le proviseur entra"—precedes the novel, while the end, extending beyond itself, lies beyond the end. This is true for both the fabula and the discourse, which includes all manner of discourses within its voracious genre. It is within this tension between a text with a beginning and an end, aesthetically correct according to Aristotle's *Poetics,* and an unlimited texture, whose deictic tightness obeys no laws of nature or reality, that the nature of the novel lies.

The analysis of description proposed by structuralist theory can be usefully reframed and recuperated for a historical deployment of such an overly bold generalization. Think of David Lodge's historicizing typology based on the different deployments of tropes (1977). His analysis is limited to rhetorical figures but can be extended to the forms of deixis-run-wild that we have observed in Flaubert. For these tropes stand as synecdoches for the heterogeneity of worlds, a heterogeneity that expands as each era denaturalizes what its predecessors have painstakingly bound together. A descriptological history of the novel thus becomes a history of binding. Description binds elements and aspects otherwise disconnected, whatever their ontological status. What needs binding, what appears to be disconnected, depends on the relationship between the novel and the world (of the readership). This turns description into a form of world-making that is distinct in yet another sense from the illusory sense of mimetic representation. There is nothing realistic about this world-making. On the contrary, fiction makes worlds and, hence, undoes (the self-evidence of) that form of world-making we think that we know.

Notes

Originally published in Italian as "Descrizioni, costruzione di mondi e tempo della narrazione," in *Il romanzo*, vol. 2 of *Le Forme*, edited by Franco Moretti (Milan: Einaudi, 2002), 189–224. Published in English in *Narrative Theory: Critical Concepts in Literary and Cultural Studies*, vol. 1, edited by Mieke Bal (London: Routledge, 2004), 341–88.

1. According to logic, the many descriptions that language users forge can be either definite, indefinite, or demonstrative. See Neale's extensive discussion of Russell's famous 1905 article on the subject (1990).

2. On criticism of description, see Genette's famous article "Frontières du récit" (1969); Hamon's classical studies (1981, 1991); and Adam (1993). For the logic of the supplement, see Derrida (1967).

3. On *Tess*, see, among many others, Bullen (1986), Tanner (1968), and Vigar (1974); see also Miller (1970) for emphasis on, respectively, the relationship between visibility and mood, the reality effect this relationship produces, and the manipulations of focalization that bring these effects about. Irwin (2000) takes this visuality in Hardy's novels as a pictorialism close to visual art.

4. The space available here prevents me from going into the debate on experience's trickiness. I must, however, refer to two key publications from feminist cultural theory that question the validity of experience as an analytical category. Although feminism is not at issue in this essay, the arguments against the self-evident appeal to experience would be useful cautionary tales for any literary scholar or critic who considers narratology "counterintuitive" or inadequate to account for the reading experience. See Scott (1991) and de Lauretis (1983).

5. Caserio (1999) foregrounds chance in the modernist novel in England. Banfield (2000) probes and complicates facile characterizations of the modernist novel as subjectivist.

6. In *Souvenirs d'égotisme*, Stendhal complained that the boredom of writing descriptions distracted him from writing novels. Gide's narrator in *Les faux-monnayeurs*, who indicts description for hindering the imagination, phrases the more common complaint. While expressed by writers, both complaints point to readerly difficulties that I prefer to call "boredom."

7. On narrative drift, see Chambers (1999).

8. I have put these grammatical "persons" in quotation marks because of the logical problem of the notion of speaking "in the third person" (explained in Bal 1997b), and because of the ideological problems of the concept of "voice" for grammar, suggested by De Man (1979).

9. McHale makes this claim about Faulkner's late novels, such as *Absalom, Absalom!* (1987). Since I wish to use the term "postmodern(ist)" in a specific sense, not as a *pass-partout* for things contemporary, I refer the reader to Van Alphen's analysis of the term's current uses (1989).

10. Quoted in Adam (1993, 60; my translation).

11. Adam refers to Perrine Galand-Hallyn's study of Virgil (in Meyer and Lempereur 1990).

12. Among those who complained about this feature of description is André Breton (in his first surrealist manifesto), but he was neither the first nor the last to do so (Adam 1993, 22).

13. Sara Payson Parton, "Leta: A Sketch from Life," in *Fern Leaves*, quoted and commented on by Hamilton (1998, 145).

14. As paraphrased by Adam (1993, 60).

15. See Miller (1995).

16. Modernist literature is known to be "difficult" and, perhaps for that reason, elitist. Yet having heard of a student's grandfather (a postman), who after fifty-odd years still never goes to sleep without first reading a few pages of *La recherche,* and having met a high school teacher who reads the entire four thousand pages every year anew, I suggest we suspend even such democratically intended judgments.

17. The distinction between "being" and "doing" is part of the traditional narratological distinction between elements subject to description and elements subject to narration. See Rimmon-Kenan (1983).

18. This qualifier refers to the triple activity of *showing*: pointing, arguing, and self-exposing. See the introduction to Bal (1996), based on Nagy (1979).

19. The concept of *ground* refers to the foundation of meaning production: the reason why a sign is given a specific (kind of) meaning: "it stands for that object, not in all respects, but in reference to a sort of idea, which I have sometimes called the *ground* of the representamen" (Pierce in Innis 1984). The way the concept works is most clearly explained in Peirce's typology of signs on the basis of grounds (Innis 1984, 9–10).

20. On this production of characters and the fabula of love in Proust, see Bal (1997a), esp. part III. For all narratological terms used in this essay, see Bal (1997b).

21. References are to the Scott-Moncrieff and Kilmartin translation (1981). Emphasis is added unless otherwise indicated.

22. Although space prevents me from following his example here, I wish to suggest that an analysis similar to that of the fountain by Hubert Robert in the garden of the Prince de Guermantes would readily bring to light the rhetorical tightness of this descriptive passage (White 1999).

23. One of the motivations for the negative judgments that accompany the descriptions—in terms of both social class and ethical judgments—is the continuous adjustment that problematizes appearance. Another, I contend, is to isolate for consideration the ethics of representing the other as such, which ultimately leads to an ontological assessment. See Bal (1997a).

24. In spite of his impassioned engagement with and emulation of visual representation, Proust's suspicion of description is often, as here, also continuous with Jewish cultural attitudes toward images, which suspect them of seducing the reader/viewer into an excess, the excess of realistic belief. The religious variant of this excessive belief is idolatry. See Meltzer (1987).

25. This creative deployment of grammar finds a reversed parallel in the unexpected plural of the title of this novel: *À l'ombre de jeunes filles en fleurs.*

26. Proust ridiculed more classical descriptions—of entities more stable than characters, e.g., of buildings or nature, as in his own boyhood description of the church of Combray. He also experimented with such descriptions more constructively (Genette 1972). I am interested, here, not in Proust's theoretical and critical views on descriptive literature, but in his novelistic solutions to the problems of description.

27. For the strong sense of the concept of ambiguity and its relevance for the novel, see Rimmon (1977). On Proust's Vermeer passage, see Didi-Hubermann (1990).

28. Shakespeare, *The Rape of Lucrece,* 1382–93.

29. He wrote only two narratives: *Venus and Adonis* and *The Rape of Lucrece.*

30. These remarks are further developed in my article "Aestheticizing Catastrophe" (2005); Spitzer (1983); Benjamin (1977).

31. In fact, this murderous rage is a *locus classicus* of the notion that the Oedipal complex is as much the father's problem as it is the son's.

32. For more on the interaction between words and images in this poem and the issue of (self-)exposure in it, see Bal (1996, chap. 7).

33. Wagner (1996, 2).

34. Mitchell (1994, 157 n. 19): "all ekphrasis is notional, and seeks to create a specific image that is to be found only in the text as its 'resident alien.'"

35. Wagner (1996), usefully, compares ekphrasis to "cousins" such as "iconotext" and "intermediality." "Iconotext" is the use of an image (by way of reference or allusion to, in an explicit or implicit way) in a text or vice versa. This is more widely termed *imagetext* (15), while *intermediality* refers to "the 'intertextual' use of a medium (painting) in another medium" (17).

36. See Calame (1991) for this interpretation of ekphrasis. On the function of the detail in the novel, see Schor (1987).

37. For a detailed analysis of this text, and this passage in particular, see Bal (1996, 225–54). See also Fineman (1991) on the "subjectivity effect" (his term) in this "proto-novel" (my term).

38. Procedural description is the second category distinguished by Adam, after "description of a scene or a tableau" and before "description d'une promenade" (1993, 76–81). Clearly, Adam's stylistic typology is entirely based on narrative integration, called *motivation* by Hamon (1981). For a relevant analysis of this prototypical case, see Sprague Becker (1995). For a general reflection on ekphrasis from various angles, see Wagner (1996), Krieger (1992), Mitchell (1994), and Heffernan (1993).

39. The viewer is only presumably male; among the spectators in the theater is also the young woman Satin, Nana's future lover, who is equally fully described.

40. Harter (1996, 15, 15, 25).

41. This last sentence is meant to encourage a retrospective rereading of Hamon's structuralist work as relevant for a poststructuralist reading. My own discomfort with my earlier *Narratology* notwithstanding (expressed in the revised second edition, 1997b), it seems counterproductive to abandon the structuralist thrust presented in such key works of narratology as Hamon's books.

42. Apropos of a discussion with Gérard Genette, I have argued against the epistemological leap involved in narratological typology (1991). Hamon (1981, 1991) looks especially to texts of readability, according to Barthes's conception of readerliness versus writerliness. Lodge (1977) offers a rhetorical typology that can usefully be integrated with Hamon's. In *Narratology* I have attempted a synthesis of both (1997b, 36–43).

43. And, even more so, its reception. The fact that Nana is involved in a lesbian relationship is, unfortunately, not indifferent to some readers' responses. See my comments on this (1996, chap. 6).

44. Mitchell is one of the key figures in so-called word-and-image studies. Before attention to visuality became so generalized in literary and cultural studies—i.e., before the turn to visuality—Mitchell wrote such key books as *Iconology* (1985), still crucial today to this interdisciplinary field.

45. Douglass (1982 [1845], 81–82).

46. See Tompkins (1985).

47. Barthes (1973, 19).
48. See Schor and Majewski (1984).
49. Blanchard uses this phrase (1980, 104–5).

References

Adam, Jean-Michel. 1993. *La description.* Paris: Presses Universitaires de France.
Alphen, Ernst van. 1989. "The Heterotopian Space of the Discussions on Postmodernism." *Poetics Today* 10 (4): 819–38.
Arnauld, A., and P. Nicole. 1981 (1662). *La logique ou l'art de penser.* Paris: Vrin.
Bakhtin, Mikhail. 1968. *Rabelais and His World.* Translated by H. Iswolsky. Cambridge, MA: MIT Press.
———. 1970. *La poétique de Dostoievski.* Translated by Isabelle Kolitcheff, introduction by Julia Kristeva. Paris: Editions du Seuil.
———. 1981. *The Dialogic Imagination.* Edited by Michael Holquist. Translated by Caryl Emerson and Michael Holquist. Austin: University of Texas Press.
Bal, Mieke. 1991. *On Story-Telling: Essays in Narratology.* Sonoma, CA: Polebridge Press.
———. 1996. *Double Exposures: The Subject of Cultural Analysis.* New York: Routledge.
———. 1997a. *The Mottled Screen: Reading Proust Visually.* Translated by Anna-Louise Milne. Stanford, CA: Stanford University Press.
———. 1997b. *Narratology: Introduction to the Theory of Narrative.* 2nd rev. ed. Toronto: University of Toronto Press.
———. 1999. *Quoting Caravaggio: Contemporary Art, Preposterous History.* Chicago: University of Chicago Press.
———. 2005. "Aestheticizing Catastrophe." In *Reading Charlotte Salomon,* edited by Monica Bohm-Duchen and Michael Steinberg. Ithaca, NY: Cornell University Press.
Banfield, Ann. 2000. *The Phantom Table: Woolf, Fry, Russell and the Epistemology of Modernism.* Cambridge: Cambridge University Press.
Barnes, Djuna. 1936. *Nightwood.* With an introduction by T. S. Eliot. London: Faber and Faber.
Barthes, Roland. 1973. *Le plaisir du texte.* Paris: Editions du Seuil. Translated by Richard Miller as *The Pleasure of the Text.* New York: Hill and Wang, 1975.
———. 1976. *S/Z.* Translated by Richard Miller. New York: Hill and Wang.
Bartsch, Shadi. 1989. *Decoding the Ancient Novel: The Reader and the Role of Description in Heliodorus and Achilles Tatius.* Princeton: Princeton University Press.
Benjamin, Walter. 1977. *The Origin of German Tragic Drama.* Translated by John Osborne. London: New Left Books.
Blanchard, Marc Eli. 1980. *Description: Sign, Self, Desire. Critical Theory in the Wake of Semiotics.* The Hague: Mouton.
Brooks, Peter. 1984. *Reading for the Plot: Design and Intention in Narrative.* New York: Knopf.
Bullen, J. B. 1986. *The Expressive Eye: Fiction and Perception in the Work of Thomas Hardy.* Oxford: Clarendon Press.

Calame, Claude. 1991. "Quand dire c'est faire voir: L'évidence dans la rhétorique antique." *Etudes de Letrres* 4.

Caserio, Robert. 1999. *The Novel in England, 1900–1950: History and Theory.* New York: Twayne.

Chambers, Ross. 1999. *Loiterature.* Lincoln: University of Nebraska Press.

De Lauretis, Teresa. 1983. "Semiotics and Experience." In *Alice Doesn't: Feminism, Semiotics, Cinema,* 158–86. London: Macmillan.

De Man, Paul. 1979. "Semiology and Reading (Proust)." In *Allegories of Reading: Figural Language in Rousseau, Nietzsche, Rilke, and Proust,* 57–78. New Haven, CT: Yale University Press.

Derrida, Jacques. 1967. *De la grammatologie.* Paris: Editions de Minuit. Translated by Gayatri Chakravorty Spivak as *Of Grammatology.* Baltimore: Johns Hopkins University Press, 1976.

Didi-Hubermann, Georges. 1990. "Appendice: Question de détail, question de pan." In *Devant l'image: Question posée aux fins d'une histoire de l'art,* 271–318. Paris: Editions de Minuit.

Douglass, Frederick. 1982 (1845). *Narrative of the Life of Frederick Douglass an American Slave, Written by Himself.* Edited by Houston Baker Jr. New York: Viking Penguin.

Fineman, Joel. 1991. *The Subjectivity Effect in Western Literary Tradition: Essays toward the Release of Shakespeare's Will.* Cambridge, MA: MIT Press.

Genette, Gérard. 1969. "Frontières du récit." In *Figures II,* 49–70. Paris: Editions du Seuil.

———. 1972. "Métonymie chez Proust." In *Figures III,* 41–66. Paris: Editions du Seuil. Translated by Alan Sheridan as *Figures.* Vols. 1–3. English Selections. New York: Columbia University Press, 1982.

———. 1980. *Narrative Discourse: An Essay in Method.* Translated by Jane E. Lewin. Ithaca, NY: Cornell University Press.

———. 1983. *Nouveau discours du récit.* Paris: Editions du Seuil.

Hamilton, Kristie. 1998. *America's Sketchbook: The Cultural Life of a Nineteenth-Century Literary Genre.* Athens: Ohio University Press.

Hamon, Philippe. 1981. *Introduction à l'analyse du descriptif.* Paris: Hachette.

———. 1983. *Le personnel du roman. Le système des personnages dans les* Rougon-Macquart *d'Émile Zola.* Geneva: Droz.

———. 1991. *La description littéraire. Anthologie de textes théoriques et critiques.* Paris: Macula.

Harter, Deborah. 1996. *Bodies in Pieces: Fantastic Narrative and the Poetics of the Fragment.* Stanford, CA: Stanford University Press.

Heffernan, James A. W. 1993. *Museum of Words: The Poetics of Ekphrasis from Homer to Ashbery.* Chicago: University of Chicago Press.

Innis, Robert E., ed. 1984. *Semiotics: An Introductory Anthology.* Bloomington: Indiana University Press.

Irwin, Michael. 2000. *Reading Hardy's Landscapes.* London: Macmillan.

Johnson, Barbara. 1980. *The Critical Difference: Essays in the Contemporary Rhetoric of Reading.* Baltimore: Johns Hopkins University Press.

———. 1987. *A World of Difference.* Baltimore: Johns Hopkins University Press.

Krieger, Murray. 1992. *Ekphrasis: The Illusion of the Natural Sign.* Baltimore: Johns Hopkins University Press.

Lodge, David. 1977. "Types of Description." In *The Modes of Modern Writing,* 93–103. London: Edward Arnold.

McHale, Brian. 1987. *Postmodernist Fiction.* London: Methuen.

Meltzer, Francoise. 1987. *Salome and the Dance of Writing.* Chicago: University of Chicago Press.

Meyer, Michel, and Alain Lempereur, eds. 1990. *Figures et conflits rhétoriques.* Brussels: Editions de l'Université de Bruxelles.

Miller, J. Hillis. 1970. *Thomas Hardy: Distance and Desire.* Cambridge, MA: Harvard University Press.

———. 1995. "Narrative." In *Critical Terms for Literary Study,* ed. Frank Lentricchia and Thomas McLaughlin, 66–79. Chicago: University of Chicago Press.

Mitchell, W. J. T. 1985. *Iconology: Image, Text, Ideology.* Chicago: University of Chicago Press.

———. 1994. *Picture Theory: Essays on Verbal and Visual Representation.* Chicago: University of Chicago Press.

Nagy, Gregory. 1979. *The Best of the Achaeans: Concepts of the Hero in Archaic Greek Poetry.* Baltimore: Johns Hopkins University Press.

Neale, Stephen. 1990. *Descriptions.* Cambridge, MA: MIT Press.

Peirce, Charles Sanders. 1984. "Logic as Semiotic: The Theory of Signs." In *Semiotics: An Introductory Anthology.* Edited and with an introduction by Robert E. Innis, 4–23. Bloomington: Indiana University Press.

Proust, Marcel. 1987–89 (1913–27). *À la recherche du temps perdu.* 4 vols. Edited under the direction of Jean-Yves Tadié. Paris: Gallimard, Bibliothèque de la Pléiade. Translated by C. K. Scott-Moncrieff and Terence Kilmartin as *Remembrance of Things Past.* London: Penguin Books, 1981.

Rimmon, Shlomith. 1977. *The Concept of Ambiguity: The Example of James.* Chicago: University of Chicago Press.

Rimmon-Kenan, Shlomith. 1983. *Narrative Fiction: Contemporary Poetics.* London: Methuen.

Russell, Bertrand. 1905. "On Denoting." *Mind* 14:479–93.

Schor, Naomi. 1987. *Reading in Detail: Esthetics and the Feminine.* New York: Methuen.

Schor, Naomi, and Henry F. Majewski, eds. 1984. *Flaubert and Postmodernism.* Lincoln: University of Nebraska Press.

Scott, Joan. 1991. "The Evidence of Experience." *Critical Inquiry* 17:773–79.

Shakespeare, William. 1912 (1594). *The Rape of Lucrece.* Edited, with notes, introduction, glossary, list of variorum readings, and selected criticism by Charlotte Porter. New York: Thomas Y. Cromwell.

Spitzer, Leo. 1983. *Essays on Seventeenth-Century French Literature.* Translated, edited, and with an introduction by David Bellos. Cambridge: Cambridge University Press.

Sprague Becker, Andrew. 1995. *The Shield of Achilles and the Poetics of Ekphrasis.* London: Rowman & Littlefield.

Tanner, Tony. 1968. "Colour and Movement in Hardy's *Tess of the d'Urbervilles.*" *Critical Quarterly* 10 (Autumn): 219–39.

Tompkins, Jane. 1985. *Sensational Designs: The Cultural Work of American Fiction, 1790–1860.* New York: Oxford University Press, 1986.

Vigar, Penelope. 1974. *The Novels of Thomas Hardy: Illusion and Reality.* London: Athlone Press.

Wagner, Peter, ed. 1996. *Icons—Texts—Iconotexts: Essays on Ekphrasis and Intermediality.* Berlin: Walter de Gruyter.

White, Hayden. 1999. "Narrative, Description, and Tropology in Proust." In *Figural Realism: Studies in the Mimesis Effect,* 126–46. Baltimore: Johns Hopkins University Press.

Zola, Émile. 1965 (1877). *L'Assommoir.* Paris: Fasquelle.

———. 1897 (1882). *Nana.* Paris: Bibliothèque-Charpentier.

———. 1971 (1874). *La ventre de Paris.* Paris: Garnier-Flammarion.

Part 2 **Interdisciplinary Methodology**

5. Scared to Death

Le métaphorique ancre l'invention conceptuelle dans la culture. Du fait de la métaphore, là où le neuf abonde, le passé surabonde.
—*Judith Schlanger,* Les concepts scientifiques

The notions of fetishism and ideology, in particular, cannot simply be appropriated as theoretical instruments for a surgical operation on the bourgeois "other." Their proper use depends on an understanding of them as "concrete concepts," historically situated figures that carry a political unconscious along with them. —*W. J. T. Mitchell,* Iconology

When I say that I am scared to death that it is going to rain,[1] I don't mean that literally. I am not even really afraid at all. I just want to emphasize my irritation about standard Dutch weather by the use of an expression usually called metaphor. Metaphors are forms of language use that are somehow special in terms of meaning. How exactly is a matter of debate. I do not wish to contribute to that debate.

When poets use metaphors, we assume they do so to say something new—or to "say the unsayable." That is why metaphors are cognitively stronger than "normal" language use. In her novel *Le vice-consul,* French author Marguerite Duras repeatedly uses metaphors to describe the crowds which populate the Vietnamese landscape, like the following: "Sur le talus s'égrènent, en files indiennes, des chapelets de gens aux mains nues" ([date], 175). Roughly—as literally as possible—this means something like: "On the mounds, one after another, walk rosaries of people, bare-handed." What a terrible translation! The verb "s'égrener" is used for picking berries as well as for praying with rosaries. Small, identical units, one by one, one after another. Prayers, murmuring, endless: those are, for me at least, the most immediate associations of the combination "s'égrener" and "chapelets." Rosaries of people: one sees it in one's imagination. Long

queues; one after another; at equal distance; systematic, many, anonymous. This metaphoric use of language has doubtless semantic surplus value. Poetic metaphors can also have affective surplus value: they can be moving, aesthetically pleasing; they can even hurt one's feelings. Opinions vary about the cognitive surplus value. Although I do have my opinions about this and will advance these later on, I don't feel like entering this debate.[2] My concern lies elsewhere. I am not interested in the content or the adequacy of a particular theory, but in the question: "How to deal with theory?"—with both "deal with" and "theory" meant in the general sense. If I use a specific theory to broach this question, that, as much as the choice of the particular theory, is already a statement on "theory."

Scared to Death of Theory

Although the number of speakers scheduled suggests the opposite, the call for papers for the "Point of Theory" conference was received ambivalently by a considerable number of people. "What do I have to do with theory?/I am against theory/I don't know anything about theory" were three variations of the theme "no." And whereas the "no" was a constant element in these reactions, the alleged reasons were variable. "What do I have to do with theory?" indicates that the speaker doesn't see the "point" of theory. According to our call for papers, this was a very good topic for a talk, but nevertheless "no" was the answer. "I don't know anything about theory" refers to a sense of personal qualification, esteemed unfit for the conference. And "I am against theory" implies that one knows about it, but after having considered "theory," one judged it negatively. These are three good reasons to say "yes" to our call, and many, fortunately, have done so.

One person alleged yet another motivation for his "no": "Theory scares me to death." I found that interesting, and pressed the person for more information. He found theory intimidating, and its practitioners "tough" and "scary." Theory is difficult; the theorist speaks jargon; theory sets rules and thus functions like fundamentalism. Hence, the conference topic was "scary" and the person concerned "scared to death." Fortunately, we have been able to convince this person of the opposite: that his views and feelings were relevant, that we didn't mean that kind of dealing with theory, and that he should come to see. Which he did.

What was surprising about these responses is not their negativity but the taking for granted of a general notion of "theory"; a generalization which the conference title promoted by not specifying theory, yet challenged by asking for theory's "point." Apparently there is a general sense of what "theory" is. For some, theory is the opposite—or the "other"—of empirical inquiry; for others, of practice; for yet others, of interpretation. In other words—if I interpret these

"others" correctly—it is taken to be, respectively, free-floating, abstract, or objective. Yet none of the speakers at the conference speaks of theory in that way, and all of them argue in their theoretical discourse for some form or another of empirical analysis, practice, and interpretation.

Of course, we did not mean by "theory" such an authoritarian, threatening regulation for how "real science" should behave. We meant something that Jonathan Culler calls "the most convenient designation," the nickname even, for a somewhat messy interplay of interdisciplinary perspectives coming from linguistics, literary studies, psychoanalysis, feminism, Marxism, structuralism, deconstruction, anthropology, sociology.[3] While literary studies have been more seriously interested than before in what these disciplines and theoretical perspectives have to offer, conversely, these disciplines have become more interested in what makes their discourses "literary."

The interaction between disciplines through theory amounts to more than, to something different from, a mutual borrowing of methods; its issue is a fundamentally different conception of scholarly discourses, including theory. Nicely looking symmetrical phrases like "the death of metaphor and the metaphor of death" or, to make it worse, "the rhetorical grammatization of semiology and the grammatical semiotization of rhetoric," to play on De Man's wordplay, do have serious methodological consequences. I would like to argue that the negative attitudes toward theory, understandable as they may be in terms of individual histories, are the result of a generalizing use of language which I call metaphorical. This brings me back to the concept of metaphor which I will use here as a metaphor of theory-in-general.

Given the hybrid history of the field, the fact that metaphor is a favorite concept in literary theory can be seen as due to historical accident. It stems from classical rhetoric, and it belongs as much to law, literature, and linguistics, as to semiotics. This multidisciplinary background makes the concept of metaphor an appropriate metaphor for "theory" as Culler described it. For that same reason it has the potential as well as the problems of what Isabelle Stengers calls a "concept nomade." The word "metaphor" figures on moving vans in Greece. That fact makes us aware of its "literal" meaning of mobility and displacement and reflects the position of the concept between the disciplines, usefully illuminated by the idea of moving household goods. I would like to exploit the historical accident that metaphor is the privileged concept of literary theory, whereas elsewhere it is "just used" to argue, on yet another level of metaphoricity, for the point of (literary) theory within the scientific and, to a certain extent, social goings-on at large.

To make myself clear: I understand by metaphor the substitution of one term by another. The new, metaphorical term establishes similarity between the two,

on the basis of a difference that grounds the substitution. The substitution is somehow meaningful. Often, the new term brings to light new, unexpected meanings. But that is not necessarily the case. Duras's rosaries do that; the expression "scared to death" does not. Theories of metaphor differ in the delimitation and description of meanings which are replaced, added, and, I want to add, obscured. For some, only words are replaced; for others, entire frames of reference. I want to make this a bit more specific and focus on *narratives* imported by metaphors.

The notion that metaphors yield some sort of gain cannot hold in general. Often metaphors are used out of intellectual laziness, or to other effects. The Dutch high school jargon "cool" for everything positive relieves the speaker of the necessity to specify what is so positive. It is a metaphor, for it substitutes the sense of touch—the domain of temperatures—to that other domain that remains unspecified and variable, but can be anything but temperature-related. The gain is that the speaker indicates that he or she belongs to a certain group—a group within which the metaphor is immediately understood. Hence, its meaning is double: positive evaluation and group identity. The "literal" meaning, say, a fresh temperature, recedes into oblivion.

Even abbreviations can be used like metaphors. Once upon a time I had to think before understanding "PC." Not even up to the use of the abbreviation for personal computer, my background in French studies always made me go through the detour of "Parti Communiste" before reaching "politically correct." Not that I don't *know* what it means; but I resist the group identity. I'd rather be into French than scared to death of PC. Yes, I know I am a bit behind. Not long ago—during the bulk of my American times—"politically correct" was a good thing; meaning that you take women and minorities into consideration when deciding things like appointments or the content of a course; the term had not yet been appropriated by the opponents of such considerations. In this public acceptance speech for my appointment at the chair of literary theory, with a personal qualification in women's studies in the arts, I would like to establish a connection between "theory," more specifically: theory of literature, the metaphorical expression "scared to death," and the problem of "PC." In other words: what do scholarship and society have to do with each other? And I want to build my argument around the concept of metaphor.

Metaphors as Narratives

A few years ago I had the privilege of collaborating briefly with physicist and philosopher of science Evelyn Fox Keller. Keller had made two studies of the connections between language and science. The first was about the way scientific in-

ventions and ideas are presented to the larger public. The study focused on the word "secret" as in "the secret of life." The second study was about the language in which biology continues to build on evolutionary theory. A central concept in that work was the term "competition," traditionally related to "struggle for life" and "survival of the fittest." The price to pay for this attention to competition was a lack of attention to collaboration, an evidently indispensable element in the sexual reproduction of organisms. One doesn't need to be a biologist to see that this privileging of one term over another has potential consequences for the further development of the theory itself.

In the first study the issue was the use of metaphors which one can still maintain to be "innocent," "just language": rhetorical. But the second study demonstrated that language cannot really be dissociated from the scientific theory itself, and that in that capacity it did influence the observations and manipulations the theory made possible. I will concentrate on the first study. It concerned the discourse the developers of DNA used to present the importance of their research to the public. That discourse was filled with words carrying a long tradition. Thus, the initial molecule was called mother-molecule, and nature was constantly referred to as a woman; the unknown which the project aimed to understand was "the secret of life," which had to be found, if necessary by means of violence (Keller 1989). And Keller interpreted this discourse as follows:

> And if we ask, whose secret life has historically been, and from whom has it been secret, the answer is clear: Life has traditionally been seen as the secret of women, a secret *from* men. By virtue of their ability to bear children, it is women who have been perceived as holding the secret of life. (1989, 4)

Here I limit myself to just one aspect of this discourse: the metaphorical one. I want to focus on the metaphor in that word "secret," that sounds too common and ordinary. Whereas the word "secret" in combination with life or nature has indeed become quite usual—just as usual as the expression "scared to death"— the word is here, I contend, metaphorical. For it is a substitute for something else, not a single term but, I will argue, a story. The difference between it and the equally common word "unknown" may be subtle, but it is relevant.

What is unknown, as the negating prefix suggests, can be known. The subject of that knowing is the researcher. What is secret can also be known. But here, the subject is not quite the researcher. The word "secret" implies an action, hence, a subject of withholding. If there is a secret, then somebody is keeping it. This fits into the network of gendered language in which nature and life are made feminine. And it implies a story in which secrecy is an act. "Secret" as metaphor for the unknown establishes an opposition between two subjects: the researcher

who wants to know the secret and "woman" who withholds it. This opposition is easily turned into hostility, as the well-known metaphor of Francis Bacon shows, who wanted to put Nature on the rack to torture her secrets out of her.

But this gendering of the unknown comes with a second aspect of the word "secret" which is of an altogether different nature. A secret that must be found out implies a process in which that finding out takes place. The series of events involved in that process can be considered a narrative. That narrative is "told" by the user of the metaphor. The narration is subjective in the precise sense of emanating from a subject. The word tells the narrative in the version—from the perspective—of the subject of "unknowing" who feels excluded by the lack of knowledge and experiences it as an action by an "insider," the subject of knowing and withholding. That subject is the narrator's opponent. This interpretation of metaphor as mini-narrative yields insight, not into what the speaker "means," but into what a cultural community considers acceptable interpretations; so acceptable that they are not considered metaphorical at all.[4]

Recently I ran into a comparable case in a special issue of the journal *Semeia* devoted to the connections between metaphors of war and women. Here, too, the inconspicuous metaphorical character of ordinary terms which carry a subjectivized narrative remained unnoticed (Niditch 1993). Since in this case the texts stem from an ancient culture, hence different from our own, the authors were careful not to project anachronistically contemporary norms onto the past. The case is somewhat complex but deserves the necessary explanation because it concerns a dilemma we come across all the time. The issue is the question whether in the ancient Middle East something like just war was thinkable, and whether rape could be an acceptable practice therein.

The author, Susan Niditch, struggles with the difficulty that ethical norms differ according to time and place, whereas the language in which we write about other cultures is also time and place bound. In that context she raises the question whether "just war"—in the biblical framework, "holy war"—is possible and, if so, whether or not in such a war the practice we call rape can have a place. Thus, she writes about the biblical book of Numbers:

> Of course, enslaving the enemy (20:11) and forcing its women into marriage are the terms of an oppressive regime and difficult to imagine under the heading of that what is just. (1993, 42)

The result of her reflection is not my point here. I am interested in, first, the notion "oppressive regime." The word "oppressive" is anachronistic in terms of the object under study—Numbers—and the stake of the struggle described is

hostility over land, not disagreement over human rights within the United Nations or something like that. The context in which Niditch's words were written makes the notion very much to the point: I read her paper during preparations for the Gulf War, at a time when the description "oppressive regime" almost inevitably referred to Saddam Hussein. In other words, the description had a precise meaning including moral echoes and an imaginative and image-like resonance daily fed into on television—like a dream image. Without author and readers being aware of it, the description thus becomes metaphorical. It becomes a metaphor by means of which the Western present with its norms and values collapses with the Middle Eastern past, and this happens in a paper, in the very sentence, in which an explicit attempt is made to avoid such anachronisms.

Yet this is not my primary point. What concerns me in the sentence is that something, in the attempt, is carried over, a description, equally anachronistic by the way, of rape. The author wished to avoid that term because of its anachronism, and the concessive clause in which the description "oppressive regime" occurred was meant to help that avoidance. "Forcing its women into marriage" is Niditch's attempt to avoid the anachronism. She doesn't want to call the action rape, she argues, because in the culture under discussion, it was not perceived as such. Even if the war cannot be called just, the taking of women is culturally acceptable and therefore cannot be called rape. This is undeniably a sound argument. Except for one aspect.

In cultural anthropology this position would be called relativist; the not-so-felicitous alternative to ethnocentrism. This academic dilemma has been around for the better part of this century in the human and social sciences. It has a precise parallel in the social and political dilemma of moralism versus relativism (or "tolerance"); the imposition of one's own norms versus the acceptance of those of others, even if the latter are perceived as "oppressive." I would like to attempt, at least, to disturb that dilemma.

Niditch replaces "rape" with "forcing into marriage"; elsewhere, the action is called wife-stealing. As a cultural phenomenon it is in some cultures acceptable and ordinary and is known in anthropological and historical studies. I agree with Niditch that "rape" is an obscuring term that fails to address the cultural status of the event. Also, it seems pointless to accuse the biblical culture, three thousand years after the fact, of a violation of human rights and feel better about our own behavior. Yet the alternative is unacceptable to me. Rather, in the awareness and acknowledgment that the term is "ours"—and leads to a lot of disagreement in the culture I live in—I would like to take a closer look at the contested term "rape." In other words, I want to *confront* the phenomenon through the word we *would* use if we were to speak "ethnocentrically" and see what happens. That

confrontation, that collision, might be the most productive attitude toward the dilemma. It comes to what Gerald Graff, in his recent book about the American PC syndrome, calls "teaching the conflicts" (1992).

The word "rape," then. That word is more often used as a noun than as a verb—which is my first worry. It is one of those nouns which imply a story.[5] Here, I want to argue that, first, the word "rape" itself is a metaphor that obscures the story it implies and, second, that this obscuring locks us up in the dilemma that needs to be overcome.

Rape—the action for which we use that term: that of sexually appropriating another subject without her consent—has different meanings in different times and cultures. Its meaning depends on the status of, in particular, women in relation to men, and the status of the individual subject in relation to the community and its juridicial organization. It is thinkable that the action concerned is interpreted as rape by a part of the culture at stake, and not at all by another part. Cultures which differ from "ours"—it becomes harder and harder to use "us" and "ours" in this context—tend to look more homogeneous and more coherent at a distance than they probably are. That deceptive vision is, precisely, the basis of ethnocentrism. Therefore, I assume that within each community, large or small, ancient or recent, far or close, differences increase as one's vision approaches. This, mind you, is an assumption modeled on my own culture and could appear as ethnocentric; but it is a structural assumption, not a semantic one, and therein lies the important difference. My assumption also holds for the meanings of words and notions. "Rape" implies an event, if not an entire story with a number of episodes. It is a word that, in the words of Barbara Johnson, contains a "difference within": an internal divisiveness (1987, 1988).

Forging a noun out of a verb—nominalization makes the concept analyzable, discussable. That is a gain. There is also a loss. What gets lost from sight is the active character of the referent, the narrative of action including the subjectivities of the agents involved.[6] With the subject of action the responsibility for the action also disappears—with responsibility having a culture-specific meaning according to the status of the individual in it. Instead, the entire narrative remains an implication, skipped as it were, in the abbreviation that is the noun. The subject who uses the word is, say, the story's narrator. The subject whose vision is implied in the word is its focalizer. Then there are the actors. The process in which all these figures interact, the fabula, is dynamic: it brings about change. All this is lost when a noun is used instead of a verb which would necessitate their naming.

These aspects can be brought back into view by a narrative analysis of the noun. The narratological analysis of the term "rape" is not complicated, yet not unambiguous. We have to appoint a narrator. The subject of action, the rapist, needs to be mentioned. Then, there is the subject into whose body the action is

done, in whom it brings about change. Reflection on the nature and the extent of that change warrants an amount of attention not triggered by the noun. Then, who is the focalizer? Is it the rapist, who would be likely to call his action something else, or the raped one, the victim who experiences the action? Or is it the narrator, and if so, does this agent identify with either one of these two positions? The noun doesn't tell, and I don't want to answer the question in any general way. The point is in raising it. The realization of this narrative duplicity seems more productive than the unreflected choice for one of the possible answers. That, though, is what Niditch does by hastily adopting a description she considers more fitting for the ancient culture. That relativism is, in fact, condescendent. For if we take other cultures as seriously as our own, then the phenomenon in question deserves at least recognition as an event with "a difference within," an internal divisiveness which the quick narratological analysis clearly indicates.

"Rape," that seemingly simple and clear noun, can thus be seen as a grammatical metaphor: a term that replaces another. It is a case of the metaphorization of grammar; except that, just like Keller's "secret," it does not replace another term but an entire narrative. The item replaced and displaced, obscured, is a story with several agents, a variability of interpretation and a difference of experience. What is sex, or theft, or lawful appropriation for the one may still be a violation of the subjective integrity for another—whether culturally accepted or not; but who, then, is the culture? Such an analysis and recognition of the narratives and the subjective meanings they entail do, at least, disturb the academic as well as the social dilemma between ethnocentrism and relativism.

Comparing this case with the metaphor that represented people like rosaries, a striking difference appears. In the Duras passage the metaphor yielded many more meanings than any one "literal" description could convey. In the cases of "normal" words, the opposite happens. Here, too, a multiplicity of meanings is possible. But here the metaphor yields these meanings up only when it is considered as such. In other words, the *concept* of metaphor produces the insights. And this, then, brings us back to concepts, those theories in miniature.

The Concept of "Metaphor" and the Metaphor "Concept"

Metaphors are not vague, poetic oddities or decorations but fundamental forms of language use with an indispensable cognitive function, in addition to the more generally recognized affective and aesthetic functions.[7] Let me first indicate why it makes sense to consider theoretical concepts as metaphors. Metaphors have three aspects to them. Firstly, they substitute something for something else. This substitution establishes similarity between two items. That is meaningful be-

cause the new term illuminates something in the meaning of the first term—or, to the contrary, obscures something. The second term must differ from the first, bringing a new, different element or perspective. At the same time the metaphor must be understandable, semiotically acceptable. One must be able to connect the new element or perspective to the old term. Hence, some degree of similarity is needed. This similarity does not have to lie in the meanings of the term itself but may be brought in by the respective contexts of the two terms. The combination of similarity and difference makes for the new, the creative, the informational surplus of metaphor. That surplus is crucially important for concepts, for through the use of concepts the scholar is supposed to learn something new about the objects.

Secondly, metaphors displace meanings, redirect them to something else, for example, from the events to the subject that gives them meaning in an implicit narrative. This directing makes metaphor a powerful heuristic tool. Through that mobility of the "lens," all kinds of unseen and unforeseen aspects of the first term come to the fore. This "reach" of metaphor is very important for concepts. It enables these to produce, in addition to a surplus of information, a contextual network for the object. Thirdly, metaphors offer a second discourse within which the first term can be placed. Seeing masses of people like rosaries imports a religious, in this case Catholic, framework which raises all kinds of questions concerning poverty in Asia and the necessity to do something about it—as well as the way to do it, the issue of charity, so deeply religious a notion. Just as the expression "scared to death," but a bit less innocently, this metaphor brings two discourses and two frames of reference into collision. This aspect is best called framing. For concepts, especially those nomadic concepts that constitute the fragile foundation of interdisciplinary scholarship, this framing might well be crucial.

This standard theory of metaphor which, in its ambition to characterize concepts, becomes also an epistemology, is a kind of "searchlight theory." It is not so much meant to predict, explain, or generalize, but, to the contrary, to specify, analyze, get an eye for differences. Differences between objects and differences between the aspects of the concept as metaphor: differences within. Concepts, according to philosopher of science Isabelle Stengers, serve the purpose of organizing a set of phenomena, determine the relevant questions to be asked about them, and determine the meaning of the possible observations concerning them.[8] In that sense, concepts are theories and, hence, may be evaluated like theories. According to the summary of standard procedures for the evaluation of scientific theories Thomas Kuhn provides in his paper "Objectivity, Value Judgment, and Theory Choice," such evaluations follow a standard set of norms. A useful theory is accurate, is consistent, has a broad reach, is simple and produc-

tive (1986). Not that these norms are unambiguous, but as rules of thumb they serve their purpose reasonably well. Concepts can be judged according to the same norms.

But, as I said before, concepts are not only theories but also metaphors. And metaphors can yield intellectual gain when they raise new questions and suggest new perspectives. They can also entail loss when they are thematically closing and semantically vague. That was the case with the metaphors "secret" and "rape," which required analysis to bring back their obscured meanings. The same can happen with concepts. These, too, are liable either to obscure or to illuminate through their metaphoric work. Concepts are productive because, according to Stengers, they bring order and meaning to phenomena and make these "askable." But concepts are limiting, sometimes vague, the opposite of specifying that is. Concepts are not only theories but must also be judged as metaphors if we are to bring these aspects to light.

An example is the grammatical category of "voice." The term refers to the speaker of an utterance, the implicit or explicit "I" supposed to be speaking, and the form in which this subject speaks. In the first instance, the concept is helpful; for example, in the analysis of narratives, it entices the analyst to address the question "who speaks?" It is the question of responsibility for the meanings proposed to the reader or listener. Compared to classical structuralist semantics and narrative theories derived thereof, where meanings were seen as abstract units unrelated to, and hence unaffected by, the speaking subject, this is a good step ahead. The concept is also accurate, for there is indeed always a subject of speech, even if that subject is not alone and is internally divided. And the concept is productive, for it encourages asking further relevant questions. But it is also counterproductive. It is unhelpful when its metaphorical aspects are not perceived but still carried over: those "commonsense," self-evident meanings which produce dogmas. The concept of voice hangs together—is consistent—with a set of questions which have dogmatic status in the humanities. I would like to use the concept of voice to put that kind of dogmatism on the table.

Of course, with its connotation of bodiliness—embodiment—the term "voice" immediately brings to mind Derrida's critique of the preference for voice over writing. This preference, Derrida argues in *Of Grammatology,* partakes of a philosophy of language in which the illusion of immediacy as "pure" origin of language occupies center stage.[9] Here, I want to focus on the fact that the question of the subject—the productive yield of the concept—almost automatically entails the question of intention. The issue of intention is so dogmatic that it seems almost impossible to circumvent it and raise questions that are not derived from it. And yet intention is a psychological concept bound up with the modern

West, and it surely does not have a universal, uniform meaning. In other words, as a concept it behaves like "rape" (Bal 1992).

In a brilliant analysis of the rhetoric of a passage from Proust's *À la recherche du temps perdu,* Paul de Man demonstrates the confusion between grammar and intention that the concept of voice entails. In the passage he analyzes, De Man reads—rightly, I think—a poetical statement representing Proust's literary vision. The passage consists of a series of correspondences between inside and outside which together suggest that metaphor is the best way of achieving the poetic effect sought. The text itself, however, is basically metonymic, De Man claims.[10] I can only cite a fragment of the fragment here, but enough, I hope, to convey De Man's point:

> Cette obscure fraîcheur de ma chambre était au plein soleil de la rue ce que l'ombre est au rayon, c'est-à-dire aussi lumineuse que lui et offrait à mon imagination le spectacle total de l'été dont mes sens . . .
>
> [The dark coolness of my room related to the full sunlight of the street as the shadow relates to the ray of light, that is to say it was just as luminous and it gave my imagination the total spectacle of the summer, whereas my sense . . .][11]

In terms of structure, the imagery is more like the cliché "scared to death" than like the literary metaphor "rosaries of people." It is based on the complementarity of dark and light, which, paradoxically, makes dark more "illuminated," hence more "enlightened," brilliant, and wonderful to be in, than light itself. The juxtaposition of room and street, dark and light, inside and outside produces the meanings; not a similarity. Hence, the figuration is metonymical.

If we project the author's intention—his narrative as well as his argumentative "voice"—onto the grammatical "voice," then we must conclude that Proust fails. His text does not do what he says it should. De Man writes about this passage:

> The term *voice,* even when used in a grammatical terminology as when we speak of the passive or interrogative voice, is, of course, a metaphor inferring by analogy the intent of the subject from the structure of the predicate. (1979, 18)

It would of course be absurd to conclude that Proust fails as a writer because the concept is frustrating. Not because literature as an art is above and beyond theory. Nor because the choice to apply the concept of metaphor is only a "trial" that can demonstrate "error." But it would be absurd because the concept that raises the question of consistency between intent and practice is itself metaphorical. Hence, it cannot be "applied" as a dogmatically protected concept; what hap-

pens is a productive collision between two rhetorical figures, Proust's writing and the concept. The metaphor in the concept "voice," brought in unnoticed, collides with the metonymy through which metaphor is recommended.

The result of that collision is not a total loss. De Man draws attention to the paradox, which he calls, with a good sense for metaphor, a "state of suspended ignorance." Proust can write beautifully, but in his argumentation he is wrong, and that only enhances the tension, the density, the richness of his text. The concept, too, survives the accident, but it is irremediably damaged. The damage, however, is therapeutic. The meaning "intention" must be amputated. In this case, and to open up yet another metaphoric discourse, the literary text has pronounced sentence over the concept.

And yet. The insight in the text, the capacity to assess and savor its incredible complexity fully, came about thanks to the half-failed attempt to characterize it by means of this concept. Not in spite of, but thanks to the uncontrollable metaphoric potential of the concept. This collision could be a model—a metaphor—of the effect of theory in all those disciplines and perspectives which Culler mentioned in his definition of "theory," and which I call for convenience the "cultural disciplines." The violent metaphors I have used to describe this encounter serve a rhetorical purpose. I wanted to demonstrate the violence in the far-reaching effect of the concept "voice," which I was still able to evaluate partly positively, thanks to the attempt to make explicit what its metaphoric baggage is. I could also have appealed to the register of the erotic to characterize the encounter between Proust's text and De Man's theory, and then we could all have gone home happy. But then again, clarity would have been sacrificed; insight into the elimination of aspects that conceptual metaphors entail would not have been driven home.

There are, of course, other views of theories and concepts. Views according to which concepts are conceived of as instruments which can only succeed or fail because their precise content is beyond discussion. Views according to which concepts must not be metaphorical because metaphors entail a margin of vagueness and ambiguity. Such a view makes it hard to notice the metaphoricity of concepts, which, after careful screening, are judged acceptable. For example, the implication that grammatical voice and intention are conflated might remain obscured. I would, indeed, be scared to death of such a theory, wherein concepts remain out of critical reach and have no yield other than as a paraphrase of what is already known. Proust would be admired for his metaphors, because we already admired those. And because he advocates them himself, and the author is boss. Seemingly modest, put in the service of literature, such a concept is tyrannical, violent. Believing Proust at his word, such a concept overrules the words of the text Proust wrote.

Theory as Practice

Discussions of metaphor tend to be endless debates about which definition of metaphor is the most accurate, debates usually conducted through examples and counterexamples. In this paper I wish to stay far from such basically formalist detailing, which I leave gladly to others more expert than I. I am, instead, interested in the *effect* of the concept of metaphor, precisely in its lack of clarity, its vagueness, its ambiguity, its undecidability, and, by extension, of all concepts to the extent that they are by definition metaphorical. So far, the attempt to "name" an expression, however unfinished and dubious the results, has produced insight. Duras's description of Vietnamese people has shown more aspects, has yielded a plurality of meanings, has become itself a rosary of polysemes. The struggle with banal clichés has demonstrated how "normal" language use carries stories along.

To understand language use, we need concepts, and "metaphor" is such a concept. But concepts consist also of language, and their use is also language use. As my halfhearted attempts at analysis kept showing, a concept is not a ready-made mold, no matrix, model, pattern that yields automatically accurate descriptions of an object—here, language use. Most theoretical texts on metaphor present attempts to "fix" the concept in such a way. I want to advocate a different way of "doing theory"; one which I like to describe as "theoretical practice." In such a practice, the confrontation between concept and object is a kind of rubbing of two forms of language use against each other which changes both. In that sense, too, concepts are always also metaphors.

If the examples I have discussed—"scared to death" and "rosaries of people"; "rape" and "secret"—are any indication, metaphors are affectively as well as cognitively effective, and that effect is not limited to metaphorical signs themselves but also affects the discourse within which these are embedded; the meanings both discourses, together, produce. This, in turn, affects the cultural/analytical dilemma: the question is not whether "rape" is acceptable in one culture and not in another, but which subjects are obscured by such a term, what discourses these subjects evoke as soon as we analyze them into visibility.

Taking risks is the motto of an academic pursuit ready to face losing like a good sport. This is how Thomas Kuhn reasoned, in his analysis of scientific practices. It seems appropriate, then, to end on one of *his* metaphors; one which entails gain and loss. Kuhn discusses the responses to his book *The Structure of Scientific Revolutions*. In that review he refers to the classical distinction between "context of discovery" and "context of justification." Decisions made during the scientific research program and which lead to results are totally different from ones alleged to defend those results. Kuhn indicates how this distinction, in turn,

mystifies yet another context, which he calls the "context of pedagogy," in other words, the teaching of science: history of science, methodologies, philosophy of science, teachings that occur in some form or another in any academic pedagogical program.

This context is characterized by a substantial simplification in the representation of the process of research. Thus, examples in textbooks are not at all the cases which actually led to the discoveries they are alleged to illustrate, nor those used in defense of the result. The standard experiments hardly played any part in the decisions that led to the discoveries, nor in the formulation of theories about them. (Kuhn's examples are mainly from the sciences—like Foucault's pendulum, recently elevated to the status of overdetermined example in the humanities as well.)[12]

That the process of decision-making in the sciences is thus simplified doesn't bother Kuhn too much. But as a representation of the process of scientific decision-making such as the choice of theories, such a simplification does not provide a good basis for *analysis*. And here is his metaphor: "These simplifications *emasculate* by making choice totally unproblematic" (1986, 387; emphasis mine). I wholeheartedly subscribe to Kuhn's protest against simplification. Simplification is something altogether different than simplicity, that criterion for the evaluation of theories. These two differ as much as, say, covering a lot and empirical content. Dutch poet Lucebert once used the notion of simplicity in a poetical statement in a poem:

I try in poetic fashion
that is to say
simplicity's luminous waters
to bring to expression
the space of life in its entirety.[13]

Lucebert's poetic and poetical metaphor suggests that simplicity is illuminating and enlightening, as much as Proust's cool obscurity; simplification, in contrast, obscures. Instead of making more things, elements, aspects visible by illuminating complexities, simplifications render these things invisible. In this sense, "rape" is just such a simplification.

But "to emasculate" is a strong charge, bringing back, suddenly, the gender-specific perspective, the semantic domain of violence, and fear. Would "scared to death," then, be the precise expression for something profoundly disturbing? The metaphor "to emasculate" for simplification can trigger many associations and questions. Given its usual metaphoric-semantic network, it seems safe to assume that Kuhn is invoking impotence, powerlessness. Who, or what, loses its

power? If the lack of problematicity is nonmasculine, is it masculine to be problematic, to be, so to speak, in trouble? Is it masculine to find deciding difficult? And the overall question: What makes science so gender-specific? I give up answering these questions; it wasn't me who came up with the metaphor. Appealing to Kuhn's "voice" and his likely answer that he didn't mean the metaphor to be taken so dead seriously do not seem satisfying to me. But I do hear in Kuhn's metaphor an appeal to a group identity which does not appeal to me.

But what I can say is this: These questions can only be asked if the metaphor is, just like a concept, unprotected, up for grabs; only if neither the self-evidence provided by their cliché-ishness, nor the invulnerability provided by their artistic potential, stands, to use a Dutch expression, like a pole above water: fixed, certain, obvious. "To do theory" is a commerce with theoretical concepts and objects; it is attempting to analyze the objects with the help of the concepts as well as the other way around, not by "applying" concepts like tools but by bringing them into touch with objects, if necessary, into collision. When an analysis fails, new insight can still emerge; more new insight than when a protected concept is routinely applied. De Man's confrontation with Proust's dark room made that clear.

What, then, does theory have to do with "scared to death," on the one hand, and the problem of PC, on the other? Gerald Graff, in his less-than-radical recent book on the subject, advocates that we turn the problem PC into something productive by making the struggle into a starting point of academic teaching, including the structure of the curriculum. His description of theory is on the simplistic side, but not wrong:

> "Theory" . . . is what erupts when what was once silently agreed to in a community becomes disputed, forcing its members to formulate and defend assumptions that they previously did not even have to be aware of. (1992, 53)

Kuhn, I suppose, wouldn't mind this definition. At any rate, it does not at all refer to the kind of regulating with which austere methodologists of the kind I like to call "theo-theorists" tend to be obsessed, and of which others are "scared to death." In this sense, Graff's definition disarms the individual I staged at the beginning of this paper.

Graff's definition does not refer either to something that is often, but wrongly alleged to be equivalent to ideology; mostly by people who consider themselves as standing outside, or above, the clamors of PC-people. Those who are "against theory," in general, argue their position according to Graff and Culler—and I agree with that—by alleging that theory is ideological. But this resistance to theory is itself rather ideological. As Terry Eagleton formulated it:

Without some kind of theory, however unreflected and implicit, we would not know what a "literary work" was in the first place, or how we were to read it. Hostility to theory usually means opposition to other people's theories and an oblivion of one's own. (1983, 7)

Not that theory is different from ideology in any absolute way. The two share a family likeness: both are metaphors. But whereas the former illuminates because it specifies, the latter obscures because it simplifies. And whatever else Kuhn's metaphor says about simplification, it definitely does point at danger.

Those, finally, who find theory "too difficult," and themselves not knowledgeable enough, consider theory as something finished, complete, something you can succeed or fail to master, or speak, like a foreign language. I make that comparison on purpose, because theory is often perceived like "jargon," if not "a secret language"; an intimidating group language that can shut you out.

Once, not long ago, I gave a lecture for the American Association of Art Museum Directors, at the association's request, on the potential contribution of theory for museum work. It went very well, and the response was nice, the discussion productive. Hardly back home I received from one of the participants one of those priceless cartoons the *New York Times* produces to connect to people's obsessions, representing a woman at a social event saying to a man— note these cartoons tend to come in this gender distribution—"Oh, you're a terrorist; thank God, I understood 'theorist.'" Specialized languages, apparently, scare to death.

Of course, there are many theories, which come into use after the decisions about which Kuhn knows much more than I; theories which you understand if they belong to your area of research, and not, if they are too far removed from what you know. Most theories in the sciences are totally incomprehensible to me; that seems both obvious and acceptable. But "theory" in general—theory as in "the point of theory"—is not a language, not a thing, not a whole. It is, rather, a way of interacting with objects. An interaction which does justice to the mission of the university to produce new knowledge and not just conserve traditions.

In that sense, theory is a practice, a form of interpretation, not the pinnacle of objectivity as much as a touchstone for subjectivity; not abstract but empirically anchored. This practice is neither politically correct, nor politically incorrect; it is not bound to party politics, nor to specific ideological positions. Yet, in an important sense, theory can be called political. And that political meaning is, simultaneously, an academic, scholarly, scientific meaning. To end on a quotation of my favorite theorist, the American philosopher Charles Sanders Peirce, founder of semiotics:

Conservatism, in the sense of a dread of consequences, is altogether out of place in science, which has, on the contrary, always been forwarded by radicals and radicalism, in the sense of the eagerness to carry consequences to their extreme. (Peirce 1955, 58; quoted by Culler 1988, xvi)

Risk: the readiness to face loss, to lose face, is indispensable in any academic pursuit.

Notes

Originally published in *The Point of Theory: Practices of Cultural Analysis,* edited by Mieke Bal and Inge E. Boer (New York: Continuum, 1994), 32–47.

1. The Dutch expression badly translated is "als de dood," literally, "like death" or "as if death," a very common cliché which means "to be very afraid," but not necessarily seriously "scared."

2. The literature on metaphor is enormous. One contrast: Ricoeur (1979) versus Derrida's "White Mythology" (1974). See also Lakoff and Johnson (1980). A clear summary of various conceptions of metaphor is provided by Culler (1981).

3. See Culler (1988), esp. "Literary Criticism and the American University," where he analyzes succinctly the developments and misunderstandings which have led in the U.S. to the "culture wars" (Gerald Graff's title) summarily indicated as "PC." More on this later.

4. The metaphor of secrecy has much more background than I can provide here. See Keller (1986) and Kittay (1984).

5. I have devoted a previous inaugural lecture to this issue (1988b). The argument developed there appeared in a slightly different form in English (1991, 60–93).

6. This point was enthusiastically argued by Kress and Hodge (1979). I have gratefully used their views in my analysis of the book of Judges (1988a).

7. So, in spite of my earlier reluctance to argue for any particular theory of metaphor, I do have to endorse this particular view: metaphors do have cognitive relevance.

8. Stengers: "Un tel concept a en effet pour vocation d'*organiser* un ensemble de phénomènes, de définir les questions pertinentes à son sujet et le sens des observations qui peuvent y être effectuées" (1987, 11).

9. Derrida analyzes the philosophy of language of Jean-Jacques Rousseau in this context. See *De la grammatologie* (Paris: Editions de Minuit, 1967), esp. part II: "Nature, culture, écriture."

10. The correspondences are substitutions of one term by another but not, like in metaphor, on the basis of similarity—grounded in difference—but on the basis of contiguity in time, place, or logic.

11. De Man (1979). The quotation, in De Man's translation, is on 13–14. For the Proust passage, see Proust (1954, I, 83).

12. Hardly recovered from Foucault's blow to the humanities as a power-free playground, students of postmodernism now had to face Umberto Eco's novel *Foucault's Pendulum,* too "serious" about itself to qualify for the label.

13. "Ik tracht op poëtische wijze / dat wil zeggen / eenvouds verlichte waters / de ruimte van het volledig leven / tot uitdrukking te brengen." Lucebert (1974, 47).

References

Bal, Mieke. 1988a. *Death and Dissymmetry: The Politics of Coherence in the Book of Judges.* Chicago: University of Chicago Press.

———. 1988b. *Verkrachting verbeeld: Seksueel geweld in cultuur gebracht.* Utrecht: Hes.

———. 1991. "The Politics of Citation." *Diacritics* 21 (1): 24–45.

———. 1992. "Rape: Problems of Intention." In *Feminism and Psychoanalysis: A Critical Dictionary,* edited by Elizabeth Wright, 367–71. Oxford: Blackwell.

Culler, Johnathan. 1981. "The Turns of Metaphor." In *The Pursuit of Signs: Semiotics, Literature, Deconstruction,* 188–209. Ithaca, NY: Cornell University Press.

———. 1988. *Framing the Sign: Criticism and Its Institutions.* Norman: University of Oklahoma Press.

De Man, Paul. 1979. "Semiology and Rhetoric." In *Allegories of Reading: Figural Language in Rousseau, Nietszche, Rilke, and Proust.* New Haven, CT: Yale University Press.

Derrida, Jacques. 1967. *De la grammatologie.* Paris: Editions de Minuit. Translated by Gayatri Chakravorty Spivak as *Of Grammatology.* Baltimore: Johns Hopkins University Press, 1976.

———. 1974. "White Mythology." *New Literary History* 6:5–74.

Duras, Marguerite. 1966. *Le vice-consul.* Paris: Gallimard.

Eagleton, Terry. 1983. *Literary Theory: An Introduction.* Minneapolis: University of Minnesota Press.

Graff, Gerald. 1992. *Beyond the Culture Wars: How Teaching the Conflicts Can Revitalize American Education.* New York: Norton.

Johnson, Barbara. 1987. *A World of Difference.* Baltimore: Johns Hopkins University Press.

———. 1988. "The Frame of Reference: Poe, Lacan, Derrida." In *The Purloined Poe: Lacan, Derrida, and Psychoanalytic Reading,* edited by John P. Muller and William J. Richardson, 213–51. Baltimore: Johns Hopkins University Press.

Keller, Evelyn Fox. 1986. "Making Gender Visible: In the Pursuit of Nature's Secrets." In *Feminist Studies/Critical Studies,* edited by Teresa de Lauretis, 67–77. Bloomington: Indiana University Press.

———. 1989. "From Secrets of Life to Secrets of Death." In *Three Cultures: Fifteen Lectures on the Confrontation of Academic Cultures,* Evelyn Fox Keller et al., 3–16. The Hague: Universitaire Pers Rotterdam.

Kittay, Eva. 1984. "Womb Envy: An Explanatory Concept." In *Mothering,* edited by Joyce Trebilcot, 94–128. New York: Rowman and Allenheld.

Kress, Gunther, and Robert Hodge. 1979. *Language as Ideology.* London: Routledge & Kegan Paul.

Kuhn, Thomas S. 1986. "Objectivity, Value Judgment, and Theory Choice." In *Critical Theory Since 1965,* edited by Hazard Adams and Leroy Searle, 383–93. Tallahassee: University Presses of Florida.

Lakoff, George, and Mark Johnson. 1980. *Metaphors We Live By*. Chicago: University of Chicago Press.

Lucebert. 1974. *Verzamelde gedichten*. Edited by C. W. van de Watering. Amsterdam: De Bezige Bij.

Mitchell, W. J. T. 1985. *Iconology: Image, Text, Ideology*. Chicago: University of Chicago Press.

Niditch, Susan. 1993. "War, Women, and Defilement in Numbers 31." *Semeia* 61:39–58.

Peirce, Charles S. 1955. "The Scientific Attitude and Faillibilism." In *Philosophical Writings*, 42–59. Edited by J. Butchler. New York: Dover.

Proust, Marcel. 1954. *À la recherche du temps perdu*. Paris: Gallimard.

Ricoeur, Paul, 1979. *The Rule of Metaphor: Multi-Disciplinary Studies of the Creation of Meaning in Language*. Translated by Robert Czerny with Kathleen McLaughlin and John Costello. Toronto: University of Toronto Press.

Stengers, Isabelle, ed. 1987. *D'une science à l'autre: Des concepts nomades*. Paris: Editions du Seuil.

Stengers, Isabelle, and Judith Schlanger. 1991. *Les concepts scientifiques: Invention et pouvoir*. Paris: Gallimard.

6. Telling, Showing, Showing Off

For "A," in loving memory[1]

Setting as Image, Nature as Sign

New York City, in many ways the heart and icon of American culture, allows the casual stroller to be struck by the semiotic charge of environment. Its layout, with its central axis, centripetally drawing toward its green heart reminiscent of the indispensable nature it has replaced, its monumental avenues running along the park, states the importance of a balanced intercourse between background and figure, between overall plan and detailed specifics, and between organization and spontaneity.

The tourist entering Manhattan from downtown might not even be struck by the neat symmetry in the middle of the city: Central Park, the token of an indispensable, domesticated preserve of nature-within-culture, with the two major museums, preserves of culture and of nature, on each side. The symmetry is taken for granted, and so is the rationale that sustains it. The city plan itself points to elements of the city's life.

To the right, on the more elegant East Side, stands the Metropolitan Museum of Art, or the Met: the treasury of culture. The great art of the world is stored and exhibited here, with a quantitative as well as expository emphasis on Western European art as if to propose an aesthetic base for the social structures that reign in this society. It makes the world around the park almost look normal.[2]

The museum fits all the priorities of its own social environment: Western European art dominates, American art is represented as a good second cousin evolving as Europe declines, while the parallel treatment of "archaic" and "foreign" art, from Mesopotamian to Indian, literally kept in the dark, contrasts with the importance accorded to the "ancient" predecessors—the Greeks and Romans. The

overall impression is one of complete control, possession, storage: the Met has the art of the world within its walls, and its visitors have it in their pocket.

The West Side is, today at least, less "classy." On the left-hand side of the park stands the American Museum of Natural History. Around ten A.M., yellow dominates the surroundings when endless numbers of school buses discharge the noisy groups of children who come to the museum to learn about life. A booklet for sale in the museum, published in 1984 and reissued in 1990, somewhat pompously entitled *Official Guide to the American Museum of Natural History,* makes sure the public does not underestimate the institution's importance on the city map. It begins as follows:

> The American Museum of Natural History, a complex of large granite buildings topped by towers overlooking the west side of Central Park, has spread its marvels before an appreciative audience for over a century. Its stored treasures work their magic on millions of visitors every year and are studied by resident and visiting scientists and scholars from all over the world. A monument to humanity and nature, the museum instructs, it inspires, and it provides a solid basis for the understanding of our planet and its diverse inhabitants.[3]

The *Guide* is nothing like a guide: it does not provide floor maps and lists of exhibits, nor does it suggest an itinerary or feature a catalog. It is emphatically a self-presentation that represents the main thrust of the institution's ambition. If taken as a symptom of the museum's sense of self, it strikes one by its insistence.[4] This grandiose image of the museum is clearly not taken for granted. The emphatic and repeated representation of the institution's ambition signals an unease about itself, a lack of self-evidence that harbors the conflicts out of which it emerged and within which it stands: an unsettlement.

There is nothing surprising about this unease: we are confronted with a product of colonialism in a postcolonial era. The past clashes with the present of which it is also a part, from which it cannot be excised although it keeps nagging from within the present as a misfit. By way of an exploration of the issues pertaining to display, that unsettlement at the heart of this monument to settlement and the ways it is dealt with will be the subject of inquiry in this chapter.

This monumental institution houses the "other" of the Met in three senses, all three paradoxical. First, it is devoted not to culture but to nature. But nature is provided with that fundamental, defining feature of culture: history. Second, in this museum animals predominate, presented in their "natural" settings, whose representations are crafted with great artistic skill. Natural setting is the backdrop of the animal kingdom. But then a few rooms are devoted to peoples: Asian, African, Oceanic, Native American. These are precisely the peoples whose artistic products are represented in the Met in remote and dark galleries. These are

the "exotic" peoples, those who produced works that we only reluctantly, and un-
sure of our judgment, classify as art. These works of art are exhibited here as ar-
tifacts, rigorously remaining on the other side in James Clifford's Art-Culture
System.[5]

The juxtaposition of these peoples' cultures with the animals constitutes the
conflict at the core of this museum, distinguishing it from its unproblematically
elitist colleague across the park. By this very division of the city map, the univer-
sal concept of "humanity" is filled with specific meaning. The division of "cul-
ture" and "nature" between the East Side and West Side of Manhattan relegates
the large majority of the world's population to the status of static being, assigning
to a small portion only the higher status of art producers in history. Where "na-
ture," in the dioramas, is a backdrop, transfixed in stasis, "art," presented in the
Met as an ineluctable evolution, is endowed with a story. But the American Mu-
seum of Natural History presents its own story, too: that of fixation and the denial
of time.[6]

Yet in the representation of those foreign peoples, artistic production is an im-
portant part of the display. The artifacts function as indices of the cultures whose
structures and ways of life have been elaboratedly crafted by the museum's staff,
past and present (mainly past). Yet their works of art are indices, not of the art of
the peoples, but of the realism of their representation. They serve an "effect of the
real," an effect where the meaning "realness" overrules the specific meanings.[7]
Instead of artifacts processed into aesthetic objects as they would be on the east
side of the park, they are indices interpreted as nature.[8] The American Museum
of Natural History houses the Met's other in this third sense, too: it displays art
as nature, for when "nature" turns out to be hard to isolate, "art" will assist, but
as nature's handmaiden. While the Met displays art for art's sake, as the climax of
human achievement, the American Museum of Natural History displays art as in-
strumental cognitive tool: anonymous, necessary, natural.

This exposition, both in the broader, general sense of "exposing an idea" and
in the specific sense of exhibition, points at objects, and in that gesture makes
a statement. The constative speech act conveys a "text," consisting of the com-
bined proposition of "these artifacts are natural (as opposed to artistic)" and
"this (conception) is real." I hope to analyze this text further, decomposing it into
its constitutive "sentences," as I read them during my visit to the museum in 1991.

Who Is Speaking?

A first element that needs to be brought out in the open is the invisible "I," the
subject of the text, that slippery deictic element that has no meaning outside the
discursive situation itself. Let me be emphatic, first, about the wrong answer that

might slip in here: the expository agent is *not* the present curators and other museum staff. The people currently working in museums are only a tiny connection in a long chain of subjects.

Who, then, is this "I" who is "speaking" in the American Museum of Natural History, what is this expository agent's semantic makeup, and which discourse can it speak? For any museum with a past of this dimension, the agent is historically double and "monumental," serving collective memory. The historical two-sidedness—its inherited status and material condition doubled with its agency within New York society in the 1990s—emanates from all the pores of the building as you approach, then enter it.

The American Museum of Natural History is monumental not only in architecture and design, but also in size, scope, and content. This monumentality suggests that the primary meaning of the museum is inherited from *its* history: comprehensive collecting as an activity within colonialism.[9] In this respect, museums belong to an era of scientific and colonial ambition, stretching out from the Renaissance through the early twentieth century, with its climactic moment in the second half of the nineteenth century. It belongs in the category of contemporary endeavors such as experimental medicine (Claude Bernard), evolutionary biology (Charles Darwin), and the naturalistic novel (Émile Zola), which claims to present a comprehensive social study. Such projects have been definitively compromised by postromantic critique, postcolonial protest, and postmodern disillusionment.[10]

But that troubling prefix *post-* doesn't make things easier. Any museum of this size and ambition is today saddled with a double status; it is also a museum of the museum, a reservation, not for endangered natural species but for an endangered cultural self, a meta-museum.[11] Such a museum solicits reflections on and of its own ideological position and history. It speaks to its own complicity with practices of domination, while it also continues to pursue an educational project that has to be adjusted to new conceptions and pedagogical needs. Indeed, the museum's use for research and education is insisted upon in its self-representations, including the *Guide.* The "I" thus begins to point to itself.

The critique of nineteenth-century collectionism misses its purpose if it fails to confront the remote past—the Victorian era as the late twentieth century's bad conscience—with the present, whose ties to what it critiques need assessment as well. That is the trouble with *post-,* as with the disciplines that pursue an archaeology of meaning. On the one hand, the prefix suggests a detachment, a severing of the umbilical cord that binds our time to history; on the other hand, it reminds us of what it leaves behind, insisting that we settle accounts with the "post-" within ourselves.[12]

Here, therefore, I will look at the meta-museum status of the displays in the American Museum of Natural History as I found them. I will examine how the

gesture of display meets the content of the proposition and reveal how the museum as an expository agent shows its hand in showing others. This analysis engages the museum discourse *now,* and probes its effectivity today. The focus is not on the nineteenth-century colonial project but on the twentieth-century educational one. And while Donna Haraway described and criticized the way in which the collection was compiled in the past, I will consider the rhetoric of the museum in justifying or passing off the legacy of that past ambition, its forms of address in the present: where "I" says to "you" what "they" are like.

The space of a museum presupposes a walking tour, an order in which the dioramas, exhibits, and panels are viewed and read. Thus it addresses an implied viewer—in narratological terms, a *focalizer*—whose tour produces the story of knowledge taken in and taken home. I will focus on the display as a sign system working in the realm between visual and verbal, and between information and persuasion, as it produces the walking learner. My analysis will concentrate on a small portion of the second floor, as I visited it in the fall of 1991.

Entering the imposing hall at the main entrance on Central Park West, and prepared by the monument of Theodore Roosevelt outside, the words of Roosevelt fall upon the visitor. His statements are engraved on all four walls. The personification of the historical expository agent speaks of the values that this institution—at the time—was expected to bring home to the nation. On the left facing the entering visitor is the statement "Youth," on the right "Manhood." Turning around to see the writing on the opposite wall, you read "The State" on the left, and "Nature" on the right. In order to explicate what I mean by the need to pay attention to the meta-museum status of the museum, let me quote a line or two from each. Remember, we are reading what was written at the beginning of the twentieth century.

Youth

. . . Courage, hard work, self mastery, and intelligent effort are all essential to a successful life

Manhood

. . . All daring and courage, all iron endurance of misfortune make for a finer nobler type of manhood

The State

. . . Aggressive fighting for the right is the noblest sport the world affords

Nature

. . . There is a delight in the hardy life of the open . . . There are no words that can tell the hidden spirit of the wilderness, that can reveal its mystery, its melancholy, and its charm

The museum's installations for the most part come from a time when youth was defined through the virtues of masculinity and the goal of life in terms of success. Masculinity, in turn, was defined by aggression and sublimation. Nationhood promoted war, and women were not spoken about. Nature was mystified in terms that express while hiding them ("hidden spirit") the qualities of femininity that put both nature and women up for grabs.

It is good, therefore, that these texts remain on these walls. All it would take, to make them work toward a better understanding of the historical embeddedness of what would otherwise seem to be a halfheartedness inside the museum, is an indication of that historicality. One could inscribe their agency within the chain of history by pointing out how these statements, meant in the first decades of the century to have an everlasting, universal value, demonstrate that history most prominently is change, although not necessarily evolution. The imposing, monumentally inscribed walls could be made the first object of display instead of a display of unquestioned, naked authority.

The most obvious problem of the museum is the collocation, in its expository discourse, of animals and foreign peoples as the two others of dominant culture. The visual displays speak to the visitor in more than just informational terms; they also present a surplus discourse. Similarly, "collocation" is more than just visual juxtaposition; by speaking at the same time about animals and foreign peoples, the displays communicate an ideology of distinction, which has this conflation as its sign system.[13] I contend that the double function of the museum as a display of its own status and history (its meta-function), as well as of its enduring cognitive educational vocation (its object-function), requires an absorption, *in the display,* of that critical and historical consciousness.

This double mission entails a specific exchange between the verbal and visual discourses. One could expect that whereas the visual displays, the dioramas which form the bulk of the museum's "treasures," must be preserved as objects of the museum's meta-function, the panels containing verbal explanation and information as well as the *Official Guide* are more easily adjustable and would present the displays critically. The sign system of the verbal panels constitutes precisely the museum's luck: it provides the latitude to change.

Putting forward the "I," the expository agent who is "speaking" this text, means transforming the interaction between visual and verbal representation so as to provide the one with a commentary on the other. The displays can then point at their own discourse as not natural, but as a sign system put forward by a subject. The written panels do demonstrate an awareness of the burning issues of today's society. However, it is not only the successes but also the absence of an acute and explicit self-criticism and the presence of an apologetic discourse that I wish to focus on. Reading an exposition willfully brackets such important but,

from a semiotic perspective, contingent aspects as personnel, material and financial constraints, requirements made by regents and sponsors, and the conditions of the building. The question "Who is speaking?" will not lead to a name, a scapegoat, or a moral judgment; it will, hopefully, lead to insight into cultural processes.

Asian Mammals: The Politics of Transition

Turning left at the stairs near the Roosevelt Memorial at the Central Park West side of the museum, the visitor enters the Hall of Asian Mammals (see fig. 6.1). S/he is surrounded by dioramas of animals whose strangeness has long been effaced by that even more "natural" museum, the zoo. The animals are placed against painted backdrops known from postcards and geography books. The dioramas are impressively realistic. This realistic rhetoric is helped by the relative darkness in the hall, which makes visitors invisible to themselves while the dioramas are illuminated from within. This obscurity is obviously necessary for preservation; *at the same time* it sustains the effect of "third-person" narrative that, literally, highlights the object while obscuring the subject. There is a tension here, perhaps a paradox, inherent in the museum as a whole, between common and strange. The displays hover between the attempt to represent reality as natural through an aesthetics of realism and the attempt to demonstrate the wonders of nature, through an aesthetics of exoticism.[14]

As in the other halls, the double edge of the museum's discourse of exposition is acutely felt: the imitation of nature, striving for perfection ("Look! That's how it is"), foregrounds itself by that very telos ("I am showing you this"). Other, less conspicuous elements, potential speech acts, stand in tension with this major one. The skillful but ruthlessly artificial painting, the protective glass, the neat separation of species, the limited size of the settings compared to the animals, make one constantly aware of the representational status of this "nature."

But the effect of the real reconciles the two discourses. This is one form of "truth-speak," of the discourse that claims the truth to which the viewer is asked to submit, endorsing the willing suspension of disbelief that rules the power of fiction. For the visitor entering through this hall, the discourse of realism sets the terms for the contract between viewer or reader and museum or storyteller.

At the far end of this hall, the door opens to the Hall of Peoples of Asia. Within the framework of the mimetic success of the realism in the Hall of Asian Mammals, the transition from this cultured "nature" to culture *as* nature—from mammals to peoples—is inherently problematic. The most obvious problem is the juxtaposition of animals and human foreign cultures. The doorway between the

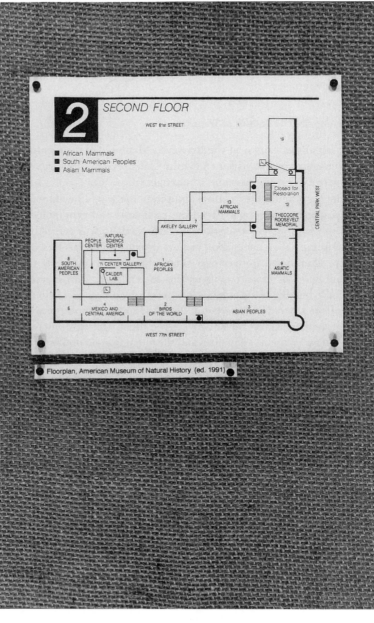

Floorplan, American Museum of Natural History (ed. 1991)

FIGURE 6.1

two halls is semiotically charged as a threshold. At this threshold the difference between the colonial past and the postcolonial present lends itself to different meaning productions.

In the case of these two Asian departments, there is a sign of an awareness of the need for a transition; but it remains on the level of symptom, not signal. This transition is monitored by a small display, within the Hall of Asian Mammals, at the far end to the right, between the Indian rhinoceros on the left and the water buffalo on the right. In contrast to the dioramas, this little window contains only one bare exhibit, black against an undecorated orange background: a nineteenth-century statue from Nepal. The title is "Queen Maya giving birth to the Buddha from her side" (fig. 6.2). It represents an elegantly shaped female surrounded by decorative ornaments. It is at odds with the other displays in this hall.

The panel underneath it contains key phrases which elaborate the transitional status of this statue's display:

Queen Maya giving birth to the Buddha from her side, Nepalese bronze, 19th century.

According to popular tradition, Gautama, the historical Buddha, was born to Queen Maya of Kapilavastu as the result of a visit by a white elephant with golden tusks who ran around her bed three times and then returned to the Heavenly Mountains. Buddhism, one of the principal religions of Asia, has many stories of the previous lives of the Buddha as a compassionate soul in the bodies of animals. As a consequence, many Buddhist sects are vegetarian.

The verbal presentation is consistently anthropological. Keeping its purpose and status distinct from the museum of high art on the other side of the park, this display has an artifact from a "low" moment of the history of Buddhist art, low because the moment of making coincides with the moment of acquisition: the nineteenth century. This temporal coincidence deprives the artifact of historical patina and scarcity, a requirement for high-art status. Typically, nothing is noted about its style, as it would be in the Met. It is, moreover, thoughtfully presented as anchored in "popular tradition," the nameless other of individual elite art. From art it thus becomes anthropological evidence of a timeless culture.[15]

The verbal text accompanying the statue frames it thoroughly in its specific transitional function. A close reading makes that clear. The mention of the white elephant introduces the animal element which justifies the curious collocation of this artifact with "nature" and with the animals in their settings in the hall. Looking back, the visitor notices that the statue is facing the centerpiece of the hall, two life-size elephants, gray with white tusks. The historical information concerning Buddhist mythology, emphasizing the difference from Christianity in

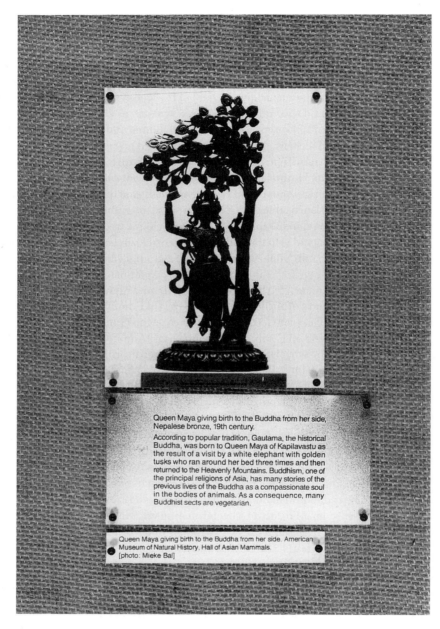

Queen Maya giving birth to the Buddha from her side,
Nepalese bronze, 19th century.

According to popular tradition, Gautama, the historical
Buddha, was born to Queen Maya of Kapilavastu as
the result of a visit by a white elephant with golden
tusks who ran around her bed three times and then
returned to the Heavenly Mountains. Buddhism, one of
the principal religions of Asia, has many stories of the
previous lives of the Buddha as a compassionate soul
in the bodies of animals. As a consequence, many
Buddhist sects are vegetarian.

Queen Maya giving birth to the Buddha from her side. American
Museum of Natural History, Hall of Asian Mammals.
[photo: Mieke Bal]

FIGURE 6.2

metempsychosis' polytheistic tendency ("many stories"), serves the explanatory function that is so important in the museum's scientific-educational vocation. But language's density entails that more is provided than explanation. Polytheism is a loaded concept in the West. Buddhism may be "one of the principal religions in Asia," but the word "sects" in the following sentence is pejorative in a culture whose dominant ideology is monotheistic. This pejorative connotation is enhanced by its plural form. In addition to the colorful story, this word "sects" further estranges Buddhist culture from the Western viewer. But the official *explanandum* of this statement is Buddhist vegetarianism, and one may well wonder what the relevance of that anthropological feature is in connection to the Hall of Asian Mammals.

As it turns out, it is highly relevant, not for Asian mammals but for American educators and the function of anthropology. Anthropology is pervasively present in this museum as the unquestioned supplement of biology; the Hall of Pacific Peoples, for instance, is named for Margaret Mead.[16] The discipline of anthropology has speculated extensively on the origins and meanings of alimentary taboos (Douglas). One explanation that has gained wide popularity is educational (Oosten and Moyer 1982). Taboos on food, along with sexual taboos, serve the purpose of teaching distinction. By forbidding certain connections or incorporations—or collocations and metonymies—people learn to respect the difference between self and other. Taboo-izing cannibalism, for example, teaches "savages" that they are humans not animals. This learning is necessary for the survival of the species.

In the Hall of Asian Mammals, the reference to vegetarianism may suggest a prior form of savagery. The taboo on the consumption of meat affirms the distinction, not between humans and animals but between animals including humans, and plants. In other words, for these Buddhist sects the defining property of humans is to need avoidance of animal food because humans *are* (close to) animals. The history of the Buddha as told in this panel is supposed to prove this point. He was fathered by an elephant. And the elephants down in the center of the hall suddenly stand as witnesses to their mythological brother.

Thus the panel accompanying the display of the statue does not question and criticize as outdated the collocation of human artifact with animals but, on the contrary, sustains it. Self-reflection is weakened in favor of naturalization; "I" disappears behind "them" who cannot speak back, although "they" are alive and kicking as a culture. The words read as an explanation of the relevance of human presence in the animal realm, but they do so by qualifying the humans in question as being close to animals, closer than "we" are. This human presence is only emphasized as the object of representation; the obvious human performances in the hall's dioramas, especially in the painted scenery, remain relegated to the unnoticeability of realism. Realism is the truth-speak that obliterated the human

hand that wrote it, and the specifically Western human vision that informed it. In contrast, the statue represents humanity, even in some conception of its essence—birth, that is—and it is an index of the humanity represented in the next room: foreign and exotic. The question arises: what is the more specific meaning of the visual display, that it needs to be sustained so emphatically by words?

The statue represents a woman, "naturally" as close to animals as humans come, and it represents her in the most "natural" of poses, in giving birth. But this is not an ordinary birth whose representation would strain the tolerance of educational prudishness; it is a mythical birth from the woman's side. There is an instance here of cultural similarity rather than difference. In the Hebrew Bible, Genesis 2 represents the first woman's emergence out of the side of the first, androgynous creature, a birth that resulted from an equally unorthodox conception.[17] Pointing this out would be an act of "anthropologizing" Western traditions as an effective strategy of showing the problematic of anthropological representation of others. But instead, the strangeness of this nature-woman is emphasized.

By selecting a representation of femininity which reaffirms woman's closeness to nature through an unnatural fiction presented as a foreign other, the subject of the mixed-media speech act of exposition has accomplished a semiotic feat. The expository agent has managed to mitigate in this local transition the ideological oddity of the museum as a whole. The metaphorical equation of "woman" to "nature," so familiar in the culture betokened by and surrounding this museum, mediates between mammals and foreign peoples, emphasizing the otherness that justifies the relegation of these peoples to this side of Central Park.

Gender politics are thus intricately enmeshed with ethnic stereotyping. For there is more to this visual ideologeme than meets the eye: the Buddha himself, in spite of his masculinity, is aligned with the archfemininity of giving birth. Associated with this double naturalness of birthing femininity and mythical remoteness, he is authenticated as the proper authority to prescribe vegetarianism as a feature of animality. And it is this surplus of ideological information that the panel with the verbal representation is conjured up to "explain." The visitor is now prepared for the acceptance of the ambivalent display in the next hall: the showing of peoples as nature. And what extends before the learner is culture frozen in a clever double structure which, according to the panel at the entrance, can be read alternatively as unfolded in space or developed in time.

The Contest between Time and Space: Evolution and Taxonomy

The Hall of Peoples of Asia proposes a double representation, offering a choice of two frames: through time and through space (fig. 6.3). The spatial presentation divides Asia into regions, moving "from Japan westward to the shores of the

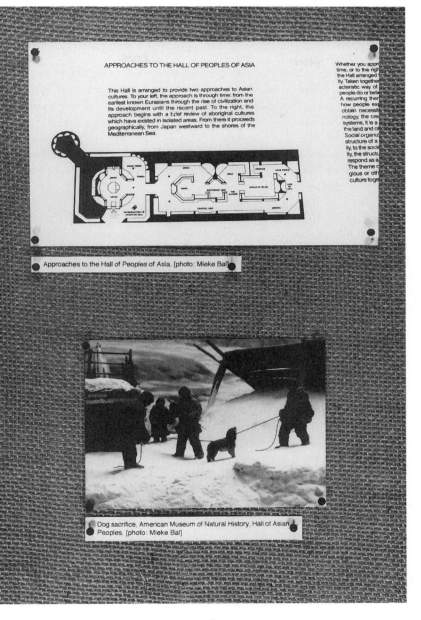

APPROACHES TO THE HALL OF PEOPLES OF ASIA

This Hall is arranged to provide two approaches to Asian cultures. To your left, the approach is through time: from the earliest known Eurasians through the rise of civilization and its development until the recent past. To the right, the approach begins with a brief review of aboriginal cultures which have existed in isolated areas. From there it proceeds geographically, from Japan westward to the shores of the Mediterranean Sea.

Whether you app
time, or to the rig
the Hall arranged
ity. Taken togeth
acteristic way of
people do or beli
A recurring ther
how people ex
obtain necessit
nology, the cre
systems, it is a
the land and ot
Social organiz
structure of a
ily, to the soci
ity, the struct
respond as a
The theme o
gious or oth
culture toge

Approaches to the Hall of Peoples of Asia. [photo: Mieke Bal]

Dog sacrifice, American Museum of Natural History, Hall of Asian Peoples. [photo: Mieke Bal]

FIGURE 6.3

Mediterranean Sea." Taking the spatial route entails the likelihood of skipping the temporal one, which is tucked away in the corner, while the temporal option inevitably leads into the spatial section at the end. Turning left, then, is the most obvious thing to do.

After electing to take this route through time, the leading phrase that guides the visit is first stated on the introductory panel and then again as the headline for all sections: "Man's Rise to Civilization." The question as well as the program it entails are posed clearly:

> How did man achieve civilization? We have no final answers but we have *archeological traces* and *anthropological parallels* by which to create possible models. (My emphasis.)

The conflation of time and space is made possible through the unstated notion of the primitive, so dear to the forefathers of the museum. The collocation of trace and parallel is the speculative tool that proposes answers to unanswerable questions whose very statement implies, literally, too much for words. "Man's rise to civilization" encompasses the universal concept of "man," the evolutionism of "rise," and the transhistorical generic use of "civilization." These are the three presuppositions that inform this museum's other, the Met. As Douglas Crimp phrased it apropos of Malraux's *Museum without Walls*: the Met displays "art as ontology, created not by men and women in their historical contingencies but by Man in his very being."[18] The three concepts functioning as a running head throughout this hall frame the hall's contents as "not-art." These concepts insert the awareness that the double access to this hall is based on an untenable distinction. "Time" will become a question and "space" will be the metaphoric cover-up of its unanswerability.

Tucked in the corner that extends into a rotund space is the section devoted to "Man's rise to civilization in the Near East." To the left of the entrance are the Greeks, singled out with panels that sing their praise in unambiguous terms: panel 10 headlines "Troy and Western Civilization," while panel 11 bears the title "The Ionian Achievement." The archaic Greeks are represented by Homer, and are selected to establish the connection to "our own" culture. This is not a surprising choice, and may be partially informed by the irresistible attraction of iconic thinking: we are looking at a culture where excellence was an ideological core, hence, excellence is selected as its synecdochic representative.[19] These Greeks are praised for their investigation of "nature to the limits of human intellect," suggesting the happy outcome of an evolution that has just been traced before us. The panel on Ionian culture offers a neat example of the way time overtakes space in this section:

Asian ideas and innovations were integrated with local genius. A century ear-
lier, Ionian thinkers had laid the basis of the philosophies of Socrates, Plato
and Aristotle. Seeking answers to the nature of the world, the Ionians looked
to their own experience rather than myth to discover first principles.

Suddenly, as we approach "our own"—that is, European culture—anonymity
yields to great names, and the characteristic of the culture selected for represen-
tation is the very definition of the scientific pursuit that this museum represents.
The voyage ends with a conflation of the two temporal moments between which
stretches the period to which the "rise to civilization" has led.

The Greeks, then, are not just an episode or stopping place on a voyage
through time but the emblem of the highest level of civilization. Representing the
Greeks at the transition between the time-bound and the geographically ordered
exhibits on the Asian peoples is a gesture that qualifies the concept of Asia, giv-
ing meaning to the presentation "from Japan westward to the shores of the
Mediterranean Sea": from utterly foreign to cozily familiar. But, more impor-
tantly, this placement qualifies the concept of the museum as a whole. It functions
as a transition, this time not between animals and foreign peoples, but between
the latter and "us." It installs the taxonomy of "us" and "them" by proposing the
Greeks as the mediators, just as the woman in the Buddhist statue functioned as
a mediator. The Greeks, closer to Western culture than any of the peoples repre-
sented in the museum, stand for the highest form of civilization, both starting
point of "our" culture and endpoint of Asian cultures.

The time frame initiated, then, is not that of a casual voyage through time.
Transforming temporal tourism into knowledge production, the time frame is
that of an evolutionism colluding with taxonomy, dividing human cultures into
higher and lower, the ones closest to "ours" being the highest. It would be fea-
sible, although not easy, to walk backward, to undo the telling of this Eurocentric
story, but the museum has not provided panels that make such a reversed story
readable. Indeed, between the spatially developed presentation and this climax
of time, the most marginal items mitigate the transition: "the approach begins
with a brief review of aboriginal cultures which have existed in isolated areas," in
order to begin seriously with Japan. After entering the hall via the Greeks, all
peoples represented in it can only be less developed, more foreign.

Semiotically speaking, this transition from time to space functions as a shifter.
The full implications of Benveniste's distinction between the personal language
situation of "I"-"you" exchange and the impersonal representation of "him,"
"her," or "them" are relevant here. The two axes are not symmetrical: in a normal
conversation the "I"-"you" positions are reversible, while the "third person" is
powerless, excluded. But in the case of exposition, the "you" cannot take the po-

sition of the "I." While the "I"-"you" preside over the "third person," the "I" performs the representation, the gesture of showing, in conjunction with a "you" who may be real, but is also imaginary, anticipated, and partly molded by that construction. The peoples represented in the American Museum of Natural History, just like the animals, belong irreducibly to "them": the other, constructed in representation by an "I," the expository agent. The "you" for whose benefit the "third person," here the Asian peoples, is represented, is constructed by implication as suitable readers of the show. That construction is foregrounded in the opening chapter on the Greeks: by emphasizing the Greeks' influence on the culture in which the museum functions, the addressee is marked as belonging to the Western white hegemonic culture. The difference of the represented and displayed other is thereby increased: made absolute and irreducible.

The degree to which that "I," the subject of representation, is readable in the representation of the display itself opens up the possibility of a critical dimension. For any self-representation of the subject implies a statement concerning the subjectivity of the representation as potentially fictional. But instead of stating and foregrounding the "I," it proposes to identify with the Greeks, an apparent "third person." This privileging of the Greeks appeals to ideological allegiance, without exposing the subjectivity of the agent performing the appeal. The construction of such a radical division between self and other works to deny the divisiveness in contemporary society where cultural diversity is present—so much so that the construction of an unified category of "them" is no longer possible.

Hence the need to obscure the "I"-"you" axis through the metaphorization of the Greeks as "our" stand-ins. But the very act of foregrounding that is readable in the gesture of obscuring this "I"-"you" interaction—in other words, the construction of subjectivity within the representation—remains invisible. It obscures itself in the ambiguous evocation of the people that stands between Asia and Europe, between archaic and modern, between "them" and "us." Evolutionism serves to blur the boundaries built up by taxonomy.

What is really on display for the addressee who insists on "speaking back" is this rhetorical strategy where words are used to provide images with meanings they would not have otherwise. Instead of the panels on which words give meaning to the order of things, large mirrors might be a more effective ploy. Strategically placed mirrors would not only allow the simultaneous viewing of the colonial museum and its postcolonial self-critique, but also embody self-reflection in the double sense of the word. They could lead the visitor astray, confuse and confound the walker who would lose her way through evolution and instructively wander around, perhaps panicking a bit, in diversity.[20]

Circular Epistemology

The museum's current expository agent has made effective use of the possibilities of visual and verbal channels of information to convey very different positions and mitigate tensions. What matters here is the effort to reconcile instead of enhance tensions by shedding verbal light on visual objects, and by imposing a particular, semiotically loaded order on chaos. This use of expository discourse is foregrounded in the double presentation of the Hall of Peoples of Asia through time—storytelling as well as history writing—and through space—taxonomy as well as geography. Within each of these presentations, the specific semiotic potentials of each medium are also reflected upon. In the presentation through time, there is a panel enigmatically and possibly ironically called "Prehistoric Storytelling," which presents a perfect example of the conflation of "archeological traces" and "anthropological parallels" to "create possible models" of "man's rise to civilization."

Grammatically speaking, the phrase refers to a narrative self-reflection: "prehistoric" qualifies storytelling, and we can expect a theory of storytelling specific to prehistory. The explanation demonstrates the kind of epistemological usage visual storytelling allows:

> The panels displayed here, made by 19th-century Siberians, tell stories of daily life. Dominated by tales of hunting both sea and land mammals, they also include scenes of the settlement that show the kind of houses, sleds and other items commonly used by those people. The panels at the upper left and upper right even depict the dog sacrifice shown in the Koryak exhibit to the right. For the Siberian viewer, each panel is a complete account and clearly reflects the well-known exigencies of daily life.
>
> For thousands of years, peoples have told such stories both orally and graphically. The painting at the back shows a hunting scene from the site of Catal Huyuk, in Turkey, about 6500 B.C.

This text is a good example of the kind of knowledge production and, consequently, of the epistemological seduction going on in this museum. First of all, it foregrounds visuality as the crucial form of reception. It describes the ideal viewer as the model addressee. But, surely, there is no such person as a Siberian *viewer* of these panels, at least, not if by that denomination the prehistoric Siberian is meant and not an occasional visitor from eastern Russia. The nineteenth-century Siberian maker of these images cannot be asked, nor does he or she have any direct relation to the prehistoric peoples who represent this episode in the

history of "man's rise to civilization." The panels this viewer is supposed to understand so readily are irreducibly of a different time and place. The presence of the text panels suggests that they address a literate viewer, while prehistory is (problematically) defined by illiteracy.

But that may be precisely the point; the text proposes to take this information in the mode of the prehistoric humans: visually. Why is that so important? The second striking element of the panel suggests an answer to this question. This model addressee reads the panels as *complete* and as *accounts*. The combination of these two features describes the aesthetics at stake: realism, the description of a world so lifelike that omissions are unnoticed, elisions sustained, and repressions invisible. The direction given by this verbal rhetoric is to read the panels realistically in this double sense: as complete accounts for a contemporary member of the represented culture. This mode of reading is further strengthened by an incredible density of meta-representational signs, all symptomatic of a desire to make representation coincide with its object: "clearly" leaves no room for doubt; "reflects" borrows the very terminology of realism; "well-known" disqualifies as ignorant the surprised viewer who hesitates to willingly suspend disbelief; "daily" emphasizes the ordinary, anonymous, the opposite of individual excellence or noticeable events, again with an effect of the real. Who would dare to doubt the truth of the representation after such pedagogy? The "I" has made the irreversibility of the "I"-"you" axis foolproof.

Following this insistence on realism, the trace is wed to the parallel. The second paragraph of the panel brings up the epistemology at stake. The nineteenth-century Siberian is conflated with thousands of years of similar men. The peoples in question do not have a history, any more than does the "nature" depicted in the dioramas. They are prehistoric, and therefore they qualify for this museum of *natural* nonhistory. The background painting, although different in style and medium, is placed so as to form a literal-visual background to the modern panels (fig. 6.4). Representing hunting scenes, they provide the idiom with which to read the panels on the foreground.

The issue is not addressed explicitly, but the conflict it hints at is present in the epistemology for which these panels are made to work. Within this utterly realistic display, the images are said to be symbolic. For the use of symbols is what characterizes civilization, as it is stated in the neighboring panel where reliance on archaeological traces and anthropological parallels is proposed as an epistemology. It reads:

> The beginning of modern man may go back almost 500,000 years. But only in the last 5,000 years has man achieved civilization, which is characterized by the dominant role of symbols.

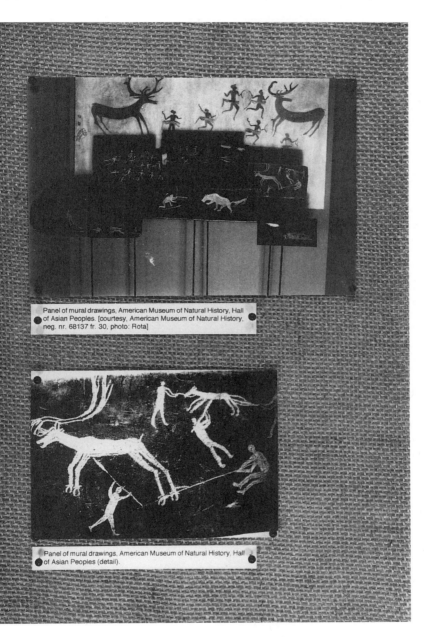

Panel of mural drawings, American Museum of Natural History, Hall of Asian Peoples. [courtesy, American Museum of Natural History, neg. nr. 68137 fr. 30, photo: Rota]

Panel of mural drawings, American Museum of Natural History, Hall of Asian Peoples (detail).

FIGURE 6.4

This appeal to symbolism is already a problem in terms of the crystal-clear realism claimed in the introductory panel. But the argument leading to this conclusion is circular, and deserves a closer analysis.

The explanatory panel is not alone in preparing one for the viewing of the visual objects. Immediately *preceding* this exhibit on prehistoric storytelling, there is an exhibit presenting a model of the Koryak group, representing, in addition to "the well-known exigencies of daily life," a rudimentary representation of the sacrifice of a dog. Or so it seems, visually (see fig. 6.3). In imitation—realistic representation—of one small section of one of the nineteenth-century artifacts (fig. 6.4), the display represents a "real" dog sacrifice, showing little mannequins spearing a dog tied with ropes. "What are they doing to that poor dog?" exclaimed one of the numerous children who walked by. "I don't know," said the teacher lamely. "It's mean!" replied the child.

The epistemological connection between this exhibit and the Siberian panels is based on the trace-parallel conflation. Clearly, the exhibit imitates the artifact, but the artifact has been interpreted realistically in the first place. The dog sacrifice, symbolically represented on the artifact, is taken to be "symbolic" of the "real life" it points to. (Hence, the appropriateness of the child's exclamation "It's mean!") In the narrative of the walking tour, the realistic model, however, *precedes* the historical object it imitates, thus enhancing belief in the anthropological truth of both the modern display and the ancient image. This visual argument is comparable to the idea of an anthropological representation of Western culture through the crucifixion of men with headdresses made of thorns, or tied up bodies pierced by arrows, and other varieties of martyrdom. "It's mean!" foreigners would cry out. Our children don't. Civilized, they know a symbol when they see one.

The connection between the nineteenth-century artifact and the twentieth-century exhibit is based on a powerful rhetorical figure: metonymy. The later exhibit comes first; the older Siberian panel follows. This sequence allows for a reversal of "model" and "copy," of two different levels of (representations of) the real. Visually, it seems as if the Koryak exhibit shows the truth of the Siberian panel. The reference to the copy of a "really old" painting, the Turkish find from about 6500 B.C., provides the authentication of this conflation of time into space. But the trouble is, this painting, representing hunting scenes, does not have a trace of a dog sacrifice.

As usual, the verbal panel mediating this epistemology of juxtaposition makes the slippage in this epistemology explicit. It is a slippage from space to time, and from present to past:

> The Koryak *live* in Northeastern Siberia, a place of extreme cold. . . . Our knowledge of shelter and clothing during the Ice Age is limited, but we can be certain that prehistoric man adapted to the climate much as have the

Koryak. . . . [A]s *shown* to the left, the people ritually sacrificed dogs as offer-
ings to the spirits of the hunt and the settlement itself. (My emphasis.)

The link between contemporary but geographically remote cultures and the pre-
historic past is presented as a *certain* connection, and the dog sacrifice repre-
sented in the twentieth-century exhibit *shows* how the people in the past actually
did things. The discourse of display is practically irresistible. The realistic rep-
resentation of a fictional leftover of a culture long gone is taken as the source for
an older artifact that will now have to be read realistically through this rhetoric.
Realism, here in a visual form, is one of the primary forms of "truth-speak" the
museum uses.

 This display, I assume, predates current awareness of the problems of knowl-
edge production it entails. How does the mixed-media nature of museum dis-
course help this rhetoric along even today? To be sure, this circular argument
would never pass so massively unnoticed in a verbal historical analysis. My point
is this: the visual panels get away with this rhetoric because the order in which
they are displayed constitutes the syntax that gives the well-shaped "sentence" its
meaning. But the combination of exhibits can only pull this off because the ver-
bal direction, the rhetorical setup of the addressee's semiotic attitude, sustains
the circle. This specific collaboration between visual and verbal sign systems par-
takes of an epistemology that is very much in place in our present-day culture. All
that effort is invested into stating the realism of this particular section in order to
establish and sustain that circular epistemology. "Prehistoric storytelling" thus
gains an unintended connotation: this is a prescientific, mythical way of telling
the story of cultures we cannot know, a prehistoric historiography practiced in
the 1990s.

In the Beginning Was the Word

After the Hall of Peoples of Asia, our journey through the semiotics of display
takes us through the "Birds of the World" to the Hall of African Peoples on the
right. The panels, here, demonstrate a serious attempt to cope with the contra-
dictions of a contemporary race-conscious society. They are evidently quite
recent and could provide the critical note indispensable for a museum such as
this one to be effective in the 1990s. And to a considerable extent they do so.

 The entrance panel on the left wall states the contemporary educational am-
bition of the hall:[21]

With the swift transition from tribe to nation, much of Africa's past is disap-
pearing. The heritage remains, however, to influence the character of the new

nations and, in the New World, to give to Afro-Americans an individuality of their own. Although this hall deals largely with the past, it can perhaps help to gain a better understanding of the present.

This panel stating the educational purpose of the hall sits on the wall outside of the hall proper, and this position spatially signifies the distance today's museum curators take from the conception of the hall of some fifty years ago. Thus it begins to semanticize the deictic, slippery "I" by means of spatial distancing; spacing writes difference.[22]

But the meaning of spacing depends on museum syntax. In itself, the panel suggests a critical project: to explain the problems of contemporary multiracial society by its roots in colonialism. This critique could work if it were sustained throughout the exhibits. If this self-critique is not pursued inside the hall, however, it remains a preface, whose spatial position outside the hall reflects its ideological position of framing what happens inside with an apology. The problem can be compared to that of quotation, indirect discourse within a narrative. The narrator, here the expository agent's present incarnation, "quotes" the descriptive discourse inside the hall—the dioramas. Quotation in narrative is introduced, or moderated, by what is termed "attributive discourse."[23] Attributive discourse has a double function: it attributes the quotation to a speaker, and it qualifies the quotation's content. The distancing of this panel from the hall would work to neutralize that attribution, if it were the only introduction.

But this panel is only a first step in an elaborate set of frames. Framing is so emphatic and elaborate here, that the subject's dilemma shows through. The entrance is further framed by two bright window cases whose rhetoric adopts the second form of truth-speak the museum uses: scientific discourse. In the far distance and in the dark hall, we can already glimpse one of the displays in the realistic mode, and the contrast is striking (see fig. 6.5 for an example).[24] The introductory exhibits at the entrance, "family" on the left and "society" on the right, present three-dimensional graphic models of that essence of Africa which only scientific analysis is able to provide. The connotation of these models is "scientificity," with reliability as its primary feature, thus visually proposing that what we are about to see is the truth of Africa, not the historically produced mixture of "science" and "fiction" which constitutes the basis of contemporary vision, and whose critical analysis I had been expecting on the basis of the verbal introductory panel. Thus the critical project announced by the panel as the outer frame is overwritten by the scientific one of the second-level frame (fig. 6.5).

After this double, conflicting introduction, the first displays within the hall— although not yet within its main body—are devoted to "foreign influences" on the left and "Africa today" on the right.[25] In agreement with the introductory

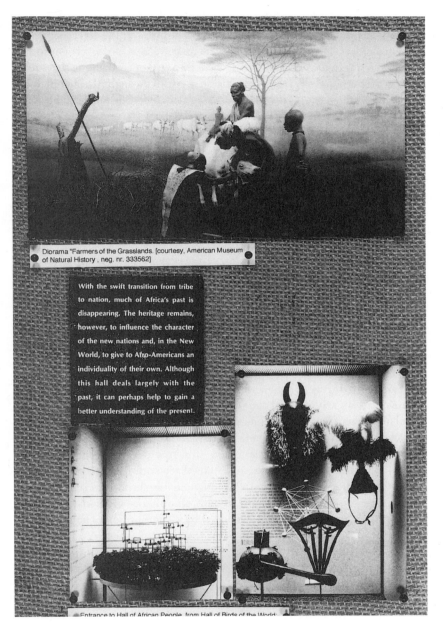

Diorama "Farmers of the Grasslands. [courtesy, American Museum of Natural History, neg. nr. 333562]

With the swift transition from tribe to nation, much of Africa's past is disappearing. The heritage remains, however, to influence the character of the new nations and, in the New World, to give to Afro-Americans an individuality of their own. Although this hall deals largely with the past, it can perhaps help to gain a better understanding of the present.

Entrance to Hall of African People, from Hall of Birds of the World.

FIGURE 6.5

panel, both are more about what Africa has been made of by colonialism than about its "natural history." But the latter will nevertheless be the object of the subsequent displays. Hence, these two displays function as a third level of introductory framing, after the critical and the scientific one, now presenting the double voice of the museum's contemporary vision of Africa through Africa itself.

"Foreign influences" is divided into economic, political, and religious influences. The political situation is thus represented:

> The imposition of foreign rule created political entities much wider than existed before, *and this might have been advantageous,* but the same powers that set up these unities failed, usually, to consolidate them. They existed largely on paper alone; the common sentiment that must underlie any truly unified nation was lacking, and with the removal of foreign military force the imposed unity tended to crumble. (My emphasis.)

This presentation is quite critical: foreign rule—colonialism—imposed an order that it failed to maintain. Indeed, the repeated use of the concept of imposition demonstrates the critical project; and so do words like "failed." In contrast, the criticism hardly conceals reconfirmations of the values that produced the colonial situation in the first place.

Thus the idea that wider political unities would be better than small-scale organizations remains unargued, as does the legitimacy of any imposition whatsoever. The basis of the desirable large-scale nation is a common sentiment that Africans failed to muster. Its indispensable nature is stated in generalizing phrases like "any *truly* unified nation." Finally, the sorry consequences of the removal of military force demonstrate the conflicting message: critique in the word "imposed" qualifying "unity"; but uncritical in the presentation of "tended to crumble" as the inherent weakness of the Africans unable to sustain the goods. Hence, there remains room for the suggestion that colonialism was bad for Africa because it was not radical and lasting enough: if only the foreign rule had managed to impose its alien system more durably, all would be well today.[26] There is not a word on the social systems dislodged by the imposition of large-scale nations.

This verbal message is conflicted in its double view of what happened to Africa. The visual exhibits illustrating this double view are all critical of what became of Africa's political organization. But instead of representing the violence done to Africa, the exhibits are mostly caricatures and presented as such. The visual displays illustrate the verbally expressed view; the "third person" itself here sustains the constative statement. The image of Africa has been replaced by the image of its protests against alienation, but these protests are not directed against

the foreign colonizers; they are ambiguously presented as self-criticism. Hence, the combination of words and images turns the tables on the critical project: Africa is ridiculous and it says so itself (see fig. 6.6).

The relation between verbal and visual messages comes close to contradiction in the section of this display devoted to religion. The verbal text states that Islam was far more successful in its attempt to impose itself than Christianity because the latter, being "far less unified and much more in conflict with traditional African values,"

> had a largely disruptive influence, socially and politically. The African countered by making of these new religions something of his own, and this genius for selective adaptation is now bringing forth distinctive, new and vital beliefs in Africa.

Again, this text is critical of colonialism, denouncing Christianity's destructive influence and projecting a positive image of Africans ("genius"). Visually, however, these words are overruled: with an unrecognizable rosary as the token item referring to Islam, my overall impression of this exhibit is its emphasis on Christianity (see fig. 6.6).[27] The display is unified by a Virgin Mary in the center, accompanied by a wise man holding a ritual bowl topped by an African symbol of a bird. The former element will be recognized by Westerners as Christian; the latter is African, but can easily be mistaken for one of the three wise men at the Christian Nativity scene. Standing slightly behind the Virgin, and placed so as to suggest submissive offering, the visual syntax does not suggest African religious genius.

This is an effect of visual syntax. The message is of a submission to Christianity rather than a genius for appropriation. The Madonna is central and the ensemble is the largest visual element in this window. Moreover, it is the only one that is immediately figurative, hence, the only recognizable visual element. Its unambiguous message is, therefore, Christian primacy. The African element, although on display, is syntactically made invisible.

In the most negative reading of this sequence—by no means the only possible one—the visitor is set up for a solidarity with the moral rightness and righteousness expressed in the outer framing panel, only to become caught in a narcissistic reflection on Africa as "we" have made it—on Western expansion more than on that which was sacrificed by it. Failing to enforce awareness of that mirroring—failing, for example, to install mirrors so as to visually insert the viewer and thus enable "you" to become, momentarily, an "I"—the content of the constative speech act might entirely negate the critical message.

This triple introduction frames the main part of the hall, where the various peoples are represented in the traditional manner of early anthropology. The

Political caricatures from display "Political Influences", middle section of "Foreign Influences", American Museum of Natural History, entrance to the Hall of African Peoples. [courtesy, American Museum of Natural History, neg. nr. 63549 fr. 36]

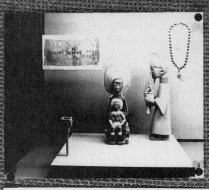

Display "Religious Influences", right-hand section of "Foreign Influences", American Museum of Natural History, entrance to the Hall of African People (mirror image of the display). [courtesy, American Museum of Natural History , neg. nr. 63549 fr. 35]

FIGURE 6.6

combination of authentic artifacts presented as realistic details, and life-size puppets representing otherness in a frozen posture, obviously belong to what the museum, in its meta-museum function, must preserve. The panels here, matter-of-factly, add no different dimension, no criticism, no self-awareness. The visitor's semiotic attitude remains thus in suspense. Of course, the "you" is here more than anywhere differentiated according to cultural and racial allegiance. Reassured and self-centered by the opening, the white Western viewer is prepared to take in visual and verbal information in wonder at otherness. What happens to the visitor of African descent, I cannot tell; supposedly, the reassuring effect of the introduction will not be lost on her, either. The frame fails to provide the visitor of either background with the lasting mirror s/he needs in order to see the African peoples within history.

So far, I have discussed the negotiation of transition according to the former itinerary, which leads up to the most emphatically elaborated entrance. The monitoring of the effect described above is confirmed by even a casual look at the other entrance of this hall. While the entrance just described thematized the relation between representation of the past and understanding of the present, this one is firmly positioned in a search for beginnings.

From this side, the hall bears the title "Man in Africa," proposing a universalism that cancels out the specificity of African peoples to which the hall is devoted. History is effaced in favor of prehistory, of the archaeology of human society of which African Man is the primary index. There is a panel on the left called "Early Humans in Africa," and an exhibit on the right called "The Beginnings of Society."

The display on the left shows a photograph of, supposedly, the earliest human footsteps, those indices par excellence of real human existence and location (fig. 6.7). The exhibit on the right shows the earliest economic activities of herding, cultivation, hunting and gathering, toolmaking. This entrance honors the continent as the cradle of humanity, indeed, of civilization. But whereas at the other side the influence of "us" on "them" frames the information on Africa, here "African Man" becomes "Man" in general, not a forerunner to the same extent as the Greeks. Thus it does not challenge the standard conception of history as bound up with writing, the state, and the military. Instead, the very longevity of African societies blurs their historical position. "The Beginnings of Society" speaks of a universal humanity whose *primitive* stage is associated with Africa. The scientific fact of Africa's long history is here sustaining the signification of a primitivism that stands outside of history, and of which the displays inside present the frozen images.[28]

Again, the frame is more sophisticated than that. Approaching the main body of the hall from this direction, the visitor goes through a narrow doorway into

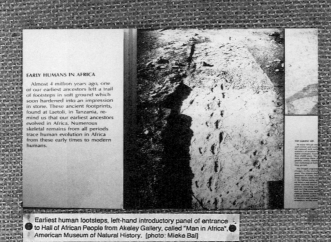

EARLY HUMANS IN AFRICA

Almost 4 million years ago, one of our earliest ancestors left a trail of footsteps in soft ground which soon hardened into an impression in stone. These ancient footprints, found at Laetoli, in Tanzania, remind us that our earliest ancestors evolved in Africa. Numerous skeletal remains from all periods trace human evolution in Africa from these early times to modern humans.

Earliest human footsteps, left-hand introductory panel of entrance to Hall of African People from Akeley Gallery, called "Man in Africa", American Museum of Natural History. [photo: Mieke Bal]

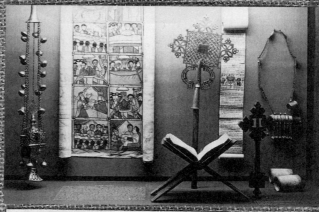

"Christianity", right-hand window after entrance from Akeley Gallery, presenting Ethyopia; American Museum of Natural History. [photo: Mieke Bal]

FIGURE 6.7

"Africa" proper, with Ethiopia on this side of the geological division according to "lands": river valley, grasslands, desert, forest. The reason why Ethiopia occupies this exceptional position is readable in the exhibits. It might be because it is in Ethiopia that the oldest signs of human life were found. But there is another reason, too, at least on the connotative level.

The first two exhibits are devoted to "Christianity" on the right and "Warfare" on the left. The display "Christianity" begins with the fourth century B.C.E. and the Solomonid dynasty of the third century C.E., with claims going back to Solomon and Sheba. The word "Christianity" in the display's title centers the entire presentation, so that it makes us view the oldest exhibit as a prehistory of later Christianity.[29] The notion of Jewish culture does not appear; yet Solomon can hardly be considered a Christian personage. The major visual exhibits in this window are a visual narration of the story of Solomon and Sheba, painted on canvas, and a written one, with an illustration (see fig. 6.7).

May we take a stretch of the suggested walking tour in the museum as a text, a narrative with a story to tell? The consequence of such a view seems inescapable. Whichever entrance one chooses, then, the Hall of African Peoples can only be approached through Christianity. This could be imagined as a relevant way of introducing Africa's history, but it is not an appropriate introduction to "Africa" as the ethnographic self-identical frozen continent that the hall presents. Instead, the entrances through the concept of Christianity function as an address to the viewer to go through a rite of passage: through a reversal of priorities and a suspension of logic (the conflicting messages), the visitor is prepared for a viewing of African peoples through the lens of Western Christianity. The various exhibits potentially presenting Africa with due variety and internal difference are thus neutralized by the *a priori* identification of the targeted visitor as belonging to the culture which produced this museum.

For others—most notably, the visitor of African descent—the entrance presumably poses a problem of alienation. Either armed or saddled with Christian identity, the visitor faces an "Africa" which is already a fiction: a story focalized in a particular way, where bias supplements knowledge and metaphoric translation neutralizes foreignness—hence, a vision. The overall concept of the hall as well as of the other anthropological halls freezes cultures in a static representation based on the concept of typicality. It represents human bodies as samples of ethnic unity, and it shows cultures outside of history.

Let me end this analysis with an extreme case of what it is that the elaborate framing actually frames; a "specimen" of what you get to see inside this dark representation of the African continent. To be sure, the diorama in the dark center of this Hall on Mbuti Pygmies is obviously dated. I wish it were dated explicitly as well. It doesn't take much, it seems to me, to use this datedness to emphasize the

representational status of the exhibit. If it were up to me, I would foreground the kind of anthropological knowledge put forward in the past, and its historical genres. It is so strikingly disturbing that I can only show it in this book in a modified form, by including at least one representation of the expository agent[30] (see fig. 6.8).

The diorama is as beautifully crafted as it is seductively realistic. The emphasis is on small people with naked, shiny skins. Most striking is its accompanying text panel. This, too, I will quote only in modified form, with emphasis on the words upon which, I think, even a minimal meta-museum panel ought to reflect. For a textual analysis, the panel is easily broken up into three parts, which I number:

1. The Mbuti Pygmies of the Ituri forest typify both physical and sociological *adaptation*. Their small stature (4′6″ maximum) and *light skin color* helps them to *move about easily and unnoticed,* their economy requires few tools, with no animal or plant raising. Gathering mushrooms, roots, fruits and honey provides the bulk of the diet, but the hunt shapes Mbuti society. No *band* can number beyond what local food sources can support, and to avoid hunting out any area, each band must move monthly.
2. The family is the basic unit, but though families may start out together on a hunt, they soon split into age groups. The men set up the nets and stand guard with their spears. Youths stand *further back* to shoot with bows and arrows. Women and children drive the game into the nets, also *gathering* plant foods on the way. Before the hunt a fire is lit as an act of propitiation to the forest God. *One youth practices with his bow, while another signals the hunters to hurry.*
3. The central Ituri forest, Northeast Congo, on the north bank of the river Lelo. The foliage and trees were *collected* in the Budongo forest, an extension of the Ituri, in Uganda. (Emphasis and paragraph numbering added.)

The first part of the panel provides the kind of information you also find in the halls of animals. Clearly, early anthropology was heavily invested in being a science like biology, and had learned a lot from Linnaean classification and Darwinism. The word "typify" indicates the former, the word "adaptation" the latter discourse. The insistence on "third-person" discourse demonstrates how easily the repeated third-person pronouns ("they" and "them") construe an us-them discourse in which the "us" part remains invisible, yet predominant as a speaker.

The second part, while equally faithful to the discourse of early anthropology, displays two additional features: gender stereotyping and a shift from generalizing anthropological discourse to descriptive discourse. The reference

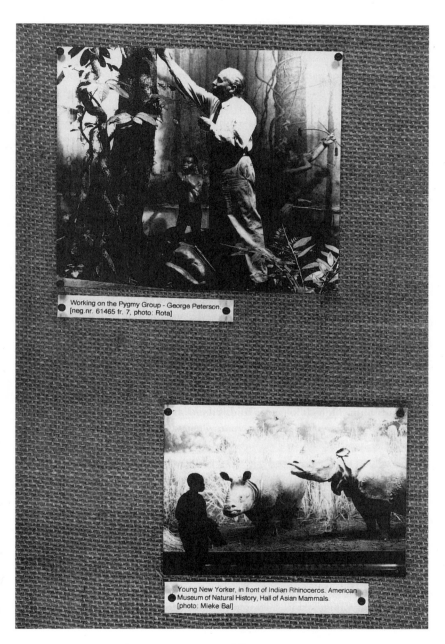

Working on the Pygmy Group - George Peterson.
[neg.nr. 61465 fr. 7, photo: Rota]

Young New Yorker, in front of Indian Rhinoceros. American
Museum of Natural History, Hall of Asian Mammals.
[photo: Mieke Bal]

FIGURE 6.8

accordingly shifts from the Mbuti Pygmy people to this representation of it, the diorama. The first shifter is "further back," a deictic element that, linguistically speaking, has no referent outside the situation of speech. It is the sign of expository agency. This deictic element facilitates the shift to the final sentence of this part, which describes the display. Such shifts partake of the truth-speak of realism; they transfer the plausibility from the description of the "real people" allegedly based on anthropological knowledge, to the representation in this fictional work of art.

The final part is the credit line. It functions like the footnote in scholarly publications, identifying sources so as to make the presentation verifiable and, hence, trustworthy. The formal resemblance to the crediting footnote turns it into a third form of truth-speak, that of "scholarly seriousness." This is largely rhetorical. Although it makes sense for a museum to keep track, in its archives, of the places where material objects were gathered, the information is not going to do anything to help the visitor track down the source for verification. Hence, the line is a piece of truth-speak in the precise sense: in its very stating of the truth—specifying that not all the material came from the same place—it is lying—suggesting that the representation is truthful. It fleshes out the authority of the expository agent who must get away with the shift noted above, and still be believed.

A second remark concerns the "symptom," the small detail that betokens this problematic semiosis around truth. That is the choice of the word "collected." This word reflects back on a synonym used earlier in the panel, "gathering." The Mbuti women are said to be gathering; the museum, in contrast, collects. Both gather or collect vegetation. Why use a different verb? Each word has a different frame, pointing to a different subject. Collecting is what scholars, pioneers, art lovers, colonialists, and museums do; gathering is what primitive folk do. "I" collect, "they" gather. Now, it seems extremely useful, educational, to take advantage both of the need to preserve this outdated presentation and to show, not just the Mbuti, but also the way "we" got to know "them."

In Western cultural history, images have been assigned the function of showing, words of telling, and these two strategies of representation are in competition even within each medium, verbal and visual art.[31] Plato and Aristotle, while figuring as individual heroes of Man's Rise to Civilization for their appeal to experience rather than myth to seek answers to the nature of the world, also set the tone for an endless discussion on the respective semiotic merits of "telling" versus "showing" in literature. A parallel discussion took place on the representational capacities of visual art, which insistently sheds doubt on the ontological possibility of visual telling.[32] The Hall of African Peoples provides a glimpse into the ideological motivations for such a hierarchization of the arts and its intimate connection to the scientific appeal to *"their own"* experience. To deny the image's capacity to tell stories is one way of claiming narrative innocence for visual display.

The story that the museum could tell, and whose telling would make its present function so much more powerful, is the story of the representational practice exercised in this museum and in most museums of its kind. This is the story of the changing but still vital collusion between privilege and knowledge, possession and display, stereotyping and realism, exhibition and the repression of history. There are indications that the expository agent is interested in pursuing this difficult project.

The fact remains that the representation of the peoples of Africa as visually graspable deprives them of their history, in a manner not breaking radically with the colonial imposition of "foreign influences." The representation outside of history goes hand in hand with the representation of typicality. And typicality ignores the very individuality that is the basis of the concept of high art on which the Met is grounded. There, artifacts have a name attached to them, and a date, but no social context. Here, in the very attempt to *show* foreign cultures, the displays *tell* a story. But it is not the story of the peoples represented, nor of nature, but of knowledge, power, and colonization—of power/knowledge.[33] Yet that story does not show its hand as much as it could; it does not tell "in the first person." If only that act of storytelling and its subject were foregrounded more, the museum would be better equipped to respond to the expectations of a postmodern critique. It is ironic that natural history excludes history, and by that exclusion it excludes nature itself (fig. 6.8).

Picking Up Crumbs

This interpretation of some problems in this museum demonstrates the inherent *tension* of such educational institutions and, by extension, of display as an act of constative demonstration or exposition, even when a well-intentioned and expert staff is in charge of the expository agency. I have focused on problems, leaving it to the standard presentations such as the *Official Guide* to propose a different view, not because there is nothing to be content with, nor to blame anyone in particular, but because the problems appear ineluctable, instructive, and serious.

The two major forms of truth-speak, realism and scientific discourse, together with the scholarly truth-speak like the citation of sources, as they compete for the conquest of constative authority and demonstrative persuasiveness, are embodied in the "chapters" constituted by displays in a natural setting and articulated systems: dioramas and diagrams. They each entertain a different dynamic between visual and verbal signs. They seem contrasted in their manners, while convergent in their results. This convergence suggests that realism, where the hand of the maker obscures itself and the words informing the visual image make their

speakers invisible, is as strongly discursive as is the scientific foregrounding of discursivity in diagrams, figures, and explanations.

Surely, the expository agent has clearly put considerable efforts into inserting a critical edge onto its old treasures. However, I want to demonstrate that agency does not coincide with intention. The attempts to alert the visitor to ideological problems take three stances. The first is explicit and repeated comparisons between the cultures on display and "Western culture." This could help to remedy excessive "othering," although the absence of "our" culture as part of the display remains an oddity that threatens to neutralize the effect of the comparisons.

One example of this effort is the presentation of African masks. The display of various masks bears the title "Masks and Social Control," and the verbal panel accompanying it explains their function. The person wearing the mask does not speak as an individual but in the name of society. The panel compares masks with the wigs and robes that judges in the West wear to denote society as the speaking subject. The visual display remains a collection of exotic items, but what makes this case noteworthy is the fact that the text does show the critical intent in its very offering of understanding.

Another well-represented strategy for critical presentation is the insistence on continuity of tradition. This is particularly emphatic in a minor, third entrance to the Hall of African Peoples, coming from the Center Gallery, which is devoted to African tradition in African American culture. The display makes clear that slaves saved the African traditions in the guise of selective adaptation. The notion that African American culture is African as much as it is American is an important one that still needs to be driven home to segments of the American public, and thus this entrance's display is true to the intention expressed on the outer frame panel at the entrance through the birds' section.

The third strategy is explicit self-reflection. Nowhere are the panels and the exhibits ironic—ironic toward the museum and its own background, that is. As I suggested earlier, an astute use of mirrors might have helped to encourage a reversal of the trajectory in the Hall of Peoples of Asia, and might insert the viewer into the foreign world represented at crucial moments. Thus, alterity would be mixed with acknowledgment that the world that grew out of this colonial endeavor is the one each visitor today participates in. Some representation of colonial violence at key moments such as at the entrance to the Hall of African Peoples is, I think, indispensable. But visual and verbal detypifying measures can help to get away from holistic representation, from the synecdochic trope which underlies these halls.

Some displays are more successful than those discussed above in suggesting a different approach to the meta-museum, one that integrates the conveyance of knowledge of the object with an understanding of the construction of it by sub-

jects. There are, indeed, displays where the verbal panels do not contradict the visual exhibits. There are exhibits which are so strong in their visual persuasion that no panel can counter their rhetoric. And there are displays where the exhibits do benefit from the critical edge brought in by the verbal accompaniments.

One example of the latter case may serve as a way of opening up to an integration of a nonconflicting representation and the kind of self-critique that the museum might develop more. At the same time, it constitutes an instance of the third strategy to draw attention to problems that the museum uses: the emphasis on burning issues in the West, so as to avoid exoticist setting off of the other as absolutely different. I quote this example because in its ambivalence it contains both the liabilities and the assets of a museum such as the American Museum of Natural History.

Somewhere in the middle of the Hall of African Peoples, there is a small display related to Pokot women. The accompanying text reads as follows:

> When women work together at their chores in company, or drink beer together, they also formulate a body of opinion that by its very unity influences the behavior of men.

The implications are that the division of labor in Pokot society is gender-based; that women have the leisure, the means, and the desire to spend time together; that they discuss matters concerning their lives during those periods. All this is obvious enough; yet the following conclusion is not. The shape of social life produces a discourse, the text says, which is unified enough to make an impact. It influences the men. The implications are important: here lies the power of women even if they don't have it any other way.

But just like the other texts, this one has a meta-discursive implication. It also says that in general, discourse, even unofficial discourse, does shape social reality. This particular discourse derives its shaping effect from its unity. But this is not a feature of Pokot women's discourse in particular. Any discourse that is socially unified will be stronger in its reality-shaping effect than one that is not. This holds true for the particularly powerful educational discourse of the museum as well as for all expository discourse. If the visual and verbal interaction between exhibits and panels collaborate to sustain the repression of the conflicts that inhabit the museum's endeavor, then it will convey a sense of unity that contributes to the shaping of social reality. In fact, that is the stated ambition of such educational institutions.

The fractures within this mixed discourse of images, words, and spatial distribution are representative of similar fractures within the social reality of New York City, the center of a world having difficulty coping with its colonialist in-

heritance. And this similarity is tricky: it may naturalize what should, in fact, be enhanced as historically specific and, hence, changeable. The peoples inhabiting New York City are members of a world that cannot too easily endorse the prefix *post-* of postcoloniality. As such, the conflicts in the museum point at problems and breaks in the unity of an overall discourse of domination. But there is a predominance of one particular element, a convergence of an attraction that is already very powerful: the tendency to believe in the truth of the knowledge represented through fiction.

Different museums speak different fictions, but what these fictions have in common is that they show their objects, not their own hand or voice. "Showing" natural history uses a rhetoric of persuasion that almost inevitably convinces the viewer of the superiority of the Anglo-Saxon, largely Christian culture. At the end of the evolutionary ladder, a pervasive speaking "I" is itself absent from the content of the shows, the "monstrations" that the museum's displays are. Showing, if it refrains from telling its own story, becomes showing off.

Notes

Originally published in Mieke Bal, *Double Exposures: The Subject of Cultural Analysis* (New York: Routledge, 1996), 13–56.

1. I am grateful to Michael Ann Holly for her very pertinent remarks on an earlier version of this chapter. This seems the place to explain the dedication of this chapter. When I first published a version of it, I had dedicated the paper to Alexander Holly. Alexander had told me to go to the American Museum of Natural History to see the whale, instead of always going to the Metropolitan Museum of Art. In his child's wisdom, he persuaded me that showing animals is just like showing art. I got stuck at the Buddhist statue and never got to see his favorite. Alexander died the week the paper appeared, and he never knew the surprise I had been preparing for him. He gave me the first idea for the connections I am trying to establish in this book. For that reason, and because he will always be the fourteen-year-old boy he was then, I dedicate this chapter now to his memory. He could have said "That's mean!" to the representation of the dog sacrifice I will mention later. He could also have become—was on his way to becoming—one of the finest critics of just such epistemological and pedagogical tricks.

2. For an illuminating discussion of naturalization in literature, see Culler (1997). Hamon (1981) uses the term "motivation" for a similar phenomenon: rhetorical devices which allow description to pass themselves off as "naturally" belonging in the narrative which in fact they interrupt. My use of the term "naturalization" here is meant to enhance the rhetorical nature of the experience of the city layout.

3. Zappler (1990, 3).

4. The term "symptom" is meant in its specific, Peircean sense of inadvertently emitted sign. Whether one wishes to connote the term with medical or Freudian connotations of signifying disease or dis-ease is up to the reader. See Sebeok (1994, 24–28).

5. James Clifford presents an illuminating and witty version of Greimas's semiotic square

according to Frederic Jameson. Like Jameson, Clifford uses the semiotic analysis to map out the structures of ideology, not to suggest—as Greimas would—that meaning production must be limited in this way (Clifford 1988, 224); Greimas and Rastier (1968); and Jameson (1981).

6. See Johannes Fabian's classic critique of the evasion of time in ethnography, *Time and the Other* (1983).

7. The term "effect of the real" (*effet de réel*) was successfully introduced by Barthes (1968). The term is problematic as well as attractive; see my critique (Bal 1991a, 109–45). Briefly, the term refers to literary phenomena such as description whose connotation of a second meaning, "this is reality," becomes more important than the primary meaning of what is specifically described.

8. For the distinction between artifact and aesthetic object, see Ingarden (1965); the distinction has been taken up again by Iser in his version of reception aesthetics: *The Act of Reading* (1978). The terms "icon," "index," and "symbol" are used in the Peircean sense; a short text that explains all the important terms has been published as Peirce (1984). For an introduction, see Sebeok (1994) and the introduction to Bal (1994).

9. The relation between domination (in the field) and collecting (for the museum) has been argued by Haraway (1989). On the problematic of collecting, see Stewart (1984); Messenger (1989); and Ames (1986). A more general volume on the subject of collecting is Elsner and Cardinal (1994).

10. For the latter critique, see Fischer (1986).

11. The meta-museal function of a museum like the American Museum of Natural History has been analyzed by Ames (1986).

12. Or with the "wild man within," whose existence Corbey denies so vehemently; see Bal (1996, chap. 6). See White (1978) on the logic of the "ostentive self-definition by negation" at stake here. For a critique of the (neo)colonialism within postcoloniality, see Spivak (1993).

13. The word "distinction" is meant here in the specific sense given to it by Bourdieu's study *Distinction* (1984).

14. In other rooms of the museum, a third representational strategy is deployed: the aesthetics of scientificity, which projects aesthetically pleasing and cognitively convincing three-dimensional diagrams. This strategy is more emphatically present in the halls of animals, which I will not analyze.

15. On the semiotic status of evidence, see Eco and Sebeok (1983). On "tribal art" as cultural evidence, see Clifford (1988, 187–252). I am largely in agreement with Clifford's reading of the museum, but I am not convinced that his distinction, borrowed from Ames, between "formalist" and "contextualist" protocols fully accounts for the semiotic strategies used in the Met and the American Museum of Natural History, respectively. "Aesthetics" is also a context, which is why "formalism" necessarily fails. In both cases, the works are used as indices, specifically as synecdoches, but the "whole" for which, as a "part" of it, they stand is different for each. *Time* is the crucial factor, the ground whose absence (in this museum) or presence (in the Met) produces the meaning of the representative object.

16. I cannot resist referring to Clifford's quotation from a letter written by Mead, which I wish he had analyzed in more linguistic detail. Let me just quote a few telling phrases: "We are just completing a culture"; "They have no name and we haven't decided what to call them yet"; "They are . . . revealing . . . providing a final basic concept"; "and having articulated the attitude toward incest which Reo [Fortune] outlined as fundamental in his Encyclopaedia ar-

ticle"; "they are annoying" (for not fitting the categories); "A picture of a local native reading the index to the *Golden Bough* just to see if they had missed anything"; "we are going to do a coastal people next" (Clifford 1988, 230). Fabian's subtitle for *Time and the Other* (1983) is ironically illustrated here: how anthropology makes its object. See Mead (1932, 740). The discourse is structurally identical to that used by biologists, in particular in the classification of animals. See the end of the section on the Hall of African Peoples.

17. For an analysis of Genesis 2 and 3 in these terms, see Oosten and Moyer (1982) and Bal (1987, 104–30).

18. Crimp and Lawler (1993, 56).

19. See Nagy's study *The Best of the Achaeans* (1979).

20. This remark should not be taken to advocate a general and uncritical use of mirrors. The new installation of the National Museum of the American Indian, opened in 1994, has a mirror placed at the end of the circuit. That mirror, next to the exit door, shows the exiting visitor but nothing of the installation. As a result, its effect is the opposite of what I am proposing here. It isolates the visitors from the objects from First Peoples' cultures they have just seen, and if any feeling is solicited it seems one of relief rather than of solidarity or hybridic identity. See Hill and Hill (1994). In contrast, see Janssen (1994) and Bal (1996, chap. 4).

21. Going back for a final check in December 1994, this particular panel had been removed in view of a temporary installation, "The First 125 Years." I don't know if and how, and where, it will return.

22. If this spatial distancing is read as the writing of moral distancing from a position remote in time, it becomes an emblem of Derrida's theory of *différance*. See his *Writing and Difference* (1978).

23. Prince (1982).

24. This is not the diorama you first glimpse, which is on a desert people, but a comparable one. No photograph was available of the first one.

25. The hall itself is dark, protecting the fragile dioramas; the entrance with these displays on each side is like a short corridor. "Africa" decidedly takes the shape of a female body.

26. This idea becomes even more painful as it points out, by way of similarity, that this is precisely how the nation in which this museum stands succeeded in leaving its lasting "benefits" in the space it conquered. Could it be that this possible similarity-in-opposition appealed to the expository agent's "unconscious"?

27. As a Western European with a (remote) Catholic background, I suppose I read this installation differently from someone who knows African religious culture. But that is precisely the point: this museum claims to inform "us" about "others"; its main purpose is epistemic-pedagogical.

28. On primitivism in literature, see Torgovnick (1990); especially in art, see Hiller (1991).

29. This construction of chronology as an ideological tool is a well-known problem in scholarship. I have discussed it at some length in Bal (1988). David Carrier reminds us of Gombrich's double structure of chronology in Gombrich (1968, 16–17). Carrier distinguishes between an annal (a simple listing of events in order of their occurrence) and a narrative. I find Carrier naive in assuming that a list like Gombrich's Egyptian pre-naturalism, Greek naturalism, Byzantine anti-naturalism, the Renaissance revival of naturalism, the development of naturalism, the end of naturalism in the nineteenth century is a "simple listing of events" and not a (focalized) narrative. Gombrich's insistence on naturalism as the ordering principle for the

history of art is as biased as this museum's insistence on Christianity as the "beginning" of the Hall of African Peoples. The most incisive critique of Gombrich's naturalism that I know is Bryson's *Vision* (1983).

30. The problem in which I found myself entangled here is: How to discuss a representation without simply perpetuating through display the problem I wish to point out? See Bal (1996, chap. 6).

31. In *Reading "Rembrandt"* (1991b), I argued that the difference between visual and discursive representation is one of modes, not of media, and that each medium is by definition mixed.

32. For an incisive critique of major attempts to theorize essential differences between the visual and the verbal, see Mitchell (1985).

33. For a reconsideration of this Foucaultian concept, see Spivak's brilliant critique of dogmatic philosophy in "More on Power/Knowledge" (1993, 25–52).

References

Ames, Michael. 1986. *Museums, the Public, and Anthropology: A Study in the Anthropology of Anthropology.* Vancouver: University of British Columbia Press.

Bal, Mieke. 1987. *Lethal Love: Literary Feminist Readings of Biblical Love Stories.* Bloomington: Indiana University Press.

———. 1988. *Death and Dissymmetry: The Politics of Coherence in the Book of Judges.* Chicago: University of Chicago Press.

———. 1991a. *On Story-Telling: Essays in Narratology.* Sonoma, CA: Polebridge Press.

———. 1991b. *Reading "Rembrandt": Beyond the Word-Image Opposition.* Cambridge: Cambridge University Press.

———. 1994. *On Meaning-Making: Essays in Semiotics.* Sonoma, CA: Polebridge Press.

———. 1996. *Double Exposures: The Subject of Cultural Analysis.* New York: Routledge.

Barthes, Roland. 1968. "L'effet de réel." *Communications* 4:84–89. Translated by Richard Howard as "The Reality Effect." In *The Rustle of Language,* 141–54. New York: Hill and Wang, 1986.

Bourdieu, Pierre. 1984. *Distinction: A Social Critique of the Judgement of Taste.* Translated by Richard Nice. Cambridge, MA: Harvard University Press.

Bryson, Norman. 1983. *Vision and Painting: The Logic of the Gaze.* London: Macmillan.

Clifford, James. 1988. *The Predicament of Culture: Twentieth-Century Ethnography, Literature, and Art.* Cambridge, MA: Harvard University Press.

Crimp, Douglas, and Louise Lawler. 1993. *On the Museum's Ruins.* Cambridge, MA: MIT Press.

Culler, Jonathan. 1975. *Structuralist Poetics: Structuralism, Linguistics, and the Study of Literature.* Ithaca, NY: Cornell University Press.

Derrida, Jacques. 1978. *Writing and Difference.* Chicago: University of Chicago Press.

Eco, Umberto, and Thomas A. Sebeok, eds. 1983. *The Sign of Three: Dupin, Holmes, Peirce.* Bloomington: University of Indiana Press.

Elsner, John, and Roger Cardinal, eds. 1994. *The Cultures of Collecting.* London: Reaktion Books.

Fabian, Johannes. 1983. *Time and the Other: How Anthropology Makes Its Object.* New York: Columbia University Press.

Fischer, Michael. 1986. "Ethnicity and the Postmodern Art of Memory." In *Writing Culture: The Poetics and Politics of Ethnography,* edited by James Clifford and George Marcus, 194–233. Berkeley: University of California Press.

Gombrich, E. H. 1968 (1960). *Art and Illusion: A Study in the Psychology of Pictorial Representation.* London: Phaidon Press.

Greimas, A. J., and François Rastier. 1968. "The Interaction of Semiotic Constraints." *Yale French Studies* 41:86–105.

Hamon, Philippe. 1981. *Introduction à l'analyse du descriptif.* Paris: Hachette.

Haraway, Donna. 1989. *Primate Visions: Gender, Race, and Nature in the World of Modern Science.* New York: Routledge.

Hill, Tom, and Richard W. Hill Sr., eds. 1994. *Creation's Journey: Native American Identity and Belief.* Washington, DC: Smithsonian Institution Press.

Hiller, Susan, ed. 1991. *The Myth of Primitivism: Perspectives on Art.* London: Routledge.

Ingarden, Roman. 1965. *Das literarische Kunstwerk.* Tübingen: Niemeier.

Iser, Wolfgang. 1978. *The Act of Reading: A Theory of Aesthetic Response.* Baltimore: Johns Hopkins University Press.

Jameson, Frederic. 1981. *The Political Unconscious: Narrative as a Socially Symbolic Act.* Ithaca, NY: Cornell University Press.

Janssen, Edwin. 1994. *Narcissus en de poel des verderfs / Narcissus and the Pool of Corruption.* Rotterdam: Museum Boymans van Beuningen.

Mead, Margaret. 1932. "Note from New Guinea." *American Anthropologist* 34:740.

Messenger, Phyllis Mauch, ed. 1989. *The Ethics of Collecting Cultural Property: Whose Culture? Whose Property?* Albuquerque: University of New Mexico Press.

Mitchell, W. J. T. 1985. *Iconology: Image, Text, Ideology.* Chicago: University of Chicago Press.

Nagy, Gregory. 1979. *The Best of the Achaeans: Concepts of the Hero in Archaic Greek Poetry.* Baltimore: Johns Hopkins University Press.

Oosten, Jarich, and David Moyer. 1982. "De mythische omkering: Een analyse van de sociale code van de scheppingsmythen van Genesis 2–11." *Antropologische verkenningen* 1 (1): 1–34.

Peirce, Charles S. 1984. "Logic as Semiotic: The Theory of Signs." In *Semiotics: An Introductory Anthology,* edited by Robert E. Innis, 4–23. Bloomington: Indiana University Press.

Prince, Gerald. 1982. *Narratology: The Form and Functioning of Narrative.* Berlin: Mouton.

Sebeok, Thomas. 1994. *Signs: An Introduction to Semiotics.* Toronto: University of Toronto Press.

Spivak, Gayatri Chakravorty. 1993. *Outside in the Teaching Machine.* New York: Routledge.

Stewart, Susan. 1984. *On Longing: Narratives of the Miniature, the Gigantic, the Souvenir, the Collection.* Baltimore: Johns Hopkins University Press.

Torgovnick, Marianna. 1990. *Gone Primitive: Savage Intellects, Modern Lives.* Chicago: University of Chicago Press.

White, Hayden. 1978. "The Forms of Wildness: Archeology of an Idea." In *Tropics of Discourse: Essays in Cultural Criticism.* Baltimore: Johns Hopkins University Press.

Zappler, Georg. 1990. *Official Guide to the American Museum of Natural History.* New York: American Museum of Natural History.

7. Enfolding Feminism

Figuring It Out

In the seventies, defining femininity seemed so important because it enabled women to seek a ground for bonding. Somehow, it took me a long time to understand that ontological communalities don't necessarily lead to common politics.[1] In my experience, women had not been socialized to trust, and care for, other women. Their training had been obsessively to encourage jealousy and rivalry instead of trust, and all the care had to go to the men and the kids. Unlearning this turned out to be harder than we would have liked.[2] The tenacious presence of family metaphors—sisterhood cannot be thought of outside of the familial ideology—was a superficial but telling symptom.[3]

By the time I discovered the irresolvable contradictions between the two elements "identity" and "politics," common womanhood had been set aside in favor of difference. "Being a woman is not enough"; feminism as a common project had to surrender to the insight that "all the women are white, all the blacks are men, but some of us are brave."[4] The pain of that insight is not over, and solutions that don't get trapped in the overruling ideology that caused the problem in the first place—say, individualism—are still hard to find.

Through these well-rehearsed divides, another runs rampant and does damage by being reduced to slurs: the theoretical divide between concerns that fall under ontology, such as what opponents dismiss as "essentialist," and concerns of epistemology, which first justified and then unjustified special corners of the academy called "Women's Studies."[5] Roughly, post-Kantians and anti-Cartesians can't talk to each other; they can only scream. This division demonstrates that women are no smarter than other people. Which, I find, is too bad.

As much as these two approaches to feminism seem "naturally" incompatible, simply following as they do an age-old division in philosophy, it seems obvious

to me that the question of whether women know differently[6] cannot be separated from the question of whether women are different.[7] Nor can either question be separated from the political issues that splice feminism into invisibility and, worse, ineffectivity, at the moment of its indisputable success.

The issue that lies at the heart of both epistemology and ontology is the bond between existence and knowledge.[8] In spite of brief moments and rallying cries such as "thinking through the body," today's debates in feminism are polarized around what such insights left behind long ago.[9] This bond is complicated by the consequence of the ensuing bond between subject and object. Feminism has not succeeded in articulating this bond beyond the divide that makes the endeavor to account for the intricate relationship between existence and knowledge itself unthinkable. Epistemology and ontology are both incompatible and inseparable.

Two examples must suffice. As the dénouement of Roman Polanski's 1994 film *Death and the Maiden* so troublingly suggests, you never know the truth even if you hear the accused say it himself. Uncertainty severs the bond between epistemology—knowing the truth, with confession as its ultimate end and lie—and ontology—the truth exists, even if it cannot be known. Yet, as Jodie Foster so utterly convincingly conveys in Jonathan Kaplan's 1988 film *The Accused,* it is urgent that the truth be recognized. The epistemological question is of vital importance for the ontological possibility of Jodie's character.

The tragic fate of feminism in the 1990s can be mapped out in the unresolved dispute between these two classic and controversial films. Mapped out more clearly there, one could argue, than it is in the disputes between FACT and MacKinnon, humanist and poststructuralist feminisms, political-activist and academic-theoretical feminisms, feminist metaphysics and scholarship, unreconstructedly white and antiracist feminisms, unreconstructedly straight and queer feminisms, and, for me the most tragic dispute, between victim speech and fun talk. If there is change from decade to decade, perhaps the most painful divide lies here. Rape, gender-based torture, pornography, and other forms of abuse got many feminists excited in the seventies. Rather suddenly, the tone of complaint that these issues seemed to entail became unbearable, and instead of the discourse and theory being changed, it was the thematics that was replaced. "Enough complaining" led to a focus on pleasure, as if the two areas of interest could not coexist.[10]

Some of these changes and divides are inevitable and even productive. I am all for a certain eclecticism, for multiple battles on various grounds to be fought simultaneously. The worst waste of energy for feminists is to fight other feminists on the ground of a difference of opinion. Much energy, I find, has been and continues to be wasted in this way. What can be done about it depends on insight into what went wrong. The indictment of a continued predominance of privileged

groups has been heeded, at least verbally with lips, but also transformed into an uncritical celebration of differences—only acceptable in the plural. In the United States and its tentacles, differences have been co-opted into an individualist conception of identity as an accumulation of differences. Hence the slogan "race, class, and gender," which, countering its political grounding, became an obnoxious slur that exacerbated disagreements. It's a trap; as long as you don't omit a single difference from the list, we are all different enough again to keep us apart. In Europe, on the other hand, identity itself has been marked, if not erased, by difference within.

At the level of institutional feminism, this geopolitical difference has played itself out in the creation of campuswide programs, in which the faculty of all departments have united under the banner of women's studies, now renamed gender studies, thereby further expanding their reach but at the same time diluting feminism's visibility. In Europe, the creation of separate research institutes or departments has had a ghettoizing effect. In the United States, affirmative action has left some ineradicable traces, at least here and there. European women's studies centers, firm in their policy of difference within identity, remain as massively white as mainstream departments remain massively male. This difference between American and European academic culture, immediately visible, is the best argument in favor of some version or other of "I'd rather be accepted as a woman/as a black person than refused as one"—which is my bottom-line policy in these things. And having failed to make the connections that—women's/gender studies departments fear—would make them invisible, they are now available for the taking, to economically exasperated administrators.

Now that the hopes that rallied around femininity and difference have been exhausted—and, ironically, female pleasure is beginning to become a boring topic at a time when we can no longer ignore the fact that rape and other violence against women have not diminished—a new rallying cry is needed. I personally am longing for one that does not require consensus on priorities, or decisions on whether it matters what femininity is and, if there is such a thing as femininity, what that is. I therefore propose to give that cry the form not of a "position" to be defended and used to tighten the mazes of the networks but of a metaphor.

Metaphor, as I have argued elsewhere, is a powerful tool for overcoming the dichotomy between epistemology and ontology.[11] Moreover, a well-chosen metaphor is semantically enriching, affectively powerful, and can be so innovative that it offers an antidote against the temptation of recidivism. This latter aspect is mightily productive. For the metaphor as rallying cry must avoid the old traps, including the one that divides us up into generations to be left behind. Admitting that I turned away from institutional feminism when someone hissed "you Kantian!" instead of "you bitch!" in my ear, my passionate commitment to the issues

involved in feminism makes me want to continue trying to think these on a different model. For now, a very productive metaphor for what feminism has been, could become, and should pursue, I submit, is the *fold*.

The fold is another of Gilles Deleuze's inventive concepts, through which he tried to overcome the consequences of old concepts. It is the term through which he actualized the thought of baroque philosopher Leibniz.[12] To offer the new millennium a term with such a background may sound hopelessly nostalgic. Yet I wish to give it a try. Despite Deleuze's current popularity, the possibilities of the fold as a manner of thinking have not been taken up by feminism. Rather, Deleuze has inspired ontologists and epistemologists, although they have remained opposed to each other. His antisubjectivity has led to a neo-ontology of the subject, an often sentimental, romantic plea for nomadic subjectivity that flies in the face of the same pernicious problem as sisterhood, and now seems scandalously exploitative in a world of real migration.[13] On the other hand, Deleuze's metaphor of the rhizome—attractive as it is, in a formal, primarily epistemological sense— for replacing structure, remains caught in an ontology of common genetic origin.[14] Hence, this metaphor is not fit to overcome the divide most in need of being bridged.

This Deleuzian metaphor of the fold—less romantically inclined than the nomadic, less biologically fixed than the rhizome—is more simply grounded in a material manner of thinking, yet has no genetic connotations, and is basically anti-originary. I will argue that the "fold" catches the nature of relationship beyond the rift between ontology and epistemology, and, politically speaking, beyond identity, essentialist stability, but also beyond the individualist pluralization that killed identity politics.

The move beyond subjectivity-only is necessary because the exclusive focus on subjectivity has encouraged a navel-gazing sterility that has benefited an ineradicable individualism. The fold's potential to overcome individualism derives from the way, as a figure, it helps us think, not the position of the subject caught in the abyss between victimhood and pleasure, or that of the object as, for example, in some sentimentalizing forms of ecofeminism, but the relationship between the two. This relationship is mutually transformative; it is neither static nor slippery but durative in a dynamic way. And since the fold remains a rather banal, material figure, it de-romanticizes the idea of relationship itself. At the same time, its visual appearance in the form of smooth, tactile, often appealing satin or velvet, while "catching" and hence imprisoning the look whose autonomy it threatens, also lures and seduces. Attracted to its inner secrets, we want to know (epistemically driven) what is in it. But there is nothing, so there is no ontological trap that can captivate us.

Thus, the figure of the fold has the capacity to enable us to suspend, or chal-

lenge, the divisions mentioned above. It neither cancels nor ignores the provisional interests that inform such divisions but enables us to probe, utilize, and then overcome, not them but their hold over feminism as a theoretical practice. Last but not least, it helps articulate the relationship between feminism as a movement of women and as a concern for issues, a way of thinking, that men can and must share.

Because of the fold's history as an emblem of baroque philosophy and visual art, I will draw upon works of visual art to make this argument. By doing so, I wish to demonstrate what I am arguing: to propose the fold not only as a model for argumentation, but as argument in and of itself. Of all the senses, vision has been the most deceptive one, used and abused for untenable claims about ontology as well as epistemology.[15] It is the sense that requires distance, separateness, and, at the same time, spatial proximity. It resists the direct communication of bodies implied by hearing and touch. It relies only on surface. As the primary sense of seduction, it colludes with both violence and pleasure. In all these respects, it seems, vision is not the most reliable sense at all.

Worse, this sense has been identified with a predominant model of vision—Renaissance perspective, the visual shape later articulated by the Cartesian *cogito*.[16] Yet, precisely because of all these dangers, vision can become the domain in which the feminist virtues of the fold can best be articulated, under the argument that what is gained with maximum difficulty will be easier to expand beyond itself. I will be suggesting such expansion of the reach of this theoretical figure by connecting visual folding to the dimension most alien to it: time. To avoid those simplifications that specifically affect temporality and that discussing such a figurative and material figure as the fold in theory entails, and in keeping with what I wish to argue, I can only put the issue forward through "cases." I will invoke these as allegories.

Beyond Representation

Let me first explain the fold through an allegorical example of a practice of looking, which is also an allegory of where we are now, feminists before our own results. For the most significant rift in feminism exists on a level that is both theoretical and utterly practical. It involves the subject and the object, and resolving it requires a rethinking of both. A rethinking is necessary between, on the one hand, an orientation in feminism toward the subject that probes the conditions of feminine or female subjectivity in or out of specific contexts and, on the other, an orientation—informed and motivated by feminism—toward the object that probes the potential productivity of an outward relation that, as such, is inflected

by feminism. As long as the subject-object opposition remains in place, it is over-layered by the opposition between the (different, feminine) subject and the way it perceives the object: ontology and epistemology remain separate. In probing this opposition of orientation, I am trying to articulate a way out of the double framing that comes with a focus on representation.

Anyone who has followed up on Spivak's founding article, "Can the Subaltern Speak?" has lost the innocent belief that speaking *about* and speaking *for* others is either possible or avoidable.[17] Representation, hovering as it does on the edge between these two incommensurable yet inextricable meanings, remains a glib and troubled notion. As a result, the point of feminist academic work, and of any political action that is not directly activist, has come under siege. Within the academy, both critical analysis and identity politics have begun to turn against themselves. Meanwhile, speaking *with* others, an old tradition in anthropology, can only be a false dialogue rife with power inequity.[18]

Spivak's indictment of representation's double bind should, of course, not be taken as a reason for giving up on analyzing representations. Instead, a more materially grounded search for at least partial solutions to the dilemma can yield a reconsideration of allegory. My own position toward allegory has always been one of deep suspicion, considering the cultural tendency to invoke this figure to explain away such disturbing representations as, for example, the rape of Lucretia.[19] More recently, and under the influence of deconstructive theory, I have been led to consider allegory not necessarily as escapist but, more literally, as a way of potentially speaking *through* the discourse of others.[20] If taken seriously, the preposition "through"—unlike "for," "about," or "with"—precludes an unmodified return of the subject to the state before speaking.

How can we mobilize the figure of the fold to make a decisive move here? I will argue that the fold stands for a different relation between subject and object, one that bypasses the problem of representation's ambiguity. It is able to do so thanks to the specific temporality it entails—one that refuses the divide between ontology and epistemology. As I will explain below, the specifically "baroque" point of view that the fold emblematizes engages the subject in a voyage through the field of the object that unhinges the distinction between those two positions.

My first allegory is the following case of a conflict between representation and presentation. In the Musée du Louvre, Caravaggio's *Death of the Virgin* cannot be viewed easily. This large canvas from 1605–6 hangs too high for comfort as well as opposite a window whose light reflects in the glass, preventing the humbled viewer, who cranes her neck to see it, from getting closer, and who then tries distance, all in vain. From a distance, the reflections blind you; close up, your neck hurts, the angle is too wide, the image too flat.

But in the process of trying, you can become absorbed in the effort and end up seeing things that an easy glance would not reveal—if it were hung in ideal museal circumstances, invisible circumstances, that is. *Not so fast!* says this infelicitous installation; it requires time. During that time, the relation between the subject and object of looking hurts your body. Although it is obvious that visual images can *evoke* or *represent* time—the past, the future, or two or more moments simultaneously—it is more difficult to see how they can *be* in time without simultaneously unfolding that being in time as film and literature do: in a sequential development, a time axis whose continuity moves forward. The temporal realism that sticks to those media is tenacious, even if different rhythms can bring temporal variation into play, as in fact they routinely do in those media. It is, I contend, those naturalizations of time that make such works fictional, in the specific sense of the suspension of history; *ahistorical.* Conversely, art that foregrounds time, that alerts its viewers to their inhabiting of time, is *historically active.* Thus, it contributes to the current challenges of conceptions of history as safely remote. It enfolds the past within the present.[21]

In my attempt to understand the fold in action—in time—differentiating temporal existence became an urgent part of thinking the relationship between that object—the painting—and myself. The painting in its current installation unwittingly foregrounds four different aspects of time that the figure of the fold entails: *bodily experience, material corruption, virtual sensuality,* and *actualizing attention.*[22] These aspects of time all engage the subject's willingness to enfold within, or with, the object. None of them is compatible with either a spiritualized, idealist, or grossly materialist ontology. Caravaggio's work makes such a good kickoff point because it is hyper-illusionistic, yet antirealist to the point of being almost nonfigurative, or hyper-figurative. It refuses to yield to the pressure to spiritualize. But it effectively refrains from telling stories the way classical Renaissance art did. Nor is his work descriptive of an object that can be represented as such. Its narrative dimension derives instead from its appeal to an interaction with the viewer, to its own processing in time rather than to representing time in a represented fabula.[23]

The frustration at trying to see Caravaggio's Louvre painting entails a physical realization of the difficulty of seeing. It inaugurates the oscillation between the object coming from the past and the viewer standing in the present. This image does not "give itself," although it pretends it does. The curtain that separates front from back; the apostles chatting in the wings behind the curtain; the subdued light coming from the back at the left and barely seeming to reach the front, as if underlying a depth that otherwise is not so convincing; a division in planes, each occupied by groups of figures: it all seems constructed to prove that the

painter knew the history of his art, had studied Raphael, had mastered the ruses and paradoxes of perspective. Before Descartes, he stands here as a model of post-Cartesian thought.

For, if we take that large curtain literally, it is an embodiment of the baroque fold, an instruction for use that tells you that depth circles back to the surface, the only outcome of a voyage through a picture plane (fig. 7.1). Once reassured that all is fine, as it should be in Italian art after the Renaissance, the viewer arrives at a big black hole, where the vanishing point should be, but isn't. This hole, literally, enfolds what it resists, encapsulating the expectation of linear perspective in its refusal to allow the illusion of objectivism that that mode of representation carries, exposing it as carrier only—as metaphor. Turning to the far left, one hits three faces—a close group, barely readable, excluding you from the conversation, making it forever impossible to find out if they are saints or actors. Rejected by this group, as by conventional realism, and turning back with the light, one arrives, finally, at the main character, so close to the picture plane that she is hard to see. Rather than contributing to the depth, this figure comes forward, into the viewing space that is already so uncomfortable. The nasty reflections of the Louvre window take on a meta-artistic sense. Not so much the face as the neck, whose wrinkles may indicate age for aficionados of realism but also "do" the Leibnizian fold, which dictates a cyclical look without outcome; not so much the face as the oversized hand without strength; not so much that hand as the other hand, resting on the stomach that has borne the child, preposterously dead, before its mother; not so much the Virgin as the senseless neck of Mary Magdalene, bent in mourning. It is not quite possible to unify this image, whose elements send you on from one to the other, keeping your look busy.[24]

The body of the Virgin, so indecently exposed, yet hard to see—dead, old, and scandalously corporeal—cannot be taken as a whole; it cannot be put safely at a diagonal, at an increasing distance from the viewer. Instead, the very line that inscribes linear perspective takes off in the opposite direction, toward us, not diminishing the size of the telescoped body but making it gradually larger, until it threatens to invade the viewing space. The confrontation with the dead body would be easier to sustain if it were sent in the opposite direction, head in front, lower part of the body farther away. But no; if the direction of the light enhances some detached parts of the upper body, the inverse perspective foregrounds the feet, indecently dead, gray feet that emerge to sight at the end of a second, third, tour of the image. Feet that definitely impede a transcendental view of death in a spiritual appropriation of the events through an untenable split between body and mind. Those troubling feet point to the apostle standing in for the viewer, preventing the latter from approaching; preventing, also, any attempt to spiritualize death.

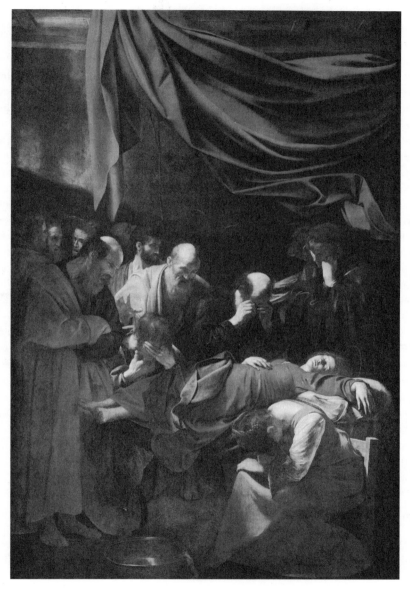

FIGURE 7.1 Michelangelo Merisi da Caravaggio, *Death of the Virgin*, ca. 1605–6, oil on canvas.
Musée du Louvre, Paris. Photo: Erich Lessing/Art Resource, NY.

This painting declares the unity of image untenable. It shrinks the depicted space to the point of impeding the master gaze of a viewer kept at bay. The scene is cut off at both sides, and in front, establishing a threatening, absorbing continuity, imposing proximity with the space of the Louvre, of the late twentieth-century viewer. The painting does this, but only in relationship to the twentieth-century viewer in that situation in the Louvre, like a post-Albertian agent that unwittingly contributes to the articulation of a post-Cartesian definition of subjectivity.

What's the point of this arresting of time, as a performance of the legacy of a tradition of high art that was almost exclusively inhabited by male figures and inhabiting an institution that emanates a nationalistic power adverse to everything feminism stands for?[25] By way of the fold, it is possible, indeed, productive, to remain involved, albeit at the edge, in a culture that can neither exclude nor fully accept those it considers its "others." Let me suggest that feminism can only move on by riding precisely that position on the precarious crest of history's waves. Caravaggio in the Louvre, then, is my allegory of being at the margin of that institution, and of desiring, needing, to participate in the culture in place there. It is an allegory of the place many people occupy, whatever their ontological status and relative difference may be. It is also a position that can be transferred—metaphor does that—to a range of other situations.

Other art today similarly addresses questions regarding issues of space, the body, representation, and difference—through its work with time. And some of that art, I contend, proposes ways of seeing that are both baroque and ways of seeing the baroque: enfolding past within present, articulating what makes Caravaggio's paintings exempla of the fold. They are baroque *bodies* in the two senses of the word: ontologically corporeal more than ever before, and bodies of thought. And they involve an epistemology of what that could mean—the presence of the human body. Dead or alive, but present, while accounting for the impossibility of that presence.

From House-Wife to House-Woman

At the end of the nineties, we still stand there: confronted with a masterpiece too high for us, in an institution that will not accommodate us, prevented from having a clear view of the dead flesh of the icon of a hostile but culturally sanctioned femininity. The situation is allegorical and as such—as a discourse through the other—we must make the best of it. Is there a way to reach over time and gender gaps in one move? Through the fold, subjectivity and the object become codependent, folded into one another, and this puts the subject at risk. The object

whose surface is grazed by the subject of point of view may require a visual engagement that can only be called microscopic and in relation to which the subject loses his or her mastery over it. In view of this codependency, it makes sense that any appeal to knowledge by either of the two in turn should be based on an awareness of a similar codependency between the sources of our insights into this matter. This already makes the divide between ontology and epistemology untenable.

If it matters that Caravaggio belongs to the ineradicable canon that is massively gendered male, a status the location of his *Virgin* in the Louvre only underscores, let me now begin at the other end. My second allegory is borrowed from a woman artist working today. French-American sculptor Louise Bourgeois makes a canny use of baroque folds to, so to speak, take art out of the Louvre into lived reality. Her interest in the fold translates into explicit and implicit references to Bernini, a sculptor as emblematically baroque as Caravaggio the painter. Bourgeois repeatedly responds explicitly to Bernini's thinking, through the fold.[26]

Less explicitly, but perhaps more clearly visible, her "theorizing" of the fold comes across in a work from 1983 that belongs to a series of related works, each titled *Femme Maison*. Over a number of years, the artist produced, in many drawings and sculptures, the semitransfiguration of a female figure into a house, which both imprisons and inhabits her body. But the common theme does not reify the meaning of each of these works. Some emphasize the anxiety of women locked up in the existence of the family; others foreground the liberation of a woman standing on the roof of the house. Still others suggest the power this confinement of women also yields. Most of them remain powerfully ambiguous. Many are square, rectangular, angular, in a nearly hostile way. All somehow address the condition of women in the Western family of the 1950s and 1960s. They are arguably feminist works.

By the same token, the figure of the woman whose head is replaced by a house neatly fits the art historical category of surrealism. Quite literally, these works can be construed as critical responses to Max Ernst's series *La femme cent têtes* and, by extension, as critiques of surrealism's sexist practices. Both these interpretations have some merit; neither is decisive or satisfactory. Both imprison the works in a prefabricated template, which reduces them, instead of deploying what they have to say "about" feminism and surrealism, and what have you.

In the most Berninesque work of this series, a hostile skyscraper voluptuously sinks into a royal robe of folds (fig. 7.2).[27] These folds refuse all tendency toward regularity. On one side, toward the bottom, the folds confess to the deception of their illusory infinity as surface, when the base becomes sheer matter. Elsewhere, the folds detach themselves from the interior mass. The sculpture denies the core implied in the idea of depth but also of unification. Here and there, the folds are

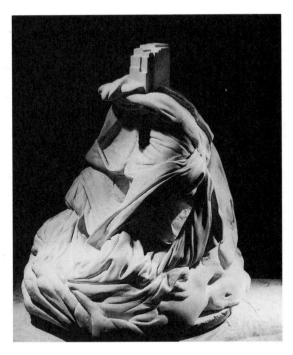

FIGURE 7.2 Louise Bourgeois, *Femme Maison,* 1983. Marble.
25 × 19½ × 23 in.; 63.5 × 49.5 × 58.5 cm. Collection Jean-Louis Bourgeois.
Photo: Allan Finkelman.

knotted, turning infinite texture into inextricable confusion and liberation into imprisonment. The cone-shaped body, sagging under its own and the house's weight, remains a body, refuses to go up in flames like Bernini's *The Ecstasy of Saint Teresa* or be elevated toward transcendence like his *Beata Ludovica Albertoni.*[28] Firmly fixed on a visible disk-shaped bottom, this body is as heavy as Ludovica's, but it does not believe in miracles.

On top, like a head, stands the angular skyscraper of twentieth-century architecture. It looks forlorn, small, and lonely. The gigantic body of folds, folds of flesh, that surround and incorporate this building, states simultaneously mutual dependency and threat. This sculpture absorbs architecture in a secular, disenchanted, yet merry acceptance of the materiality of body, house, and sculpture between them. A house in which women are locked up but also given mastery, a house that confines and protects but can also be escaped, often fails to protect, weighs the body down. But lest we escape reality by bowing for transcendence

and tragedy, the folds, knotted around the building as the body's neck, are also just what they appear to be. Between figuration and conceptualism, Bourgeois winks at us when, from one angle, the surface full of secrets is just a garment lovingly warming the lonely house. The architecture here, in this exploration of frightful interventions in space, encompasses motherly care, humor, and companionship. In opposition to the Vitruvian tradition, this house-woman, while refusing the rigidity of classical symmetry, endorses the caprices of body and matter.[29]

The sculpture not only establishes an enfolded relationship between past and present, but it adopts, probes, and transforms the baroque fold. By playing out the "debate" about representation with Bernini, it also refuses to answer the question of whether it matters that it was made by a woman. In the years after this sculpture was made, feminism was deeply committed to the affirmative action sometimes called "gynocriticism" and dug up women artists whom the process of canonization had passed over. And whereas this seems a not very spectacular position today, like affirmative action in the "real world," Bourgeois's work makes a case for the complexity of that question, which, I contend, cannot so easily be left behind.

Again, then: does it matter that the artist is a woman? It does, which explains why so many revisionist art historians rush to celebrate this exceptional artist-as-woman. If the twentieth-century West is to have a heroine in the visual arts, Bourgeois is a good candidate. She, however, will have nothing to do with that recuperation. To Bourgeois, it doesn't matter if the artist is a woman, and rightly so, for the issue of recognition has fared poorly in the hands of affirmative action that makes a fashionable fetish out of art that deserves better.[30]

On another level, though, it does matter, for arguably, the experience of bodily confinement in the mud of housewifery called motherhood, can only be so acutely yet humorously rendered if one knows the experience from one's own body. It doesn't matter, though, because all those—men or women—who feel isolated, confined, by the very mastery deceptively given to them as a consolation prize can align with this sculpture, fold themselves into it, seek shelter within its knot.

The point here, though, is that the work was made by a woman, just as Caravaggio's *Death* was made by a man; hence, engaging with it from the other gender on the model of the fold requires an embodied engagement with the other gender on *its* terms.

How can we envision such an engagement? For this, let me return to Deleuze. His account of Leibniz focuses less on that baroque philosopher's ideas of logic and fundamental laws than on his views of perception and sensation, identity, and the activity of matter. Deleuze mediates between the two domains, through the concept of point of view, using it as a guideline for engagement with the world,

people, and objects. The figure of the fold shapes a kind of point of view unlike the one still in use. Instead, this point of view is derived from Renaissance perspective. But it also shapes a mode of argumentation. Take the following rendering, by Deleuze, of Leibnizian point of view:

> Leibniz's idea about point of view as the secret of things, as focus, cryptography, or even as the determination of the indeterminate by means of ambiguous signs: *what* I am telling to you, *what* you are also thinking about, do you agree to tell *him* about *it*, provided that we know what to expect of *it*, about *her*, and that we also agree about who *he* is and who *she* is?[31]

This complex sentence is easier to read through its rhythmic movement than through its syntax and proposition. In other words, it embodies, or does, what it states, thus itself enfolding epistemology within ontology. Following the paradox of "determination of the indeterminate" and the subsequent colon, its rhythm performs the movement back and forth between subject and object of point of view, emphasizing the mobility that characterizes it. Objects, seen as enfolded within the subject in a shared entanglement, are considered events rather than things—events of becoming rather than being. The sentence itself, then, presents what it also re-presents. Yet it neither speaks "for" nor "about" others. But I, as other to it, can choose to walk with, on, or in it.

The fold as a figure (of thought, of matter) insists on surface and materiality. This materialism of the fold entails the involvement of the subject within the material experience, thus turning surface into skin, in a relation that is *correlativist*. The fold within Caravaggio's painting sets in motion the process or performance of the painting that entangles the viewer across time; a process, moreover, that itself takes time, thus foregrounding the double temporality of the image and the look that takes hold over it. Deleuze's formulation folds into itself both the object—as in other kinds of perspectivism—and the subject: "If the status of the object is profoundly changed, so also is that of the subject. We move from inflection or from variable curvature to vectors of curvature that go in the direction of concavity."[32]

Unlike the individualist appropriation of difference, this baroque point of view is emphatically not a subjectivist relativism. In my opinion, such subjectivism has led to an excess of the "personal voice" in feminist writing. For all the importance this voice has had as a critical intervention, it does not offer a way out of scientistic generalization. It remains caught in individualism. It has first been dismissed, then simply appropriated, absorbed in male-stream discourse.[33]

Deleuze's formulation, here, demonstrates the epistemological weight of folds as the embodiment of a position beyond subjectivism yet far removed from objectivism:

Such is the basis of perspectivism, which does not mean a dependence in re-
spect to a pregiven or defined subject; to the contrary, a subject will be what
comes to the point of view, or rather what remains in the point of view. That is
why the transformation of the object refers to a correlative transformation of
the subject.[34]

For a feminism that still cannot rest on the results of affirmative action, this may
appear to be a tricky position. The subject is not pregiven. No stability can be de-
rived from it. The fold emblematizes the point of view in which the subject must
give up its autonomy.

In spite of the dangers of renewed obliteration, endorsing this wavering point
of view fully yields new advantages that can help overcome individualist traps
without romanticizing sacrifice or idealizing transcendence. Again, a work of art
shows a possible direction. In addition to a slowdown due to the emblematic
difficulty of seeing, the object/subject of my third allegory will sharpen our
awareness of the spatial aspect of the fold: its power to suspend the apparently
self-evident divisions between large and small, which encompasses the collectiv-
ity (of sisterhood) and the individuality (of difference).

The body that enfolds a house, as in Bourgeois's *Femme Maison,* is also an
embodiment of a questioning of that other opposition that has bogged feminism
down: that between private and public life, one of many political and ideological
counterparts of individualism. If feminism is to deploy the figure of the fold to re-
pair severed links, this one is waiting in the "workshop of possibilities."[35] That
this opposition lies rock-hard between a theoretical feminism and an effective
practice will become apparent through a third aspect of the fold, and a third alle-
gory. Here, the relationship between women and house takes a radical turn.

Actualizing Attention

Going from a disenchantment with subjectivity to hypostatizing the object may
be another trap of representation. The object comes to mirror the painful victim-
hood that subjectivity has been increasingly denied. Hence, to the extent that
such a projection partakes of the binary opposition between subject and object
that continues to wreak such havoc, I would agree with Christine Battersby when
she claims that "the urgent problem for feminist theory to address is not the prob-
lem of the subject, but the problem of the *object*"[36]—if it were not for the binary
opposition that such a claim maintains. Instead, it is in the relationship between
the two, a relationship defined as enfolding and that all but suspends the very na-
ture of subjectivity as severed from objecthood, that a different feminist position

can best be articulated. Again, visual art can suggest ways to do this, but again, this is due to a "theoretization" of the limits of classical ideas of vision in a practice of enfolding. Here, there are no visible folds, only temporal, yet very material, ones.

Colombian artist Doris Salcedo makes the visualization of duration the crucial weapon in her art, which wages war against violence and for its obliteration. Her work demonstrates how we can think a temporality of the fold as an effective figure of thought beyond the oppositions that pester feminist theory. Her sculptures militate against forgetting by making used furniture the site of the presence of the dead. Salcedo attempts to break the wall between private and public by bringing the disappeared victims of violence into the public domain from which their murderous deaths have torn them away. Spatially, she does this by using old kitchen furniture as the ground for her sculptures. Temporally, she gives them, in ways I will try to indicate below, the duration of the fold, specifically, a *lasting actuality*.

Time is most often conceived on the axes of duration, sequentiality, and rhythm. Duration is measured according to outside standards, the vastly different experiences of it notwithstanding (Einstein's dream). Sequentiality continues to suffer from the twin diseases of the *post hoc, ergo propter hoc* fallacy that conflates succession with causation, and the Oedipally inflected *post hoc, ergo contra hoc ph*allacy that conflates succession with progress and generational antagonism, lived out in the hostile rejection of all that precedes it. Any attempt to understand feminism in terms of generations is inevitably entangled with, at least, the latter. In my personal experience, feminism has suffered great damage because of it, perhaps fatal. So, an attempt to think time differently, on the model of the fold, gets me thoroughly excited. Salcedo's work on time foregrounds, aggrandizes, to the point of hyperbole, a temporality least reckoned with yet most important for a lived feminism beyond all the divides mentioned earlier. This is the temporality of actuality.

Actuality is the most intense moment of presentness, which, by definition, passes unnoticed. In George Kubler's poetic account:

> Actuality is when the lighthouse is dark between flashes: it is the instant between the ticks of the watch: it is a void interval slipping forever through time: the rupture between past and future: the gap at the poles of the revolving magnetic field, infinitesimally small but ultimately real. It is the interchronic pause when nothing is happening. It is the void between events.[37]

Actuality, then, is the stretch of the fold where the eye risks itself inside, into invisibility to itself, not to reach depth but to reemerge with or on the fabric, on

the skin of the other. Salcedo promotes that risky voyage while fighting the anonymity of actuality. She fills its void, stretching its space to *make time* for remembrance of the dead, who died in the past but are violently dead *in actuality*. Beyond the everyday bombardments of fleeting images, art seems a suitable place for us to stop and invest these deaths with cultural duration.

Again, we are facing a problem of representation. Recent re-memorializations of the Holocaust have made it increasingly clear that art cannot in any simple way represent horror and violence. Representing the Holocaust in art leads to charges of having made "beauty" out of horror and "fiction" out of a reality whose realness it is so utterly important to maintain; also, given the experiential intensity of horror, of representing the unrepresentable. Yet, important as these cautionary discussions are, it is equally important that the Holocaust, for these very same reasons, not be allowed to disappear from the cultural scene.[38]

Moralizing prescriptions of what art can or cannot focus on are out of place— or should I say, out of time—in an era as riddled with violence as ours. Activist art made and exhibited over the past two decades has made that clear enough. Salcedo's art, although not as "loud" as most activist art, cannot exist within the confines set by this prescriptive view, which is in fact grounded in a resilient formalism. For without the outside world and its politics of violence, there is, in her sculptures—which are both big and discrete, ordinary and stunningly powerful—simply *nothing to see*. No image, no beauty, no forms. No visual folds of smooth velvet. Her work requires living, not seeing, the fold.

If television news, newspaper headlines, and journalistic photographs are to be casual purveyors of the horrors that take place, then the Benjaminian anxiety about the amnesiac effect of visual speed is entirely justified. Yet it is the same Benjamin who wrote: "Every image of the past that is not recognized by the present as one of its own concerns threatens to disappear irretrievably."[39] Salcedo's art, while sharing the interactive production of duration, enforces such recognition through a strong sense of mood—in this case, a tragic and rebellious one, tender even, and at times humorous, but one that is always fighting melancholic paralysis. This makes me want to endorse it as an allegory of a surviving feminism (fig. 7.3).

Exposing pieces of used furniture in an art gallery compels the viewer to think about time. For it positions the pieces in the past in which they were used, ensconced in the private sphere, unspectacular. What do we viewers do with these pieces? The sheer fact that they are now in a museum indicates that the private realm of the home has somehow been violated. This violation of the home is represented in Salcedo's early work. According to Charles Merewether, some of her early pieces *look like* wounded surfaces: "Chairs are covered by a fine skin of lace as if seared into the wood, bones are embedded into the side of a cabinet, a spoon forced between the seams of wood of a kitchen bureau."[40]

FIGURE 7.3 Doris Salcedo, *Unland: The Orphan's Tunic*, 1997. Wood, cloth, and hair.
31½ × 96½ × 38½ in.; 80 × 245 × 98 cm. Courtesy Alexander and Bonin Gallery, New York.
Photo: David Heald.

Thus, these early sculptures represent the violation of the private lives of the victims of violence, by displaying the violence itself on the objects that were taken out of their lives, just as they themselves were dragged out of their homes to be slaughtered. The furniture is stubbornly banal but at the same time slightly anthropomorphized, to enact the violence that depleted its territory, the home. It is as if the small things that evoke woundedness have taken up *mimicry* to adapt to the environment of the outside world in order to be less noticeable.

In contrast to her earlier works, though, the pieces in Salcedo's 1998 *Unland* exhibition (New Museum of Contemporary Art, New York) are committed to a fundamentally different mode of (re-?)presentation, one that understands, proposes, then rejects and offers alternatives to, the predicament of the art/horror connection that so worries contemporary thought, and to the double bind of representation caught between speaking for and speaking about. This work succeeds in overcoming the joint predicaments of speaking for, about, and with those who cannot speak. I use *Unland* to formulate the subject-object relationship in terms of a temporal "enfolding." Looking at Salcedo's earlier work in the light of this later work, we can see that there the violence was in a sense still represented and, therefore, inevitably repeating it. The relation between victim and

violence was established on the basis of indexical signification—through the deployment of furniture and kitchen utensils as extensions of the victims, evoking them through these synecdoches of their lives—but the violence itself was perpetrated on the objects by means of other objects so that *it*, not the victims, was visually re-presented.

The later work—in the *Unland* exhibition—radically transforms not the theme but the mode of representation. The difference is that this work operates entirely by means of duration. Here, *duration* has become the major tool for turning the direction of the narrative from third person, out-there, concerning the other, to second person, here, to touch the viewer in the most concrete bodily way possible. The fold, although not materially represented—no curtains here—is physically enacted, and this in ways that engage the subject—both maker and viewer—and the object, the violated victim.

Irreversible Witness (1995–98) and *The Orphan's Tunic* (1997), which are both included in this exhibition, are extremely fragile, nearly impossible to make, and nearly impossible to see. The material is still furniture—kitchen tables, a child's cot—but the signifying element is extreme in its finesse, fragility, and durability: human hair, and a bit of silk. It is important that the two materials are combined. Silk is as biological, as animal, as hair. Spun by mean creatures, it is reworked into decoration by humans, most likely women weaving clothes for their children.

The Orphan's Tunic combines the silk and hair to produce a surface that evokes—re-presents, without representation—death in its gray discoloration and endures in its shiny surface. *Irreversible Witness* has sewn a child's metal cot onto a table using an intricate fabric of silk and hair. The sheer number of hairs used, a hole drilled patiently into the thick wood for each hair, while irresistibly operating the existential contiguity of indexical meaning production, bears testimony to the time of the work's making as a homage to the dead, whose bodies remain remembered through their hair only.

This use of hair makes a statement about material and bodily corruption outside of representation. Hair is more durable than any bodily tissue, as durable as bone. But bone's relation to death is too ordinary and predictable. While also being a bodily synecdoche, bone can only represent death symbolically. Hair is what was once lovingly combed, what shone and framed the face now gone. The fragility imposes respect and distance as an extreme form of the "don't touch" taboo that applies in venerable art museums. Salcedo's recent works resonate, by contrast, with the clumsy hanging of Caravaggio's *Virgin*. But the most important performance of these pieces is the way they enfold their viewers by means of the near impossibility of seeing.

This is how, on the edge of visuality, it enfolds the subject and the object. In

FIGURE 7.4 Salcedo, *Unland: The Orphan's Tunic* (detail).

order to actually see what makes these ordinary tables different from the tables in
our own homes, what makes them worth putting in a museum, the viewer needs
to come closer, dangerously close, since awareness of the fragility of the objects
makes approaching feel like violence. One gets closer and closer, feeling less and
less comfortable and more and more voyeuristic, penetrating into the home of
this bodily presence. And, even with forewarning, the actual perception of the de-
tails—the sewing, the braiding, the weaving of the hair—comes as a shock (fig.
7.4). Actuality comes out of its dreariness, is stretched out like long hairs. Step-
ping backward, then approaching again, the shock is just as intense.

Here, there is no longer any representational third-person narrative as it was
present in the earlier works. The representation of the violation of lives, of homes,
by the kitchen spoon or bones inserted into the wooden furniture is now replaced

by the performance of *attention*. And whereas the slow, myopic attention makes the viewer feel in her own body what intrusion into someone's life is, that keen and ambivalent attention does not repeat the violence; it counters it. Remembering the dead does not redeem them; reflecting on one's intrusion does not take the sting of voyeurism out of looking in. But between repetition and redemption lies the cultural activity of suspending the course of time that makes the passing of repetition too easy, offering it protection under the wings of redemption.

In a mode and mood that points most emphatically to a politics of embodied, enfolded vision, Salcedo's sculptures work on the basis of the *performance of duration*. They slow down to the extreme; make you dizzy from the back-and-forthness between microscopic and macroscopic looking where no eyeglasses or contact lenses will quite do the job. Looking itself becomes tortuous, almost torturous. Like Caravaggesque confinement in a space of shadows and luminosity where body parts are so foreshortened as to enter the viewer's space, making her recoil, these surfaces, whose structure of microscopic detail conjures up such massive violence as to make it impossible for any historical or journalistic account to encompass it, so foreshorten time as to enter the viewer's lifetime, breaking its linearity and regularity. The viewer's enfolding in, and Salcedo's speaking through, the other that she has partly become and the encounter from which, through her, the viewer cannot escape continue long after the intense experience of time has faded back into everyday life.

De-allegorizing Feminism

But allegorical reasoning must not be deployed as an escapism from the harsh realities feminism is trying to address. Escapism threatens the productive power of allegory. Indeed, my grumpiness with much feminism that has come my way, as stated at the beginning of this article, has not been suspended. Nor do I wish to replace a philosophical or political argument with an enthusiasm for art. Allegory here is used on the model of the fold: as a way to enfold myself within what I perceive as objects that have something of crucial importance to say about a feminism that is defined neither by essentialist exclusivism nor by hyper-differentiating dilution but by an engagement in issues to which it has so decisively sensitized many people.

At first, Caravaggio's painting in situ helped me to articulate why history cannot be "reconstructed" as other than the present. The old masters are not disappearing, nor should they be, because we have uncovered the exclusions their adoration performed, and that discovery must help in preventing a relapse. Even the difficulty caused by the institutional elevation—here, also literalized by the hang-

ing—need not prevent our engagement with the representation by a male artist of a dead woman, whose life as model is the most profoundly misogynistic fantasy imposed on our cultures. The Virgin is dead, but virginity is not. Nor is the Louvre and what it stands for.

Men have always spoken *for* and *about* women—representing them. From that mud, our cultures have been shaped. It has been extremely useful, indispensable, to mark women's ontological difference from the men that did this. In the name of that ontology an epistemological breakthrough has been possible, so that feminism can safely be said to have been one of the most important intellectual movements of the second half of the twentieth century. Against the second fallacy of sequentiality—the one that implies progress—I would not want to forget the provisional importance of even a naive essentialism. It was, after all, when that moment of common womanhood gained momentum that the differences that made it illusory became visible. Instead of casting out what is no longer satisfying, I would rather enfold it, or myself within it.

Bourgeois's marble folds enfold that cultural past, updating it, making it more experientially relevant for women who live today, and for men enfolded in that life. Is that an ontological or epistemological proposition? Just as her house is in the process of becoming enfolded within the body of the woman confined in it, so her ontology—being a woman artist—is only relevant epistemologically, to the extent that we must not stop recuperating women's voices. It would be doing Bourgeois an injustice, and by extension, all women who we thus, finally, take seriously, to posit her work as an *object* that is, ontologically, different.[41] Nor can her subjective ontological femaleness be either ignored or simply brought to bear on her work. It is only in the interstices of history in which women live different lives from men—not because they *are* different but because they are confined in difference—that, momentarily, the sex and gender of an artist matters.

Thanks to the forceful enfolding of object into subject through stretching time, the dead enfolded in our lives by Salcedo can no longer be written off, passed over, under the banner of a refocusing of feminism toward "female pleasure," even if we can speak neither for nor about them, and even if lament is only a cultural song and dance. Men and women have the same confrontational difficulty in seeing the surface structure of these works, although what they see also depends on who they are. The dead whose violation is actualized are women and men. Does this mean that gender is no longer an issue, that other, more burning problems require our attention?

Allow me to refrain from answering this question, which accepts no either/or. There is a small difference, though, that is neither ontological nor epistemological but enfolded in both. *The Orphan's Tunic* is made of human hair and the silk from a dress a little girl wore day in and day out when the artist was working in

the village where the little girl lived. Her mother had made the dress for her. Then the mother was killed. The dress, the material presence of it in Salcedo's work, remains stubbornly gendered in a multiplicity of ways. Faced with this work, you can't even question if it matters whether the artist, the little child, or the viewer is female or male.

In other, earlier writings, I have tried to deploy the metaphor of the navel as an alternative for phallic thought.[42] I still believe it has great analytical potential, and Elisabeth Bronfen's deployment makes an excellent case for this. At this point in history, I also feel inclined to try to think of alternatives for the exclusive interest in bodily metaphors and the obsession with the origins in feminist thought. In light of the dangers of clinging to subjectivity as the primary issue and origin as the only way to define it, the navel, for all the advantages this metaphor offers over the more usual ones, might suggest an essentializing not of the female body per se but still of the body, and of the mother's body of which the navel is an ineradicable index.

Where the navel, as Bronfen explains,[43] offers an adequate representation of the subject as knotted, there is something to say for the fold in feminism as an alternative to, or liberation from, the navel. Not one for us to stare at, delighted, embarrassed, self-enclosed, but one that refuses to obliterate the mother, including her sex and gender, yet that does not need the literal and perhaps fixating index to her body to keep her importance alive.

The relationship between these two key metaphors, the navel and the fold, can be envisaged as follows. The navel is a fold, but not every fold is a navel. The navel is inscribed in the body; the fold, hovering between touch and vision, necessitates some distance from it. The navel articulates the way cultural subjects are "knotted"[44]; the fold suggests ways to disentangle that knot. In that sense, the navel describes; the fold promises. Finally, the navel is a concept for a feminist critical analysis of representation; the fold is a concept for articulating a position beyond the inextricable knot of representation.

The silk of Salcedo's little girl's dress, made by her dead mother, replaces bodily essentialism with a reminder of materiality and work. Thus the fold can be a bodily index that reminds us, without sentimentality, of the importance of remembering. A scar of dependency that instills in every one of us the need to acknowledge that being is becoming, that the past is the only future we have.

Notes

Originally published in *Feminist Consequences: Theory for the New Century*, edited by Elisabeth Bronfen and Misha Kavka (New York: Columbia University Press, 2001), 321–52.

1. Long before this became a political issue, I began feeling increasingly bewildered by the use of "we"; see Torgovnick (1994). Not knowing who belongs to the group for which I am speaking, I will resort to the first-person singular as much as possible.

2. "We," here, is not used as a symptom of "the full deceptiveness of the false cultural 'we'" (Torgovnick 1994, 265), but refers to myself and my feminist friends of the seventies.

3. See Keller and Moglen (1987).

4. See Hull, Scott, and Smith (1983).

5. For a good account of conflicts in feminism, see Hirsch and Keller (1990).

6. Code (1991).

7. Battersby (1998).

8. Perhaps the most important polemic against epistemology (read: epistemology only) is to be found in Adorno (1956). A useful collection of papers on feminist epistemology is Alcoff and Potter (1993). See also Longino (1990, 1995) and Keller (1984, 1992) for excellent accounts of the inseparability in practice of epistemology and ontology.

9. Gallop (1998).

10. Do I sound grumpy? I have often felt that the interest in female pleasure—whose importance I emphatically underwrite—has been used as a weapon to shut up feminists engaged in anti-abuse activism, under the rather banal banner of fashion.

11. Bal (1994). Reprinted here in chapter 5. For the ontological consequences of metaphors in scientific practice, see, for example, Keller (1995).

12. See Deleuze (1993). For an extensive discussion and deployment of the fold, in particular in relation to visual art, see Bal (1999).

13. Battersby (1998, 195).

14. Ibid., 192–95.

15. See Keller and Grontkowski (1983); see also Bal (1996).

16. Among many examples of the critical analysis of the *cogito,* see Descombes (1991). Panofsky already attempted to reason perspective as a cultural, not a natural, mode of representation in *Perspective as Symbolic Form* (1991). For an excellent discussion of perspective, see Damisch (1987; trans. 1994).

17. Most accessible in Spivak (1987).

18. This has been convincingly argued by anthropologists. See, for example, Fabian (1990).

19. See chapter 2 of my book on Rembrandt, *Reading "Rembrandt"* (1991), and chapter 7 of my *Double Exposures* (1996).

20. Classically, De Man, *Allegories of Reading* (1979).

21. For an extensive argument for this view, see Bal (1999).

22. The distinction among these four temporalities has been argued in detail elsewhere; see Bal (2000).

23. For an extensive argument and demonstration, see Bal (1999).

24. Some elements of this description have been borrowed from Askew's monographic study of the painting (1990).

25. See Duncan (1991) on the Louvre and nationalism; and Battersby (1989), on the genderedness of the very notion of art.

26. For example, in sculptures such as *Baroque* (c. 1970) and *Homage to Bernini* (1967).

27. *Femme Maison,* marble, 63.5 × 49.5 × 58.5 cm, 1983.

28. On Bernini's *Teresa,* see Lavin (1980); on his *Ludovica,* see Careri (1995).

29. This "fluid" or "viscous" view of architecture has been presented effectively by Lynn in "Body Matters," who took his inspiration from Irigaray, *Speculum of the Other Woman* (1974), and *This Sex Which Is Not One* (1977), esp. "Volume without Contours" and "The Mechanics of Fluids."

30. A particularly painful case is the current celebration of Charlotte Salomon, an unjustly neglected artist who is now "benefiting" from her status as a female artist who suffered trauma—an emblem in the "trauma industry." This is not to argue against the serious study of trauma or of Salomon (e.g., Van Alphen 1997), but against superficial and exploitative trendiness in academic topics, including in feminism.

31. Deleuze (1993, 22).

32. Ibid., 19.

33. Just recently, a book appeared with the enticing title *Philosophy in the Flesh: The Embodied Mind and Its Challenge to Western Thought,* which might be expected to take up Gallop's title *Thinking through the Body* fifteen years later. Alas, it turns out to reiterate the universalist claims attached by "cognitive linguists" to male-inflected metaphors from capitalist America. Just try getting away with making such a claim for the metaphor "life is a box of chocolates" (Lakoff and Johnson 1999)!

34. Deleuze (1993, 19–20).

35. Kierkegaard, *Stages on Life's Way* (1845), 11:76; cited by Battersby (1998, 162).

36. Battersby (1998, 127).

37. Kubler (1962, 17).

38. See Van Alphen (1997) for an extensive and clear discussion of issues pertaining to Holocaust representation.

39. Benjamin (1968, 255).

40. Merewether (1998, 20–21).

41. In this respect, I completely agree with Krauss when she writes: "art made by women needs no special pleading, and in the essays that follow I will offer none" (1999, 50).

42. See Bal (1991). The metaphor had been elaborated in close interaction with Bronfen, who also used it, in *Over Her Dead Body* (1992), and offered an extensive theorization through it, in *Knotted Subject* (1998).

43. Bronfen (1998, 1–98).

44. See ibid.

References

Adorno, Theodor W. 1982 (1956). *Against Epistemology.* Translated by Willis Domingo. Oxford: Blackwell.

Alcoff, Linda, and Elizabeth Potter, eds. 1993. *Feminist Epistemologies.* New York: Routledge.

Alphen, Ernst van. 1997. *Caught by History: Holocaust Effects in Contemporary Art, Literature, and Theory.* Stanford, CA: Stanford University Press.

Askew, Pamela. 1990. *Caravaggio's "Death of the Virgin."* Princeton, NJ: Princeton University Press.

Bal, Mieke. 1991. *Reading "Rembrandt": Beyond the Word-Image Opposition.* Cambridge: Cambridge University Press.

————. 1994. "Scared to Death." In *The Point of Theory: Practices of Cultural Analysis,* edited by Mieke Bal and Inge E. Boer, 32–47. Amsterdam: Amsterdam University Press; New York: Continuum.

————. 1996. *Double Exposures: The Subject of Cultural Analysis.* New York: Routledge.

————. 1999. *Quoting Caravaggio: Contemporary Art, Preposterous History.* Chicago: University of Chicago Press.

————. 2000. "Pour une interprétation intempestive." In *Où en est l'interprétation de l'oeuvre d'art?,* edited by Michel Régis, 239–67. Paris: École Nationale Supérieure.

Battersby, Christine. 1989. *Gender and Genius: Toward a Feminist Aesthetics.* London: Women's Press.

————. 1998. *The Phenomenal Woman: Feminist Metaphysics and the Pattern of Identity.* Cambridge: Polity Press.

Benjamin, Walter. 1968. "Theses on the Philosophy of History." Thesis V. In *Illuminations.* Edited by Hannah Arendt. Translated by Harry Zohn. New York: Schocken Books.

Bronfen, Elisabeth. 1992. *Over Her Dead Body: Death, Femininity, and the Aesthetic.* Manchester: Manchester University Press.

————. 1998. *The Knotted Subject: Hysteria and Its Discontents.* Princeton, NJ: Princeton University Press.

Careri, Giovanni. 1995. *Bernini: Flights of Love, the Art of Devotion.* Translated by Linda Lappin. Chicago: University of Chicago Press.

Code, Lorraine. 1991. *What Can She Know? Feminist Epistemology and the Construction of Knowledge.* Ithaca, NY: Cornell University Press.

Damisch, Hubert. 1987. *L'Origine de la perspective.* Paris: Flammarion. Translated by John Goodman as *The Origin of Perspective.* Cambridge, MA: MIT Press, 1994.

De Man, Paul. 1979. *Allegories of Reading: Figural Language in Rousseau, Nietzsche, Rilke, and Proust.* New Haven, CT: Yale University Press.

Deleuze, Gilles. 1993. *The Fold: Leibniz and the Baroque.* Translated and foreword by Tom Conley. Minneapolis: University of Minnesota Press.

Descombes, Vincent. 1991. "Apropos of the 'Critique of the Subject' and the Critique of this Critique." In *Who Comes After the Subject?,* edited by Eduardo Cadava, Peter Connor, and Jean-Luc Nancy, 120–34. New York: Routledge.

Duncan, Carol. 1991. "Art Museums and the Ritual of Citizenship." In *Exhibiting Cultures: The Poetics and Politics of Museum Display,* edited by Ivan Karp and Steven D. Lavine, 88–103. Washington, DC: Smithsonian Institution Press.

Fabian, Johannes. 1990. *Power and Performance: Ethnographic Explorations through Proverbial Wisdom and Theater in Shaba, Zaire.* Madison: University of Wisconsin Press.

Gallop, Jane. 1988. *Thinking through the Body.* New York: Columbia University Press.

Hirsch, Marianne, and Evelyn Fox Keller, eds. 1990. *Conflicts in Feminism.* New York: Routledge.

Hull, Gloria T., Patricia Bell Scott, and Barbara Smith, eds. 1983. *All the Women Are White, All the Blacks Are Men, but Some of Us Are Brave.* Old Westbury, NY: Feminist Press.

Irigaray, Luce. 1985a (1974). *Speculum of the Other Woman.* Translated by Gillian C. Gill. Ithaca, NY: Cornell University Press.

————. 1985b (1977). *This Sex Which Is Not One.* Translated by Catherine Porter and Carolyn Burke. Ithaca, NY: Cornell University Press.

Keller, Evelyn Fox. 1984. *Reflections on Gender and Science.* New Haven, CT: Yale University Press.

———. 1992. *Secrets of Life, Secrets of Death.* New York: Routledge.

———. 1995. *Refiguring Life: Metaphors of Twentieth-Century Biology.* New York: Columbia University Press.

Keller, Evelyn Fox, and Christine R. Grontkowski. 1983. "The Mind's Eye." In *Discovering Reality,* edited by Sandra Harding and Merrill B. Hintikka, 207–24. London: Reidel.

Keller, Evelyn Fox, and Helen Moglen. 1987. "Competition and Feminism: A Problem for Academic Women." In *Competition among Women: A Feminist Analysis,* edited by Helen Longino and Valerie Miner, 21–37. Old Westbury, NY: Feminist Press.

Kierkegaard, Søren. 1988 (1845). *Stages on Life's Way.* Edited and translated by Howard V. Hong and Edna H. Hong, 11:76. In *Kierkegaard's Writings.* Princeton, NJ: Princeton University Press.

Krauss, Rosaline. 1999. *Bachelors.* Cambridge, MA: MIT Press.

Kubler, George. 1962. *The Shape of Time: Remarks on the History of Things.* New Haven, CT: Yale University Press.

Lakoff, George, and Mark Johnson. 1999. *Philosophy in the Flesh: The Embodied Mind and Its Challenge to Western Thought.* New York: Basic Books.

Lavin, Irving. 1980. *Bernini and the Unity of the Visual Arts.* New York: Oxford University Press for Pierpont Morgan Library.

Longino, Helen E. 1990. *Science as Social Knowledge: Values and Objectivity in Scientific Inquiry.* Princeton, NJ: Princeton University Press.

———. 1995. "To See Feelingly: Reason, Passion, and Dialogue in Feminist Philosophy." In *Feminisms in the Academy,* ed. Domna C. Stanton and Abigail J. Stewart, 19–45. Ann Arbor: University of Michigan Press.

Lynn, Greg. 1993. "Body Matters." *Journal of Philosophy and the Visual Arts.* Special Issue: The Body, ed. Andrew Benjamin, 60–69.

Merewether, Charles. 1998. "To Bear Witness." In *Doris Salcedo,* ed. Charles Merewether, 20–21. New York: New Museum of Contemporary Art.

Panofsky, Erwin. 1991 (1927). *Perspective as Symbolic Form.* Translated by Christopher Wood. New York: Zone Books.

Spivak, Gayatri Chakravorty. 1987. *In Other Worlds: Essays in Cultural Politics.* New York: Methuen.

Torgovnick, Marianna. 1994. "The Politics of 'We.'" In *Eloquent Obsessions: Writing Cultural Criticism,* ed. Marianna Torgovnick, 260–78. Durham, NC: Duke University Press.

8. Intention

intention
—a determination to act in a certain way, a resolve
—what one intends to do or bring about; an aim
—(phil.) a concept; esp. a concept considered as the product of
attention directed to an object of knowledge
—the purpose or resolve with which a person commits or fails to
commit an act, as considered in law
—(archaic) import, significance

A Concept We Hate to Love

"Intention" is a concept close to home for most of us, and it is problematic primarily for methodological reasons, although also for political ones. Methodology and politics come together in this concept in the sense that it is bound up with *individualism*. Whatever their explicit positions, both traditionalists and those who think of themselves as progressive are replete with individualist habit.[1] So this concept cannot be wished away. I am all too aware that our culture is not ready to abandon the individualism that subtends it. How, then, can *intention* best be discussed when it appears to go without saying that artists' intention is the bottom line of all inquiry?

To make the most convincing case and to demonstrate an academic practice that is both common and rarely examined, the argument here will be presented as a polemic: as a debate for and against the use of a particular concept—intention—in cultural analysis. One of my aims is to demonstrate the form such a polemic can take if the issue at stake is truly intellectual, and "trashing" is emphatically considered unproductive. The outcome of this debate will subsequently allow me to reorient rather than reject the concept outright. Lastly, through this reorientation I will open up the question if and how cultural

analysis, beyond broadening the scope of particular disciplines, is also *funda-mentally* different from the mono-disciplines that constitute the humanities. In other words, by discussing one traveling concept, *intention,* together with its "foreign" counterparts *agency* and, as I will argue, *narrativity,* I will attempt to assess the nature of cultural analysis as a traveling discipline that cannot settle down.

When we are standing before a work of art, and we admire it, are touched, moved, or even terrified by it, when a work of art somehow seems to do something to us, the question of artistic intention loses its obviousness, for the artist is no longer there to direct our response. Something happens in the present, while someone did something in the past. That act, we may suppose, was willful, intentional. What is not so clear is that between the event in the present and the act in the past the same intentionality establishes a direct link. While it would be futile to doubt that an artist wanted to make her work of art and that she proceeded to do so on the basis of that will, the control over what happens between the work and its future viewers is not in her hands. But that later event is still, logically, a consequence of that act—the doing of an agency.

Present—past. It is history's mission to be attentive to change over time. It is a cultural commonplace—in the present—that art, more than other things, has the remarkable capacity to move us in the present. If this contention can be maintained, regardless of the question of what non-artistic objects do to us, then the history of those cultural activities we call in shorthand "art" has its task cut out from the start: to understand the agency of works of art across time. This task is not predicated upon a universalist conception of "beauty," but on the simple fact that all works of art, even those made today, require time and a change of situation to reach their receivers and "do" things to them. Art "works" across time, if not eternally. But the artist is involved only part of the way. He disappears, gives his work over to a public he will not know. What happens after the work has been made is not determinable by artistic will.

Reasonable as this view seems to me, I have had ample opportunity to observe that it is not generally accepted as a starting point for the questions about the arts that guide research and analysis in the humanities today. This may be because it still entails two unresolved problems. The first is a theoretical, philosophical one: the nature of the agency that performs the work's effect needs elucidation. The second is a practical, epistemological problem: the methodology of interpretation needs a new standard to replace the documentation that traditionally provides data on the artist's intention. To solve these two problems, I will stage a discussion both between an art historian and myself as a cultural analyst, and between two artworks. Through this staging, I will demonstrate how the method of cultural analysis, even if practiced in relation to the classical objects of a mono-discipline such as art history, differs fundamentally from art history's methodol-

ogy. My aim is to further strengthen the case for a program of cultural analysis that (at least) supplements the separate disciplines in general and art history in particular.

As I have already stated, the concept of *intention* will be probed, not simply rejected. Owing to the popularity of intentionalism in the cultural disciplines, the task at hand is to offer a satisfying alternative. In terms of analysis, here the object/subject of close reading is triple: old art, contemporary art, and art history. Old art is the kind of art that can demonstrate my case most clearly, because often there is simply not enough documentation to prove intention. Contemporary art, I will argue, is as much in need of *historical* interpretation and as little bound to the artist's intention as old art. Art history, in contrast, *is* bound to intentionalism. It is represented here by someone whom I highly respect as a serious scholar in her field, and from whose work I have often learned. I select her because the quality of her work warrants what I have called, elsewhere, a "critical intimacy."[2] The format of discussion itself—which, of course, I can only approximate in a single-author essay—requires such intimacy, if it is not to flounder in pointless and simplifying polemic.[3]

Svetlana Alpers is one of America's leading historians of Old Master painting, the most traditional object of art history. She often takes current responses to these old works of art as a starting point. Yet her work is committed to accounting for the artist's intention. For me, this is paradoxical. In this essay, I will explore the consequences of her discourse of intention for the understanding of the artwork it yields, and for the self-styling of the discipline of art history. I will do this by bringing in an alternative concept to fill the void left by the elimination of intention. The concept of narrativity will be my antidote to intention. Alpers explicitly rejects this concept for visual analysis. For her, as for many art historians, narrativity smacks too much of language.

Taking up what I have learned from her insistence on intention, from her ongoing attentiveness to the visual features of images, and from her resistance to the use of the concept of narrativity for the analysis of visual art, I will engage a dialogue with her work to explore the possibility of accounting for the agency of images over time. This agency can be attributed neither to the artist nor to the viewer, but, as I will conclude, only to the process that happens between these two parties when the product of the former becomes the product of the latter, that is, when viewing becomes a new way of making.

Forms of Abandon

The room smells. The work looks messy. The sculpture drips. Norwegian artist Jeannette Christensen makes sculptures out of Jell-O. Do they keep? No. That's

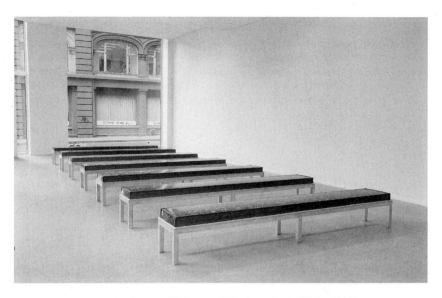

FIGURE 8.1 Jeannette Christensen, *Tiden lager alle sår,* 1996 and 1997, installation of seven steel benches with red Jell-O.

the point. Look at this one (fig. 8.1). What does it mean to say: "That's the point"? That question is the point of this essay.

Christensen's 1996 installation has an untranslatable title: *Tiden lager alle sår,* a pun on "tiden leger alle sår." "Time heals all wounds" becomes "time makes all wounds." Different, but as ambiguous and ambivalent as the English expression "killing time." Elsewhere I have written about the temporality of this installation. Here, I propose it as a companion piece to Rubens's representations of the drunken Silenus, or his sleeping Samson, as analyzed by Alpers. Christensen's installation gives form to *abandon.* And abandon is the opposite of intention.[4]

The seven bright red, human-sized Jell-O benches looked gorgeous at first. But their existence was fragile, from the start wavering on the edge of decomposition. During the four weeks of the installation, things happened to them. The suggestion of pleasure and food, light and beauty, yielded to the other association that had been lurking around all along: the association with wounded, fallen soldiers, with decay and death. At one moment, early on in the show, when the benches were still fresh and brightly colored, the enigma of sexual and temporal difference came up. This ambiguity remained, hovered around: desire, deadly wounds, feminine voluptuousness, built on happy, slightly nostalgic childhood memories of Sunday desserts, yet already future altars in honor of scarred, disintegrating, sacrificial bodies. Humorous and hyperbolic, deeply serious and

FIGURE 8.2 Jeannette Christensen, *Tiden lager alle sår,* 1996 and 1997,
installation of seven steel benches with red Jell-O. Detail after four weeks (two colored puddles).

mournful. The sweet smell of the traditional dessert would soon become a sickly
smell evocative of blood. The moment when the sweet smell turned bad could
not be pinpointed.

Early on in the exhibition, visitors touched the benches, sometimes tasting the
Jell-O, poking their fingers into it to test its elasticity. Unlike with Old Master
paintings, this physical contact was allowed. But then the benches started to grow
old, to dry, to harden in some places and liquefy in others, and people stopped
eating and touching; instead, they felt disgust. And then something else totally
unpredictable and unforeseen happened as well. Some of the benches started to
drip and bleed, making gorgeous pools in suggestive shapes on the floor. This
separation of colors was an unexpected effect of abandoning the sculpture to time
(fig. 8.2). Whereas the entire process of decay was a matter of merging and blur-
ring boundaries, the colors, all on their own, moved in the opposite direction.
They split into red and yellow. A golden yellow overlayered and embraced the
red, creating erotic shapes that became strong metaphors for erotic desire as
imagined inside the body. Red and yellow playing together; blood and urine,
voluptuous golden desire.

If history is defined by its attention to change over time, then this work is
"about" history. The question I want to raise here is simple: Who did this? The

puddles, with their shapes and color schemes, just happened. The artist did not know they were going to happen. Of course she expected some form of decay, and abandoning her beautiful, sharply cut, translucent forms to that decay was her act, its unmasterable effect, her "point." But she was still flabbergasted by the puddles, and happy as well, because they were "beautiful." Yet their aesthetically pleasing appearance was not a consequence of her will, or an expression of her subjectivity, a reflection of her authorial intention. Did she make the puddles? She caused them to happen, but she did not shape their shapes in the way she shaped the sharply cut benches. The contrast between the sharp cutting of mastery and the appealing, pleasing result of the shapes produced by abandon is structural, not arbitrary. This contrast is what structures change across time. But again, who did this?

If this event had happened four hundred years ago, there would have been no photographs to document what happened to it once it was abandoned to time. Today we have at least that: slides, transparencies, photographs. No documentation of the design, just a few reviews, a catalog essay—all interpretations. The photographs show that what happened is a change, a transformation of form and color, not a loss of form, not formlessness. The sharply delineated form of the "classically" perfect benches became a different, baroque form based on color and color distinction.

In contrast, take the *Narcissus* in the Galeria Nacional de Arte antiga in Rome, a contested Caravaggio painting from four centuries ago (fig. 8.3).[5] The knee of the figure in that painting comes forward with an emphasis that, common sense tells us, *must* have been the artist's intention. The hand that made this picture obeyed a mind that decided to make the most of chiaroscuro, and thus painted flesh out of oil so that it would come forward in a very sensuous way. "So that": this way of putting it suggests more intentionality than is warranted. The artist *did* paint it in this way, and lest we make more of the historicizing of the concept of the "artist as craftsman-only" than seems justified, the hand and the mind were working together. The result is the fleshiness of the knee.

But the formulation "so that" is mystifyingly ambiguous: Does it mean "with the consequence that" or "in order that"? Is the causality mechanical or psychic? And is the knowledge of that causality located with the maker or the viewer? These are three important questions with respect to "intention." The first differentiates consequence, or effect, from intention. Effect is the state of things as it differs from the prior state, the cause. As deconstructionist criticism has amply argued, causality is only an inference from the later state or event.[6] That inference, logically, is the doing of the person making the inference, a reader or a historian, not of the maker of the work. The second question, which superimposes its doubt on the first, differentiates mechanical from psychic causality. The for-

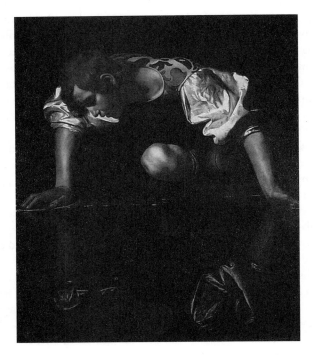

FIGURE 8.3 Michelangelo Merisi da Caravaggio, *Narcissus*, ca. 1600,
oil on canvas. Galeria Nacional de Arte antiga, Rome.

mer can be attributed partly to the maker—still on the basis of inference by the
reader—and partly to technical circumstances and material possibilities. Psychic
causality is more clearly located in the maker, but there the muddled nature of
subjectivity comes into play. We know human subjects are not, as Freud phrased
it, master in their own house. Even those averse to psychoanalysis will concede
that thought depends on the historical moment and social circumstances, that is,
on frames of reference. We also know that even the keenest and proudest of artists
are limited in their freedom. Such factors as commissions are only the most overt
and clearly limiting elements.[7] To make matters worse, the third question—the
location of the knowledge about cause—cannot be resolved. Even if an artist
leaves explicit and extensive documentation concerning her intentions, the *ques-
tions* that produce the knowledge of intention are raised by the historian, not im-
posed by the artwork.

Caravaggio's *Narcissus* is invoked here to make this point. A feature of this
painting that has often been noticed is the knee. It is impossible to prove whether

the artist meant that knee to be central to the wheel shape of the body for reasons of composition only, or for the purpose of "figurability," in other words, to produce a meaning "figurally," as Hubert Damisch phrases it. In a casual discourse about artistic agency, I can accept that the latter is likely, given the meanings the painting as a whole produces and the insistent way it does so "figurally." But what I mean with such a statement would not be covered by "intention." Rather, the ambiguity of "to mean," in my view, helps to avoid pointless debate. In fact, Damisch and I agree on the notion that the question is relevant, undecidable, yet not completely arbitrary, and that the answer to it "means something" (Damisch 1996, 31).

What we know we can never know (but only surmise, or project from our own twenty-first-century perspective, or decide to think against all odds) is whether or not the knee was meant—intended—to look like, as Damisch has it, a hyperbolic, iconic phallus (Damisch 1996, 32). The phallic shape would be the element that gives this representation of narcissism a strong, psychoanalytic, and hence "modern" reality. This reality is an important reason why the painting "works," "acts" for us in the present. This "work" is performed even for those who turn their backs on psychoanalysis, simply because that theory and its vulgarized interpretations are around us today, as a frame. They were not around at Caravaggio's time, even if phallic shapes were. Must we feel bad about such projections? Must we make them and then later disavow them? My answer is an emphatic no. Such meanings are partly responsible for the excitement that makes us admire, like, even love the painting; that is, they are partly elements of agency.

Yet the knee does, without a doubt, have that specific shape, which, combined with the fleshiness, signifies "penis" *now*; the size that makes it "hyperbolic" is part of that meaning production. As a consequence, "phallus," Damisch's word, is descriptively right, even if a particular viewer chooses not to take that (kind of) meaning into account. The shape is "out there"; the meaning is not, cannot be. It can only come to mean something when it is instituted as a sign. And that requires a subject willing to attribute meaning to it.[8] Yet without that attribution of meaning, the shape itself, remaining in the shadow as a sub-figure, may not be perceived at all. So positive existence—"out there"—is doubly meaningless.

One reason for the reluctance to attribute that particular but by no means compulsory meaning to that undeniable shape can be the sense of anachronism: Caravaggio did not know psychoanalysis, hence, had not had the opportunity to develop the habit of seeing sexual things in ordinary shapes. Yet psychoanalysis is the context within which this kind of meaning is most often discussed. The argument of anachronism is quite common, and although I have a number of objections to it, I will only signal one of them. Speculation on what the artist might have known about a postromantic subjectivity is indeed pointless, but we

can still safely assume that he knew the difference between a penis and a simple *boule* (Damisch 1996, 31), that he knew what power was (but supposedly without the particular awareness we have of it today), and that he knew there was a link between these two elements. The two elements that make the figuration of a phallus socially meaningful—namely, power and male sexuality—were known to him.[9]

I am interested neither in affirming nor denying the possibility that the knee "was meant to" mean what Damisch says it means. There is something arrogant in such claims. Who are we to assume that people at the turn of the sixteenth century had no *intuitive* sense of such things? And even if we discard meanings we consider anachronistic, we can only do so after the fact, after they have occurred to us in the first place. Thus, by protecting the painting against retrospective impositions, we inevitably do violence to its effect (and to ourselves). I will not discuss this issue of what might be called the "propriety" of psychoanalytic interpretation, primarily for reasons of the debate I am trying to stage. For Alpers would, I presume, not be interested in this at all. My claim about intention in this chapter is not contingent upon the acceptance of psychoanalysis as an interpretive frame.

I bring up the knee because there is an aspect to its effect that we definitely know could *not* have been *meant* by the painter in the intentionalist sense of that verb, because, like the separation of colors in Christensen's sculpture, it was, so to speak, out of his hands. Yet that aspect, too, is descriptively "right." I am referring to the knee's detachment from the body. The knee, itself bright, is surrounded by darkness, and this makes it come forward as if in isolation. This kind of contrast was part of Caravaggio's stock-in-trade. The reflection in the water reiterates the detachment. *But the contrast has been deepened, radicalized, over time.* The fabric of the boy's clothing has melted away into the surrounding darkness. As a result of the denuding effect of time and the difference between our own time and the thoughts that "live" today, one can now speculate that the work is "about" the failure, rather than the success, of narcissism. For what we see is the Lacanian *corps morcellé,* or fragmented body, rather than the imaginary wholeness that narcissism conjures up as a protection against the specter of that fragmentation.[10]

This interpretation is, of course, also wildly anachronistic. But, unlike the phallic shape Damisch saw in the knee, this detachment, whatever its meaning, while more obviously than ever not intended, is also more undeniably "there." It is not a shape in itself, but the edge of a shape, a form, in the sense of appearing progressively detached from the indistinct background. When this form crystallizes out into something different from what surrounds it, we cannot prevent it from becoming a *figure* liable to produce meaning. Yet the progressive apparition of the form in a detached figure as the darkness of the background takes over and

erases the dark velvet garment that was the tenuous link with the body—that, we know with certainty, is an effect of time. The painter did not "know" it.[11]

Did Caravaggio cause it to happen? Did he, like Christensen, abandon his painting to time? Strictly speaking, he did. Not, we may suppose, that he knew what time would do to his figure's knee: separate it from the body and open it up to meanings he most probably didn't have "in mind," even if he had made an object—this painting—that performed this separation. But neither did our twentieth-century sculptor know that her puddles would separate into colors. The difference is, she did know she would not be able to know. She willfully endorsed the conception of learning that Shoshana Felman derives from psychoanalytic theory—as knowing that you do not know—and puts it in opposition to knowledge that becomes corrupted into "opinion, prejudice, presumption."[12]

This corrupted knowledge is, I contend, the kind of knowledge that underlies intentionalism. The importance of knowing the artist's intention is thus doxic— unarguable, commonplace, dogmatic. Caravaggio did not know *what* he could not know, but, as both the craftsman he is claimed to have been and the artist we have construed him to be since romanticism transformed our sense of the figure of the artist, he knew that what he made would change over time. Whether he knew that consciously or as a habit developed through his work as a technically savvy painter, we cannot know. In contrast, Christensen's sculpture *addresses* this changing of art over time; that is its point. She intended it to do just that, regardless of her lack of knowledge of the outcome. To put the case more strongly in favor of my intentionalist opponents: her abandonment is willful; his was not.

Paradoxically, Christensen's intention is to let go of intention. Caravaggio's, on the other hand, was overtaken by abandonment; that is, even if we are invested in tracing intentions, we assume he did not *will* abandon.[13] But isn't it the artist's ambition that his work will outlast the time allotted him to master it, even though he knows better than anyone that paint, canvas, oil, even meaning, are not eternal, not stable in time? Clearly, we have reached a shady area where all pronouncements are condescendent, unwarranted, and, in the end, futile.

This futility makes it necessary to carry the question of intention beyond epistemological considerations. For it is the question of intellectual relevance that is of importance here. How far does the notion of intention take us toward understanding pictures? This is the idea that Christensen's work, as a theoretical object, puts forward, in a gesture that links her work to Caravaggio's as commentary is linked to artwork. In an exploration of historical subjectivity—of intentionality fragmented and changing over time—the splitting of colors betokens the notion that intention, agency, and subjectivity are not whole, not even in the putative moment of execution, because the work is made to change over time, and thus to slip out of control. Unforeseeable as this event was, the artist endorsed the impossibility of mastering meaning.

Productive Opposition

"As a result [of Roger de Piles's oppositional argument], even today it is hard to look at Poussin in different terms—to see that to look at him as a philosopher-painter appealing to the mind, rather than to the eye, is a way of seeing him and not the thing itself" (Alpers 1995, 89). "Him," as opposed to "the thing itself." The opposition Alpers formulates here, in her explication of de Piles's influence in doing just that, is the one between mind and body, like the one between person, subject, intention, and the work, object, result, or effect. Alpers is opposed to this opposition. So am I. When I read this, I saw what was wrong with a term I once had used to overcome it, namely, *propositional content.* I had used this term to indicate an area of meaning production not causally related to the artist's intention. The argument I made was bound to be misconstrued, and, as a result for which I take responsibility, the debate I conducted with, among many others, Svetlana Alpers proved to be less productive than it should have been. The present discussion is an attempt to rework this debate, which concerns the issue of the differences between seeing "him" (the artist) and seeing "the thing itself" (the painting). Differences, mind you, in the plural.

In a paper to which Alpers once kindly responded critically, I formulated an attempt to make a case for a notion of pictorial narrativity that would take the image not as an illustration of a narrative that is already around, but as the production of a narrative that would necessarily be new, or different, as a result of the pictorial gesture folded into the viewer's compulsion to read. In order to argue for a specifically pictorial narrativity, I was adamant that recognition is not the underlying mode of processing. But Alpers was not quite satisfied. She resisted my invocation of narrative.[14]

She had written about narrative in painting before. The oppositional structure which, I thought, seemed to underlie much of Alpers's work has often made me feel uneasy: descriptive versus narrative (Dutch art, *Las Meninas*), genius versus business (Rembrandt), nationalism versus transnational humanism (Rubens). While opposition, by virtue of its clarity, is often a helpful tool for communicating complex ideas, it also tends to simplify them.[15] But Alpers then proceeds to complicate the opposition again. A most compelling case of her complicating gesture is her argument that the "feminization" of Rubens missed the possibilities for gender-bending—she calls it androgyny—in his work (Alpers 1995, 138). This case appeals to me for a number of reasons, only one of which is my interest in gender and representation. It also appeals to me—I should say, allegorically—because of the gender ambiguity I see in Christensen's work, where the ambiguity is not at all based on the peaceful coexistence of two possibilities, but on the overruling of one by the other through the violence of time. What is at

first a camp sort of femininity, in association with "sweet and beautiful," later becomes an equally hyperbolic tragic masculinity, when the bodies of Jell-O develop associations with wounded soldiers. Meanwhile, the gender hyperbole in the Caravaggio according to Damisch is strongly gender-specific, even if the psychic condition named after this figure is emphatically not.

But my primary interest in this case stems from a theoretical point. Alpers points out that even when gender roles are reversed in the reception of Rubens, the opposition is maintained, at the cost of understanding Rubens's play with gender as a performance rather than as fixed and ontological (Alpers 1995, 147–50). I couldn't agree more, especially in view of the intricacies of the relationship between performance and performativity in their impact on the image. Alpers explains the oppositional hang-up as a Saussurian, structuralist bias that makes oppositional thinking a cultural condition. The attention to Rubens's abandonment to flesh as a way around gender opposition has been all but erased by later ways of looking at his work, she argues. Whereas Christensen made me understand Caravaggio better, Watteau, Alpers claims, obscures aspects of Rubens. Her argument, which I find compelling, not only made me think about specific issues—here, Rubens's performance of gender—but also pushes me to revise my own opposition to opposition.

The opposition I would like to revise runs as follows. Alpers is primarily interested in the making of images—in what motivates, informs, and impels that making. She attributes her interpretations to the artist through various terms that I will discuss below, thus securing "historical weight" for them—her cautious way of stating the case without overstating her claim positivistically. I prefer to attribute the interpretation to (my historically embedded reaction to) the image's semiotic power to produce meaning for and with us, *now*. One implication of this difference is that Alpers's primary concern is historical in the sense of understanding the past, while mine is historical in the sense of trying to place present-day viewing within its own historical frame.

I wish to explore opposition—and this one in particular—as constructive, positive, creative, for opposition is also performative. But the "speech act" it performs is not predetermined. In order for opposition to be positive, it must exceed its own binary structure. In the case of my opposition against intentionalism here, this entails the need to suspend the analogy between the contemporary artwork and its old counterpart. It also requires that the issue of will be superseded by something else. Hence, instead of trying to understand Caravaggio's will by reflecting on process in Christensen's sculpture as a user's guide for it, I wish to understand his performance, his doing—its result, its effect, and its affect.

Performance is precisely the word Alpers used (1995, 64) to distinguish Rubens's act of making from his unreadable mind ("I was not trying to offer a

reconstruction of what might have been in Rubens' mind when he started the work, but rather the intentionality of the work itself . . .'"; 65). But rather than seeking historical weight for the interpretation of that performance, I look at it from, or with, Christensen's experiment, which helps me to disentangle kinds and degrees of doing through the variable relations between making and time, relations that harbor the undoing of intention.

Without common ground there is no discussion, no productivity in debate. Therefore, establishing that common ground is a first condition for productive opposition. Alpers and I share a keen interest in images themselves, an interest, that is, in close reading as a form of attention. This interest in images is not at all obvious, or common, in art history. On the contrary, a distinct lack of interest in actual images is demonstrated by many art historical publications. There, images are too often merely illustrations (called "evidence") in support of an academic argument, drowned, as the latter are, in precedents, sources, and documents, or strangled by patrons, whose intentions displace those of the artist. Alpers drew my attention to this years ago, and the observation shocked me.[16]

I do not think I am misreading Alpers when I claim that, in addition to this commitment to the image, we also share a commitment to articulating representation in relation to ideology, politics, and aesthetics, in the belief that these domains cannot be separated. We share this commitment, even if the kind of politics, and the emphases we place on it, may differ considerably. This commitment is obvious from the articulation of abandon in relation to pleasure and aesthetics, flesh and paint in Rubens, an articulation that can be called, without much distortion, a *politics of abandon.* In a different but even more enriching way, this commitment leads to the most interesting parts of Alpers and Baxandall's book on Tiepolo, on which more shortly (1994). Perhaps, most importantly, we both, in different ways, attempt to get away from an iconographic concept of narrative images based on their conformity to, or deviance from, a literary source, that is, away from the idea of "illustration."

But against this ground of common interests, we differ on key points. These stand out as figure does against ground, giving relief to and thus clarifying the opposition I wish to probe here. I am interested in intention versus viewing, or "reading" (my term), overdetermined as that opposition is by past versus present as the primary frame of reference. Since how we differ on this point has been given relief by Alpers's writings against (a certain notion of) narrative, against the ground of my ongoing interest in narrative that so strongly and continuously benefits from her hermeneutics of suspicion and her focus on the danger of reducing visuality to literary concerns, *narrative* is the term I have to bring into the discussion here.

The Logic of Intentionalism

Before doing so, however, I shall first explicate my understanding of Alpers's discourse of intentionalism through a close reading of passages from *The Making of Rubens*. In this book, Alpers's deployment of the concept is sophisticated and challenging. Its deployment is most explicit in the first chapter, whose argument she sums up at the beginning of the second chapter: "The aim [in chapter 1] was to reconstruct Rubens' intentions—the engendering in the sense of the begetting of the *Kermis*" (1995, 65).

What we have here is a move—and the rest of the book goes on to show that it was an intentional (!) one—from intention to origin, then on to genealogy and begetting (as the male's part in it). Thus the issue of intention itself, in a rather biblical mode and choice of idiom, is mythically gendered male. This turns out to be central to the book as a whole. But we do not find this out until we have read the third chapter, where the gender-bending mentioned earlier becomes a central concern. On the same page, we then find the rejection of the mind as the site of intention—"to see that to look at him as a philosopher-painter appealing to the mind, rather than to the eye, is a way of seeing him [Rubens] and not the thing itself"—and the displacement of intention onto the intentionality of the work.[17]

The argument of the first chapter has it that the representation of Flemishness in the representation of partying peasants is combined, slightly awkwardly, with iconographic allusions to an antiquity that transcends nationalism, and with a pleasure in painting that, moving from "he wanted to do" to "he did," shifts the argument from intention as a state of mind to the performance of pleasure in freedom. To give a sense of the intricacies this shift entails, the following merits quoting:

> Rubens does not *intend* us to separate out his portrait of the Flemish peasants from the aspect under which he presents them—so firmly has he *tried* to bind and so define his view of the state of Flanders and its people to this old, general view of humankind. (41–44; emphasis added)

This passage already suggests that the "intentionality of the work" is—in the sense Michael Holly might pick up on as a case of prefiguration—its response to later interpretations, among which Alpers's own in its previous phase of unfolding. In this formulation, intentionalism works as a lens through which to focus attention on the work, an attention protected by blinders that keep out any distracting knowledge that has accrued to the image like the dust of time.[18]

Although this focusing of attention is the productive result of the discourse

of intentionalism, it also has another side. It lends authority to the specter of the artist's authority over the vision that is not necessarily, or not entirely, his. Although Alpers points out those visual features of the image that bring in these two views of Rubens, one might also wonder, for example, where the *hierarchy* established between nationalism and a supranationalist humanism should be located: in the viewer or in the maker's will? For, on the basis of the same features, one might instead describe, perhaps even more convincingly, their lack of inte-gration, the messy and conflicted juxtaposition of these two sentiments. My sense that Alpers's own subjectivity is here inevitably intertwined with interpretation and its construction of intentionality suggests a shadow of herself as what literary critics call, with a term I find problematic for the same reasons, the *implied author*.[19]

This term refers to the author, or maker, as his or her image comes across in the work. It is the personified unification—the unification through turning into a person—of the meanings an interpreter "sees" in the work. The term was coined to encourage a disjunction between the implied author and the historical person who made the work, a disjunction necessary to account for those fictions with "unreliable narrators." Its use, however, demonstrated an unforeseen problem. The concept allowed projections of meaning by critics to be unproblematically attributed to the author, thus, literally, *authorizing* interpretations while obscur-ing the hand that makes them—the critic's. The tool, again, is the ambiguity of "meaning" as both "to mean to" and "to mean." I would put this problem forward as a footnote to Alpers's account of Rubens's double allegiance to nationality and humanism, with the latter serving to overcome the limitations of the former.

To mean to, or to mean, that is the question. There is no inherent bond be-tween these two usages of the verb. Symmetrically, its double sense plays tricks on the viewer. The question of Caravaggio's detached knee comes up again, this time in terms of readability. Does a shadow obfuscate the image, or does it en-hance its relief in the way Rembrandt sometimes obscures a sitter's eye so that we will take a better look?

Further complicating the notion of intention is the intricate mixture of modal-ities of logic involved in any attempt to pin down intentionality, a mixture I came to discern through Christensen's willed but unmasterable abandon. The meta-phor of traveling concepts is again helpful here, as is the practice of close reading through the concept under scrutiny. The methodological issue can be stated as follows: when the itinerary of an intentionalist argument is signposted in terms of the plurality of logics it involves, it seems, at best, to lay out a map that comprises a patchwork of considerations, none of which is bound by necessity to any other.

The following passage demonstrates this (for analytical purposes, I number the argument's structural units):

Why [1] did Rubens take up the peasant subject in the first place? How can
we explain [2] his concern to depict the peasants at this moment [3]? What
were the circumstances [4] in Flanders [5] . . . and Rubens' attitude [6] toward
them at the time he painted the *Kermis*? How far can they take us in viewing
the picture [7]? (Alpers 1995, 25)

This passage leads up to the section "Circumstances I," one of three sections
that, in the first chapter, alternate with three other sections, all called "Painting"
and also numbered I to III.

I distinguish seven steps above, barely noticeable because they are connected
by the commonsense use of ordinary words—by linguistic habit, although not by
the necessities of logic. I disentangle them here, not because I object to common
sense (which I often do but not obsessively), or because of a craving for neatness,
but because their unraveling sheds new light onto the complexity of subjective
agency and intention. And this as much for the argument at hand as for the intri-
cacies of the transforming of subjectivity in Christensen's *Tiden* and Caravag-
gio's *Narcissus*.

"Why" (1) asks for intention, although if it were not for the subsequent attri-
bution to the proper name, it could, ambiguously, refer to a more open causality,
as does "explain" (2), which asks for determining cause. The two do not neces-
sarily overlap. Reference to "moment" (3), as distinct from subjectivity, refers to
historical context positioned in time, diachronically, whereas "circumstances"
(4) position history synchronically, thickening the moment in a suspension of
time that allows it to spread out so as to surround the image. This is the question
of framing. "In Flanders" (5) specifies context—or rather, frame—as a moment in
national history. This makes sense in the case of a painter who was also a diplo-
mat, but it also narrows down what the frame of reference is assumed to be.

The decisive discursive activity of binding occurs in the final two elements.
The word "attitude" (6) binds "what happened" to Rubens as a subject, as an in-
dividual with his political views, specifying "circumstances" to mean psychic re-
sponse. Most pertinently for my analysis, in (7), Alpers's discourse implies that
all these questions or considerations pertain to the picture as an object of view-
ing. This outcome of the itinerary of the underlying concept of intention is illu-
minating, as it brings Alpers's position within reach of a position that would not
put intentionality at the center. For, as the passage from pages 41–44 (quoted ear-
lier) appears to suggest, the connection between intention and viewing can also
be reversed, since the work responds to our response to it. Not only does the ob-
ject cast a long shadow over us across time; we also cast a shadow over the object.

This is beginning to look like a circle that defines the image, a circle that moves
back and forth between the seventeenth and twenty-first centuries, encircling the

act of making as a performance embracing the act of viewing that has not yet taken place but that it already acknowledges. Is it vicious or hermeneutical, or can this circle be characterized differently? To be better placed to answer that question, I will, for now, connect intentionality to its other side, that is, to the image's relation to subjectivity as viewers construct it through meaning. In other words, I will separate the implied author from its Siamese twin, the critic whose product it is.

The Performance of Thought

The concept of intention is, for Alpers, bound up with her strong commitment—which I share—to avoid subordinating the image to the discourse about it, and of which it can, at best, be seen as an illustration. But we differ on where to look for a more helpful term. Whereas I agree with her resistance to the subordination of images to language, I in turn resist the idea of "pure" visuality. My commitment to interdisciplinarity stems from the sense that there is no opposition between image and language. Neither linguistic nor visual artifacts can be isolated from their frames or considered dead objects, since they perform in performance and performativity. If we try to avoid thinking in terms of an essentialist opposition between visual and linguistic domains, we are forced to come to terms with the notion that images may be mute. But they are no more stupid, thoughtless, passive, or arbitrary when mute than when subordinated to language.

How, then, do images produce meaning beyond the obvious, word-by-word, but rather uninteresting meanings that texts are so much better suited to express? In this sense, an iconographic analysis limited to meanings dictated by theological or political debate, as documented in sources, bypasses the key question of *how* images not only convey the master's message—whether the master is the artist or the commissioner—but also articulate thought visually. In other words, the question is, How do they *think*? How can they be intelligent but at the same time offer ideas for reflection and debate, ideas in which the political and ideological flavor cannot be distinguished from the domain of visuality itself?

In their Tiepolo book, Alpers and Baxandall use the term *pictorial intelligence* to denote this (1994). In my *Reading "Rembrandt,"* I proposed *propositional content* as an encompassing term for the "thought" of pictures as distinct from their aesthetic or "purely visual" aspects. My resistance to an essentializing ontology of the media was the main thrust of that book. But, as I mentioned above, with hindsight and through the rethinking that Alpers compelled me to do, I find the term *propositional content* problematic because of its potential implications, one of which is to maintain the oppositions I sought to avoid.

The most tenacious problem posed by this term is that the word *content* is

predicated upon a form/content opposition, which is again overdetermined by the qualifier *propositional.* The latter term comes from logic, a rather un-visual domain, one not "thick" enough to sustain analysis of cultural works, and it means "content" as emphatically distinct from "form." It suggests, moreover, that there is an outside to the image, inevitably construed as prior—which was what I was trying to avoid in the first place. Finally, through its link to logic, it encourages the reaffirmation of precisely that opposition that Roger de Piles put in place, and which the passage quoted earlier, from Alpers's *The Making of Rubens,* describes in all its problematic implications. Logic implies a mind, a "him" that produces it. I can trace the logic in Alpers's argument in favor of intentionalism, but when it comes to Christensen's and Caravaggio's works, logical analysis will not do. Yet there is thought, there are ideas—and these works produce them. They perform them, visually and temporally, through a necessarily shifting subjectivity.

To be sure, my second thoughts about the association with exteriority should not be taken as a plea for formalism. Exteriority is very much involved in any processing of images, from the social environment of their making to that of their various readings. But the representation the image offers, performs, or *is* can relate to it or respond to it yet not be explained by it, let alone reduced to it. The fundamental untenability of the status of any image as object only—hence, of the formalist or immanent criticism of images—is best assessed when the visuality of the image is respected, including its meanings and the way they are produced. Any separation of form and content will damage such an assessment.[20]

The implications for the notion of intention of meaning and its production, as exemplified by the Christensen/Caravaggio "debate" with which I began, were brought forward by reception aesthetics.[21] The exteriority, here, consists of the gaps, the discrepancies, and the problematic assumption of causality between process and object, between the muteness of the object and the need to (re-)-activate it. But if the activity of filling in the gaps is a matter of reconstructing the maker's intention, then it would be insulting for visual art to suppose that the work needs that effort, just as a solely iconographic reading off the page of meanings is an insult to the work's visuality and its capacity to make meaning through that visuality.

Gaps *are* not exterior; reception aesthetics claims they are *in* the work. But they *produce* exteriority. Better still, they undermine the distinction between exteriority and interiority. Again, Christensen's sculpture helps probe the depths of this insight, having demonstrated that it is indeed not possible to distinguish exterior from interior. The unforeseen, and unintended, later exterior effect was inherently caused by interiority, by the body of the sculpture itself. Exteriority, then, becomes a problem only when it is disavowed.

But if I now understand the potential implications of the term *propositional content* and must therefore abandon it, this is not really very helpful. Giving up that term neither solves the problems of the intentionalist circle suggested by the problem of the concept *implied author* nor disposes of the problem of narrative as dangerously hovering between preestablished literary meaning and unmasterable process. In view of the attempt to stage a productive polemic, it makes sense to look to my opponent for an alternative. And, since *pictorial intelligence* was the term Alpers proposed as an alternative to *visual narrativity,* I expect that a further probing of the two terms she put in opposition might help to solve the problem left hanging by intentionalism. So I will examine *pictorial intelligence* first, then see how it could possibly relate to, or even encompass, the more specific term *pictorial narrativity.*[22]

Toward the end of the Tiepolo book, in a close reading of the Würzburg *Treppenhaus* frescoes, Alpers and Baxandall's formulation suggests that *pictorial intelligence* might, indeed, be a satisfying option. For the passage draws attention quite precisely to the tension, in intentionalist accounts, in the relationship between interpretation, meaning, the maker, the viewer, and the effects of time, as highlighted here in the Christensen/Caravaggio cases. The passage comes after a description of the successful adaptation of the depictions of three "foreign" continents to the circumstances of changing light and moving perspective. The depiction of the fourth continent, Europe, the authors note, does not seem to fit in very well.

There seems to be a certain awkwardness in the *Europe* section when it is compared to the other three, at least when they are compared in terms of the rococo principles of ambiguous dimensionality, horizontal balance, and the figuration of bodies in movement. However, they write, "rather than writing off *Europe* as a relative failure, *it is better* to make a case for it by *constructing* a function it can be seen as meeting" (Alpers and Baxandall 1994, 154; emphasis added). Who would not fully agree that respect for the object requires a suspension of judgment based on preestablished principles? This is how a work of art, or any image for that matter, can become a theoretical object. Such an object "occurs" when it is *observed* (which implicates the subjectivity of the viewer) and when it *resists* (which implicates the "intentionality of the work") normalization into the theory previously held. Thus, paradoxically, respect for the image as *immutable object* requires acknowledgment of its *transformation*: it demands we see it differently. Hence, the artwork is not an immutable object only, but acts over time and across subjectivities. If the artwork is to be respected on its own terms, it must be undone and redone again and again.[23]

Alpers and Baxandall's decision that "it is better" indeed implies taking a position on this holding off of what we think we know. But if holding off is better,

what, then, do we do instead? The verb "constructing" makes clear that the act that follows is a construction from the vantage point of the present, as any psychoanalytic interpretation of Caravaggio would be. However, such a construction of "a function it can be seen as meeting" begs the question of intentionality so strongly that the term *pictorial intelligence* seems to blur rather than clarify the issue.

Both Christensen's puddles and Caravaggio's detached knee can be seen as fulfilling a function, provided we construct one for them. However, the connection of each to the kind of thought, in relation to making, that the notion of pictorial intelligence suggests remains stubbornly ungraspable and diverse. The puddles fulfill a function, one they entice us to construct for the work as a whole: that of giving a positive account of time as aesthetically productive in its very unmasterability. In other words, *the aesthetics of time entails the limit of intentionalism.* As such, Christensen's puddles can be seen as theoretical objects.

Responding to the question that the puddles address to it, the detached knee fulfills a related but slightly different function. It makes us aware of the bizarre arbitrariness of the effect of time, and, simultaneously, of the inescapable meaning-producing machine that figurative art cannot help but be, even if meaning abducts the figures from the image's initial state. Whereas the puddles' "theory" was primarily a theory of temporality that deployed fragmented notions of subjectivity to make its point, *Narcissus*'s "theory" primarily denaturalizes the unification of meaning, using time to make that point. Instead of asking whose intention is at work here, we must now ask to whose pictorial intelligence we are responding.

In the *Europe* section, the construction presented in the discussion of Tiepolo's work is a wonderful reading of the image, opening it up to important political and aesthetic concerns. These, in turn, account for what is no longer awkwardness, but without explaining the former "awkwardness" away. "Concerns," but whose? Tiepolo's, I have no qualms about that. But, as in the itinerary of intentionalism in the Rubens passage, both the subject and the nature of "accounting" remain elusive.

The authors continue their reading, however, by ascribing their construction to the work and its maker: ". . . its *purpose* and conditions of viewing are different . . ." (154; emphasis added). The keenly political analysis could only benefit from a thickening of the subjectivities involved. For it is true that the content of the construction—a certain centralizing of Europe as a compulsory vantage point from which to look at the other continents—can convincingly be seen as part and parcel of the ideology of Tiepolo's time, and—why not?—of Tiepolo himself. On the other hand, though, the interpretation has a distinctly contemporary, postcolonial feel to it, which is what makes it so compelling:

In fact, perhaps one has no business looking at *Europe* from the same upper gallery from which one looks at *Asia, Africa* and *America*. If anything, one should look *from Europe*. . . . *Europe* is the rubric, the initial code. . . . The ostensible frame of reference is Europe with the other three parts of the world as tributary. (154; emphasis in text)

The rhetorical color of this passage is telling: "one has no business," "one should"; Eurocentrism is presented as a code that presides over meaning production. This is quite clearly both discourse from today—belonging to cultural politics—and a successful attempt to bind that discourse to a visual image from the past. In other words, the awkwardness that set off this thought is itself a construction—carrying meaning, hence, a sign—of the present—of Alpers and Baxandall. Thus, "awkwardness," that productive heuristic device, is a tool that helps reposition the work in the present and break it open from its formalist self-enclosure. Why would one wish to disavow this bond, where past and present meet without merging?

This political interpretation cannot be located in the pictorial intelligence of the maker only. It would be a shame, indeed, to detach it from the present, which gives the work the specific appeal for which the Tiepolo book is in fact pleading. But how can such a bond between past and present be theorized without de-historicizing the painting? This is the crux of the argument I am having *with* Alpers—in the strong sense of that preposition. In this theorization, which will also answer the question about the nature of Alpers's circle posed earlier, the idea of narrativity can no longer be avoided. For what I mean can, in part, be understood through a concept—a special form of subjectivity—that is bound up with narrative.

The meeting point where pre-Enlightenment politics and postcolonial sensibility come together to illuminate each other is the point where awkwardness and its solution intersect. This meeting point can be construed as a case, or zone, of *free indirect focalization.* Long ago I coined this term in analogy with *free indirect discourse* to describe cases where the point of view or focalization seems to lie with a subjectivity that is a conflation of the narrator and the character, or of the subject and the object of figuration.[24]

But how does this term accommodate not the narrator and the character, both agents interior to the fiction, but the pictorial subject and the external viewer? The details Alpers and Baxandall foreground are infused with meaning and affect; indeed, they have no meaning without affect. And the authors acknowledge this. The analysis is followed by an account of what they call a "delayed Tiepolo effect" (160). There are two reasons why I propose the term *free indirect focalization* as a provisional tool to account for this description of Tiepolo's *Europe* section, an account that must include its awkwardness, which is the evidence

of the presence of its present-day viewers within it. The first is that the thought—
the meaning illuminated and thickened by affect, which the authors rightly de-
scribe as pictorial—cannot be attributed to the work's "intelligence" alone.
Therefore, the viewer is brought into the picture; or rather, the picture, like the
dripping benches, reaches outside, into an exteriority across time. There is
"thought," that is, intelligence; it is pictorial, but not confined to the interior of
the work. Nor can the participants in the dance of ideas be merged or neatly dis-
entangled. Abandon is appropriate here—abandon to the process of art, and
whatever that may entail.

Narrative Abandon

The second reason for my use of the emphatically narratological term *free indi-
rect focalization*—and this leads me to the final point I wish to make—is that this
instance of response constitutes a narrative. Hence, it seems quite relevant that
Alpers and Baxandall's analysis is connected to an act of storytelling. It is a story
of viewing and its difficulty, of the temporal deferral inherent in the connection
between viewer and image, a kind of Freudian *Nachträglichkeit* to which the
characters must abandon themselves.

The description is set in an evasive third person—"one"—which barely cov-
ers the first-person narrative in which the characters are also the narrators. The
narrative runs as follows:

> For an hour or two after leaving the Treppenhaus, one is every time teased by
> a sense of having failed to attend to a dimension of Tiepolo's picture that, in
> retrospect, registers strongly. The picture has a tart sort of moral after-taste.
> The effect was not noticed and reflected upon in the presence of the picture.
> But when one hurries back to the Treppenhaus to attend directly to what must
> have been neglected, it again becomes elusive on site: the morale still cannot
> quite be seen or located. There seems a diffused meaning here that condenses
> only *after having seen* the picture. (160; emphasis added)

This story is a wonderful account of what would be exterior to the image if images
were bound to their maker, for the effect it narrates is out of his reach. This ruth-
less exteriority, however, can only complete the communicative loop, or circle, on
condition that the temporal effect of delay is accepted as an integral part of the
image. In other words, only if the narrator is willing to become a character *within*
the enlarged image—no longer a formal unit but an unmasterable event—can pic-
torial intelligence perform its work.

Precisely for these reasons, then, *that* work—the work of the work of art—
must be defined as narrative, whether the image tells a tale or not. The authors of
Tiepolo and the Pictorial Intelligence have known this all along. Early on in their
book, struggling with an anti-narrative hope, they wrote:

> But in making *visual* sense of depiction we become narratively engaged. [. . .]
> If we wish, positively, to give the peculiarity of the pictorial its due, we need
> some minimalist sense of narrative—we need a sort of para-narrative. Para-
> narrative would refer to the human elements we infer in making visual sense of
> a pictorial representation. (42; emphasis in text)

Narrativity is here acknowledged as indispensable not because all pictures tell
stories in the ordinary sense of the word, but because the experience of viewing
pictures is itself imbued with process. In this process, interiority and exteriority
interact and get entangled without actually merging into a unified stability, so that
formalist accounts will inevitably fail, and delayed action must be retrospectively
adopted.

Para-narrative, if I interpret the term correctly, means something like a sense
of narrative but without an eventful, preestablished, and recognizable story; in
other words, not a story told "in the third person." But, I would suggest, there are
other narrative modes not contingent upon such a traditional conception of nar-
rative. The need for a new term stems from underestimating narrative, its possi-
bilities, and its potential for experiment. What I find extraordinarily insightful
and sensitive in this passage is that the authors here invoke *para-narrative* to ac-
count for the pictorial itself: "If we wish, positively, to give the peculiarity of the
pictorial its due . . ." The Greek preposition *para-* means "sideways," stepping
aside in order to see.

As a concept, then, *para-narrative* seems to convey the indispensable idea
that I am also attempting to articulate here. As a term, with its suggestion of sec-
ondarity and marginality, however, it distracts from the central mediating func-
tion that narrativity can fulfill in Alpers and Baxandall's attempts to do full justice
to the processual visuality of images, as well as to their—not *his*—"intelligence,"
without separating them as if they were different pursuits. Christensen's drip-
ping, smelly, mildewing Jell-O enacts that narrativity. My borrowing of concepts
and ideas from literary theory to further articulate this narrative is an attempt to
get away from giving hierarchical precedence to language. Here, there is no story
outside the image.

The Jell-O has a narrator but not a maker; the materiality of the stuff, in its
transformation, tells its own story—"in the first person." The sweet smell, the
disgusting smell, but also the beautiful shapes and colors throw themselves at the

viewer in an attempt to enforce a free indirect focalization. It is the Jell-O turning bad that smells. But without the visitor, it would not, would it? What is a smell but a typical feature of an object penetrating the body of a viewer? My wording here, to all intents and purposes, resonates with Alpers's begetting of Rubens. There is gender-bending going on here as well. As a parody of begetting, the bodily power of the object to get inside the viewer articulates, or embodies, yet another element of the theoretical object's thoughts.

The Jell-O sculpture, ever resourceful in finding new ways of keeping us focused on the vagaries of time, turns the dilemma posed by the two major narrative modes into a productive solution that is not the result of a dialectic with a happy ending but of a further differentiation. In its initial beauty, it posited "third-person" narrative and its claim to objectivity and distance but with its often-objectifying denigration of characters. Then, when the sculpture began its process of decomposition, it drew attention to itself, as in "first-person" narrative. But as viewers ate from it and the smell began to turn bad, it enforced a lively face-to-face interaction, as Erving Goffman, that pioneer of close reading of social process, would have it (1974).

Neither "third person" and its iconographic version, nor "first person" and its subjectivism, which tends to fall back into the authoritarian, elitist claims of connoisseurship, are the final station of Christensen's sculpture's process. When the Jell-O sticks to the visitor's finger, or when the smell hits the body of the viewer, what comes about is not what I would call para-narrative but, more simply and more emphatically, narrative "in the second person."[25] It is the unmasterable domain where the "you," the viewer, and the "I," the allegedly image-internal narrator, meet; that, I submit, is the arena where "in making *visual* sense of depiction we become narratively engaged." Such an engagement is historical: in the present, connecting to the past. It is through the concept of second-person narrative that we can theoretically account for an image's agency, which reaches across time, without neutralizing it and the historical differences its passage entails.

Understanding this process requires detailed attention to the image, including to that aspect in it that conveys a sense of subjectivity, agency, even intention. It also requires a complex but urgent historical framing. The commitment to understanding this crucial feature of visual art in its full social relevance is where the opposition between Alpers's intentionalism and my interest in narrative melts away, like Christensen's Jell-O. When Alpers wrote, in *The Making of Rubens*, "This [Alpers's account so far] leaves out what is most puzzling and also what is particularly pleasurable about the painting—or *more properly* what was puzzling and what was pleasurable to Rubens . . ." (1995, 44; emphasis added), she bridged the gap between two untenable positions through a self-correction that is, perhaps typically, her own stance, a word that appeals to authority—more

properly—in the very gesture of abandoning herself to the pleasure that she, as an art historian, gets out of art.[26] It is because her writing remains in that tension, because it never resolves its own ambiguities, because it cannot be reduced to a logic she so earnestly pursues, that I will always learn from it, in and on that elusive but crucial domain shared by teaching, social life, and art—of second-personhood.

Abandoning Authority

And so the travel through the discourse of intentionalism and a practice of narrativity has arrived at a point where I must leave it to the reader to decide where to go next. They can continue with me, in further search of a concept that can fully grasp the complexities that have accrued along the way, leaving *intention* behind, even if for now there is no definite place for us to go. Or they can remain in Alpers's domain, where intention is common and comfortably recognizable as a concern, yet where teachers like Alpers both provoke and confuse compliance with the discipline of the discipline. The choice, I contend, is the one between moving into cultural analysis or staying with art history. By engaging the same (kind of) objects—works of art in need of historical understanding—these two areas may be compatible, but they are surely in tension.

This tension, I hope to have demonstrated, is not only quite strong, perhaps even radical; it is also productive. It produces insights that neither my nor Alpers's earlier work quite displayed. If I may take this situation slightly allegorically as a measure of the differences between art history and cultural analysis, the conclusion would have to be that the most desirable would be an academy with an explicit place for both disciplines. Mine is an argument, should it be needed, against cutting departments, a threat that emerged in the wake of the merging that came with the turn to cultural studies; the most practical, material drawback of that turn.[27]

But if we can claim a place for both (because the tension itself—the knowing we cannot know, in the sense of "own," the "truth," or meaning, of cultural objects—is what makes the debate productive), then debate itself, as the privileged mode of teaching and learning, ought to be the central pedagogical mode in the practice of cultural analysis. This is one reason why, in this essay, I have been close-reading the work of an esteemed colleague from the other country—art history. But debate, as we all know, is not by definition productive. More often than not, it forecloses any advance in the collective effort to learn that we are better off (un)learning. To allege Felman's view of teaching again, debate, if not truly open, forecloses learning and instead makes the participants, each in their stronghold positions, fall into "opinion, prejudice, presumption."

My effort has been to map out a space for intersubjectivity in this sense. A space where the argument of the other (here, in some ways, even the opponent) can produce its best elements. A space, too, where the argument of the speaker (here, me, as the author of this essay) yields maximally to the other position, to produce more knowledge. This would be the "interminable task" of "analytical apprenticeship" (to recycle some of Felman's headings in her article on teaching), an apprenticeship where ignorance is not opposed to knowledge but is an "integral part of the very *structure* of knowledge" (Felman 1983, 29).

If I, as the author of this single-author essay, have the privilege of the provisional "last word" here (Alpers will perhaps respond elsewhere), the emphasis on "provisional" must be understood as heavy. For I have not remained unaffected by the resistance to my views phrased in the quotes and summaries of Alpers's (and Baxandall's) work. The aftermath of this effect is not in my knowledge-as-possession but rather in the structure of my knowledge, where ignorance belongs too. In other words, I do not know what the concept of intention will look like, even to myself, a few years from now. But I do know it looks different since writing this essay.

This staged discussion was meant to suggest the kind of discussion between disciplines and cultural analysis, as an interdiscipline (as a discipline that has no existence without *inter*connections to other disciplines), that would be the most helpful. It has strived neither to a merging nor to an abandonment of disciplines—the latter of which would leave them to their defensive self-protection—but to keep the work being done in both areas vital. As I see it, the key to such productive debates is the concept *critical intimacy*.[28] Making the case, in other words, pushes the presentation of academic discussion to its extreme, while at the same time reframing the relinquishing of intention so as to include my own. Relinquishing my position as teacher, I will stage another teacher and be her student. For, in Felman's view of pedagogy, the difference between teacher and student is dramatically reduced since both are guided by ignorance, process, and the collective pursuit of knowing how to not know.

Notes

Originally published in Mieke Bal, *Travelling Concepts in the Humanities: A Rough Guide* (Toronto: University of Toronto Press, 2002), 253–85.

1. As well as being a word that is easy to understand, *habit* is also an important concept in Peircean semiotics. The best access to the concept is offered by Teresa de Lauretis's discussion of *experience* in her 1983 article "Semiotics and Experience," which opens with an anecdote from Virginia Woolf. This story beautifully demonstrates the combination of understanding, perception, and physical response that is involved in nonreflective responses to the

world. By bringing in this concept here, I wish to underscore the near-"instinctive" quality of the appeal to intention in the cultural disciplines.

2. See Bal (2002, chap. 8).

3. For this reason, and also to make the issue concretely relevant for the study of the humanities' objects, I engage the concept of intention here through a discussion with the concrete deployments of intentionalism in the work of Alpers, rather than taking such theoretical classics as Anscombe (1957), which contains useful logical analyses, or the volume on literary intention edited by Newton-de Molina (1976) as my starting points. For a succinct, useful overview, see Patterson (1995).

4. On Silenus, see Alpers (1995, chap. 3). On Christensen, see Bal (1998, 1999).

5. The attribution is considered uncertain, although I am convinced by Gregori's arguments (1985, 265–68) in favor of it. For further support, see Marini (1974, 162–63, 387–89), Bardon (1978, 94–114), and Cinotti (1983, 518–20).

6. For a lucid explanation of the reversed logic of causality, see Culler (1983, 86–88). In art history, this reversal has been articulated by Baxandall (1985).

7. For a meticulous analysis of a number of other Caravaggio works, based on the relationship between artwork and commissioners, see Treffers (1991), in Dutch, and a more recent version, in English (2001). Although Treffers would probably disagree with the position I am defending here, I consider his analyses as strong evidence against intentionalism.

8. Without discussing its detail, I must cite Peirce's definition of the sign at this point. "A sign, or *representamen,* is something which stands to somebody for something in some respect or capacity. It addresses somebody, that is, creates in the mind of that person an equivalent sign, or perhaps a more developed sign. That sign which it creates I call the *interpretant* of the first sign. The sign stands for something, its *object.* It stands for that object, not in all respects, but in reference to a sort of idea, which I have sometimes called the *ground* of the representamen" (Peirce 1984, 4–23; emphasis in text).

9. For arguments against the notion that psychoanalytic interpretations of premodern artifacts are anachronistic, see Bal (1991a, 227–41).

10. See Silverman (1996) and Bal (1999, chap. 8).

11. I am grateful to Michael Holly, who first drew my attention to the work of time in producing this effect.

12. As I mentioned before, Felman discusses learning, and teaching, in the context of Freud's discovery of the value of knowing the limits of knowledge, or of not knowing (1983, 32n15).

13. This paradox resonates with my discussion of mystical experience in chapter 2 of *Travelling Concepts* (2002). The fact that, here, the paradox can be extended to intention in general justifies in retrospect my extension there to eroticism, beyond the metaphorical comparison of mystical to erotic experience.

14. The argument is now most easily accessible in Bal (1991b, chap. 5, esp. 198). Alpers responded in a personal communication.

15. It is the damaging aspect of opposition that I am attempting to neutralize or at least counter as best as I can in this chapter. The beneficial effect of complexity lies in its suspending of simplification, not in complexity for its own sake.

16. Because, I suppose, the commonsense view of what art history is about would suggest otherwise. Two almost arbitrarily selected examples—with different thrusts and results—of this overruling of the image by documentation, and of the artist by patrons, came to my atten-

tion in my readings on Caravaggio: Gilbert (1995) and Treffers (1991). Both studies are excellent in their way, and I learned much from them, about Caravaggio as well as about historical analysis. But whereas Gilbert pays attention to the images as such in relation to their making and effect, Treffers's exclusive interest in the sources informing the iconography all but obscures the visuality of the works. He reads the meanings "off the page" or, rather, "off the painting," in the double sense of "off."

17. Alpers's position here—the primacy of the intentionality of the work—is close to Eco's (1990); in art history, it has become attached to the name of Baxandall (1985).

18. See Holly (1996).

19. For the first articulation of this concept, see Booth (1961). For a critical assessment, see Bal (1997, 18, 76).

20. This is my fundamental problem with Summers's discussion of intentionalism within art history (1985–86). Summers posits a binary opposition that thoroughly manipulates the discussion when he writes, "If the work of art is truly cut loose from intention, then art becomes autonomous" (308). If this were true, then his conclusion, "Intention is also thus radically contextual" (311), would be inescapable. My argument goes in the opposite direction. Intentionalism, whereas often compatible with contextualism, leads away from the aspect of "context" as accounting for art's effective and affective results. I would blame this problem on the concept of context itself. As I have argued in chapter 4 of *Travelling Concepts* (2002), *context* is a mystifying term for what *framing* explicates much more adequately.

21. The classic text of this movement is Iser (1978). Kemp is among those art historians who brought these ideas to bear on visual art (1985).

22. Thomas Crow, another well-known art historian, proposes the term "the intelligence of art" in a sense that comes close to that of Alpers's term. See his book that bears this term as its title (1999).

23. I have made a similar claim for the strangely reversed leg of Bathsheba in Rembrandt's painting on that subject, in *Reading "Rembrandt"* (1991b, chap. 6).

24. Bal (1997, 159–60). For the concept of focalization and its relation to visuality, see chapter 1 of *Travelling Concepts* (2002).

25. On the ins and outs of second-person narrative in painting, see Bal (1999, chap. 6).

26. See Derrida (1982, 1–38) for a deconstruction of "proper."

27. See Bal (2002, introduction and chap. 1).

28. See Bal (2002, chap. 8).

References

Alpers, Svetlana. 1995. *The Making of Rubens.* New Haven, CT: Yale University Press.

Alpers, Svetlana, and Michael Baxandall. 1994. *Tiepolo and the Pictorial Intelligence.* New Haven, CT: Yale University Press.

Anscombe, G. E. M. 1957. *Intention.* Ithaca, NY: Cornell University Press.

Bal, Mieke. 1991a. *On Story-Telling: Essays in Narratology.* Sonoma, CA: Polebridge Press.

———. 1991b. *Reading "Rembrandt": Beyond the Word-Image Opposition.* Cambridge: Cambridge University Press.

———. 1997. *Narratology: Introduction to the Theory of Narrative.* 2nd ed. Toronto: University of Toronto Press.

———. 1998. *Jeannette Christensen's Time.* Bergen: Center for the Study of European Civilization.

———. 1999. *Quoting Caravaggio: Contemporary Art, Preposterous History.* Chicago: University of Chicago Press.

———. 2002. *Travelling Concepts in the Humanities: A Rough Guide.* Toronto: University of Toronto Press.

Bardon, Françoise. 1978. *Caravage ou l'expérience de la matière.* Paris: PUF.

Baxandall, Michael. 1985. *Patterns of Intention: On the Historical Explanation of Pictures.* New Haven, CT: Yale University Press.

Booth, Wayne C. 1961. *The Rhetoric of Fiction.* Chicago: University of Chicago Press.

Cinotti, Mina. 1983. *Michelangelo Merisi detto Il Caravaggio: Tutte le opere.* Vol. 1 of *I pittori berghamaschi: Il seicento.* Bergamo: Edizioni Bolis.

Crow, Thomas. 1999. *The Intelligence of Art.* Chapel Hill: University of North Carolina Press.

Culler, Jonathan. 1983. *Roland Barthes.* Oxford: Oxford University Press.

Damisch, Hubert. 1996. "Narcisse baroque?" In *Puissance du Baroque: Les forces, les formes, les rationalités,* edited by Else Marie Bukdahl and Carsten Juhl, 29–42. Paris: Galilée.

De Lauretis, Teresa. 1983. "Semiotics and Experience." In *Alice Doesn't: Feminism, Semiotics, Cinema,* 158–86. London: Macmillan.

Derrida, Jacques. 1982. *D'un ton apocalyptique adopté naguère en philosophie.* Paris: Galilée.

Eco, Umberto. 1990. *The Limits of Interpretation.* Bloomington: Indiana University Press.

Felman, Shoshana. 1983. *The Literary Speech Act: Don Juan with J. L. Austin, or Seduction in Two Languages.* Translated by Catherine Porter. Ithaca, NY: Cornell University Press.

Gilbert, Creighton E. 1995. *Caravaggio and His Two Cardinals.* University Park: Pennsylvania State University Press.

Goffman, Erving. 1974. *Frame Analysis: An Essay on the Organization of Experience.* Boston: Northeastern University Press.

Gregori, Mina. 1985. "Narcissus." In *The Age of Caravaggio,* edited by Mina Gregori, 403–9. London: Macmillan.

Holly, Michael Ann. 1996. *Past Looking: Historical Imagination and the Rhetoric of the Image.* Ithaca, NY: Cornell University Press.

Iser, Wolfgang. 1978. *The Act of Reading: A Theory of Aesthetic Response.* Baltimore: Johns Hopkins University Press.

Kemp, Wolfgang. 1985. "Death at Work: A Case Study on Constitutive Blanks in Nineteenth-Century Painting." *Representations* 10:102–23.

Marini, Maurizio. 1974. *Io, Michelangelo da Caravaggio.* New York: Metropolitan Museum of Art and Electa/Rizzoli.

Newton-de Molina, David, ed. 1976. *On Literary Intention.* Edinburgh: Edinburgh University Press.

Patterson, Annabel. 1995. "Intention." In *Critical Terms for Literary Study,* edited by Frank Lentricchia and Thomas McLaughlin, 135–46. Chicago: University of Chicago Press.

Peirce, Charles Sanders. 1984. "Logic as Semiotic: The Theory of Signs." In *Semiotics: An Introductory Anthology,* edited by Robert E. Innis, 4–23. Bloomington: Indiana University Press.

Silverman, Kaja. 1996. *The Threshold of the Visible World.* New York: Routledge.

Summers, David. 1985–86. "Intentions in the History of Art." *New Literary History* 17:305–21.

Treffers, Bert. 1991. *Caravaggio: Genie in opdracht: Een kunstenaar en zijn opdrachtgevers in het Rom van rond 1600.* Nijmegen: SUN.

———. 2001. "The Arts and Crafts of Sainthood: New Orders, New Saints, New Altarpieces." In *The Genius of Rome: 1592–1623,* edited by Beverly Louise Brown, 338–71. London: Royal Academy of Arts.

Part 3 **Visual Analysis**

9. Telling Objects: A Narrative Perspective on Collecting

> It is a definite social relation between men, that assumes, in their eyes, the fantastic form of a relation between things. —*Karl Marx*[1]

> In the same process that constructs the world as a view, man is constructed as subject. —*Martin Heidegger*[2]

> When you leave fiction you rediscover fictions. —*Jonathan Culler*[3]

Narrative Introduction

This paper comes from two directions, reflecting two major interests I have been pursuing for some time. The one concerns narrative as a discursive mode; the other, collecting. It seems to me that an integration of these two interests is worth the attempt, and the subject of this collection of essays the best opportunity I can imagine.

To begin with a narrative of my own: I have been working on narrative through the eras of structuralism and poststructuralism. In the beginning, I was interested in analyzing literary narratives, and when my search for reliable tools was frustrated, I stepped aside to fix a few, develop some others, and construct one or two more. But I became dissatisfied, for a while, with what I had, or perhaps I lost interest in simply "applying" those tools. A sense of purpose was lacking. As soon as I understood how narrative was made, I wanted to know how it functioned. Thus I got caught in the question of how narrative functions socially, ideologically, historically; how it changes and what people do to make it change, and to what purpose. All along, the question of what kinds of texts can be called narrative, what makes a narrative special, was part of what I was trying to understand.

Although there are many aspects to narrative, the one I was most fascinated by is the interplay between subjectivity and the cultural basis of understanding,

whether you call it objectivity or intersubjectivity. Not that these two concepts are identical, of course; but they both claim to cover the status of things *outside* the individual subject. This is, of course, the paradoxical status of all art and literature, of all cultural expressions. On the one hand, both in the production and in the reception, subjectivity is the bottom line. Yet the object produced and interpreted must be accessible, materially (object-ively) and discursively (semiotically, qua meaning, that is). Cultural objects must signify through common codes, conventions of meaning-making that both producer and reader understand. That is why they have to be intersubjectively accessible. A culture consists of the people who share enough of these conventions to exchange their views (*inter*subjectively), so that making cultural artifacts is worth some subject's while.

Here lies my particular fascination with narrative—and, as I will bring up later, with collecting. In narrative, I discovered, this paradoxical situation is doubled up. Objectively, narratives exist as texts, printed and made accessible; at the same time, they are subjectively produced by writer and reader. Analogously, the discursive mode of narrative feeds on this paradox. They are ostentatiously "objective": in terms of speech-act theory,[4] narratives are *constative* texts: like affirmative sentences, they make a statement—describing situations and events, characters and objects, places and atmospheres. Like newspaper reports—a narrative genre—all narratives sustain the claim that "facts" are being put on the table. Yet all narratives are not only told by a narrative agent, the narrator, who is the linguistic subject of utterance; the report given by that narrator is also, inevitably, focused by a subjective point of view, an agent of vision whose view of the events will influence our interpretation of them. In my previous works I have given this subjective presence in narratives the name of *focalizer,* and the activity in question, *focalization.*[5] In many analyses of narratives I have since been engaged in, this concept turned out to be crucial for insight into the tension between socially accessible objecthood and the characteristic subjectivity of narratives. This makes all narratives by definition more or less fictional; or, conversely, it makes fictionality a matter of degree.[6]

Narratives fascinate me because of this dual ambiguity that makes them almost exasperatingly difficult to understand; a difficulty that is at odds with the widespread use of this mode. Not only are the large majority of verbal texts narrative; it is also obvious that verbal texts are not the only objects capable of conveying a narrative. Language is just one medium, perhaps the most conspicuous one, in which narratives can be constructed. Images, as the tradition of history painting demonstrates, can do so as well, not to speak of mixed media like film, opera, and comic strips. I began to wonder if the exclusive focus on language in the study of narrative didn't limit the range of observations in a somewhat arbitrary way. But here as with the subjectivity question, one way of exploring the impact of such

doubt is to take an apparently extreme counterexample, and see if that it is the exception that *breaks* the rule. While stretching the concept beyond its confining force, one must also ask the question: How far can you go? What if the medium consists of real, hard material objects? Things, called objects for a good reason, appear to be the most "pure" form of objectivity. So examining the question of the inherent fictionality of all narratives can as well begin here. In other words, can things be, or tell, stories? Objects as subjectivized elements in a narrative: this possibility adds a third level to the duality of narrative's paradox.

From the other direction comes a totally private interest in collecting. Not necessarily in collections, but in what might be called the collector's mind-set, or the collecting attitude. Whereas it is virtually impossible to define collecting and, narratively speaking, to mark where that activity begins, a collecting attitude is unmistakable and distinct. Yet definitions of collecting tend to be irremediably fuzzy. Thus Susan M. Pearce's useful textbook for museum studies, *Museums, Objects and Collections* (1992), defines collecting through a definition of museum collections, which "are made up of objects" that "come to us from the past," and which have been assembled with intention by someone "who believed that the whole was somehow more than the sum of its parts."[7] If we take the "past" element loosely, as I think we must, as loosely as the existence of museums of contemporary art and of contemporary "exotica" forces us to take it, this definition appears to hold equally for interior decorating, the composition of a wardrobe, and subscribing to a journal or book series, even for finishing reading a book. Starting an inquiry with a definition of its subject matter inevitably leads to frustration: either the definition is too narrow and doesn't cover the whole range of its objects; or it is so broad that a lot of other things are covered by it too. But perhaps—and here my private interest joins the academic one—these attempts at a priori definition are themselves contingent on a view of knowledge that is ultimately at stake in the problem of collecting. As enigmatic as this may sound, knowledge that begins with definitions is very much like knowledge based on collections and classifications of objects.

If one begins reflecting on collecting in a narrative mode, it is equally hard to say when collecting begins to be collecting, as opposed to, say, buying a thing or two. If you buy a vase, and you then come upon a similar one, you can buy the second one because it matches the first one so nicely. That doesn't make you a collector, not yet. Even when you buy six vases, in different sizes but in matching color and similar in material, style, and historical provenance, you can still argue that you need six different sizes to accommodate the different lengths flowers come in, and you like the matching for the harmony it provides within the house. As someone who lacks the collecting spirit, that is how far I would go myself. But my friend who has the spirit in him pushed on after vase number six, and now he

has fifty, all beautiful, undamaged period pieces of roughly the same style, and the flower justification doesn't work anymore. He doesn't need any justification, because one day he happily found himself a collector. Since then, I have kept an eye on his buying behavior in general. I see it happening much earlier now, when he starts to collect some new "series" of objects—a special kind of molded plastic box, cheap little things; or baskets, or books in first impressions, or bits of stained-glass windows. Sometimes I can see the attraction, and shyly go for an item for a collector's reason myself, but so far it hasn't really happened to me in any serious way.

If I try to integrate my professional interest in narrative with that private one in collecting, I can imagine seeing collecting as a process consisting of the confrontation between objects and subjective agency informed by an attitude. Objects, subjective agency, confrontations as events: such a working definition makes for a narrative, and enables me to discuss and interpret the meaning of collecting in narrative terms. Perhaps it can bring to light aspects of the topic that tend to be overlooked. This, then, will be my particular focus on the subject in this essay. I will discuss collecting as a narrative; not as a process about which a narrative can be told, but as itself a narrative.

Collecting as a Narrative

Briefly put, I need the following concepts to discuss narrative, in the subject-oriented sense in which I choose to consider it. I understand narrative to be an account in any semiotic system in which a subjectively focalized sequence of events is presented and communicated. A few terms need clarification here. The sequence of events, brought about and undergone by agents, is the *fabula,* more commonly called plot; the agents—subjects of action—on this level are called *actors.* As I said earlier, the subjectivization is called focalization and its agents, focalizers. The subjectivized plot is called *story*: it is what is being told in signs— words, gestures, images, or objects—that others can understand. The semiotic subject producing or uttering that account is called the *narrator.* The distinction between focalizer and narrator is necessary because a narrator is able to subsume and present the subjective view of another, as in "I felt her quiver at the sight of her nerve-wrecking father," where the first-person narrator renders in the compound *nerve-wrecking* the subjectified vision of the other person. This split between narrator and focalizer can even accumulate in several degrees, as in "He saw that she realized he had noticed that she was aware of the lipstick on his collar."

According to Aristotle, Western cultural history's first narratologist, a fabula

has a beginning, a middle, and an end. The story precisely manipulates that order, as when it reverses beginning and middle in the structure called *in medias res*, and the possibility of such manipulations is the very characteristic feature of narrative. More often than not, chronology is mixed up in narrative. To consider collecting as a narrative makes us focus, precisely, on the non-obviousness of chronology. So, our first inquiry might be: Where does it all begin?

Beginnings: Many

Looking back at the story of my friend's vase collection, it is noticeable that the beginning is exactly what is lacking. One object must have been the first to be acquired, but, then, when it *was* first, it was not being collected—merely purchased, given, or found, and kept because it was especially gratifying. In relation to the plot of collecting, the initial event is arbitrary, contingent, accidental. What makes this beginning a specifically narrative one is precisely that. Only retrospectively, through a narrative manipulation of the sequence of events, can the accidental acquisition of the first object *become* the beginning of a collection. In the plot it is prehistoric; in the story it intervenes *in medias res*. The beginning, instead, is a meaning, not an act. Collecting comes to mean collecting precisely when a series of haphazard purchases or gifts suddenly becomes a meaningful sequence. That is the moment when a self-conscious narrator begins to "tell" its story, bringing about a semiotics for a narrative of identity, history, and situation. Hence, one can also look at it from the perspective of the collector as agent in this narrative. Would that make it easier to pinpoint the beginning? I think not. Even when a person knows him- or herself to have the collector's mind-set, the category of objects that will fall under the spell of that attitude cannot be foreseen. The individual one day becomes aware of the presence of an eagerness that can only be realized *after* it has developed far enough to become noticeable. Initial blindness is even a precondition for that eagerness to be developed, hidden from any internalized ethical, financial, or political censorship. It is of the nature of eagerness to be accumulative, and, again, only retrospectively can it be seen. Stories of collecting begin by initial blindness—by visual lack. So this beginning, too, is of a narrative nature.

Between the object and the collector stands the question of motivation, the "motor" of the narrative. Just as Peter Brooks asked the pertinent question "What, in a narrative, makes us read on?"[8]—so we may ask what, in this virtual narrative, makes one pursue the potential collection? Motivation is what makes the collector "collect on," hence, collect at all. Most museologists have that question at the forefront of their inquiry, and in a moment I will survey some of their

answers. From the narratological perspective of this essay, the question of moti-
vation underlies the unclear beginning, the false start. This question is called to
replace, or repress, that other beginning, which is that of the object itself *before* it
became an object of collecting. Motivation is, then, both another narrative aspect
of collecting and its intrinsically ungraspable beginning.

When we look at explanations of motivation, however, articulation of under-
standing recedes and yields to another narrative. Pearce begins her discussion of
motivation with yet another beginning:

> The emotional relationship of projection and internalization which we have
> with objects seems to belong with our very earliest experience and (probably
> therefore) remains important to us all our lives. Equally, this line of thought
> brings us back to the intrinsic link between our understanding of our own bod-
> ies and the imaginative construction of the material world . . .[9]

This view is part and parcel of the story of origins of psychic life as constructed
by psychoanalysis, in particular the British branch of object-relations theory.[10]
Although I cannot go into this theory and its specifically narrative slant here,[11] the
unspoken assumption of this quotation is directly indebted to that theory, and
therefore deserves mentioning: the desire to collect is, if not innate, at least in-
herent in the human subject from childhood on. This type of explanation par-
takes of a narrative bias that, in its popular uses, both explains and excuses adult
behavior.

From motivation in childhood, Pearce moves to phenomenologically defined
essential humanness—and storytelling is again an indispensable ingredient:

> The potential inwardness of objects is one of their most powerful characteris-
> tics, ambiguous and elusive though it may be. Objects hang before the eyes of
> the imagination, continuously re-presenting ourselves to ourselves, and telling
> the stories of our lives in ways which would be impossible otherwise.[12]

According to this statement, collecting is an essential human feature that origi-
nates in the need to tell stories, but for which there are neither words nor other
conventional narrative modes. Hence, collecting is a story, and everyone needs to
tell it. Yet it is obvious that not every human being is, or can afford to be, a collec-
tor. The essentializing gesture obscures the class privilege that is thereby pro-
jected on the human species as a whole. From this doubly narrative perspective,
Pearce goes on to discuss as many as sixteen possible motivations. It is worth list-
ing these, for the list is significant in itself, and each motivation mentioned im-
plies a story in which it unfolds: leisure, aesthetics, competition, risk, fantasy, a

sense of community, prestige, domination, sensual gratification, sexual foreplay, desire to reframe objects, the pleasing rhythm of sameness and difference, ambition to achieve perfection, extending the self, reaffirming the body, producing gender identity, achieving immortality. Most of these motivations have a sharply political edge to them, and the more difficult they are to define, the less innocent they appear when one tries. Thus the aesthetic impulse, probably the most commonly alleged motivation and the least obviously political one, is defined by the French sociologist Pierre Bourdieu in terms that are both tautological and political-utopian:

> The aesthetic disposition, a generalized capacity to neutralize ordinary urgencies and to bracket off practical ends, a durable inclination and aptitude for practice without a practical function, can only be constituted within an experience of the world freed from urgency and through the practice of activities which are an end in themselves.[13]

In other words, you can only bracket off practical ends if you truly do so, and to have this disposition (or "capacity"!) you need to be rich—so rich, that the rest of the world hardly matters. The means are projected first as disposition, then as capacity: I recognize again the essentializing move that defines humanness through an extension of a feature of one privileged group.

Pearce's list is both troubling and compelling. What makes the list so compelling is the sense of increasing urgency in the "collecting drive," from relative luxuries like aesthetics to needs as "deep" as extending body limits, constructing gender identity, and, climactically in the final position, achieving immortality. The trouble with the list, however, is its character *as* list, the enumeration of what thereby appear to be different motivations, none of them explicitly political. Discussed one by one, each motivation is neutralized by its insertion in this mixed list. But the paradigmatic character of this presentation conflicts with the implicit systematic, which appears when the items are ordered differently. The desire for domination, inconspicuously mentioned somewhere in the middle of the list, might receive more emphasis were the list to be turned into a coherent set of aspects of the same impulse, connected, that is, with the construction of gender identity, the achievement of sexual gratification, and the divine—or childish— desire for immortality, to mention only the most obvious ones. Underlying most of these motivations, I would suggest, is another kind of developmental narrative, that of the many strands, developments, and framings of a concept capable of connecting them all: fetishism.

This missing term is the one that has a long tradition of connecting the psychoanalytic narrative explanation to the Marxist-political critique. Yet fetishism

conflates and sums up the large majority of the motivations in Pearce's list. To help get this concept and its implications for the beginning of collecting as a narrative into focus, let us turn to James Clifford's seminal essay, "On Collecting Art and Culture."[14] In answer to the question "Why do we collect?"—the question that enmeshes explanation and origin, articulating the one through narration of the other—Clifford qualifies a certain form of collecting as typical of the Western world:

> In the West, however, collecting has long been a strategy for the deployment of a possessive self, culture, and authenticity.[15]

And Clifford goes on to explore the relevant aspects of that particular collecting attitude. Such an attitude, then, is predicated on a particular view of subject-object relations as based on domination. The separation between subject and object this entails makes it impossible for a subject, caught in the individualism characteristic of that separation, to be part of, or even fully engage with, a group. To the extent that this is a cultural feature, one cannot simply escape it; the most one can do is "make it strange," make it lose its self-evident universality.[16]

This merciless separation between subject and object makes for an incurable loneliness that, in turn, impels the subject to gather things, in order to surround him- or herself with a subject domain that is not-other. Small children do this, collecting gravel, sticks, the odd pieces that grown-ups call junk but which, for the child, has no quality other than constituting an extension of the self, called for to remedy the sense of being cut off. Adults are likely to disavow the similarity between their own forms of collecting and this childish gathering: they would rather claim that the collection makes their environment more "interesting"; but "interesting" is a catchphrase destined to obscure more specific *interests* in the stronger sense of German critical philosophy.[17] This stronger sense of *interests* becomes painfully obvious when, as tends to be the case, the object of gathering is "the other." For then, objects of cultural alterity must be made "not-other." Clearly, the act of collecting then becomes a form of subordination, appropriation, depersonification.

This process of meaning production is paradoxical. The "not-other" objects-to-be must first be made to become "absolute other" so as to be possessible to all.[18] This is done by cutting objects off from their context. It is relevant to notice that the desire to extend the limits of the self—to appropriate, through "de-othering"—is already entwined with a need to dominate, which in turn depends on a further "alterization" of alterity. This paradoxical move, I will argue, is precisely the defining feature of fetishism in all senses of the term.

In Clifford's analysis, collecting defines subjectivity in an institutional prac-

tice, a definition he qualifies, with Baudrillard, as both essential and imaginary: "as essential as dreams."[19] Essential, but not universal; rather, this particular need is for him an essential aspect of being a member of a culture that values possessions, a qualification that might need further qualification according to class and gender. And it is imaginary to the extent that it partakes of the formation of subjectivity in the unconscious, which is itself the product of the collision and the collusion of imaginary and symbolic orders. Deceptively, collections, especially when publicly accessible, appear to "reach out," but through this complex and half-hidden aspect they in fact "reach in," helping the collector—and, to a certain extent, the viewer—to develop their sense of self while providing them with an ethical or educational alibi.

Beginnings: One

With this reflection as background, it becomes easier to understand the narrative nature of fetishism as a crucial motivation for collecting. The literature on fetishism is immense; I will limit myself here to the common ground between the three most directly relevant domains: psychoanalysis, social theory—say, in the guise of Marxist analysis—and visuality. As for the anthropological concept of fetishism, it will be conceived here as largely a Western projection, and as such integrated in both Freudian and Marxist views. Psychoanalytically speaking, fetishism is a strong, mostly eroticized attachment to a single object or category. As is invariably the case in this discipline, that attachment is explained through a story of origin—the perception, crucially visual, of women's lack—and of semiotic behavior.

It is a story that has been told and retold.[20] The child "seeing in a flash" that the mother has no penis identifies with this shocking sight in a first metaphorical transfer of "absence of penis" to "fundamental, existential lack," and acts on it. This negative "presence" in the mother, because of its negativity, can only be the product of symbolization; visual as the experience is, there is nothing object-ive about vision. "Lack" is not the object seen, but the supplement provided by the seeing subject. If this negative vision is as crucial in the formation of subjectivity as it appears to be in Freudian theory, I wish to emphasize the crucial negativity of vision it implies. Vision, then, is both bound up with gender formation and with semiotic behavior; it is an act of interpretation, of construction out of nothingness. If the penis must have this founding status, so be it. But, then, it is not the member that makes members of the ruling class, but its absence that is the foundation of vision as a basically negative, gendered act of fictionalization.

The child denies the absence in a second act of symbolization. This time, he

denies the negativity. Superposing fiction upon fiction, the absence becomes presence, and the child is back to square one in more than one sense. Later on, the fixation of this denial results in the displacement of the absent penis onto some other element of the body, which must then be eroticized for the grown-up child to become fetishistic. This constitutes the third act of symbolization. This other element of the body—this object that must become the paradigm of objectivity: semiotically invested objecthood—is subjected to a complex rhetorical strategy. In this strategy three tropes contribute to the perversion of meaning: *synecdoche,* the figure where a part comes to stand for the whole from which it was taken; *metonymy,* where one things stands for another adjacent to it in place, time, or logic; and *metaphor,* where one thing stands for another on the basis of similarity, that is, something both have in common.

Examples of these tropes in general use are well known. A sail stands for a sailboat as a synecdoche: it is part of what it signifies. Smoke stands for fire as a metonymy: it is contiguous to fire, both in space, since you see the smoke above the fire, and in time, since it develops out of the fire; and even in logic, as is suggested in the expression "no smoke without fire." A rose stands for love as a metaphor: both rose and love are transient, beautiful, and have the potential to hurt. These rhetorical strategies work as follows in the structure of fetishism. First, the substitute for the penis is synecdochically taken to stand for the whole body of which it is a part, through synecdoche: a foot can become eroticized in this way, for example, or "a shine on the nose," as in Freud's case history of the English governess "Miss Lucy R." in *Studies in Hysteria* (1895). Or the substitute can be valued as contiguous to the body, through metonymy: for example, a fur coat, stockings, or a golden chain. But, second, the whole is defined, in its wholeness, by the presence of a single part that is in turn a synecdoche for wholeness, the penis whose absence is denied. In another world this body part might not have the meaning of wholeness, and therefore of the lack "we" assign to it. But if taken synecdochically, the penis can only represent masculinity, whereas the object of fetishism in this story is the woman's body, essentially the mother's. Hence, metaphor intervenes at this other end of the process, in other words, the representation of one thing through another with which it has something in common. The wholeness of the female body can only be synecdochically represented by the stand-in penis that is the fetish, if that body is simultaneously to be metaphorically represented by the male body.[21]

Note that this entire rhetorical machine, which puts the female subject safely at several removes, is set in motion by a *visual* experience.[22] This multiple removal allows us to get a first glimpse of the violence involved in this story, which might well become a classic horror story. I contend that it is this intrinsic violence that connects this Freudian concept of fetishism with the Marxian one, at least,

as the latter has been analyzed by W. J. T. Mitchell in his seminal study of discourses on word and image distinctions.[23]

Mitchell compares and confronts Marx's uses of the terms *ideology,* with its visual and semiotic roots, *commodity* and *fetish,* and brings to the fore a number of fascinating tensions in those uses. Fetish, Mitchell reminds us, is the specifically concrete term Marx used in order to refer to commodities, a strikingly forceful choice, especially when one considers it against the background of the developments in anthropology at the time. "Part of this force is rhetorical," Mitchell states.

> The figure of "commodity fetishism" (*der Fetischcharacter der Ware*) is a kind of catachresis, a violent yoking of the most primitive, exotic, irrational, degraded objects of human value with the most modern, ordinary, rational, and civilized.[24]

The anthropological notion of the fetish is clearly needed for the rhetorical purpose of this contrast in the well-known process of radical "othering" of other cultural practices—which is why it seems inappropriate even to bring it in as anything other than this Western projection. Mitchell pursues this rhetorical analysis of the concept in a footnote that is worth quoting in full:

> The translation of *Ware* by the term "commodities" loses some of the connotations of commonness and ordinariness one senses in the German. But the etymology of "commodities," with its associations of fitness, proportion, and rational convenience (cf. "commodious") sustains the *violence* of Marx's figure, as does the obvious tension between the sacred and the secular. The origin of the word "fetish," on the other hand (literally, a "made object"), tends to sustain the propriety of the comparison, insofar as both commodities and fetishes are products of human labor.[25]

The violence, both in the Freudian and in the Marxian conception of fetishism, is brought to light through rhetorical analysis, and consists of multiple degrees of *detachment.*

In both cases, it is also through the visual nature of the event (Freud) or object (Marx), respectively, that this violence is necessary. Mitchell's analysis of the way the visual metaphor functions in Marx's cluster of concepts—ideology, commodity, fetish—convincingly demonstrates how crucial this visuality is for Marx's rhetoric. For my purposes the insistence on vision of both Marx and Freud in their accounts of the (narrative) emergence of fetishism and of fetishism's essence, respectively, matters primarily because of the paradoxical

subjectivation of objects that is the intrinsic other side of the objectification of subjectivity described in these theories. What gives visuality its central relevance is the deceptiveness of its object-ivity. Vision is by no means more reliable, or literal, than perception through the other senses; on the contrary, it is a semiotic activity of an inherently rhetorical kind. The violence Mitchell points out is not due to the rhetoric itself, but to the need to obscure it.

This paradox enables Slavoj Žižek to push this subject-constructing power of objects one step further, and to come up, not with a Marxian Freud, but with a Lacanian Marx. In his discussion of ideology, he writes:

> We have established a new way to read the Marxian formula "they do not know it, but they are doing it": the illusion is not on the side of knowledge, it is already on the side of reality itself, of what the people are doing. What they do not know is that their social reality itself, their activity, is guided by an illusion, by a fetishistic inversion.[26]

And a little further on he "translates" this relational social reality onto the objects that are positioned in it. Putting it as strongly as he can, Žižek writes:

> The point of Marx's analysis, however, is that *the things (commodities) themselves believe in their place,* instead of the subjects; it is as if all their beliefs, superstitions and metaphysical mystifications, supposedly surmounted by the rational, utilitarian personality, are embodied in the "social relations between things." They no longer believe, *but the things themselves believe for them.*[27]

Žižek goes on to argue that this is a Lacanian view to the extent that it is a conception of belief as "radically exterior, embodied in the practical, effective procedure of people."[28] The function of ideology— Žižek's concern here—is, then, like the junk accumulated by the child, or the objects collected by our hero the collector: "not to offer us a point of escape from our reality but to offer us the social reality itself as an escape from some traumatic, real kernel."[29]

There is no point in pushing the similarity between Marx and Freud too far, however. On the contrary, the concept of fetishism needs to be rigorously reinstated in its full ambiguity as a *hybrid.* True, both appear to be not only fixating on the visual aspect of fetishism, but also in its wake on the twisted relation between subject and object to the extent that, for Lacan, they can change places. They both articulate these aspects in a narrative of origin where vision as both positive knowledge and perverting subjectivity constitutes the core event. Yet it is in the plot of their respective narratives that their crucial difference lies. Freud's story is that of individual development, of the little boy growing up with the burden of his early negative mis-vision. Marx's story is the grand narrative of History.

In both cases, there is a discrepancy between the narrator and the focalizer. The narrator "tells" his story in a nonverbal way, the Freudian subject by acting out his erotic fetishism, the Marxian subject by living his historical role, including the acquisition of commodities, perhaps in the mode of collecting. For Freud, the narrator is an adult male agent, for Marx, the historical agent. This narrator is by necessity stuck with a double vision, embedding the focalization of adult and child, of lucid agent and deceived idolator, indistinguishably. Freud's focalizer has fully endorsed the doubly negative vision of the child, including the remedial denial and the fetishistic displacement. Marx's focalizer is a self-conscious agent standing within the historical process and endorsing as well as denouncing false consciousness and the idols of the mind.[30] Far from demystifying commodity fetishism from a transcendental position outside history, Marx turns commodities themselves into figurative, allegorical entities, "possessed of a mysterious life and aura."[31] The self-evident acceptance of motivations listed by Pearce is an acknowledgment of the inevitability of this double focalizer.

If this double focalizer can be retained as the most central feature of fetishism in both Freud's and Marx's sense, and, in turn, this double-edged fetishism as a crucial element of motivation, then it becomes easier to see, not the self-evidence but the inevitability of the impulse to collect within a cultural situation that is itself hybridic: a mixture of capitalism and individualism enmeshed with alternative modes of historical and psychological existence. In other words, rather than presenting that impulse through a list of independently possible motivations that sound innocent, collecting must become, through an analysis of its complex of motivations, a true *problematic*. A problematic is a complex epistemological problem that is at the same time a political hybrid; it is neither dismissible as simply ethically objectionable, subject to the moralism that sustains liberalism, nor is it ethically indifferent and politically irrelevant. In contrast, the hybrid notion of fetishism, able to account for the entanglement of agency in a political *and* individual history, should be assigned its rightful—because productive—place as the *beginning* of the beginning of collecting seen as narrative. This is why there is no unambiguous beginning. For its very search is bound up with, as Naomi Schor put it in her interpretation of a broken gold chain in Flaubert's *Salammbô*: the "original and intimate relationship that links the fetish and the shiny, the undecidable and the ornamental."[32] Collecting fits this bill more than nicely.

Middle

Aristotle wasn't stating the obvious when he insisted that narratives also have a middle. For whereas the beginning is by definition elusive, it is the development of the plot that is the most recognizable characteristic of a narrative. The retro-

spective fallacy that alone enabled the speculative beginning is itself the *res* in whose middle the structure of *in medias res* takes shape; the beginning *is* the middle, and it is constituted as beginning only to mark the boundaries of the narrative once the latter is called into being. Conversely, once a beginning is established, it becomes easier to perceive the development of the plot of collecting. Again, one can focus on either the objects or the collector as narrative agents, and, again, their stories do not converge. The objects are radically deprived of any function they might possibly have outside of being collected items. According to an early theorist of collecting, this deprivation is so fundamental as to change the nature of the objects:

> If the *predominant* value of an object or idea for the person possessing it is intrinsic, i.e., if it is valued primarily for use, or purpose, or aesthetically pleasing quality, or other value inherent in the object or accruing to it by whatever circumstances of custom, training, or habit, it is not a collection. If the predominant value is representative or representational, i.e., if said object or idea is valued chiefly for the relation it bears to some other object or idea, or objects, or ideas, such as being one of a series, part of a whole, a specimen of a class, then it is the subject of a collection.[33]

If this change in the nature of the object is not taken as an articulation of a definition but as an event, it might be illuminating to see this event of deprivation as the core of collecting as itself a narrative, particularly as such a change in nature is a *narrator's* decision. Note the strikingly modern semiotic vocabulary employed: objects are inserted into the narrative perspective when their status is turned from object-ive to semiotic, from thing to sign, from collapse to separation of thing and meaning, or from presence to absence. The object is turned away, abducted, from itself, its inherent value, and denuded of its defining function so as to be available for use as a sign. I use the words "abducted" and "denuded" purposefully; they suggest that the violence done to the objects might have a gendered quality. This will become more explicit below.

The new meaning assigned to the object, Walter Durost suggests, is determined by the syntagmatic relations it enters into with other objects. These relations may be synecdochic ("part of a whole," "one of a series") or metonymic ("valued chiefly for the relation it bears to some other object or idea"). But this relation is also always metaphoric ("a specimen of a class"): the object can only be *made* to be representative when it is made representational, standing for other objects with which it has this representational capacity in common. This insertion, by means of rhetoric, of objects defined by objecthood into a syntagm of signs is the body of the narrative that emerges when we choose to consider col-

lecting so. Violence is done to the objects in each episode of collecting, each event of insertion that is also an act of deprivation. This is not a one-time act, for meaning changes as the collection as a whole changes. As the narrative develops, each object already inserted is modified anew.

This narrative development can perhaps be made clearer through apparent counterexamples. Aberrant plots like single-object collections, aborted collections, as well as anti-collecting—the accumulation of objects *not* related—demonstrate the plotted nature of collecting conceived through the objects. Another way to emphasize this aspect of collecting is the frequently occurring change in the ordering of an extant collection, or a number of different collections whose intersections are reorganized. A striking example of this re-plotting is provided by Debora J. Meijers's analysis of the new organization by Christian von Mechel around 1780 of the Habsburg painting collection.[34] Whereas the objects in the collection remained virtually the same, the collection itself was set up in such a different way, conveying, through this re-plotting, such a different conception—not only of this particular collection but of collecting itself as a mode of knowledge production—that Meijers is able to argue for an epistemic break as the meaning-producing agency. In terms of the present discussion, the objects as things remained the same, but the objects *as signs* became radically different, since they were inserted into a different syntagm. The act of insertion, accompanied by the act of deprivation of objecthood as well as of previous meanings, propels the plot forward as it constitutes the development of the narrative. In spite of the anti-narrative synchronicity of Meijers's Foucaultian perspective, in which the two epistemes, before and after the break, are compared in their static epistemological makeup, the dynamic "life" of the objects during the process of their insertion into a collection clearly stands out in her analysis.

Considering the collector as a narrative agent, the motivation itself is subjected to the development of plot. Unlike the suggestion emanating from Pearce's listing of motivations, motivation changes according to its place in the narrative. The notion, developed above, that a complex and hybrid kind of fetishism—indebted to childhood gendering as well as to submission to political history, to memory as well as to lived experience in the present—underlies collecting in the Western world implies a fundamental instability of meaning. If initially—always retrospectively understood—the predominant aspect of the fetishism that informs collecting is anchored in anxiety over gender, this emphasis is likely to shift on the way. It may shift, for example, from obsessive attachment to each one of the objects in itself to investment in collecting as an occupation; or from accumulating to ordering. But more significantly, the relation to the fragility of subjectivity itself may shift. In one episode of this narrative, the extension of subjectivity through investment in the series of objects fit to stand in for the absent attribute

of the past may overrule other affects. In another episode, not gender but time—death—can get the upper hand. In accordance with Freud's concept of the death instinct, subjects constantly work their way through the difficulty of constituting themselves by re-enacting a primal scenario of separation, of loss and recovery, in order to defer death. Collecting can be attractive as a gesture of endless deferral of death in this way; this view provides Pearce's "achieving immortality" with a meaning more intimately related to narrative. As Peter Brooks has argued,[35] this need to repeat events in order to hold off death is the very motor of narrative.

But this elaboration of collecting as a narrative of death can also come to stand in tension with its other side: the desire to reach the ending. What if, to recall another of Pearce's categories, the perfection, or completion, strived for is actually reached? Of course, it is not a question of real, "objective" perfection—although when the series is finite, completion is quite possible. Perfection, as a subjectively construed standard of idealization, may come so dangerously close that the collector cannot bear to pursue it. Unlike what one might tend to assume, this is not a happy, but an extremely unhappy, ending of our narrative.

Endings

If completion is possible, perfection is dangerous. Completion may be a simple way of putting an end to a collecting narrative—defining it, so to speak, as a short story—in order to begin a new one. The collection that harbors all items of a given series will have no trouble extending itself laterally, and will start a new one. Perfection, the equivalent of death in the sense that it can only be closely approximated, not achieved "during the lifetime" of the subject, is one of those typically elusive objects of desire like happiness, or the satisfaction of any other desire. Perfection can only be defined as the ending; as what brings collecting to a close by default. It is an imaginary ending that owes its meaning to the contrast between it and what can be called the contingent ending. The latter is the product of such contingent happenings as running out of space, disposing of collections, changes in desires, changes in forms of storage, sales, gifts or death—not death as constitutive force in subjectivity but as arbitrary event.

Again, in order to make sense of this random set of notions, a narrative perspective can be helpful. According to the logic of plot, or of theories of fabula, of structuralist genealogy, the particular combinations of beginnings, middles, and endings that make up a story of collecting allow illuminating specifications of collectings. Reduced to its bare minimum, the structuralist model designed by Claude Bremond, for example, which is the simplest of its kind, presents "narrative cycles" as processes of amelioration or deterioration of a situation, according

to the wish or desire of a primary agent. The possibilities Claude Bremond lists in his model are not so much "logical" in the general sense (as he claims), but rather, specifically, ideo-logical and psycho-logical.[36] Thus a fetishistic subject whose gender and historical identity heavily depend on the possession of certain objects supposedly undertakes to acquire these. The episode leading up to the acquisition of each object that so contributes to this subject's sense of self and fulfillment constitutes one step in the process of amelioration for this subject. The accomplishment of acquisition constitutes the closing of the cycle, which opens up the next one: either the renewed desire for a similar object that typically indicates the collector's mind-set, or the desire for a different kind of fulfillment that signals the premature ending of the story of collecting. Rendered in this way, the process of amelioration takes place at the intersection of private and public, psychic and historic existence, and the episode contributes to the shaping of this subject as much as the subject shapes the episode.

This structure can, and indeed must, be complicated in two ways. The position of the initiating subject can be filled in differently. A process that brings amelioration to the collector, for example, can bring deterioration to the object-being as it forfeits its function and, by extension, to the subject who held, used, or owned it before. Thus, the same process needs to be assessed twice over, in order to expose the subjective nature of the meaning of the event. The second complication is constituted by a further specification of the amelioration itself—or the deterioration. Bremond distinguishes processes like accomplishment of a task, intervention of an ally, elimination of an opponent, negotiation, attack, retribution. These types are obviously derived from folktales, and their relevance for collecting seems far-fetched. Yet their allegiance to a specific type of plot—one in which hostility is a major factor—unexpectedly illuminates a side of collecting that was already present in Pearce's list: competition, domination. Each of these—and others are of course conceivable—turn the event into something other than what it seems in the cheerful light of most of the many isolated motivations.

For at the intersection of psychic and capitalist fetishism, the narratives such analyses entail turn collecting into something else again: a tale of social struggle. This struggle over "ameliorations" by means of an attack on someone else's property with the help of money; negotiation over prices; elimination of a rival; accomplishment of the task of developing "taste"; expertise competing with that of others—all these plots engage subjects on both sides of the "logic of narrative possibilities," and on both sides of gender, colonialist and capitalist splits. If the plot evolves so easily around struggle, then the collector's opponents are bound to be the "other": the one who loses the object, literally by having to sell or otherwise yield it, or, according to the visual rhetoric of Freud's little boy, by forfeiting

that for which the collector's item is a stand-in. Paradoxically, the narratives of collecting enable a clearer vision of this social meaning.

Notes

Originally published in *The Cultures of Collecting,* edited by John Elsner and Roger Cardinal (London: Reaktion Books, 1994), 97 –115.

1. Karl Marx, *Capital,* I, 72; cited in Mitchell (1985, 189).

2. Martin Heidegger, "The Age of the World View"; cited in Hooper-Greenhill (1992, 82).

3. Culler (1988, 203).

4. Speech-act theory considers language from the angle of its effectivity. It was first developed by J. L. Austin, and set out in his posthumously published *How to Do Things with Words* (1962). Austin proposes a distinction between utterances that are constative, informative, and those that are performative—that have no meaning other than the act they, in fact, *are* (like promising). When you say "I promise," you *do* it; that is the only meaning the verb has.

5. My theory of narrative can be found in Bal (1992a). For discussions with other narrative theories, see Bal (1991b).

6. This conclusion is reached through different routes by historiographers like White (1973, 1978).

7. Pearce (1992).

8. Brooks (1984).

9. Pearce (1992, 47).

10. Represented primarily by Klein (1975) and Winnicott (1980).

11. But for the persistent carryover between explicating articulation and explanations of origin in psychoanalysis, see Pavel (1984).

12. Pearce (1992, 47).

13. Bourdieu, *Distinction* (1984), 54; cited in Pearce (1992, 50).

14. Clifford (1988).

15. Ibid., 218.

16. This was the purpose of my analysis of a few rooms of the American Museum of Natural History, published as "Telling, Showing, Showing Off" (1992b). Reprinted here in chapter 6.

17. For a good, succinct discussion of this concept of interest, see Geuss (1981, 45–54) and, of course, Habermas's own seminal book *Knowledge and Human Interests* (1972).

18. To clarify the issue, I am radicalizing Clifford's argument slightly (1988).

19. Baudrillard (1968, 135); Clifford (1988, 220).

20. Freud (1963); Fenichel (1946).

21. For a feminist critique of fetishism, see Schor (1985b); and for a feminist reflection on female fetishism, see Schor (1985a).

22. For a more extensive analysis of the intimate—and narrative—connections between psychoanalysis and visuality, see Bal (1991a).

23. Mitchell (1985, 160–208, esp. 191).

24. Ibid., 191.

25. Ibid.

26. Žižek (1989, 32).

27. Ibid., 34.
28. Ibid.
29. Ibid., 45.
30. Mitchell (1985, 176).
31. Ibid., 188.
32. Schor (1985b, 119).
33. Durost, *Children's Collecting Activity* (1932), 10; cited in Pearce (1992, 48).
34. Meijers (1991).
35. Brooks (1984, passim).
36. Bremond (1973, 1980).

References

Austin, J. L. 1962. *How to Do Things with Words.* Cambridge, MA: Harvard University Press.
Bal, Mieke. 1991a. "Blindness or Insight? Psychoanalysis and Visual Art." In *Reading "Rembrandt": Beyond the Word-Image Opposition*, 286–325. Cambridge: Cambridge University Press.
———. 1991b. *On Story-Telling: Essays in Narratology.* Sonoma, CA: Polebridge Press.
———. 1992a. *Narratology: Introduction to the Theory of Narrative.* Toronto: University of Toronto Press.
———. 1992b. "Telling, Showing, Showing Off." *Critical Inquiry* 18 (3): 556–94.
Baudrillard, Jean. 1968. *Le Système des objets.* Paris: Gallimard.
Bourdieu, Pierre. 1984. *Distinction: A Social Critique of the Judgement of Taste.* Translated by Richard Nice. Cambridge, MA: Harvard University Press.
Bremond, Claude. 1973. *Logique du récit.* Paris: Editions du Seuil.
———. 1980. "The Logic of Narrative Possibilities." *New Literary History* 11:398–411.
Brooks, Peter. 1984. *Reading for the Plot: Design and Intention in Narrative.* New York: Knopf.
Clifford, James. 1988. "On Collecting Art and Culture." In *The Predicament of Culture: Twentieth-Century Ethnography, Literature and Art*, 215–51. Cambridge, MA: Harvard University Press.
Culler, Jonathan. 1988. *Framing the Sign: Criticism and Its Institutions.* Norman: University of Oklahoma Press.
Durost, Walter. 1932. *Children's Collecting Activity Related to Social Factors.* New York: Columbia University Press.
Fenichel, Otto. 1946. "Fetishism." In *The Psychoanalytic Theory of Neurosis*, 341–51. London: Routledge.
Freud, Sigmund. 1963 (1925). "Some Psychological Consequences of the Anatomical Distinction Between the Sexes." In *The Standard Edition of the Complete Psychological Works*, edited by J. Strachey, 8:133–42. London: Hogarth Press.
Geuss, Raymond. 1981. *The Idea of a Critical Theory: Habermas and the Frankfurt School.* Cambridge: Cambridge University Press.
Habermas, Jürgen. 1972. *Knowledge and Human Interests.* Translated by Jeremy J. Shapiro. London: Heinemann.
Heidegger, Martin. 1951 (1927). "The Age of the World View." *Measure* 2:269–84.

Hooper-Greenhill, Eilean. 1992. *Museums and the Shaping of Knowledge.* London: Routledge.

Klein, Melanie. 1975. *The Psycho-Analysis of Children.* New York: Delacorte.

Meijers, Debora J. 1991. *Kunst als natuur: De Habsburgse schilderijengalerij in Wenen omstreeks 1780.* Amsterdam: SUA.

Mitchell, W. J. T. 1985. *Iconology: Image, Text, Ideology.* Chicago: University of Chicago Press.

Pavel, Thomas. 1983. "Origin and Articulation: Comments on the Papers by Peter Brooks and Lucienne Frappier-Mazur." *Style* 18:355–68.

Pearce, S. M. 1992. *Museums, Objects and Collections: A Cultural Study.* Leicester: Leicester University Press.

Schor, Naomi. 1985a. "Female Fetishism: The Case of George Sand." In *The Female Body in Western Culture: Contemporary Perspectives,* ed. S. Rubin Suleiman, 363–72. Cambridge, MA: Harvard University Press.

———. 1985b. "Salammbô Bound." In *Breaking the Chain: Women, Theory and French Realist Fiction,* 111–26. New York: Columbia University Press.

White, Hayden. 1973. *Metahistory: The Historical Imagination in Nineteenth-Century Europe.* Baltimore: Johns Hopkins University Press.

———. 1978. "Interpretation in History." In *Tropics of Discourse: Essays in Cultural Criticism,* 51–80. Baltimore: Johns Hopkins University Press.

Winnicott, Donald W. 1980. *Playing and Reality.* London: Tavistock.

Žižek, Slavoj. 1989. *The Sublime Object of Ideology.* London: Verso.

10. Reading Art?

Fear not. This woman cannot kill. She is only an image. Caravaggio's *Medusa's Head* (fig. 10.1) shows us the essence of the *femme fatale,* the monster who is able to kill men, visually, just by looking, and being looked at. This myth alone raises a first important point about images and their cultural place; about visual culture. Jacques Lacan understood the creepy, spooky quality of this being-looked-at-ness, and made it the starting point for his reconsideration of the gaze. But no, she won't kill. Not because she is "just" an image. Even within the game we play, the game of "reading fiction," of "willing suspension of disbelief," she won't kill. Like

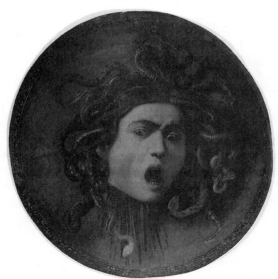

FIGURE 10.1 Michelangelo da Caravaggio, *Medusa's Head,* 1600–1. Galleria Uffizi, Florence.

most Medusas in the history of art, this head, allegedly able to petrify the spectator, is without power—why? Because she is without a look. She averts her eyes. Art historians have a lot of relevant things to say about this work, concerning the suspicion that this is a self-portrait—how interesting that a painter should depict himself as this blinded Medusa—the commission, the iconographic tradition, Caravaggio's other works, other Medusas, other disguised self-portraits. What is there, in addition to all those questions, to *read*?

In the following pages, I will make a case for a concept of *reading* images that is neither predicated upon a linguistic invasion of visuality, nor exactly identical to what art history has construed as its proper domain. This concept of reading is both broader and narrower than that. The method or, more modestly, procedure has in common with ordinary reading that the outcome is *meaning*, that it functions by way of discrete visible elements called *signs* to which meanings are attributed; that such attributions of meaning, or *interpretations*, are regulated by rules, named *codes*; and that the subject or agent of this attribution, the reader or viewer, is a decisive element in the process. Furthermore—and that is the focus of this chapter—each act of reading happens within a sociohistorical context or framework, called *frames*, which limit the possible meanings. Some aspects commonly discussed in art history remain outside this concept—all those visual aspects that do not contribute to the construction of meanings—whereas others exceed the confines of that discipline, like those predicated upon the notion of syntax, rhetoric, and narrative.

Appropriation

Caravaggio's *Medusa* can provide a first overview of the issues broached here. Medusa looks away, and she looks terrified herself. What could possibly frighten her, who cannot even see the frightening snakes on her own head? There is a story attached to this vision, a story we can read. But that's only a pre-text. According to that pre-text, Perseus has petrified Medusa by means of the mirroring effect of his own shield, and is thus able to behead her. And who would not be terrified at being beheaded? This story is dissolved, however, by the confrontation with the image, because the self-portrait presupposes a mirror, too, and makes the figure, the monster, change sex. Is Perseus merged into Medusa? Is the painter the model; the killer, the addressee? The starting point for a reading of this image could be: the insistent look is not mirrored. Yet the portrait remains an event of *facing*, strangely reassuring, because Medusa loses her otherness in the partial exchange with him who sees her. As Louis Marin pointed out in an interpretation of this painting, "The frontal portrait doubles and visually animates, figuratively, the correlation of subjectivity . . . the model is 'I' and 'you' and the spectator is 'you' and 'I.'"[1]

The mythical pre-text is not irrelevant, but it becomes an intertext brought in for questioning; the viewer is implicated in the gendered myth of assigning lethal power and monstrosity by some sort of identification stimulated by the transsexual movement between model and figure. This confusion allows a sensibilization to the fright, not provoked but undergone by Medusa. The look that looks away installs narrativity by turning the figure into the character of a narrative, not the ancient one about Perseus, but the visual one in which things happen between an image and a viewer. Medusa looks away in order to get you to look away with her, to escape the myth that binds her into an evasion from that frightening role. Medusa "speaks," visually, in an exhortative mode, enticing "you" to look, with her, for the true source of the fright, in the ideology that turns women into monsters.[2]

I was just reading away. Reading an image, on its own terms, taking its elements — signs like "words"?—at face value, the painting "at its word"—see what it has to say. Putting myself in the place of the "you" a text always addresses, but, then, a looking "you." Reading a story that happens in the act of looking; yet reading it. I would like to talk about reading, reading images, reading art. It is my contention that the use of the concept of "reading" has a potentially important political relevance along with a semiotic power of specification.

When I gave my book on "Rembrandt" the title *Reading "Rembrandt,"* I knew what I was doing. I thought, but erroneously as it turned out, that stating clearly in the introduction what I intended to do in the book would protect me from the charge of linguistic imperialism that the title suggests, admittedly, at first "sight."[3] Now, let me reread that phrase: at first sight? Does this way of phrasing the misunderstanding insinuate that visual people are superficial readers, and that those who misconstrued my argument about reading are not only inclined to privilege vision over reading, but to stick to a "first sight" interpretation of the former? In other words, is reading more profound than "sighting," which is superficial? Is seeing a form of sightseeing, of seeing sites, seeing aside; is it tourism, objectifying and appropriating, exploitative and consumerist; and on the side, lateral, misfiring, looking away? Of course, it is not all those things, not by definition, you all know that or you wouldn't be reading this essay, but sometimes it is, and many art historians today are worried about that. But nor is *reading* by definition profound. So the opposition suggested by the phrase "at first sight" is deceptive. Yet language and images pertain to two different media, and if a binary opposition between the two is in no way arguable, not by standards of logic at any rate, a difference in modes of expression and communication between the realm of the visual and that of the linguistic is too obvious to try to challenge it. So, what I will say does not entail a suppression of the differences between texts and images.

Linguistic imperialism has had its damaging effects even by the doing of the most keen and interesting critics, and I will cite an example in a moment. "Ap-

plying" linguistic or language-based theories to visual art can be as blinding as it
can also be revealing, as in fact any notion of "application" is already blinding, be-
cause it consists of putting blinkers on, deliberately. Yet I have, I think, good rea-
sons to maintain the notion of "reading" art, maintaining it as adequate, illumi-
nating, providing surplus heuristic value, and as a critical tool. This is a position
paper, meant to engage you in a discussion of how the business of "art," the rou-
tines, habits, traditions of talking about, and dealing with, art can be made more
complex and relevant through such a notion.

A first, and in fact central, issue is framing. Let me make an extreme case. At
the time she was still married to him, this innocent, sweet 1892 drawing by
Toulouse-Lautrec was sent to the husband of a friend of mine as a postcard by
one of his students (fig. 10.2). The text on the back was a not very clear message
to the effect that she liked his classes and wanted to get to know him better. Noth-
ing particularly troubling about that, although the step was unusual. But in con-
nection with this innocent-enough message, the almost arbitrary image on the
postcard seemed so incongruously out of place, that instead of the childlike in-
nocence the image had possessed for my friend so far, she—and her husband as
well—immediately saw the postcard as an invitation and the image as utterly sug-
gestive of sexual initiative. Much more so than, say, Manet's *Olympia,* of which it
is so often said that it is shockingly overt in its sexual overtones, so much so that
the professions of the represented women as prostitute and house servant, re-
spectively, are never questioned.[4] *Olympia* has become too much of a classic
for any serious person to take the painting, sexually, at face value. Toulouse-
Lautrec's sleepers of indeterminate sex[5] don't do any of the things Olympia is
charged with doing, yet in the situation there was no doubt as to what the image's
message was meant to be. In blatant disregard for the artist's intentions, the his-
torical context, the historical use the image might have been put to, my friend and
her husband *read* the image.

I quote this example because, at a time when I was not at all working on
images, in a domestic situation, I immediately saw her do something which I
knew was in some way wrong, in another way very right—as subsequent events
proved. The act of interpretation was reinserting the image within a larger whole
that included my friend, and even, potentially, affected her life. Here is a clear case
of appropriation of an image, insertion of it within another textual whole—the
pass the student was trying to make at my friend's husband—which semioticians
call *reframing.* It brings out possible meanings in an image that one did not think
of before it was reframed in this way. This act is the opposite of historical inter-
pretation. The new frame, of course, was much more complex and comprehen-
sive than just the connection between back and front of the postcard, between
text and image. It included many other frames, of which the association between
bed and sex, but, also, the clichés of cultural plots and the trespassing of assigned

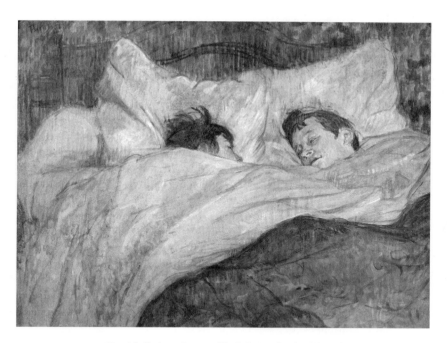

FIGURE 10.2　Henri de Toulouse-Lautrec, *The Bed,* 1892, drawing. Musée d'Orsay, Paris.
Photo: Erich Lessing/Art Resource, NY.

roles are only fragments. The new frame also obscured aspects of the image. For example, the situation in which a woman student approached a man by way of this image made the obviously lesbian overtones of the representation irrelevant, or better: invisible.

The *reading* event was also double: the student had first read the drawing, realized its potential, connected it to her own intention, and, to use a pun, put her stamp on it. This was an act of appropriation. It was that stamped image that my friend and her husband read in a second round. Correctly, as far as the intention of the student was concerned; obviously erroneously in any art historical sense. But the reading itself "made sense," so what we have, as an object of reflection, is an act of reading, however idiosyncratic. The case may seem extreme, but it is not essentially different from any other processing of images. Similarly, what we study as "art" consists primarily of such "stamped" images. With my book I wanted to draw attention to the innumerable acts of reading that constitute "art" in the ongoing history of its functioning. Obviously, then, this ongoing history cannot be identified with the discipline called "art history," although in a way it *is* an art history, just as well.

The example is, of course, so idiosyncratic that it doesn't bear in-depth

analysis; academically speaking it is futile. But not every act of reading is so contingent, hence, futile. The postcard was a bit like a reframing of Rembrandt's *Syndics* in an ad for underwear that I once found in a slide projector, and that changed my reading of the *Syndics*. In the ad, three women in underwear have been placed in the painting, so that the men appear to be reacting to the unexpected presence of women in their business world. I had never seen that painting in terms of voyeurism, in spite of the obvious staging of the gaze. In Rembrandt's work, the mobility of that man seems to insert another "discourse," a narrative of some sort of interruption that serves to emphasize that the men are actually alive and kicking. The mobility of the one man on the left who is half standing up does seem to imply a statement on vision more than on capitalist assessment of the fabrics they are allegedly gauging; but in the reframed image, a woman in underwear is simply inserted. Through this reframing the same figure becomes a businessman using his gauging skills to evaluate women's bodies, whose clothing it becomes his business to see, and see through. This piece of pop art is a representation of an act of reading, a "stamped" image that displays its stamp, just like the Toulouse-Lautrec postcard sent by the student. More than the name of the individual who did the stamping, it is relevant to realize who, which social constituency, is doing the reading.

Reading an image, I would like to emphasize, is nothing like reducing images to linguistic discourse. Instead of remaining locked within the binary opposition that has, I think profoundly wrongly, been construed around the two media, or modes, I would like to go over those aspects of *reading* that articulate aspects of seeing whose taking into account I consider not only relevant and meaningful, but also *visually* indispensable. On certain conditions.

Neither Speech nor Icon

One important issue, it seems to me, is the status of signs in communication, a process called semiosis, and the subjects involved in that process. Before going on to show how reading art can be an effective way of understanding an image and its cultural position in a critical manner, I would therefore like to clear two misunderstandings about the alleged connections between image and language: the analogy between speech and vision, which affects the status of the subjects and their acts, and the conflation of iconicity and visuality, which is a matter of the status and modes of operation of the sign.

To begin with the latter, the term "icon" is semiotic, derived from the writings of Charles Sanders Peirce, and tremendously useful to help semiotics free itself from the linguistic stronghold that almost made it useless in the French tradition. But using the term as a synonym of "visual" is throwing it away and, with it, the

possibility of "reading" (semiotically) the visual (as such). I may simply remind you of what Norman Bryson and I wrote in our state-of-the-art overview in *Art Bulletin*: "As Peirce clearly states, the iconic is a quality of the sign in relation to its object; it is best seen as a sign capable of evoking non-existent objects because it proposes to imagine an object similar to the sign itself" (1991). Peirce's definition runs as follows: "An *icon* is a sign which would possess the character which renders it significant, even though its object had no existence; such as a lead-pencil streak as representing a geometric line" (Peirce 1984, 9–10). Iconicity is in the first place a mode of reading, based on a hypothetical similarity between sign and object. This means that we assign to the sign a character which makes it significant.

Thus, when we see a portrait, we imagine a person looking like the image, and we don't doubt the existence, in the time of the painting's production, of such a person; we don't demand substantiation of that existence by other sources. Whether or not we know the name and status of Frédéric Chopin, we believe that Delacroix, in his portrait of Chopin, did depict an existing person who "looked like" this canvas, and whose name was Chopin. Hence, the sign—the portrait—*is*, is taken to be, Chopin. Similarly, we think we know the face of a self-portraitist, say, Rembrandt, even though other painters have presented a face of Rembrandt quite different from his self-portrait, just because we adopt the iconic way of reading when we look at Rembrandt self-portraits, to quote Svetlana Alpers's example.[6]

But the example of portraits might wrongly suggest that the icon is predicated upon the degree of "realism" of the image. An abstract element like a triangular composition can become an iconic sign whenever we take it as a ground for interpreting the image in relation to it, dividing the represented space into three interrelated areas. Leo Steinberg (whose *Sexuality of Christ* constitutes the clearest example of reframing within art history), for example, makes this division in his paper on *Las Meninas* (1981). Instead of visuality in general, or realism for that matter, the decision to suppose that the image refers to something on the basis of likeness is the iconic act, and a sense of specularity is its result. A romantic sound of violins accompanying a romantic love scene in a film is as iconic as the graphic representation of Apollinaire's poem about rain in the shape of rain.

Second, I want to raise the issue of communication between subjects, by taking my distance from the position made popular by the late Louis Marin. That position is most reputedly laid out in his famous articles on Italian and French painting, the often reprinted analysis of Poussin's *Arcadian Shepherds*.[7] The example of *Las Meninas* (Madrid, Museo del Prado) can clarify this point as well. Marin's model of analysis draws on speech-act theory, a theory best known to art historians through John Searle's response to Foucault's interpretation of *Las Meninas*. Foucault argued that the painting inscribed the invisibility of the viewer, whose place is taken by the royal couple reflected in the mirror. Searle contests this interpretation by arguing that the viewer *cannot* be there where logically he must be. I

won't go into the question of which logic Searle refers to, which is *not* really that of linear perspective although he refers to it, but instead consider his interpretation as a reading according to a specific theory. Speech-act theory is based on the notion that speaking is an *act,* which has an *effect,* which can succeed or fail. In *Reading "Rembrandt"* I have criticized this model as follows.

Foucault interpreted the painting as self-reflexive, and claimed that in that capacity it stages the absence of the viewer. Searle contradicts Foucault's view by arguing that the work is paradoxical, taking the visual existence of the painting as proof that the representation *on* it cannot be impossible. Here is a sample of his strikingly positive discourse: "We know that the paradoxes *must* have a *simple* solution because we know that the scene depicted is a visually possible scene" (Searle 1980, 256; my emphasis). But thus he missed the point of Foucault's reading.[8] Foucault has been faulted for not doing his homework on perspective, but the point he made was an act of reading: interpreting the painting as a proposition, as a visual work that *has something to say.* Searle's submission to the work is indicated by his taking the painting, as it were, at its word: visual evidence is privileged positivistically. Taking the picture tautologically as proof of itself, rather than taking the work as questioning itself, he takes it to affirm itself, thus averting all possible questions it might challenge viewers to raise. Thus he silences the work, strikes it dumb; vision is, again, taken as blind surrender to a "first sight," as the stupidest thing one can do.

This "realism" in turn makes the solution to the paradoxes *simple*—unified, that is. The desirability and the possibility of the solution are implicit in the syntax of Searle's sentence, rather than explicitly stated. But paradoxically, Searle submits to "what his eyes see," only to turn his back immediately on visuality. Although the self-evidential effect of the painting is attributed to its visuality, the solution to the paradox proposed by Searle is, not surprisingly, linguistic.

Drawing upon speech-act theory, Searle proposes the following simple solution:

> Just as every picture contains an implicit "I see," so according to Kant every mental representation contains an implicit "I think," and according to speech-act theory every speech act can be accompanied by an explicit performative, for example, "I say." But just as in thought the "I" of the "I think" need not be that of the self (in fantasy, for example), and in speech acts the "I" of the "I say" need not be that of the speaker or writer (in ghostwriting, for example) so in the *Meninas* the "I" of the "I see" is not that of the painter but of the royal couple. (487)

Rather than cite the obvious and relevant—but problematic—cases of "third-person" versus "first-person" narrative, Searle uses the unlikely, irrelevant, and

hardly illuminating case of ghostwriting to argue that the "I" can be different from the declared speaker.[9] In ghostwriting the *speech act* performs the identification of one speaker, the subject of the utterance, with someone s/he is not but chooses to be for the time of the utterance. The word "ghost" in that expression suggests the uncanniness of the doubling of the subject and proposes to see the subject of writing as an image, albeit an image of the invisible—which is what ghosts are. The reason why different narrative structures are more problematic as well as more relevant is precisely because in those structures sheer subject-identity is not assumed but challenged.

Here is the problem with this theory. The mode of reading images based on speech-act theory rests on the assumed analogy between seeing and speaking. In its simple form, this analogy is untenable for two reasons: it conflates different modes of perception without examining the implications of that conflation—thinking and seeing; speaking is hardly an act of perception—and it conflates different subject positions in relation to acts—visually representing, not seeing, would be the act parallel to speaking.

To be sure, the insight that vision is as much subject to the social construction of the visual fields and the modes of semiosis we are trained to adopt as speech is subject to the social construction of discourse has been an important impulse for a critical approach to visual art. But assuming an unargued analogy between "I see," "I think," and "I say" is not the same thing as criticizing and undermining an unwarranted opposition between two media; rather, it obscures the issues involved in such a critique. That analogy also allows another conflation, that between acts of production and acts of reception, to pass unnoticed.

The latter conflation reduces the unstable "I"-"you" interaction of the personal language situation to one stable and unified. There is a world of difference between interaction, which leaves the subjects distinct but distributes their respective power, and conflation, which blurs and entangles the identities of the individuals concerned. Strictly speaking, the act analogous to speaking would be painting, not seeing the result, and the act analogous to representing something visually "out there" would be "third-person narration." Thus, Marin's model as practiced by Searle also represses the verbal aspects of his response by repressing his own position as a viewer. This theory, then, offers escape from the troubling involvement in the Caravaggio *Medusa* I have suggested earlier. Thus, it takes the critical sting out of the idea of reading; it appropriates the idea of reading in favor of an avoidance of a reading that could entail trouble.

The conflation of addresser and addressee, of representing visually with viewing, demonstrates again paradoxically the absorption of the critic into the work. In Searle's response to *Las Meninas,* for example, denying his own position, he increases his own importance. He conflates what *Las Meninas* distinguishes so

exemplarily: the master and the servant, whose interdependence can only be assessed so long as a minimum of autonomy is preserved for each. In the case of this painting, it is easy to see what readerly aspect gets erased.

Svetlana Alpers convincingly argues that Velázquez does not reject the humble work of craft. The attention to that aspect requires a reading that avoids the conflations Searle got entangled in. The portrait, the self-portrait, is explicitly crafted, not simply assigned by the social hierarchy; it is made by the self, out of brushstrokes. However, such signs are necessarily ambivalent. They rest on a sense of humble, honest work whose humility they aim, at the same time, to subvert. It is a mistake to believe that craft and art are in opposition. Art subsumes craft as its necessary but insufficient condition. It is in this respect, as a *presupposition,* a discourse whose relevance makes the work possible, that both class and gender are inscribed by Velázquez. For Velázquez an ambivalence toward work as craft and service is not surprising, for *Las Meninas*'s focus on social roles makes it less than likely that the painter will manage to repress his own position as a servant entirely. The very effort to define royalty through those who make it is a symptom of this awareness. The bodily contiguity between painter and attendant symptomatically signifies the return of the repressed. This reading is based on *interdiscursivity*: it takes the painting as an intervention in, and response to, social discourses that were relevant at his time, and are still, or again, or differently, relevant in our time.

Reading is an act of reception, of assigning meaning. The viewer reframes the work—which is, in this specific sense, a "text"—not simply as it suits him or her, according to contingent circumstances, as in the case of my friend's husband's student. She reads according to a "vocabulary," a selection of elements taken to be signs, and connected in a structure that is a syntax in the semiotic sense: a connection between signs that yields a coherent meaning which is more than the sum of the meanings of the individual elements. Vocabulary and syntax can be learned, taught. They guarantee the right to reading, each person's access to culture. But, according to the "I"-"you" interaction, each viewer can bring her own frame of reference.

The Need to Read

The point I am trying to make is not that "reading" is inherently richer, more pertinent, or more subtle than any other mode of looking. I am contending that every act of looking *is*—not only, not exclusively, but always also—a reading, simply because without the processing of signs into syntactic chains that resonate against the backdrop of a frame of reference an image cannot yield meaning. But en-

dorsement of this basic semiotic principle, that is, awareness of the act of reading and the place of these factors in that act, helps to come to terms with the difficulty of being confronted, as a woman, with the particular imagery that surrounds us and seems to impose its view—of us, on us. And, similarly, with the pressure that a simplistic view of "history" puts on us to accept that "that's the way things are" in our culture.

Instead of arguing, then, for an analogy between painting and language, I would like to discuss some of the tools that semiotics has developed, with or without help from linguistics; to examine how the idea of *reading* helps address questions of meaning and the power over meanings, without reducing the image to what it is not. Framing, and analyzing the relevant frames, is one such tool. Anybody confronted with Rembrandt's *Blinding of Samson* (fig. 10.3) is shocked out of his wits, but, nevertheless, it will be framed: seen as biblical image, the painting will emphasize the wickedness of the woman who, they say, enjoys her cruel victory, viciously obtained through lying, and for money. The cruel victory can be seen on her face, they say.

Refusing that framing forces the viewer to revert to the image and look again.

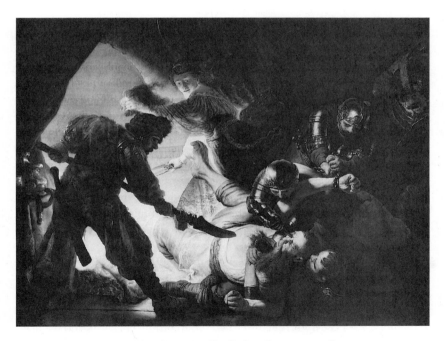

FIGURE 10.3 Rembrandt van Rijn, *The Blinding of Samson*, 1636, oil on canvas.
Städelsches Kunstinstitut, Frankfurt am Main.

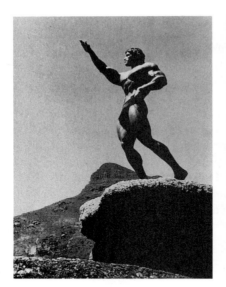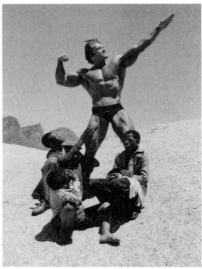

FIGURES 10.4 & 10.5 George Butler, *Arnold Schwarzenegger*, photographs.
© George Butler (Contact Press Images).

Doing that, I happen to be unable to see such cruelty on the face; I rather see shock, the same shock as my own. But the framing of the work by the doxic memory of an unread biblical story does the job for whoever is, by such a frame, *predisposed* to see it. One can also frame it totally differently, as a representation of pure pain. Unlike the doxic-biblical one, which is, in this case, misogynistic, such a frame is, say, humanistic, and, as a result, the misogyny recedes a bit. Or one frames it as a statement on blindness, an obsession for visual artists, and emphatically so in Rembrandt.[10] Vision is at stake, then, and the work's horror becomes self-reflexive. One can easily see how the intersection of these frames can help us in dealing with a work such as this without staying confined in the tautological exclamation "the horror! the horror!" that was so confusing in one of English's literary masterpieces, Conrad's *Heart of Darkness*.[11]

Framing is a constant semiotic activity, without which no cultural life can function. Trying to eliminate the activity of framing is futile, but it does make sense to hold readers accountable for their choices of frame. Framing an image of bodybuilding on the cover of a magazine devoted to that sport, for example, is unambiguous: the male body is exposed as a proud product of sport, and the magazine format of its presentation frames the image as "popular culture." To counter

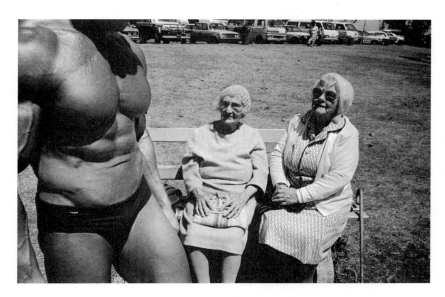

FIGURE 10.6 George Butler, *Arnold Schwarzenegger,* photograph. © George Butler (Contact Press Images).

this, to elevate his sport to an art, Arnold Schwarzenegger had black-and-white photos made of his body, and exhibited these in an art gallery. You can easily see how the image now interacts with a discourse of high art. Such framing can go on within the representation itself; in one photograph (fig. 10.4), the figure of the bodybuilder has adopted a pose that is not only readable within the idiom of high art, but of a particular class of high art: mythological history painting. The Olympic pose turns the athlete into a god, a god who, we read on, owns the land that surrounds him, to his glory. No other people populate that land.

Well, that's not quite true (fig. 10.5). Standing where he stands, with the Table Mountain as a background, the figure re-enacts the conquest of South Africa as if it were empty space instead of populated. Suddenly, the image becomes ironic; the dominating position of the athletic hero over the admiring black boys, highly embarrassing. An embarrassment, I am happy to say, that the hero is paid back for in another image where, beheaded, he becomes objectified by a slightly amused female look cast on him by two elderly ladies sitting on a bench when he jogs by (fig. 10.6).[12]

Analyzing the way images are, and have been, framed helps to give them a history that is not terminated at a single point in time, but continues; a history that is linked by invisible threads to other images, the institutions that made their pro-

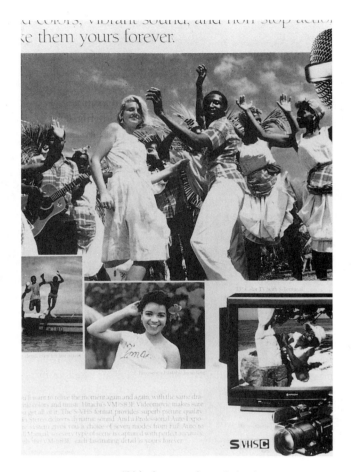

FIGURE 10.7 "Make them yours forever," advertisement.

duction possible, and the historical position of the viewers they address. The advertisement (fig. 10.7) for a sound system makes a good case. And since this is "popular culture," not "high art," one isn't interested in intention; moreover, since it is an advertisement, effect is more relevant.

The festive atmosphere speaks to the consumers' desire to enjoy themselves, and some of these viewers will be more sensitive to the suggestion of free time, others to sunshine, yet others to travel, things that, the image suggests, one can actually buy.

Although one could spend hours on the subtleties and complexities of this ad,

I would like to draw your attention to the representation of framing itself. The three smaller images on the lower half all represent some form of "exotic life": the very life whose attractiveness is supposed to appeal to the viewer. But this "life" is represented *as* framed, imprisoned, captured, and exported; these forms of life are snapshots. But thus they emphasize the other framing that goes on: the joys of simple fishermen, the beauty of an exotic girl, the honest craft of a society unspoiled by industrialization: all aspects of the confining, condescending clichés through which our culture constructs its "others." They are framed as well as fixed.

The main image, the upper one, takes up the central place and, within it, the white woman, who is as central as the reflected royal couple in *Las Meninas*. Welcomed in her white dress to sing and dance with black people whose garb is also as white as possible within the confines of the stereotypical colorfulness betokened by red elements, the white woman clearly serves as the focus of the image, the point of entry, the Medusa head that draws us in and confounds us. Her place in the image is a matter of *syntax,* another useful tool that semiotics has to offer. Of course, art historians call that composition. The difference, however, is important.

Syntax refers to the structural relationship between elements, and so does "composition"; but the elements connected by syntax are considered *signs,* and processed as such. Seen as a composition, the image shows pleasure in interracial intercourse; but semiotically speaking, as readable "text," it is problematic in its syntax, which makes composition significant. The central position of the white woman is, then, a sign of her central position in the world. The fact that she is cheered by the black men recalls Roland Barthes's analysis of the black soldier saluting the French flag as a sign of his submission to colonialism (1967). With the image thus framed, the verbal slogan that accompanies the image is so disturbing, it becomes highly ironic: "Make them yours forever." It refers interdiscursively to the two discourses of appropriation: colonialism and marriage. As it turns out, these discourses are the actual ground on which the image's effect is fixed.

Guess what, or who, the "them" becomes through such interdiscursive feeding. Through it, the white woman becomes an ambiguous sign where these two discourses cross: subject of the colonial appropriation, she is also, syntactically, part of the image to be appropriated—by the viewer, enticed to buy this particular audio equipment, and, in fantasy, power over whatever it is that attracts him most in the image.

For the ad caters to a variety of tastes. And the syntactic principle alerts us to the presence of tiny visual elements that might be taken as random visual "noise," quite normal in photography, but that, in an exercise of reading, become meaningful. What to think, for example, of the small element visible between the legs

of the second dancer on the right? The tiny sign I want to point out is syntacti-
cally positioned like an embedded subordinate clause within a sentence. In the
distance, far from the represented carefree world of pleasure, we see the bent-over
body of a gardener in tight blue jeans. Seen from behind, this black man is plant-
ing; the history of plantations creeps up. I will refrain from speculations about
what fantasies this tiny figure can arouse: slavery, a man taken from behind sug-
gesting a passive homosexual position emphasized by the tight jeans he is wear-
ing, but I choose to read in it the inevitable presence of, and submission to, work
in a world which offers pleasure for sale.

 This reading was based on the visual elements of the ad, and in it I made use
of semiotic tools for reading: frames and interdiscursivity; syntax and signs. The
point is: no element can be dismissed as meaningless. The result, or product, of
my reading is something like a statement: a propositional content I attributed to
the ad, activating it, putting *it* to work. By making, perhaps making up, a propo-
sitional content for an image, I am opening up the possibility that images can pro-
duce meanings normally denied to the visual. They can signify contradictions;
they can respond negatively. Negation is one of the elements of language that
seem hard to visualize. Burke said that images could not negate; nor, said Freud,
can dreams. Freud offered the proposition that the presence of contradictory ele-
ments together make up a denial. I think that is not even necessary; denial can be
represented visually.

 A drawing of Judith does precisely that (fig. 10.8). Negation becomes part of
the message as soon as pre-text and interdiscourses are taken into account, and,
as I argued above, framing inevitably does that, so that these interdiscourses are
inherently part of the processable image. The drawing allegedly represents Ju-
dith. As soon as we hear the name or see the scene, we are already, willy-nilly, in-
volved in the frame of biblical heroism, cultural misogyny, the conflict of loyalties
where this woman is heroic for killing the enemy and lewd for trapping a man
through sex.

 But one can hardly deny that another relevant frame is narrative; not a partic-
ular narrative, but the abstract, structural idea of narrative. This is an image which
we process by imagining a story. Things happen. One of the things that happens
is that a woman is cutting a man's throat. One might speculate about the *care* her
facial expression seems to convey. But I want to draw attention to the small signs
the syntactic structure includes in the image: the two soldiers outside.

 As narrative elements, the soldiers function on different levels. In the fabula,
they fail their duty to stand guard. In the story, they represent focalization, the
narrative equivalent of perspectival centering. The event happening in the fore-
ground is not being *seen*. In the text, they serve as rhetorical figures, again in
different ways. Synecdochically, that is, as part representing the whole, they sig-

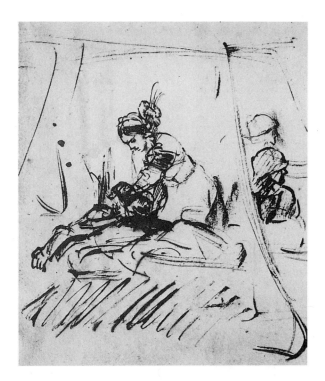

FIGURE 10.8 Rembrandt van Rijn, "Judith Beheading Holofernes," ca. 1652. Meso di Capodimonte, Naples.

nal the military frame in which the event happens, and from which it derives its meaning. Thus, the figures of the soldiers drive home the important point that Judith is being heroic, not lurid. Metonymically, that is, as signs of what comes next, they signify that she is in danger of being caught in the act. As metaphor, the soldiers represent distraction, a statement on vision and its difficulty; a narrative form of blindness. All these readings of the soldiers converge, perhaps. But they also demonstrate the readerly quality of images.

Reading Through, Skin-Deep

Let me give one last example of the point of *reading* images; one that undermines the notion that images depend on their maker's intention. This here (fig. 10.9) is a crayon drawing by Dutch contemporary artist Treska van Aarde. It represents a young girl. Needless to point out the elements in the image that show that the

FIGURE 10.9 Treska van Aarde, *Schreeuw* (Scream).
In private collection of the artist.

girl is in a state of horror. The mouth seems to scream, the hair is raised, a hand holds her slim throat. Less conspicuous elements are the transparent representation of her face and body. So far, there is no particular need to "read" the image. But why not give it a try?

If we assume syntax, the elements must be taken to have meanings that are related. The thin throat overlaps with the thin handle of what could be a mirror, the triangle covering her breast being its base. The screaming mouth puns, then, with the mirror itself. Color, the insistent brightness of the ground and the colorlessness of the figure, must then also be signs. Signs, not "pure" visual elements but units that produce meaning. When we begin to interpret the meaning of these signs, we are crossing the border that separates art history from semiotics.

The consequence of that border-crossing is that iconography yields to intertextual reading.[13] Various intertexts can be invoked as products of the discourses to which this image responds. Within the discourse of representations of chil-

dren, for example, there are Ingres's chubby cupids, attractive, with appealingly
soft skins, happily celebrating female beauty when they accompany Venus rising
from the sea. Such beauty is often called "female sexuality"; it is obviously thus
misnamed, for such images are primarily invoking male sexuality—the sexuality
to which they appeal. The cupids, here, are children as seen by adults. Over
against such children, Van Aarde posits her girl. The girl Van Aarde represents is
shown as seen, experienced, by herself. She it is who holds up the mirror the cu-
pids hold up for Venus. Venus's discourse is thus evoked and responded to; the
discourse where female narcissism thinly veils male desire is equally questioned.
What this girl sees in her mirror is not available beauty, as, for example, in
Velázquez's Venus, but horror; a horror that she cannot even see.

This is where we cannot miss the notion of reading. So far, one may want to
call the procedure iconography. The black hole before the girl's mouth refers to
the mirror that is Venus's traditional attribute, the sign of woman's vanity. But
then it becomes necessary to read interdiscursively. For "Venus before the mir-
ror" is not just a tradition of images. That tradition derives its meaning from a dis-
course that backs it up. And the "discourse" in which this traditional mirror func-
tions—gets its meaning—is the one of male sexuality. Women's vanity is a desired
feature of women, it takes good care of their beauty, and it shows that they care,
which suggests they make that beauty available.

But Van Aarde's girl doesn't see her face. The mirror loses its realistic illu-
sionary reference and only keeps its ideological one. The interdiscourse is com-
plex; two different intertexts play. Van Aarde's mirror speaks, not just to the pre-
sumably pleasurable gaze of a beautiful woman contemplating her trade, but also
a woman who suffered lethal damage from it. The mirror responds to Rem-
brandt's Lucretia's false mirror. In *The Suicide of Lucretia* in the National Gallery
in Washington (fig. 10.10), the woman who is about to kill herself after, and be-
cause, she was raped holds the dagger as if it were a mirror. Thus, that image rep-
resents a perverted Venus tradition by showing the mirror not as an instrument
of self-reflection but as one of self-immolation; the mirror not as supporting
beauty but as an alien and hostile construction.

Van Aarde's mirror is more than iconography; it is not a stylistic bow to pre-
decessors, but a meaning-producing engagement with the discourse that sustains
that tradition. It is reframed as that which surrenders the girl: "beauty" puts her
at risk. At the same time, the mirror covers her mouth, preventing her screams
from going out, from being heard. The mirror/sign of "beauty" *is* her mouth. In-
deed, if one combines these meanings, the only possible interpretation imposes
itself: this work represents a girl whose substance as a subject has been de-
stroyed—the transparency—by a horrible violence done to her, in the name of
her "beauty," and the locus of that violence was her mouth. Van Aarde made this

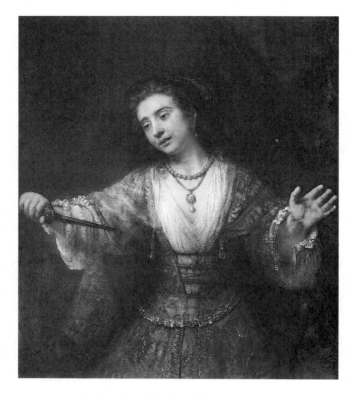

FIGURE 10.10 Rembrandt van Rijn, *The Suicide of Lucretia,* 1664, oil on canvas.
National Gallery of Art, Washington, D.C.

image without thinking what she was doing; she didn't know what it meant. Indeed, as a reader of her own, intuitively produced image, the artist *discovered* something about her own history that she didn't know. She read in the image her hands had made that, in a long-buried past, she had been repeatedly orally raped by her father. That didn't leave her much room to gaze fondly at her beauty.

The work was made as part of a creative therapy; the woman suffered from serious incapacitation and had sought help without knowing what troubled her. She was put to work with paper, paint, crayon. When she saw what she had made, she was seized by the message: she read her own work as something outside her, as, precisely, such a mirror that turns her into a "third person." Its readability made it possible for her to re-emerge from the timeless mud of trauma. She thus read her own soul. The work was her memory; her forgetting had caused her incapacitation.

Reading History

To put it strongly, if provocatively: "reading" art is a subjective act, but it is not idiosyncratic. Instead, the image becomes a meeting ground where cultural processes can, precisely, become *inter*subjective. It is an act that requires the present tense to interact with the past tense. It is an act that declares the image and even its tiniest elements to be saturated with meaning, its semantic density constituting its social, cultural relevance. But, and this is perhaps the most important aspect of such a view, precisely because of this density, the image loses its apparent coherence. Small elements turned into signs can subvert the overt, overall meaning so as to inscribe something that didn't seem to be there, yet appropriates the image for a counter-message, a counter-coherence.[14] As we have learned from early semioticians, difference reigns amongst signs, constitutes them. If art history considers an element as not-fitting it tends to construct it as alien, a later addition, for example. Reading capitalizes on such elements, in contrast.

Where does that leave art history, or, in other words, how can art history relate to such a view? By the contingencies of history, the study of art got the name "art history," unlike, for example, literary studies. As a consequence, the historical perspective is one out of several elements in the latter, the overwhelming one in the former. Although I am more at ease with a discipline where history is not an *a priori* but a framework that puts it up for constant evaluation and readjustment than with one where its place is dogmatically ascertained, I am myself keen enough on the historical accountability of what we do to be able to accept that "history" is the rule of the game. But what "history" means is another question.

My partiality to reading is an attempt to integrate the questions of the social history of art, lucidly phrased by Griselda Pollock as "what made this possible," with an inquiry into what that deictic little word "this" means.[15] Deictic elements refer to the situation of utterance; "this" means nothing outside a context, a situation, in which a finger can be pointed. That situation is historically situated, inexorably, in the present. The present is historical, too. "This," then, is not just the painting someone in the present points to, but the relationship between historically situated viewers and this object that came to us from the past but is now here. It inevitably imposes the present tense on the verb: what *makes* this possible.

The concept of history has been thickened by philosophers and writers who questioned its simplicity. Walter Benjamin argued that history is inevitably altered by our memorization of it. Many of you know the famous story by Jorge Luis Borges "Pierre Menard, Author of the Quichote." The story is a paradigmatic example of a postmodern literature that questions the foundations of its own art.

Pierre Menard is a deceased poet who had verbally transcribed portions of

Cervantes's *Don Quichote*. The narrator states that, although verbally identical to Cervantes's text, the transcription by Menard is "almost infinitely richer." He then goes on to demonstrate how that is possible by comparing a half-sentence. I will quote a rather long stretch of Borges's text:

> [Cervantes] wrote (part one, chapter nine):
>
> > . . . truth, whose mother is history, rival of time, depository of deeds, witness of the past, exemplar and adviser to the present, and the future's counsellor.
>
> Written in the seventeenth century, written by the "lay genius" Cervantes, this enumeration is a mere rhetorical praise of history. Menard, on the other [hand], writes:
>
> > . . . truth, whose mother is history, rival of time, depository of deeds, witness of the past, exemplar and adviser to the present, and the future's counsellor.
>
> History, the *mother* of truth: the idea is astounding. Menard, a contemporary of William James, does not define history as an inquiry into reality but as its origin. Historical truth, for him, is not what has happened; it is what we judge to have happened. The final phrases—*exemplar and adviser to the present, and the future's counsellor*—are brazenly pragmatic.
>
> The contrast in style is also vivid. The archaic style of Menard—quite foreign, after all—suffers from a certain affectation. Not so that of his forerunner, who handles with ease the current Spanish of his time. (Borges 1962, 69)

Borges's Menard has, the narrator says toward the end, "enriched, by a new technique, the halting and rudimentary art of reading: this new technique is that of the deliberate anachronism and the erroneous attribution" (71).

Of course, what this fictional story proposes is not that we all start to copy historical works in order to update them. But there is an interesting point to make about the reversal Borges's narrator operates, without really saying so, between writing and reading. Writing, and by extension, painting, is an act of reading, and reading is a manner of rewriting or repainting. And such acts, Benjamin knew, don't occur in "empty" time but in a time filled by the present. In the present, social agents, subjects with more or less easy access to the codes that direct the cultural integration of images, confront images and see mirrors held up to them. How to read, that is, how to give meaning to messages one vaguely senses but fails to analyze when only dogmatically restricted methods are consecrated as "historical" or "visual" enough: that seems to me a valuable contribution of semiotics

to the understanding of art; art, not as a fixed collection of enshrined objects, but as an ongoing, live process. For some, even lifesaving; for others, just enlivening; for us all, part of life.

Notes

Originally published in *Generations and Geographies in the Visual Arts: Feminist Readings,* edited by Griselda Pollock (London: Routledge, 1996), 24–41.

1. "Le portrait de face dédouble et anime visuellement, figurativement, la corrélation de subjectivité. . . . Le modèle est 'je' et 'tu' et son spectateur 'tu' et 'je'" (Marin 1988b, 86).

2. I have further developed this reading of Medusa in *Double Exposures* (1996).

3. The best reader of that book was Griselda Pollock (1993).

4. An exception is Pollock (1992). See also "His Master's Eye" in Bal (1996).

5. Of course, their sex is not "really" indeterminate; the figures are both women, and as far as the image evokes a sexual reading, the sexuality represented is lesbian.

6. This example is mentioned by Svetlana Alpers (1988). For a study of Rembrandt's self-portraits, see H. Perry Chapman (1990). A semiotic perspective on his self-portraits, related to psychoanalysis, is proposed by Bal (1991).

7. See Marin's two best-known articles on this problem (1983, 1988b).

8. Foucault (1973). On Foucault's views of visuality, see Rajchman (1988) and Jay (1993).

9. Rather than ask the obvious question why seeing, thinking, and speaking should be identical in structure, I want to address the symptomatic choice of examples. Searle's example of the "I think" structure in fantasy is problematic; his "I say" example is highly surprising.

10. On blindness as a self-reflexive theme in Rembrandt, see Bal (1991, 286–360).

11. Not coincidentally, this tautological confinement tends to reinforce stereotyping and "othering." Here, the blind and blinding horror automatically blames the woman figure; in *Heart of Darkness,* the horror is textually ambiguous but in the reception, easily translated as horror of black Africa.

12. On bodybuilding in relation to cultural constructions of masculinity, see chap. 5 of Van Alphen (1992).

13. On the overlap and the distinction between these two methods, see Bal (1991, 177–215).

14. On the importance of constructing counter-coherences, see my study of the biblical book of Judges (1988).

15. Pollock, oral communication.

References

Alpers, Svetlana. 1988. *Rembrandt's Enterprise: The Studio and the Market.* Chicago: University of Chicago Press.

Alphen, Ernst van. 1992. *Francis Bacon and the Loss of Self.* London: Reaktion Books.

Bal, Mieke. 1988. *Death and Dissymmetry: The Politics of Coherence in the Book of Judges.* Chicago: University of Chicago Press.

———. 1991. *Reading "Rembrandt": Beyond the Word-Image Opposition.* Cambridge: Cambridge University Press.

———. 1996. *Double Exposures: The Subject of Cultural Analysis.* New York: Routledge.

Bal, Mieke, and Norman Bryson. 1991. "Semiotics and Art History." *Art Bulletin* 73 (2): 174–208.

Barthes, Roland. 1967. *Elements of Semiology.* Translated by Annette Lavers and Colin Smith. New York: Hill and Wang.

Borges, Jorge Luis. 1962. "Pierre Menard, Author of the Quichote." In *Labyrinths,* 62–71. Harmondsworth: Penguin Books.

Butler, George. 1990. *Arnold Schwarzenegger: A Portrait.* New York: Simon & Schuster.

Chapman, H. Perry. 1990. *Rembrandt's Self-Portraits.* Princeton, NJ: Princeton University Press.

Foucault, Michel. 1973. "*Las Meninas.*" In *The Order of Things: An Archaeology of the Human Sciences.* Translated by Alan Sheridan, 3–16. New York: Vintage Books.

Jay, Martin. 1993. *Downcast Eyes: The Denigration of Vision in Twentieth-Century French Thought.* Cambridge, MA: Harvard University Press.

Marin, Louis. 1983. "The Iconic Text and the Theory of Enunciation: Luca Signorelli at Loreto (circa 1479–1484)." *New Literary History* 14 (3): 253–96.

———. 1988a. "Contrepoints." In *L'effet trompe-l'oeil dans l'art et la psychanalyse,* edited by R. Court et al., 75–104. Paris: Dunod.

———. 1988b. "Towards a Theory of Reading in the Visual Arts: Poussin's *The Arcadian Shepherds.*" In *Calligram,* edited by Norman Bryson, 63–90. Cambridge: Cambridge University Press.

Peirce, Charles S. 1984. "Logic as Semiotic: The Theory of Signs." In *Semiotics: An Introductory Anthology,* edited by Robert E. Innis, 4–23. Bloomington: Indiana University Press.

Pollock, Griselda. 1992. *Avant-Garde Gambits, 1888–1893: Gender and the Colour of Art History.* London: Thames & Hudson.

———. 1993. Review of Bal (1991). *Art Bulletin* 75 (3): 529–35.

Rajchman, John. 1988. "Foucault's Art of Seeing." *October* (Spring): 89–117.

Searle, John. 1980. "*Las Meninas* and the Paradoxes of Pictorial Representation." *Critical Inquiry* 6:477–88.

Steinberg, Leo. 1981. "Velázquez' *Las Meninas.*" *October* 19:45–54.

———. 1983. *The Sexuality of Christ in Renaissance Art and Modern Oblivion.* New York: Pantheon Books.

11. Reading Bathsheba: From Mastercodes to Misfits

Introduction

According to commonly held views, if not to common sense, Rembrandt's painting of *Bathsheba* in the Louvre may be described by three different genre labels or categories: as a *realistic* painting, a *nude,* and a *history* painting (fig. 11.1). All three categories appear readily applicable and unproblematic. I do not wish to challenge them. Instead of taking the peaceful coexistence of these labels for granted, however, I employ them in this essay as three hermeneutic keys that can help viewers connect the painting to meanings that are contemporary to the perspective of a late-twentieth-century viewer. Such a use of categories as tools for meaning-making involves viewing in a hermeneutic practice that I call "reading" in order to distinguish it from other aspects of viewing, such as aesthetic assessment, technical examination, and erotic response.

In this respect, genre labels are directions for use, promoting distinct, although interacting, modes of reading. They function as *mastercodes,* or categories that direct the viewer to approach a work, or a detail, with a set of predetermined (and usually unexamined) assumptions, values, methodological approaches, and, in some cases, associations, which together establish the ground (called code) for the attribution of meaning. Each of these three mastercodes—realism, the nude, and narrative (of which history painting is an expression)—generates a different, and conflicting, interpretation of an image. At stake is the work's complex readability, the difficulty of making sense of it entirely with the help of just a single mastercode.

This essay explores the possibilities of "reading" visual art through activating three modes of meaning production: genre labels, signs, and the interaction between painting and the visual and textual traditions to which the image relates— the iconographic precedent. Each mode of meaning production may operate

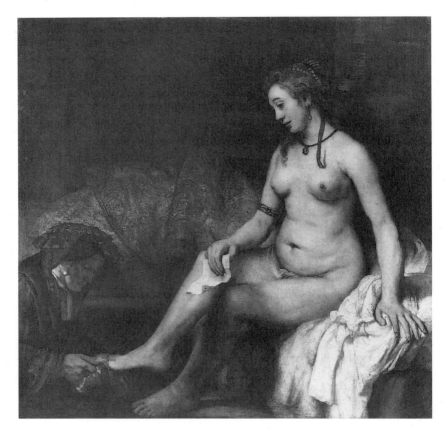

FIGURE 11.1 Rembrandt van Rijn, *Bethsabée au bain,* Musée du Louvre, Paris.

within each of the mastercodes by which we may read a work. At the center of this discussion is the notion of *distortion*. Distortion occurs when common modes of reading enter into tension, or even conflict, with one another, so as to turn a particular detail into a sign of incoherence. My examination will center around three details: the letter Bathsheba holds, the red spot on the corner of that letter, and Bathsheba's introspective gaze. In each of these three details, the three mastercodes meet, struggle, and interact, generating three different interpretations of the work, each of which is in itself incomplete and inconclusive. Those details are *signs,* triggering events of meaning-making.[1] I will argue that the details pose, suppose, or even submit a conflict of interpretations that draws the reader in by necessitating activity of the interpreter.

Genres as Mastercodes

Of these three genre labels or mastercodes, realism predominates, both in Rembrandt's painting and in art historical and literary traditions in general, and is therefore foregrounded in this essay. The other two, the nude and history painting, can be considered derivative codes, feeding off realism but also put under pressure by it, as well as, in turn, complicating realism. The realism of *Bathsheba* is obvious, evidenced, for example, by attempts to interpret the painting in terms of Rembrandt's life. Some viewers, who believe an artist's life illuminates his art, may see in it a portrait of his common-law wife, Hendrickje Stoffels. This kind of specific identification requires knowledge, not of the pictorial tradition but of biographical data, and is acquired only through acquaintance with constructions of the historical "Rembrandt": we know Hendrickje's face only through the representations that have been assumed to represent her on works labeled as by "Rembrandt."[2] Reading the painting as a portrait of Hendrickje is a realistic reading, even if the information upon which it is based has been questioned. This biographical mode of reading is, however, only the most obvious employment of realism as a mastercode. Other realistic readings attribute sadness to the figure, a melancholy attributed to her introspective gaze, which is subsequently interpreted with reference either to events in Hendrickje's and Rembrandt's life or to the biblical story the painting evokes. Each of these traits is a category from "real life," and the search for a cause is an act of psychological realism, turning the figure into a person.

This category of realism has, in turn, an impact on the other two categories: the nude and history painting. As a nude, for example, the realistic identification alters an anonymous or generic "woman" into "a specific woman," perhaps Hendrickje. The genre of the nude, which feeds upon generic abstraction, is thus put under pressure. It makes the voyeuristic gaze less comfortable.

Viewed simply as a nude, *Bathsheba* could qualify as moderately voyeuristic. It exhibits the woman's body without representing the voyeuristic gaze itself either for identification or for ridicule. The viewer is left alone. Moreover, Bathsheba seems to be unaware of the viewer, which tends to make her an objectified site for (possibly) erotic contemplation. The painting does not thematize or narrate any contact between the naked woman and the viewer, neither making an appeal for help nor acquiescing to being viewed. The voyeuristic reading is further supported by the story to which the image refers—its pre-text. The biblical narrative mentions the woman's nakedness, the enticing effect it has on the voyeur, and the subsequent rape. Here, the genre of the *nude* intersects with the genre of *history painting*, based on *narrative*.

The code of history painting, and the visual tradition in which the work stands and to which it refers, adds to the tension. As elaborated in Eric Jan Sluijter's essay,[3] the painting depicts, or refers to, a theme popular in history paintings in the sixteenth and seventeenth centuries. It is one of a number of subjects based on a story of illicit viewing, of which *Susanna and the Elders* is doubtlessly the prototype. The popularity of such themes is in itself evidence of the interconnectedness of the nude and history painting as genres. The verses of 2 Samuel 11 narrate how King David, after sending his army off to battle, remains idle in Jerusalem. Strolling on the roof of his palace, he sees a beautiful woman bathing. He sends a messenger to fetch her and has intercourse with her. When she becomes pregnant, he calls her husband, Uriah, back from the front, to cover up the rape/adultery. Uriah, however, three times refuses to enjoy the comfort of his home while his comrades at the front are fighting. This refusal seals his fate. David sends him back to the front with a letter for his general Joab, in which he orders that Uriah be placed in military danger so that he will die. This happens, but at the cost of major losses. Joab sends a message with the bad news of the losses, but mitigates it with the good news of Uriah's death. God condemns David, and the prophet Nathan admonishes him through a fable. The child born of this event dies.

In Rembrandt's painting, we may not immediately recognize the iconographic subject of Bathsheba. Even if we do not, we still sense that something is happening; we are infused with a sense of narrative. "Something is happening," conveyed by the apparent narrative aspect of the painting, is similar to "a woman, perhaps Hendrickje" conveyed by its apparent realism, and to "what a beauty" or, to quote a double connoisseur of art and of female beauty, Sir Kenneth Clark: "a kind of beauty which is dependent on inner life and not on physical form,"[4] responding to the work's genre as a nude. It particularizes the subject of the painting in terms of a norm outside itself. In each case, the work is being read, given meaning with reference to standard categories through which meaning is culturally constructed. This is how realism encompasses, and is in tension with, the other two genre labels.

Denaturalizing Mastercodes

Each of these three genre labels is obviously applicable to this work, but each is problematic. The nude as a genre promotes a conflation between aesthetics and sexuality, and encourages a sexual response based on objectification; it assumes the woman is passive and precludes her engagement with the viewer. Narrative as a genre encourages a projection of preestablished textual meanings onto the visual work, making the work itself more difficult to *see* because we only see,

or rather, project, what we already *know*. Reading and looking within a realistic mode naturalize the content and thus leave the viewer vulnerable to, or even promote, ideological manipulation. As the mastercode encompassing the others, realism removes the viewer away from the activity of looking itself and diverts attention to the outside world, the world of the viewer's literary culture (the Bible, for example), their historical knowledge (the biography), their psychological insights (the cause of the sadness), or of their erotic habits (visual provocation of eroticism). If used as a more limited code, however, realism can also be brought into tension with other codes. Interpretation always, by necessity, brings in a variety of external meanings. The interpretation I am constructing, however, attempts to counter the naturalizing self-evidence of realism by taking the other two codes out from under its sway.

The realistic mode of reading is particularly powerful. First, realism finds support in textual details for its construction of a *holistic* content. The "convention of unity" is so powerful because of the pressure it brings to bear on one's choice of interpretation. Primarily under the influence of deconstruction, the assumption that works are a unity has been shown to stimulate strongly ideological interpretations, to erase disturbing details which do not fit, and to impose a Romantic conception of organic growth that is not relevant to works unrelated to the Romantic tradition.[5] Thus, not only are Rembrandt's paintings discussed in terms of unity and their attribution to the painter challenged if the work is not unified, but even the very notion of "oeuvre" is predicated on the desire to construct a "text" called "Rembrandt" that constitutes a whole. The concept of text as I employ it should be distinguished from that of "work." A work is the physical artifact before us, including the frame, exhibited in a museum or reproduced in a book, and perceived by the viewer as the object to apprehend in the act of viewing/reading yet still outside her or his grasp. A text is what we make of a work when reading it: it is a meaningful, well-structured whole.[6] This is fostered by the presupposition of a single author and the authority it creates.[7] This alleged unity of the oeuvre, and of its constitutive works, breaks down in the face of the practice of "Rembrandt" as a studio artist.[8] In addition, the convention encourages the projection of "masterplots" of life stories and pre-textual plots, such as Rembrandt's life and David's greatness as a king of Israel, which gloss over, even ignore, the marginal, that is, details that do not "fit" the masterplot such as the attendant, the letter, or the woman's unfocused gaze.[9] However, using the challenge to unity as a cover for resistance to interpretation may well be based on the same unifying fallacy it tries to avoid. Rather than simply rejecting unity and refusing to come to any conclusion about the "meaning" of the painting, I suggest we consider the painting's unity as a construction, and self-consciously examine what happens when we push such readings to their logical conclusions. Specifically, I

wish to explore the place of the detail in relation to the whole that any of the mastercodes encourage us to construct.

One important motivation to do this is the consideration of gender. As Naomi Schor has demonstrated, "details" that do not fit become even more challenging if they happen to be the arena in which a battle over the marginality of women is fought.[10] To counter that tendency, I here explore the implications of a mode of reading which I call "reading for the text," specifically, locating the detail in relation to a larger explanatory whole, often a narrative, which it qualifies or even challenges. The desire for wholeness, with its roots in the unconscious, informs the compulsion to project unity onto the image or text, and thus to ignore details that do not fit, that threaten to fracture desired unity. It is perhaps here that the genres of realism and of the nude join forces: the desire for wholeness underlies much of Western culture's preference for visual representations of the female nude because men seek completion in the representation of women *as* whole.[11] Modes of reading that look for details that do not fit are potentially useful tools for antirealist, critical readings. Reflection on the status of details and their relation to the whole is necessary if we are to prevent the recuperation of details as "signs for the real."[12]

"Reading art," then, is an important interpretive strategy that, paradoxically, foregrounds the specific elements of visual works. It thus counters linguistic imperialism because it examines the premises of connecting the image to the pretext by pointing out the tensions between the two.[13] In the *Bathsheba* the curtain, the cloth in the background, the cloth the woman is sitting on, but also the woman's bracelet and necklace, which might be seen as elements that give texture to the meaning of a painting: they fill up the surface in such a way that the representation passes for realistic. On the other hand, there remain many details, in both verbal and visual texts, that neither contribute to the recognition of the theme—nor "tell" a story. They seem to have no particular meaning at all, although they are clearly and insistently significant. I will discuss those elements as signs or, more precisely, as sign-events that contribute to our awareness that the work is processed as something we may call a *text,* even if no specific meaning can be assigned to them. It is the reader who decides which elements are discrete signs and which are not.

Such signs make readers process, not a particular text, but a general sense of "text": a sense of coherence, of structure, of narrativity, of meaningfulness, emerges, but no specific meaning, or, rather, a plurality of possible meanings emerge—whose undecidability is precisely the token of meaningfulness.[14] The signs that produce this sense are what I would like to call, with reference and in partial contrast with Barthes's signs for the real, "signs for the text." They undermine randomness by generating a set of possible stories, possible meanings,

that are left undecided, but that mercilessly emerge in the act of looking as soon
as we grant more viewing time than a quick glance.

Reading (for the) Text

In terms of this concept of text, most representational works in the Western tra-
dition pose a difficulty: that of self-evident textuality. No one will deny the textual
status of the *Bathsheba* painting, for example, at least according to my broad defi-
nition of text. The work has a frame that delimits it, a subject that gives it seman-
tic coherence, and a composition that gives it formal structure. It is meaningful,
even if interpretations vary, and it is full of signs. Its textuality, as I wish to point it
out, however, is primarily based on the tensions between the three mastercodes
that all apply to it, yet do not sit easily together. For *Bathsheba* is a complex work
in terms of the various modes of reading to which it gives rise.

The story is utterly doxic, that is, it is well known to the general public, yet
hardly *read* in its textual form.[15] "Bathsheba" is so much so that even serious and
sophisticated scholarship fails to do justice to the details of the biblical text. For
the knowledge the viewer may have of that text is not innocent of later readings
superimposed on it; as I have more than once been able to check, most people
have a vague "memory" that Bathsheba was responsible for her own rape. This is
a frequent response which demonstrates the risks of the notion that recognition
is denotative. For it is an interpretation which 2 Samuel 11 does not at all call for,
but which has in effect been imposed on the story through an unacknowledged
word-image interaction, facilitated by a broader cultural context in which women
tend to be blamed for their own rapes.[16]

At first sight, the identification of the subject as Bathsheba is based on the vi-
sual tradition, not the textual one. But the relation is more complex. An icono-
graphic reading, which travels from the text via the preceding images that inter-
pret and reinterpret it to the image at hand, will identify the subject relatively
easily if the reader possesses enough familiarity with the visual tradition. The
naked woman, the vague suggestion of a roof in the background, the servant oc-
cupied with the woman's toilet, and the letter in the woman's hand (not men-
tioned in the story of 2 Samuel 11) are all firmly established in the pictorial tradi-
tion. But if we bracket the iconographic tradition, it is at first sight not so easy to
interpret the work as a narrative. The scene is rather static; no action takes place
other than the routine manipulation of the woman's foot by her servant. Recog-
nition of the subject rests more probably on a somewhat uncomfortable logic,
which reverses the relationship between the visual pre-texts and their verbal pre-
text. The fact that the woman is naked, and that her toilet is being attended to,

seems to be enough to suggest she is being prepared, "made beautiful," for a man. This connection suggests that the image be interpreted in terms of the doxa. Out of reach of a critical response, the power of this implied viewer hovers over the woman's visual existence. Yet there is a strong sense of narrativity even if one is unacquainted with the Bathsheba tradition, which, I contend, can therefore be accounted for neither by mere iconographic, nor by thematic recognition, nor by narrativity alone. As for the pre-text, reference to the biblical story is scarce. We do not see any explicit sign of the spying king. One might argue that while the biblical story has the king send a servant, a messenger, to bring the woman whose view had kindled his desire, instead we have the letter, delivered by the messenger. However, this seems a rather arbitrary way of connecting the painting to a story where no letter delivered by the king's messenger to Bathsheba is mentioned. The letter is superfluous, a supplement, a detail, yet seems so "natural" that it calls the reader-for-the-text's attention to the unnaturalness of the sense of wholeness it disturbs. I take the letter as the starting sign, therefore.

Without the letter, it is not so easy to construct a narrative around the painting's major narrative axes: elderly woman cleans nails of naked woman's foot? Woman holds a letter she just received? While the woman's pose, her body, but not her gaze, turned slightly toward the viewer, serves the voyeuristic purpose, it does not produce an alternative narrative, or fabula. As Sluijter (1998) also argues, only when the viewer identifies with King David the voyeur—when, in other words, the body is offered to both the king and the customer—can a narrative be constructed, but that would bring the viewer into an uncomfortable position.

On the other hand, the woman's look is remarkable. She is undeniably melancholic and reflective, which is enhanced by the fact that her head turns away from the viewer while her body does not. These features remain virtually non-narrative, however, because they are related neither to each other nor to a fabula. But they counter the voyeuristic effect in that the woman's unwillingness to communicate with the viewer problematizes the latter's position.

Although the image clearly makes sense as a whole, what sense it makes cannot easily be decided. We are left with a sense of narrativity that is not fulfilled; with a sense of wholeness that does not satisfy; with a frustrated need to position ourselves in relation to the viewing situation the narrative should bring forth but does not. These dead ends leave us with a strong awareness of textuality that we cannot fill with a satisfying narrative.

Still, the letter remains, bringing to mind the women writing, reading, or receiving letters in interiors by Pieter de Hooch, Gerard Ter Borch, and especially Jan Vermeer. Its iconographic and narrative status is almost ambiguous enough

to make the work shift genres, from history painting to genre painting. The letter would then function in a radically textual way: as an indicator of genre, even as a pun on genres.

This does not make it any easier to decode, however. Iconographically, the letter is a type-sign referring to clandestine love.[17] So it is possible to relate the letter to the melancholic look on the woman's face. Once that connection is made, the impulse is to go to the biblical story to establish such a link, as the iconographic tradition is likely to have found it there. To put it strongly: the visual tradition informs (our readings of) the biblical story, not, at this point, the other way around. And if one looks for a letter that is linked to "infidelity" in 2 Samuel 11, one will indeed find one; but Bathsheba never sees it. It is the letter that David writes to the leader of his army, and in which he orders the latter to expose the bearer, Uriah, to mortal danger.[18]

That letter is, literally, the harbinger of death. After Bathsheba's appropriation by the king, it ushers us into the second, grimmer part of the story. Assigning that sinister function to it, then, is a way of dealing with the biblical images. This is a semiotic explanation of what happens when literature becomes a visual subject. Here, elements of the story are rearranged, motifs striking in their dramatic function are combined with motifs that have a stark effect on visual imagination. This way of reading a biblical story visually, of taking up its motifs in juxtaposition and rearranging them in the space of the paint surface, leads us to ignore the temporal and spatial place of each motif in the narrative sequence.

Thus, the visualization of Bathsheba reading the letter alludes to the letter condemning Uriah to death. The visual tradition is based on such a doxic, rather than a literal, reading of the biblical pre-text, in which a number of assumptions regarding gender relations in the story are also endorsed. From this perspective Bathsheba is implicated in Uriah's death.

Relating the letter in the painting to this pre-textual biblical reference can help the reader account for Bathsheba's melancholic look, but only at the cost of a blurring of meaning. Given this reading, Bathsheba's gaze narratively anticipates the future death of her husband. This interpretation of the letter and the figure's psychology, however, changes the status of both. Since, according to the literary story, Bathsheba has no knowledge of the function of the letter—indeed, of its very existence—the letter becomes *the* sign for pictorial textuality, affecting the other signs related to it. It is a deceptive, "false" sign of narrativity, and through its influence the melancholic gaze itself becomes a sign for textuality. It counters the painting's apparent verisimilitude and reveals the figure's function as a semiotic object, as a machine for generating meaning. This is one way in which "reading for the text" counters realism.

The Telling Detail

The letter is a conspicuous, indeed, central sign in the work. It is placed in the center of the surface; its color sets it off from the softer colors that surround it. By the many possible yet equally deceptive associations it evokes, it seems saturated with meaning, without having any specific meaning. This is what makes the letter a sign of textuality.

There is, however, a tiny detail: the barely visible little red spot on the left corner of the letter, which mirrors precisely these characteristics. This spot is, I feel, spectacular as well as specular. It is where Rembrandt's painting differs from all the others that include a letter, as if to foreground the letter's centrality. It is a strange spot; what might it signify—sealing wax or blood? If one takes it as a seal, it becomes a detail that enhances the reality of the letter: it becomes a sign for the real. The letter as a represented object is made to "look like" a real letter, and, employing Barthes's concept of the effect of the real, this connotation of reality accounts for the red blot's occurrence as detail. Here, however, is where the codes conflict, as this interpretation does not quite work once we come to consider it more closely.

If the red blot is a seal, it is strangely placed: not in the middle (its likely place) but in the corner of the letter. The very contrast of red against white, as the white of the letter contrasts with the surrounding colors, calls attention to its strangeness. If the red blot cannot logically be a seal, perhaps it can be blood. This possibility sets the turmoil of speculation in motion again: like the letter itself, the spot can be interpreted as a proleptic sign of impending violence, conferring this sense of violence onto the letter that contains and generates it. It refers, then, to the violent appropriation of the woman holding it by David, the subsequent murder of her husband, Uriah, and, later, the death of the child born of the rape.

The semiotic status of the spot is self-reflective: the spot is nothing in itself, has no positive meaning, and thereby foregrounds its semiotic nature. The spot mirrors the letter. It can do so, however, only if the letter has already announced the violence described in the pre-text, but inflected through the visual (nonviolent) tradition of the nude in the visual tradition that it triggered. The position of the red spot also activates the letter as a sign for text in that it mirrors exactly the letter's position in the painting: central yet decentered focal point on which all other details converge, yet a detail that can remain buried under a realistic reading eager to explain it away as sealing wax. The spot is to the rest of the letter what the letter is to the rest of the painting, to Bathsheba's melancholic gaze, among other things: it is a symptom of "text."

By their insistent suggestion of meaning, the signs discussed here, the letter and its red spot, the introspective gaze, demand a coherence that is not, after all,

substantiated by the work as a whole standing on its own, nor substantiated with reference to the biblical pre-text. In fact, the strangest thing about them is that by their very function of pointing at textuality, these signs pronounce the lack of coherence, the lack of a particular overall meaning within the painting, as well as the need, or compulsion, to move back and forth between the painting and the text. Signs like these, signifying at once their suggestion of meaning and meaning's deceptiveness, cannot be recuperated in terms of any of the usual categories of signs. They resemble most closely, while at the same time being most radically opposed to, the signs for the real, to which we will now turn briefly.

The Line of Sight

As I have discussed, the impulse to read realistically is strongly induced by the *Bathsheba*. This produced conflicting readings in an attempt to understand the letter through the pre-text, highlighting its semiotic function. A textual reading, therefore, leaves the letter—and its red corner—in visual isolation since the biblical text never describes Bathsheba holding a letter.

Let us begin again, not with the letter but with Bathsheba's staring gaze, a humanistically more appealing subject to commence with. As I stated, her melancholic look, directed nowhere, requires psychological motivation. This need for motivation is produced by the lack of connection between her look and the old servant. When two figures are facing each other, we expect them to look at each other, to be somehow involved with each other. The composition of the painting emphasizes this expectation: a diagonal line from the heroine's head to the servant's returns in the lower diagonal formed by Bathsheba's arm and leg. The letter is boxed in the middle. But instead of communicating with each other, the two women are preoccupied with their own thoughts, whose intensity is emphasized equally. The veiled old woman, sitting humbly at the heroine's feet, looks intently upon the object of her care. Her hand displays the tension we can see as a sign of "work" and that we can now recognize as a double sign for realism and textuality. The pressure of the hand refers at first sight to the "real" work of taking care, but the slightly overdone effect refers back to itself *as* sign for the real.

If we continue with a realistic reading, we would expect that the intense pressure could not but "touch" Bathsheba's toes and distract her from her self-absorption, generating a story of mundane, everyday reality. But, then, Bathsheba undermines the expectations of the narrative mode of reading by denying the sequence of such events. For she is staring so intently that she is clearly not about to act. Visually, her position as much as forces her to direct her gaze toward the elderly woman, but she is instead equally intently engaged in staring vacantly. Fol-

lowing the lines of the painted surface, her line of sight is interrupted, and the letter is the locus of its breach. If the letter were not there, the painting's line of sight would make almost no sense at all. In realistic terms, Bathsheba's distracted gaze is the sign that produces need for the letter.

But this is a reversal of the function of the letter as discussed in the preceding section, where it, not Bathsheba's gaze, was claimed to trigger the reader's speculative activity. Here, instead, it is the insistently inward look of the woman that gives the letter its purpose, so that we are far removed from the letter's power to turn the look into "text." As a sign for the real, then, her stare is a sign, rivaling the status of the letter as a sign. It overwhelms the potential narrative function of the letter as psychological motivation for an act—staring—which is culturally considered strange, or meaningful. This gaze is the ideal sign for the real: powerful and overwhelming, it asserts itself, without necessarily being recognized as such. All the problems of holistic or pre-textual readings are swept aside: that the reference to (and the subsequent recognition of) 2 Samuel 11 contradicts the letter as motivation, that the letter stands out as a sign more clearly than does the look precisely because the letter is less easy to explain, and that the sign-status of the letter is emphasized by the red spot which mirrors it: all this is swept aside, suppressed, by the realistic interpretation of the inward look as melancholic.

Return to Sender: The Letter Writes Back

The tensions between these two modes of reading, the realistic and the textual, are intimately related to the ideological consequences of the cultural attitudes toward verbal and visual media, to the fact that these are seen as media rather than as modes of reading. We cannot overlook the fact that the troublesome visual sign in the *Bathsheba* is a letter, not just any sort of sign but a visual text, a self-reflexive sign for textual coherence. But a letter is also a verbal text, visually representing "verbality." The most fascinating aspect of this tension between the letter as sign for text recuperating the look for its cause, and the look as sign for the real recuperating the letter for its effacement, becomes clear when, and only when, the viewer knows 2 Samuel 11 *as a text,* not as a doxa; in other words (and punning on a Lacanian punning title), the instance of the letter is the cause of the contradictory effect.[19] The icon is thoroughly verbal, but in its verbality is equally thoroughly visual. We may or may not appeal to a visual tradition that makes the letter a more effectively iconographic sign in the standard sense. That is, the opposing signs bring us back to the kind of iconography that I call pre-textual reading. But an attempt to bring in the actual pre-text while eliminating the imposition of its diffuse readings is more rewarding for a *visual* assessment of the

work than is merely relying on the pictorial tradition. The "instance of the letter" is the little detail that hooks us and imposes the presence of the pre-text to which allusion is made, the detail, also, that allows that text to spread out and take over.

When we examine the pre-text to which the letter refers us, reading it as a literary text instead of doxically "remembering" it, we find that it is as troublesome as the painting; it, too, has a detail that does not fit. The tension there is elaborated between a verbal but quite visual image—"Who smote Abimelech the son of Jerubbesheth? did not a woman cast a piece of a millstone upon him from the wall, that he died in Thebez?"—and a text—the letter from David which contains Uriah's death sentence and which the victim himself carries to the executioner. This misfitting image (occurring in verse 21) is a metaphor which does not make sense in any "logical" way, that is, in terms of the fabula as a sequence of events. It thereby symptomatically insists on the (literal) text as *other* than a (doxic) story. The image deserves special attention, also because it is so starkly and, indeed, disquietingly visual. As I hope to show, its status as "misfit" points at, and is pointed out by, the "misfit" in the "Rembrandt." Finally, it is ideologically troublesome. Displacing the issues raised in the text in which a rapist needs to cover up first his rape, then the subsequent murder he brings about, this metaphor attempts to pass as self-evidently true a negative judgment on the woman in the story that no detail in the text supports. For this metaphor suggests that Bathsheba has provoked her own rape, that she is the real culprit, that the murder was caused by her sheer visual existence. Thus it connects the text to the genre of the nude. The image may be taken as a symptom of the narrator's hidden agenda; the subsequent doxic versions of the story, as well as its many visual representations within the genre of the nude, provide evidence of the success of that agenda. The relation between the painting and its out-of-place letter and the text and its out-of-place image is emphasized by the coincidence of *the place of the letter* in the two works. Indeed, that place is as conspicuous and thereby as invisible as that of the letter purloined in Poe's famous story.

The letter may be read as an allegory of literality. It is both the visual center of the painting, in terms of distribution of space, and the textual center of the story, since the letter holding Uriah's death sentence in the story literally occupies the middle verse of the chapter. We might consider it in terms of Mitchell's four levels of spatial form in literature.[20] These four levels are the material form of the text, the represented space, the form in the structure of the story, and the meaning that we "see"—before our mind's eye—when we understand a text. The verse in which the letter figures is literally central. The letter also occupies a middle position in the represented space, since the text is divided between events taking place in the palace in Jerusalem and events taking place at the front. The letter being transferred between these two spaces stands between them, and rather than

connecting, separates them, since a letter is needed to convey the message from the one space to the other. And it is also structurally central and mediating because in terms of the aspects of narrative, it represents an intermediate position. In narratological terms, this intermediate position of Uriah's letter can be described as follows. The letter as spoken but not directly quoted discourse stands ambiguously between narrative voice and direct quotation, spoken discourse. In terms of speakers, David, the "speaker" of the letter, needs the messenger, the victim of his scheme, in order to reach his addressee, who is to carry the scheme out. The event of which the letter is the center, its transmission from one place to another, is the only moment in the story where focalization,[21] the perception of the narrative object, is excluded; Uriah holds the letter, but does not read it. This lack of focalization has grave consequences: failing to connect visuality with textuality by reading, he will die. The letter in the painting comes to be emblematically represented by the letter in the text: it can be seen but not read; it functions visually but not verbally. In both, the letter, then, is an *image*: a visual sign autonomous enough to work as a sign, yet embedded in a framework both which it supports and by which it is supported. In terms of action, the letter stands between private violence (rape) and its concealment, and public violence (murder) and its concealment, as a brief moment of suspension. As a central event, the letter is also an emblem of a specific view of storytelling: a story that tells itself, that happens as it unfolds.

Given this central position of the letter in the text, the central position of the letter in the painting can be seen as a visual reference to the spatial position of the letter in the text. But by reading it in this way, we can come to recognize even more. For in 2 Samuel 11 the letter killed. This murderous quality is both obvious and invisible, as the text surrounding it works to conceal it. The major devices of this concealment are twofold: it uses breaches of narrative logic and metaphor as symptom so central that it becomes allegory. Narratively, the content of the letter does not correspond to the events that fulfill its orders; instead of killing Uriah alone, the letter kills many soldiers. But the metaphor of the woman with the millstone, on the other hand, poeticizes the story. By its form of a metaphor whose motif is out of place, it underscores a textual mode other than sequential narrative, one that lends itself better for visual representation. Thus metaphor becomes the alien element that produces the reversal of the story's meaning. Its effect is comparable to that of Bathsheba's melancholic gaze in the painting: both the metaphor and the gaze can be taken either to explain away the lack of unity in the picture and reassure, or to enhance the strangeness of the intervening letter and thereby trouble the reader.

The rhetorical figure in verse 21 seems to juxtapose the victim Uriah, who has been killed by David's letter, and the tyrant Abimelech, who was deservedly

killed by a heroic woman. The evocation is a starkly visual and exceedingly metaphorical image:

20. And if so be that the king's wrath arise, and he say unto thee, Wherefore approached ye so nigh unto the city when ye did fight? knew ye not that they would shoot from the wall?

21. Who smote Abimelech the son of Jerubbesheth? did not a woman cast a piece of a millstone upon him from the wall, that he died in Thebez? . . . Then say thou, Thy servant Uriah . . . is dead also.[22]

The metaphor is overdetermined thematically, since between the two murders there are at least six common elements: death, woman, wall, battle, shame, folly. All six motifs connect the metaphor to the letter as well: containing a sentence of death because of a woman, a death that is to take place at the wall and in battle, the letter brings shame to Uriah, its carrier, because he was foolish enough to be honest. Yet in spite of this thematic overdetermination, the metaphor is displaced, since Bathsheba, the woman in the story, is the victim, not the victor: raped, she lost her husband in the aftermath of the implicit struggle between the two men for her possession, and she will lose the child born of the rape. Uriah is a victim, too, since he loses his wife and his life. Abimelech, in contrast, is a usurping king: a tyrant. The metaphor is both thematically motivated and at the same time absurdly unmotivated by the lack of narrative parallel, thereby producing a sense of displacement.

The metaphor is unmotivated narratively, since the thematic motives do not relate the metaphorical woman, the vehicle—the woman-with-the-millstone of Judges 9:53–54 who killed—to the woman it refers to—Bathsheba, the victim who is first raped and then widowed. The closer relation is, of course, between the shameful and foolish victim of Judges 9:53–54 and David the mighty king of Israel. The displacement therefore is so empathic that it is both difficult and urgent that we make sense of it. We can do so if we allow ourselves to read the patriarchal text as possessing, hidden in its problematic detail, a critical, perhaps self-critical, potential.

The visuality of the image invoked in 2 Samuel 11:21 can help sort out this confusing displacement. The comparison is highly visual even in its own pre-textual reference: the vivid pre-textual image of Judges 9:51 and 53 described a woman standing high on top of the threatened tower of defense, dropping a millstone—instrument of her peaceful work displaced into the military situation—on the head of the usurper. The image is also highly gendered. In Judges, the fallen tyrant is so ashamed of being killed by a woman that he orders his arms-bearer to

kill him quickly so that nobody will be able to say he was killed by a woman. In
retrospect, then, it is tempting to read into the visuality of the image the geogra-
phy of the female body and the intimidating impression it makes on the terrified
male: the towering woman, threateningly impressive in the eyes of the bluffing
tyrant who is approaching too closely the entrance to the city, figuring the en-
trance to the woman's body. We can argue that this visualization of the female
body informs the comparison in 2 Samuel 11, which in turn informs the "Rem-
brandt" painting.

The function of the metaphoric comparison, with all its distortions and irrel-
evancies, is to displace the guilt for the violent event from the king onto his vic-
tim. The metaphor, rather than Uriah, carries the letter over, shifting the story
from a literal into first a metaphorical, then an allegorical reading. And true
enough, the issue that motivated the entire story is, indeed, the power of the fe-
male, a power that brought about the moral fall of Israel's king of kings, a power
that, according to a patriarchal view, only the most absolute, tyrannical power of
the male can hope to conquer. And what is that power? Nothing but the visual
power of her body. Seeing her naked, David the voyeur is compelled to have her,
regardless of the price he has to pay: his moral integrity, his best soldiers, and,
later, the life of his son. The metaphor drives home the "truth": that readers have
the reassuring option of salvaging the reputation of the king by blaming vision
and the woman, an option readers in the modern West eagerly adopt. The *image*
of Bathsheba brought the king down.

This text is not just a defense of voyeurism and the ensuing rape, although on
one level of reading it comes close to that, exactly as does the painting.[23] When
read at face value, as most critics do who fall into the trap of its metaphoric moti-
vation, the image stands for the woman's responsibility in the event.[24] The diffi-
culty of disentangling the metaphor's narrative structure makes ignoring its sta-
tus as sign attractive. Thus conceived, the metaphor functions as a sign for the
real, but the "real" in question carries with it a specific gender-ideology. In order
to step outside of this ideology, we must reverse the perspective and look at the
image, including its problematic details *as a text, composed of signs*: take it literally.

The image as a whole signifies displacement, and in that respect resembles the
spot on the letter in the painting. Displaced out of the center (of the letter) in the
painting, while representing a central concern, and displacing the guilt of the vio-
lence from perpetrator to victim in the text, the displaced image not only dis-
places guilt and responsibility, but also draws attention to displacement. As we
discussed, its complex structure, both compositionally and narratively, which
counters any attempt to disentangle it by narrative logic, refers back to the letter,
which made the event and this response to the event possible. The metaphor in
2 Samuel 11:21 was produced by the letter carried over, in the middle of the text,

from one side of the represented space to the other. In other words: the letter also stood for displacement, for transition, for reversal. As the crux of the text, the letter engendered all subsequent textual figurations. This is not so because the letter happens to be itself a representation of a text but because, as an image, it structures the set of signs around it into "text." The sophistication of the letter's central position draws attention to the sophistication of the metaphor it produces, and whose apparent confusion may be very significant. Less than real, its meaning is ideological, and its means of conveying meaning, textual.

Reading Distortion

If we now return to the letter with the red spot in its corner that Bathsheba holds in the painting, we discover that it, too, points up to another detail; the painting has its own "verse 21"—a detail that does not fit, a distortion of structure, a voyeuristic tendency, and a geography of the female body. For those who are willing to read with the text, not the doxa, and with the detail, not the "official story," the painting holds a surprise.

Bathsheba's body is the place I suggest we finally look. The painting is, after all, on one level just a female nude, as gorgeous as Rembrandt's *Danaë* in St. Petersburg and as intriguingly strange. If we look at the body, without taking for granted that it is just a female body presented for our delectation, we notice that the body is twisted. It is only slightly—hardly perceptibly—twisted. The twist has the same function as the metaphor in 2 Samuel 11: it allows us to endorse the ideology of voyeurism and, siding with David, blame the exposed woman, but also to resist such a position. Her legs are crossed, and their crossing, pointed at by the letter that partly covers it, is the locus of the distortion. It is there that narrative and ideology, and textuality and realism, collide and collude. This is the motivation for my discussion of these concepts as "in tension."

The issue is the right leg. The mastercode of narrative that enables us to read the work as a history painting takes the leg in one direction. Narratively speaking, the legs are crossed so that the servant/procuress can fulfill her duty and prepare the woman for royal rape. But this is a realistic consideration; realism remains the mastercode. At the same time, however, the nude takes the leg in the other direction. For rhetorically speaking, the body is turned toward the viewer, who stands in for the king as the voyeur whose act of vision prepares *him* for the rape. The point at which these two codes intersect constitutes the "syntax" of the work's resistance, its "misfits." The distortion comes to preclude this smooth appropriation of the work by a plain, patriarchal story of voyeurism. For if coherent and unproblematic voyeurism were the point, crossing the figure's legs the other way

would have been much more convenient; nothing needs to hamper realism. Although the figure's right leg is crossed over her left leg, the right foot remains at the right side of the knees. Had the figure crossed her legs the other way, no awkward twisting would have been necessary. But then the body would not have been turned as much toward the viewer. So the twisting seems to be the point, and we can read that twist as the shift from realism to textual self-consciousness; genre labels shift from mastercode as mastering code, to misfitting distortion, that turns the potential voyeur into a resistant "misfit." Just such a misfit as Uriah, who refused to play David's game.

Indeed, this reading becomes quite plausible in the face of the letter. First, in the middle of the diagonal line leading from Bathsheba's melancholic *look* to her foot in the servant's hand, there is a text: a letter. Second, the line from Bathsheba to the servant only emphasizes the fact that she does not look where her eyes are directed. Her inward look goes nowhere, rigidified as it is in melancholy. Is she already mourning her murdered husband? Or her appropriated body? Or her not-yet-conceived son? That in itself is a highly self-conscious textual construction, for she is only being prepared for the insemination whose success will *then* lead to the murder of Uriah and the death of the offspring. Both her melancholy and the letter are radically out of place as well as absolutely central.

Until this very day, readers eagerly adopt the notion that *since* the biblical text lets the murderer blame the victim through metaphor, she *must* have provoked the event. Thus the text retrospectively accuses Bathsheba of exhibitionism, rather than David of voyeurism. But our reading of the painting's textuality disturbs such an illusion. This is why the body had to be twisted and the legs crossed in such an awkward way: this pose was necessary to expose the geography of the female body as well as that exposure itself. The twist foregrounds textuality, constructedness, contradiction.[25]

Conclusion

In conjunction with this very literary reading of the literary pre-text, what can we conclude about the painting's signs and the modes of reading they allow us to endorse? The two readings of the letter as sign for text and the look as sign for the real are mutually exclusive, incompatible yet competing because they each recuperate the other sign within their reach. The simultaneous occurrence of both sign-events is impossible. Yet both interpretations are alternatively possible. In other words, another commonplace about the distinction between visual and verbal art has to be sacrificed: we must discard the notion that verbal works are processed sequentially, in time, while visual art can be viewed in a single mo-

ment.[26] The viewer who wishes to reflect on both possibilities of interpretation needs to shift from one mode to the other. So does the reader who wishes to account for both the realistic-ideological appeal of the metaphor in 2 Samuel 11 and for the textual effect of the letter, which undermines that appeal. Both readings are nonsequential and nonsimultaneous.

The incompatibility and the irreducible gap between them make the entire painting hinge on a gestalt shift, makes the painting akin to the rabbit-or-duck drawing. Is this a text or a scene, a narrative or a display, a painting or a woman? It cannot be both at the same time, for the power of signs for the real resides in this exclusivity. Thus we must conclude that signs indeed are events, and that we viewers are the subjects who bring about these events. We choose between the rabbit and the duck, the text and the woman. And we have the possibility of choosing both, although not within the same reading event.

But these readings are not *imposed* by the work; realism as a self-conscious, self-reflexive mode of reading can help us *not* read in this way. There is no reason to argue that signs for the real are more descriptive, more visual, less narrative, than other kinds of signs. They participate in the narrative, descriptively or otherwise, and they are visual or verbal according to the work and the element in which they function. If they tend to overwhelm other signs, it is because of the cultural habits with which we approach the works, not because realism is inherently powerful. Just as in the case of the letter, it depends on us viewers to interpret the doubling of the end of Bathsheba's left braid either as a shadow of the braid or as a painterly trace, as a thing that effaces the work of the representation or as a symptom that foregrounds it.

Notes

Originally published in *Rembrandt's "Bathsheba Reading King David's Letter,"* edited by Ann Jensen Adams (Cambridge: Cambridge University Press, 1998), 119–46.

1. For an introduction to these basic semiotic concepts, see the introduction to my book *On Meaning-Making* (1994).

2. How deceptive such a circular knowledge can be is demonstrated by Alpers's comparison of Rembrandt's own self-portraits and Jan Lievens's portrait of Rembrandt (1988). We think we know the face of "Rembrandt," and use that knowledge to identify self-portraits in details of his history paintings. Since we like Rembrandt's art better, we believe his self-representations more accurate than Lievens's representation of "Rembrandt," which presents us with a quite different face. I find this conflation of aesthetics and realism quite telling.

3. Sluijter (1998).

4. Clark (1980, 23). Clark presents an exquisite case for the intricate connections between realism and the nude, and between aestheticism and eroticism. In the same paragraph from which

this quote is taken, he writes about "gap-toothed Saskia" and "Hendrickje's adorable appearance" with the kind of contempt men in the street employ in assessing women as "bodies."

5. Such a concept of text has been challenged by deconstruction; see, for example, Derrida (1987).

6. Nor do Romantic works themselves fit this idea of unity too neatly. It is striking that much work in deconstruction focuses on Romantic works in particular, to begin with De Man (1979, 1984); Chase (1986) is a good example. See Culler (1981, 1983) and Van Alphen (1987) for illuminating discussions of the convention of unity.

7. On the problematics of authorship in connection with textual unity, see Derrida (1984, 1988); Kamuf (1988).

8. The published volumes of the Rembrandt *Corpus* demonstrate in their tone and focus the urgency of maintaining unity in the face of its demise. Rembrandt Research Project et al. (1982–89).

9. See Habermas (1972) and Jameson (1981) for critiques of the masterplot. Freud's predominant masterplot of the Oedipus complex has been sufficiently criticized and the alternative of a pre-Oedipal plot in which the mother is central has convincingly been advanced. See Silverman (1988).

10. See Schor (1987) on the detail is of crucial importance for this essay. A few examples from my *Reading "Rembrandt"* (1991): the women-in-excess in the Tobias drawing (179–84) and the sketch of the *Last Supper* (201–6); the mismatch between woman and man in the *Adoration* drawing (207–11); the discordant levels of reality in the Washington *Joseph* which isolate, but also foreground, the female figure (45–47); and the empty fist in the Berlin *Susanna*, which foregrounds the status of misogyny as a cultural center in which the complicity of art and science must be acknowledged (171–76).

11. The argument refers to the psychoanalytic theory of castration anxiety. See Freud, "On Femininity" (1965 [1933]) and the final essay of Rose (1986), with a wonderful counterpart to the female nude on 224.

12. This tendency makes the success of Barthes's concept of "the effect of the real" quite problematic (1986).

13. Mitchell (1985) has convincingly argued that the often alleged opposition between verbal and visual art as between discrete and dense sign-systems (proposed by Goodman 1976), although appealing as the most sensible and the least hierarchical of the current formulations, is not entirely without problems. Mitchell argues that Goodman's blind spot is rooted in his fundamentally apolitical attitude, which makes him unaware of the conventions and value systems underlying representational practices. See esp. Mitchell (1985, 70–74). Specifically, one problem lies with the conflation of the theoretical status of signs and the way they actually function. Verbal art—although composed of discrete words which can normally be described individually as signs—does not *function* by way of a reader discerning words individually. In order to "tell" a narrative syntagma of the form subject-action-object, a text needs more words than just the three that fill the slots in the syntagma. This is a problem with Bryson's chapter entitled "Perceptualism" (1983). His theorizing of connotation in painting as what is superfluous for the sheer recognition of narrative syntagm seems to suggest that minimal narrative syntagm is linguistic. As a sequence of mere words, then, language may be discrete; as a form of representation, it is not.

This is why much of the scholarship on word and image relations, however valuable in other ways, is theoretically based on the wrong premises. See, for example, Camille (1985),

who, in spite of his opposition to verbocentrism, constantly seeks to map the *equivalent* visual signs to match the words. The problem is enmeshed with the confusion between ideas and propositions on the one hand, and sentences on the other. Thus, Gombrich's statement that images cannot distinguish the universal from the particular (1949), and Burke's similar statement that images cannot represent the negative (1968). To be sure, the fundamental difference between illustrations of a text, as in Camille's material (1985), and representations of a (doxic) story, as in many "Rembrandts" discussed in my book, cannot be overestimated. Nevertheless, the matching, even as "literally" (!) as possible, between images and words will have to pass through the common idea which each represents within the possibilities of its own medium. Matching is never quite translation.

14. I wish to insist, at this juncture, that undecidability is not the same thing as indeterminacy, let alone randomness. For a clear and short exposition of the difference between these two, see the afterword to Derrida (1988). I want to recall that undecidability is always a *determinate* oscillation between possibilities (for example, of meaning, but also of acts). These possibilities are themselves highly *determined* in strictly *defined* situations (for example, discursive—syntactical or rhetorical—but also political, ethical, etc.). They are *pragmatically* determined (148; emphases in text).

15. As in the telephone game children play, each new telling of the story that remains unchecked against the text distorts it further. "Doxic," then, refers to the unargued commonsensical assumptions about a story's meaning that make up its "ideology." In Bourdieu's terms: "the universe of the undiscussed" (1977, 168).

16. See Bal (1991, chap. 2), for a fuller discussion of this issue apropos of "Lucretia" and for references.

17. Leclerc (1977) wrote perhaps the most congenial contemporary response to the love letter in Vermeer's *Woman Writing a Letter*. In this essay she attempts to reorient the traditional iconographic interpretation of the motif away from the cliché of marital infidelity into the direction of a woman's sphere. Gallop criticizes Leclerc's feminist reading/writing for its repression of class consciousness (1988, 165–78).

18. As I argue shortly, the letter is a shifter in the biblical story, too. The story is, moreover, curiously confused where it deals with relations between signs, women, and death. See Bal (1987), for a detailed analysis.

19. One may want to elaborate on Lacan's title: "L'instance de la lettre." I will not do so here, but let me just evoke three of the many associations generated by the word "instance": "example," in straight English; "agent," in reversed "Franglais," e.g., as a translation of the French "les instances du récit"; "insistence," as a filling and enhancement of a graphic gap. For the *Bathsheba* all these meanings are relevant.

20. Mitchell (1980, 283–85).

21. Focalization is a narratological term, referring to the interpretive perception of the narrative contents. It is close to, but not identical with, the more traditional term of "narrative point of view." See Bal (1991, 158–60), for a discussion of the potential of this concept for visual analysis.

22. The translation is taken from *The Holy Scriptures of the Old Testament: Hebrew and English*. There is discussion of the weapon: millstone or piece of millstone. The translation might also be "one millstone," with emphasis on the singular, which alludes to the one stone on which Abimelech killed all his brothers save one. See my analysis of this issue in Bal (1988).

23. Needless to say that no one in her or his right mind will attempt to excuse David fully.

But blaming him individually is a more pernicious way of staying outside the ideologeme which informs the story and to which the viewer is subjected as much as the king.

24. In *Lethal Love* (1987), I analyzed in detail two critical responses to this metaphor, one (Perry and Sternberg 1968; reprinted in Sternberg 1985) entirely falling into the trap and eagerly buying into a superficial sexist interpretation, another one more subtle and technically "correct," yet, after carefully mapping out the complex structure, which is nevertheless unwilling to interpret its very complexity along with its overt meanings (Fokkelman 1982). As a result, even this careful critic misses the point of the sign for the real, the image's self-effacement. Compared to the *Las Meninas* discussion, the first of these interpretations would be comparable to Foucault's and Searle's "naive" (read: nontechnical) assumption about perspective, and the second to Snyder and Cohen's more sophisticated mapping of the "real" perspective, both, however, missing the point that Steinberg highlights, which incorporates the passion for technical righteousness. Foucault (1973, 3–16); Searle (1980); Snyder and Cohen (1980); Steinberg (1981).

25. I hesitate to mention this, reluctant as I am to fall back into intentionalist criticism, but X-rays have revealed that Bathsheba's head has been dramatically changed in the course of the making of this image (see Van de Wetering 1998). Initially, the head was tilted upward, her eyes gazing outward, perhaps at the viewer. Thus, the exposed body was more exposed, and this exposure psychologically supported. Changing the head made it easier for the viewer to be sympathetic. Thus, it is sometimes argued, Rembrandt subverted the genre of the nude.

26. This commonplace view persists in spite of overwhelming evidence that viewing necessarily takes time. See Goodman (1976, 12) and Riggs, Ratliff, Cornsweet, and Cornsweet (1953), for optical evidence, and Pritchard, Heron, and Hebb (1960) for psychological evidence, both quoted by Goodman (1976). For a theory of sequential reading of verbal art, see Perry (1979).

References

Alpers, Svetlana. 1988. *Rembrandt's Enterprise: The Studio and the Market*. Chicago: University of Chicago Press.

Alphen, Ernst van. 1987. *Bang voor schennis? Inleiding in de ideologiekritiek*. Utrecht: HES.

Bal, Mieke. 1987. *Lethal Love: Literary Feminist Readings of Biblical Love Stories*. Bloomington: Indiana University Press.

———. 1988. "The Displacement of the Mother." In *Death and Dissymmetry: The Politics of Coherence in the Book of Judges*, 197–230. Chicago: University of Chicago Press: University of Chicago Press.

———. 1991. *Reading "Rembrandt": Beyond the Word-Image Opposition*. Cambridge: Cambridge University Press.

———. 1994. *On Meaning-Making: Essays in Semiotics*. Sonoma, CA: Polebridge Press.

Barthes, Roland. 1986 (1968). "The Reality Effect." In *The Rustle of Language*. Translated by Richard Howard. New York: Hill and Wang.

Bourdieu, Pierre. 1977. *Outline of a Theory of Practice*. Translated by Richard Nice. Cambridge: Cambridge University Press.

Bryson, Norman. 1983. "Perceptualism." In *Vision and Painting: The Logic of the Gaze.* London: Macmillan.

Burke, Kenneth. 1968. *Language as Symbolic Action: Essays on Life, Literature, and Method.* Berkeley: University of California Press.

Camille, Michael. 1985. "The Book of Signs: Writing and Visual Difference in Gothic Manuscript Illumination." *Word and Image* 1 (2): 133–48.

Chase, Cynthia. 1986. *Decomposing Figures: Rhetorical Readings in the Romantic Tradition.* Baltimore: Johns Hopkins University Press.

Clark, Kenneth. 1980. *Feminine Beauty.* New York: Rizzoli.

Culler, Jonathan. 1981. *The Pursuit of Signs: Semiotics, Literature, Deconstruction.* Ithaca, NY: Cornell University Press.

———. 1983. *On Deconstruction: Theory and Criticism After Structuralism.* Ithaca, NY: Cornell University Press.

De Man, Paul. 1979. *Allegories of Reading: Figural Language in Rousseau, Nietzsche, Rilke, and Proust.* New Haven, CT: Yale University Press.

———. 1984. *The Rhetoric of Romanticism.* New York: Columbia University Press.

Derrida, Jacques. 1984. *Margins of Philosophy.* Translated by Alan Bass. Chicago: University of Chicago Press.

———. 1987. *The Truth in Painting.* Translated by Geoff Bennington and Ian McLeod. Chicago: University of Chicago Press.

———. 1988. *Limited Inc.* Translated by Samuel Weber. Evanston, IL: Northwestern University Press, 1988.

Fokkelman, J. P. 1981. *King David.* Vol. 1 of *Narrative Art and Poetry in the Books of Samuel.* Assen: Van Gorcum.

Foucault, Michel. 1973. *The Order of Things: An Archaeology of the Human Sciences.* Translated by Alan Sheridan. New York: Vintage Books.

Freud, Sigmund. 1965 (1933). "On Femininity." In *New Introductory Lectures on Psychoanalysis.* Translated by James Strachey, 139–67. New York: W. W. Norton.

Gallop, Jane. 1988. *Thinking through the Body.* New York: Columbia University Press.

Gombrich, E. M. 1949. "Review of Charles Morris's *Signs, Language and Behavior.*" *Art Bulletin* 31:68–73.

Goodman, Nelson. 1976. *Languages of Art: An Approach to a Theory of Symbols.* Indianapolis: Bobbs-Merrill.

Habermas, Jürgen. 1972 (1968). *Knowledge and Human Interests.* Translated by Jeremy J. Shapiro. London: Heinemann.

Jameson, Frederic. 1981. *The Political Unconscious: Narrative as a Socially Symbolic Act.* Ithaca, NY: Cornell University Press.

Kamuf, Peggy. 1988. *Signature Pieces: On the Institution of Authorship.* Ithaca, NY: Cornell University Press.

Leclerc, Annie. 1977. "La lettre d'amour." In *La venue à l'écriture,* ed. Hélène Cixous, Madeleine Gagnon, and Annie Leclerc, 117–40. Paris: Union générale d'éditions.

Mitchell, W. J. T. 1980. *The Language of Images.* Chicago: University of Chicago Press.

———. 1985. *Iconology: Image, Text, Ideology.* Chicago: University of Chicago Press.

Perry, Menakhem. 1979. "Literary Dynamics: How the Order of a Text Creates Its Meanings. With an Analysis of Faulkner's 'A Rose for Emily.'" *Poetics Today* 1 (1–2): 35–64, 311–61.

Perry, Menakhem, and Meir Sternberg. 1968. "The King through Ironic Eyes: The Narrator's Devices in the Biblical Story of David and Bathsheba and Two Excurses on the Theory of the Narrative Text." In *Ha-sifrut,* 263–92.

Pritchard, R. M., W. Heron, and D. O. Hebb. 1960. "Visual Perception Approached by the Method of Stabilized Images." *Canadian Journal of Psychology* 14:67–77.

Rembrandt Research Project et al., 1982–89. *A Corpus of Rembrandt Paintings.* Vols. 1–3. The Hague: M. Nijhoff.

Riggs, L. A., F. Ratliff, J. C. Cornsweet, and T. Cornsweet. 1953. "The Disappearance of Steadily Fixated Visual Objects." *Journal of the Optical Society of America* 43:495–501.

Rose, Jacqueline. 1986. *Sexuality in the Field of Vision.* London: Verso.

Schor, Naomi. 1987. *Reading in Detail: Esthetics and the Feminine.* New York: Methuen.

Searle, John R. 1980. "*Las Meninas* and the Paradoxes of Pictorial Representation." *Critical Inquiry* 6:477–88.

Silverman, Kaja. 1988. *The Acoustic Mirror: The Female Voice in Psychoanalysis and Cinema.* Bloomington: Indiana University Press.

Sluijter, Eric Jan. 1998. "Rembrandt's Bathsheba and the Conventions of a Seductive Theme." In *Rembrandt's "Bathsheba Reading King David's Letter,"* edited by Ann Jensen Adams, 48–99. Cambridge: Cambridge University Press.

Snyder, Joel, and Ted Cohen. 1980. "Reflections on *Las Meninas*: Paradox Lost." *Critical Inquiry* 7:429–47.

Steinberg, Leo. 1981. "Velázquez' *Las Meninas.*" *October* 19:45–54.

Sternberg, Meir. 1985. *The Poetics of Biblical Narrative: Ideological Literature and the Drama of Reading.* Bloomington: Indiana University Press.

Wetering, Ernst van de. 1998. "Rembrandt's Bathsheba: The Object and Its Transformations." In *Rembrandt's "Bathsheba Reading King David's Letter,"* ed. Ann Jensen Adams. Cambridge: Cambridge University Press.

Part 4 **Postmodern Theology**

12. The Rape of Narrative and the Narrative of Rape: Speech Acts and Body Language in Judges

The book of Judges is a strikingly violent book. Men murder men, women murder men, and men murder women. I see all these categories of murder as related, but I contend that the man-woman murders are, narratively speaking, generative of at least the woman-man murders, if not of all. It is on the man-woman murders that I will focus. The young women who are the victims are, because of their sexual maturity and their institutional background, disruptive of the social structure as well as of the narrative; their rape or murder works to cure both—to bring about social order and to lead the narrative to its next phase. Although in general there are many nameless minor characters, it is striking that the three young women who are murdered have no names, in spite of their crucial role in the narrative; this anonymity eliminates them from the historical narrative as utterly forgettable. I wish to speak about them and, in order to be able to do that, I will give them names. Jephthah's daughter, whose death is caused by her being daughter, will be referred to as *Bath,* the Hebrew word for daughter; Samson's first wife, killed because her status as a bride was ambiguous, will be called *Kallah,* which means bride, but which also plays on *kalah,* destruction, consumption. The victim of chapter 19, who is dragged from house to house and gang-raped and killed when expelled from the house, will be called *Beth,* house.

Traditional scholarly readings define the topic of the book of Judges as the difficult establishment of the people in monotheism and in the land, and the wars against the native inhabitants this entails. The stories of the individual heroes, judges, or deliverers are supposed to enhance this overall political theme. This interpretation, on whose details I will not elaborate here, leads to the elimination of exactly eleven out of twenty-one chapters from the "core" of the book: the two opening chapters, four of the Samson saga, and the so-called epilogue of five

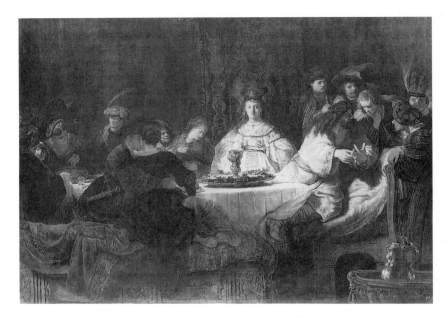

FIGURE 12.1 Rembrandt van Rijn, *Samson Posing the Riddle to the Wedding Guests,* 1638. Gemäldegalerie, Dresden. The bride takes the position of Christ in figure 12.2. The position as a sign includes the isolation, danger, and victimization involved for Christ in the Leonardo painting.

chapters. The majority of the chapters do not, by this interpretation, really count as "real Judges material." In a study that I have completed recently, I argue that this view rests on an attempt to base the coherence of the book on political history, whereas a case can be made for social history as the main issue around which the stories evolve. If we take the social issues seriously, the rejected chapters become central. The crucial issue is the transition from what I call patrilocal marriage, the nomadic form of marriage wherein the woman remains in the house of her father, while the husband, whose relationship to her is much more casual and less permanent, visits her occasionally.[1] Disturbing as it is, the extreme violence of chapter 19 becomes, then, a central rather than a peripheral event. The intertribal war of the end is therefore not a side issue, not an accident meant to show that the people need a king, but a logical step in the struggle at stake. The set of wars against the natives is not the only problem the Hebrews had to face. "Going astray," the expression used for both religious and sexual "unfaithfulness," is a central issue confronting the fathers threatened with the loss of their daughters and the husbands who want their wives to live in their clan.

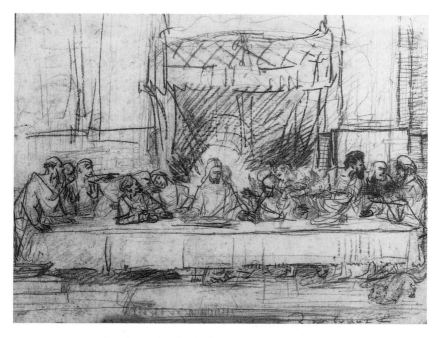

FIGURE 12.2 Rembrandt van Rijn, "Sketch After Leonardo's *Last Supper,*" 1635. Robert Lehman
Collection, Metropolitan Museum of Art, New York. The Leonardo serves as a model for the composition
of Rembrandt's *Samson Posing the Riddle to the Wedding Guests.*

Speech Acts: The Word Become Flesh

I would like to present one aspect of the narrative that is directly related to this so-
cial issue: the use of language for violence. Inspired by both Shoshana Felman's
playful and seductive, brilliant analysis of speech acts,[2] and by Elaine Scarry's im-
pressive and depressing, equally brilliant analysis of violence,[3] and worried by the
more and more obvious limitations of narrative theory as I had myself contributed
to construct it, I became interested in the relation between narrative structure and
the characters' speech acts that both disturb and construct it. The central act of
violence in the book of Judges is the rejection, rape, torture, murder, and dis-
memberment of the young woman, usually but fallaciously referred to as "the
concubine," in chapter 19. She dies a violent death as a result of the competition
between her patrilocal father and her virilocal husband. Eve Sedgwick's title *Be-
tween Men* applies here.[4] Sexual abuse is the form chosen for the revenge of the
old institution over the new. Her death and the story of it are not only violent but
also narratively ambiguous. She dies, we might say, several times or, rather, she

never stops dying. The agents of her death are similarly unclear; the act keeps being displaced from one man to the next, until we reach the narrative situation of the end where all the male agents involved turn out to have contributed to her death. Not only is this woman raped to death (and rape is, as I will argue, an act of body language); her body is subsequently used as language by the very man who exposed her to the violence. Her dismemberment for semiotic purposes, a repetition of the gang-rape, can be seen as a miniature of the narrative of Judges as a whole. Where the narrative seemed to fail to construct history, rape becomes the generative event. The relations between language use in the book and the narrative that constitutes the book are what I would like to explore in this paper.

How can a dead woman speak? Why does she have to be dead in order to be able to speak? And what is speech in a book of murder? How does speech relate to action, affect lives, and bring about death; how does speech relate to the body; and how does the view that emerges from these questions affect the status of the text itself as speech?

As is typical of linguistic studies, speech-act theory has been developed around a few core examples. For J. L. Austin the favorite example is marriage, where the utterance of the word accomplishes the deed.[5] Felman works with the example of seduction. Similarly, in this paper there will be a central speech act that emblematizes both my reading of Judges and the view of speech I see in it. In memory of Beth's dismembered body, my core speech act is both one and many, it is both central and decentered, less clear as a case than seduction, although more "cutting"—the French would say: *tranchant.* The speech act I will focus on is the *riddle and the vow.* It is the one that questions meaning, while it is excessively meaningful; the one that is overmotivated and whose force is more central, as its meaning, than its meaning. It is a speech act that hovers between the two genres, while exploiting the ambiguity of both. On the one hand, Judges is full of riddles, the speech act of the *lacking* meaning. Riddles ask for meaning because without the answer, they don't have any. Samson's riddle at his wedding hardly conceals its sexual meaning, but it rests on a confusion—a "who is who?"—that questions this meaning. The subjects of the performance at stake in the riddle are anything but clear. And that lack of clarity is at the same time the riddle's force: the motivation of its utterance whose trace the riddle is. It is this disproportion between a lack of meaning and an excess of force that makes the riddle the emblematic speech act through which we will explore the power of language and its relation to events, to history, and to narrative.

On the other side, we have the speech acts based on an excess of meaning, acts that emblematize the power of words in the most radical way. Their meaning being death, they bring death, they kill. There is an opposition between the fatal word and the speechless, powerless character that is killed by it that drives the

proportion between force and meaning into radical dissymmetry. But the excessive meaning that kills is at the same time motivated by a need to establish the overwhelming power of meaning that is the underlying force of the act. Again, there is no way to tell the force from the meaning.

The difference between riddle as a deficit of meaning and the fatal word as an excess of meaning breaks down in the case that will be the central and decentered example here: the *vow*. Denoting an as-yet-unknown, hence, nonexisting victim, the vow belongs on the side of the riddle. Killing that unknown victim, however, becomes its excessive meaning that at the same time instates the radical dissymmetry of power between speaker and victim. Hence, it is an act whose meaning is excessive but whose force is no less excessive. Thus, it challenges the assumption that the force and meaning of utterances can be somehow distributed or that they are different, distinct aspects.

Where seduction rests on the capacity and power of the victim to misunderstand,[6] hence, to participate, be it perversely, in the speech act, the vow, to the contrary, the promise of gift eliminates the victim from the linguistic process. The only function in the communicative process left open to the object, a function that the three victims of Judges each seem to cling to, is to become speech, in body language. Beth (formerly the "concubine") is again the most extreme case: she is conditionally given to many, the condition being that the rapists leave the husband alone. The gift is repeated after her death: her body is cut into pieces and sent to the tribes, as a letter containing a message. This is a case, if ever there is one, of the scandal of the speaking body.

Samson's Riddle: The Word Become Woman

During the seven days' party preceding his wedding, Samson "put forth a riddle" to the thirty Philistine companions of the feast. The riddle runs as follows:

> Out of the eater came forth food
> and out of the strong came forth sweetness. (14:14)

As a speech act, the riddle is based on a position of power. The subject who proposes the riddle knows the answer, while the addressee does not. Moreover, there is power in the initiative itself. It presupposes the right to be listened to, the obligation on the part of the addressee to invest the effort to find the answer. In the case of a stake, the power is betokened by the possession of the stake. There is a conditioned promise involved. All these aspects are explicit in the speech act that precedes the riddle itself, its staging:

Let me now put forth a riddle unto you; if you can declare it me within the seven days of the feast and find it out, then I will give you thirty garments and thirty changes of raiment; and if you cannot declare it me, then you shall give me thirty linen garments and thirty changes of raiment. (14:12)

The companions accept the challenge. Thus they submit themselves to the power of the addresser; they hope or trust that they can reverse the situation.

When, later, the answer is revealed, it turns out to be a "bad" riddle, a riddle that cannot be "found out" at all by anybody else but the addresser. The riddle's answer/meaning is Samson's secret performance and transgression, the killing of the lion and the eating of honey out of the corpse's belly. The event is fraught with ambiguities, and so is the riddle that represents it, that assigns to it a core function in the narrative. The distinction between the general and the particular has not been respected. The riddle turns out to be based on an event that has been told by the narrator to the reader, not by Samson to the companions. Without that narrative act, the event remains particular and cannot be "found out." The riddle as a genre is based on another impossibility: although it must be understandable *after* explanation, it cannot be before. The explanation turns the arbitrary into the logical and the particular into the general.[7] Given these conventions and their transgression, we can at this point already predict that the companions need to appeal to resources other than their own inventiveness to find the riddle out. And given the structure of power involved, we can foresee that the revelation of the riddle as an inaccessible one must cause a crisis.

The relation between riddle and vow is so far a simple one: a riddle with a stake contains a vow.[8] The vow, in this context, is the conditioned promise of something else. The stake is, typically, not the subject itself or the addressee, but a third object, or a third person for that matter. This introduction of the third person in the process is what distinguishes the vow from many other speech acts. The obligation it entails not only compensates the indeterminacy implied in its being conditional *and* future, but it is also in its turn compensated by the derivative third object, stake, or victim. Unlike the seduction through promise of marriage, the vow involves an objectification that excludes the object from the process, yet decides over her life and death. The victim of the vow does not have the possibility of accepting or rejecting the arrangement. Her collaboration in the speech act is not conditional for its "felicity." The asymmetry, then, becomes a dissymmetry, a power structure that radically separates the third party from the process as a nonparticipant, yet the most thoroughly affected one.[9]

The riddle predicts that dissymmetry. The stake proposed is, as we have seen, the symbol of the power structure that Samson tries to establish through the riddle. The all-male company in which the speech act is accomplished, together

with the generic feature of unsolvability, and the future tense that points to the future wherein the wedding-to-come necessarily breaks the all-male unity by the introduction of the woman, the crisis that cannot but break out because of the dissymmetry of interests, all suggest a problematic of possession in the future where a woman is at stake.[10] Is she, also, the stake?

The riddle has a meaning that is its answer; it has a meaning as riddle, and the act of proposing it has a meaning. The analysis of these three semantic aspects shows not only that the distinction between force and meaning fails but also that its failure itself is thematized *in* the meaning. The answer to the riddle is given by the companions, who have used Kallah to get the answer through Samson himself. Hence, the riddle's meaning is self-referential. This self-referentiality is appropriate, as the answer reveals:

> What is sweeter than honey?
> And what is stronger than a lion? (14:18)

Samson, the hero of strength, signifies himself in the riddle, his strength: force. Here, too, force precludes meaning.

A second feature of the meaning of the riddle-and-answer combination is the paradox in the riddle and the banality in the answer. Samson's extraordinary strength is the semantic core of the answer, as its concealment is of the riddle. There is an attempt to be someone very special that is encouraged by the hero's, the *gibbor*'s, encounter with the lion in the previous episode, and that suggests his power to him; hence, the riddle.[11] The special power that his strength encompasses is, however, secret by definition, and not necessarily available in all circumstances. Proposing the riddle, then, is not only using that power; it is also a way to make it known. But, paradoxically again, the game depends on secrecy, and the revelation of the answer destroys the power. There is a logical conflict the subject is entangled in, and which leads, ultimately, to the failure of the act.

The answer, as already suggested, cannot be found out without the help of a mediator between subject and addressee. Samson has to reveal the answer himself, and the question is how this self-referentiality can be broken open, in order for the companions to have access to the knowledge. The meaning of the riddle as revealed in the answer is the combination of sweetness and strength. But the site of strength, its subject, is not, as is generally assumed, Samson himself; at least, not univocally. The lion, in the founding scene of the riddle, is not Samson but his antagonist. The one whose belly yields sweetness like honey is combined, conflated, with the strong one. The first meaning of the riddle is, then, the formidable woman. The identification with the lion does not predict much good for her; the lion can only yield sweetness when dead.

On the third level of meaning, proposing a riddle is, as we have already suggested, usurping a position of power that the subject may not (yet) deserve. The conflict that ensues from that usurpation is signified in the generic properties of the riddle itself. The companions, then, need to go and find access to the subject's mind. They go to the most obvious candidate: the woman. The choice is obvious not only because of the wedding situation, but also because the identification between sweet and strength in the riddle signifies marriage itself, and proposes that conflation as its meaning. It expresses, in fact, Samson's view of marriage. Samson will be subjected, then, to (part of) himself, in order to reveal instead of conceal it. The dialogic speech act that is the combination of riddle and answer requires a third party, an "excess" whose trace remains in order to betoken the force at stake. That violence will be used to erase that trace, a violence that, as another aspect of force, will leave its trace in its narrative account is therefore unavoidable.

But how can we talk about these meanings at all? We can do so on the basis of the presupposition that there exists a sequence of events that not only trigger, motivate, the speech act, but also determine its meaning. Without the event with the lion, known to us, unknown to the participants—hence, without its secret— there is no meaning possible in the riddle. There lies precisely its generic flaw: riddles are supposed to be generalizable. This narrative anchoring in the particular story of this particular *gibbor* is what makes it, as a riddle, both impossible and typical of the series of riddles in the book of Judges. It makes it the motor of the narrative.[12] It brings it close to the vow. The outcome of the riddle is equally embedded narratively in the whole story. It determines its status as a particular type of speech act: the one that lacks meaning. It has no meaning outside the sequence; hence, its motivation and meaning are but one. Narrativity produces the riddle and answer, and the latter requires the narrative. The metonymic relation between narrative and riddle is the *slip* of the speech act. As in psychoanalysis, the slip is not the excess of the narrative; it is its motor. As such, it motivates, energizes—it *is* the narrative. Hence, on this level, too, force and meaning are conflated.

If this is the case, then, we must conclude that the riddle, as the motor of the narrative, signifies already the end of its plot(ting): Kallah's death. The force of the speech act is motivated by the need to undo the woman who mediates between the subject and the addressee and who is, ultimately, the stake. The sequence that the riddle constitutes by linking the lion episode to the following one follows the line of increasing violence, only to end in Kallah's death. This linear movement is itself signified in nonlinear predictions; the meaning that is her death is predicted much earlier. The dead lion prefigures it, the companions announce it, and Samson triggers it. When they try to find out the riddle, the companions say to Kallah:

Entice your man that he may declare unto us the riddle, lest we burn you and your father's house with fire. Have you called us hither to impoverish us? (14:15)

The first sentence here signifies the conflation between Samson and Kallah; it is obviously she, not Samson himself, who must declare the riddle to them, after getting the answer from him. The second part of the sentence predicts Kallah's death, as the bride living in her father's house. The death, conditionally promised, equals the vow in the proposition of the riddle. The last sentence attributes responsibility to her, but if we look at the passage that precedes the wedding, we see that the subjects who "called them hither" are, again, both Samson and the Philistines. It is significant that, all through Kallah's story, the agents are thus conflated.

As in psychoanalysis there is no story without the motivation, the force that pushes the subject to tell it, and that lies both in the past and in the present of the speech act, similarly, there is, in Judges in general, and in this riddle episode in particular, no riddle without story, and no story without riddle; no present tense without a past that predicts the future. It is in the future that the word of the speech act becomes flesh, burned flesh; and the flesh is female.

The Riddle as Vow and the Vow as Riddle

We have seen that the riddle was proposed within the context of a vow: a conditioned gift. The basic feature of the riddle, its concealed meaning, made it possible for the narrative logic to produce the third party, the mediator, object of violence toward which the sequence leads, as the ultimate object of the conditioned gift. This turns the riddle into a vow, a vow like Jephthah's: one that promises to give what the subject does not *know*. To know and to possess, both expressions for the sexual encounter from the male perspective, are thus intimately related. One cannot possess what one does not know, for how can one know whether or not one possesses it? And one cannot give what one does not possess; hence, giving the unknown is a priori an act of abuse.

Riddles have a specific relation to the real in which they interfere. They pose, and dispose of, the unknown; so do vows. The first vow of the book of Judges is the case that the traditional readings of the book eliminate as part of the prologue: the conditioned gift of Achsah, Chief Caleb's daughter, to the prospective conqueror of Kiriath-sepher, the city of books. This vow is the example of the "proper" vow: although it disposes of the daughter in a way we would, today, not rave about, it is in accordance with the tradition it signifies, and the following

episode shows that it is, within the context, "proper" enough to serve as a model.[13] Unless we are extremely ethnocentric, we cannot refer to this gift as rape. Nor, for that matter, as history in the traditional sense. It does not generate the next episode; it does not relate to the rest of the book by continuity. The vow is fulfilled, and its beneficiary is generally considered to be the model of the ideal judge. The vow leaves no rest, nothing to regret, to blame, or to guess. Nothing to tell.

In comparison to Samson's riddle, this vow/riddle makes explicit what the other one tried to conceal: the identity of the third party, the stake, she who has no participation in the speech act while she is its object. The vow modifies the real in that it triggers a narrative sequence: first, the *gibbor* qualifies for the award, changing the situation of the city; then, he receives the award, changing the situation of the daughter. Achsah becomes, through this narrative, an *'almah*. She accedes to the third of the three phases of female maturity, and is thus separated from her father.[14]

Riddles have a specific relation to truth: they establish it. Truth is, let's say, a perfectly adequate relation between a statement and its referent, between language and the material reality it represents. Riddles conceal that reality, but their answers, which are always, typically, the only possible answer, are undeniably true. One does not challenge the answer to a riddle. The same holds for vows. The vow promises the gift of the unknown object; once the identity of the object is revealed, there is, at least within the biblical epistemology, no possible challenge to it, as Bath-Jephthah's fate sadly shows.

This feature of the riddle is interestingly exploited by Yael in verses 4:20–23. The exhausted Chief Sisera, on his flight after the defeat of his army, is invited by Yael to seek refuge in her tent. He prepares to go and sleep, and then Sisera gives Yael an order:

> Stand in the opening/door of the tent and it shall be, when any man comes and asks you and says: is there any man here? you will say: none.

Is this speech act a riddle, a vow, or something else? It is an order in the first place. But as an order, it misfires. Sisera's circumstances do not give him the authority required for ordering. The failed order embeds a question of identity that assimilates it to the riddle. The question is not, this time, *who* the man will be, but *what* he is: a man, or not a man? Typically, the negation allows for indeterminacy, and in the space created by that property, both characters respond to the speech act in a different way. For Sisera, the answer was obviously meant to deny his presence; it was an order to lie. For Yael, the speech act was a riddle, and riddles have perfect truth-value. Hence, the answer meant for her: no man. The riddle

consists, then, of finding out how a man can be no man. Her answer is: as a dead man, and she acts upon it. This can be read as a response to Samson's riddle: how can a strong lion/woman yield pleasure? Answer: if she is a dead lion/woman. Sisera's involuntary riddle shares properties with the vow as well. It is emphatically phrased in the future tense, the object is not participating in the dialogue, and, as is systematically the case in the vows of Judges, it leads to death. Turning the misfired order upside down, Yael "obeys" it, but turns the lie into a question of identity.

Riddles have a specific relation to desire. They stage the desire to know which is the erotic desire of the Hebrew male. Proposing a question is proposing, for the addressee, the possibility of knowing: of knowing the object of the desire to know, of enjoying her, as the stake of the game. Samson's riddle—caught in the web of the narrative that produced and was produced by it—was about the desire to know what yields pleasure through violent appropriation, and that is precisely the view of eroticism that the book exclusively represents.

The riddle that becomes the interpretation of the negative vows, the threats that we also find in the book, has a similar relation to desire. Two examples suffice here. When Barak does not take Deborah/Yahweh's promise of victory at face value, in 4:8, it is because, like Jephthah, he needs help from a real *gibbor,* someone unlike himself. Deborah turns his vow ("if you will go with me, I will go") into a riddle when she responds with the negative promise:

> I will surely go with you; but the road you undertake shall not be for your honor; for Yahweh will give Sisera into the hand of a woman. (4:9)

As a reversal of the daughter of the chief, Sisera, the chief of the enemy army, will be given into the hand of the real victor: a woman. The riddle that ensues from this threat is, of course, the identity of the woman, who is, however, this time not the object but the beneficiary of the gift. Again, the sexual aspect of the riddle is part of it. The woman can only "get at" the fugitive through seduction, through the promise of safety, comfort, in her tent, in her bed.[15] Giving him into the hand of a woman is, then, nothing else than what custom prescribes: to give in marriage.

The negative vow, toward the end of Judges, to give no daughters as wives to the Benjaminites leads to a question that provides another striking example of the sexuality inherent in riddles. The vow threatens to exterminate the tribe of Benjamin, hence, to destroy the wholeness of the people. The riddle it entails is, then: how to provide wives to the Benjaminites without breaking the vow not to give them? The question of identity is implicit: who can these wives and nonwives be? But, again, the indeterminacy also allows for the other possible question: how can

they be Israelite women, in spite of the vow? Again, the truth of the riddle, the reality-changing aspect of the vow, cannot be questioned. And, again, the answer is logical in retrospect. The issue of the riddle is not in the gift or in the identity of the object, both being determined by the vow and the law. The issue turns out to be the question: How to avoid giving? The objects of the gift—women—and women who will guarantee ethnic purity through endogamy—will not be given but stolen, abducted; in our understanding, certainly raped.[16] The negativity of the description matches the negativity of the production: only by killing those who are *not* the objects of the riddle can those objects come into existence.

If desire is acted out in such negative, destructive ways, and if the narrative needs these actings-out in order to move on, we cannot but draw the conclusion that between narrative, desire, and violence there is a close bond. The violence the riddles in the book result in is the form taken by the appropriation that, according to Felman, is implied in seduction. The riddle-as-vow and the vow-as-riddle both explore the modalities of appropriation by language, by the power relations involved in speech acts. The playful reversal that seduction allows, and that Felman's own text illustrates—the reversal that gives the addressee the possibility of escaping the status of object and of gaining that of subject—is strictly impossible in the case of the fatal speech act, riddle and vow. The appropriation is performed outside of the object's participation. The appropriation is there radical, deadly.

The Daughter's Body Language as a Challenge to Fatherhood

Samson's riddle causes Kallah's death just as much as Jephthah's vow causes Bath's. Apart from Samson, it seems to be primarily the father who, in Judges, performs the crucial speech act of the vow. Jephthah despairs over his cognitive failure. Not knowing whether or not he will qualify as a *gibbor,* he gives away what he does not know. It is his fatherhood that he gives away, showing that it is, in this sense, as insecure as is that of Manoah, Samson's failing father. Both fathers speak too much and are punished for it. Whereas Manoah is corrected by the messenger, Jephthah never learns the lesson. He seems to be a compulsive speaker, and, moreover, he seems pretty good at it. His success in the negotiations over his position as leader (11:6–11), his shrewd device to tell an Ephraimite from a Gileadite (12:5–6), and his tendency to negotiate before fighting show that, for Jephthah, the mouth that utters words is closely related to what the Hebrew so happily expresses as "the mouth of the sword."[17] The lethal quality of his words adds to that effect. The question that arises from that relation is: Is there a bond between speech and violence, and is that bond a polemical response to the failure, inherent in fatherhood, to reach material contiguity with the daughter? I will return to

Jephthah's central role in the narrative of this problem, but, in order to assess the relations between the speaking killers and the language of their victims, we will first look at the daughterly speech acts, which are, typically, acts of body language.

Body speech, like verbal speech, never stands alone; in other words, the sign is always part of a "text" and its utterance, of a sequence of utterances. Achsah's confrontation with her father, when she claps her hands to attract his attention and then claims her due, is initiated by her nonverbal act that prepares her father for a surprising, yet respected desire. Her speech is successful; again, she provides a model against which the subsequent body speeches of the daughters stand out as its negatives. Within the limited focus of the present discussion, Achsah is not only a model as the daughter who, given away, yet assumes a subject position. Her story reveals that she is also a model of daughterly speech acts. Her request must be situated within the thoroughly patriarchal structure where daughters are promised as conditioned gifts, as stakes for military bravery, where they are the shifters between the two coherences of political and social history. She, too, is vowed away for the sake of the "higher" interests: war and "national" unity. But within those limits, she shows what language, if "properly" used, can perform: it can result in water, rather than fire. In the interpretations of her story, it is often assumed that it functions etiologically to explain the claim of Achsah's descendants, to the wells which "by their situation seemed naturally to belong to Caleb's descendants."[18] The assumption that there is a conflict at all between the two groups contradicts what is often taken to be the uncontested primacy of virilocal marriage and the patriliny that excludes the daughter's father. I suggest, indeed, that the claim for her own descendants must be seen in the light of the non-self-evidence of virilocy. If Achsah claims the wells, she seems to cause surprise precisely because it is not so "natural" that her descendants are different from Caleb's. The etiological function receives, then, a much more profound meaning: the claim is not just a matter of personal ambition but of social transition. Othniel has as much interest in this issue as has Beth's father in chapter 19.

If patrilocy versus virilocy is, indeed, the underlying issue of the conflict, the body of the daughter as the material mediator of the line of descent is the site of the struggle. It seems appropriate, then, that the language used is body language. Generating history—descendants—the body also generates narrative, but only if it is violated as is Beth's, not if it functions "properly" as does Achsah's. The daughter, by using body language in her address to her father, acknowledges the function that is assigned to her. Since the father, in his vow, disposes of her body, her distancing from him in following a husband is acted out in the semiotic use of the body. Speaking through it, she signifies its performative power: the force of the speech act. Thus recuperating, for her *as* body, a subject position, Achsah's gesture sets the limits to the father's absolute power. That limit is the body as pro-

ducer of descendants: life. The water she claims is the indispensable material support of the life whose production saves her subjectivity. At the same time, the bodily nature of her speech act enhances the materiality of the daughter's way to establish descent, as opposed to the father's: through her body. Her daughterly submission also contains her future motherhood.

At the other end of the book, Beth's body language sadly echoes Achsah's. She also uses her hands, but she cannot forcefully clap them; rendered powerless by the men's abuse, she can only passively lay down her hands in a meaningful direction. Where Achsah's father responds to her gesture with the acknowledgment of her right to speak, to desire, to be, the husband of the already destroyed Beth responds with the opposite attitude. Instead of the question "what unto you?" (what do you want? [1:14]) he gives the order: "Up!" Beth's gesture is not acknowledged as an initiator of the phatic function. The hands on the threshold that both accuse and implore are ignored by the husband to whom they are addressed. Beth's claim to safety in the house is countered by the husband's final attempt to take her to *his* house. In some sense, her gesture is similar to Achsah's, however. Both women are addressing the man who gave her away. Both choose to follow the husband, leaving the father. But while Achsah addresses her father from above, Beth addresses her husband from below. The gift of her was improper; it led not to marriage and descendants but to rape and death; instead of assessing her subject position, it destroyed it. While Achsah's father faces her, Beth's husband steps over her.[19] When in the morning he opens the door, the verb used is *jephtha*.[20] And indeed: "behold, the woman, his [patrilocal] wife." The language is that of visuality, of voyeurism, of one-sided power relations. It is here that the hands on the threshold, Beth's final, powerless act of body speech, are mentioned, and ignored. They misfire. Like Achsah, Beth speaks within the limits assigned to her: as body. But where Achsah, whose daughter position was "properly" acknowledged, could add verbal speech, Beth can speak no more.

Beth's story does not end on this gesture. It is one of a series of increasingly violent events generated by her rape. Her body is put to further semiotic use. The peaceful deal between Caleb and Othniel was possible because their blood relation allowed them to overcome, or rather to ignore, the virtual conflict between patrilocy and virilocy. It was mediated by Achsah's request for the life source. This deal is inverted into an ever-increasing mechanism of violence brought about by a deal that betokened the refusal to respect the bodily integrity of the daughter. Beth's body will be used to speak, but it is no longer Beth who speaks. Her body is

> divided, limb by limb, into twelve pieces, and he sent her throughout all the borders of Israel. (19:29)

FIGURE 12.3 Rembrandt van Rijn, "The Levite Finds His Concubine
in the Morning" (no date). Kupferstichkabinett, Berlin-Dahlem.
Although the body lies still, the right hand seems to move.
This enhances the sign-function of the gesture.

The totally destroyed subject becomes the speaker to the whole nation. The ob-
scure, anonymous husband gains, through the use of her body as language, a po-
sition that comes close to that of a *gibbor*. This act turns the domestic conflict into
a major political issue.[21] But unlike Othniel, who also used Achsah to establish
himself as a husband as powerful as the father, this man gains his position through
the destruction of the daughter/woman whose body could have brought him life.
Beth's dead body can speak, but by a perverse twist it is the man who totally sub-
jected her, not herself, who speaks. In order to assess the meaning of this differ-
ence, let us return briefly to the body language that precedes the two discussed
instances: the rape.

 The meaning of the particular punishment inflicted on the attempt to estab-
lish virilocal marriage has been understood in various ways, none of them satis-
factory. Although the threat of homosexual rape is sometimes interpreted as a

challenge "to standards of proper cultural civilized behavior, as the Israelites would define such behavior,"[22] as a symbolic gesture, its meaning in relation to the other body speech acts of the story is not examined. The oblivion of these relations leads to astonishing gestures of repression. Robert Alter gives a clear instance of this repression.[23] He qualifies the story of Judges 19 as a "heterosexual companion-piece" of Genesis 19. The threat is here separated from the "real" act in a way that conceals the *language*: force and meaning together.[24] In a sense, rape is the body speech act par excellence. It is well known that rape victims experience the act as aggressive, not lustful; the rapist as a misogynist full of hatred, not as the excusable frustrated loner. Homosexual rape is equally motivated by hatred of the object, and it is "logical" that it is often committed by heterosexual men. Rape being motivated by hatred, not by lust, men who hate and fear women and their attraction to them will rape women, while men who hate and fear men and their attraction to them will rape men. Homophobia and heterocentrism parallel gynophobia and androcentrism. To rape is to speak the hatred. Often, the act is accompanied by (or should we say: accomplished through?) offensive verbal language, as if the symbolic meaning of the act needed to be enhanced. It is also an act of cutting, of dividing the flesh, destroying its wholeness, hence, the subject. It alienates the victim from herself *and is meant to do so*. Why, then, is there so much hatred on the part of the inhabitants of Gibeah, and why is it addressed to the man? Why is the language chosen to express the hatred this particular body language of sexuality, and why is rape required to promote the narrative further? The rapists hate the man for challenging their institution of sexual relations. That the punishment has to be sexual is already motivated by this contiguity between crime and punishment. The issue is the "natural" right of physical property of the father over the daughter, in an attempt to make fatherhood "natural" by imposing bodily contiguity as its basis.

The language of rape can be seen in the light of this obsession. The aggression of rape is the speech act of contiguity par excellence. The hatred is spoken by one body into the other. But there is more to it. The threat of rape of the husband is the threat to turn his body into anybody's property. Thus the rapists signify the insult on the father's property that the man is guilty of. The daughter belongs "naturally" to her father; this is the only accepted and culturally sanctioned contiguous bond. Going away to another man, going astray, is going to be any man's property. Any man, the arbitrariness of signification of relations that is so hard to accept, is understood as "every man." Between the "natural" owner and "any man," there is no difference as long as the daughter's choice is not acknowledged, her subject position ignored. It is the man who, by taking away the daughter, is responsible for her being anybody's, everybody's property. The gift of Beth, her

rejection by the husband and delivery to the rapists, acknowledges that meaning.[25] It is the gesture by which the Levite submits to the other institution.

If the homosexual rape is thus the equivalent alternative to the heterosexual rape of Beth in the night-long torture session, the host verbalizes this equivalence very pointedly. To rape is to humiliate, and that is to be done not to the man but to the daughters. The reluctance to male rape occurs not simply because men are more valuable subjects and hence have a primary claim to protection, for the murder of men is not precisely shunned in the book of Judges. It is, more profoundly, because raping him would be a symbolic gesture, signifying the responsibility of the man for the daughter's alienation from the father, while raping her partakes in the contiguity that is so basic to fatherhood. That is why the rapists do accept the gift of Beth, while they refused the gift of the two daughters that was a simple compensation.

Judges 19 ends with an imperative: *speak,* a masculine-plural response to the mute speech of Beth's divided flesh. Just as the husband responded by a misfired order, since the circumstances were, to use Austin's happy term, "infelicitous," the tribes fail their response by abuse, since they address their order to speak not to the "speaker" but to the husband. The speaking body itself is ignored: the tribes blame the Benjaminites, not the husband and what he stands for. Thus, the speaking body fails to speak because it is not listened to. There lies the deepest scandal of the speaking body: it is not permitted to speak.

The daughters, in Judges, speak through their bodies, thus showing the materiality of speech in its specific, socially determined framework. Their speech acts reveal that it is the female body that is the stake of the speech act that circumscribes it. It produces, in the men between whom they are defined or divided, the identity that is indispensable to the construction of the *gibbor.* Full possession, full power of disposal over the daughter's body, is what they desperately try to come by. The materiality that their relations to their offspring seems to lack is produced by the contiguity they seek. Contiguity, and its linguistic figuration, metonymy, is the foundation of the speech of the daughters. The question that then arises is: How do the fathers act as speakers in their strife for materiality?

The Mouth of the S/word

At this point, we have to return to Jephthah, the hero of the cutting word. When he realizes that his word killed his daughter, he laments over himself. The confusion, signified not only in his "blaming the victim" but even in a so-called copist

error,[26] points to the basic problem of Judges, which is the problem of father-
hood, the father line, and the construction of the "people" through it.

One of Austin's favorite metaphors is fire; one of Don Juan's characteristic
assets is his sword. Felman points out that the interesting challenge to truth im-
plied in fire is that it is undecidable whether it is a thing or an event.[27] The same
can be said of the sword-in-action, the instrument of "rupture," the breaking off
of relations, and of "*coupure*," the cutting: penetrating and dividing. The same
can be said of words: are they things, to be placed in a sequence and to be read by
innocent bystanders, or are they events not that *are* things but that *do* things?
Jephthah is the master of manipulation of the sword, word, and fire. His cutting
sword kills, in close collaboration with his cutting language. His fatal words are
motivated by the same conflict that caused the murder of Beth: insecurity about
lineage, history; an insecurity that generates the narrative, using rape and murder
as its device.

The language of the fathers is a language of power. It is through that language
that Jephthah establishes himself as the head of the Israelite people, in his nego-
tiations with the elders of Gilead (11:6–11). The central element and the stake of
the negotiations are Jephthah's sword: he requires appointment, not as a tempo-
rary, military *katsin,* but as permanent head, *rosh,* after the victory. But negotia-
tion is not only about or for power; it is also based on power. Thus Jephthah ne-
gotiates his own status as leader over the people that had expelled him as the son
of "another woman," a "harlot" or patrilocal wife, on the basis of his power as a
master of the sword. The term "head" seems appropriate for the hero of the
mouth: to be "head" compensates on more levels than one for the expulsion from
the father house, from history, from contiguity with forefathers and offspring.
The fatal vow, utterly futile since the Judge has sent his spirit already, displays
Jephthah's addiction to negotiation, the speech act of and for power. We may
wonder why the repetition compulsion is so insistent. Negotiation is based on
power; who has none, has nothing to negotiate with. But it is also a recognition of
the limits of power; the negotiator has something, and lacks something. Jeph-
thah, the to-be head of the people, hero of might, has the power of his s/word, but
he lacks some other power, the power that would give him security, certainty
about his victory. If the divine Judge is appealed to here to decide, first, to ac-
complish, next, the victory Jephthah is hired to perform, it is because the nego-
tiator, the man of speech, realizes that fundamental lack.

Like Don Juan, Jephthah is a master of "rupture" and "*coupure.*" Breaking
away from the father's house, he later breaks with his only child, a break that costs
him his identity—and her, her life. His attempts to counter this movement of
"rupture," of breaking, by reinserting himself in the line, use "*coupure,*" killing,
just as in the case of the rapists in chapter 19. The weapon of negotiation, the

mouth that must provide him with the position in history that he strives for, is replaced with the weapon of killing that must materialize the delicate, insecure position he thus conquered: the mouth of the sword. His basic insecurity betrays itself doubly in his fatal vow: not only does he show himself to have no confidence in his own *gibbor*-ship, he also proposes a riddle with a stake that is contiguous to himself. The "comer-out of his house to meet him" is also the materialization of his relationship to his (father's) house. The daughter's body that can either secure the line or destroy it, according to his power over her, is his "exclusive possession."

It is precisely the exclusivity of that possession[28] that can never be secured. Fatherhood is never certain, the father line is always doubtful, and Jephthah, the son of the "other" woman, is well placed to realize it. The use of the s/word that he seems to master so well is itself not a clear-cut enterprise. The *shibboleth* episode in 12:5–6 is, in its ambiguity, a *mise en abyme*[29] of Jephthah's problematics, which in its turn is that of the whole book. It parallels the rape scene of 19 in that function. The situation is war; we are in the middle of the political coherence. The mouth of the sword, not the mouth of the word, is the appropriate weapon in the circumstances. But Jephthah abuses the word; he uses it in inappropriate circumstances. Killing, as he now has learned, is tricky; the sword can kill the self. It is crucial to tell—to know—a Gileadite from an Ephraimite, a member of the father house from the others. The trick Jephthah devises to "judge," that is, to distinguish, is verbal: a riddle, again. The question is: Who belongs to the father line? The criterion is the "proper" pronunciation of the word *shibboleth*, "proper" being according to the pronunciation in the father's house. Language determines the father line. The mouth of the word enables the mouth of the sword to be effective, not the other way around. As such, the episode signifies the priority of language over the body, while at the same time proclaiming the materiality of language, its bodily effectiveness and foundation: its basis in contiguity.

Derrida relates *shibboleth* to circumcision, the cut that divides and defines. Circumcision is not an issue in Judges, but it is replaced. Two cuts take over its function: the rape that kills the inappropriately appropriated woman, and the cut of the mouth of the s/word. It is, then, not the male member that is circumcised, but the male word. Derrida formulates it as follows:

> The circumcision of the word must also be understood as an event of the body, in a way essentially analogous to the diacritical difference between *Shibboleth* and *Sibboleth*. It was in their bodies, in a certain impotence of their vocal organs, that the Ephraimites experienced their inability to pronounce what they nonetheless knew ought to be pronounced *Shibboleth*. The word *Shibboleth*, for some an "unpronounceable name," is a circumcised word.[30]

That the impotence or potency is situated not in the male member but in the male head, the site of knowledge, of symbolization, but also the site of the knowledge of the insufficiency of symbolization, is quite appropriate. Jephthah has learned, in his long career as *gibbor,* how to become a hero of masculinity, of paternity: of memory. Memory, the historization of language, is another form of its material-ization. Master killer, he is also the master speaker of the book of Judges. It is through his story that the narrative of the deliverers and that of the judges, so ob-stinately separated by many philologists, are convincingly linked together.[31]

There is yet another relation between the mouth that utters speech and the body. It is represented in the material satisfaction of the mouth par excellence, food, and it is used to express bondage. Bonding it does indeed, not only between father and husband but also, in the narrative, between the two major "cuts": rape and murder. Bread, *lehem,* the material consecration of bonding that the messen-ger, in chapter 13, refuses to accept from Samson's prospective father, is again the object of rejection and temptation in chapter 19. In his attempt to keep his daugh-ter, Beth's father confronts the husband in his own house, in Beth-lehem, the house of bread. The site of the exclusive possession of the daughter is also the site of the father's speech. After three days of hospitality, the husband prepares to leave the house, but the father will not let him go. He retains him with the words:

Support your heart with a morsel of bread, and afterwards you shall go your way. (19:5)

The noun "heart" recalls the expression "to speak to her heart" in verse 3, misin-terpreted today as kind concern.[32] It refers to the site of reason. The expression in 3 means "to persuade her." If we take it that the heart has a similar function here, the father's words may suggest that the husband be more reasonable, that he accept the house of bread as a better place to be, and the father house as the appropriate place for the daughter to be, for lineage and history to establish themselves.

The last part of this speech seems a failure through abuse: the next episode shows that the father had no intention to let the man go; the promise is no promise-with-a-future. But this may be yet another case of a failure, not of the speaker but of the addressee, a failure to understand the force rather than the meaning. The question—or the riddle—implied in the speech act is: What will the husband's "own way" be, after having strengthened his heart with the father's bread? Like Manoah's invitation, the father's invitation to share a meal is an at-tempt to establish the group, the community of the father house. After eating the father's bread, the man is expected to have "his own way" within the father house. The speech act is meant to establish, through bread, the contiguity that only the

daughter can provide. The failure, then, is misfire: the circumstances are inappropriate. The father does promise with the intention to carry out his promise, but the riddle is not acknowledged by the addressee. Food, then, is more than the material satisfaction of the mouth. It is also what relates the word to the body. Bread is spoken rather than eaten; as spoken attempt to establish who belongs to the father's house and who does not, the offer of bread is the offer of contiguity, of participation in the material symbolization of fatherhood. Taking the daughter away from the father without providing his own "way," his own house of bread, the husband cannot but fail to replace the father. Once arrived at his house, there will be no bread for the mouth, only the mouth of the knife that will cut and separate, not bond and share.

The mouth of the s/word is, in Judges, the site of the materiality of language as a mediation between symbolic fatherhood and its material anchoring in the daughter's body. Bread, or corn,[33] or the water that allows it to grow is virtually the positive side of the contiguity to be established, but it is unsuccessful because the speech act misfires. The sword as well as the penis of the rapist is the negative side of the same attempt: one group, line, contiguity is established through separation from the other. The priority of the word itself uttered by the mouth of the father who is so forcefully motivated to use force as speech is betokened in the core speech act of the failing father: Jephthah's vow, which does not feed the mouth, but kills through it.

Jephthah's *shibboleth* device was an attempt to tell one group from the other. To tell, in this sense, is to differentiate, to discriminate. The act is the one that gave the book of Judges its title, explicit in the Greek version: *krittein*, to judge. It is also, to differentiate, the etymological meaning of critique. The more usual sense of "to tell" is: to produce narrative, to recount. *Shibboleth* seems, in this light, a failure to match the speech act of judgment, of differentiation, with the speech act of narration that is the speech act par excellence of memory; the speech act, also, that brought forth the book of Judges. If memory is the asset of maleness, if knowledge is the token of fatherhood, judgment is the decisive speech act that arbitrates between failed and successful attempt to actualize, to materialize, fatherhood. Judgment is the ideal that is replaced, by the powerless father, with the mouth of the s/word. In this sense, the *gibbor* is not a judge, in spite of his status as head. *Gibbor*-ship as represented by Jephthah is, rather, a reversal of judgeship—its impotence.

The cutting quality of the word that is meant to establish contiguity, the contiguity of ideal fatherhood and that, like fire, hovers between being thing or event, is linked to, placed in contiguity with, the site of "true" or "proper" contiguity: the house. The house is the word's other side, the materialization of the word whose materiality can only cut, not bond. It is the word's stake, as the site of fatherhood, betokened by the daughter's bondage in it. And it is the word become

stone, its unavoidable realization, the hard aspect of the fugitive word used to produce meaning, permanence, memory. The narrative of Judges is, if about anything, about building the house, an enterprise that turns out to be highly problematic since the social structures that are to be its foundation are shaken.

This meaning of the book is generated by the characters' speech acts, not by the narrator's discourse. The story is not told; it is *done*. Beginning with Achsah's gift and gesture, the story becomes a story proper, a story with a future, at the moment of Samson's riddle. Kallah's death, Bath's sacrifice, and Beth's utter destruction string the episodes together. Beth's rape is the climax of the violence and of the narrative. If we can conceive of the final composition of the book as one narrative at all, it is thanks to, not in spite of, chapter 19—the chapter that critics tend to eliminate, teachers to skip, and believers to disbelieve.

Notes

Originally published in *Literature and the Body: Essays on Populations and Persons,* edited by Elaine Scarry (Baltimore: Johns Hopkins University Press, 1988), 1–32. I am grateful to the Gemäldegalerie, Dresden, the Metropolitan Museum of Art, Robert Lehman Collection, and the Kupferstichkabinett, Berlin, for permission to reproduce the Rembrandt works.

1. This form of marriage is known in anthropological literature under different names, all equally mystifying. As early as 1929, Morgenstern enumerates all the cases he sees in the Hebrew Bible, without however discussing the consequences of his discovery for the interpretation in "*Beena* Marriage"; see also "Additional Notes on *Beena* Marriage" (1931). I contend that the words traditionally rendered as "concubine" (*pilegesh*) and "prostitute" (*zonah*) refer to a patrilocal wife. Although I object to Morgenstern's idealizing term "matriarchy," the integration of this type of marriage in biblical interpretation has far-reaching consequences. See my *Death and Dissymmetry* (1988a).

2. Felman (1980).

3. Scarry (1985).

4. Sedgwick (1985).

5. Austin (1975).

6. The power to misunderstand is crucial not only because it entails a position of participation in the communication process. Misunderstanding is, as Culler argues in *On Deconstruction* (1983), a central aspect of semiosis. Where Eco (1976) defined signs as everything that can be used in order to lie, Culler stresses the other side of the same definition: it is everything that can be misunderstood. The Bible provides a good case.

7. For an analysis of Samson's riddle, see Eissenfeldt (1910).

8. In the literature on vows in the Hebrew Bible, no connection is established with the riddle, while all the vows have arguably such a relation. See, for example, Brams (1980) and the popular Davies (1962).

9. The distinction between asymmetry and dissymmetry is crucial for this essay. The word *asymmetry* refers to an absence of symmetry, while *dissymmetry* refers to a relevant relation

wherein the expected and "logical" symmetry is replaced with a distortion of it that allows power to take its place between the two related subjects.

10. For those who doubt this deep involvement of the "woman problem" in the episode, I refer to Rembrandt's painting *Samson Posing the Riddle to the Wedding Guests* (fig. 12.1). The work is modeled on Leonardo da Vinci's *Last Supper*, which is a significant choice. The woman is isolated in the all-male company, and depicted as utterly alone. She has the position of Christ; Rembrandt's interpretation of her victimhood is strikingly sympathetic compared to the commentaries that massively blame this victim. Rembrandt's "Sketch After Leonardo's *Last Supper*" (fig. 12.2) shows his interest in the spatial features of the work and his repetition of them in the Samson painting.

11. The noun *gibbor* is usually translated as *hero*. I argue in an earlier work that the concept needs more careful analysis. Briefly, it holds within it the ideas of power, physical power and/or political power, violent behavior, and maleness. The frequent combination *gibbor havil* is best translated as *hero of might*. The concept of hero is arguably different for each culture. Hence my decision to leave it untranslated. See Bal (1988a).

12. For this concept, see Brooks (1984). Although Brooks tends to bypass the role of women as motors of the narrative, his idea if elaborated in that direction can be useful precisely for a gender-specific approach to traditional narrative.

13. We have here an obvious case where neither ethnocentrism nor cultural relativism can solve the problem; the event is clearly in accordance with social traditions and can only be criticized when distance from the context is acceptable. I do not want to argue that it should not be criticized; it should be, however, on a different level than the other events that I call "improper." It is only when a distinction such as this is carefully made that we can establish the system of values inscribed in the book, which is a prior condition even for beginning a critique.

14. The three phrases are *na'arah,* young girl, approaching physical maturity yet in full possession of the father; *bethulah,* the state of transition, of full ripeness, ready to be handed over from father to husband; and *'almah,* just married, not yet pregnant, handed over to the husband. The very existence of these three concepts shows that the handing over of the daughter from father to husband is a crucial event that influences not only the lives of the young women but also the social structures that define the power relations between men.

15. See for a typical interpretation of the scene as repressed sexuality, Zakovitch (1981). The article is interesting also for the blindness it displays. Focusing on a possible sexual interpretation, the author fails to notice the *problematic* aspects of sexuality—its less glorious aspects, like a fixation on the mother—that his very evidence clearly suggests. See Bal (1988b).

16. There is here again a question of the evaluation of a different cultural practice. The first of the two abduction scenes implies so much violence, however, that the negative value judgment, if implicit, is not impossible. For the problem of evaluation free of ethnocentrism, see Fabian (1983) and Lemaire (1978).

17. Given the subject of this essay, it seems appropriate to translate the expression literally and replace the more usual English expression, "the edge of the sword," by its Hebraic counterpart.

18. Cohen (1980, 160).

19. Jephthah's visual confrontation with Bath at the moment of the revelation of the identity of the victim can be compared to these two other scenes of focalization. Jephthah does also, in a way, ignore his daughter, since he says that he himself is destroyed. He then blames her for

his destruction. This confusion of self and other points to a problem that we also see at work in Freud's "Taboo of Virginity": the incapacity to separate, as both the cause and the acting out, in the writing, of the taboo. See Bal (1988a).

20. Patrick D. Miller Jr., drew my attention to this verb, whose significance for the construction of the "countercoherence," the social interpretation, is considerable. His thoughtful and sympathetic response to a previous version of this analysis has been an important encouragement to me.

21. Explaining the story of Beth as etiological, as an explanation a posteriori of the intertribal war, is an act of manipulating the political coherence into a position of dominance that is by no means justified. The fallacy it rests on is betrayed by the "rest" the interpretation leaves out: it does not explain why intertribal war is integrated into a narrative claimed to be about external war.

22. Niditch (1982).

23. Alter (1984).

24. In *La volonté de savoir* (1976), Foucault convincingly argues the inseparability of language and sexual experience, indeed, the formative effect of the former on the latter. It is obvious that Alter misses this relation. As a result, he comes close to the illogical, and actually homophobic, assumption that the entire population of the town of Sodom was driven by homosexual desire. The repression of the linguistic presence of homosexual rape in Judges 19, on the other hand, is also evidence of the realistic fallacy.

25. In a certain sense, the rejection of her can also be seen as abjection. See Kristeva (1982).

26. The narrator says: "besides *him* he had son nor daughter," and the commentators are quick to "correct" the error into "besides her." Too quick; they miss the point of the whole book.

27. Felman (1980, 151).

28. The idea of "exclusive possession" of a woman comes from the opening sentence of Freud's "Taboo of Virginity" (1918): "The demand that a girl shall not bring to her marriage with a particular man any memory of sexual relations with another is, indeed, nothing other than the logical continuation of the right to exclusive possession of a woman, which forms the essence of monogamy, the extension of this monopoly over the past." This statement and its "logic" are the best formulation of what is at stake in Judges.

29. See Dällenbach (1977) for a theory of this figure that denotes the miniature within a narrative. For a critique of that theory, see Bal (1986, chap. 4).

30. Derrida (1986, 344).

31. In *Murder and Difference* (1988b), I have analyzed the theory of Wolfgang Richter, *Traditionsgeschichtliche Untersuchungen zum Richterbuch* (1963), which is generally accepted (see, for example, Mayes 1983). The theory is not only based on a circular argument, but is also clearly devised in order to get rid of the disturbing case of Deborah. It is interesting that Jephthah is presented not as a counterargument, since he "cuts through" the distinction, but as central evidence.

32. Trible (1984).

33. It is interesting that two of the many possible meanings of the meaningless word *shibboleth* are "ear of corn," which relates it to Samson's destruction of the crop that kills Kallah, and "stream of water," which recalls Achsah's claim and, by antithesis, Bath's sacrifice as a burnt offering.

References

Alter, Robert. 1984. *Motives for Fiction*. Cambridge, MA: Harvard University Press.

Austin, J. L. 1975 (1962). *How to Do Things with Words*. Cambridge, MA: Harvard University Press.

Bal, Mieke. 1986. *Femmes imaginaires: L'Ancien Testament au risque d'une narratologie critique*. Paris: Nizet.

———. 1988a. *Death and Dissymmetry: The Politics of Coherence in Judges*. Chicago: University of Chicago Press.

———. 1988b. *Murder and Difference: Gender, Genre and Scholarship on Sisera's Death*. Translated by Matthew Gumpert. Bloomington: Indiana University Press.

Brams, Steven J. 1980. *Biblical Games: A Strategic Analysis of Stories in the Old Testament*. Cambridge, MA: MIT Press.

Brooks, Peter. 1984. *Reading for the Plot: Design and Intention in Narrative*. New York: Knopf.

Cohen, A. 1980. *Joshua. Judges: Hebrew Text and English Translation*, with introductions and commentary. London: Soncino Press.

Culler, Jonathan. 1983. *On Deconstruction: Theory and Criticism After Structuralism*. London: Routledge & Kegan Paul.

Dällenbach, Lucien. 1977. *Le récit spéculaire: Essai sur la mise en abyme*. Paris: Editions du Seuil.

Davies, G. Henton. 1962. "Vows." In *The Interpreter's Dictionary of the Bible* 4:792–93.

Derrida, Jacques. 1986. "Shibboleth." In *Midrash and Literature,* edited by Jeffrey Hartman and Sanford Budick. New Haven, CT: Yale University Press.

Eco, Umberto. 1976. *A Theory of Semiotics*. Bloomington: Indiana University Press.

Eissenfeldt, O. 1910. "Die Rätsel in Jud 14." *Zeitschrift für die Alttestamentliche Wissenschaft* 30:132–45.

Fabian, Johannes. 1983. *Time and the Other: How Anthropology Makes Its Object*. New York: Columbia University Press.

Felman, Shoshana. 1980. *Le scandale du corps parlant: Don Juan avec Austin ou la séduction en deux langues*. Paris: Editions du Seuil.

Foucault, Michel. 1976. *La volonté de savoir*. Paris: Gallimard.

Freud, Sigmund. 1918. "Taboo of Virginity." In *The Standard Edition of the Complete Psychological Works*. Vol. 11. Edited by J. Strachey, 191–208. London: Hogarth.

Kristeva, Julia. 1982. *Powers of Horror: An Essay on Abjection*. New York: Columbia University Press.

Lemaire, Ton. 1978. *Over de waarde van culturen*. Baarn: Ambo.

Mayes, Andrew D. H. 1983. *The Story of Israel between Settlement and Exile: A Redactional Study of the Deuteronomic History*. London: SCM Press.

Morgenstern, Julius. 1929. "*Beena* Marriage [Matriarchat] in Ancient Israel and Its Historical Implications." *Zeitschrift für die Alttestamentliche Wissenschaft* 47:91–110.

———. 1931. "Additional Notes on *Beena* Marriage [Matriarchat] in Ancient Israel." *Zeitschrift für die Alttestamentliche Wissenschaft* 49:46–58.

Niditch, Susan. 1982. "The 'Sodomite' Theme in Judges 19–20: Family, Community and Social Disintegration." *Catholic Bible Quarterly*, 367–68.

Richter, Wolfgang. 1963. *Traditionsgeschichtliche Untersuchungen zum Richterbuch.* Bonn: Peter Hanstein Verlag.

Scarry, Elaine. 1985. *The Body in Pain: The Making and Unmaking of the World.* Oxford: Oxford University Press.

Sedgwick, Eve Kosofsky. 1985. *Between Men: English Literature and Homosocial Desire.* New York: Columbia University Press.

Trible, Phyllis. 1984. *Texts of Terror: Literary-Feminist Readings of Biblical Narratives.* Philadelphia: Fortress Press.

Zakovitch, Yair. 1981. "Siseras Tod." *Zeitschrift für die Alttestamentliche Wissenschaft* 93:364-74.

13. Lots of Writing

Introduction

Esther's dramatic second banquet in the book of Esther, one out of many mentioned in the story, has understandably attracted painters; drama is a visually representable form of narrative.[1] Rembrandt's 1660 painting *Esther's Banquet,* in the Pushkin Museum, Moscow, is my favorite painting on this subject, but precisely because it does not enhance the scene's narrativity or its dramatic tension (fig. 13.1). The three figures who, in the biblical story, are engaged in the most dramatic interactions with one another are each rendered here as if cocooned within an invisible veil, self-absorbed, silent, and isolated from the others.[2] Moreover, Haman, who is facing Esther, seems to be blind (fig. 13.2).

Another painting by Rembrandt, *Haman's Downfall,* dated 1665 and currently in the Hermitage, St. Petersburg, represents the next episode in the Esther story, the downfall of the plotter (fig. 13.3). Haman is strangely represented as almost literally falling forward, about to topple toward the viewer as he quits the scene; and here there is no doubt about his being blind (fig. 13.4).[3] In this work, the scene is even more strikingly drained of its narrativity; with Esther absent and Mordecai present, it is not the narrative event itself, but rather its proleptic meaning—Haman's displacement by Mordecai—that is represented.

Rembrandt is generally considered a narrative painter, exceptionally so even for a Dutch artist (see Alpers 1985), but here, in representing a lively, highly dramatic scene, he has eliminated movement from the image. In this still medium, the figures are emphatically arrested, as if to represent the stillness of visual art itself. And once self-reflexion becomes a mode of reading these paintings, another, more complex type of reflexivity is activated, one which courts paradox. On the one hand, due to its representation in a wordless medium, the scene's emphasis falls on speechlessness, the lack of communication between the figures mirroring

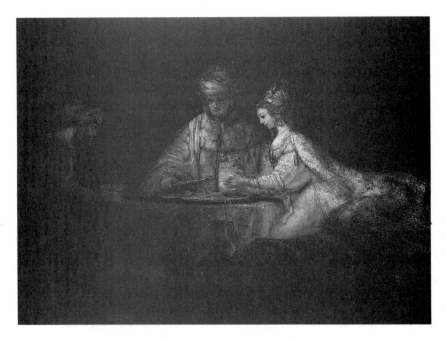

FIGURE 13.1 Rembrandt van Rijn, *Esther's Banquet,* 1660. Courtesy of the Pushkin Museum
of Fine Art, Moscow.

the non-linguistic quality of a painting. In the text, on the other hand, direct dis-
course—speech—is used to dramatize climactic confrontations. Both works are,
in this respect and in contrast to each other, self-reflexive, articulating the truth of
their medium at the moment of diegetic truth. Neither work appears to make any
use of food, the pretext for the banquet. But there is more.

The episode of Haman's downfall, following Esther's masterly plotted de-
nunciation, offers a different, negative relationship to the respective media, a sys-
tematic inversion or countermirroring. In the visual text (i.e., fig. 13.3), blindness
acquires a particular status that challenges the very visuality on which it is based,
a status paralleled by the description of this scene in the New English Bible: "At
that Haman was dumbfounded" (Est. 7:6).[4] Where sight falls in the visual work,
words fail in the verbal one.

The failure of both sight and speech is reflected in the following remarkable
statement: "The word left his [the king's] mouth, and they covered Haman's
face" (7:8).[5] The king verbalizes what he sees, and his word causes Haman's face
to be covered. Words are things that do things here, to paraphrase J. L. Austin
(1975); words are the principal agents of this narrative. In causing Haman's face

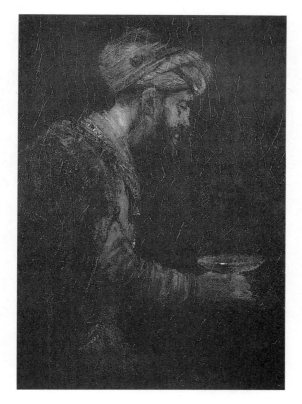

FIGURE 13.2 Detail of *Esther's Banquet*.

to be covered, words blind him; the inability to see thus enters the verbal scene, just as in *Esther's Banquet* (fig. 13.1), the visualized figures are unable to speak. Hence, Rembrandt foregrounds only what is already in the text, and the neat distinction between speech and vision falls flat. Rembrandt's paintings enable us to better read the text by demonstrating how it has already been read.[6]

I shall use these paintings as a gloss on the book of Esther, approaching the text from the perspective of Rembrandt's interpretations of it. Assuming that the realm of visual representation has its own devices for supporting interpretive claims, I shall endorse its heuristic power and accept that it has something to add that verbal argumentation might well, so to speak, fail to see. What, then, is Esther's feast? As we shall see, it is a feast of writing, and its relation to Purim lies in its expression of the tension between writing and randomness, between agency and luck, or lot.

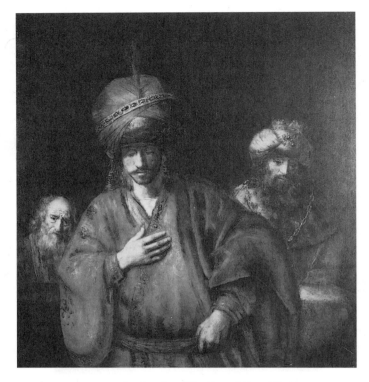

FIGURE 13.3 Rembrandt van Rijn, *Haman's Downfall*, 1665.
Courtesy of the Hermitage, St. Petersburg.

Writing is precisely the mediator between sight and speech. Using the representational system of language as its code, writing requires sight in order to be processed, that is, for what Roman Jakobson called its phatic function. The Esther scroll is a celebration of writing and, as the climax of the story, so is Esther's banquet. Lot(s) of writing happen(s) in Esther, and writing is where words and images, the visual and the verbal, converge; where, specifically in Esther, fate and agency, randomness and history, Providence and plotting dovetail. Writing is also, of course, the medium that produced the book of Esther.

In Esther, writing both partakes of and struggles against the lots that allegedly gave Purim its name. For, as is often the case in biblical literature, the celebration is a working through of the ambivalence associated with what is being celebrated. And there are plenty of reasons to feel ambivalent about writing. While it is commonplace in cultural anthropology to consider the invention of writing the inaugurator and index of civilization, what has also been acknowledged is that the careful political management of literacy has contributed to oppression and to the

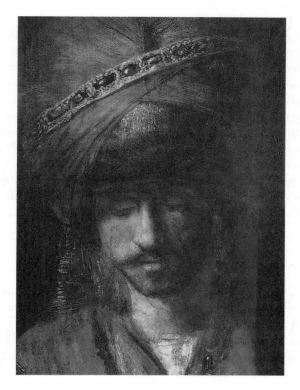

FIGURE 13.4 Detail of *Haman's Downfall.*

centralization of state power.[7] Writing has been a tool of the elite, a means of en-
forcing inequity and exploitation, of promulgating ideology through religion,
and of generalizing laws; it has definitively impressed upon its practitioners a par-
ticular view of history that rendered collective memory futile and undermined
the participation of the masses in oral history—all of which can be thematized in
a political reading of Esther.[8]

In political terms, the pronounced centrality of writing and the efficiency of
the Persian postal system corresponded to the king's rule over many peoples, that
is, to both the appropriation of power and the abuse of power for the (attempted)
destruction of a particular people and their culture. Writing was the instrument
of a real, historical threat (Haman's first decree). In epistemological terms, Plato
described (in the *Phaedrus*) the destructive effect of writing on memory, which
was usually associated with the breakdown of archaic, small-scale "democra-
cies." As it happens, in Esther the displacement of memory by writing also oc-
curs, in the chronicle of Mordecai's deed, but it is enacted by Ahasuerus, the very

ruler whose centralized and autocratic power extended "from India to Ethiopia."
His failing memory should not be too hastily ridiculed—a ridicule so often based
on a contemptuous presumption of little psychological depth or realistic plausi-
bility in ancient texts that it cannot avoid the charge of anachronism, if not arro-
gant evolutionism.[9] Instead, the king's poor memory should be seen as a reflex-
ion of the inevitable but ambivalent shift toward the predominance of writing
staged by the text. But if Esther is about writing, however, it is also about itself.

Given the centrality of writing in the book of Esther, self-reflexion seems a
relevant concept with which to approach the text, and the two Rembrandt paint-
ings indicate that this text's reflexivity may be highly complicated. In reflecting
upon the possible uses of self-reflexion here, I shall therefore propose that it
yields a perspective on Esther that extends beyond the question of the historical
connection between "lots" and Purim.

Self-Reflexion

Self-reflexion is too fashionable a concept to be endorsed unreflectively. If the Es-
ther scroll centers on writing, then it may be considered a self-reflexive text; and if,
as I shall argue, Esther reflects the uncertain status of writing and the ways in
which writing produces reality—the reality of the threat to and the salvation of the
Jews—it may represent a case of postmodernism *avant la lettre*.[10] Is this pushing
anachronism too far? This question can only be answered in connection with the
very problematic of self-reflexion, for I will argue that the concept's appeal for
contemporary criticism is precisely its ambiguity, which frees representation from
its ties to the psychological realism of nineteenth-century Western fiction.

Notions of self-reflexion are not only popular in literary criticism, due to the
impact of postmodern literature and deconstructionist writing; they have also be-
gun to circulate in art criticism, particularly with respect to the visual arts. Fou-
cault's remarks in *The Order of Things* at the end of his chapter on Velázquez's
Las Meninas beautifully expresses this mode of reading:

> Representation undertakes to represent itself here in all its elements, with its
> images, the eyes to which it is offered, the faces it makes visible, the gestures
> it calls into being. . . . Representation, freed finally from the relation that was
> impeding it, can offer itself as representation in its purest form. (Foucault
> 1973, 16)

The specific relevance of visual art to a discussion of self-reflexion stems from the
representational imposition of the *subject*: while literature can be about *itself*, en-

abling critics to ignore the reader, self-reflexive visual art imprisons the *viewer*. This distinction invites a more complex interrogation of the concept and enables us to historicize it, too. For transposed to the literary text, within the framework of a reading-oriented theory of texts, self-reflexive reading entails a complication: Whose/Which self is being reflected? The identity between the work and its subject—between work as labor and work as product—is not unified; it is fragmented by the intrusion of the reader, whose position is inherently paradoxical: Is she or he part of the self that is being reflected or reflected on? If so, then the self-reflexive mode of reading, in which the reader is subsumed by the work, would not encourage reader reflexivity. The self would remain whole, while only the reflexion became fractured; if the reader were not part of the self being reflected (on), then the self would be disrupted from the start, and, again, reader reflexivity would not be encouraged. What I contend is that this obliteration of the reader dehistoricizes the critical endeavor even if, or precisely when, its overt aim is historical reconstruction.

This mode of reading is made double-edged by its relationship to narcissism. As an effectively anti-realistic strategy, it is a means of reading for the work itself or, to use Linda Hutcheon's term, for the "narcissism" in the work (1982, 1988). Resonating with its mythical, visual, and psychoanalytic connotations, "narcissism" also invokes the particular pictorial quality and the erotic near-gratification of self-reference. In the book of Esther, the reader is constantly reminded of the connection between visual beauty and power during the main character's adventures; once the instability of writing becomes the central theme for the self-reflexive reader, the power of beauty and the power of writing are enmeshed, and, as I shall argue, even the conventional gender division is destabilized.

The paradoxical entanglements contained by the concept of self-reflexion were particularly visible in the heated debate of 1980–81 that arose over Velázquez's *Las Meninas* between philosophers and art historians, which I have analyzed elsewhere (Bal 1991). As mentioned already, Foucault, a philosopher and hence a professional discursive self-reflector, opened his study of the classical age with a thirteen-page reflection on this painting.[11] He saw the work as inscribed with the invisibility of the viewer, whose place is taken by the royals—a view that to me suggests an unexpected symmetry between the seventeenth-century Spanish painting and the ancient Hebrew text, in which the royal position is taken over by the outsider, Esther the Jewess. John Searle (1980), a philosopher, significantly, of language and hence of discourse, saw the work as typically paradoxical precisely because the viewer could *not* be (yet *must* be) in the same place as the royal couple. The term "paradox" upset two critics[12] and amused others, thus provoking a series of responses, both to Searle's interpretation and to the painting itself.

These responses focus on the position of the viewer in relation to the mirrored image of the king and queen at the center of the work. The debate itself forms an appropriate intertext for self-reflexion because, at least in the articles by Searle and by Snyder and Cohen, there is a striking discrepancy between the positions that these critics espouse in their discursive reflections and those that they reflect—mirror—in their discourse. This discrepancy points to the argumentational "other," the connotative rhetoric of the texts. In other words, the critical texts lend themselves to the kind of specular and speculative reflexive reading that makes self-reflective reading genuinely relevant to critique. However, such a reading strategy might also lead to a complacent sense of triumph, a self-congratulatory pleasure in discovery. In other words, once self-reflexion becomes common practice, reading for "narcissism" is at risk of becoming narcissistic itself. What gets lost is a perspective on the historical position of self-reflexion, and that is, indeed, a powerful argument against this mode of reading, to which we will have to return.[13]

As I have suggested, self-reflexivity is a mode of reading that seems paradoxical because it leads the interpreter to submit to a position ostensibly determined by the work. As in a Hegelian master-slave dialectic, the reader is so overwhelmed by an apparently triumphant "discovery" of self-reflexivity that s/he tends to abandon his or her own position for the self-reflexive one that the work seems to propose, thereby forfeiting the self-reflexion of the viewing or reading subject. But if reflection of/on the work entails reflexion of/on the viewer's position, then any submissive response is paradoxically non-submissive: it refuses to obey the command of reflection. In other words, an order of non-submission can be neither obeyed nor disobeyed. This paradox mirrors Esther's position at the moment in the narrative when she is ordered to disobey (Est. 4:8–17).[14] The question of obedience as a paradox, not as a neat opposition between the "good" obedient queen and her "bad" disobedient predecessor, is thematized throughout the narrative. Bound to obey both her relative and her husband, Esther is forced to disobey both men in order to obey, thereby emancipating herself from the power of the two men and of their writing. Reading the book of Esther self-reflexively elicits a comparable compromise, that is, one must read the text anachronistically (say, postmodernistically) in order to gain a perspective on history—on Esther as neither realistic nor postmodern, but as the historical "other."

The paradoxes and possible confusions proffered by the concept of self-reflexion are produced by the ambiguity of *both* parts of the term: self and reflexion. The former requires the reader to consider which self is reflected, that of the work or (and?) that of the reader. Assuming that self-reflexion risks the reader's entanglement within the work, it must endorse the reflection of/on *both* selves. This is suggested by the ambiguity of the word "reflection," meaning both (vi-

sual) mirroring and (discursive) thinking.[15] Self-reflection as mirroring suggests the Lacanian mirror stage as an early, visually based construction of the self *in* self-alienation, while discursive self-reflection/reflexion invokes self-critique.

The two ambiguities of the word "reflection," coupled with the corresponding pair of selves to be reflected, yield four possible positions, which together comprise a useful typology of self-reflection/reflexion. The mirroring and the analytical, discursive forms of reflexivity differentiate between an unreflective, possibly unconscious, doubling of the work and a conscious position toward the work that problematizes representation. In the first case, there are again two possibilities, depending on the meaning of "self" involved.

1. *The fantasmatic position.* Here, the critic responds to the self of the work only, viewing it as radically other and leaving him- or herself safely out of reach—or dangerously unconscious. This is Haman's mistake when (in Est. 3:6) he fantasmatically projects his rage at Mordecai, over a purely personal insult, onto the Jews at large, generalizing Mordecai's insult as Jewish insubordination. Seeing Mordecai as the mirror of his people, Haman fails to see the mirroring relationship between himself and Mordecai, that is, the reversibility of their relative positions. This failure to see (himself) is Haman's *lot*, his *pur*, which will foil his plot because it undermines his autonomy as an agent.

2. *The narcissistic position.* If, by contrast, the two selves are conflated in the mirroring, while the reflection remains non-reflexive (i.e., non-analytical, non-discursive), the result will be symptoms of primary narcissism, as described by Lacan (1979). This mode of self-reflexion can be read in the self-absorbed isolation of the three figures in each of the Rembrandt paintings. It is obviously also operating in Haman's childish dream of grandeur, in which he can imagine only himself as the object of the king's honoring (Est. 6:6–8). This is why Rembrandt's Haman is blind: already curbed in the first painting (fig. 13.1), he loses his balance and falls down in/out of the second (fig. 13.3). The discursive mode of self-reflexion, which entails that one take an explicit position on the reflexive qualities of the work and the self, can likewise assume two distinct forms.

3. *The theoretical position.* If reflexivity is limited to the self of the work, the work will be viewed as a theoretical statement about representation. The text or painting thus becomes a theory, as *Las Meninas* becomes a theory of classical representation. The letters in Esther become statements about writing and its prevailing relationship to reality (e.g., Est. 1:19). The critic who observes that "conveniently, Esther seems to know nothing of the irrevocability of Persian law" (Murphy 1981, 167) endorses this self-reflexion unreflectively; for him, apparently, writing reflects reality, and everything else is subsumed by this certainty.

4. *The metacritical position.* The second form of discursive reflexivity (and the fourth mode of self-reflexive reading) is one in which discursive, reflexive

Ruth and Esther

self reflection	self excluded	self included
visual mirroring	1 fantasma (3.6)	2 primary narcissism (6.6-8)
discursive reflection	3 text = theory (1.19)	4 metacriticism (8.5)

FIGURE 13.5 Reading reflexivity in the book of Esther.

reading involves both the self of the work—the way in which it problematizes itself as representation—and the self of the critic, whose position as, say, an art historian or a philosopher is also subject to reflexivity. This type of self-reflection/reflexion requires that the splitting of the agency of writing staged in the narrative be viewed as a representation of the critic's position. In this mode of self-reflection/reflexion, our model is not the blind Haman but the (in)sight(ful) Esther, whom Rembrandt represents as fully aware of her isolated position, yet who accepts her split subjectivity, adopting Mordecai's position and risking death to save the lives of her people. Reading Haman's decree "properly" as not only a reflection of reality, but also an opportunity for intervention, given writing's inscription of delay (see below), while also recognizing the embeddedness of subject positions, Esther sees that she must rewrite the fate of the Jews (Est. 8:5). Hers is the position that the critic would do best to mirror (see fig. 13.5).

This mode of reading has two major problems, one of which, its generality, may be countered by specifying self-reflexion according to this systematic analysis. The second problem, its lack of historical awareness, is more difficult to remedy. I would contend, however, that this approach to the book of Esther is historical in two ways. First, by committing this blatant anachronism, the historical position of the critic is at least foregrounded, which is precisely what does not occur in less overtly anachronistic readings (see n. 9). Thus the unity between text and critic that is the basis of most criticism is disrupted, leaving room for historical awareness, including awareness of the impossibility of historical reconstruction. Second, it is impossible to identify writing as a major theme of the narrative

without acknowledging writing's relation to power, and thus acknowledging the anthropological view of writing as the beginning of history. In other words, any analysis of writing will be necessarily reflexive, or self-historicizing, hence the product of the fourth mode of self-reflexive reading: the mirroring of history in criticism. This mode requires discursive reflexivity, which posits the historical positions of text and reader in relation to each other.

The historical position of the reader relative to the text that I would advocate is less committed to (illusory) reconstructions of the past than to an awareness of difference in similarity. Along these lines, I have argued elsewhere (Bal 1987) that the unstable beginning of patriarchy (as represented in Gen. 2–3) is visible from the vantage point of the equally unstable end of patriarchy that we are currently witnessing. Similarly, the emphasis on writing in Esther betrays its unmarked status there, a status that is shifting today as writing becomes marked, or visible, again. Today, writing is no longer considered self-evident, no longer "taken as read." The exercise of power through writing, as (em)plotted in Esther, becomes visible and can be more readily problematized in an age of letter bombs, when the reach of the sender, hence of the power holder, is manifested in and extended by an information-technology revolution. Our faith in the irrevocable nature of writing has been destabilized by computer technologies that enable us to alter or even delete what is written, to falsify records, to do what Esther does: to overrule in practice what was irrevocable in theory, using similarity for difference (cf. Est. 3:12–15; 8:9–11). Self-reflexion thus dictates, for the ancient author as for the modern critic, that writing (the book of) Esther is to (con)textualize Esther writing.

Esther Writing Esther's Writing

Lots, laws, banquets, and letters: these are the devices deployed in the plot of Esther. All are inversions (or perversions) of their standard functions, which enable them to become agents, controlling the characters who (mis)handle them. Lots are perverted by plots, laws target the individual instead of regulating the general, banquets function as fasts instead of feasts, and letters are disenfranchised from their senders. All four devices relate to writing: Haman's own lot is cast when his casting of lots leads to the writing of the decree, thus organizing lot randomness into plot system; laws are certainly written, but the power inherent to their status as written is seriously weakened by their lack of enforcement; banquets are occasions for the writing of decrees; and letters, of course, constitute the very embodiment of writing. But letters are also manifestations of writing's problematic status as a speech act: in fixing the ephemeral flow of speech, writing delays

(hence undermines) its efficacy. I contend that Esther can be read as a reflection on/of precisely these aspects of writing.

With respect to the two central letters, then, it is obvious that the second one reverses the first, which had been explicitly declared irrevocable (Est. 1:19). Ahasuerus's/Haman's letter decreeing the extermination of the Jews is annulled or erased by Ahasuerus's/Mordecai's letter decreeing the extermination of the king's enemies. At first reading, these two letters seem almost identical, mirroring each other with an elegant symmetry. But this mirroring is only an effect of their being paraphrased; neither letter is actually quoted in the canonical text. When they are written out, as in the apocryphal supplement, they are totally different, and, as it turns out, their symmetry is sacrificed to their inscription (see the rest of Esther 3:13; 16:12). This is a first indication that mirroring may be an illusion, that reflection needs to be reflected upon. These letters are instances of mirroring as narrative plot elements, not mirroring as texts. And if we read the letters as distinct supplements to the canonical text, encrypted by the excursus to the Apocrypha, it turns out that the second letter is not just a reversal of the first. A people is thereby supplemented ("and also for the Jews in their own script and language" [8:9]) as well as an action ("unite and defend themselves" [8:11]). Thus the diffusion of the subject of writing is enhanced.

Plot and counterplot prove asymmetrical on yet another score: one is initiated by lot, the other by reading (the first letter). The lot is a random "text" read by Haman and blindly obeyed, while the decree is a plotted text that is disobeyed. The response to Haman's decree can be read as a reflection on reading, offering an alternative to blind submission. Reading is a response, a reader-response. The letter/counterletter confrontation constitutes a reader-response theory, proposing that reading is neither fixed by nor independent of the text. Obedience to the text (of Haman's decree) would have entailed killing; disobedience to the text, in the sense of ignoring or bracketing it, would also have entailed killing. The danger of this binary opposition—between overestimating and underestimating the power of writing—is represented in the narrative by the split between Haman's fall/Esther and Mordecai's elevation, on the one hand, and the necessity of writing the second decree, on the other: that is, the second decree is not rendered superfluous by Esther and Mordecai's victory. What is needed, both to save the Jews and to preserve reading as a historically meaningful act, is an adequate reading by a competent and committed subject who disposes of autonomous agency.[16] There cannot be an exact mirroring, for there is no more symmetry between oppressor and oppressed, between attack and defense, between letter and reply than there is between subject and mirror image. With the engagement of speech in narrative, in the plot, writing can alter only what is already there.

What, then, does the written narrative of the book of Esther teach us about

writing? How can it make us more self-conscious about the writing we do about the writing it presents about writing—of letters as communicative action, of decrees as prescriptive behavior, of chronicles as delayed participation in history, of writing as mirroring the text of Esther?

Writing serves social functions, as described by anthropological critique; it is also related to narrativity and has semiotic functions. As it happens, in Esther the social functions of writing are exemplified by its narrative and semiotic functions. The act of writing is emplotted in such a way as to undermine the standard social functions of writing, as conceptualized in the orality-literacy debate, thereby inviting reflection on the politics of writing and reading.

The primary writer is (or should be in a true autocracy) the king, who uses it to exercise his authority. But even in his first letter condemning Vashti, the only one that he could conceivably have written himself, the king's exercise of power goes awry on three levels of increasing seriousness. First, on his own initiative, Ahasuerus's authority is diminished by the agency of his "wise men," who effectively undermine the authenticity of the king's writing by dictating its contents (Est. 1:19–20). Second, and as a consequence, his superior status is reduced by the elaboration of his personal humiliation at the hands of the disobedient Vashti as an insult to all men ("Queen Vashti has done wrong, and not to the king alone" [1:16]) that must be countered by a law to reinforce the authority of "*all* husbands, high and low alike" (1:20).[17] And third, Ahasuerus's authority as a male, thus revealed to be the real issue, is further undermined when Esther ends up organizing the writing (in the plot) and even doing some writing herself.[18] Hence, as if to emphasize the ambivalence of writing's complicity in the use and abuse of power, state, class, and gender are respectively undermined by writing. This is the statement on the *social* function of writing that can be read in the self-reflexivity of writing in Esther.

The *narrative* function of writing in the scroll further undermines the presumed but illusory certainties of writing. The three decrees that structure the plot stage the ambivalence of writing insightfully and in detail. The first decree, deposing Vashti, was meant to forever ensure the obedience of wives, hence ensuring male power over women in private and in public. However, its excessiveness and fearful defensiveness, possibly parodic (Murphy 1981, 159), ensure nothing but the decree's own failure, which is played out in the rest of the story. The submission of women cannot be guaranteed in or by writing, the story teaches us. Esther's initiatives embody her agency, her exercise of power against the royal rule that has stipulated the absoluteness of her powerlessness: namely, the interdiction against her being, or even *approaching*, the king. Vashti's punishment, the law of the first decree, is thus negated by Esther's symmetrical transgression.

The second decree, Haman's (p)lot, which is even less Ahasuerus's doing than the first, is equally irrevocable, but nevertheless proves to be equally futile. Haman's decree is less ambitious, more limited in scope, stipulating the submission—albeit absolute via extermination—of only a marginal segment of the population: one people instead of all wives. It is more circumspectly grounded not in "wisdom," that is, human opinion, but in Haman's version of Providence: the lot cast in his presence (Est. 3:7) to set the date for fulfilling the terms of the decree. Writing alone, this casting of lots seems to say, is too shaky a ground on which to build. But the rule of lot is countered by the Providence that Mordecai suggests to Esther (4:14). Writing, intended to fix, does not fix well enough.

Again, the narrative mode itself, constructed on the basis of temporal sequentiality, is mirrored by, and mirrors, the incidental "rests" of writing. For in the narrative, writing is used to produce danger, but not defeat; what separates the two is the temporal space of delay or deferral that, inherent to writing, undermines precisely the fixation it aims for. This delay is a crucial feature of writing, its negative feedback loop, here exploited to represent the revocability of the irrevocable. It is what makes identification among the relevant parties—writer, reader, and object—impossible, as recently argued so well in the critique of anthropology.[19] Writing's fixation entails a "not yet" that calls for a sequel and that mirrors narrative's pursuit of an ending (Brooks 1984). The narrative play of letter writing foregrounds the unwarranted pretense of writing-as-power, of what-is-written as "never to be revoked."

So crucial is this feature of delay in writing that its staging in Esther becomes almost comical in one of the episodes considered "implausible" by realist standards and as signifying the king's limited intelligence by psychological standards.[20] In addition to the letter, a communicative mode of writing, and the decree, an authoritarian mode, a third type of writing, the *chronicle,* is used in the narrative. In a "historical" narrative, this is the self-reflexive genre par excellence, as it is incorporated in another chronicle. The events narrated in Est. 2:21–23—how Mordecai saves the king—encapsulate those narrated by the Esther story as a whole—how Esther and Mordecai save the Jews, thus also saving the king's integrity. Both "third-person narratives" and historical reports, the chronicle and the scroll of which it is a part, represent something outside themselves. The chronicle is in this sense a *mise en abyme.*[21] Thus it is significant that this chronicle, necessarily written after the event, is not read, not integrated as history, not acted upon until much later. In that sense, too, the chronicle is a *mise en abyme* of this story about the delayed effects of writing.

Obviously, this chronicle story also demonstrates the negative effects of writing on memory (Plato's warning) since Ahasuerus thinks of rewarding Mordecai only when he *reads* about the event, not when it actually occurs. But rather than

interpreting this connection between writing and memory anachronistically as proof of the king's dim-wittedness, what I see here is another instance of self-reflexion. For the delay in writing exemplified by the king's forgetfulness is utterly indispensable to the narrative plot, which is in turn indispensable to saving the Jews from the dangers of writing, which is in turn indispensable to instituting Purim. Such is the lot of writing: what's discursive is recursive.

Ahasuerus's real power lies in his identity as the reader of the chronicle, and in the adequacy of his reading; his memory fails in order to motivate his real function. The written text, which was impotent before the king read it, acquires in the reading the power to force the king to act: justice must be done to/served by the writing. This self-reflexion also applies to us: as delayed readers, we are likewise called upon to see that good deeds (such as Mordecai's, which, in fact, consisted of conserving knowledge and using it to avert danger) do not go unrewarded, that people do not get destroyed.

Finally, the *semiotic* function of writing is also foregrounded in the book of Esther. If we take the Peircean typology of signs as a model not of truth, but, like the Rembrandt paintings, as a reading approach or strategy, we can view the writing in Esther as at once symbolic, indexical, and iconic, with the very fact that it fits all three categories signifying its crucial role in the text. Writing's tripartite role is also, as I hope to show, precisely what binds all the elements of the plot together.

First, writing is *symbolic,* as the first, most ambitious decree demonstrates. It is deployed in lawmaking even while it embodies the law itself. This occurs in three stages, each more expansive than the last, which turn an event into a sign, making it meaningful via repetition: (1) generalization, (2) publication, and (3) multiplication.

1. The generalization of Vashti's disobedience as a crime punishable by law makes a violation the grounds for a rule and turns a random occurrence into a precedent. Vashti's crime was thus to have *signified,* to have made possible this semiotization of her act. The ambivalence of writing immediately becomes visible again; it is part of the package, so to speak: for although the act is criminalized out of fear that it will become widespread, its being written into law actually promulgates it by publicizing the crime's meaning. Thus, fear of contagion inflates a domestic disagreement into the sign of a generalized battle of the sexes. What is reflected (upon) here, in my view, is the danger of generalization, which conjures up enemies and turns a disagreement into a war.

2. Its being written into law publicizes the event, literally—for such publication would have had much the same effect as a newspaper would today. The publication of the event is meant to make an impact on each and every household. Like the newspaper delivered to the door, the letter about Vashti would have reached all men and changed their relationships with women (Est. 1:22). Publi-

cation is the semiotic consequence of generalization and is what makes it irrevocable.

3. With publication, the writing is multiplied, sent "to every province in its own script and to every people in their own language" (Est. 1:22; 3:12; 8:9). This third stage, expansion by multiple translation, further emphasizes the semiotic nature of the ideological act of generalization. But it is also here that writing acts against itself. Thanks to the multiplication of Haman's decree, Mordecai learns of the projected pogrom and is able to counteract it, by writing back.

Second, writing is also represented in Esther as _indexical._ It is emphatically materialist, with its materiality signified by the king's signet ring. This ring, meant to produce "pure" indexes—wax impressions of the seal—becomes the means by which indexicality is perverted. On the one hand, the king's letters can be copied, but only from an original issued personally by—from the person of—the king. But, on the other hand, the copies are processed via the signet, shifted from the king's finger to Haman's (Est. 3:12). The king's mistake is precisely his removing the ring from his body, thus severing the contiguity on which indexicality is based. This is a mistake that the king later corrects: although he entrusts the recovered signet to Mordecai, he seems to monitor what is written in his name (8:8), and, in any event, no conflicts arise between what the king desires and what is written in this later episode.

By thus emphasizing the materiality of writing, the text also establishes the continuity between writing and (other forms of) body language. Dress becomes a form of communication whenever it attains semiotic status by indexical signification, such as the royal regalia worn by Mordecai during his honorary tour through the city. Haman, the writer of the plot-letter, devises this indexical code himself, when he adds to "royal robes" the emphatic index "which the king himself wears" (Est. 6:8). The signet ring, which gave him royal power, is not enough for Haman, who wants to _be_ the king, and the index is the most appropriate sign of this impossible conflation that would render signs superfluous. Thus he stipulates that iconic signification—robes that _look_ royal—is not enough.

Another instance of indexical "body writing" is the (conventional, hence symbolic) sign of royal favor expressed by touch. This index is doubly coded: the king holds the scepter, thus extending his body as the (symbolic) sign of his power, and the scepter touches Esther. It may be sheer coincidence that this tool by which the king enacts his connection to his subject bears an iconic relation to the phallus, likewise coded as power, but, in any case, the scepter also resembles the writing tool, the use of which will later be granted to Esther.

Third, writing is _iconically_ meaningful in this text. With its publication, the decree is displayed, a display foreshadowed by the demonstration of wealth as power at the first banquet. As a means of controlling the future, by decree, and of

preserving the past, in the chronicle, writing also iconically signifies fate: Providence as opposed to chance. In the case of both writing and fate, certainty is dependent on some agency. What is written can be annulled by a timely intervention (thanks to the delay inherent to writing in general and to narrative in particular), just as the lots cast can be counteracted by plotting, and Providence aided by courage and wit. These iconic meanings of writing, then, strengthen the connections among the different plot elements already produced by symbolic and indexical signification. The semiotic functions of writing help us to read Esther as a meaningful, relevant statement about writing's interactive nature: just as writing requires reading, so does the book of Esther require readers.

But if the self-reflexive text thus encourages (discursive) reflection on the act of reading, the resulting self-reflexion entails reflecting on the agent, or subject, of that act. It seems meaningful that the writer of the story's last letter is the one whose very existence as a subject needed to be written first: Esther, touched by the royal scepter, ends this narrative of writing with an act of writing-as-power: "And Queen Esther and Mordecai the Jew wrote, giving full authority and confirming this second letter about Purim" (9:29). The narrative has accomplished its remarkable movement from the king whose authority has already been undermined to the powerful woman who began this narrative in a state of utter powerlessness, as orphan, woman, commoner, foreigner. This narrative also moves from the randomness of lots to the organization of Purim by writing, lot's counteraction. But it took the entire narrative to reveal Esther as a fully realized agent, or subject. For subjectivity is by no means self-evident.

The Subject of Writing

Foucault's remarks on *Las Meninas* provoked the question, Whose self is reflected in self-reflexion? As it turns out, the book of Esther adds a new dimension to this question, for, to begin with, it stages the question's unanswerability. The male subject is represented as dispensable, shifting, and unstable, with writing as the locus of this representation. The female subject, on the other hand, blatantly dispensable at first, is also the one to reemerge, strengthened, and ultimately to take over, albeit as a result of the instability of subjectivity.

In order to comprehend the view of subjectivity entailed by this self-reflexive text, it is necessary to reject the realist and psychological readings to which Esther has been traditionally subjected. I propose to avoid the temptation to see the characters in terms of psychological plausibility by foregrounding their functional status. What then becomes obvious is that, as narrative agents, the characters are both unstable and interchangeable. For example, Vashti is integral to the

production of Esther. The plot requires the elimination of Vashti in order to open up a space for Esther to fill. But there is more to the narrative function of the first queen. As an agent of ideological reflexion, she must be eliminated for the sake of the ideology of male dominance. But Vashti is eliminated only to be restored as Esther, who takes her place and avenges her by reformulating disobedience as achieving power. Vashti's refusal to be an object of display is in a sense a refusal to be objectivized, hence to be robbed of her subjectivity. Esther's insistence on appearing before the king and using the tools of display to do so ("On the third day, Esther put on her royal robes" [5:1]) is the positive version of Vashti's negative act; Esther appears not for show but for action, not as mere possession but as self-possessed subject; finally, to drive this continuity between Esther and Vashti home, it is Esther who then makes the king appear at her banquet.[22]

Similarly, Haman, in all his wickedness, is necessary to the production/motivation of Mordecai and his counterplot. Although he seems to come out of nowhere in Est. 3:1, without Haman and his (p)lot we would have no narrative, hence no Purim. It is highly appropriate, then, that the name of the festival is derived from his initial act. Haman's introduction as a newcomer rather than as one of the established characters can be seen as a narrative stratagem to avoid too much monitoring of Esther's behavior by the enraged wise men (Est. 1:16–22).

Esther and Mordecai serve to produce and motivate each other: without Esther, Mordecai would have no access to the court; without her cousin, Esther would have no access to news from the city. Both sources of information are necessary to make up for the defects of writing. The narrative production of characters makes a psychological reading both futile and mystifying. Such a reading obscures the very issue that is foregrounded by this narrative: the instability of subjectivity.

With this in mind, it is easy to see that writing is the semiotic act par excellence in which the subject is destabilized, and, again, Esther exploits that destabilization for its plot. Indeed, the awareness of historical discrepancy helps us to reflect on the historicity of the very notion of subjectivity. As Derrida reminds us, the notion of writing as expression of the self is a modern one, emerging with the pre-Romantic individualism of Rousseau, and may itself be symptomatic of the loss of the self in writing. It seems to be a nicety of history that this same Rousseau used himself as a weapon against the law which decreed a *prise de corps* (!) against him. And, as Peggy Kamuf recalls, it is in and through the signature, considered indexically contiguous to the body of the writer, that the illusory stability of the subject/writer is signified. The need for the signature is the need for indexicality.

But the Esther narrative severs the tie between signature and subject. The shifting of the signet ring from body to body is the narrative representation of the subjective instability that writing promotes. Kamuf rightly emphasizes the *even-*

emential status of the signature, its narrativity, when she observes that "signature occurs in a difference from itself and an address to the other" (1988, 18). The writings in Esther dramatize this mobility of the subject/writer. The chronicle (2:23), for example, has no subject. Lacking a represented self—a chronicle is a "third-person" narrative in which the thematic subject, the agent of the events, is what's written about in a so-called objective presentation—the chronicle also lacks a signature: it is written in the presence of, not by, the king. The subject of the chronicle is, however, otherwise inscribed, notably in the structure of address, here dramatized by the delayed reading.

For writing to fulfill its destiny, it is not enough that it be written in the presence of its intended reader; it must actually be read in order to fully achieve its deployment *as* writing. Without being realized by reading, writing remains a dead letter. In other words, the reader is the ultimate subject of writing, responsible for its consequences, for the actualization of the reality it proposes. By rewarding Mordecai, Ahasuerus shows himself to be a competent subject in this specific sense, with his apparently defective memory used as a narrative ploy to drive the point of reading home.

The description of the apparatus of royal administration and of the postal system (Est. 3:12), to give another example, while plausibly read as a demonstration of power or as circumstantial evidence of the text's historicity, can also be seen in light of the shifting subject of writing. The act of writing is broken down into its various aspects, each performed by an unidentified agent, or subject: the secretaries are summoned (by whom?); the writ is issued (by whom?);[23] it is drawn up in the king's name, which specifically means not *by* him but *for* him by someone else; and it is sealed with the king's signet, which is no longer on his finger. The stamp intended to validate the identity of the writer becomes instead the index of anonymous writing.

Again, writing emblematizes a feature that is displayed by the narrative in other ways as well. Subjectivity is placed in question generally, and the plot is built on that questioning. The irony of Est. 6:4–6 provides one example among many. Haman must decide the honor that is destined to be Mordecai's, but he mistakes the subject who is to be honored. The king mistakes Haman for a reliable adviser; hence the name of the subject to be honored is irrelevant. Because Haman wishes to use his power to merge his subjectivity with the king's, he does not identify the people who are to be destroyed, which would have saved his enterprise. Thus the plot turns on subjectivity by default.

As if to foreground the intimate complicity of language in this plot of mistaken identities, Haman's use of language is doubly defective when he mistakes the identity of the man to be honored (6:7–9); when Haman misreads the king's speech, he utters an anacoluthon, producing "bad" language, and he misfires,

producing a "bad" speech act. Hence, the same speech act demonstrates the failure of both "writer" and "reader" due to unwarranted assumptions about subjectivity.

If we read the text from the perspective suggested by the Rembrandt paintings, as reflections of and on the vexed relationship between text and subject, the problematic of the subject of writing encapsulates the entire narrative: its language, its plot, and its characters. And the reader is not excluded from this perspective, but merely delayed by writing, with his or her response on hold. Haman's blindness in the Rembrandt painting (see fig. 13.3) threatens to infect the viewer/reader, toward whom his body is emphatically directed; the icon of blind eyes is dangerously indexical as body language.

Conclusion

At this juncture, a critical question must be addressed: What have we gained by applying this willfully anachronistic contemporary concept to this ancient text? While it will be for others to say what, if anything, has been gained, I can suggest a few possibilities. I wish to make no claim about the historical meaning of the text, let alone about authorial intention or the origins of Purim, but I do think that I have made a case against the nineteenth-century model of reading predominant in many interpretations that do claim historical validity. While the enigma of Purim's origins and the meaning of its name are not, cannot be, resolved, I have opened up a space for an interpretation of the meaning of *purim* that is relevant to the contemporary reader, while also illuminating aspects of the text whose pertinence can hardly be denied.

Guided by an oddity in the two Rembrandt paintings, I have tried to draw a few lines that break up the text even as they pull its various elements together, not to yield a deceptive coherence but to problematize unity. By looking into the various meanings of self-reflexion and the ways in which these meanings appear to be dramatized in Esther, I have developed a view on the ancient text that affects the subject of criticism. For if reading is the only way to breathe life into the dead letter of the text, and if, moreover, reading is a matter of historical importance, then Esther herself becomes a mirror for the contemporary critic. If engaged, like her, in exposing the abuse of power, the danger of writing, and the instability of subjectivity, the critic will escape neither responsibility for her activity nor the encapsulation of that activity in historically diverse, subjectless writing.

Thus, writing criticism in accordance with Esther entails not obscuring either its predecessors or its opponents, not denying either its complicity or its agency. The book of Esther demonstrates that writing is not necessarily either a deadly

weapon or an innocent toy; closer to the time bomb than to anything else, however, it can be countered by virtue of its delayed effect. Hence, when involved in the act of reading—the deferred completion of writing—critics should be aware of both their (overt or covert) allegiances (reading is an act in which subjectivity is dispersed) and their own inevitable contributions to this act (it is an act).

In terms of allegiances, one cannot but reflect on the question of where the "rest" of one's subjectivity lies: that is, with Ahasuerus's "wise men" and their battle or with Esther and Mordecai and their collaboration. Should one endorse/reject the generalization of Vashti as "all women"/the individualization of Esther as different from Vashti? This question of implicit allegiances to ideological positions is less obvious than it seems precisely because obvious positions are offered as a lure. It is only too easy to disavow Haman's genocidal impulse, but the mirror also reflects more insidious generalizations from a single individual to an entire people, more subtle expressions of hatred for the other, whoever he or she might be. Those positions and their similarity to the obvious ones should be brought to awareness by a reflexivity that extends to the critic him-/herself. By insisting on the complex functioning of writing and the instability of its subjects, the book of Esther shows that critics are no more autonomous or stable than any other readers/writers; hence, their network of unconscious allegiances is both inevitable and dangerous.

In order to draw all readers in, *purim* must be a form of plurality. *Haman's Downfall* warns the viewer not to be blind to the mirroring power of the text, which extends beyond any immediate or simple historical veracity into the realm of historical agency. Had Mordecai and Esther been as blind as Haman, they would not have been able to read the writing on the wall. Seeking the historical origins of Purim in a forlorn past, safely out of reach, the critic may forfeit her or his own *purim*. For when the lots have been cast, and another people imperiled, the critic reading Esther cannot passively submit to the dictate of lots: obedience has been revealed as the wrong attitude. It would be an ironic misreading of the mirror of Esther to see the scroll as reflecting only the history of the Jews and one of their festivals. By reading it as a text about reading/writing, however, one is invited to reflect upon all the issues implicated in it: upon gender, power, and the state; genocide and otherness; submission and agency—in short, upon history.

Notes

Published in *Ruth and Esther: A Feminist Companion to the Bible (Second Series)*, edited by Athalya Brenner (Sheffield: Sheffield Academic Press, 1999), 212–38. This version was published in *Poetics Today* 15, no. 1 (Spring 1994): 89–114. I would like to thank Daniel Boyarin for

having suggested the idea for this paper, and Fokkelien van Dijk Hemmes, Athalya Brenner, and Ovira Shapiro for their help with the Hebrew text. An earlier version of this paper was published in *Semeia* 54 (1991): 77–102. Reprinted by permission of SBL.

1. See Berg (1979, 31–58), for an analysis of banquets and fasts, and their relationship to Purim.

2. For an analysis of such self-absorption in paintings, as opposed to "theatricality," or interaction between characters and viewer, see Fried (1980).

3. The question of whether Rembrandt intended to represent these episodes or whether the works received their titles later is as irrelevant to my perspective here as the question of whether "Esther" really instituted Purim or was a fictional representation of/justification for the festival.

4. New English Bible with the Apocrypha. The less striking Hebrew phrase translates simply as "And Haman was scared." I have chosen to draw upon a modern, popularized version of the biblical text because I am not really focusing on an accurate reading of the "original" (whatever that may be), but rather on the cultural vitality of the text as it has increasingly resonated over time.

5. Here, the Hebrew remains ambiguous. Hebrew scholars have suggested "and Haman's face [was] clouded," or "Haman's face fell, became bland." I have allowed myself to play with these possibilities, but obviously my argument does not depend on these particular words. What matters is the power of words to defeat, even kill, and, conversely, the visual impotence expressed in the ambiguity of seeing as an epistemological and a perceptual act.

6. I shall not go into the vast number of existing interpretations, even by way of translation. Although any reconstruction of the "original" meaning is, in my view, doomed to failure, attempting a closer reading would, of course, require an analysis of the canonical Hebrew text—which, again, is not pertinent to my argument.

7. See Lemaire (1984, 104). For the connection between religion and the economy of the state as supported by writing, see Adams (1966). Diamond (1974) argues against evolutionism in this domain. Goody (1977, 1968) offered the now-classic critique of the repression of orality by writing; and Lévi-Strauss's classic text, Rousseau-istic in its nostalgia, is "The Writing Lesson" (1955). Precisely because of the Romantic residue in the orality/literacy debate, I should point out that I use the term "writing" here in the limited sense of script, not in the extended sense ascribed to it by Derrida (1976). I do not, however, view innocence and non-violence or, indeed, a state of culture-without-writing as the opposite of literacy. On the contrary, the tensions that I perceive in writing as it participates in the plot of Esther demonstrate the fragility of just such an opposition. I do not consider the Derridean view of writing intrinsically incompatible with the political critique of writing's complicity in domination.

8. While it is widely assumed that literacy was relatively widespread in Israel from the eighth century on, oral history, at one time the only form of history, has never totally disappeared from cultural life in Israel or anywhere else.

9. See, e.g., Sasson (1987): "Yet the events of barely a fortnight earlier are so hazy in his memory" (337); and "dim-witted monarchs" (341). Sasson's approach to Esther seems to reflect the hidden evolutionistic ideology of many works that are characterized as "literary" approaches to the Bible. The view that the chronicle episode is implausible is widely held (see, e.g., Berg 1979, 63). Sasson applies such anachronistic criteria as psychological plausibility in order to present the text as a typical, comically cute piece of ancient literature, by which Sas-

son means all premodern literature, from Hellenistic romance through medieval fabliau, up to Voltaire's *contes philosophiques*. My own view is that Ahasuerus should not be judged on his intelligence, but rather considered as a necessary agent of the plot, which is, by another reflexive turn, about plotting. Measuring the biblical story by standards derived from the modern psychological-realist novel is almost universal in commentaries; see, for example, Moore (1971, liii, liv), who finds the characters lacking in depth and compares Haman with Oedipus, to whom he fails to match up. One wonders about the unstated gender ideology in Moore's approach, in which a realist bias also seems evident (see, e.g., the description of Mordecai as "the greater hero . . . who supplied the brains while Esther simply followed his directions" [lii]). To my mind, it is the critic who lacks depth here.

10. Both self-reflexivity and ontological uncertainty are considered characteristic of postmodernism; see Hutcheon (1988); McHale (1987); and Van Alphen (1992).

11. Foucault (1973). Critics who took up the challenge of Foucault's self-confident *placing* of the work within his own argument made little of the specific intertextual relationship between the painting and the philosophical argument, a relationship that was inverted in the subsequent critical debate. Foucault's intention was not to say anything special about *Las Meninas*, but to make *Las Meninas* say precisely what he had to say about the classical age. It seems to me that this alleged use of a "masterpiece" as a mere example was partly responsible for the emotional responses that Foucault's piece provoked. But in Foucault's writing, there is no such thing as a mere example. *Las Meninas* provided the philosopher with the discourse that he needed: a visual one. This appropriation was quite strategic: it enabled him to evade the charge of simplification (which, ironically, is precisely what he was charged with). The Foucauldian view relativizes visuality by its strong emphasis on the irreducible difference between words and images: "But the relation of language to painting is an infinite relation. It is not that words are imperfect, or that, confronted by the visible, they prove insuperably inadequate. Neither can be reduced to the other's terms: it is in vain that we say what we see; what we see never resides in what we say. And it is in vain that we attempt to show, by the use of images, metaphors, or similes, what we are saying; the space where they achieve their splendor is not that deployed by our eyes, but that defined by the sequential elements of syntax" (9). This attitude toward the relationship between discourse and visual image also holds for my heuristic use of the two Rembrandt paintings here.

12. See Snyder and Cohen (1981), whose dismay seems to stem from the well-known discomfort engendered by interdisciplinary discourse. In one of their many defensive reactions to the language Searle uses, they refer to another critic as being "in the Foucault-Searle line," and to his use of the term "ambiguity" as "a less exotic logical crux" than "paradox" would entail. Indeed, Snyder and Cohen seem to be reacting primarily to the use of philosophical terminology. Their irony is just a little too heavy-handed for the context, and their scare quotes, intended to undermine the terms they frame, seem merely sarcastic. The focus of the irony, however, is not only the alien discourse, but also, precisely, the threat resulting from seeing the painting in terms of "the Foucault-Searle line."

13. See the introduction to Hutcheon (1982) for a discussion of this criticism.

14. Van Alphen (1988, 59), addresses this paradox by differentiating between the reading attitudes proposed by the text and those adopted by the reader. He distinguishes four possible attitudes in relation to the corpus he discusses: (1) the realistic text read realistically; (2) the postmodern text read postmodernistically; (3) the postmodern text read realistically; and (4) the realistic text read postmodernistically. A realistic text, then, is a work that is not entirely

realistic, but that both fits the conventions of realism and has elements that enable, or even encourage, a "postmodern," self-reflexive reading attitude. In the book of Esther, which is neither realistic nor, of course, postmodern, the problem of obedience is thematized on the level of the narrative.

15. The different spellings—"self-reflexion" for mirroring, "self-reflection" for thinking— are not consistently applied and do not hold in French, where the same word carries the same ambiguity. If we have two different words, at least they are homonyms, close enough semantically to be confused in practice.

16. See Tompkins (1980) for a relevant view of the historical significance of reading.

17. Murphy (1981, 59), mentions this elaboration of event into law as a wisdom motif in Esther, recalling Prov. 31:10–31 and Sir. 9:2. For a claim that Esther belongs to wisdom literature, see also Talmon (1963).

18. Contra many commentators who emphasize Esther's obedience, it must be stressed that she is more like Vashti than they care to admit. Each is guilty of disobedience in terms of *approaching the king,* hence of taking control over her relationship with her husband. Otwell (1977, 69), for example, sees Esther as merely "the primary Old Testament example of an obedient daughter" [*sic*].

19. Fabian (1983). *Time and the Other* closely examines the impossibility of what Fabian calls "coevalness," or the simultaneity of the anthropologist's observation/participation and writing. This impossibility by definition renders the anthropological endeavor itself illusory.

20. See Clines (1984, 259), among many others, for an example of the realist bias; see Sasson (1987), for an example of the psychological bias. As I argued above, these anachronistic standards are generally harmful, as they obscure other issues and the narrative motivations that might illuminate them. Thus their limited perspective on the text does not do justice to its historical-literary specificity and thereby leads to a tacit complicity in ethnocentrism or rather, as I like to call it, "parontocentrism."

21. A *mise en abyme* is a sign that represents the work as a whole and that is itself incorporated in the work. This term, by now quite well known, was introduced by André Gide and extensively studied by Dällenbach in his *Le récit spéculaire* (1977). I have commented on and elaborated Dällenbach's use of the term (1986, 166–80).

22. The occasionally made assertion (totally groundless) that Vashti was asked to appear naked before the king does point to this incident's impression of objectifying display and to its gendered quality. Although Ahasuerus is criticized by some for his "male chauvinistic behavior" (Clines 1984, 257), Vashti's refusal, which would be justified in light of that view, is often criticized nonetheless, with the inconsistency typical of unreflective gender ideology. Identifying with ancient patriarchy, some critics tend to endorse, to fully underwrite, the sexism in the event while remaining blind to the shakiness of male power that the episode also underscores. Rabbi Zlotowitz (1976, 46–51) exemplifies this tendency. After quoting from ancient commentaries which deny Vashti any honorable motivation and conclude that she deserved death, Zlotowitz states not only that she was indeed killed, but also that Ahasuerus had Vashti killed. Interestingly, at the very moment when this critic provides an imaginary murderer/subject to carry out this imaginary murder, he neglects to specify the subject of his own text, thus endorsing the ancient commentators' view and allowing himself to be unreflectively reflected in ancient ideology.

23. By Haman, obviously, but this is not *stated.*

References

Adams, Robert. 1966. *The Evolution of Urban Society: Early Mesopotamia and Prehistoric Mexico.* Chicago: Aldine.

Alpers, Svetlana. 1985. *The Art of Describing: Dutch Art in the Seventeenth Century.* Chicago: University of Chicago Press.

Alphen, Ernst van. 1988. *Bij wijze van lezen: Verleiding en verzet van Willem Brakmans lezer.* Muiderberg: Coutinho.

———. 1992. *Francis Bacon and the Loss of Self.* London: Reaktion Books.

Austin, J. L. 1975 (1962). *How to Do Things with Words.* Cambridge, MA: Harvard University Press.

Bal, Mieke. 1986. *Femmes imaginaires: L'Ancien Testament au risque d'une narratologie critique.* Utrecht: HES.

———. 1987. *Lethal Love: Feminist Literary Readings of Biblical Love Stories.* Bloomington: Indiana University Press.

———. 1991. *Reading "Rembrandt": Beyond the Word-Image Opposition.* Cambridge: Cambridge University Press.

Berg, Sandra Beth. 1979. *The Book of Esther: Motifs, Themes, and Structure.* Missoula, MT: Scholars Press.

Brooks, Peter. 1984. *Reading for the Plot: Design and Intention in Narrative.* New York: Knopf.

Clines, David J. A. 1984. *Ezra, Nehemiah, Esther.* New Century Bible Commentary. London: Marshall, Morgan & Scott.

Dällenbach, Lucien. 1977. *Le récit spéculaire: Essai sur la mise en abyme.* Paris: Editions du Seuil.

Derrida, Jacques. 1976. *Of Grammatology.* Translated by Gayatri Chakravorty Spivak. Baltimore: Johns Hopkins University Press.

Diamond, Stanley. 1974. *In Search of the Primitive: A Critique of Civilization.* New Brunswick: Transaction Books.

Fabian, Johannes. 1983. *Time and the Other: How Anthropology Makes Its Object.* New York: Columbia University Press.

Foucault, Michel. 1973. *"Las Meninas."* In *The Order of Things: An Archaeology of the Human Sciences.* Translated by Alan Sheridan, 3–16. New York: Vintage Books.

Fried, Michael. 1980. *Absorption and Theatricality: Painting and Beholder in the Age of Diderot.* Berkeley: University of California Press.

Goody, Jack. 1977. *The Domestication of the Savage Mind.* Cambridge: Cambridge University Press.

———, ed. 1968. *Literacy in Traditional Societies.* Cambridge: Cambridge University Press.

Hutcheon, Linda. 1982. *Narcissistic Narrative: The Metafictional Paradox.* New York: Methuen.

———. 1988. *A Poetics of Postmodernism: History, Theory, Fiction.* London: Routledge.

Kamuf, Peggy. 1988. *Signature Pieces: On the Institution of Authorship.* Ithaca, NY: Cornell University Press.

Lacan, Jacques. 1979. *The Four Fundamental Concepts of Psycho-Analysis.* Edited by Jacques-Alain Miller. Translated by Alan Sheridan. London: Hogarth Press and the Institute of Psycho-Analysis.

Lemaire, Ton. 1984. "Antropologie en schrift: Aanzetten tot een ideologiekritiek van het

schrift." In *Antropologie et ideologie,* edited by Ton Lemaire, 103–26. Groningen: Konstapel.

Lévi-Strauss, Claude. 1955. "Leçon d'écriture." In *Tristes tropiques,* 312–24. Paris: Plon. Translated by Doris Weightman and John Weightman as "A Writing Lesson." In *Tristes Tropiques,* 294–304. New York: Penguin, 1992.

McHale, Brian. 1987. *Postmodernist Fiction.* London: Methuen.

Moore, Carey A., ed. and trans. 1971. *Esther.* Anchor Bible. Garden City, NY: Doubleday.

Murphy, Roland E. 1981. *Wisdom Literature: Job, Proverbs, Ruth, Canticles, Ecclesiastes, Esther.* Grand Rapids, MI: Eerdmans.

The New English Bible with the Apocrypha. 1976. Oxford Studies edition.

Otwell, John. 1977. *And Sarah Laughed: The Status of Woman in the Old Testament.* Philadelphia: Westminster Press.

Sasson, Jack. 1987. "Esther." In *The Literary Guide to the Bible,* edited by Robert Alter and Frank Kermode, 335–42. Cambridge, MA: Harvard University Press.

Searle, John. 1980. "*Las Meninas* and the Paradoxes of Pictorial Representation." *Critical Inquiry* 6:477–88.

Snyder, Joel, and Ted Cohen. 1981. "Reflexions on *Las Meninas*: Paradox Lost." *Critical Inquiry* 7:429–47.

Talmon, Shemaryahu. 1963. "'Wisdom' in the Book of Esther." *Vetus Testamentum* 13:419–55.

Tompkins, Jane P. 1980. "The Reader in History: The Changing Shape of Literary Response." In *Reader-Response Criticism: From Formalism to Post-Structuralism,* edited by Jane P. Tompkins, 201–31. Baltimore: Johns Hopkins University Press.

Zlotowitz, Meir. 1976. *The Megillah: The Book of Esther.* New York: Mesorah Publications.

14. Postmodern Theology as Cultural Analysis

Points of Departure

Western culture as we know and live it today was built on several interlocking structures, one of which was theological, specifically, Christian. Present-day culture in the West, therefore, cannot be understood without theology. Postmodern theology is the study of this presence of the past within the present.

For all our postmodern protestations in the form of either post-Enlightenment atheism, postcolonial religious pluralism, or even, as is deplorably fashionable today, sentimental returns to a God generated by millennial anxiety, the cultural present is unthinkable, indeed, unimaginable, without an understanding and acceptance of three premises. First, Christianity is there; that is, here (in Europe and the Americas, at least). Second, Christianity is a cultural structure that informs the cultural imaginary, whether one identifies with it in terms of belief and practice or not. Third, Christianity is just that; hence, it is neither the only cultural structure nor the only religious structure around. While these premises define the cultural present, it is my assumption in this essay that they also underlie any possible postmodern theology. In other words, theology in our time must be a cultural discipline, and the study of religion must be a branch of cultural analysis, whose boundaries with other cultural disciplines are porous and provisional. In such a conception, no privilege can be granted to any particular religious tradition or any cultural structure—such as religion—over any other—such as politics, education, or "culture" in the narrow sense, as the practices and products of the imaginary.

This position is grounded in a number of further premises. The first of these premises concerns history as the study of the past. The importance of history lies not in attempts to reconstruct the past but in understanding the present. Understanding culture serves the purpose of making the world we live in understand-

able and thereby a place with more freedom, with all kinds of choices. Knowledge of the past derives its relevance from this ongoing presence of the past within the present, not as its precursor or source but as an ineradicable, integral part of the present. The pervasive presence of religion in the past is therefore a presence in the present as well, a presence that no one can escape, that informs politics and education, moral behavior and juridical decisions alike.[1]

A second further premise concerns the cultural disciplines. If "culture" is the object of study in the disciplines of art history, literary studies, classics, and such social disciplines as anthropology, then the endeavor, again, must be an understanding of the present as integrative and dynamic. This conviction entails a need for interdisciplinary work as an indispensable framework for any study within separate disciplines. Moreover, no field within this large arena can afford to limit itself to its traditional self-identity. The fundamental permeability of fields of study concerns both the "medium"—literature cannot be isolated from visual art, for example—and the social area—"high" and "popular" art cannot be isolated from each other. Visual and verbal culture interpenetrate, as do everyday culture and the more contemplative, imaginary cultures of leisure. Religion is part and parcel of the cluster constituting this fundamentally mixed culture.

While this position precludes any practice of theology in separate endeavors, it also makes the study and understanding of the religious legacies whose off-shoots pervade Western culture an indispensable element of the analysis of culture. It is a flaw in current academic practices such as cultural studies that they underestimate the importance of the integration of what used to be "theology" or "religious studies" in any attempt to grasp how we live the past inside the present.

I have argued and explored these premises in earlier work, which I can only refer the reader to here. In a recent study, I made an argument for the consequences of this position for historical work in the domain of visual art (*Quoting Caravaggio: Contemporary Art, Preposterous History*, 1999). Earlier, I was involved in exploring ways in which biblical literature could be interpreted as both strange—"old" and "foreign"—and relevant to today's post-Enlightenment culture (this work is probably why this chapter ended up in *The Blackwell Companion to Postmodern Theology*, 2001). Elsewhere, I explored the interrelations of verbal and visual culture (1991 around Rembrandt; 1997 around Proust), and the negotiations carried out in the present to deal with that mixture, specifically in the practice of exhibiting. For the purposes of this volume, I would like to present one spin-off from that earlier work and touch upon one later development of it, in order to argue for the importance of the integration of the traditional topics of study in a radically different analytical setting which—why not?—might go by the name of "postmodern theology."

Theology, then, is the name for a specialization within the domain of cultural analysis that focuses, from the point of view of the integrative premises outlined above, on those areas of present-day culture where the religious elements from the past survive and hence "live." Consequently, a postmodern theology must account for those aspects of that special domain that are "other" to the past. If the field of study is the Bible, then postmodern theology must account for the social meanings, including the "literary," political, and artistic ones, of biblical literature in today's world—within the context of the heritages of other religions, other cultures. Sometimes the field of study is what is traditionally called "art history," namely, those portions of visual culture that represent or evoke, or otherwise engage, religious traditions, or, to put it differently, those elements of religion that function in the visual domain. This field includes medieval stained-glass windows as well as films such as Robert Duvall's *The Apostle* (1997). But the visual can no more be distinguished from expressions in other media than fictional or aesthetic objects can be from objects of everyday life. Postmodern theology is liable to study gospel traditions and convent life, denominational schools and the ideological makeup of charitable foundations, and the presence of religious discourse in lay politics and religious tenets in the practice and theory of law. But to make this field less large and muddled, without falling back onto the traditional text-based sources, let me confine the discussion here to postmodern "visual theology."

It is obvious that the cultural heritage of Western art is to a large extent bound up with past religious purposes and events. In such cases the work to be done by a postmodern theology with such imagery is to account for it, that is, to examine and analyze it in order to understand the effective and affective result of encounters in the present with such "works of art." For the sake of integrating the premises indicated above, I will select the cases for my demonstration from the latter domain, not traditionally considered directly theological.

In the limited space of this contribution, I will outline two case studies that I have conducted recently within which these premises have proved productive. The first concerns an attempt to articulate an approach to some of Caravaggio's paintings of religious subjects. This is a spin-off of my book on the painter as revised by contemporary art. The paintings attract flocks of tourists, many of whom profoundly enjoy the images without necessarily sympathizing with the religious content, or even recognizing, let alone understanding, it. Far from deploring this "loss of tradition" as conventional art history would tend to do, or explaining the meanings of the original work, the attempt, then, is to offer an explanation for— and to argue on behalf of—the continued relevance of elements of our visual culture that are not understood today in the terms of the past (nor need they be). The

second case study concerns an inverse itinerary: to present an image that, far from suffering a loss of tradition, suffers from an excess of it. Here, I was dealing with an image that is already overgrown with the weeds of later ideological reception. The goal was to bring to this image a fresh understanding, in a culture which is not only post-Enlightenment in its overt atheism, but which is also—or should be—post-misogynistic in its confused reception of the narratives that came to us from older religious traditions.

Caravaggio Today

There's a dogma in the discipline of art history which says that images from the past must be understood in terms of the artists' and patrons' intentions. In the many cases where the documentation is insufficient and intention diffuse, such as where the Italian master Michelangelo Merisi da Caravaggio is concerned, this dogma is particularly problematic. We know that many of his images represent biblical scenes or religious moments: conversions, callings, or devotional scenes. It is relatively easy to track down the precise meanings of the details in such images; for example, in terms of the patron's wishes to make a stand in favor of a theological fine point that matters to the religious order that commissioned the painting. Such research, standard in the history of art, pertains to what I would call a modernist theology, one based on historical reconstruction and the purity of theological meaning as directly derived from theological documents.

At the same time, however, today the most striking aspect of Caravaggio's work is seen to be the profound sensuality of his representations of the human body, especially the male body. It is a well-known fact that, although the painter depicted scenes figuring, for example, the Virgin and Mary Magdalene, no female nude by his hand is known. His male figures, on the other hand, saints or not, are often sensuously depicted nude or semi-nude bodies. The status of this aspect of such paintings cannot be accounted for in the terms that are offered by modernist theology or art history. This sensuality cannot be attributed to the artist's overt intention, especially not in cases of commissions by religious authorities, but neither can it be construed as unintentional. We simply don't know and perhaps shouldn't care; instead, we ought to accept that the mind is unreadable and does not dictate meaning and effect. Instead, it seems more important to recognize that the tension between the paintings' sensuality and their religious content is the product of the present and its dogmas. For it is our time, not Caravaggio's, that appears to find a tension between these two areas of human experience. As if to disavow the aspect of Caravaggio's paintings that troubles scholars most today, art historical work labors to make the case for either the artist's deep religiosity or

his faithful execution of his patrons' wishes.[2] What I referred to above as modernist theology is not "pure" theology, but an active, polemical repression of bodily and sensuous aspects of life from theology. This repression has its counterpart in art history's reluctance to acknowledge the importance of studying the tradition of the female nude and its many variations and ramifications.[3]

My interest is not in contesting the artist's religiosity, of which we know nothing apart from his paintings, or the influence of his patrons on their iconography. What I find relevant for the articulation of a postmodern theology would be, rather, the acknowledgment of the scholars' deep commitment to "save" the art from itself. This commitment has nothing to do with any theological "truth"—God—Christian or other. The compulsion to explore Caravaggist iconography in the most subtle theological detail in order to "reconstruct" its historical meanings is in fact profoundly anachronistic, either as art history or as theology. For it is based on a division between body and spirit which is, I contend, *not* historical, but rather an anachronistic projection from a more recent past, often indicated by the term "Victorian," which is still rampant in present-day morality.[4] To be sure, such studies can be relevant and useful for their precision and the underlying acknowledgment of a mixed-media culture in the past. But instead of, or in addition to, such studies, I see the sensuality in Caravaggio's images as being utterly compatible with, indeed, an integrated part of a baroque religious sensibility that was, so to speak, the everyday life of the Counter-Reformation. More importantly, it accounts for the images' appeal to viewers in the present. And, according to my premises, its theological relevance, if any, must be anchored in that appeal. Far from leading to anachronistic interpretation as my work has often been accused of doing, I contend it is only from this "presentist" perspective that a historical account can be meaningfully attempted.[5]

Perhaps trying to satisfy his clients' wishes or, at other times, only paying lip service, this artist was, for all we know, primarily a painter invested in probing the possibilities of his art from the perspective of his lived reality. This reality included—we must surmise from what we see—the presence of sensually rich, enticing bodies in his representations. Caravaggio's images are profoundly and decisively erotic. It can only be on and in such bodies that the religious content took hold. If theological interpretation is to be meaningful, its task is to account for this bodily aspect of religious experience, not to dismiss it as idiosyncratic or to privilege one domain over the other.

The sensuality and religiosity must be taken together, not only to account for Caravaggio's specificity as a painter, but, more importantly, to learn from these images something about religion as lived experience instead of dead, authoritarian letter. This lesson concerns what has been called "relationality."[6] And if religion, etymologically if not essentially, concerns relationality, then chances are that

the very sensuality of Caravaggio's paintings is their theological content, for which the references to the dogmatic position he was commissioned to depict is no more than a frame.[7]

As it happens, contemporary—postmodern—conceptions of art are also more invested in art's relational potential, its performativity, than in its iconography. Thus the bond between a theological interpretation of images based on traditional religious content and an account of art's powers has more than an incidental common ground in relationality. We can learn something from painting, not as a transparent medium of representation but as alternative semiotic production. Painting offers something we don't know, or have forgotten: something books don't teach us but images can; something, ultimately, that, in more senses than one, *matters.*

By exploring sensuality and representation together, Caravaggio was the first to make utter illusionism into a statement on the body. Two of his works on religious subjects give a sense of what this entails. *The Crucifixion of Saint Peter* (fig. 14.1) and *The Conversion of Saint Paul* (fig. 14.2), both from 1601–2 and both large canvases (230 × 175 cm), were commissioned as a set. They were painted to be companion pieces in the Cerasi Chapel of the Church of Santa Maria del Popolo in Rome, where they are still found today. The site, the hanging, and the duration of their time in this chapel constitute a frame in the double sense. In the first place, these paintings in their past and present site also suggest what Caravaggio's bodily illusionism does *not* entail. Here, there is no narrative "in the third person," no telling stories of others that concern us only for the lesson drawn from them by church authorities. There is no referential illusion that the temporality of the image is safely ensconced within the historical past of the dramatic events. The painstaking theological-iconographic analysis carried out in a spirit of modernist historiography, correct and therefore valuable as it otherwise is, utterly fails to account for this defining aspect of the works.[8] Yet here they are, in this church, where thousands come to see them. In order to benefit from these paintings *in situ,* we must endorse the obvious fact that tourism, not religion, the lust for art not for God, sensuous visual appeal not spirituality, brings most viewers into this church, and to these paintings. So what experience do they solicit and enhance that might have cultural, even specifically theological, relevance today?

First, there is the site itself, the conditions of viewing that allows or forbids. To see the paintings fully, one needs to stand between them, something the casual visitor, under pressure of time because of the one-euro coin inserted into the automatic lighting machine, is not allowed to do. As far as temporality is concerned, this pressure ironically makes up for the limited access, for on this utterly mundane level one is made acutely aware of bodily frustration and the effect of duration. Instead of standing between them, one cranes one's neck and feels the pressure of seeing quickly, amidst so many others, and obliquely. A lack of access is

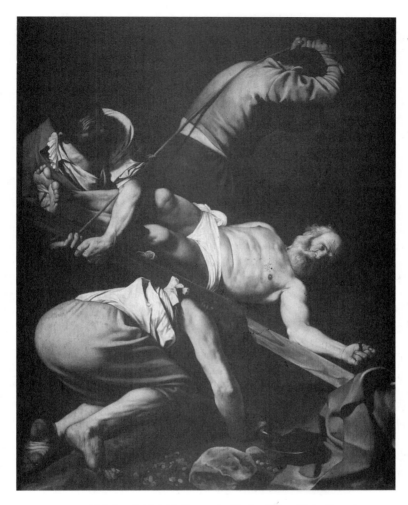

FIGURE 14.1 Michelangelo Merisi da Caravaggio, *The Crucifixion of Saint Peter*, 1601–2.
Santa Maria del Popolo, Rome. Photo: Scala/Art Resource, NY.

inherent to this viewing experience; a sense of the partial and the transient, the impossibility of possessing these images, to stare at them at leisure, to own and objectify them.

The second relevant aspect of the experience concerns the kind of representations the images offer. These are figurative paintings, proposing not just a fictional happening but a specific bias toward that happening as well.[9] To sum-

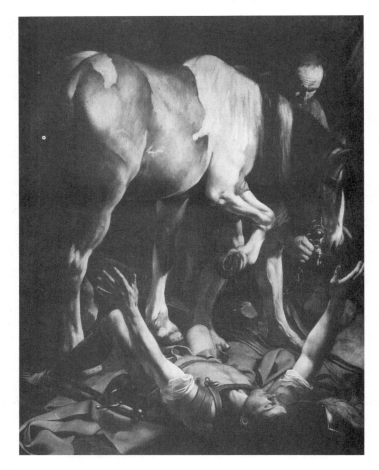

FIGURE 14.2 Michelangelo Merisi da Caravaggio, *The Conversion of Saint Paul*, 1601–2.
Santa Maria del Popolo, Rome. Photo: Scala/Art Resource, NY.

marize the result of a long analysis of their painterly mode as it clashes with their
mise-en-scène, these two paintings are totally *illusionistic* in their texture yet to-
tally *artificial* in their figurativity. This disjunction between illusion and realism
sharpens the qualification of illusionism as a tool for attracting the embodied look
which the figuration further elaborates. Both scenes are utterly theatrical. This
theatricality solicits a look that is both engaged and devoid of mimetic illusion.
This is powerfully visible, for example, in the figure of Peter. He is lifting his head
and shoulder to look away in boredom at having to pose in an uncomfortable

position for too long. Similarly, Paul is displaying his muscles, tense from holding up his arms for the length of time it takes to paint him so painstakingly. Thus, the figures don't come to us as saints from biblical stories but as people, actors playing these saints, in a play staged for us.

Why is that important? The tension between illusionistic painting and artificial, anti-narrative figuration has been brought to awareness most effectively not by art historical commentary but by Derek Jarman's 1986 film *Caravaggio*, another visual work of art, made in and for our time. The transformation of the acting friends and assistants who set up the tableaux vivants for Michele as he paints, into the actual paintings that result, is a precious tool for art history classes, for it drives home a sense of the performativity that mediates between illusion and theatricality. And while this film seems to be indifferent to theological knowledge, it seems less in tension with the paintings *in situ* than with the art historical iconographic readings that ignore their frame and their actual effect. For it turns the sensuality of the studio, the intimacy of lived reality in which the paintings were made, into a plausible way of being with the stories of the apostles.

The clash—or harmony—between illusionism and theatricality impels the viewer to look differently at the details of the scene and the painter's work. Peter's fingernails are dirty but his hand does not bleed, is not pierced by the nail. And, in case you are mistaken, the arbitrary spatial direction of the nail, doubly oblique, confronts you with the impossibility of reconciling but also of ignoring the two modes of representation at stake. For the nail is bent away from the wood and toward the picture plane. Thus it drives home the point that it does not connect to the wood to which it is supposed to fix the hand. Instead, the posing man is holding it, but, due to the duration of the session, loosens his grip, forgets to keep it straight. This is a real man, not a legendary saint or a historically remote narrative figure. It is a man who does odd jobs, who, just one or two years ago, saw a turn-of-the-century celebration, who perhaps witnessed the burning of Giordano Bruno at the stake a few streets from the studio, and who is now posing for Michele. Illusionism serves not realism but its opposite. What can we do with such a scene of crucifixion? We are accustomed to associate crucifixion with the utter sacrifice—of life for faith—that Christianity proposes as a model for religion. What if it is presented to us as a play and, if not as playful, as an act rather poorly performed, and thereby perversely comical, conveying the contagious fun of an afternoon among friends?

The point, I submit, of Caravaggio-according-to-Jarman is to do with community, with intimacy, as a value of intensity; a relationality which does not require compliance with the exclusivist morality of heterosexual monogamy. The narrative *on* religion—as distant, in the past, and regarding others who can only be models—is overwhelmed by a narrative *of* religion. At least, if we conceive of

religion in the lay sense of binding and bonding outside of the discourse of pos-
session and permanence that continues to characterize thought on relationships
that involve the body.

This relationalist activism of the paintings is more specific than this. *The Cru-
cifixion of Saint Peter* manifests this activism against narrative third-person dis-
tanciation and the temporal closure it entails most famously in the figure of the
man holding the shovel. This figure is helping out the other actors for whom lift-
ing the cross with a live man on it is not the easiest way to spend an afternoon. He
has the dirty feet of a street worker, the rough, reddish elbows of a manual laborer,
and an incredibly live, fleshy pair of buttocks that press through his pants so as to
make you look twice both at them and at the shapely, manly shoulder. This man's
body is totally real; its back is turned obliquely toward the viewer, seducing you
to come in or, at least, to stay captivated. You keep throwing in one-euro coins.
Looking, even at religious imagery, clearly, is not a disembodied flight into piety
but an act mediated through the body.

This look, then, engaged in an intense travel across the picture plane, stops at
the sight of the dirty soles of feet, the fingernails, the irritated facial expression,
and the fleshy, tactile buttocks. Thus, the viewer, body and soul, is drawn *inside*
the event, this world of sensuality and bodily engagement with a collaborative ex-
istence of pleasure and work, of enjoyment and helping out, of something whose
intensity makes it so special without enforcing a specific interpretation of what
one sees.

Once the viewer is caught by the painting's way in, the painting at the right-
hand side of the chapel continues the spatial captivation in a time-consuming
process. It also seems to comment on a feature of the *Crucifixion*: the fact that this
painting resists eye contact.[10] The figures hauling up Saint Peter's cross are too
busy to look at us. The helper who most directly pulls us in does so by turning
his buttocks to us. And Peter, whose face is more or less directed toward the
viewer, only seems to face us because he is looking away from the others, clearly
aggravated, as if thinking, or saying to the audience in a theatrical aside: What's
all the fuss about?

Standing in the crowd, craning our neck to see, it may occur to us that the fuss
is, among other things, about space, or the lack of it. Caravaggio has been accused
of a lack of spatial skills; his spaces seem overcrowded, sometimes arbitrarily
cropped and unharmonious. But continuing our adventure in Rome, we come to
realize that this is all for the good. *The Conversion of Saint Paul* clearly demon-
strates that Caravaggio knew exactly what he was doing with his famous confined
spatiality. This painting is an extreme case of the claustrophobic representation
of space. Yet the center of the picture is a deep black hole. As one critic phrased
it, "the clarity has a bare-bones drive; the man's stretched arms and the corre-

sponding horse's legs set up the center of the drama as a deep hole."[11] The low point of view makes you almost afraid of the horse's bulk and menacing lifted foot. And whereas the figures in the *Crucifixion* look in different directions, here they are blind.

This is most emphatic, of course, in Paul himself, whose shell-covered eyes—cleverly taken up by Jarman, who covers the eyes with coins—are close to us, symmetrical to the man's buttocks in the other picture. But the clearest structural device used to bind the two pictures together from left to right, despite the chronological oddity—the *Paul* represents the beginning, the *Peter* the end of apostleship—is *light*. In the *Peter* the light comes from somewhere at the left, in front of the picture plane. Once attracted, you follow it to step inside. In the *Paul* the light comes from somewhere to the right, behind the picture plane. It leaves the back of Paul's head in the dark, emphasizing the skin of his chest and the inside of his arms, as well as the large flank of the horse and the balding forehead of the older man holding the horse. This man is also afflicted by blindness.

Paul is lying with his legs spread open, his arms and hands stretched out to receive whatever it is the light brings. Grace, revelation, the third-person story of modernist theology would say; and, thanks to the predominance of iconography, the painter could make sure that this third-person story passed muster.[12] But this second-person story invited ordinary people with live bodies into the scene, just as the helper in the *Peter* did with his buttocks. The space has grown more confined, the body more passive, receptive. Taken together, the erotic quality becomes poignantly concrete, so much so that the blindness comes to signify the substitution of touch for sight, a radicalization of the thought of visual tactility.

This reading is not a homosexual interpretation in any simple, anecdotal sense. In a postmodern theology it is pointless to either attribute or deny homosexuality to the artist. But writing homosexuality out of the present "work" of Caravaggio's saints would be another gesture of modernist purification. Instead, before embarking on an analysis of this body of images, we must declare and endorse the presence of this centering of sensuous appeal on male bodies. In a sense that is not confined to identity politics, this art is both theological and homosexual. Contemporary American painter David Reed adopts the theoretical thought implied in Caravaggio's pair of paintings but radically changes it. For no body can be seen in his painting. Yet the utter physicality, the sense-based involvement of the body, is just as keen. The body, in his work, is made drastically present, but not as an actor on the stage. The body that cannot escape, does not wish to escape, the *touch* of this painting, is that of the viewer. It makes the erotic quality equally intense but infinitely malleable. The viewer becomes the sole actor and the painting the sole seducer, a "trisexual" figure whose primary characteristic is to be universally available, for whom it may concern.[13]

What temporality is at stake here? As a result of the visual erotics, the mobilized body, conjured into participation qua body, is the same body whose eyes are doing the looking. Hence, these paintings militate against the disembodied gaze we have learned to cast on images. That gaze is atemporal and does not even know that it has a body, let alone a body involved in looking.[14] Instead, the Caravaggio works propose a mode of looking which is not only a desirable one for these paintings but also the only possible one, the only one that leads to seeing. They solicit a participatory look, one beyond that of "participatory observation" based on coevalness, the long-standing ideal of anthropology.[15] This intellectual posture, this embodied look, is not only epistemologically indispensable, as was participatory observation for modernist, self-conscious anthropological knowledge; it is ontological. Taking into account the deceptiveness and other drawbacks of this epistemological mode, the notion of *performance* would seem more appropriate for characterizing it.

Performance, in anthropology, is the construction of knowledge about a culture *with* the people and through collective research and discovery, as Fabian argued in a study which, loyal to its thesis, is an account of just such an endeavor. Performance is an act; it is doing. Most often the word is used to indicate ontological dynamism, as in J. L. Austin's famous linguistic theory of performativity. In theater, performance is when a play becomes a play; without performance, it remains a text. In reception-oriented theories of reading, the same notion of performance is used to define a specific ontological status of textuality. Without reading, the book remains a dead object, existing only as a thing in space.[16] Text and image belong rigorously in the same ontological domain here, for neither one exists as "pure."

Caravaggio's two religious paintings draw their viewers through a double play on the concept of performance. Their emphatic theatricality opens the audience up to the idea that one can play various parts, provisionally participate in—experience from within—an event that took place in the past but that is also being enacted in the present; an event perhaps not otherwise available to each of us. We are offered this participation in a light, voluntary tone, with a wink, so to speak. This is a liberal seductiveness, easy to accept. But then things get more serious. The sensuous appeal of the two paintings together, in their neck-craning site, perform, also, qua painting. They operate in this respect through their visual modality as distinct from, but cooperating with, their theatricality. This performance in the second sense thickens the first one. This mode is no longer so voluntary; its appeal is more powerful, punitive, the penalty of refusal being the impossibility of seeing and enjoying the paintings beyond superficial and quick glancing.

On the one hand, then, each viewer is given the opportunity of playing a part in an erotic relationality clearly homosexual in kind: the men-only, the attraction from behind, the dark cavity, all encourage male homosexual fantasies; a relationality

based on unexpected encounters and brief, provisional role-playing. But it would be a mistake to reduce the images' work to a specific, limiting kind of sexuality. The second performativity enables the once-seduced viewer to relate to the bodies in the images in any way he or she wishes. The point of the general "trisexual" sexiness available is not to enforce an experience that is alien for some, too common for others. The point is to offer a different experience of bodiliness and relationality through the encounter with vision. Far from the appropriating eroticism of the pornographic visuality, these images propose an alternative visual seduction, no less erotic, but unabusive, unexploitative; a decolonized erotics of vision.

Whether or not one recognizes theological relevance in this relationality does not preoccupy me greatly. But even if one limits the field of theology to the more classical sense of the remnant of past fantasies and imagery, of stories and myths that we call biblical literature as they remain present today, the use of sacred stories for the deployment of the double performativity of Caravaggio's paintings of religious subjects must be recognized as relevant. Personally, I would be more interested in a conception of theology as the exploration of alternative possibilities for relationality which traditional morality, religion and, indeed, art history do not enhance, so that it can be brought into connection with the bodily experience of otherness available in the church of Santa Maria del Popolo. It is precisely because of, not despite, its location in a church that the sexuality embodied here entails an experience that is by definition different, and more profound than whatever a particular viewer's sexual practice might be.

Reframing Judith

Two factors obstruct this expansion of religious subject matter. First, some subjects are already so tenaciously overdetermined, overwritten by ideological interpretation, that they are not open to the kind of experience the Cerasi Chapel offers. Second, churches are not the only locations of art that might have theological relevance in a postmodern perspective. Museums, the worldly version of churches, are more likely places for it, with their equally ritual function and ideologically imposing power. In the second case study, I would like to focus more on framing, which is the companion to performativity in a postmodern cultural analysis, with or without theological specialization.

To do justice to the differences between the members of the public and the aspects of the art works that museums display, I have proposed, in my book *Double Exposures,* to work with the concept of framing—in its double meaning as mentioned above. That book was based on the idea that the concept of framing enables museum workers to display art while also showing what they do, how they do it, and why. Easier said than done is an obvious objection, and until the

FIGURE 14.3 Gerrit Pieterszoon Sweelinck, *Judith Showing the Head of Holophernes*, 1605.
Museum Boijmans van Beuningen, Rotterdam.

summer of 1998 I had no answer that would satisfy those who mustered that appeal to the alleged rift between theory and practice. At that moment I received a request from the Museum Boijmans van Beuningen in Rotterdam to help present a newly acquired, early seventeenth-century non-canonical painting to the public. This provided me with the precious opportunity to test if, and how, such revisionist presentations are possible in practice.

My experimental exhibition was primarily an attempt to work with the notion of framing as a way of freeing exhibition practice from the constraints of traditional monography and narrative itinerary. Underlying this experiment was Derrida's rich text on the frame as parergon, as a kind of supplement to the work of which it is also a part; to simplify: the notion that the frame is the link between work and world, not the cut between them, however hard it tries to be just that cut. As it happens, the object I was to work with had a place in the theological

FIGURE 14.4 Installation shot of Sweelinck's *Judith*.

canon. The painting in question was *Judith Showing the Head of Holophernes* (fig. 14.3), by Gerrit Pieterszoon Sweelinck, from 1605. Given the expectation— frame as setup—that I would reiterate the misogynistic castration theme so often projected on this subject, I did not wish to do a thematic presentation. Thematics so often seems to be the sole alternative to monographic shows, and so easily becomes totally ahistorical, that I was reluctant to endorse it, even though there was some pressure from others in the museum to do so. I have reported on the experiment elsewhere;[17] here, I would simply like to point out how, *in practice*—a practice not of viewing, as in the Cerasi Chapel, but of exhibiting—a kind of cultural-analytical perspective can again gain relevance for a postmodern theology. With Caravaggio I attempted to place the engagement with the sensate body and the erotics of relationality within the religious subject rather than to see it as its repressed other. In the museum, in contrast, the possible theological potential is paradoxically situated in the movement away from theology.

Beneath an introductory text at the entrance to the exhibition space (fig. 14.4), at a distance of one meter from the wall, I put a display case with seven household utensils depicting Judith and other biblical heroines. An information leaflet outlined the concept of the show. It began with the title of the show, followed by the title of the painting, and then continued with a presentation of the painting as part of the collection. The paintings mentioned there were displayed, in the traditional manner, side by side, on the long left wall, with enough space between them

to allow looking at each of them in isolation. This modernist mode of hanging fitted the content of this section—or frame—which was based on a traditional preoccupation of art museums. Only the painting on a related subject, *Jael Showing the Body of Sisera to Barak,* by Speckaert, had an individual caption. This painting most obviously invited comparison with the Sweelinck and was hung closest to the new work but on the opposite wall; it also served as a shifter to the following section. Its caption read: "With her sensual mouth, looser hair and bare leg, Jael is much more sensually depicted than Sweelinck's Judith. There is more narrative movement in this painting; the story isn't finished yet." My hope was that the comparison might invite viewers to consider the two paintings, not in terms of relative aesthetic merit or of reiterations of a theme, but as two different modes of visually dealing with a narrative subject.

The second section, described subsequently in the information leaflet, was central to the entire presentation. Paradoxically perhaps, I titled this section of the leaflet "*Judith* as masterpiece," adding the somewhat different meaning of the phrase, due to a quote from Sweelinck's contemporary critic Karel van Mander, to the effect that Sweelinck had mentioned to him that he'd rather be a "good painter . . . than a great monarch." This quote brought in a topic of great resonance today: ambition.

The use of the problematic term "masterpiece" was meant to trigger reflection on it, since the category is not at all self-evident for this painting. What followed then reflected my intuitions about the ambitious quality of the painting. This was both the most complex and the most paradoxical frame: the painting itself was the frame, spilling over into the surrounding works that had been brought together on a variety of grounds; it was, after all, about the internal variety of the painting. A screen with two wings was placed just before the two short walls that led to a transitional cabinet. Hence, the works on these sections of walls were half-hidden—by the wings of the screen—from the visitor as he entered.

The right-hand corner was crowded, with six portraits of women, all from the first half of the seventeenth century, some oval, and, stylistically as well as canonwise, totally unrelated. Only one caption accompanied this ensemble. Whereas the women's portraits served, literally, as a backdrop, I put four other works closer to the Sweelinck on the wings of a screen, to foreground the genres represented within the painting. Here, I had to contend with "historical evidence." Van Mander reports Sweelinck's own words about his ambition, albeit in indirect discourse. These words were put on the screen in large print above the painting: ". . . a good painter rather than a great monarch." The point was not to ignore this evidence, or to give it more status *as evidence* than such indirect, gossipy reporting warrants; this is why I avoided historicizing lettering, choosing a modern typeface instead. Nor did I want to infuse the centrality of the painting with more canonizing intentionalism.

But the historical "effect of the real" that such quotes produce did have a historicist purpose. The notion of ambition—a word used in the information leaflet but not on the wall—has a contemporary resonance today. By drawing attention to the ambition of the artist, who, by all accounts, would be considered mediocre by traditional art historians and art critics, the viewers were enabled to frame the work with empathy. Thus, by mentioning Sweelinck's ambition instead of glorifying great art or putting the painting at a historical distance from today, the viewers were helped to identify with the artist, across time, enabling those who wished for it to have what one historian would call a "historical experience"—which is emphatically not based on a conflation between past and present. On the contrary, as Didier Maleuvre argued about the historicity of things in his 1999 book *Museum Memories*: "To be historical, an object must have seceded from time: it cannot be one with its temporal becoming. The historical object is therefore one that belongs neither to its original setting—from which it has been singled out—nor to the present—in which it resists assimilation."[18] And the historical experience consists of living through the caesura that inheres in the historical: "The historical is the stuff of the past which, by being remembered in the present, desists from being in the present: it is what cannot be reconstituted in the present." The frame, precisely, separates, acknowledges the separation, and thus *links* present to past, and this experience infuses subjects in the present with the temporal density that "history" provides.

Moreover, the ambition of the painting seemed not simply to be its desire to excel. Instead, the ambition took a specific turn, embodied in the attempt to excel *in many genres*. This aspect provided a frame through which to "read" the painting on its own terms, while keying it into a historical experience based on empathy. This specific ambition was visually indicated by surrounding the work with paintings from the collection exemplary of each of these genres; paintings, again, not selected for their canonical status or their aesthetic quality but because they could serve to explain Sweelinck's work, just as that work honors these genres; glosses or visual footnotes, rather than stylistic commentaries. This multiple-genre frame seemed all the more attractive because it allowed the viewers to realize for themselves not only *that* genres in painting differ, but also *which* genres they individually find most interesting. The four "footnotes" were: a still life underscoring the lower left corner; a domestic scene with a curtain, referring to the upper left; a landscape on the upper right; and a portrait on the lower right.

How does this presentation—of which I have had to simplify the account here—bear on the question of a postmodern theology? The foregrounding of framing and the deconstructive dispersal of the canonical interpretation of the Judith story are a strategy for achieving a relevance for theology as cultural analysis. The strategy of dispersal and the foregrounding of framing itself by means of pluralized frames were attempts to account for the painting in terms that were not

thematic, that did not immediately focus on the Judith subject. But, clearly, to present a *Judith* without paying attention to the most obvious frame, the thematic one, would be disingenuous and beside the point. Visitors would expect it, and might quickly lose interest if the theme were artificially avoided. But three traps lurk here: the predictably misogynistic interpretation of the theme, the ahistorical reification of any theme, and the visual tedium of repetition.

My endeavor was to exploit the thematic frame by blowing it up from the inside, so to speak. This was done in several ways concurrently. The thematic part of the show was divided into two sections: the prints and drawings, and some paintings. Wishing at all costs to avoid the kind of thematics that surround castration anxiety or more general misogynistic fantasy, I divided the prints and drawings according to two sub-themes, and, forced by the limitations of the collection—but then wholeheartedly—I presented the paintings in terms of ambiguity, not concentrating on powerful women, the famous lady killers, but on a variety of power relations between women and men. *Lady* killers confronting lady *killers.*

However, the ambiguities could easily get lost on viewers keen on connecting this frame with the subject of the painting. To recall that subject while undercutting its centrality, I made two interventions. First, Speckaert's *Jael,* which appeared in the section devoted to the Boijmans collecting policy, was moved from that wall to be closer to the thematic section. Second, I added, in the small section to the left of the entrance, a number of color photographs of other *Judith* paintings and one drawing, all related to Sweelinck's representation of the theme in specific ways, thus countering thematic conflation.

The two most famous *Judith Beheading Holophernes* paintings—the one by Artemisia Gentileschi and the other by Caravaggio—were perhaps most likely to confront the viewers with aspects such as horror and admiration for a job well done (the Gentileschi) and the contradictory feelings evoked when the face of the decapitated figure turns out to be a self-portrait (the Caravaggio), aspects which enhance the Sweelinck in unexpected ways. These irreverent photographic copies were also meant to shock viewers into realizing the difference between imagery as such and the material work of painting; to reflect on what matters to them, the work as image or the work as thing.

The point of this working around the Judith theme was twofold: narrative and representational. First, like the Samson story, the story of Judith is often depicted in art. It has great dramatic potential. The combination of beauty and virtue presents a challenge to the subtle painter. Moreover, it juxtaposes two loyalties: Judith saves her people but is a threatening figure to men. As usual, the older woman, Judith's maid, is important for introducing nuances. In many representations she is depicted as a "madame," something which is given sexual expres-

sion in the form of the younger woman. This is why such a female figure is often placed next to Delilah, although the Bible gives no cause for this. In more subtle works, by being contrasted with the older woman, the heroine is depicted as beautiful, attractive, and hence, indirectly, sexual.

But Gerrit Pieterszoon is subtler still. He has the women resemble each other, which suggests cooperation, without an emphasis on sexual "weapons." His Judith virtuously looks away. The older woman represents her to the viewer; she looks us straight in the eye and thus assumes responsibility for our response to the event. The tension between virtue and the use of sexuality as a weapon is thus dramatically presented to the viewer. At this juncture it seemed useful to broaden the biblical frame by comparing the case of Judith with that of Jael, represented in the nearby Speckaert.

The story of Judith is similar to the subject of Speckaert's *Jael and Sisera,* a canonical Old Testament theme (Judges 4 and 5).[19] Here, too, a beautiful heroine takes action, saving her people through ruse and sex appeal. In Jael's story, unlike in Judith's, no mention is made of her virtue. Accordingly, she is rather voluptuous in Speckaert's rendering. The moment is presented when Jael is proudly about to show her prey to Barak, who was unable to achieve the same victory. A double triumph, therefore, of one woman over two men. And, in a certain sense, a theatrical performance *within* the story.

The foundation was now laid for a more integrated comparison that relates the stories to their cultural life, their popularity to the tensions between men and women, and the various traditions of depiction to the paintings and objects on display. Why is the story of the beautiful—or deadly—heroine so popular that it is so often depicted, and even tangibly present, on household utensils, whereby housewives and maids are confronted with it on a daily basis? If such artifacts have any theological relevance, then, in our postmodern perspective, this popularity of the story, its cultural presence, must be accounted for. Along with stories about Samson and Jael, the story of Judith is one of the popular mythical stories in which the power struggle between men and women ends in favor of "the weak(er) sex." These stand next to, or opposite, other stories, which have also been frequently depicted, in which women are the victims of (sexual) violence, like when Lucretia was raped and, to save her honor—or her husband's—committed suicide. Susannah (in the book of Daniel) barely escapes the same fate: she resists the threats of her two attackers and is saved from death from stoning by the young Daniel, who isolates the two Elders and is thus able to catch them out on contradictions. The domain of such stories and their ongoing popularity is mythological.

Myth, whether we like it or not, is part and parcel of religion. For a postmodern theology that neither denies the persistence of myth in the present nor en-

dorses the naturalization of myths, this intersection between myth and religion is an important area of contestation. The most important aspect of the thematic frame thus became the *variety* of such tensions, not the uniform focus on dangerous women. For me, this was the key to making this show *work*: not repeating what one already knows (or thinks one knows) but drawing upon other knowledge, to increase insight into more varied relations. It is a mistake to explain such stories simply as those of victims, of women's wickedness, or of a carnivalesque upside-down world in which women get the upper hand. Instead, they belong, together with more ambiguous and ambivalent stories, to a series of stories about women, men, and power.

Moreover, a one-sided reading often deprives one of what the depiction, visually, reveals. Many depictions, in which the story on which they are based points in one direction, visually suggest the other side of the same story. Thanks to the depiction, we see that the other side was embodied in the story from the beginning. The languid nymph about to be raped by the powerful faun emerges as a raging Fury; the lethal Delilah, the murderous Jael, and Judith sometimes seem more like the caring mother worrying about her child. If we look back at the text, which seems to have been so inappropriately interpreted, we see instead that the depiction reveals a new—and until then unseen—side. This confrontation offers an implied argument for the adoption of visual imagery in the domain of—mostly text-based—theological study.

The feelings and loyalties dealt with in such stories are ambivalent indeed. The vulnerability of the drunken or sleeping man can be seen as a rendering of the more common insight that men do not have all the power; that women cannot be totally subjugated; that uncertainty and vulnerability always also influence relationships.

The makeshift print cabinet had to be isolated from the room where the paintings were displayed because of light restrictions. In line with suggestions made by Julia Kristeva in her exhibition at the Louvre but not fully elaborated there, I wanted to draw attention to the intimate connection between beheading and portraiture.[20] I now wanted to theorize the fine portrait of Holophernes in this Sweelinck—already foregrounded by the juxtaposition of the *Judith* with the portrait of his famous brother—in more general terms. But to make that point, an even more general aspect of the depiction of the human body needed to be explored. On the one hand, bodies in interaction pose the problem of delimitation. What comprises an individual body, as opposed to the mass of lines and planes that suggest bodies embracing or bodies killing each other? The sleeping body displays a vulnerability that seems to visually raise the question of whether sleep doesn't invite the kind of killing actions that biblical heroines represent. The question of individual wholeness is also raised by decapitation as such. For is a body without a head still a human being?

The two walls with the prints and drawings were linked by my favorite quote from the original biblical story. On the left, above the works, were the words: "Look! there lies Holophernes . . ." and on the right: ". . . and his head is missing!" A head apart: from dissection to composition. Such stories about women's victory and such experiments in depicting individual limbs, vulnerable sleeping figures, and heads without bodies recur in numerous prints and drawings in the Boijmans collection. A beautiful series by Lucas van Leyden depicts no less than three of the popular "lady killers" from the Bible: Jael, Delilah, and Salome. In Ferdinand Bol's drawing of Tamar and Amnon, he reveals the other side of the story: a man rapes a woman, who has been lured with a trick.

Unlike the impersonal, separate body part or the headless body, the decapitated head stands for the essence and limits of the individual. At this point I wanted to invite the viewers to retrace their steps and take a second look at Sweelinck's painting, and perhaps at the entire room. A suggestion to do so was given in a daring, perhaps dubious, connection, presented as open to reflection and decision. On the back of the screen—in the middle of it and surrounded by a few particularly remarkable prints and drawings—I placed one of the two drawings by Sweelinck, a depiction of Saint Luke at the easel. This striking sketch shows the same jaw, cheekbone, and eyebrows that made the two women in the painting resemble each other so closely.

Looked at with this in mind, Sweelinck's *Judith* became even more surprising. Could it be a coincidence that the unusual shape of the face of both Judith and the older woman who resembles her—the prominent cheekbones and the distinct jaw—was also found in the face in this sketch? Seen in this light, it was striking that Holophernes' head again resonated in Gerrit Pieterszoon's most beautiful portrait: that of his brother, who achieved greater fame.

This last sentence, which leads back to the painting and its two primary features—ambition and portraiture—risks reintroducing relative canonicity and aesthetic judgment. As it happens, these are two major elements of the ideological power of religion framed as authoritative structure, and hence both were in need of analysis and critique. But I also wished to connect with preoccupations I could be sure would be entertained by visitors. It made no sense to expect people to come into the room with blank, empty minds. Framed as they invariably are by the traditional discourse on art, it seemed more meaningful to include such considerations—but putting them in a pluralist perspective—than to ignore their important influence.

Visually, this connection between the less successful brother, here in charge and at the center, and the more famous one who ends up decapitated—but then, also, beautifully portrayed—was based solely on the visual imprint, in the memory of the visitor, of the striking, strong features of the two murderous women, now projected over the light, barely readable sketch. Bathing in the blood-red

color of the ground, the sketch and painting may or may not have anything to do with each other.

With this experimental presentation of Sweelinck's *Judith,* I tried to make the most of that obnoxious notion, the "work of art." I was attempting to confront the various visitors who might wander into Room 4 of the museum with a different kind of confrontation with art, one that *concerns* the people who inhabit today's society, that *shocks* them into looking at old masters not as venerated yet antiquated remnants of the past, but as something that belongs to a present that entertains a lively relationship with its past.

My point was/is that there are different ways of working in museums that can increase both enjoyment and visual literacy: ways that do not reproduce, in vulgarized form, the historical scholarship conducted by museum professionals; that connect art to social and cultural life, without moralizing; that bring objects to life and life to bear on the objects otherwise so easily severed from what preoccupies the culture around them. What is usually called "a work of art" is ultimately an object, a thing that works, which occupies, in our culture, just such a position—that of a *key* between itself and the world, and vice versa.

As long as religious themes and narratives permeate a culture, they partake of the ideological makeup of that culture. Clothed in the joint authority of moralism and aesthetics, the forms they take—be they framed as "high art" or as "popular culture"—belong to that domain of contemporary culture where theology has its part to play in the general critique, or deconstruction, of what makes that culture constrictive and limiting. A postmodern theology, then, need not decide whether God exists or not, and which one God has privileges over which other Gods in a multiple society. Instead, staying rigorously on the side of the human subjects who make up and are shaped by that culture, such an atheological theology can break open the confining limitations imposed by authoritarian religion and open up possibilities of different forms of relationality that are insensitive to old, ill-conceived taboos. If I have it my way, then this is theology's postmodern mission—if such a thing is thinkable, which, perhaps, it isn't.

Notes

Originally published in *The Blackwell Companion to Postmodern Theology,* edited by Graham Ward (Oxford: Blackwell, 2001), 3–23.

1. For this historical position, see a number of contributions in Bal (1999), esp. Ankersmit.

2. Two examples of close analyses that nevertheless escape the work itself in favor of theological finery are Treffers (1991) and Askew (1990).

3. For an excellent account, see Nead (1992).

4. In fact, to call this morality Victorian is an anachronistic repression of the same structure as the attribution to Caravaggio of a non-bodily religiosity.

5. For such a rejection of my work on Rembrandt, see Podro (1993). In contrast, see Pollock (1993). Pollock's own art historical work, although theoretically grounded in a different social history than the one underlying my work, ends up in a similar practice. See, for example, her recent study of the canon, *Differencing the Canon* (1999).

6. See Bersani and Dutoit (1997).

7. A frame in the double sense of the material frame of the church in which the works were to be displayed and the ideological frame of the theological context they were called on to enhance. For this meaning of framing, see Derrida's famous essay on "parergon" (1987); also see Maleuvre (1999) and Duro (1996).

8. See, for example, Treffers (1991), but many other examples can also be alleged.

9. I am alluding to the narrative structure of any representation of happenings, where a narration—here, in paint—is inevitably colored by a represented vision, either the narrator's or a represented character's. For the narrative theory underlying these remarks, see my *Mottled Screen* (1997).

10. If one accepts this resistance as inhering in the painting, one must also reject Fried's obsessive application of the pair absorption-theatricality to Caravaggio in "Thoughts on Caravaggio" (1997). Note, in this context, the idiosyncratic use of the latter term in Fried's work, which is not to be conflated with the more common meaning I am using here, of theatricality as referring to, evoking, or imitating the stage.

11. Gilbert (1995).

12. He did this so well that even today this story gets all the attention. But such iconographic analyses do not account for the *painting,* only for what is "behind" it, outside of it. In other words, the most established of art historical methods treats the painting as a text.

13. The term "trisexual," not its content, has been borrowed from Bollas (1987, 82–96).

14. See Bryson (1983) for an early version of this distinction.

15. On coevalness as the failed potential of anthropology, see Fabian (1983).

16. The concept of reading as performance is current and most characteristic of postmodern literary analysis. Its best-known early proponent was Iser (1978); for an inquiry into the feminist and postcolonial implications of Iser's approach, see Pratt (1992) and Tompkins (1992).

17. Bal (2002).

18. Maleuvre (1990, 48–49).

19. I devoted a study to this story and the ways biblical scholarship has dealt with it in *Murder and Difference* (1988).

20. See Kristeva (1998).

References

Askew, Pamela. 1990. *Caravaggio's "Death of the Virgin."* Princeton, NJ: Princeton University Press.

Bal, Mieke. 1988. *Murder and Difference: Gender, Genre and Scholarship on Sisera's Death.* Translated by Matthew Gumpert. Bloomington: Indiana University Press, 1988.

———. 1997. *The Mottled Screen: Reading Proust Visually.* Translated by Anna-Louise Milne. Stanford, CA: Stanford University Press, 1997.

———. 1999. *The Practice of Cultural Analysis: Exposing Interdisciplinary Interpretation.* Stanford, CA: Stanford University Press, 1999.

———. 2002. *Travelling Concepts in the Humanities: A Rough Guide.* Toronto: University of Toronto Press, 2002.

Bersani, Leo, and Ulysse Dutoit. 1997. "Beauty's Light." *October* 82 (Fall): 17–30.

Bollas, Christopher. 1987. *The Shadow of the Other: Psycho-Analysis of the Unknown Thought.* New York: Columbia University Press.

Bryson, Norman. 1983. *Vision and Painting: The Logic of the Gaze.* London: Macmillan.

Derrida, Jacques. 1987. "The Parergon." In *The Truth in Painting.* Translated by Geoff Bennington and Ian McLeod, 87–82. Chicago: University of Chicago Press.

Duro, Paul, ed. 1996. *The Rhetoric of the Frame: Essay on the Boundaries of Artwork.* Cambridge: Cambridge University Press.

Fabian, Johannes. 1983. *Time and the Other: How Anthropology Makes Its Object.* New York: Columbia University Press.

Fried, Michael. 1997. "Thoughts on Caravaggio." *Critical Inquiry* 24:13–56.

Gilbert, Creighton E. 1995. *Caravaggio and His Two Cardinals.* University Park: Pennsylvania State University Press.

Iser, Wolfgang. 1978. *The Act of Reading: A Theory of Aesthetic Response.* Baltimore: Johns Hopkins University Press.

Kristeva, Julia. 1998. *Vision Capitales.* Parti Pris. Paris: Museé du Louvre.

Maleuvre, Didier. 1999. *Museum Memories: History, Technology, Art.* Stanford, CA: Stanford University Press.

Nead, Lynda. 1992. *The Female Nude: Art, Obscenity and Sexuality.* London: Routledge.

Podro, Michael. 1993. "Review of *On Reading 'Rembrandt': Beyond the Word-Image Opposition.*" *Burlington Magazine* (October): 699–700.

Pollock, Griselda. 1993. "Review of *On Reading 'Rembrandt.'*" *Art Bulletin* 75 (3): 529–35.

———. 1999. *Differencing the Canon: Feminist Desire and the Writing of Art's Histories.* London: Routledge.

Pratt, Mary Louise. 1992. *Imperial Eyes: Travel Writing and Transculturation.* London: Routledge.

Tompkins, Jane P. 1992. *West of Everything: The Inner Life of Westerns.* Oxford: Oxford University Press.

Treffers, Bert. 1991. *Caravaggio: Genie in Opdracht.* Nijmegen: SUN.

15. Religious Canon and Literary Identity

> The craze for myth is the fear of history. —*Philip Rahv, "The Myth and the Powerhouse"*

Literary Canon and Religious Identity

Let me put my cards on the table. Two cards: first, I am not religious; I am not even sure I understand what religion is, outside of the institutionalized religions, of which I want no part; second, I find the theme of this volume—*Literary Canons and Religious Identity*—an important and timely one to which I fully subscribe. Inverting the order as I have done in the title of this chapter is not to be construed as opposition to it. If I may take a guess at the motivations underlying the choice of the original title, I assume—and am happy about it—that the impulse is political, progressive, and revisionist. It must be. Why?

The whole idea of "canon" as an object of study, as it has been in recent decades, presupposes a *political* grounding for what we read as "canonical"—not in party politics but in a movement against partisanship. With meanings ranging from "yardstick" to "law" and "rule," the Greek word *kanon* refers to a desire to regulate social coexistence, a desire that institutes the political domain. Speaking about a canon, then, implies recognition that the cultural domain of reading and literacy, and of reading and following religious texts, is a political one, and that studying, or, rather, analyzing, elements of that domain is by definition—at least partly—a political activity.

That political concern in the present context can only be *progressive* and critical, aiming at real interventions, because it is from that perspective that the canon has been stripped of its innocent self-evidence. The preservers or curators of the canon don't even think about "canon," at least not as a term for analysis. They simply "do" canon; they teach, analyze, and frame the canonical texts "canoni-

cally," without questioning their choices and the self-serving methods of reading that leave the selection unquestioned. This unreflective self-evident repetition is the defining feature of canonicity.[1]

The project must be *revisionist*, finally, because the point of discussing the canon as a politically conservative force is to change its status—from self-evident power to a phenomenon to analyze and thus, by definition, to transform. The magic word "identity"—pointing to a feminist, queer, and/or multicultural perspective, and in itself connoting a progressive, politically inflected perspective—relates the need to subvert that exclusivist and oppressive power to the recognition that it is wielded by a small group of people with an identical identity. The word "identity" indicates that it is precisely this sociopolitical dominance of certain *kinds* of people over all "others," which the formation and maintenance of a canon facilitates.[2] But such a critique and revision of the canon go hand in hand with a critique and revision of the ways in which we read the canon. This other side of the double venture is indispensable if we are to *understand* the power of canons.[3]

But there is more—something more specific—to the title of this volume than this larger project of opening up: it specifies a trajectory on which this cultural process of power-wielding functions, for it connects the *literary* canon to *religious* identity. Two cultural domains usually perceived as distinct, if not opposed—one worldly, the other spiritual—are related to each other. What we read for fun, beauty, learning, or self-transformation contributes to the formation of who we are in terms of that specific cultural-political domain called religion. This analysis of the work performed by literary canons, including shaping religious identity, is quite plausible if one thinks of one of the canonical examples of an indisputably canonical text, Milton's *Paradise Lost*. This work's major thrust is a Christian revision of Hebrew scriptures suited to Milton's time and place and thus, precisely because it is such an artistic masterpiece, it helps to streamline the social environment in its ongoing Christianization. Its artistic merits are beyond doubt. Its religious content is obvious. But it has no status in any *religious* canon. Interestingly, in his famous article on the universal values of literary canons, Charles Altieri (1983) uses this example in his larger argument that canon formation is *not* political—nor religious, for that matter.

Indeed, there is good reason to insist on the differences between religious and literary processes of canon formation. The former are fixed forever; the latter are in flux. The former constitute the basis for thought and behavior in a congregation whose membership has official status. The latter are primarily conveyors of aesthetic and formal value, and the group formation they promote is repressed, sometimes fiercely denied. For now, however, such denials as Altieri's call for a countermove. There is a close bond between artistic and religious canonicity, and the indisputable literary canonicity of an indisputably religious text like *Paradise Lost* proves it. This link serves an interest that I want to bring up for discussion

before proceeding further. It is even more obvious in visual culture: the interest in *representation* as a sociopolitical tool. This notion will be important in my analysis below. And whereas I would emphasize that literature is close to visual art in its cultural "work," despite the fact that its medium is more acceptable to religions with a taboo on visual representation, I will, for now, limit myself to the written texts.[4]

The relationship posited in the title of this essay claims a *social agency* for literature. What we read transforms or confirms us, more specifically, our religious identity. The title of the volume, then, can be read as announcing the project of transforming the canon of what the Western world sees as great literature, in order to liberate and include forms of—here, religious—identity not captured by the mainstream, institutionalized religious systems that predominate there. If Milton's work was able, moreover, to promote a religious identity that included social divisions on lines of gender—and on a different level, to which I will return, of class—then all those groups who do not feel validated, inspired, and confirmed in their religious identity by such texts may benefit from the project of opening up the canon.

The need for this rethinking has become urgent because of the social phenomenon of worldwide migration, which has made the near-exclusive dominance of Christian and Judaic traditions in the Western world less obvious and has imposed participation in the social organization of, most visibly, Islamic traditions. The reality of migration has, more generally and vaguely but also more incisively, made us aware that religious identity is in fact not self-evidently Christian or indeed anything in particular. What the title of this volume contributes to that process of denaturalization of religious identity is to pinpoint the subliminal—and hence sometimes insidious—contribution to the false and exclusivist stabilization of religious identities by that seemingly frivolous or lay medium called literature.

Literature, the title of this volume suggests, promotes exclusion and mainstreaming by means of its own canon and canonization, which are by no means identical, either in content or in process, with the canons of established religions, and which may therefore appear relatively "innocent" of imposing religious identity. Precisely because religious canons are established once and for all, the more fluctuating literary canons may have a greater power to shape society.

Religious Canon and Literary Identity

I wholeheartedly underwrite the goals that such a topic implies. I also share the logic that allows it to be a sound intellectual project. If the title of my contribution inverts the terms of this topic, it is not meant to challenge or criticize it. It rather

implies an attempt to demonstrate, as an element within the larger project, that the logic of the theme is tenable precisely because of a deeper, even less visible, and therefore more insidious power game: that of binding the outcome of the process, a religious identity based on canon, to a less visible because less institutionally defined *form of identity* that is, strictly speaking, literary. This literary identity, still to be defined, infuses the religious canon in many different ways.

Representation plays a key role in it, although not the only role. And, as I will argue, the promotion of and through literary identity is connected to representation as a form of *incarnation* or embodiment. I use the word very much in Richard Dyer's sense, of promoting a particular way of considering the body as the site of spirit, not as defined by spirit qua body. As Dyer has brilliantly observed in a critique of the tacit self-evidence of a predominant "white" perception, this tradition insists on that curious notion so central to Christianity: *incarnation.* This tradition includes representing the body in suffering and sacrifice, while qua visual representation it counters the two other monotheistic traditions that resist visual representation of the body. Christianity has a stake in this that goes beyond just the wish to be liberal about art. Dyer proposes, as its primary stake, the attempt to propagate a specific sense of *embodiment* of spirit. This is a specifically "white" endeavor to the extent that, if it is to be *self-evidently* predominant, the white body must be propagated but not foregrounded. Hence, these representations are about something that, in Dyer's words, is "in but not of the body" (1997, 14).

I shall defend this thesis through a revisionist exercise of my own, by revisiting an earlier analysis that I published in my book *Reading "Rembrandt"* (1991). It proceeds from the perspective of the double knot of identity and canon, on the one hand, and religion and literature, on the other. There I contrasted the biblical canonical story of Joseph and Potiphar's wife with the equally canonical story, in the Qur'an, of the "same" fabula. The issue was the representation of women, the term of comparison was Thomas Mann's literary work *Joseph and His Brothers* (1948), and the goal was to demonstrate that even such oppressive and rigid mythical cases of women-bashing as Genesis 39 and its aftermath are not unified and need not be perpetuated in their massive misogyny. Since then, Alice Bach, among others, has taken up this case and confronted the story with other versions in a gesture aimed, in part, at decanonizing the religious canon.[5]

My issue in this self-revision is obviously neither altogether different nor exactly the same as that of my first study of the case. Religion, religious canon, and religious identity were not at issue in the earlier study as they are in this chapter — and, I wish to acknowledge at the outset, as they are in present-day Western culture. In fact, I purposely excluded them from consideration then. But the interest in revisiting this analysis is not specifically to supplement it with the considera-

tions under discussion here. Rather—in a sense following both Dyer's plea for studying what seems *unmarked,* hence "natural," and the Midrashic tradition of filling in gaps, on which all literary commentary is modeled—I am interested in the *self-evidences* it contains, which prevented me from progressing to a more complex sense of identity, one of whose importance I am now much more clearly aware.[6]

The confrontation with this earlier work of my own is further informed by a by now classical—one might say canonical—work offering a cautious and slightly revisionist defense of the literary canon: Charles Altieri's "Idea and Ideal of a Literary Canon," which uses the example of Milton's *Paradise Lost.* It seeks to articulate the universal values on which canons are based and denies the political in what he seems to consider conspiracy theories that historicize and pluralize such criteria.

Altieri's focus is literary; therefore, it is not so shocking when he claims the exact opposite as the article that follows his in von Hallberg's collection, Gerald Bruns's "Canon and Power in the Hebrew Scriptures" (1983). For Altieri, canons are legacies of cultural values that help produce "strong identities." He dismisses the political-historicizing theory advanced by new historians such as Jerome J. McGann (1981), which is of the kind that John Guillory calls the "liberal critique" (1995). Bruns, by contrast, posits politics as an important factor underlying canon formation, which Altieri denies. Although not addressed by either author, the difference in status between literary and religious canons—the one being produced in an ongoing and socially unlocated process, the other definitive and decided by religious leaders—silently accounts for that opposition and mitigates it. As stated earlier, in order to sharpen our focus I will question that opposition.

Altieri puts up an intelligent argument in favor of canons of works we "idealize" and of the possibility of articulating and promoting common principles of judgment on which to base recognition of a form of valid "idealization" (46). Thanks to that recognition, canonical texts will be preserved and read. This gives them the power to shape public, moral identities through identification. He then proceeds to specify, on the basis of the age-old fallacy of a form/content distinction, that the values inherent in canonical texts concern literary "craft" (form) and "wisdom" (content) (51). Whereas my case study below urges us to question such distinctions, here I will mention only three disturbing problems raised by the article, which make it unacceptable as a basis for our discussion. First, Altieri's argument rests entirely on the arbitrary assumption, neither spoken nor argued, that literary canons are both important and productive enough to be defended. Second, he sketches the process of canon formation as an entirely rational, directed process, thus ignoring institutional powers and wider ideological issues that contribute more diffusely to that process. Third, his criteria remain pro-

foundly, even literally, conservative. This makes them a priori unfit to help expose the self-evidence of conservatism, which any discussion of the canon seeks to do.

In view of all this, the common denominator between Altieri and myself is surprising, to me even worrying. Whereas I focused on women and Altieri on literary masterpieces, I on bodies and he on transhistorical values—in short, I on the political and he on the literary—we share a significant neglect of religion. Just as I discussed the bits from the Bible and the Qur'an as if they had nothing to do with religion, Altieri's example remains silent about the religious identity that his literary canon promotes. Until the theme of this volume came up for discussion, he got away with it, too. And so did I. Not any longer. The point of my inversion of the title is to reconsider that silence.

Ethical Non-Indifference and Artistic Merit

The first issue I wish to revisit is *the relation between ethical and artistic merit.* When studying the conjunction of Rembrandt's representation of the story with the later literary version, I was struck by the fact that Thomas Mann, in his preface to *Joseph and His Brothers,* explicitly attempts to overcome the mythical reification of misogyny that he found in the traditions surrounding the episode. He is quite proud of "the humane vindication that I had undertaken in it, the humanization of the figure of Potiphar's wife, the mournful story of her passionate love of the Canaanite major-domo and her *pro forma* husband" (1948, xi). On the strength of this uplifting political undertaking, Mann claims literary success for the episode, which he calls "unquestionably the artistic zenith of the work" (xi). Importantly, then, Mann puts forward a "protofeminist," *humanist* ideology as an argument for aesthetic accomplishment. What he claims for his retelling of a story from the religious canon is literary canonicity on ethical, political grounds.

Here is my first unargued self-evidence: instead of examining how this claim could be justified on principle, I cast it aside, typically, in a concessive subclause: "Although I am reluctant to endorse such a conflation of aesthetics and ethics" (1991, 97), while the rest of my analysis says nothing about the aesthetic—for instance, the specifically literary—merit of Mann's defense of Potiphar's wife. At this point (and on the basis of the relation between literary and religious identity, and between canon and identity that we are probing), I wish to revise this dismissal and reserve judgment on this general issue. (Not that I lacked good reason for that dismissal.)

The reason for my reservation was the *ethical indifference* commonly shown in the face of artistic excellence. Such indifference has been displayed, for example, in enthusiastic receptions of wildly misogynist novels full of rape scenes

presented as a masculine value, by Norman Mailer and Arthur Miller—which mark the beginning of feminist critique of the literary canon by Kate Millett in the 1960s. Or in the unquestioning acceptance of the literary value of South African literature, in which racist representations of black people were not even noticed. Or in the infamous case of Céline's brilliant anti-Semitic novels. This suspicion of ethical indifference was not wrong, and I still hold it. But *now* I wish to refine that view. I will not retrospectively endorse the *conflation* but will first revise and then promote Mann's claim—otherwise.

Usually this problem of the severed relation between ethics and aesthetics is resolved, albeit uneasily, by abrogating it. While acknowledging that some literature is politically disturbing yet aesthetically "great," the problematic works have never, to my knowledge, been cast out of the canon. My solution, which was to focus only on the ethical element, now strikes me as escapist. This time I would take the opposite position and examine how ethical *non-indifference*, far from being indifferent to aesthetics, informs the novel's artistic merit on its (the novel's) own terms. This will be the first step in developing a notion of literary identity. Only after that reflection will I feel equipped to further define the latter term, so as to substantiate my inversion of the title of this volume.

In the passages from Mann's preface quoted above, the vindication is already broached on two levels: that of the story and that of the fable. I noted that "by writing about him, Mann includes Potiphar's presence in the story, signifying his absence differently in the adjective pro forma. As a husband, Potiphar is only a signifier, an empty form, and it is the absence of the signified that triggers the story and makes it 'mournful'" (96). *Then* I was sensitive to the understanding Mann displayed for the woman's desire. That desire is the motive force of the fable, but the description of the character of Potiphar, however brief, gives that desire a reason, a motivation, an excuse. "Mournful" gratified me as an acknowledgment of her plight at the story level.

Now I am sensitive to the underlying endorsement of monogamy, to the suggestion "With such a husband, what can you expect?" As I have argued elsewhere, monogamy is not indifferent to either religious or, I now add, literary, identity, and biblical metaphors of "whoring" for religious unfaithfulness prove it.[7] (Without going into this now, the semantics of the verb *zanah* and the noun *zonah* around the notion of the stranger does bear out the *ethnic protectionism* that the "metaphor" conveys.)

More disturbingly, Mann's statement attributing the woman's desire to her husband's inadequacy deprives that desire of its "desirousness." An implicit moral consideration—such as excusing her adulterous desire because of the husband's deficiency—overrules the simple but profoundly subversive fact that the desire is both inalienably hers and at the same time weakens her identity—

makes her, as the saying goes, weak in the knees. In other words, the figure of Mut-em-enet in Mann's novel and the woman in the Qur'an version on which it draws, insists—more than Mann takes credit for in his preface—on a desire that is hers, while depriving her of her power to act socially and morally according to the rules. This may sound like another lame excuse, even lamer than her husband's inadequacy as a husband, but it is surely hers. And it is the site of the tangled relationship between elements that are usually distinguished—such as, first, body and spirit, and second, private and public—a relationship that I wish to foreground.

The unexamined term is *body*, in the culturally specific sense of Christianity. Importantly, Mut's being weakened by desire is her state according to a conception of the body not playing the game with spirit that Christianity promotes in its narrative representations of the embodiment of spirit. Just think of the bodily iconography in Christian art, so thoroughly in opposition to Islamic and Judaic rules against such representations. Suffering and/as sacrifice is valued through narratives such as the *Pietà* (Scarry 1985, 216). This scene depicts nativity and death in conflation, to convey the sense in which Christianity sees the bond between body and spirit. Mary is body in the sense of a vessel for spirit; Christ is body in which spirit is *incarnated, placed*: together they promote the body as a site of embodiment. The antiquated Aristotelian gender division involved in the *Pietà* imagery is further enhanced—but, again, *not* foregrounded, remaining unmarked—by the youthfulness of Mary in many such images. This suggests a heterosexual love relationship as the middle term between nativity and death. Representation, of the kind the other two monotheistic religions reject, is vitally important as a tool for promoting a sense of the body that is specific, politically suited to enhancing domination, and paradoxically, at the same time invisible because *unmarked*. Dyer argues that the representational "ideologeme" (my term, based on Jameson 1981) of incarnation invests unmarked, white bodies with self-evident power through the conception of spirit it implies, in combination with the political use to which that spirit is put as "entrepreneurial" and imperialist (14–40). This conjunction between a Christian conception of body and imperialist politics makes critical reconsideration of both literary and religious canons, such as the one I am engaged in here, urgent, relevant, and timely.

My little case study concerns desire. Why? Desire, I would think, is the systematic opposite of embodiment. It is that happening between *act* and *state* that is, in Dyer's terms, *of* the body, not localized *in* it. A fresh look at the scene in Mann that "explains," by way of a "literary masterpiece" written by a canonical white male author, what the novel's "vindication of the rights of women" amounts to may help us understand how literary identity and religious canons can inter-

sect, so as to unmask my own and Altieri's silencing of the religious element in the conceptual knot under discussion.

I am alluding to a scene where the bodiliness of desire and the impossibility of separating spirit and body become painfully clear, in the most literal sense of the adverb. It is the scene of the little knives that is absent from the biblical story. Extensively represented in Mann's novel, it is to be found in that rival canon, the Qur'an. Mann's novel, then, does more than vindicate the woman as if he were her ideological *cavalier servant,* turning her into a near-virgin by asserting her husband's inadequacy. In one sweep—a complex but effective alternation of focalizing positions, distributed between the woman Mut-em-enet, the Joseph figure called Osarsiph, and the other women in town—the novel accomplishes its literary greatness, its contribution to religious identity, and its opening up of the religious canon. Let me explain this judgment.

It is based on what happens following the woman's failed attempt to seduce Joseph—the scene, in other words, of the vindication of her desire. To assess what Mann accomplishes here, the difference from the Genesis text is important. In the Genesis text, after the fateful ultimatum that will take Joseph to prison, the nameless woman calls upon "the men in the house" to slander him, using ethnic slurs to enlist the men's solidarity with her: "And . . . she called to the men of her household and said to them: 'See, he has brought among us a Hebrew to insult us; he came to me to lie with me and I cried out in a loud voice'" (Gen. 39:14).

In my earlier analysis I paid no attention to the woman's choice of arguments. It now strikes me that, to phrase it harshly for the sake of clarity, she appeals to racial sentiment and class subordination to denigrate her husband's household management in the eyes of his subordinates by fanning their envy of the higher-ranking Joseph.[8]

The argument will be repeated to the husband, who, without discussion, takes Joseph into custody. No wonder such a story has contributed to the further hardening of both misogynous mythology and—let's not forget it—the antagonism between the intended Hebrew readers of the story and their "others," to whom this woman ethnically belongs. Note that it is the husband whom she accuses of disrespect to herself and the other men in the house. The Hebrew man is just an instrument, as are the other servants. The woman uses race and class to get round to sex. Conversely, the story uses sex to condemn femininity, while promoting—"self-evidently," without foregrounding—race and class, as well as the straitjacket of male bonding and solidarity in a hierarchically organized society. The excuse a humanist feminist perspective could offer is that the woman's strategy utilizes the only instruments available to a woman confined to the house in a predominantly man's world.

But Mann's ethical non-indifference is artistically motivated, just as the artistic quality of his work is ethically non-indifferent. Although I would need to write far more to substantiate this claim, each of the three stories, if framed within their own aesthetics, has literary brilliance. And in each case, the literary quality involves ethical issues. Because the means of, especially, narrative literature touches upon the intricate connections between private and public aspects of subjectivity, attempts to pass off objectionable ethics under the cover of literary brilliance are doomed. So are attempts to separate the two—that is, condemning a work on ethical grounds while continuing to read it canonically on aesthetic premises—through ethical indifference.

I will only touch on aesthetic concerns in Mann's text. These are both explicit in the author's preface and known to the readers of the novel who share the kind of canonical form of literature within which the novel was conceived, written, and read.

The issue is *realism*. To write a novel—hundreds of pages, realistic detail, psychology, and all that entails—Mann's vindication needs a richer source. As he complained, the Bible's meager "what" lacked the "how" and the "why": life's circumstantial detail was missing (Yohannan 1982, 431).[9] This is, at first sight, a literary issue, and what Mann gives expression to is the novel's realistic needs. Circumstantial detail is a notable feature of realistic narrative, and an important element of aesthetic judgments of such narratives that may even decide their inclusion or exclusion from the canon.[10] Realism in literature and art requires detail. Remember, though, that realism as a *belief* in the reality of the representation is also the ground for the iconophobia of Judaism and Islam. I submit that these two aspects knot together religious and literary concerns. What leads to idolatry in religion leads to sympathy in the novel, and both are equally dangerous lures to transgression. The difference is the conception of the body—as the site of embodied spirit versus as defined by spirit. This bond between religious and literary taboos, on the one hand, and conceptions of body-and-spirit, on the other, becomes clearer when we realize that there is also a legal point in Mann's complaint. Circumstantial evidence, although legally flimsy and problematic, is often the only evidence there is to indict or acquit. Hence the artistic consideration—how to gain a place in the literary canon by doing an aesthetically good job with details—*inevitably* entails considerations that spill over into the social domain, where politics and ethics meet before the law. We must not forget there is a sense in which the Greek word *kanon* means "law."

Mann's search for circumstantial detail in a story in which guilt is at stake, is, therefore, in and of itself an act of merging aesthetics and ethics; an act, that is, *against the ethical indifference of aesthetics*. This is why his statement in the preface deserves to be endorsed, say, as a philosophical position. Against a Kantian

disinterestedness, Mann, on the eve of unprecedented crimes against humanity, postulates an aesthetics of ethical non-indifference.

The Cutting Edge of Literary Identity

In this section, I will argue two further points that follow from the need for ethical non-indifference as an element of aesthetics. First, *literariness* is a tool for identity formation; second, religious canonicity is not premised on that formation but allows, even facilitates, it. I will argue these points by following Mann in his search for detail.

Mann will find his circumstantial evidence in the rival text, the later and, so to speak, derivative version. The episode appears in the Qur'an Sxii, 23–35, where the follow-up to the seduction attempt is different and more extended. Yet the Qur'an is not a novel, any more than Genesis is. While adding "detail," part of the circumstantial features in Genesis are also eliminated, which is why I don't find the terms *gap* and *gap-filling* useful; they fail to account for repression and elimination, and end up accounting only for supplementation. There is no equivalent to Genesis 39:14—no interaction with the other men in the house, no racial slurs, no appeal to class subordination to solicit sympathy.

This omission, especially of ethnic denigration, is easily explained in view of the respective ideological and religious identities of the intended readers, and by the context within which each text functions. I am most certainly not interested in further exacerbating the divide between Judaism and Islam, the respective curators of these canonical legacies.[11] I mention the omission only to footnote Mann's seemingly *quantitative* complaint. For the appeal to support and solidarity, which in Genesis carries the "argumentation" we have already seen, features in the Qur'an as well. Only the people called upon are different. The social setting shifts. Mann's choice of the Qur'an episode to aesthetically "supplement" the meager Hebrew text is therefore not at all a supplementation or gap-filling, but stems from ethical concern—an act of ethical non-indifference.

This choice highlights an important difference between the two religious texts: in the Qur'an, Potiphar's wife is not the only woman in the story. The woman, in the Qur'an, becomes subject to slander among her women friends, "in the City" (Sxii, 30). The scene is twice displaced, from men to women and from house to city. Significantly, the woman acquires public status that enables her to act. And although, according to the fable, she pulls the same trick on Joseph as in Genesis, and, hence, lends herself to the same misogynous mythologizing, the story is given an instructively different twist that prevents such stabilization. The women in the city assume that the woman is going crazy with love (Sxii, 30). She

then acts, not to disqualify or harm Joseph, nor to deny her desire, but to gain literal *sym-pathy*—that is, co-suffering from desire. Here is the passage from the Qur'an (Sxii, 31):

> When she heard
> Of their malicious talk
> She sent for them
> And prepared a banquet
> For them: she gave
> Each of them a knife:
> And she said (to Joseph),
> "Come out before them."
> When they saw him,
> They did extol him,
> And (in their amazement)
> Cut their hands: they said,
> "God preserve us! No mortal
> Is this! This is none other
> Than a noble angel!"

Then she proceeds to confess to her friends that she did in fact attempt to seduce and trick him, and that he did "firmly save himself guiltless" (Sxii, 32). Potiphar and "the men" in fact imprison Joseph for his own good, "for a time" (Sxii, 35).

When I first studied this case, I was interested by Mann's use of the Qur'an to vindicate the woman. *Now* I wonder what the contribution of the choice of that text offers more specifically in terms of the problem under consideration here, in literary as well as theoretical terms. As far as the text's literary status is concerned, first and most obviously, there is more to the historical position of Mann's text than I realized, especially in terms of ethnicity, one extremely important issue of identity. Moreover, this historical consideration—the novel's pre-Holocaust position—needs to be juxtaposed with my own, speaking from a post-Holocaust but also "global" period of migration and cultural mixing. I will return to this later.

Second, Mann's novel, by means of the—literary, realistic—detail of oranges, adds more *pain*. Remember what I said earlier about suffering and sacrifice. Literary identity as bound up with representation (later I will argue that this is but one of its aspects) is here elaborated *in terms of,* yet in critical engagement with, Christian ideology. Here pain is *not* an overcoming of the body by a spirit only temporarily housed there, but an endorsement of an undivided body of desire. In other words, here physical pain is of such a nature that, by its very metaphorical

affirmation of the woman's love pain, it transforms her desire from moral-political to bodily, in an acceptance that spirit and body are one.

I did realize that this pain was important when I wrote:

> At dessert, oranges and very sharp little knives to peel them are distributed. And when the ladies are busy peeling their oranges, Osarsiph/Joseph comes in to serve wine. Sheer fright at the *sight* of such beauty makes all the women cut their fingers, some of them to the bone. "My loves, what ever has happened to you all? What are you doing? Your blood is flowing" is the reaction of the plotting, lovesick virgin. Her intentionally insincere exclamation receives sincerity from the contiguous comment in which the speaker fails to distinguish between himself and this woman. For the narrator continues: "It was a fearful sight." (1991, 116)

Now this sharper pain, caused by the acidity of the oranges, and its bloody visibility appear more striking in terms of theorizing identity through identification, as one form of what the title of my paper promised as "literary identity." This is played out aesthetically on the level of detail of representation, and ethically on the level of shifting the interpretation of the body, confronting it with Christian conceptions.

Theoretically speaking, then, the two aspects of the differences between the versions which appear important are those I indicated as the theoretical elaboration of the literary merit of ethical non-indifference. First, literariness is the tool for identity formation. Second, religious canonicity is not premised on identity formation but allows, even facilitates, it. Concerning the first point, the novelist adequately walks the tightrope between ethical and aesthetic work by mediating on the level of the imagination. He does this by practicing a literary genre in which evaluation of the character's actions is much more common than in ancient texts, but which aesthetically calls for such mitigating and complicating tropes as irony and such narrative devices as alternating, double, and ambiguous focalization. Having created an imaginary realm that readers and characters can share, the appeal to other subjects is here also an appeal to different readers.

This happens on the level of the fable as well. The women friends *feel the pain* of their friend's desire when they feel it themselves at the moment *they* are hurt. This common pain produces *community*—literal, bodily community. Common ground is produced through heteropathic identification, to use Kaja Silverman's term—a form of identification in which the subject, rather than absorbing the other's alterity to make her the same, extols it, idealizes it, and goes out of herself to share it (1996). This is the meaning of the plural as well as of "city" in "the ladies in the City." Although the banquet takes place in the confined space of

Mut's house, the public life of the city enters that space, opening its walls and liberating her from confinement, facilitating contact.

The Qur'an text already did something similar; Mann found there his circumstantial evidence, to which the oranges as a modern "effect of the real" were easy to add. But the point that I was unable to see when I first studied this case is the importance of the conjunction of *pain* with *women* and *city* in this version. The recognition of women's public life is as important as their frail, threatened, but potentially salvaged solidarity on the basis of something so deceptively perceived as private, as desire. It is in this semantic space that the identity produced, on the imaginary level of literature, can be mobilized for a, perhaps, "religious" identity. Not religious as in Judaic, Christian, Islamic official, regulated religion, but in another sense to which I will revert in a moment.

This identity—to put it a bit flippantly, of women collectively, hence publicly, entitled to their desires even if they do not fit public morality—has no canonical status. But the texts that offer it as a possibility do: Mann's novel in a secularized world has literary canonicity; the Qur'an in its religious function has canonical status. The two cases belong to their respective mainstreams—although it seems important that these two mainstreams are quite separate—and it seems a fair guess that their canonical status is *not* due to their "vindication of the rights of women to desire." In other words, if you agree with me that this right to desire is ethically "good," it follows that neither the literary nor the religious canonicity can be confined to ethical "goodness" or "badness." Nor is the biblical story's canonical status imputable to the disturbing sentiments that its more clearly wicked woman character solicits to promote her case.

My provisional conclusion, thus, is the following. Literary merit, as modern Western culture has construed it and on which it has based its canonization process, is not concerned with good or evil in themselves, for these are culturally and historically specific, but with ethical non-indifference. Hence, ethical non-indifference contributes to potential literary canonicity. But as the case study clearly demonstrates, the canonization as either literary masterpiece or religiously institutionalized scripture is not directly based on the particular *ethical merit* of the positions represented.

The second point that I seem to have been blind to *then* and that I find important *now* (although I still feel ill-equipped to address it) concerns the element "religion." None of the passages featuring Potiphar's wife are themselves explicitly religious, although I have argued that the scene with the little knives does revisit Christian ideology critically. Rather, one would be inclined to say, at least for the two religious canons, that these passages are ancient myths that ended up being canonized for some reason that may have nothing to do with the respective laws of Judaism and Islam. This very plausible lay view of things made it easy for

me to discuss biblical texts in nontheological terms all through my work on the Bible. But since then I have learned from my feminist theologian friends that "religion" need not be like the institutionalized religions from which I long ago took leave.[12] In the historical time of global migration we are living in, religion cannot be bracketed as easily as seemed possible then.

Jonneke Bekkenkamp wrote extensively about the problem of canon and religion. She always answered my anguished questions about what religion could possibly mean for feminism if we do not limit it to the largely women-unfriendly institutionalized religions, with the etymological insistence on *binding*. If religion is what binds, it could well be one of those domains that mediate between the terms of the infelicitous, but persistent, binary oppositions private/public, individual/collective, body/spirit, and the like.[13] With that understanding, what can the subversive literary identity of our woman figure(s) mean in religious terms, so that the canonical status of at least the Qur'an version may offer something that is not "merely" literary?

Double Binding: Literary Identity and Its Religious Effects

Let me rephrase the question in a way that foregrounds the contribution already inherent in literary or, at any rate, narrative texts to what is religiously relevant. What is it that would make the triple case of Potiphar's wife's mishaps (her tricks, her powerlessness, her desire) "religious" in the sense of offering an *imaginary* realm in which such oppositions can be suspended—a realm that would be forbidden if the imagination were visually represented? First, the pain caused by the cutting knives—or was it by desire shared?—and exacerbated by acid oranges— or was it by colorful detail?—is a metaphor for the three elements covered by such oppositions, and covered over by their oppositional structure. The pain is a metaphor, however, to be taken as literally as whoring or "going strange" (that is, going with strangers)—to have the Dutch expression for adultery resonate with the Jewish tradition that uses the same word for "whore" (in the feminine) as for "stranger" (in the masculine). "Pain" translates the way the irreducible difference and the subsequent loneliness of an individual, especially one not quite firmly positioned in mainstream society, *cuts*—it severs and hurts.

But, second, the blood thus shed also stands for the hot blood of desire that is, as such, the movement out of the autistic self into a risky, dangerous, but fulfilling and, indeed, indispensable communication with another. Third, then, the pain or *pathos* is a *sym*-pathos, a pain that qua pain binds, by means of heteropathic identification, the lonely woman sick of unrequited love and her friends, who, a moment before, had dropped her like a hot potato into the well of social isolation.

The blood for me also symbolizes a multiple "marriage," the emotional deflora-
tion of the women enslaved by imposed monogamy, potentially accepting the
risks of their own desires in a social sphere where they are not alone with the one
man who owns them. Through the knives, their woman friend "penetrates" their
bodies, releasing the blood of the ruptured hymen.

Theirs is a binding that does not cancel but only temporarily suspends the
self-evidence of monogamy—perhaps even of its metaphorical counterpart,
monotheism. Now, is that religion? I don't know, but the place where I see that
possibility opened is part of a religious canon that *as a whole* is indifferent to such
issues, and such plights. This, then, is what permits the inversion of the title of
this volume. For, if the religious canon does not foreground this form of identity-
based "religion," the literary one does. *Two forms of binding can coexist.*

Let me sum up the argument so far. My inverted title requires, first, a mixing
up of the neat distinctions between religious and literary identities and canons.
As for canons, second, recognizing that religious canons are fixed forever and by
political powers, and that they have oppressive power in that they police bound-
aries, I nevertheless claim that their texts' canonical status is also informed,
strengthened, if not determined, by the kind of literary, aesthetic achievement
that informs the looser and more changeable literary canon. Conversely, the liter-
ary features of the texts produce effects that are ethically non-indifferent, so that
the neat distinction between the two types of canon falls apart. This has led to the
political need to open up literary canons even if religious canons, different in that
they are definite, are beyond such revisions. This is why, third, the canon cannot
be truly opened up by inclusions only; revisionist *interpretations* of religious
canonical texts must continue to be made.

Perhaps paradoxically, the main motivation I see for this need is to turn reli-
gious canons into literary ones, in order to facilitate the "doubling binding." The
inclusion of unofficial "shared desire" in official religion allows women to belong
to their gender group as well as to their ethnic group, with its religious identity,
while also allowing insight into what is *of their bodies.* From a perspective not
bound to established religion, the point is not to save the religious texts from eth-
ical jeopardy—to argue, for example, that the Bible and the Qur'an are, overall,
not misogynist texts while criticizing them for being so when and where they
are—for that can lead to the kind of idealistic trappings I have called "the politics
of coherence" (1988a). Neither the Bible nor the Qur'an is a unified text, and no
single text is ideologically unified anyway. Instead, I find it important to save
these religious canonical texts' *literariness* from *ethical indifference.* This gesture
opens up the tight boundaries that separate and thus protect from each other the
distinct domains of religion and literature on the level not of their texts or their
functions, but of their *readings.*

This brings me to the second element in my inversion of the volume's title. If "religion" may be extended to mean what I have just said that the cutting knives and the women's pain meant, then the literary aspect of our problem is also up for reconsideration. Ultimately, by "literary identity" I did not only mean what has emerged so far—the production, through narrative and poetic art, of identities that would not have easy access to the public domain otherwise, such as Mut's group of friends or the male subordinates in the Egyptian household in Genesis.[14] So far, in other words, I have based my argument on a rather traditional, *representational* conception of literature.

This conception remains important, to the extent that what a society considers imaginable can in fact happen.[15] Moreover, the other, more obviously and directly political sense of representation as "standing for" is never entirely out of the picture when we talk about representation. Nevertheless, as is well known, "literature" is more than the sum of possible, thinkable, imaginable representations. Three additional aspects of literature are relevant for a conceptualization of something like "literary identity": it is an *institution,* it is an *agency,* and it is a *frame.* What I understand by the concept of *literary identity* is the composite result of the cultural promotion, if not altogether imposition, through canons, of the integrated effects of literature as representation—including the intricacies of identification that representation entails: institution, agency, and framing.

First, literature is also an institution, much like institutionalized religions. Although canon formation occurs differently in each, both institutions "live by" the deployment of some version of Althusser's Ideological State Apparatuses.[16] As John Guillory argued in his entry on canon in *Critical Terms for Literary Study* (1995), the works from literary canons, far from representing, from the start, a body of texts sanctioned as great, initially served as textbooks for proper use of language. Simply by virtue of the fact that texts outlive oral speech, the literary production of a culture stabilized language use, taught proper grammar, and established a firm, class-bound distinction between literate and illiterate language. The identity that can properly be called "literary," then, is characterized as the civilized, literate, adapted, mainstream user of proper English, or Dutch for that matter. No *literary* model is required, only a literary identity in that sense. This is a cultural distinction (Bourdieu 1984) that is profoundly political. It produces the kind of identity that promotes social success, and it includes naturalizing, as when an inhabitant of Curaçao says: "The Rhine enters our country at Lobith."[17]

This institutional aspect of literature obviously has the kind of exclusivist nature that liberal critiques of the canon condemn. No critical analysis of specific canonical texts or any amount of adding of non-mainstream texts to the canon can really touch this effect of the canon. That is why analyses such as Altieri's, for all its philosophical sophistication regarding the question of why canons should

have authority, can never satisfy the critics of the canon. For, as I mentioned above, his entire argument is based on the unexamined cultural need to have canons in the first place. His article develops from the opening statement that "if we are less in need of discovering new truths than of remembering old ones, there are obvious social roles canons can play as selective memories of traditions or ideals" (Altieri 1983, 41). The premise of this statement, from which the argument then proceeds, is that such selection can be performed by and for a collectivity. But such a collectivity already presupposes its sociolinguistic streamlining. Hence more important for my argument here is the way Altieri ignores the more diffuse authority of linguistic correctness and the concomitant class elitism that *any* canon possesses.

Less obviously, however—and this serves as a small cautionary footnote to canon-bashing—the linguistic elitism produced by literary canons is also a means by which non-mainstream subjects can get access to the mainstream, and thus further expand the company of the select "happy few"—perhaps even subvert it from within. Of course, I would not propagate this possibility as a solution, but let it stand as something that canons—as long and inasmuch as they exist—cannot obviate, despite all their authority. As a straitjacket for identity, then, canonical literature, even in its most conservative guise, is permeable. For identity, like desire, is *not*—despite all religious and cultural propaganda for embodiment of spirit instead of integration of body and spirit—confined to either spirit or body.

Because of its institutional power, literature, moreover, is also a form of *agency*. Writing and reading are forms of acting. This aspect has been extensively argued by those who took up John Austin's radical transformation of the philosophy of language from representational *model,* the result of informational or constative language use, to performative *act* (1975). Jonathan Culler—in one of his articles that make him so superlatively useful and, I would say, generous, as a scholar—follows the concept of the performative from philosophy in the 1960s, through literature in the 1980s, to gender studies in the 1990s, and back to philosophy (2000). In the process, performativity—originally a rather special category of words that allow special utterances that do not state things but do them—became, first, generalized to stand for an aspect of any utterance: *the aspect of an utterance as an act.* Generalizing more, on the basis of the *iterability* on which all language use depends, not performativity but its "standard" other, constativity, became a special case of generalized performativity.

For the purpose of this chapter, the decisive move in this regard has been Derrida's insistence on the citationality that enables and surrounds each speech act. Austin explicitly excluded literature from the analysis because literary speech acts are not "serious." Derrida, on the other hand, shifting the focus from the

speaker's *intention* to the social conventions that guarantee the very possibility to perform speech acts, made the *iterability* or *citationality* of any language use the standard. This reversal subordinates intention to the social dimension—a view that Judith Butler has put to excellent use in her analysis of gender.[18] This citationality lies at the heart of literature's public status, its canon's institutional power, and its contribution to the shaping of identity. Without repetition, Butler says, no identity.

From an originating, founding act performed by a willing, intentional subject, literature's performativity becomes an instance of an endless process of repetition; a repetition that involves similarity and difference, and that therefore both moderates and enables social change and subjects' interventions—in other words, agency. In collaboration with representation and institutional power, this agency produces, shapes, perpetuates, and also potentially transforms what I here call *literary identity*. This brings me to the last aspect of literary identity: the framing that produces it and that, at the same time, it constitutes. It provides frames of reference, through which subjects can make sense—of the world, of their lives, and of the literature they read.

History, Identity, and Religious Canon

This topic requires that I return, in conclusion (as I mentioned in my discussion of Mut-em-enet's shared desire), to the historical consideration of the episode from *Joseph and His Brothers*—the novel's pre-Holocaust position—and that I juxtapose it with my own, speaking from a post-Holocaust but also "global" time of migration and of the subsequent questioning of both the nation-state and the unmarked dominance of Christianity. I will wind up by tentatively articulating, through such a twofold historical consideration, how literary identity as I have now defined it—as a product of the conjunction of representation with identification, institution, agency, and framing—can inform religious canons.

There are two distinct levels on which, in my view, this constructive power of literature as identity shaping could have an impact on religious canons. I am not saying it will be easy, mind you, but it could happen. Both pass through history. By spelling out these possibilities, I am also responding to criticism that my earlier work has received from art historians: that I ignored the historical and, hence, that my work was ahistorical.[19] The first is the level of what Walter Benjamin would call allegory. History is a model whose otherness, compared to our contemporariness, informs what we can think, feel, and do (Benjamin 1977). On this level, Mann's vindication of the female figure allegorically, obliquely, critiques the ideology of his time. I wrote about this aspect in the earlier analysis:

I would suggest that this comment on the Hebrew myth of the Jew in a foreign country, confronted by a foreigner in love with him, could only arise from a response to the historical moment. While Nazism, *with its neurotic ideology of maleness,* was beginning to make the limits between groups of subjects so absolute as to become those between life and death, the ambivalence, both sexual and ethnic, of the encounter between two ambivalent subjects became an acutely necessary alternative, an opportunity to dramatise the intensity of emotional community. (1991, 117; emphasis added)

Again, this interpretation of Mann's oblique critique of Nazism through the gender problem, in a move that is in turn allegorical, is not wrong; I would still maintain it. The relation between Nazism and gender essentialism is too important to be ignored.

But it now seems that I have passed over the importance of the simple, *literal,* and institutionally relevant fact of Mann's choice of a canonical source: the Qur'an. From the perspective of today's concerns, where gender is much more tightly embedded in a multiculturalist pluralization of religious canons, the choice seems tremendously important as a contribution to "opening up the canon." But is this not limiting the issue to the liberal critique again? Moreover, is it not an anachronistic fallacy? To begin with the second question: yes and no. It would be, if I made this interpretive claim to explain Mann's choice.

This contemporary interest can easily be reconciled, however, with the historical one. I would be inclined to argue that, paradoxically but interestingly, Mann's foregrounding of the Islamic version calls into question the "natural" primacy of Christianity and, thus, obliquely, constituted a defense of the Judaic tradition that was under threat. Bringing in a canon that is in tension with the Judaic one is an effective, because apparently impartial, way of defending the Jews' right to difference. This is an adequate historical interpretation that has contemporary resonance through the allegorical union of differences.

The literary identity at stake has a sensitivity to difference of the kind that Mann's group of sympathizing women would allegorically embody. The religious canon, by the same token, is also momentarily broken open, not really extended of course, but questioned as the only one. "Opening up the canon" is, then, not simply a matter of inclusion but of radically transforming what the word "canon" means. The literary identity helps the difference between the two canons to keep, so to speak, a foot in the door of the closed religious canons.

The one drawback of this historical interpretation is that women end up, as usual, as a metaphor for politics instead of as participants in it. To remedy this, a second level can be examined at which the constructive power of literary identity on religious canons is visible. This level is historical in a different sense; else-

where I have called it "preposterous" (1999). It consists of reversing the usual relation between past and present and articulating how the present reenvisions the past. From such a perspective, it is all the more urgent to reconsider the Qur'an version, first of all literally, as a contribution from *within* a powerful religious canon to the literary one, Mann's novel. And through the latter's shaping of literary identity, it contributes in turn to a religious canon in which literary identity, as defined earlier, helps open up, not the religious canon that is closed by definition, but the religious sensibility itself—the binding, community-making form of identification called hetero-pathic.

The desiring woman in the story, in this "preposterous" appropriation of pre-Holocaust revisionism of religious canons, is no longer the symbol or emblem of political critique, but an agent of revision. The distinction demonstrates that the literary categories in which we think themselves partake of the ideology of embodiment that keeps *white identity*—now specified in relation to such troubling categories as *autochthonous* and *allochthonous* inhabitants of Europe—invisible because they are defined by a spirit that is "in but not of the body," to reiterate Dyer's phrase. Allegory as a rhetorical device is itself a case of such ideology that separates form, representation, from meaning.

Some people think this view is correct but vastly exaggerates the influence of literature on social reality. Of course, literature does not act alone; the point is that it does act—that is, can act. A powerful example of the positive potential of such a literary identity has been suggested by various Holocaust scholars. Inmates of concentration camps, so the story goes, derived strength, possibly even survival, from the silent recitation of poetry (de Roder 2000). This statement, impossible to verify empirically, is based on testimonies of camp survivors, and on that basis I will assume its truth. The question that matters here is, what does this alleged fact teach us about the meaning of *literary identity*?

I think it is crucial to distinguish an elitist-humanist interpretation of this fact from a performative one. Both are based on an ethically non-indifferent aesthetics, which makes it easy to conflate them, but the difference is radical for an assessment of their respective impact on the status of canons. George Steiner, for example, would stand for the elitist-humanist interpretation. Citing Liana Millu's 1947 testimony *Smoke over Birkenau,* Jan H. de Roder ironically depicts Steiner's humanistic ideal of the classically educated subject, his head filled with poetry that makes him unassailably strong and morally superior (2000, 4). Since not only the uneducated died in Auschwitz, this moralizing elitism is blatantly inadequate.

A performative view of the importance of poetry for camp inmates—not at all, by the way, exclusively canonical—would go in an altogether different direction. Literature's contribution to strengthening subjects under duress would consist

not in passive absorption and subsequent recitation but in actively performing literature that has remained resilient in the subjects' cultural memories. The "reading"—performed under specific conditions, by subjects with specific, historically determined identities (to simplify, not Jews but Jewish inmates)—produced, rather than reproduced, the "literary identity" that was helpful.

In his 1997 study of contemporary art and thought on the Holocaust, Ernst van Alphen has analyzed the negative, destructive effect of depriving subjects of the reference frames they ordinarily have at their disposal to make sense. In other words, trauma—the inability to experience or form memories, and to live through events as contributions to ongoing identity formation—is an assault on subjectivity that entails depriving subjects of the frames of reference required for processing events into experiences (1997; esp. 1999).

Van Alphen (1999) explains that the nature of what happened to camp inmates led to *semiotic incapacitation*. He distinguishes four types of deficient framings: ambiguous actantial position, when one is neither subject nor object of events, or one is both at the same time; total negation of any actantial position or subjectivity; lack of a plot or narrative frame by means of which the events can be narrated as a meaningful coherence; and plots or narrative frames which are available or which are inflicted but are unacceptable because they do not reflect the way in which one partakes of the events.

The ensuing analysis of trauma demonstrates negatively what happens if one is denied access to frames, including, importantly, those frames that shape canons. Such frames are institutional, hence limiting, but also indispensable mediations between idiosyncratic, potentially psychotic individuality and the community required—in accordance with a performative view of language—to "make sense" of things. By contrast, those inmates who found reciting poetry helpful were able to activate the frames offered by literature, not to replace the frames denied to them, but to "make sense" at all in the face of semiotic and physical death. Literary identity in this sense can, ultimately, become a matter of life and death.

Instead of using women as allegories for male concerns, and with the preposterous help of a willfully anachronistic interpretation much like Mann interpreted the Qur'an for his time (in his novel but not in his preface), I can now propose a view of the literary identity based on ethical non-indifference, an aesthetics for our time. For that proposal I return one last time to Dyer's critique of racial whiteness as unmarked. Before going into the specifics of the bond between Christianity, whiteness, and colonialism, Dyer writes this on the importance of overcoming such splits in general: "There is a specificity to white representation, but it does not reside in a set of stereotypes so much as in narrative structural positions, rhetorical tropes and habits of perception" (1997, 12).

Thomas Mann did a thorough job in vindicating the stereotype of the mythi-cal wicked stepmother, but I have argued that he did a whole lot more. To do so, he in fact deployed the three means Dyer mentions. In elaborating Mut-em-enet's narrative structural position, her agency, he also liberated her from her allegori-cal role, and by forcing the reader, emblematized by the woman's friends, to experience *sym-pathy,* he changed those habits of perception, informed by Christian iconography, that allowed them to distance themselves from her as a non-real, allegorical trope of something else, as embodiment of a spirit.

Mann produced a female figure, at history's most fraught and violent time, as his contribution to life with desire because it is of the body. To perform that feat, he pro-ceeded to undercut the close bond between monotheism, monogamy, and mas-culinity, by depicting for our imagination the "adulterous" woman as a figure who *produces*—in her rather nasty, painful agency, limited but also enabled by institution and framing—the condition that permits us to think religious canons differently.

Notes

Originally presented as the plenary lecture at "Literary Canon and Religious Identity," Tenth Conference of the Society for Literature and Religion, Nijmegen, September 7–9, 2000. Also published in *Literary Canons and Religious Identity,* edited by Erik Borgman, Bart Philipsen, and Lea Verstricht (Aldershot: Ashgate, 2004), 9–32.

1. This is not to say that such lack of reflection is "innocent." As Lawrence (1992) wrote in her introduction to a volume of essays on the "British" literary canon: "The formation and revision of literary tradition and the canon reflect ideological struggle rather than a natural aesthetic order." Hence she articulates her volume's thrust as follows: "Perhaps it is more accu-rate to say that these essays explore the way literary canons disguise their own histories of vio-lence" (2).

2. In this sense, the present theme forms part of a larger project already well under way, at least since the late 1970s. In 1981 an institution, itself as canonical as the annual English Insti-tute held in the United States, produced a famous collection of essays called *Opening Up the Canon* (Fiedler and Baker 1981).

3. This is not only a political necessity but also, even primarily, an intellectual, academic one. For understanding is the "official," "canonical" task of the academic endeavor.

4. The reason I insist on this affiliation between the two arts is that the prohibition of mak-ing graven images has realism, not vision per se, as its target. I will return to this below.

5. For a critical reading of the story that also criticizes the ongoing tendency to read the Genesis version alone, see Bach's *Women, Seduction, and Betrayal in Biblical Narrative* (1997, esp. 34–127).

6. A preliminary word on methodology. I call my blind spots and omissions self-evidences rather than gaps because, in my view, the latter word is insufficiently clear about the repressions at work in so-called gaps, while I also object to the suggestion of their empirical status. This is the focus of my discussion with Perry and Sternberg (1968), and Fokkelman (1981) in *Lethal*

Love (1987, chap. 1). The notion of gaps has been put forward by phenomenologists (primarily Ingarden) and put on the map of literary studies in the updated version of Iser (1978).

7. I argued that the metaphor of whoring, for going after other gods, in parts of the Hebrew Bible should be taken much more literally than it usually is. If we accept that the verb "whoring" has a much more social, anthropological meaning than prostitution, then, when it is used in the masculine form, it is not, or not only, metaphorical. The bond between the imaginary but obsessive concern for monogamy (of women) and the imagery of prostitution in biblical indictments of polytheistic wanderings was an important element in my study *Murder and Difference* (1988b) and, more extensively, in *Death and Dissymmetry* (1988a).

8. This puts her in the category of an ill-understood Delilah, who calls on the tribesmen to defeat Samson, and distinguishes her overly sharply from her *narrative* sisters, Yael and Judith, who deploy the same feminine wiles but are ethnically on the "right" side.

9. See also Yohannan's earlier thematic study of the story (1968), which is based on the kind of mythologizing theme that I aimed to undermine in my case study.

10. On the aesthetics and ethics of detail, see Schor (1987).

11. For an important argument in favor of this restraint, see Said (2000). See also Bardenstein's analysis of similar symbols in opposed traditions (1999).

12. Also, I have become a bit more intrigued—albeit also worried—by what De Vries calls "the turn to religion" (1999). I do not share in this movement, but I do acknowledge its presence and cultural significance.

13. As her title indicates, Bekkenkamp (1993) called the texts that she discussed—canonical and noncanonical, literary and religious—*sources* for theology.

14. That sort of identity is "literary" in that it is fictional: an example, a model, of what exists or can be made to exist or is at least *thinkable* in a society but not actually present there.

15. See the argument in *Death and Dissymmetry* (1988a) for this anthropological relevance of the literary imagination.

16. "Live by" resonates with Lakoff and Johnson's groundbreaking cognitive approach to metaphor (1980, 1999), quite relevant to my attempts to make metaphors more "literal." Althusser's concept (1971, 1977) remains important, as Silverman has argued for its twin concept "interpellation" (1992).

17. This is an old Dutch joke in anticolonial circles. Geography books used in Dutch schools were simply transferred to the colonies, where "our" country was, equally simply, that foreign country that the local children had never seen.

18. Austin (1975); Derrida (1988); Butler (1990, 1993).

19. I have replied to that criticism at length in *Quoting Caravaggio* (1999).

References

Alphen, Ernst van. 1997. *Caught by History: Holocaust Effects in Contemporary Art, Literature, and Theory*. Stanford, CA: Stanford University Press.

———. 1999. "Symptoms of Discursivity: Experience, Memory, Trauma." In *Acts of Memory: Cultural Recall in the Present,* edited by Mieke Bal, Jonathan Crewe, and Leo Spitzer, 24–38. Hanover, NH: University Press of New England.

Althusser, Louis. 1971. *"Lenin and Philosophy" and Other Essays.* Translated by Ben Brewster. London: New Left Books.

———. 1977. *For Marx.* Translated by Ben Brewster. London: New Left Books.

Altieri, Charles. 1983. "An Idea and Ideal of a Literary Canon." In *Canons,* edited by Robert von Hallberg, 41–64. Chicago: University of Chicago Press.

Austin, J. L. 1975 (1962). *How to Do Things with Words.* Cambridge, MA: Harvard University Press.

Bach, Alice. 1997. *Women, Seduction, and Betrayal in Biblical Narrative.* Cambridge: Cambridge University Press.

Bal, Mieke. 1987. *Lethal Love: Feminist Literary Readings of Biblical Love Stories.* Bloomington: Indiana University Press.

———. 1988a. *Death and Dissymmetry: The Politics of Coherence in the Book of Judges.* Chicago: University of Chicago Press.

———. 1988b. *Murder and Difference: Gender, Genre, and Scholarship on Sisera's Death.* Translated by Matthew Gumpert. Bloomington: Indiana University Press.

———. 1991. *Reading "Rembrandt": Beyond the Word-Image Opposition.* Cambridge: Cambridge University Press.

———. 1999. *Quoting Caravaggio: Contemporary Art, Preposterous History.* Chicago: University of Chicago Press.

Bardenstein, B. Carol. 1999. "Trees, Forests, and the Shaping of Palestinian and Israeli Collective Memory." In *Acts of Memory: Cultural Recall in the Present,* edited by Mieke Bal, Jonathan Crewe, and Leo Spitzer, 148–68. Hanover, NH: University Press of New England.

Barthes, Roland. 1968. "L'effet du réel." *Communications* 4:84–89. Translated by Richard Howard as "The Reality Effect." In *The Rustle of Language,* edited by Roland Barthes, 141–54. New York: Hill and Wang, 1986.

Bekkenkamp, Jonneke. 1993. *Canon en Keuze: Het bijbelse Hooglied en de Twenty-One Love Poems als bronnen van theologie.* Kampen: Kok Agora.

Benjamin, Walter. 1977. *The Origin of German Tragic Drama.* Translated by John Osborne. London: New Left Books.

Bourdieu, Pierre. 1984. *Distinction: A Social Critique of the Judgement of Taste.* Translated by Richard Nice. Cambridge, MA: Harvard University Press.

Bruns, Gerald L. 1983. "Canon and Power in the Hebrew Scriptures." In *Canons,* edited by Robert von Hallberg, 65–84. Chicago: University of Chicago Press.

Butler, Judith. 1990. *Gender Trouble: Feminism and the Subversion of Identity.* New York: Routledge.

———. 1993. *Bodies That Matter: On the Discursive Limits of "Sex."* New York: Routledge.

Culler, Jonathan. 2000. "Philosophy and Literature: The Fortunes of the Performative." *Poetics Today* 21 (3): 48–67.

Derrida, Jacques. 1988. *Limited Inc.* Translated by Samuel Weber. Evanston, IL: Northwestern University Press.

Dyer, Richard. 1997. *White.* London: Routledge.

Fiedler, Lesley, and Houston Baker, eds. 1981. *Opening Up the Canon: Selected Papers from the English Institute.* Baltimore: Johns Hopkins University Press.

Fokkelman, J. P. 1981. *King David.* Vol. 1 of *Narrative Art and Poetry in the Books of Samuel.* Assen: Van Gorcum.

Guillory, John. 1995. "Canon." In *Critical Terms for Literary Study,* edited by Frank Lentric-chia and Thomas McLaughlin, 233–49. Chicago: University of Chicago Press.

Iser, Wolfgang. 1978. *The Act of Reading: A Theory of Aesthetic Response.* Baltimore: Johns Hopkins University Press.

Jameson, Fredric. 1981. *The Political Unconscious: Narrative as a Socially Symbolic Act.* Ithaca, NY: Cornell University Press.

Lakoff, George, and Mark Johnson. 1980. *Metaphors We Live By.* Chicago: University of Chicago Press.

———. 1999. *Philosophy in the Flesh: The Embodied Mind and Its Challenge to Western Thought.* New York: Basic Books.

Lawrence, Karen R., ed. 1992. *Decolonizing Tradition: New Lives of Twentieth-Century "British" Literary Canons.* Urbana: University of Illinois Press.

Mann, Thomas. 1948. *Joseph and His Brothers.* Translated by Helen Tracy Lowe-Porter. New York: Alfred A. Knopf.

McGann, Jerome J. 1981. "The Meaning of The Ancient Mariner." *Critical Inquiry* 8:55–79.

Millu, Liana. 1947. *Smoke over Birkenau.* Translated by Lynne Sharon Schwartz. Philadelphia: Jewish Publication Society.

Perry, Menakhem, and Meir Sternberg. 1968. "The King through Ironic Eyes: The Narrator's Devices in the Biblical Story of David and Bathsheba and Two Excurses on the Theory of the Narrative Text." *Ha-sifrut,* 263–92.

Pollock, Griselda. 1999. *Differencing the Canon: Feminist Desire and the Writing of Art's Histories.* London: Routledge.

Rahv, Philip. 1953. "The Myth and the Powerhouse." *Partisan Review* 20:635–48.

Roder, Jan H. de. 2000. *Het schandaal van de poëzie: Over taal, ritueel, en biologie.* Nijmegen: Vantilt/de Wintertuin.

Said, Edward. 2000. "Invention, Memory, and Place." *Critical Inquiry* 26:175–92.

Salomon, Nanette. 1991. "The Art Historical Canon: Sins of Omission." In *(En)Gendering Knowledge: Feminism in Academe,* edited by Joan E. Hartman and Ellen Messner-Davidow, 222–36. Knoxville: University of Tennessee Press.

Scarry, Elaine. 1985. *The Body in Pain: The Making and Unmaking of the World.* Oxford: Oxford University Press.

Schor, Naomi. 1987. *Reading in Detail: Esthetics and the Feminine.* New York: Methuen.

Silverman, Kaja. 1992. *Male Subjectivity at the Margin.* New York: Routledge.

———. 1996. *The Threshold of the Visible World.* New York: Routledge.

Vries, Hent de. 1999. *Philosophy and the Turn to Religion.* Baltimore: John Hopkins University Press.

Yohannan, John D. 1968. *Joseph and Potiphar's Wife in World Literature.* New York: New Directions.

———. 1982. "Hebraism and Hellenism in Thomas Mann's Story of Joseph and Potiphar's Wife." *Comparative Literature Studies* 19 (4): 430–41.

Part 5 **Cultural Analysis in an Expanded Field**

16. Meanwhile: Literature in an Expanded Field

"Meanwhile": this adverb of simultaneity sums up Benedict Anderson's classical theory of the formation of imagined communities that, once upon a time, became nations in the experience of their subjects. Although the media that facilitated that creation are reputedly almost obsolete today—the newspaper and the novel—the current interest in media makes this older version of "mediatic" power quite intriguing. If any medium works by means of "meanwhile," it is the Internet, that enemy of the novel that, we complain, distracts people from reading a good old novel at home near the hearth on a quiet winter evening. Yet there the "meanwhile" does not a priori create the feeling of "nationness." Instead, arguably, it mitigates, perhaps even destroys, it.[1] As a result, new imagined communities emerge based on all manner of communalities. No generalizations about what "meanwhile" connects seem possible at this time.

The main character in Tchicaya U Tam'si's *Ces fruits si doux de l'arbre à pain* (1987) is a judge, in the recently decolonized Congo. That is, he is a professional guard of boundaries of a specific kind: those between good and evil. As a judge, he stands for the need to uphold boundaries and for the survival of the community, indeed, of the species. But, as Judge Raymond Poaty soon finds out, it is impossible to maintain the clarity of the domain that he serves. This confusion is an allegory for the state of the contemporary world. What worries him, as a firm believer in justice, is the way the state of his new nation ignores, destroys, and erases that boundary.

Faced with the case of a serial murder of prepubescent girls, also an instance of ritual sacrifice, the boundary he lives to uphold threatens to collapse. First, socially: no witness will speak, for magic overrules civilian duties; then, personally: the tradition he is asked to ignore is also part of himself; and finally, politically: it is suggested that the perpetrator of the crimes—or sacrifices—is a high-ranking political figure, perhaps the president. The judge's task is defined, he realizes, by

a nation that does not know its subjects. What nation is that? Are its borders drawn in Brazzaville or in Paris? And since they were first drawn in Paris, at any rate, the new nation is doomed to be in jeopardy from the start.

This novel, by the Congo's most famous writer, is written in the language we know as "French" and the genre we know as "the novel." Both language and genre form the reader's horizon of expectation, or horizon *tout court*. Thanks to that horizon, we can read the book unprepared, untrained, and unknowing of the "context" that responsible readers are alleged to bring to their acts of reading. I can read it without knowing whether the many proverbs and set phrases have the same tone as the adolescent French jargon of Poaty's younger son, which, with my training in French, is easier for me to recognize. I can read it without grasping the meaning of all its strangeness, with its many shifts of voice, semi-magical plot elements, lyrical passages, and political allusions. Reading this book—an expatriate African cultural artifact published in Paris—and, even worse, writing about it in a public forum, I cross the border that European canon formation has silently drawn around my field; a border that coincides, also, with the line between professional competence and personal curiosity. Lines between legitimate and not legitimate, between proper and improper: in some sense, these lines are the kind of borders I find most problematic about nations.

Nations, however we define the concept, are defined, protected, and exist through borders that, arbitrarily or not, include and exclude. Through the borders that surround and delimit them, nations are about belonging and not belonging, about legitimacy and illegality, about safety and the lack of it, before they are, in any way, about identity, cultural specificity, and language. Borders have been drawn both around nations and around literature; to some extent they are the same borders. If borders define nations, they also define academic turfs. This ambiguity is a semantic "meanwhile." And whereas the Congolese novel *Ces fruits si doux* does not at all thematize national borders, it was this text that pushed me in that direction and inspired me to articulate the following thoughts.

Borders and their untenability define this novel's plot, characters, discourse, and imagery. Conversely, these literary elements embody complex ideas about borders. The question of nation and the unclear borders that define it, which underlies this novel's plot, is "thickened" by every manner of literary device that narrative allows. The specifics of the narrative situation—who speaks, who focalizes?—blur boundaries even between the subjects. The first-person narrator at the beginning is identified only as a son of the family (by his use of the word "maman"), until the moment the father-judge interpellates him: "Sébastien! . . . Tu n'as pas de devoirs à faire?" (15; Sebastian, don't you have any homework?). And before we know it, the musings of the father appear to have taken over, without further ado. And then another transition occurs, imperceptibly.

The external narrator begins to describe the judge in a distant tone, so as to inform the readers. This narrator's description of the judge's outward appearance moves into the focalization of another of the judge's sons without the slightest warning. "La peau n'est pas grasse, elle est même un peu sèche" (The skin is not greasy; it is even a bit dry) still sounds plausibly descriptive, but the next sentence, "Il a renoncé à porter la moustache à la Hitler, au dire de Sébastien, l'irrévérencieux" (He gave up wearing his Hitler mustache, according to disrespectful Sebastian), suddenly betrays an internal focalizer who attributes intention to the character, indirectly cites his brother, and judges the latter: "Il est fou, ce gosse!" (The lad is mad!). The description continues in the more familial tone of this focalizer, but it is still only later that we realize its object is not the father but the brother.[2]

Christian proverbs, French clichés, and Congolese sayings, as well as profound thoughts of political philosophy, are mixed, along with speakers and focalizers. The mix even becomes outrightly disturbing when, later in the plot, the enemies of the Poaty family have equally easy access to unspecified focalizing positions. Is this Bakhtinian form of narrative a metaphor for the unclear state of the nation? Or is the nation's troublesome wavering between freedom and corruption, modernization and tradition, murder and magic—in other words, the plot—a metaphor for the state of literature in a poetics of boundary crossing? The question I am asking is, Is this novel about nations and borders or about narrative literature? Is the new nation in which it is set an allegory for national politics "after" colonialism—I dare not say "*post*colonial"—and the predicament of justice therein? Or is the ambiguous and problematic political situation described here an allegory for literature's potential to contribute to social thought? The latter question is, I think, the key question, and the condition for literature's capacity to produce knowledge lies in the refusal to answer it. Its unanswerability forms part of the proposition I wish to explore here.

Knowledge and nation, brought together through a discussion of literature: together, these three—nation and knowledge "in" literature—form a timely and ambitious combination. To see how much so, it may be useful first to ask some questions about these three elements in isolation. First, in a world of globalization where mega-powers and mega-capitalism are the primary and slippery antagonists to be contended with, in a world that is leaving the nation-states in disarray, what do we do when we focus our energies on the study of "the nation"? In a historical moment in which, with hindsight, we realize that nation-states, old and new, exist thanks to the redrawing of the world map by colonial powers (Yewah 2001), is there not a nostalgic touch in this interest as well as in the overt worries about globalization and local nationalisms? And what do we mean with all those buzzwords that constitute the discursive field of hip cultural analysis,

how do we connect them, and what do we hope to accomplish by mobilizing them? Nation, nationalism; ethnicity, minority, globalization: is there any merit in bringing the world into the study of cultural objects through such concepts, other than to flag a progressive sense of "political thinking" in a discipline suffering from the threat of obsoleteness? Does this theme help us in any substantial way to increase, strengthen, rethink, or otherwise get a more solid and relevant handle on the kind of knowledge we produce?

Second, knowledge is also subject to the probing of the way it erects boundaries in the thrust of globalization. I'll even bracket the obvious inequalities in the access to knowledge that remain bound to economic and national limitations. Obviously, we only need to think of the ongoing "brain drain" from everywhere in the world to the U.S. academy, where the system's expert absorption of political trends that oppose its power remains irresistible. This is just a symptom of the deeper problem, which is, as Arjun Appadurai formulated it, much more serious:

> Globalization as an uneven economic process creates a fragmented and uneven distribution of just those resources for learning, teaching, and cultural criticism that are most vital for the formation of democratic research communities that could produce a global view of globalization.[3]

The systemic consequence of this situation is what he calls "a growing disjuncture between the globalization of knowledge and the knowledge of globalization" (2000, 4). Such formulations draw our attention to the need to keep the two elements tightly bound together. Here, it binds the conditions and objects of knowledge—if you like, subject and object—by means of a knot that is indispensable if we are to understand changes in the world behind which, temporally speaking, knowledge producers inevitably lag. Knowledge is a focus, which, prior to any knowledge construction, tells us what is worth knowing and what can be known. Borders, here, can never be taken for granted.

Third, in the face of the developments in literary theory from New Criticism through structuralism, to poststructuralism and beyond, all of them developments that countered the temptation of referential reading, what reflection theory of representation underlies the topic of this essay? Where, in the literary text or in the field of literary culture, do we locate the ideas of nation and nationalism, and which literary aspects and elements in our field does this focus risk making invisible?

The novel I have chosen to analyze in this essay offers innumerable opportunities to address these critical questions and to turn reflection on them into a productive, constructive activity. To take advantage of these opportunities, I would like to look at knowledge as a practice conceived of according to Appadurai's

challenging concept of "the research imagination." For him, this term points to the ways we imagine "good-enough" research, according to often "taken-for-granted" standards on which our research ethics are based. Of these standards, "replicability" is the "hidden moral force" (2000, 11). Whereas, traditionally, this force sustains the idea of "value-free" research, for Appadurai, replicability fore-grounds the non-individual—in other words, the profoundly social—nature of research even if individuals experience and imagine their work as individual (11).

Today this social character of knowledge production raises the question of plausible protocols, theories, and models that enable transnational and truly global knowledge production. This question calls for a research imagination that accommodates cross-cultural and intersocial diversity, as well as for comparison and distribution of attention.[4]

In all its groundbreaking brilliance, the work of Judith Butler under-illuminates two aspects of performativity, which, I believe, deserve a more prominent place: memory and narrative. "Memory" as a hub where the individual and the collective, the personal and the social spin around each other; "narrative" as the process that mediates through these whirling forces between past and present, as the mode in which memory takes place: both explain how performativity works in cultural practice. One such practice is the construction of knowledge. I imagine replicability not as a prescriptive but a heuristic standard. As such, it can help us to assess the deployment of research protocols, not as a search for what we already know (a re-search), but as a search for what, in the unknown, can be meaningfully connected to what we thought we knew but wish to reenvision.

As such, it makes me want to find points of entry into novels such as U Tam'si's, which are embedded in cultures and languages I don't know, so that I must shed my protective shield of expertise in favor of the literary text as the source of knowledge. My task in this endeavor is procedural: it is to theorize and justify the model of knowledge that makes it possible for the research imagination to establish a heuristically productive affiliation with the literary imagination. Bringing narrative theory, my field of specialization of old, to bear on this novel, then, is not a priori a Eurocentric domestication of difference, but rather a search for ways to expand the questions this theory helps us to ask through the resist-ance this novel mounts against it.

Replicability, then, is the tool neither for iteration nor for comparison mobi-lized to distinguish between "good" and "bad" scholarship, but for shifting the boundary between commensurable and incommensurable objects. As a result, the affiliation between the research imagination and the literary imagination can suspend the insidious normative standards inevitably implied in comparison, even in a judgment of incommensurability (Melas 1995, 275), and instead posit, in the words of Edouard Glissant, "equivalences that do not unify."[5] This shift-

ing, which Natalie Melas sees as the task of comparative literature, forces me to transgress and shift boundaries of all kinds.[6]

The field of cultural analysis of literature gives rise to a number of areas of potential tension, hence, of interest. I'll mention two of them. Some work done in the area concerns the dangers of the recent rise in nationalism. Other studies, in contrast, claim attention for nations often overlooked in mainstream publishing venues. Overlooked either because of their geographic location, at what only a totally blind internationalism would persist in calling the periphery—for example, Southeast Asia—or because their recent emergence from colonial near-erasure has not yet been fully recognized—for example, Aboriginal peoples, sometimes called "First Nations," for a reason.

For a cultural analysis of the novel, it matters that, as Jonathan Culler points out in an issue of *Diacritics* in honor of Anderson, the semantic and the pragmatic—the novel as imagination, its representation of the space of a community and of the world as a nation, and the rhetoric that addresses its readers as nationals—are not always clearly distinguished in Anderson's pioneering book (1991, 25–30). Both dimensions receive a temporal metaphor or key in Anderson's book in the temporal adverb "meanwhile," which denotes simultaneity. In the practice of reading novels (and newspapers), community is built through the awareness that others are reading about the same events simultaneously, although Culler points out that this counts for newspapers but maybe not for novels. In novels of a certain kind, an omniscient narrator structures the simultaneity of plot elements by means of the shift to other spaces introduced by "meanwhile." Significantly, this type of novel would be the old-style realist novel à la Balzac.

The adverb "meanwhile" does not have that function in U Tam'si's novel. This text avoids the two structural markers of mainstream fiction in the West: the infelicitously named "omniscient narration" form as well as consistent limited point of view or focalization, the latter either outside of the diegesis, as in behaviorist literature, or intradiegetic, as in Henry James and followers. There is no omniscience in the confused world of Judge Poaty and his family. On the contrary, knowledge is constantly in the making, never achieved. Focalization—narrative power and agency—is in the hands of neither the good nor the bad guys. Hence there is no clear denouement either. Nor is there room for the kind of individualistic consciousness limited by rules or focalization and behaviorism.

These shifts in focalization, which are so confusing on first reading, denote precisely the opposite: subjectivity is both individual and collective, and, like knowledge, it is never fully achieved. In U Tam'si's novel the structural function of "meanwhile" is redundant. This redundancy, in turn, casts light on the kind of literature that Anderson considers so central to the formation of nationalism. It brings out where the normative standard in this theory lies. Without the incommensurability of this Congolese novel, we might not notice that the nationalism

allegedly nurtured through community building is as much predicated upon individualism and claims to knowledge.

Another potential confusion in Anderson's classic also concerns an aspect of the construction of subjectivity. In this case, the notion of "address" confuses the second person structured by the narrative with the actual readership. Culler untangles these confusions in a close reading of some passages of two of Anderson's key examples, José Rizal's 1887 Philippine novel *Noli me tangere* and Mario Vargas Llosa's 1987 *El hablador*. These examples, also cited by numerous other respondents to Anderson's book, have acquired the same kind of paradigm status as the theory they are purported to substantiate. And, like this theory, they are worth going back to one more time.[7] Culler convincingly shows that in Rizal's novel, the reader is addressed not as a national, or as a local of Manila, but, at times, clearly as an inhabitant of the metropolis who might be enticed to visit, or at least imagine, the colony. This is especially the case in the descriptive passages. Here, information about Manila is given that locals already possess. "Meanwhile" takes on the meaning of implicating outsiders in this "local knowledge" (to allude to Clifford Geertz's 1983 classic).

In *El hablador*, the Andersonian notion of the "imagined community" itself is at stake. The alternate chapters, "spoken" by a voice that is *not* part of the indigenous community yet that speaks "for" it, is, as Doris Sommers (1996) and others have claimed, not represented as an adequate picture of the Machiguenga. So what standard is this, then? Are we meant to read this novel as a political tract or, worse, as a shadow of actual political tracts, so that, far from adding to our knowledge, it only reconfirms what we already know (that Vargas Llosa's politics are assimilationist)?

El hablador itself, as a literary text, counters such limited readings in two ways. In this sense the novel is a good example of the literary imagination helping the research imagination. First, it undermines the ambiguous narrator's authority by ending each of the alternate chapters with the folkish relativization "Eso es, al menos, lo que yo he sabido" (This, at least, is what I came to know), as well as by inserting frequent modal expressions of uncertainty.[8] This device goes further than just putting the narrator's authority under erasure. It inserts a sense of secondary orality, or spokenness, much like the *skaz* the Russian formalists were so fond of. Through this device, it also posits knowledge at the heart of the national identity that this novel represents as complex, unattainable, and, perhaps, undesirable. The *perfecto* of "he sabido" and the insistence on the first person foreground the notion that knowledge is something you don't "have" but acquire, within the limits of your subjectivity. Thus the formula already counters any reading that imputes to these chapters the claim to authenticity. Second, stylistic strangeness, including ungrammatical conventions, produces a stylistic impetus for an endorsement of the reader's ongoing estrangement from these chapters, in

order to avoid easy assimilation. The chapters are vehicles of a complicating conception of alterity that folds the reader—not the "yo" but the "tu" to which the "hablador" speaks—into the strangeness. As a result, the "other culture" can neither be assimilated—as Vargas Llosa's overt political position advocates—nor held at bay as incommensurable. For it is the reader who is able both to read and understand the discourse and to remain sensitive to its strangeness.[9] Instead of facilitating assimilation, the desire to read on, which the novel as a whole produces, the strangeness impels the reader to recognize dissimilarity in a specific-enough form so as to avoid casting the discourse out into the abyss of the "non-Western." At the same time, it avoids normalization and absorption—in other words, assimilation. The non-authenticity of the *hablador*'s discourse—and, indeed, his suggested identity as the first narrator's Jewish friend—is a necessary instrument to achieve an effect that crosses borders in two directions, not one.

Ces fruits si doux raises this problem—of how to merge, say, formal and sociopolitical views. It does this not so much as a whole, qua novel, but rather as if to entice us to address it within the details of the novel. This is why I read it as a *theoretical object,* an allegory of where to go with the (inter-)discipline of literary and/as cultural studies. Two examples of how this works must suffice.

On the one hand, there are political events that almost necessitate a plain political reading. *Ces fruits si doux* would, then, be a document of the problem of corruption in emerging nation-states. Perhaps these passages can be read as political indictments—political tracts. But even in those more or less straightforward political passages, the text intentionally confuses such an easy reading through its "impure" sketch of Poaty's struggle for justice. For example, what can we make, ethically speaking, of something like this:

> Il corrompait les fonctionnaires de l'État corrompu avec l'argent qu'on avait donné pour le corrompre. (140) [He bribed the functionaries of the corrupt state with the money they had given him to bribe him.]

This sentence triggers ruminations about goals justifying means, but it doesn't make it any easier to . . . well, judge.

On the other hand, there are passages, unlike this example, which we can hope to understand only if we go with the formal flow and accept that the allegorical tenor of the text lies hidden in its most out-of-the-world fictions. In the third chapter, in which the focus has been displaced from the disappeared Poaty to Gaston, his eldest son and successor in martyrdom, a section bears the title "Il était une fois" ("Once upon a time"). The announced fairy tale is postponed for two paragraphs, which sketch the situation of enunciation. These preparatory sentences begin thus:

Les paupières de ceux qui écoutent battent pour applaudir en silence. Il ne manque pas une étoile dans le ciel. Entendent-elles ce que disent les hommes? Et, quand ils pleurent, songent-elles à les consoler? (169) [The eyelids of those who listen flutter in order to applaud silently. Not a star is missing in the sky. Do they hear what people say? And when they weep, do they think of comforting them?]

This passage emanates an atmosphere of fairy tales in which stars are like humans. Yet the discourse moves to proverbs ("la lune est plus vindicative que la femme" [the moon is more vindictive than women]), and to a reiteration of the section's title, in a tone of sadness, perhaps even despair, that recalls the censorship that permeates the novel: "Qui peut dire? On peut seulement dire: 'Il était une fois'" (170; Who can tell? One can only say: "Once upon a time"). Suddenly the fairy-tale discourse is no longer beautiful, a treasure of the culture that maintains its authentic identity against all odds of modernization and political harassment. Now it becomes a counterdiscourse, a meager outlet for ordinary people where all other discourse has become subject to censorship. Hence both the political-modernized and the poetic-traditional passages are profoundly ambiguous. Both partake of the inextricable knot that is the plight of nations whose boundaries were drawn in Paris, whatever attempts to redraw them in Brazzaville may have followed.

In terms of methodology, this tension is the one between close reading—often monographic—and the approach to literature today called "cultural studies." In his critique of Anderson, Culler remains a master of close reading, but he does not avoid the questions addressed to that tradition by the preoccupation of cultural studies. This is valuable, for the two approaches in isolation have serious drawbacks. The former, when alone, risks remaining flatly thematic and, at best, formalist, raising the question what the point of our work is. Moreover, it cannot avoid implicit judgment according to unspoken norms that, through their very implicitness, promote inclusion and exclusion. The latter, when alone, risks generalization and simplification, losing sight of what specific texts in their complexity can add to these general insights. In this case, the very refusal to assign aesthetic value is implicitly contingent upon similar standards.[10]

Together—again, in ongoing debate—the two conceptions can lead to what I like to call genuine cultural *analysis*: an analysis of literature in its agency as cultural force, but on its own terms, so that the cultural object can be emancipated from its historical burdens of being either a mirror of society or an instrument of manipulation, either an object of formalist aesthetics or a mere repository of ideas. Instead, in the confrontation and subsequent affiliation of the research imagination with the literary imagination, the literary text can be conceived of as

a cultural agent offering treasures of insights we would not easily glean from other sources such as philosophy and political documents. Thanks to its unique integration of imagination and analysis, of rendering thinkable what a society *can* think but doesn't because the complexity of it needs release from day-to-day urgencies to be effectively absorbed and integrated, literature can be culturally effective through what it is, not through its uses and abuses for other goals. Beyond both representation and ideology, a literary text constitutes in and of itself precisely the kind of debate that a well-functioning academic department can also aim to produce. Complexity is key here, for all the terms involved here are subject to critique.[11]

These areas of tension in the cultural analysis of literature all concern boundaries: between values perhaps taken too much for granted, and between conceptions of and approaches to literature in need of integration. Boundaries, or borders, are what define nations. Perhaps, then, the point is to take it the bond between knowledge and nation as a fundamental theoretical theme or allegory that organizes our work and as a key to contemporary research in all fields of culture and society. In other words, thinking "literarily," "knowledge and nation" can be seen as an allegory for a boundary-crossing practice of research in the humanities. The replicable protocol that emerges from this is fundamentally interdisciplinary. And it takes literature and other cultural artifacts seriously as domains of knowledge production.

Literary and artistic objects can, under certain conditions, become what I have called *Ces fruits si doux* above, namely, *theoretical objects*—triggers, if not containers, of theoretical ideas that are not generally available because their level of complexity makes them hard to articulate. Thus, on the basis of U Tam'si's novel, I see "nation" as an allegory of a specific kind of knowledge, one that erects boundaries and protects itself through the well-rehearsed protocols of disciplinary traditions that are no longer perceived as questionable. To question the nation or transgress its borders is to open up our research imagination while holding on to a measure of replicability as a standard. Interdisciplinarity, I contend, must not forget, or repress, the borders that discipline have erected. For, without recognizing such borders as useful in some historical moment and situation, one cannot meaningfully cross them. "Knowledge," conversely, is an allegory of a nationness based on such transgressions. Borders, in this allegory, are not instruments of violence, exclusion, and the protection of privilege, but thresholds where commensurability and incommensurability can be negotiated, provided we keep them—to speak with U Tam'si—swept clean.

Judge Poaty phrases his refusal to participate in state corruption in words that cross many boundaries at once: "Si je ne balaie pas devant le seuil de ma porte, qu'est-ce qui empêchera les malotrus de le prendre pour une décharge

publique?" (26; If I don't sweep my doorstep, who is going to prevent the uneducated guys from taking it for a public rubbish dump?). Using this metaphor that invokes women's labor is one of the many ways in which this character, torn between tradition and modernity, uses traditional proverbial knowledge to question the institutional power of his new nation.

Sweeping the doorstep is a meaningful act, embedded in a cultural situation specific enough to need recognition, yet generalizable enough to make the fictional evocation of this act also relevant for non-African readers. Poaty's attention to the doorstep is a concern for holding up the right boundaries, for sustaining the borders of the nation by means of those of justice. Justice overrules nationness: when the powers that be of the nation turn out corrupt and power hungry, Poaty refuses to participate—he is too busy sweeping—but he still entices his eldest son to return to the Congo with his bride, a Congolese woman whom he met in France. It will cost Poaty his life, for there is a touch of martyrdom in his refusal. But the result of the imaginary events of his abduction and probable, but never certified, death suspends the self-evidence of the nationness of Congo, hence, its borders. Instead of borders, Poaty's standard of justice is a horizon. The two, in this novel, are in violent, vicious conflict. The nation has become justice's opposite, a bit like current U.S. nationalism disguised as global justice. The media today do create a national community, after all, but one that keeps extending beyond borders, to the horizon. It is toward the horizon, in the middle of the jungle where the corrupt powers of Brazzaville cannot reach them, that the two surviving wives of the murdered judge and his son depart at the end of the novel.

What does this distinction between border and horizon mean? "The horizon is an interior." With this sentence, architectural historian Beatriz Colomina began an article on Le Corbusier's violent appropriation of a house built by and belonging to Eileen Gray. Being someone with a deep need for far horizons, frequently frustrated that empty horizons barely exist in the Netherlands, whereas in the opposite landscape of, say, the Alps, confinement lurks because horizons are lacking, I felt my heart flip when I read this sentence. Colomina explains that the horizon "marks a limit to the space of what can be seen, which is to say, it organizes this visual space into an interior" (1996, 51). This sentence, and the "of course!" it triggered in me, had the stimulating effect of making me rethink some of my most unreflected, naturalized opinions. Perhaps my love of horizons is not solely based on the need for freedom that I feel, but at least as much on the opposite need—for protection, shelter, and self-determination within the domain that I can, to some extent, master.

A horizon, then, is a boundary, but one that cannot be crossed. As soon as you approach it, it recedes. Poaty's attempt to communicate with his eldest son in France is thwarted by his knowledge that his letters are read by the censor, whose

arm is long enough to reach out and harm his son. A horizon is a boundary with no edge to sit on, no edge to comfortably oversee the two sides of a divide. In the ordinary sense—say, when delimiting nations—a border articulates and describes what it holds, recognizes what is outside it, and is permeable. But a horizon defines an interior space that makes its exterior invisible. The ancients thought it had no exterior, not on this earth, only an ontologically alien after- or under- world. The notion lends itself to such, and other, figurative uses. Today, having a wide horizon means to not go through life with blinkers on. I always took that to refer to people with gutsy lifestyles, willing to get out of their confinements.

I am touching on this here because I share with many contemporary scholars a tendency to construe objects of scholarship on the basis of boundaries, or bor- ders, first explored, then crossed. Every question that emerges out of studying a novel entices me to wonder if it is characteristic of the novel as a genre, literature as a linguistic artifact, art as an aesthetic category, the object as delimited. And in order to find out, I find myself studying narrative outside the novel, outside lan- guage, outside art, and outside the boundaries of the text or work itself. This crossing, in its theoretical conception, produces a dynamic not unlike a Bakhtin- ian novel, of the radical sort like U Tam'si's. The word "map," so often used for this kind of project, seems utterly reductive, because these crossings, as well as U Tam'si's devices, have so many layers, levels, and dimensions. "Meanwhile" can be imagined in its spatial version, as metalepsis or lateral expansion.

Colomina's sentence suddenly made clear to me where the tensions come from. It made me see the focus rather than the confinement, the guidance rather than the blinding of horizon-type borders. The usefulness of disciplines is not that they stultify but that they help us to see borders, so that their other sides can be seen as well. In my restless negotiations of these boundaries, I tend to look for the exits. But with the reassuring image of the "horizon as interior" in mind, I see that the appeal of the exits is overdetermined by the possibility of reentering, re- freshed because changed during the course of the journey.[12]

These reflections emerge where theory (Colomina's statement) and art (U Tam'si's novel) interact, so that a "politics of the theoretical statement" (Bhabha) becomes possible. One thing changed for me after reading *Ces fruits si doux de l'arbre à pain*. Not my ethics—I wouldn't dream of relativizing the grue- some murder, ritual or not, of young girls!—but, rather, my conviction that I know what is ethical, and what belongs to other domains of life, along with my certainty that the profound alterity of, say, magic can be kept at bay. How does this book get me to hesitate, wonder, and doubt, in other words, how does it get me to engage knowledge as process, not ready-made? Poaty doesn't doubt; not what he is see- ing, at least. As soon as the events begin to occur—in fact, even before they do—

U Tam'si's Judge Raymond Poaty *knows* the murders are ritual, and the forces are not simply those of evil but of magic.

How does he know this, and how does that affect me as reader? We witness a scene that might be a memory or an occurrence within the present, a fantasy or a fear. Sitting alone in the night, he opens up: "Il roule sa voix de gorge, la prépare pour qu'elle ait un accent grave et la couleur du sang qui coagule" (He rolls his throaty voice, prepares it to have a grave tone and the color of clotting blood). He becomes the night: "Les mots sortiront à ce moment-là de la nuit de son corps, tout parfumés d'ambre et de benjoin" (52; At that moment the words will leave the night of his body, all fragrant with amber and incense). Owing to the constant crossing of borders between subjects, places, and states, Poaty's position, contaminated by his own background, contaminates us, suspending not our ultimate decisions, but our everyday unreflected *certainties* about what is right and what is wrong.

This does not mean that, in the end, the reader will no longer hold her own ethical beliefs. But they are "thickened"—there is no better word for the kind of internal enrichment at stake—by the temporary displacements and shifts that the narrative structure imposes. One *cannot* follow (logically) the language, hence, one *must* follow it (go with the flow). Poaty is too strong, too convincing a character for you to miss out on the opportunity of traveling with him, wherever that may take you. U Tam'si's language—his French of written literature and his mixture of discourses that is the novel, his narrative skill and pace as well as his deceptive play with forms—invites a mode of reading that suspends not disbelief but rather disagreement.

My "politics of the theoretical statement," then, requires a firm anti-realism, one I implicitly endorsed apropos of *El hablador*'s felicitous lack of authenticity. The willing suspension of disbelief that has, of old, defined fiction would not warrant the heavy investment of academic attention it receives if the suspended disbelief concerned simply the reality or truth of the events and agents represented in that literature. Much more valuable is the potential that the training in literary and artistic literacy yields to willingly suspend *judgment*. In this sense, art taken as allegory or theoretical object proposes a willing suspension of the normativity of comparison. All kinds of judgments dissolve into thin air: of people and their customs, of events and their meanings, of aesthetic and synaesthetic values. In order to be able to achieve anything, we need the limitations represented by borders, whether we straddle them, cross and recross them, or remain ensconced within them. But the contemporary meaning of "meanwhile" suspends any illusion of ontology and de-ontology attached to borders. Meanwhile, that border beyond which we cannot see—the horizon, precisely because it never

stops receding—that border, I believe, helps rather than hinders our work, producing an interior, the sort of home no one can do without.

Notes

Keynote lecture at the Australasian Language and Linguistic Association Conference, "Knowledge and Nation," Wellington, New Zealand, February 12, 2003. Published in *Thamyris/Intersection,* no. 12 (2003): 183–97.

1. For an analogy between the turn of the century then and now on the basis of the social function of early cinema and the new media respectively, see Verhoeff (2002, chap. 2).

2. All the quotations in this paragraph are from page 21 of *Ces fruits si doux* (1987).

3. See Appadurai (2000, 4). This paper is part of an ongoing project of this key analyst in the social sciences. It builds on important previous work (Appadurai 1997, 1999).

4. For me, the notion of replicability resonates with Butler's work on queer theory, in relation to Derrida (1988); Butler (1993) went on to larger, more varied, political issues in 1997. See also Culler (2000).

5. Literal translation by Melas (1995, 275) of Glissant (1981, 466).

6. Melas (1995). These succinct ideas are developed at length in her forthcoming book (to be published by Stanford University Press).

7. See Culler (1999).

8. But, as Culler (1999) points out, these devices can also serve to place the storytelling within a discursive web, from within which the speaker can do no more than repeat.

9. In this respect I disagree profoundly with Sommers (1996), who claims that the incommensurability of the discourse of these chapters expresses skepticism regarding the viability of the Indian culture. I believe it expresses the need to accept its alterity and one's own limited knowledge. For an analysis of the style of the novel, see Kristal (1988), specifically his remark on ungrammatical conventions on page 165; on the novel's narrator, see Kerr (1992).

10. Melas (1995 and forthcoming) makes this point in much more depth and complexity than I can achieve here. Put a bit simplistically, a sole focus on non-elite culture leaves the distinction between "high" and "popular" culture in place.

11. See Barrington (1997) for a careful unpacking of the concepts of "nation" and "nationalism." This article is particularly helpful in suggesting ways to untangle possible confusions regarding First Nations' peoples' claims to sovereignty, with or without claims to territory.

12. My views on interdisciplinarity in the current practices of the humanities are elaborated in my recent book *Travelling Concepts in the Humanities: A Rough Guide* (2002).

References

Anderson, Benedict. 1991 (1983). *Imagined Communities.* London: Verso.

Appadurai, Arjun. 1997. "The Research Ethic and the Spirit of Internationalism." *Items* (Social Science Research Council, New York) 51, no. 4 (part I): 55–60.

———. 1999. "Globalization and the Research Imagination." *International Social Science Journal* 160 (June): 229–38.

———. 2000. "Grassroots Globalization and the Research Imagination." *Public Culture* 12 (1): 1–19.

Bal, Mieke. 2002. *Travelling Concepts in the Humanities: A Rough Guide.* Toronto: University of Toronto Press.

Barrington, Lowell W. 1997. "'Nation' and 'Nationalism': The Misuse of Key Concepts in Political Science." *Political Science and Politics* 30 (4): 712–16.

Bhabha, Homi. 1994. *The Location of Culture.* New York: Routledge.

———, ed. 1990. *Nation and Narration.* New York: Routledge.

Butler, Judith. 1993. *Bodies That Matter: On the Discursive Limits of "Sex."* New York: Routledge.

———. 1997. *Excitable Speech: A Politics of the Performative.* New York: Routledge.

Colomina, Beatriz. 1996. "Battle Lines." In *Rethinking Borders,* edited by John Welchman, 51–64. Minneapolis: University of Minnesota Press.

Culler, Jonathan. 1999. "Anderson and the Novel." *Diacritics* 29 (4): 20–39.

———. 2000. "Philosophy and Literature: The Fortunes of the Performative." *Poetics Today* 21 (3): 48–67.

Derrida, Jacques. 1988. "Signature, Event, Context." In *Limited Inc.* Translated by Samuel Weber, 1–23. Evanston, IL: Northwestern University Press.

Geertz, Clifford. 1983. *Local Knowledge: Further Essays in Interpretive Anthropology.* New York: Basic Books.

Glissant, Edouard. 1981. *Le discours antillais.* Paris: Editions du Seuil.

Kerr, Lucille. 1992. *Reclaiming the Author: Figures and Fictions from Spanish America.* Durham, NC: Duke University Press.

Kristal, Efrain. 1988. *Temptation of the Word: The Novels of Mario Vargas Llosa.* Nashville, TN: Vanderbilt University Press.

Melas, Natalie. 1995. "Versions of Incommensurability." *World Literature Today* 69, no. 2 (Spring): 275–81.

———. Forthcoming. *All the Difference in the World: Postcoloniality and the Ends of Comparison.* Stanford, CA: Stanford University Press.

Rizal, José. 1992 (1887). *Noli me tangere.* Madrid: Ediciones de Cultural Hispánica.

Singer, Brian C. J. 1996. "Cultural versus Contractual Nations: Rethinking Their Opposition." *History and Theory* 35 (3): 309–37.

Sommers, Doris. 1996. "About-Face: The Talker Turns." *Boundary* 23 (1): 91–133.

U Tam'si, Tchicaya. 1987. *Ces fruits si doux de l'arbre à pain.* Paris: Seghers.

Vargas Llosa, Mario. 1991 (1987). *El hablador.* Barcelona: Biblioteca de Bolsillo.

Verhoeff, Nanna. 2002. *After the Beginning: Westerns Before 1915.* Utrecht: University of Utrecht, Institute for Media and (Re)presentation.

Yewah, Emmanuel. 2001. "The Nation as Contested Construct." Special issue of *Nationalism Research in African Literature* 32 (3): 45–56.

Index of Proper Nouns and Titles

Homais, Monsieur (literary figure, Flaubert), 134
Homer, 125, 182; *Iliad*, 125
Hooch, Pieter de, 320
Hooper-Greenhill, Eilean, 286n2
Hull, Gloria T., 232n4
Hussein, Saddam, 155
Hutcheon, Linda, 371, 387n10, 387n13
Huysmans, Joris-Karl: *À rebours*, 100

Incarville (place-name in Proust), 86
India, 88–90, 94n26, 370, 456n9
Indonesia, 94n26
Ingarden, Roman, 205n8, 437n6
Ingres, Dominique, 307
Innis, Robert E., 140n19
Irigaray, Luce, 64n30; "The Mechanics of Fluids," 233n29; *Speculum of the Other Woman*, 233n29; *This Sex Which Is Not Mine*, 233n29; "Volume without Contours," 233n29
Irwin, Michael, 139n3
Iser, Wolfgang, 263n21, 413n16, 437n6; *The Act of Reading*, 205n8
Israel, 317, 327–28, 352, 386n8
Israelite (biblical term), 350, 354, 356

Jaafer (literary figure, *1001 Nights*), 16
Jael (biblical figure), 406, 409–11
Jakobson, Roman, 368
James, Henry, 448
James, William, 310
Jameson, Frederic, 204–5n5, 332n9, 422
Japan, 180, 183
Jarman, Derek, 399, 401; *Caravaggio*, 399
Jay, Martin, 93n14, 311n8
Jed, Stephanie, 62n3, 63n9, 64n16, 65n32; *Chaste Thinking*, 63n7
Jephthah (biblical figure), 339, 347, 349–51, 355–59, 361n19, 362n31
Jerubbesheth (biblical figure), 325, 327
Jerusalem (biblical place-name), 316, 325
Jesus (biblical and mythical figure), 361n10, 422
Jew, 373–74, 376, 378–79, 385
Joab (biblical figure), 316
Johnson, Barbara, 119, 156

Joseph (biblical figure), 418, 423, 425–27
Judges, book of, xx, 311n14, 327, 339–60, 362n24, 362n28, 409
Judith (biblical figure), xxi, 304–5, 406–11, 438n8
Jupien (literary figure), 85

Kallah (fictive name of biblical figure), 339, 345–47, 350, 360, 362n33
Kamuf, Peggy, 332n7, 382
Kant, Immanuel, 209, 211, 296, 424
Kaplan, Jonathan, 210
Keller, Evelyn Fox, 152–53, 157, 166n4, 232n3, 232n5, 232n8, 232n11, 232n15
Kemp, Wolfgang, 263n21
Kerr, Lucille, 456n9
Kierkegaard, Søren: *Stages on Life's Way* 233n35
Kilmartin, Terence, 140n21
Kiriath-sepher (biblical place-name), 347
Kittay, Eva, 166n4
Klein, Melanie, 286n10
Krauss, Rosalind, 233n41; *Le photographique*, 93n22
Kress, Gunther, 166n6
Krieger, Murray, 141n38
Kristal, Efrain, 456n9
Kristeva, Julia, 362n25, 410, 413n20
Kubler, George, 224, 233n37
Kuhn, Thomas S., 158, 162–65; "Objectivity, Value Judgment, and Theory Choice," 158; *The Structure of Scientific Revolutions*, 162

Lacan, Jacques, 72, 108, 244, 289, 324, 373; "L'instance de la lettre," 333n19
Lakoff, George, and Mark Johnson, 166n2, 438n16; *Philosophy in the Flesh*, 233n33
Lavin, Irving, 232n28
Lawrence, Karen, 437n1
Leclerc, Annie, 333n17
Le Corbusier (Charles-Edouard Jeanneret), 453
Leibniz, Gottfried, 212, 216, 221–22
Lemaire, Ton, 361n16, 386n7
Lentricchia, Frank: *Critical Terms for Literary Study*, 431

Index of Terms and Concepts

frame, framing (*continued*)
290–93, 299–305, 319, 326, 355, 396, 399,
403–12, 413n7, 431, 433, 437; of reference,
152, 242, 298, 433, 436; reframing, 292, 294–
95, 298, 307
freedom, 133–34, 249, 392, 445
free indirect: discourse, 256; focalization, 256–
57, 259; style, 5
French, 388n15, 444–45; Freudian view, 277
future, 53, 58–60, 62, 80, 224, 231, 310, 345, 347,
360, 380

gap, 253, 331, 419, 425, 437–38n6
gay, 68–69, 71, 77, 113
gaze, 17–18, 50, 53, 57, 69, 71–72, 75, 78, 80, 82–
85, 88, 90, 102–3, 116, 120, 128, 134, 218, 289,
294, 307–8, 317, 320, 322–24, 326; closeted,
71, 80, 90; disembodied, 83, 402; introspec-
tive, 314–15, 322
gender, xvii–xix, 38n32, 53–54, 63n13, 78, 112,
153, 163–64, 180, 198, 203, 211, 218, 230–31,
232n25, 246–47, 249, 275, 277, 282–85, 291,
298, 318, 321, 327, 361n12, 371, 377, 385,
388n22, 417, 422, 430–34; ambiguity, 246;
bending, 246, 249, 259; ideology, 328, 386–
87n9, 388n22, 425; as masquerade, 69,
92n5; reversal, 247
genealogy, 249
genocide, xxi, 385
genre, xix, 315, 321, 325, 342, 407, 427, 444, 454;
label, 313, 315–16, 330; in painting, 71, 321
geography, 185, 328–30, 438n17, 448
gestalt shift, 331
gesture, 184, 272, 352–54, 360, 370; pictorial,
246; symbolic, 354–55
ghostwriting, 296–97
gibbor, 345–46, 348–50, 353, 355, 357–59, 361n11
gift, 347–50, 352, 355, 360
glamour, 77, 82, 88
glance, 319, 402
global, 426, 429, 433, 453
globalization, xxiv, 445–46
God, 316, 391, 395–96, 412
gospel, 393
gossip, 406
grace, 401
grammar, 6, 139n8, 160

grammarians, 107–8
grandmother, 69, 77–78, 80–86
Greek, Greeks, 53, 120, 169, 182–84, 195,
206n29, 258
grief, 57–58
ground, 108, 112, 140n19, 262n8, 313
guilt, 31, 47
Gulf War, 155
gynophobia, 354

hair, 26, 31–34, 130, 227, 230, 406
hand, 99, 216, 323
hanging, 214, 229–30, 396, 406
happiness, 116, 284
"harlot," 356
hell, Dante's, 132
heritage, 189, 393
hero, 5, 85, 304, 339, 345, 358, 361n11, 386–
87n9, 410. *See also* anti-hero
heroine, xxi, 40–42, 101, 323, 410; Bathsheba,
327; Jael, 409; Judith, 304–5, 409; Lucretia,
41–42, 121, 125
heterocentrism, 354
heterogeneity, 97, 116, 136–38
heteropathic identification, 83–84, 86, 93n21,
427, 429, 435
heterosexuality, 354, 399, 422
history, 41, 53–58, 60, 65n32, 100, 107, 136, 163,
170–72, 174, 185–86, 189, 195, 197, 200–201,
215, 229–30, 240, 247, 259, 251, 260, 262–
63n16, 269, 273–74, 280–81, 285, 292, 299,
301, 308–10, 342, 348, 351, 356–58, 368–69,
371, 374–75, 377–78, 382–85, 386n8, 391,
395, 406–7, 412, 412n1, 415, 419, 433–34; di-
achronic, 251; *histoire*, 35n16; natural, 192,
201, 204; natural non-history, 186; of novel,
100–101, 107; oral, 369, 386n8; painting (*see
under* painting); political, 283, 340, 351; so-
cial, xvii, 340, 351, 413n5; synchronic, 251.
See also preposterous history
Holocaust, 225, 436; post-Holocaust, 426, 433;
pre-Holocaust, 426, 433, 435; representa-
tion, 225, 233n38; scholars, 435
holy war. *See under* war
home, 81; violation of, 225
homophobia, 354, 362n24
homosexuality, 68–69, 78, 85, 87, 90, 92, 112,